FIERY POOL

Peabody Essex Museum in association with Yale University Press, New Haven and London

FIERY POOL THE MAYA AN

DANIEL FINAMORE AND STEPHEN D. HOUSTON

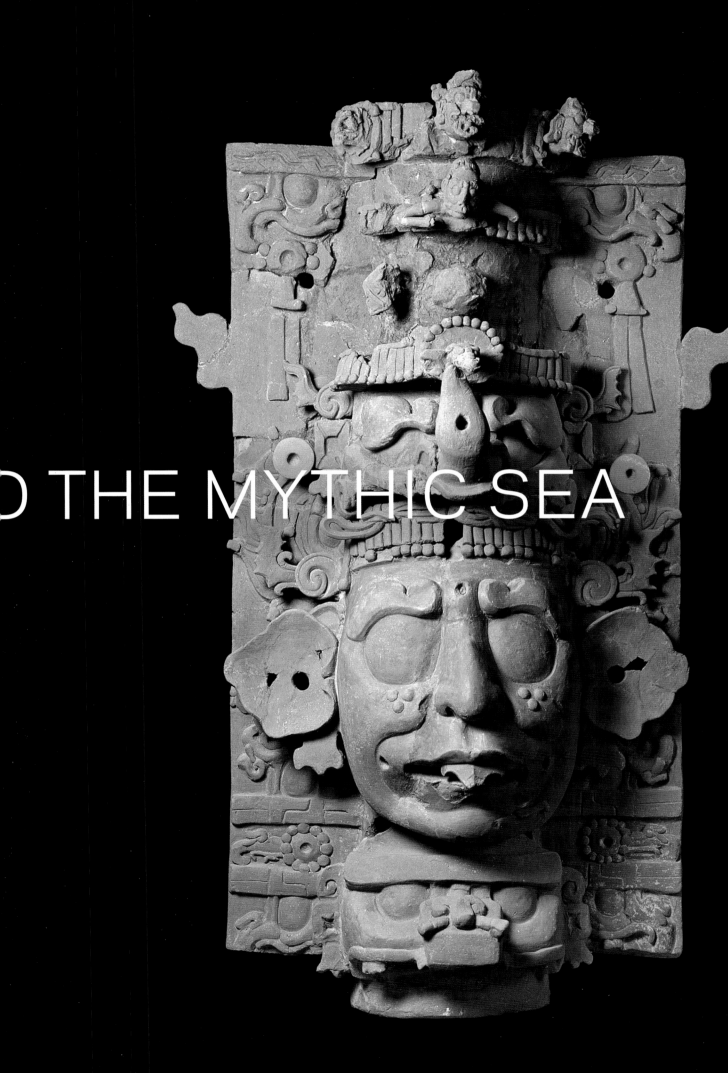

O THE MYTHIC SEA

Fiery Pool: The Maya and the Mythic Sea accompanies the
exhibition of the same name organized by the Peabody Essex
Museum, Salem, Massachusetts, on view from March 27
through July 18, 2010; and traveling to the Kimbell Art
Museum, Fort Worth, Texas, from August 29, 2010, through
January 2, 2011; and the Saint Louis Art Museum from
February 13 through May 8, 2011.

Peabody Essex Museum
East India Square
Salem, Massachusetts 01970
www.pem.org

Published in association with Yale University Press,
New Haven and London.

Yale University Press
302 Temple Street
P. O. Box 209040
New Haven, Connecticut 06520-9040
www.yalebooks.com

Library of Congress Control Number: 2009932103
ISBN: 978-0-87577-219-6 (Peabody Essex Museum, pbk)
ISBN: 978-0-300-16137-3 (Yale University Press, cloth)

 NATIONAL ENDOWMENT FOR THE HUMANITIES

This exhibition and book have been made possible in
part by the National Endowment for the Humanities:
Because democracy demands wisdom.

 EDUCATION THROUGH CULTURAL AND HISTORICAL ORGANIZATIONS ECHO ECHOSPACE.ORG

Additional support was provided by ECHO (Education
through Cultural and Historical Organizations), a program
of the U.S. Department of Education, Office of Innovation
and Improvement.

 Instituto Nacional de Antropología e Historia

 Consejo Nacional para la Cultura y las Artes

 MINISTERIO DE CULTURA Y DEPORTES Guatemala, C.A.

 INSTITUTE OF ARCHAEOLOGY BELMOPAN BELIZE C.A.

 iec TABASCO

 GOBIERNO DEL ESTADO DE TABASCO

 Fundación Televisa

Coordinated and edited by
Terry Ann R. Neff,
t. a. neff associates, inc.,
Tucson, Arizona
Designed and produced by
Studio Blue, Chicago
Typeset in Auto
and Galaxie Polaris
Printed by Conti Tipocolor, Italy,
on 150 gsm Burgo R400 Text
Color separations by
ProGraphics, Rockford, Illinois

CONTENTS

FOREWORD

Fire flutters upward; water trickles down or drops from the sky. He
is fascinated by liquid gravity, always descending, falling over, plunging,
flowing downstream, pouring into the sea. Fire draws what is caught
in it toward the sky like a passion that consumes you as it lifts you; water pulls
you under in its powerful embrace.

– D. L. Pughe on Leonardo da Vinci[1]

Not often does an exhibition offer an entirely new way of viewing the art of a great civilization. *Fiery Pool: The Maya and the Mythic Sea* does exactly that – by revealing and interpreting the importance of water to the Maya.

At the height of its achievement and power in the ancient New World, from 300 to 900, the Maya civilization encompassed hundreds of cities across Mexico and Central America; was exceptionally advanced in mathematics, astronomy, architecture, and art; practiced a complex religion; and perfected a glyph-based pictorial writing system. Today, our perceptions of this civilization and its environment span a wide gamut: from the terrestrial and urban, represented by lost jungle cities with dramatic pyramids, temples, tombs, and stone carvings; to the violent, evoked by practices incorporating blood and human sacrifice; and even to the hedonistic, conjured by the tourism industry's promotion of the Maya Riviera.

Ancient artistic imagery and writing systems can appear mysterious and impenetrable to those outside of a civilization whether because of time, place, or cultural differences. This has been especially true of the art and hieroglyphs left by the Maya as the principal clues to understanding their history, beliefs, and culture. More than eight hundred glyphs composed the elegant visual language that the Maya aristocracy and priesthood developed and had committed to ceramics, stone, shell, bone, and bark paper as part of their economic and religious system of power and tribute. Although the Spanish conquest of the Maya in the 1500s contributed greatly to the loss of the language's meaning, it is the complexity of the glyphs themselves that has presented the greatest challenge. What were long considered to be simply stylized pictures and symbols have come to be understood, since the initial decoding breakthroughs in the nineteenth century, as the keys to a decipherable cultural narrative and history.

Today, more than 90% of the known glyphs can be read, yet it was not until the late 1980s that a glyph for the sea was identified. This decoding, coupled with ongoing archaeological discoveries, has spurred concerted research and scholarship on a previously overlooked topic: Maya society prospered largely because it had developed a distinctive perspective on the sea that recognized its precious resources and pervasive influence on all aspects of life. *Fiery Pool: The Maya and the Mythic Sea* is the first major exhibition and publication devoted to this new interpretation: a larger, deeper narrative that moves us far beyond the traditional view of the Maya as a land-based civilization and their relationship to the sea as solely trade-related.

What emerges from this thematically organized exhibition is the unmistakable influence of how water coursing through their environment shaped the Maya's cyclical view of the world, carrying them from birth to rebirth. The Maya considered water an animating, intelligent force with the power to shape events; they perceived oceans, rivers, springs, and water's many other manifestations as united – literally, spiritually, and metaphorically. The sea was viewed as central to the structure of the universe, a source of life and fertility but also a fearsome, unknown place. The Maya imbued their representations of the sea and its inhabitants with sacred powers, and revered the relationship between the watery world and ancestral spirits. Ultimately, the sea was to be navigated on multiple levels: the real, the commercial, and the cosmic.

Of the almost one hundred artworks gathered for this landmark exhibition, many are acknowledged masterworks or new archaeological finds. Nearly half of the objects have never before been exhibited in the United States. Whether the works have been known previously or not, this project recognizes for the first time how integral their connections to the sea were to their conception, creation, meaning, and use.

The research and interpretation offered here represent, in effect, a highly inductive piecing together of a culture. Archaeological evidence,

exponential advances in decipherment, and extrapolation of ancient meanings and practices from contemporary manifestations of Maya culture – still extant throughout Mexico, Guatemala, Belize, and Honduras – have been brought together incisively and persuasively. Much of this is thanks to the project's cocurators, Daniel Finamore, The Russell W. Knight Curator of Maritime Art and History at the Peabody Essex Museum, and Stephen D. Houston, The Dupee Family Professor of Social Science and Professor of Archaeology at Brown University as well as a MacArthur Fellow recognized for his contributions to Maya studies. Finamore and Houston are to be congratulated for their scholarly leadership. To their respective areas of expertise, they have added that of a team of progressive scholars from diverse fields. The exhibition and publication are the fruits of this ambitious, interdisciplinary collaboration, encompassing art history and iconography, maritime culture and history, anthropology, archaeology, sociology, epigraphy, and Maya and Native American studies. We commend this team not just for its cumulative acumen but also for its exemplary spirit of generosity and collegiality. And to Finamore's and Houston's appreciative acknowledgment of the Peabody Essex Museum's talented staff, we add our own for the key roles that they have played in realizing the project's many and complex manifestations.

We are deeply grateful to the National Endowment for the Humanities, which provided timely and generous consultation and implementation grants. We thank NEH program officers Clay Lewis and Barbara Bays, as well as the anonymous reviewers of our grant proposals, for their respective guidance and endorsement. PEM would like to acknowledge the generous support of the US Department of Education's Office of Innovation and Improvement, through the Education through Cultural and Historical Organizations (ECHO) program for this exhibition and related programming. Marshaling this carefully selected group of works would not have been possible without the cooperation of our colleagues at museums in Mexico, Guatemala, Belize, Honduras, and the United States as well as those at the respective ministries of culture. Our thanks as well to our fellow institutions in Australia, the United Kingdom, and Canada. We especially thank the Kimbell Art Museum, Fort Worth, and the Saint Louis Art Museum for

joining us as venues for this nationally traveling exhibition. Our colleagues in Fort Worth and Saint Louis – Brent Benjamin, Eric McCauley Lee, Jennifer Casler Price, Matthew Robb, Linda Thomas, and Malcolm Warner – have embraced the project with energizing enthusiasm.

The Peabody Essex Museum is proud to present *Fiery Pool: The Maya and the Mythic Sea*. Dedicated to illuminating the relationship between art and culture, the museum relishes unexpected topics and fresh perspectives, and this project is part of our ongoing effort to redefine and expand the purview of maritime art and history. In addition to its revelatory findings and interpretation of the Maya as an ancient New World civilization, *Fiery Pool* also links this specific phenomenon to larger concepts with contemporary relevance. How can we understand the rise and fall of cultures? How can we read another culture and what is the role of language, writing, and art? Most timely of all is the relevance of water today. A potent, essential force in human existence and world culture, water speaks to our interconnectedness, especially as we increasingly contend with the challenges and politics of sustainability. From their understanding of water in all its forms, the Maya conceived of their environment as an ecosystem that shaped their sense of place in physical and mythical worlds. In directing our attention to what can be considered the Maya's aesthetics of ecology, *Fiery Pool* offers a telling reminder that the seemingly disparate – our time, our culture, our place in the world and those of an ancient yet still existing civilization – are connected through the elemental medium of water.

Dan L. Monroe, Executive Director and CEO
Lynda Roscoe Hartigan, The James B. and Mary Lou Hawkes Chief Curator

1. Pughe 2001.

STATEMENTS FROM INTERNATIONAL CONTRIBUTORS

Much of the territory in which the Maya culture flourished was situated close to the sea. The choice to settle in coastal areas of Mexico, bathed by the currents of the Gulf of Mexico and Caribbean Sea, hardly seems coincidental given that the ancient Maya cultivated a notable link with their natural environment and endeavored to develop in harmony with it – an important lesson for us all. In one sense, the Maya did not recognize a radical separation between the earth and the sea, thanks to their particular vision of the cosmos.

Contact with the sea influenced the creation of many objects in this exhibition, such as cache offerings, incense burners (*incensarios*), pottery vessels, pectoral ornaments, and architectural columns, most of which also bear distinctive decorative motifs that symbolize their association with watery environs. The use of marine animal remains, such as stingray spines and conch shells, for everyday items, as well as ritual paraphernalia and offerings, further strengthens this link between the sea and Maya material culture. Thanks to the preservation and meticulous study of such artifacts (conducted by both Mexican and foreign archaeologists), we are now closer than ever to understanding a complex civilization and its intimate relationship with the marine world.

It remains worthwhile to observe carefully the minute details that decorate the objects in this exhibition, since many of them express beliefs held by the ancient inhabitants of southern Mexico. Moreover, they also convey narratives about the activities and behaviors of the myriad deities that comprise the Maya pantheon. For example, the iconography on the Becan bowl (plate 82) offers us a window into Maya myth and worldview, since it represents the role of cosmic creatures in the creation of life. The incense burner from Palenque (plate 25), on the other hand, constitutes one of the finest sculpted representations of the Sun God, shown here with his characteristic sharklike features, emerging from the sea and reflecting the movement of the sky-band throughout the day.

For the Instituto Nacional de Antropología e Historia, this magnificent exhibition provides a new opportunity to present the art and knowledge of one of the most complex and fascinating civilizations of antiquity.

Alfonso de Maria y Campos, Director General,
Instituto Nacional de Antropología e Historia, Mexico City

Ancient Maya culture is well known for its social, economic, and political complexity, as well as for its hieroglyphic writing system and expressive imagery. This legacy is abundantly represented in the Museo Nacional de Arqueología e Etnología de Guatemala. Established in 1947, the Museo Nacional came into existence when Salon 5, in the Finca La Aurora in Guatemala City, was selected as the national repository for a large and important collection of Maya artifacts. The museum building, erected in the 1930s, has itself become part of the national patrimony. Guatemalan law affirms that any public work older than fifty years forms part of the inventory of national treasures. The museum now fits into that category.

Today, the Museo Nacional promotes the basic doctrine of protecting, conserving, and permitting responsible and well-informed access to its cultural riches, with the aim of serving both the general public and the scholarly community. We are therefore honored to participate in *Fiery Pool: The Maya and the Mythic Sea*, an excellent opportunity to share the extraordinary cultural heritage of Guatemala with the outside world. The topic for the project is both novel and well defined. It demonstrates the physical and ritual importance of water in Maya society, as perceived through a cosmological lens, and as channeled through a spiritual perspective that is profoundly grounded in Maya civilization.

It is well known that concentrations of Maya archaeological sites are frequently located in areas close to water, primarily because this fluid is indispensible for the subsistence of any society. Moreover, the ritual importance of water, which is represented in various Maya art scenes, sometimes metaphorically, demonstrates its incontrovertible spiritual nexus and ritual centrality for ancient Maya society.

The ancient Maya had relatively restricted access to materials associated with water, such as marine shells and conchs and stingray spines. This is supported by the fact that most of these artifacts have been discovered in royal funerary contexts, showing their ritual relevance to a high stratum of society.

Given the media focus that this exhibition will elicit with a foreign public, and as an institution connected with the Ministerio de Cultura y Deportes de Guatemala, we are honored to support this presentation of aquatic imagery in various works of ancient Maya art. Furthermore, a collaboration with the Peabody Essex Museum, an institution with a long, notable, and international history, makes the Museo Nacional de Arqueología e Etnología de Guatemala proud to share these embodiments of Guatemala's deep and varied culture.

A further point: a great number of pieces in this exhibition are the product of recent investigations by bi-national projects working in Guatemala, mostly supported by universities in the United States of America that not only promote scientific research, but also the conservation and protection of cultural patrimony. As a result of these academic interventions, our knowledge of ancient Maya societies has become clearer, motivating an ever greater number of scholars to delve further into these studies. *Fiery Pool* exemplifies that collaboration, and it is our wish and expectation that it will stimulate interest abroad in the rich cultural patrimony of Guatemala.

Juan Carlos Meléndez Mollinedo, Museo Nacional de Arqueología y Etnología de Guatemala

The National Institute of Culture and History and the government of Belize are very pleased to participate in this exhibition and book, and take great pride in the opportunity to highlight and share some of the great treasures that have been uncovered in our country. The quality and uniqueness of the objects from Belize are tangible testimony of the important role that Belizean sites played in the maritime world of the ancient Maya. At the same time, they reflect the international significance and artistic value of our national collection. We are especially pleased to feature the great jade head from Altun Ha – the crown jewel of Belize. We hope that those who read this book but do not get the opportunity to see the exhibition will come to visit us in Belize where we can share with them these and countless other relics or our great Maya heritage.

Jaime J. Awe, Director, Belize Institute of Archaeology

ACKNOWLEDGMENTS

Though the ideas presented here coalesced over many years, this volume and exhibition emerged from a series of conversations in which Patricia A. McAnany played a central role. She and Daniel Finamore were exploring the prospect of a thematically focused Maya exhibition, while she and Stephen D. Houston were sharing their thoughts about the many forms of evidence that pointed to the sea as a central force in Maya life. The two conversations converged and the project was born. In November 2006, several archaeologists and art historians working on facets of the topic came together at the Peabody Essex Museum for a brainstorming session. Jaime J. Awe, Oswaldo Chinchilla Mazariegos, Rafael Cobos, Heather McKillop, Mary E. Miller, and Karl A. Taube all helped to shape the concept based on new research and important objects. Patricia A. McAnany ultimately moved on to other projects, but Karl A. Taube continued to impact our thinking to a notable extent, especially in his conviction that cycles and their hydrological connections were fundamental elements of the thesis. In a subsequent National Endowment for the Humanities-sponsored consultation meeting, Kathleen Berrin and Richard Townsend joined the project and museum team to help articulate the exhibition.

In addition to those above who contributed to the book, the following authors shared their valuable expertise: James E. Brady, Barbara W. Fash, David A. Freidel, Simon Martin, Luis Alberto Martos López, Megan O'Neil, Michelle Rich, Matthew Robb, George Schwartz, David Stuart, and Marc Zender. Students in the Brown University spring 2009 Mesoamerican Graduate Seminar, led by Houston, crafted many of the entries. We thank Nicholas Carter, James Doyle, Caitlin Walker, Nathaniel Walker, and Cassandra Mesick, who additionally translated some text to English. Victoria Lyall also contributed an object entry. Other colleagues and friends shared specialized knowledge, information, and insights from their research on the Maya to help make this project the best it could be. We thank Jeffrey P. Brain, Lori Collins, Travis Doering, William L. Fash, Christian Feest, Virginia M. Fields, Elizabeth Graham, Nikolai Grube, John W. Hoopes, Heather Hurst, Reiko Ishihara, Julie Jones, Colin McEwen, Virginia Miller, Joel Palka, David Pendergast, Dominique Rissolo, Leslie C. Shaw, Loa Traxler, and Jaroslaw Zralka. To many more not named here, we offer our gratitude.

A project that is international in scope, such as *Fiery Pool: The Maya and the Mythic Sea*, requires the help of many. Numerous individuals and organizations were generous with ideas and logistical assistance that proved vital in avoiding the abundant shoals and eddies along our course. Bertha Cea Echenique, cultural affairs specialist in the United States Embassy in Mexico City, graciously shared her experience and insights regarding international loans. We also thank US cultural affairs specialists Carmen M. de Foncea in Guatemala City and Chantal S. Dalton in Tegucigalpa. We are particularly grateful to Alfonso de María y Campos, Director General of the Instituto Nacional de Antropología e Historia (INAH) for his enthusiastic reception of our project, and Miriam Kaiser for managing our complex requests with skill and dedication. Other INAH staff who facilitated the project include Leticia Pérez Castellanos, Marco Antonio Carvajal Correa, Juan Antonio Ferrer Aguilar, Elisabeth Flores Torruco, Emiliano Gallaga Murrieta, Pilar Luna Erreguerena, Jacobo Mugarte Moo, José Enrique Ortiz Lanz, Trinidad Rico Valdés, Juan Manuel Santín, Federica Sodi Miranda, Adriana Velásquez, and Benito Venegas Durán; Ricardo Armijo guided us around Comalcalco to our edification. Elsewhere in Mexico, we thank Rebeca Perales Vela, Diana Mogollón González, Roberto García Moll, Don Alejandro Yabur, and Doña Marina and Don Manuel of the cacao plantation "El Chontal" in Comalcalco.

In Guatemala, every member of the cultural service was unfailingly and enthusiastically helpful. We are grateful to Jerónimo Lancerio Chingo, Minister of Culture and Sports, Héctor L. Escobedo, Vice Minister of Sports and Recreation, and all the staff of the Instituto de Antropología e Historia (IDAEH), including Guillermo Díaz Romeu, Erick Ponciano, Juan Carlos Meléndez Mollinedo, and Claudia Monzón, along with Jenny Guerra of the Museo Nacional de Arqueología y Etnología. Beyond IDAEH, we thank Susana Campins, Gabriel Dubón de Deulofeu, Alejandro Enrique Deulofeu Munive, and Coralia Inchisi de Rodriguez.

In Belize, we appreciate the support of Manuel Heredia, Jr., Minister of Tourism and Civil Aviation, as well as Diane Haylock, Lita Krohn, John Morris, and Theresa Batty from the Belize National Institute of Culture and History.

In Honduras, Rodolfo Pastor Fasquelle, Minister of Culture, Arts, and Sports at the time this volume went to press, along with the staff of the Instituto Hondureño de Antropología e Historia, including Darío A. Euraque, Eva Martinez, and Salvador Varela, provided valuable assistance.

We have been lucky to benefit from the expertise and camaraderie of a team of publications professionals. We are very grateful to Terry Ann R. Neff for her thoughtful and supportive editing and management of this complex publication. The design and production team at Studio Blue, including Kathy Fredrickson, Cheryl Towler Weese, Lauren Boegen, and Claire Williams, have made a stunning presentation of frequently difficult visual material. In addition, we thank Patricia Fidler of Yale University Press, our copublisher, as well as the indefatigable Jorge Pérez de Lara, who traveled extensively to create the photography we requested.

At the Peabody Essex Museum, Executive Director Dan L. Monroe and Deputy Director Josh Basseches provided the incisive leadership that made this project possible. Lynda Roscoe Hartigan, The James B. and Mary Lou Hawkes Chief Curator, generously shared her creative energies and expertise in organizing complex publications and exhibitions to enable and guide us in many ways. No individual has been more dedicated to making this project a success than George Schwartz, Assistant Curator for Exhibitions and Research. He took on numerous critical roles as tireless researcher, author, rights and reproductions manager, liaison to photographers and authors, and so much more. Other PEM staff who contributed to the project include Gavin Andrews, Mary Beth Bainbridge, Susan Bean, Sidney Berger, Christine Bertoni, Anne Butterfield, Karen Moreau Ceballos, Allison Crosscup, Priscilla Danforth, Jeff Dykes, Jennifer Evans, Jay Finney, Peggy Fogelman, Rebecca Hayes, Mark Keene, Steve Klomps, Mimi Leveque, Kate Luchini, Gloria Martinez, Sloane Milligan, Will Phippen, Karen Kramer Russell, Sam Scott, Claudine Scoville, Anna Siedzik, Walter Silver, Gwendolyn Smith, April Swieconek, Rosario Ubiera-Minaya, Erica Udoff, Carrie Van Horn, and Eric Wolin. Dave Seibert and Kurt Weidman of Museum Design Associates crafted an inspiring installation.

In addition, we greatly appreciate the professional and personal courtesies offered by the following individuals: Bianca Finley Alper, Lynne Addison, Anthony P. Andrews, Melody Barker, Howard and Peter Barnet, Eric Beggs, Louise Belanger, Sue Bergh, Steve Bourget, Barry Bowen, Kate Buckingham, Gudrun Bühl, Marci Driggers Caslin, Rebecca Ceravalo, Arlen and Diane Chase, John Edward Clark, Allan Cobb, Roger Colten, Sandra Critelli, Deanna Cross, Gabriele Daublebsky, Felipe Dávalos, Patty DeCoster, Jessica Desany, Maria Didrichsen, Mark Dimunation, Christine Dixon, Miriam Doutriaux, Megan Doyon, Arthur Dunkelman, Anne Fahy, Enrico Ferorelli, Viva Fisher, Yvonne Fleitman, Joyce K. Gherlone, Maureen Goldsmith, Darrell Green, Susan Grinols, Fiona Grisdale, Jeff Harrison, Susan Haskell, Alexia Hughes, Sylvia Inwood, Justin Jennings, Paula Johnson and Carl Fleishhauer, Bryan Just, Nikolaos Kaltsas, Sara Kelly, Justin and Barbara Kerr, Veronica Keyes, Jonathan King, Tara Kowalski, Stephen Lash, Barry Landua, Deirdre Lawrence, Erin Lopater, Diana Loren, Susan Lunt, Kristen Mable, Irene Martin, Susan Matheson, John McAlpin, Gretchen Shie Miller, Alison Tubini Miner, Maria Murguia-Harding, Juan Antonio Murro, Kathleen Mylen-Coulombe, Helen Najarian, Nick Nicholson, Patricia L. Nietfeld, Bryanna O'Mara, Joanna Ostapkowicz, Nathan Pendlebury, David Pentecost, Ed Pollard, Nii Quarcoopome, Karen E. Richter, Carol Robbins, Merle Greene Robertson, Gary Rosenberg, Ella Rothgangel, Agata Rutkowska, Elizabeth Saluk, Erik Satrum, Carolyn Schroer, Sarah Schroth, Myra Scott, Joel Skidmore, Michelle Smith, Phyllis Smith, Rajshree Solanki, Charles Spencer, Lou Stancari, Joel Sweimler, Rachel Swiston, Barbara Tenenbaum, Patricia Tomlinson, Dirk Van Tuerenhout, Saskia Verlaan, Patricia Virasin, Jeri Wagner, Rachel Waldron, Catherine Jordan Wass, Nicola Woods, Margaret Young-Sanchez, Jeff Zilm, and Marta Zlotnick.

Finally, we offer our most heartfelt thanks to Michelle Finamore and Nancy Houston, for their unflagging support as well as their patient acceptance of our obsession with this project.

Daniel Finamore and Stephen D. Houston

CONTRIBUTING AUTHORS

James E. Brady (JEB)
Professor of Anthropology
California State University, Los Angeles

Nicholas Carter (NC)
Graduate Student, Department of Anthropology
Brown University, Providence, Rhode Island

Rafael Cobos Palma (RCP)
Profesor Investigador
Universidad Autónoma de Yucatán, Mérida, Mexico

James Doyle (JD)
Graduate Student, Department of Anthropology
Brown University, Providence, Rhode Island

Barbara W. Fash (BWF)
Director, Corpus of Maya Hieroglyphic Inscriptions
Peabody Museum of Archaeology and Ethnology,
Harvard University, Cambridge, Massachusetts

Daniel Finamore (DF)
The Russell W. Knight Curator of Maritime Art
and History
Peabody Essex Museum, Salem, Massachusetts

David A. Freidel (DAF)
Professor of Anthropology
Washington University in Saint Louis

Stephen D. Houston (SDH)
The Dupee Family Professor of Social Sciences /
Professor of Archaeology
Brown University, Providence, Rhode Island

Victoria Lyall (VL)
Graduate Student, Department of Art History
University of California, Los Angeles

Heather McKillop (HM)
The William G. Haag Professor of Archaeology
Louisiana State University, Baton Rouge

Simon Martin (SM)
Associate Curator, American Section
University of Pennsylvania Museum of Archaeology
and Ethnology, Philadelphia

Luis Alberto Martos López (LML)
Director of Archaeological Studies
Instituto Nacional de Antropología e Historia (INAH),
Mexico City

Cassandra Mesick (CM)
Graduate Student, Department of Anthropology
Brown University, Providence, Rhode Island

Mary E. Miller (MEM)
Dean of Yale College / Sterling Professor of History of Art
Yale University, New Haven, Connecticut

Megan O'Neil (MO)
Assistant Professor of Art History
University of Southern California, Los Angeles

Michelle Rich (MR)
Graduate Student, Department of Anthropology
Southern Methodist University, Dallas

Matthew H. Robb (MHR)
Assistant Curator, Ancient American & Native
American Art
Saint Louis Art Museum

George Schwartz (GS)
Assistant Curator for Exhibitions and Research
Peabody Essex Museum, Salem, Massachusetts

David Stuart (DS)
The Linda and David Schele Professor of Mesoamerican
Art and Writing
University of Texas at Austin

Karl A. Taube (KAT)
Professor of Anthropology
University of California, Riverside

Caitlin Walker (CW)
Graduate Student, Department of Anthropology
Brown University, Providence, Rhode Island

Nathaniel Walker (NW)
Graduate Student, Department of the History of Art
and Architecture
Brown University, Providence, Rhode Island

Marc Zender (MZ)
Lecturer, Department of Anthropology/
Research Associate of the Corpus of Maya
Hieroglyphic Inscriptions of the Peabody Museum
of Archaeology and Ethnology
Harvard University, Cambridge, Massachusetts

INTRODUCTION

DANIEL FINAMORE AND STEPHEN D. HOUSTON

Surrounded by the sea in all directions, the ancient Maya people of Central America viewed their world as one bounded by and integrally tied to water. To the Maya, oceans, rivers, springs, clouds, and rain were a unity, enveloping and infusing the terrestrial world with its influence. Water was more than the essential compound that sustained people and the foods they ate. It was the fundamental and vital medium from which the earthly world emerged, gods arose and returned to at death, and where ancestors resided. Above and below, on all four sides, in their past and in their future, water, embodied primarily by the sea, was the defining feature of the Maya spiritual world and the inspiration for much of their finest art.

Fiery Pool: The Maya and the Mythic Sea greatly broadens our understanding of ancient Maya people by exploring the profound but little recognized influence the oceans, and water generally, had on their perception of the world around them. Until recently, the Maya have been viewed as a group of related peoples who were deeply oriented to land. The bulk of scholarly research has looked inward to the great urban centers such as Tikal and Chichen Itza in the lowlands, and Copan in the highlands to the south, where complex social hierarchies and the agricultural systems necessary to support them have been the central focus. Meanwhile, studies of Maya art, including the most prominent museum exhibitions, have targeted the importance of kingship and lineage.[2] In retrospect, these tendencies have led to a somewhat overstated perspective on the Maya as a people concerned exclusively with genealogy, dynastic conflict, and terrestrial space. Far more often than previously recognized, the ancient Maya turned to the sea in thought, in art, and to seek objects they perceived to be of great value. This new orientation to Maya iconography and symbolism offers a holistic interpretation that integrates facets of Maya life that were previously viewed as distinct. It also delineates commonalities in beliefs over many centuries and across cultural boundaries, in ways that propose far-reaching insights into the Maya and neighboring peoples.

In the ancestral Maya worldview, the Yucatan peninsula floated like a turtle on the navigable waters of the Gulf of Mexico and the Caribbean Sea and, metaphorically, within a blazing basin of water known anciently as the *K'ahk' Nahb*, the "fiery pool," a reference to the sun as it rises in the Caribbean and sets in the Gulf of Mexico. Supernatural crocodiles breathed forth the clouds that brought rain. In primordial times, the same sea adopted the tinge and essence of blood, and was a place where cosmic battles took place between gods and sharks, and where monstrous crocodiles lost their heads in acts of decapitation. On this "platform" surrounded by coursing water, Maya society prospered and developed a distinctive perspective of the sea, its precious resources, and its pervasive influence on all facets of life.

A wealth of extraordinary art objects attests to the sacredness of the sea in Maya thought and daily life, but many of the clues that have expanded our understanding of them have emerged from major recent advances in the translation of Maya iconography and hieroglyphs. The art and culture of the ancient Maya were first brought under the glass of European scholarship in 1822, when a British publisher printed the profusely illustrated account of a semiscientific expedition to Palenque in 1787 that had been supported by the Spanish monarchy.[3] The Maya became a focus of popular fascination with the publication in 1841 and 1843 of the best-selling books by travel writer John Lloyd Stephens and his artist companion Frederick Catherwood.[4] Over time, researchers interpreted the iconography on stelae and architectural friezes as representing a culture where priests and astronomers ruled peacefully within largely vacant architectural centers. That vision was shaken in the 1960s and 1970s by evidence of aggressively competitive city-states. These were controlled by dynastic rulers who tortured and executed their captured enemies and sacrificed their own blood in rituals to consolidate their power. Texts that were once viewed as little more than royal genealogies and date sequences are now known to be stories within a broader narrative of the Maya people. Today, another profound interpretive shift is underway, based in a more nuanced understanding of Maya iconography, beliefs, and a script that is being read with ever increasing accuracy. With these epigraphic advances, the once-fragmented iconographic elements of their art can now be interpreted as components of a synthetic artistic and cultural expression that provides new and exciting insights into the ancient Maya perception of and perspective on their world.

Recognition of the centrality of the sea in the Maya worldview has been slow to emerge. Otherwise prescient about the significance of discoveries, Mayanist Alfred Tozzer stated in his posthumously published magnum opus on Chichen Itza that "boats and water scenes are seldom represented in Maya art."[5] At the time of his death in 1953, several important objects that are now known to reference water had been discovered, though the Maya as seafarers had been directly addressed in only one significant essay by Eric Thompson.[6] The famed Dresden Codex, one of four surviving Maya books, includes images of deities paddling canoes. These images had circulated among scholars since the first facsimile was published in 1848, but were viewed in the context of these texts as astrological almanacs. The appearance of Thompson's article prompted a discussion on actual Maya boat technology and design that continued for several decades. By the 1960s, discoveries of deposits of marine shells indicated that despite the primacy of maize agriculture, the sea was in some capacity also a source of food. Though framed as a discussion of subsistence, a 1971 essay by Frederick Lange included a category he called "marine-oriented religious evidence," which took account of cached shark teeth and stingray spines and spawned attention to the prospect of more robust interpretation involving raw materials and ritual objects.[7]

Questions concerning trade routes and contacts were largely the realm of theorists until the mid-1970s, when Anthony P. Andrews initiated archaeological surveys of coastal and island sites. Further ongoing investigations, for example by Heather McKillop, are contributing to a deeper understanding of the coastal Maya and their physical interaction with the sea. In particular, the work by Bruce Dahlin and others at Punta Canbalam in the north of Yucatan have highlighted physical and environmental

changes such as sea level rise and resultant erosion that must be account-ed for when studying coastal areas. Since the first dredging of the Cenote of Sacrifice at Chichen Itza in 1904, underwater discoveries have both illus-trated the importance of the watery netherworld in Maya cosmology and also provided some of the most important boat imagery. Maritime surveys of harbors and reefs, however, have yet to reveal an actual Precolumbian Maya canoe.

The isolated presence of shells and shell motifs had been noted by many researchers, but the prevalence and potential significance of sea im-agery as a body of iconography were first addressed directly by Arthur Miller in his 1982 study of the murals of Tancah, Tulum, and Xelha.[8] Perched on the eastern edge of the Maya realm, the imagery was largely interpreted from the perspective of its coastal milieu, but the internationalized art style made clear that its cultural significance was far-reaching. A 1998 issue of *Arqueología Mexicana* drew together archaeological and iconographic sources to examine Maya seaborne activity, but a truly multidisciplinary approach to the role of water among the Maya is decidedly new. Nicholas Dunning and Stephen D. Houston have recently synthesized epigraphic, iconographic, and environmental sources to highlight the discernible impact and legacy of hurricanes on the lowland Maya.[9] In similar fashion, Lisa Lucero and Barbara W. Fash have gathered evidence from architecture, iconography, and city-planning to elucidate the role of ritualized water man-agement in sacred kingship.[10]

This book casts a yet wider net that integrates these approaches into a holistic interpretation of the sea in Maya mythology, religion, and world-view. *Fiery Pool: The Maya and the Mythic Sea* presents a cross-disciplinary approach to the sea in the Maya world. Four major essays on key themes incorporate insights from art, archaeology, epigraphy, maritime history, and Native American studies. These are interspersed with eight shorter essays by experts in the field that address specific significant aspects of the topic. In-depth entries on each of the objects in the exhibition follow each section. A final coda reflects upon the wealth of ideas put forth in the book within the broader context of world art through time and place.

The introductory essay by Mary E. Miller and Megan O'Neil provides a background for the non-Maya specialist, exploring how the impulse to create art captured the reality of their world. The authors consider the materiality of Maya art, how the artists responded to and worked within their environmental milieus, as well as the conventions of representation for humans, deities, and their settings. They address who saw Maya art, what they saw within it, and its relationship to accompanying text.

In his essay, Stephen D. Houston analyzes the representation and meaning of the watery world within Maya cosmology. Iconographic and textual references to the maritime world yield insights into how the Maya represented water; what it signified as a liquid and, at times, sentient force; how the Maya cited the sea, water, and the creatures therein, includ-ing gods and supernatural beings; and sea imagery that illustrates the centrality of water and its denizens as the source of life and fertility as well as a fearsome place of the unknown.

For the Maya, the spiritual and corporeal realms of the sea were not distinct. In the third essay, Daniel Finamore explores objects related directly to maritime travel, including those made from materials acquired beyond the Maya realm and images of cosmic canoes and voyages. Luxury goods and works in gold, jade, and other materials were the product of canoe voyages and reflected the sacred power of the sea. The author discusses how, where, and why the Maya traveled by sea, as well as the function seafaring served in Maya culture that elevated the boat to a stature warranting reverential artistic representations.

Karl A. Taube's effervescent final essay investigates the role of the sea in ancient Maya creation mythology and cosmology. The Maya conceived of creation as the slaying of a primordial ocean crocodile to fashion the world. The earth floated atop the sea and cenotes, lakes, and streams were portals to the primordial and supernatural watery Underworld. The east-ern Caribbean held special importance, not only as the daily birthplace of the sun, but also as the source of clouds and wind that bring the spring and summer rains. The author presents a pan-Mesoamerican viewpoint that incorporates culturally connected groups such as Teotihuacan and the Aztecs, along with later Maya, to support deeper concepts about the Maya sea.

The Maya thought about the sea more frequently than most of them encountered it physically. Their representations were not always rooted in familiarity, but reflect both cultural interpretations and artistic stylizations based on mythology and history that arose within their regional geogra-phy. The Maya view of water and its creatures articulated throughout this volume is strikingly similar to the increasingly sophisticated perspective gaining acceptance by modern scientific society, in which the waters of the earth support interdependent communities of species that are integral to each other's survival. Though visually distinct, this environmental per-spective embraced by the Maya framed the creation and interpretation of their art in much the same manner as occurred in other traditions around the world, including that of Europe. It is easy to fixate on the blood rituals and sacrifice as examples of how differently from modern people the Maya perceived and interacted with their world. But diversity, sophistication, and strong regional and temporal variation notwithstanding, Maya art reflects a group of peoples whose insights into the world around them find compelling parallels in other times and places.

1
"Titulo de los Senores de Zacapulas," in Estrada Monroy 1979, p. 9. Translation by Stephen D. Houston.

2
The most significant and influential exhibitions of Maya art within the last twenty-five years have been *The Blood of Kings: A New Interpretation of Maya Art* (Kimbell Art Museum, Fort Worth, and the Cleveland Museum of Art, 1986); *Courtly Art of the Ancient Maya* (National Gallery of Art, Washington, and Fine Arts Museums of San Francisco, 2004); and *Lords of Creation* (Los Angeles County Museum of Art, Dallas Museum of Art, and The Metropolitan Museum of Art, New York, 2005–2006).

3
Río and Cabrera 1822.

4
Stephens 1984.

5
Tozzer 1957, p. 227.

6
Thompson 1949.

7
Lange 1971.

8
A. G. Miller 1982.

9
Dunning and Houston in press.

10
Lucero and B. W. Fash 2006; Lucero 2006C.

VISUAL GLOSSARY OF WATER AND CREATURES

	Water	Water lily	Conch shell	*Spondylus*	Fish
Preclassic 2000 BC–AD 250	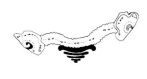				
Early Classic 250–600		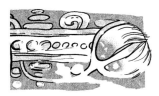			
Late Classic 600–900					
Postclassic 900–1500	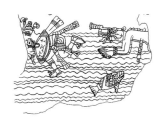				

Crocodile	Turtle	Shark	Water Lily Serpent	Plumed serpent

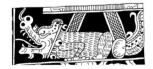 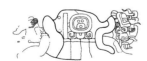 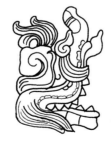 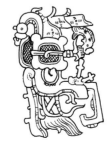 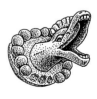

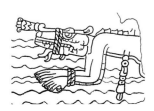 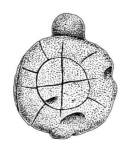 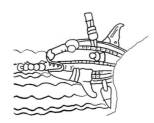

VISUAL GLOSSARY OF DEITIES

	Chahk	Shark Sun God	Sun God (solar deity)	Jaguar God of the Underworld
Preclassic 2000 BC–AD 250				
Early Classic 250–600	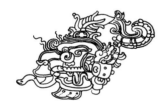	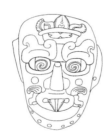	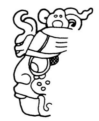	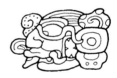
Late Classic 600–900	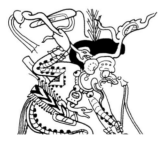		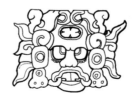	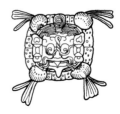
Postclassic 900–1500				

	Maize God	God L	God N

 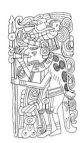 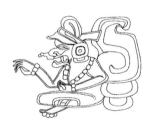

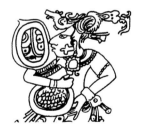 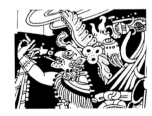

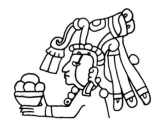

MAYA SITES

GULF OF MEXICO

MEXICO

Paredón

Pachuca

Tula

Ucareo

Teotihuacan

La Mojarra

Cacaxtla

Tres Zapotes

Pico de Orizaba

La Venta

Ticumán

Chalcatzingo

San Lorenzo

Monte Alban

PACIFIC OCEAN

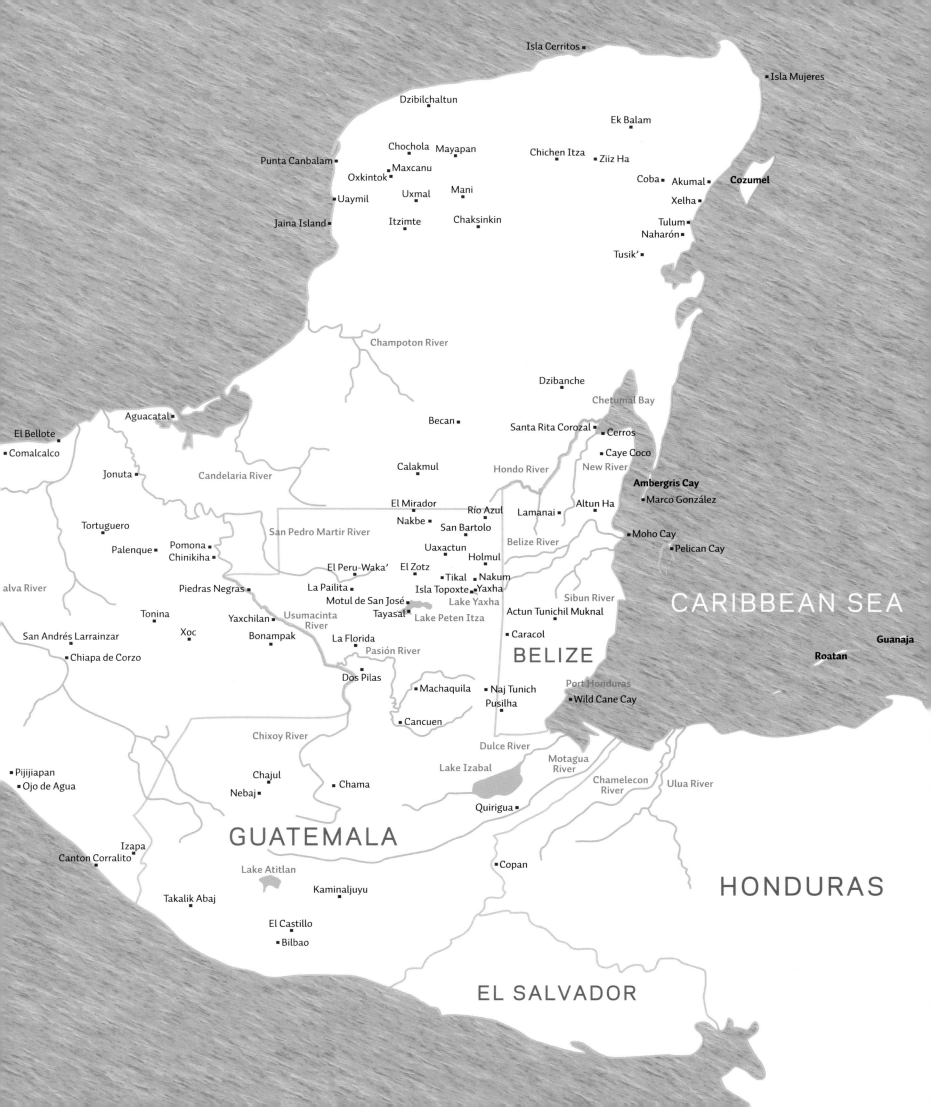

THE WORLD OF THE ANCIENT MAYA AND THE WORLDS THEY MADE

MARY E. MILLER AND MEGAN O'NEIL

Deciphering the Maya world One after another, Spanish explorers – Francisco de Córdoba in 1517, then Juan de Grijalva in 1518, and finally, Hernán Cortés in 1519 – sought to invade the Maya lands via Yucatan but found themselves under attack when they attempted to do so. Although the Aztec capital would fall to Cortés and his native allies in 1521, the Maya of Yucatan did not succumb to Spanish rule until 1542. European diseases, however, spread rapidly across the landscape, decimating populations who had not set eyes on these men from the sea. Yet, despite these massive population losses, elements of ancient Maya civilization persisted, and there are records of hieroglyphic writing in the Yucatan from as late as 1697, when Tayasal (in Lake Peten Itza) finally ceded to Spanish rule. In fact, it was a series of Maya hieroglyphic syllables written down by Gaspar Antonio Chi, a Maya scribe from Mani, at the insistence of Bishop Diego de Landa in the 1550s, that later became the key to the decipherment of ancient Maya inscriptions.

At the same time as human populations declined, an encroaching tropical rainforest, both scrub and high canopy, protected the ancient cities – most of them already centuries in ruin – from the plundering and predations that destroyed the Aztec monuments. It was also good fortune that the Maya had held almost none of the gold or other precious metals that the Europeans desired. For most of the Spanish colonial era, the ancient Maya cities slumbered as Maya peoples from highland Guatemala to Yucatan adjusted to a new global order and a new religious mandate. Although not the first outsiders to see the ruins, John Lloyd Stephens and Frederick Catherwood, who traveled to the Maya lands in 1839 and began publishing their best-selling accounts in 1841, would be the first to disseminate detailed images of cities, monuments, and texts, promoting a notion of a literate Maya civilization. However, they would not be the ones to call it that.[2]

Previous spread. Maize field, western Chiapas, Mexico; and Figurine of the young Maize God emerging from a corn stalk (plate 16).

Exploration and naming of ancient cities would give way to sustained archaeology beginning at Copan, Honduras, in the nineteenth century, to be followed by work at Chichen Itza, Mexico, and Uaxactun, Guatemala, early in the twentieth. Today, major archaeological investigation continues all across the Maya world, from Copan in the south to Ek Balam in the north and Palenque in the west (map, pages 22–23). A parallel exploration of libraries in the nineteenth century turned up three preconquest Maya hieroglyphic manuscripts, in addition to colonial-period Spanish documents, including Bishop Landa's account, that shed light on ancient Maya practices. Popular travel and increased excavations brought both ancient and living Maya to greater international attention over the course of the twentieth century; particularly under the influence of Franz Boas, ethnologists took to the field, documenting patterns of life, culture, and language.[3] Yet, the contemporary Maya would diverge along international fault lines. In Honduras, native speakers have dwindled to a few hundred; in Guatemala, the millions of Maya today are still recovering from a genocidal civil war in the 1980s; in Belize, bilingual Maya speak English or Spanish; and in Mexico, people still speak a range of Mayan languages including Yukatek, Lacandon, Tzotzil, and Tzeltal. In the 1980s, the vast rainforest cover of the region began to vanish under modern population pressures, leading to the rediscovery of ancient sites. Looting, a problem even in ancient times, has led to depredations at Maya cities, whose number, scale, and scope exceed what local governments can protect.

From the earliest studies, scholars have focused on the Maya writing system, and by the beginning of the twentieth century Maya dates could be read and correlated with the European calendar, placing the preponderance of ancient Maya cities between 300 and 900. But, armed with inadequate linguistic tools, archaeologists foundered in their attempts at decipherment until the 1950s, when Yuri Knorosov in the Soviet Union and Tatiana Proskouriakoff in the United States would bring complementary skills to deciphering the hieroglyphic writing.[4] Their work pointed to the

IT MAY BE THAT THIS COU
THAT UP TO THE PRESENT
REVEALED, OR WHICH TH
CANNOT TELL. DIEGO DE LANDA, FIRS

value of studying the imagery, including a correlation between certain glyphs and images on the one hand, and thematic and more comprehensive analyses of the iconography on the other. The last twenty years – a *k'atun*, in Maya terms – of the twentieth century and the first decade of the twenty-first have ushered in a flurry of fresh Maya studies, in part because of a greatly expanded corpus of Maya hieroglyphic inscriptions on painted pots, carved monuments, inscribed walls, and small portable objects. Incisive decipherments have opened a window onto practices that had previously been unimagined for the ancient New World, such as artists' signing of works, the selling and trading of goods, warfare and sacrifice, even humor and comedy. Deep investigations of art and writing have led to an ever more subtle understanding of the Maya vision of the cosmos: the role of mountains, sky, and water, as well as the deities of these dominions. The realm of the sea was long neglected,[5] but recent decipherments and new interpretations of the significance of aquatic imagery now make it possible to recognize its fundamental roles in underpinning ancient Maya belief.

The Maya world in space and time The earliest Maya are still enigmatic and poorly understood, but by 500 BC at the latest, Maya peoples had spread across the region and begun to move inland from the rich coastal sites that initially had attracted them. Early on, as documented particularly at El Mirador and Tikal, they began to cultivate the swampy soils near riverbanks, or seasonal water sources; by the beginning of the first millennium AD, they managed raised fields, irrigation canals with attendant aquaculture, and terraces. The rainforest offered little in the way of big game – the occasional deer or peccary would have made a feast – and they raised ducks, turkeys, and dogs alongside their distinctive hip-roofed homes. Behind the houses lay the orchard, or *pak'al*, rich with guava, zapote, nance, avocado, and wherever possible, cacao, which grows best under forest canopy.

Although most of the dense urban fabric built before the first millennium AD remains lost, with the occasional discovery beneath later constructions, the great city of El Mirador – largely built by 250 BC and abandoned by AD 100 – reveals an intact ideology based in maize, sun, wind, and water, with illuminating narratives of lively gods and heroes.[6] In many settings, the cycle of the life, death, and rebirth of the Maize God was central. The emergence of this core religious story conforms to the transformation of the Maya diet at the end of the Preclassic period, when maize and beans could provide a stable resource for a growing population. Tomatoes, chili peppers, and squash rounded out a diet that sustained both peasant and ruler. Architectural, artistic, and religious practices established during this period would remain largely consistent through the great cultural apogee of the first millennium of the era and survive intact until the Spanish invasion, despite widespread cultural decline and population collapse.

How much the Maya knew of their neighbors in Mexico and northern Central America remains obscure until the fourth century AD, when vigorous warriors from the great city of Teotihuacan nearly 620 miles (1,000 kilometers) to the north invaded Tikal, Uaxactun, and other cities, setting up hybrid regimes and introducing new religious practice. In the early fifth century, the founder of a new Copan dynasty would claim authority vested in both Maya and Mexican belief. Longer and more discursive hieroglyphic texts inscribed on stone and ceramics point to a lost tradition of books and other painted texts. Wars that broke out in the fifth and sixth centuries may have led to new robustness on the margins of the Maya world, from Coba and Palenque to Piedras Negras and Machaquila – which set the stage for a great political and economic revival during the seventh and eighth centuries, with only the occasional ideological and historical gesture to the fourth-century invasion.

The Maya were fabulously wealthy and populous for about 150 years, until late in the eighth century, when chronic warfare coupled with a dev-

NTRY HOLDS A SECRET

HAS NOT BEEN

NATIVES OF TODAY

ISHOP OF YUCATAN [1]

astating drought brought the great civilization to its knees. This so-called "Maya collapse" was marked by sudden and dramatic depopulation, abandonment of cities, and a near cessation of many practices, including the erection of dated monuments celebrating individual rulers: the last would be set up at Tonina in AD 909.[7] In their final years, some surviving Maya lords lived behind walls, waiting for the next siege; others melted away into scrub forest to live as peasants.[8] For another hundred years – long after places such as Palenque had ceased to maintain their public architecture and waterworks – cities in the Puuc hills to the north thrived. In fact, by AD 900, Chichen Itza, in the center of northern Yucatan, functioned as the capital of a large, powerful state. For some two hundred years, it was the largest city in Mesoamerica until succeeded by Mayapan, a walled site studded with over forty *cenotes* or sinkholes. The Maya political identity had fractured into small pieces by the time of the Spanish conquest in 1519, yet many cultural practices remained intact. By the 1550s, the first bishop of Yucatan, Diego de Landa, would commandeer roughly three hundred written books from the Maya, which he condemned and burned in accord with Inquisition practices. Landa himself would write down and annotate Maya hieroglyphs, providing important clues to their later decipherment.

The natural world Classic Maya civilization extended from the northern tip of Yucatan to the southern lowlands and highlands of Guatemala and Honduras, and from Chiapas in the west and to coastal Belize in the east (map, pages 22–23). Surrounded by the Gulf of Mexico, the Pacific Ocean, the Caribbean Sea, and the Atlantic Ocean, the people envisioned their world as an enormous turtle floating in a primordial sea. The dry surface

of the earth was understood to be a turtle, and the turtle's pool was ever renewed, sometimes by muddy torrents that washed away soil and felled timbers. From time to time, a slight tremble – an earthquake originating in the volcanic region of highland Guatemala tumbled structures as far away as Copan, Honduras – would indicate that the turtle was lumbering or perhaps cracking open to allow the Maize God's annual rebirth. The seismic violence in the region is noteworthy: Antigua in Guatemala had to be abandoned after a 1773 quake; a 7.1 Richter Scale quake struck just off the coast of Honduras in May 2009.

Hidden underground waters may have been perceived as a tangible Underworld.[9] Deep cenotes that formed sixty-five million years ago when an asteroid or comet crashed into Earth punctuate northern Yucatan in a ring. Rivers such as the mighty Usumacinta or the Motagua begin as trickles from volcanoes in Guatemala to run through temperate and torrid regions before emptying into the Pacific and Atlantic oceans. The Maya recognized the importance of freshwater springs that bubble up into saltwater along the Caribbean coast. Rainfall in excess of 150 inches per year allowed massive tropical rainforests to tower over some parts of their world, especially in what today is southern Belize, while little more than a scrub jungle could be supported by the twenty inches of rain that fall in northwest Yucatan, except when powerful seasonal hurricanes sweep across the peninsula.

Like the great sea turtles that still today return annually to the beaches of Akumal, literally "place of turtles," south of Cancun in Yukatek Maya, the Maya people have thrived at the edge of the sea, harvesting both fresh- and saltwater creatures. Divers working the coral reef of the Caribbean and the depths of the Gulf of Mexico elude the morays but gather edible eels like the parasitic lampreys that live in both fresh- and saltwaters, often in estuaries. Octopi of various sorts move through both deep and shallow waters. Tens of thousands of golden stingrays migrate twice a year, following warm deep-sea currents from Yucatan to Florida

Figure 1. Golden cow-nose rays migrating from the Yucatan peninsula to western Florida.

Figure 2. Standing male figurine carved from manatee bone, 200–500, Mexico or Belize. Yale University Art Gallery, New Haven, Connecticut.

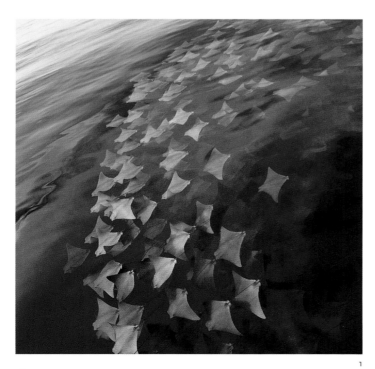

1

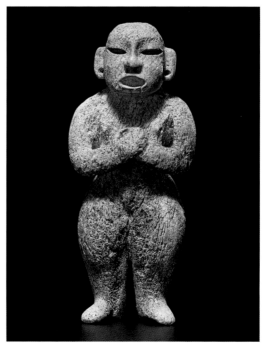

2

and traveling in an astounding visible arc (figure 1). The Maya prized their venomous spines (up to fifteen inches long on a large ray) as instruments for bloodletting, and they probably consumed the delicious flesh as well. Sharks – our own word comes from the Maya word *xook* – included the occasional great whites but more typically bullnose near shore or hammerheads out at sea. The sharks hunted in both the Pacific and the Atlantic, and the Maya hunted them in turn, valuing their teeth in particular. Divers retrieved *Spondylus*, or spiny oysters, from both oceans as well, and from depths that eventually caused hearing loss. *Spondylus* shell was a treasured material: the Maya often scoured away both spines and white nacre to expose the brilliant red-orange color. Prized rare pearls found their way into the finest tombs. Closer to shore, queen conchs thrived in both the Gulf and the Caribbean.

Estuaries in the New River in Belize and alkaline pools along the Campeche coast provided "nursery" habitats for many sea creatures; manatees, too, prefer the estuary and today roam at least as far inland as Catazaja, Chiapas, about fifteen miles from Palenque. These gentle half-ton vegetarians provided a seasonal feast, and the Maya carved their large, broad bones into ritual figurines and canoes (figure 2). Crocodiles up to fifteen feet long live along the Maya rivers, especially the Usumacinta, where the harpy eagle, the largest raptor of the Americas with a six-foot wingspan, hunts monkeys, coatimundi, and other prey. Tropical parrots, macaws, and toucans are among the large birds that bring song and color to the rainforests; the much sought quetzal lived only in cloud forest, where tropical evergreens laden with epiphytes are swathed in the moisture of near constant fog and clouds. Throughout the Maya region, boa constrictors and poisonous vipers live side by side; rattlesnakes thrive in Yucatan, but the easily irritated fer-de-lance (*Bothrops atrox*), striking from both forest floor and tree branch, remains the most deadly snake of the area. Maya kings sometimes took their names from these important animals, as well as that of the *bahlam* or jaguar, the most powerful mammal of their world. It is distinguished by its distinctive rosettes (visible in raking light even on the all-black or melanistic cats) and known for its dangerous stalking behaviors and quick crushing blows to the head that can kill even the herbivorous tapir, which can weigh seven hundred pounds.

The ancient Maya used land and water routes to conduct trade with neighboring Maya kingdoms and with cultures and polities at even greater distances; in 1502, Ferdinand Columbus would record the encounter of his father, Christopher, with a great ocean-going Maya canoe piled high with lavish cloth and goods, women and children, and with two dozen men paddling it.[10] We see earlier signs of this trade in the Classic period in the raw materials used, in the exchange of ideas and images, and in the movement of actual objects. By AD 900 or so, coastal traders were bringing alloyed copper and gold disks from lower Central America to Chichen Itza, where Maya artists transformed them with repoussé scenes of sacrifice, confrontation, and sea battles (plate 68). These gold disks would survive in the depths of the Cenote of Sacrifice along with bits of turquoise from distant New Mexico. These varied types of exchange gave artists access to raw materials from a variety of regions, offering rarity and scarcity to elite makers and elite owners.

The built world Across at least two millennia, the Maya constructed environments that made their belief system visible. Maya architecture married mass and void to landscape, using a small inventory of forms: the massed platform and its opposite, the open plaza; a volume based in the house form; and the line that gives direction, expressed in the step, path, or road. Their architecture made ideology manifest: pyramids reached to the sky, providing the setting for clouds of incense and smoke to carry messages to sky beings; openings pierced in ballcourt alleyways were liminal entrances to the Underworld. Such settings made belief and rhetoric tangible through practice and reenactment: when humans stepped into these spaces, they activated them. Pyramids with precipitous staircases became

mountains with great maws at their tops – organic animate presences that could also embody ancestors buried at their bases. They also could serve as sites of human sacrifice, where trussed war captives might be sent tumbling down the stairs. The Maya carved live rock outcroppings, such as the huge captives at Calakmul and Tikal.

Texts and pictorial representations amplified the visible built environments of Maya cities. The Maya placed stone carvings, stucco sculptures, and painted murals in specific architectural locations, making some works easy to see and obscuring others – all with intentionality. Special access was required to view the Maya murals of Bonampak within the darkened chambers of Structure 1,[11] but not to see the towering Stela 1 on the main plaza below, where the twice life-size figure of King Chaan Muwan rises up from Maize Mountain, an embodiment of the Maize God in a script enacted time and again by different rulers in different times. Tapering slightly outward at the top, the stela recalls the ancient form of the jade celt, a symbol of sustenance and preciousness. By contrast, atop Pyramid O-13 at Piedras Negras, Stela 12's complex low-relief depiction of captives was invisible from the ground and came into view only upon direct approach.

The positioning of monumental sculpture and architecture created backdrops for performance and the display of human and supernatural power, offering opportunities to experience surprise, revelation, and transcendence. Furthermore, architecture and sculpture re-created mythological places and set performers and viewers in other locations, both natural and supernatural. In Honduras, what today is known as the Copan Reviewing Stand features at its center the damaged head of what is probably the Rain God, Chahk, emerging between two giant conch shells – indicating a location at the sea's edge (figure 3). Two large simian

wind gods frame the vast architectural setting, as if marking a stage for performance. Indeed, that is probably the function of what appears to be a grand, elevated stage as seen from the West Court of the Acropolis. Here, in this inland setting, the Maya return the viewer to the ocean, governed by Chahk but marked by restrained, if not captive, winds. Twenty feet below and directly underneath this stage, three slabs deployed like ballcourt markers into the plaza floor each depict the god K'awiil, who holds out the glyph for yellow maize. This is the setting, then, for the rebirth of the Maize God rising out of the sea through a crack in the turtle shell. The wind is three-dimensional. Chahk, recalling how creatures are visually reduced and flattened when seen in water, transitions from two dimensions into three. Maize, inchoate here, remains in two dimensions, awaiting activation through timely performance and observation. The human-built environment, then, visualizes and materializes natural forces of the cosmos, not only capturing in stone what the Maya thought to be the reality of their world but also creating new physical realities in their materialization, which then became the backdrop for interactions among themselves and with the divine.

Within their architectural complexes, the Maya also created vast waterscapes, presumably the staging for reenactments of religious narratives set at or in the ocean, the lake, and the swamp. Perhaps the greatest of these was a stunning 665-foot (200-meter) wall framing part of the North Group at Calakmul, effectively turning the huge adjacent plaza into a sea and giving the space the name of Chiik Nahb (figures 4, 5).[12] Formed by modeling and molding thick stucco onto tenons protruding from a limestone wall and painted with layers of Maya blue, it featured an abundant aquatic world. Repeated glyphs name it as the "Calakmul place pool wall,"[13] with painted water-birds interspersed. At Calakmul, where water was seasonally scarce and the forest grew at a substantially slower rate than in other regions, the people evoked in this wall a world of watery wealth that stretched nearly the length of two American football fields.

Figure 3. The Reviewing Stand at Copan, Honduras, AD 769. Rendering by Tatiana Proskouriakoff. Peabody Museum of Archaeology and Ethnology, Harvard University, Cambridge, Massachusetts, 50–63–20/13322.

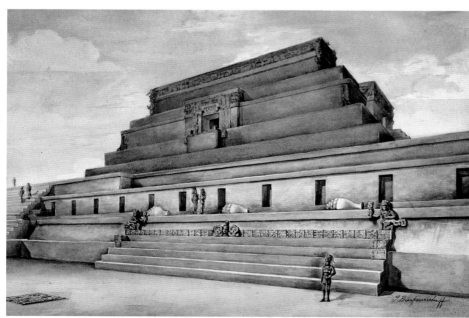

3

Although best known for towering pyramids, palaces, and theatrical settings, Maya cities included less visible feats of engineering, including the reservoir system at Tikal that made year-round habitation possible. Roughly seven streams emerge from the mountains above Palenque to spread like arteries through the body of the site.[14] Four of these streams were canalized: Palenque lords mastered and controlled the water near its source and then kept it free from obvious impurities even as it ran through areas of dense elite occupation. The Maya concept of keeping the water in its pristine and virgin state is known as *zuhuy ha*. Flowing out of springs high in the Mirador, the peak that dominates Palenque, the Otulum River ("stone walled water") runs within a stone aqueduct through the heart of the ceremonial precinct. But the hydraulics at Palenque go further: this aqueduct at the city's heart is not simply an attractive means of bringing water to the palace doorstep. Instead, much like a city storm sewer today, it serves to control the sometimes raging, torrential waters of the Otulum: without this deep, permanent, stone-lined canal covered by a land bridge, the entire site would be inundated during the rainy season (Stuart, page 42). The aqueduct terminated at a rare surviving Maya corbelled bridge, spilling the rushing water into a broad pool where it would swirl and slow before continuing down the natural cascades known today as the King and Queen's Baths. Running right through the heart of the site's sacred precinct, this river demonstrates the idea of the water-mountain, a pan-Mesoamerican concept of civilization known among the Aztecs as *altepetl*.

Visualizing the Maya world Painted, carved, or modeled, monumental or small-scale, the human body is ubiquitous in ancient Maya imagery. The males and females portrayed included rulers, their families and courtiers; esteemed visitors; and captives. They also depicted animals and anthropomorphic and zoomorphic supernaturals. Whether human, animal, or supernatural, most bodies are elaborately costumed and surrounded by objects for ceremonies, feasting, and warfare. Maya representations may situate bodies in man-made spaces or supernatural contexts. The frequent depiction of people interacting with other humans, supernaturals, or objects makes most Maya art highly narrative. The images tell stories and convey the passage of time. Hieroglyphic texts are ever-present across media, usually identifying people, supernaturals, places, and events. However, texts were not conceptually distinct from images, and scribes often exploited their graphic nature to make glyphs into images and incorporate texts and images into integrated designs.

Frames indicate supernatural locations. For example, at Yaxchilan, sculptors presented ancestors in four-lobed cartouches marked with centipede, solar, or lunar designs in the upper registers of stelae. As a result, they appear present in the celestial realm, above living rulers. These cartouches thus denote contemporaneity, the frame capturing a peek into a parallel realm. In addition, they can frame a portal through which the living and divine come together, suggesting that the boundary between these realms is porous, opened through ceremonial performance, like the carved stones embedded in the alleys of Maya ballcourts, places of liminality and porosity.

Yet, much of Maya art is otherwise framed, for the edges of many images are marked with hard lines or edges. From the late sixth century AD onward, this defining edge can be crossed, perhaps by a headdress passing over a border or a frame cutting off a body (figure 6). Even the red paint that rims many Maya vases is sometimes violated, as it is on the well-known Altar de Sacrificios, Guatemala, pot. In such cases, artists used frames to connote that the representation is a glimpse of a larger world beyond the frame, analogous to the passage of time within and

Figure 4. Detail of the watery façade on the North Acropolis of Calakmul, Mexico.

Figure 5. Detail of the watery façade on the North Acropolis of Calakmul, Mexico. Drawing by Simon Martin, courtesy Arq. Ramon Carrasco and Proyecto Arqueológico de Calakmul.

5

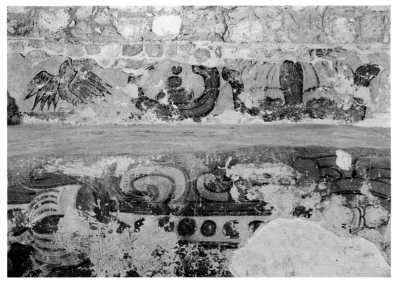

4

beyond depicted images. Such trespassing of frames, moreover, is one way that Maya art engaged the viewer, guiding modes of viewing and presence to assist interaction. Furthermore, as in the Copan Reviewing Stand, Maya art created three-dimensional frames or backdrops in which performers physically inhabited alternate spaces and activated historical and mythological narratives.

Materials of Maya art To make the art and architecture that articulated and explained the physical realities of their cosmos, the ancient Maya used a variety of materials to create forms that intersected and interacted with the natural and supernatural worlds surrounding them. They extracted materials from the earth, from the water, and from living creatures. Stone, clay, and mineral pigments were relatively permanent; more perishable feathers, wood, skins, gourds, bark paper, and cotton textiles may be known only through ancient representations of them in other media. Using drawing, painting, carving, polishing, drilling, and heating, the Maya transformed these materials into objects for personal adornment, feasting, ritual use, and divine embodiment. Some surfaces were simply polished smooth, whereas others were filled with complex pictorial and textual details deployed through shape, line, and color.

The Maya quarried a variety of stone, including limestone, sandstone, volcanic tuff, and slate, to create buildings and monumental sculptures. In much of the Maya region, limestone was the principal material, found in abundance though varying in geological composition and quality across the landscape. In a few sites, the Maya used sandstone, and where available, volcanic tuff, basalt, and slate, in rare cases moving the stone more than one hundred miles.[15] To quarry the rock, they made deep parallel inci-

sions to section off blocks, which they removed and transported elsewhere for working. Making stone objects was a reductive process: they used tools made of chert and limestone to cut and chip away excess stone and chisels and drills to create iconographic and textual elements; abrasive powders, leather strops, and flat stones smoothed and polished surfaces.[16]

The types of stones may have determined local tradition. At Palenque, the fine-grain limestone sheers off in vast sheets, lending itself to the interior wall panel. The relatively soft surface is ideal for delicate incising and shaping, allowing for extraordinary detail, such as in the panel found in Temple XXI (plate 48). Elsewhere, sculptors took advantage of the massive, blocky stones quarried from thick bedding planes. Some appear scarcely transformed after their extraction from the earth and retain the blockiness of the solid stone shaft. Stone blocks made into vertical stelae or horizontal altars, among other forms, offered multiple surfaces for text and image. At times, sculptors used contiguous sides to wrap images around monuments (plates 71, 75). In other cases, carving on multiple sides allowed artists to contrast the two-dimensionality of each surface against the three-dimensionality of the block, with attention given to viewers moving around the stone, thereby turning the practice of viewing into a more physical, corporeal experience.

Relief was the primary sculptural mode across the Maya region. The Maya created active compositions based on two-dimensional drawings, though they highlighted and enlivened these designs with some slight modeling in varying depths of relief. Although the limitations of limestone as a material seem to have curbed desires for creating three-dimensional sculpture, at Copan, the relative malleability of volcanic tuff permitted more volumetric forms, such as the multiple eighth-century stelae commissioned by the ruler Waxaklajuun Ubaah K'awiil. A governing principle of the stela was to retain proportions that align with the human body. These same proportions govern the individual page of the Maya screenfold book. In all of Maya art, the human body stands at the heart of representation.

Figure 6. Limestone panel and detail depicting the presentation of captives to a Maya ruler, circa AD 785, Usumacinta River valley, Mexico/Guatemala. Kimbell Art Museum, Fort Worth, Texas.

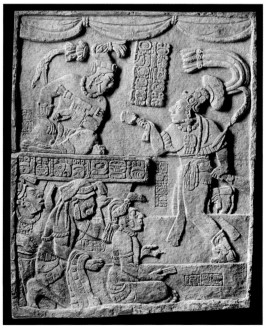
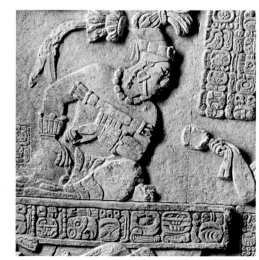

6

Although seemingly dense and obdurate, stone could also be made tractable. Crushed, then burned and pulverized, limestone reduces to a powder that can be mixed with water and crushed stone to make plaster, cement, or stucco (limestone + fire = lime; lime + water = cement). Stucco could be smoothed flat on building walls and surfaces or modeled into three-dimensional forms, especially to create dramatic, large-scale architectural ornament. On the earliest temples of the Peten and Campeche, the Maya used stucco to create enormous masks on façades of buildings, including massive faces of gods – often solar, mountain, and maize deities – in pairs on opposite sides of pyramid stairways, thereby naming buildings as abodes of these supernatural essences, as at Tikal or Kohunlich. They also used stucco to transform buildings into ornate ancestor shrines, such as the vividly colored Rosalila structure, dedicated to K'inich Yax K'uk' Mo', Copan's lineage founder.[17] Yet, stucco as a primary mode of architectural adornment became less common over time, and throughout much of the Puuc region only a thin wash coated elaborate stone ornaments. Even so, at Ek Balam in the ninth century AD, the Maya constructed a complex stucco façade around the doorway of the structure holding the tomb of U Kit Kan Lek Took', turning the building into an animate mountain. Winged supernaturals perch on top, and the mountain's toothy maw forms the structure's doorway (figure 7).[18]

Other stones were used in telling ways. Flint, with its characteristic sparking capability, served as both a useful raw material for weaponry and for ritual objects shaped into K'awiil, God of Lightning and Lineage. The Maya believed that flint had formed in the ground where lightning had once struck, and thus its application here was most appropriate. Obsidian, volcanic glass, was used for tools, jewelry, and eccentric forms. Traded widely across Mesoamerica, obsidian retains the fingerprint of a given eruption. Most obsidian can be traced to highland Guatemala with its distinctive snowflake pattern; and the characteristic green color of Pachuca obsidian reveals its source from central Mexico.[19]

Like all Mesoamerican peoples, the Maya held jade to be the single most precious material on earth. Jade typically symbolized maize – although the Maya also sought to exploit the colored veins that ran through the green stone or to celebrate rare examples of smoky black jade or creamy white albite. The hardest and most resistant stone in their world, jade had to be worked with jade tools and powder to grind away the surface to form beads and other jewelry – understood to be the Maize God's precious attire – as well as two-dimensional plaques and three-dimensional heads, most commonly to represent this deity.[20] The largest single carved jade of the ancient Maya came to light at Altun Ha, interred with a king of the sixth century AD (plate 56).[21] Erosion following Hurricane Mitch in 1998 revealed what has proved to be the greatest source of raw jade in the New World: in the Biotopo de Sierra De Las Minas, mountainous slopes near the Motagua River are strewn with boulders of the precious material, which must have been a great source of wealth for the ancient Maya who controlled it in the past.[22]

To make ceramic forms, the Maya dug clay from riverbanks or *bajos*, and caves. They added water to make the material more pliable and consistent and added sand, ash, and ground terracotta as temper to give it more solidity and durability during firing and use. Their coil- or slab-built vessels – all New World pottery was made without benefit of the wheel – were used to hold food and drink and in ritual offerings and ceremonies (plates 2, 3). They decorated leather-hard vessels with colorful slips (mineral pigments mixed with slurry) or incising, sometimes using beeswax for resist patterns, and in some traditions, appliqué. Firing in below-ground pits transformed the soft clay into hard, liquid-retaining ceramic forms, sometimes painted after firing, especially with the tenacious Maya blue.

Figure 7. Stucco façade framing a doorway on the Acropolis, late eighth century AD, Ek Balam, Mexico.

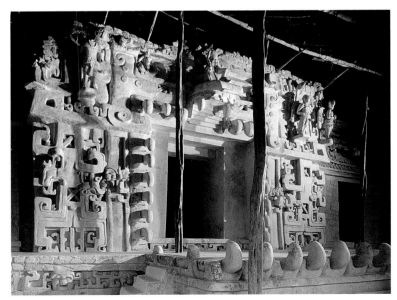

7

Preclassic ceramics largely imitated natural forms such as gourds (Mesoamerica's earliest vessels). Their volumetric forms had rounded bottoms for nestling in the earth or multiple feet to raise them off the ground.[23] In the Early Classic period, the Maya of the Peten created wide circular vessels supported by four legs or ring-stands. These forms provided opportunities to create fantastical models of the animate earth, envisioned as floating in water or supported by posts at its four corners. In a vessel found at Tikal (plate 4), the body is in the form of a turtle whose head, legs, and shell ridges poke out of the bowl's straight sides, which are painted with water imagery. The convex lid evokes a rounded turtle shell, the imagined surface of the earth; at the same time, it is the watery surface of the universe in which the cosmic turtle floats, for hovering on the surface of the convex lid is a water-bird with wings spread wide, its head forming the lid's handle. The bird's long beak pulls a bivalve from beneath the waters, thereby transforming the creature from the two-dimensionally painted lid into the three-dimensional handle. Across the Maya region, potters and painters everywhere repeated the trope in local variations, turning supports into snout-down peccaries and usually substituting a fish as the bird's prey (plate 5).[24] Thus, here the potter manipulated materials, medium, representation, and meaning to create a common natural scene but also a playful cosmological model of the earth-turtle floating in the primordial sea. The creatures reach across and transcend the universe's levels and boundaries much like the ritual practices that penetrated these levels to reach across and through to parallel realms to conjure deities and ancestors. Moreover, this vessel would have served as an offering in a tomb, filled with food or liquid for the deceased's journey from the land of the living through the watery Underworld to the solar paradise of the ancestors.[25]

The characteristic ceramic form in the Late Classic period was the cylinder vessel, taller than it was wide and without feet – a shape conducive to holding in the hands for pouring or drinking. Painted scenes and textual phrases that wrapped around these forms prompted the user to turn the vessel for a continuation of the narrative. The Maya used these vessels in palace settings, not only for drinking and feasting but also for story-telling; the painted images inspired tales to be narrated in court gatherings.

Early Classic sculptural forms suggest a single maker, that the painter and potter were one and the same. Late Classic cylinders divorce subject from form, opening the possibility of specialists within a workshop. Despite the sophisticated imagery, however, plasticity and three-dimensionality were not forgotten. The Late Classic Maya used agglomerative techniques in the adornment of incense burner stands. At Palenque, ceramicists added flattened clay slabs and rolled coils and balls to open cylinders to create three-dimensional visages of deities such as K'inich Ajaw (the Sun God) or ancestral lords (plate 25). Analogous to the heat from the fires that transformed the pliable clay into solid ceramic, heat from sacred fires kindled in bowls atop these censer stands activated and enlivened supernatural forms. The forms in turn radiated heat and emitted smoke, thereby transforming their symbolic or invisible properties into a material form that could be seen, felt, and transmitted to divinities. At Palenque, these burners were placed on temple terraces; packed dirt within kept them in place during storms and enabled them to survive to this day.[26]

The ancient Maya also used clay to create small figurines of humans, animals, and deities (plates 9–16). Most bear faces pressed from molds and bodies crafted by hand – a combination of conformity and individuality. Small and delicate, the majority can stand upright on their own, though many kneel or sit on the ground in postures akin to their placement on tomb floors, such as at Jaina Island, where many were discovered.[27] Across the Maya region, figurines depict a wide range of people and deities, including warriors and captives, rulers and attendants, and ordinary men and women. In fact, this object type offers the most insight into the array of people and supernaturals who inhabited the Maya world, their

costumes, and their mundane and ritual activities. Some may have been used as single objects, while others formed groups, creating interactive, narrative scenes of ritual practices and court life, such as the twenty-eight figurines that form a miniature royal court found recently in a royal burial at the site of El Peru-Waka' (plate 98).[28]

Although few monumental paintings survive, the Maya painted building interiors and exteriors and daubed paint on objects after firing, particularly figurines. An iron-ore-based red (often with flecks of mica, or specular hematite) was the single most common pigment, frequently covering entire exteriors, but Maya blue, made by fixing indigo onto attapulgite, a clay taken from cenote edges, was the most stunning and expensive ancient color (figure 4). Particularly for interior walls, a resilient paint was made by suspending pigments in a medium based in ground orchid bulbs and tree saps.[29] Cinnabar (or vermillion), the raw ore that is commonly found in volcanic deposits and yields mercury when heated, was often applied to burnished or incised surfaces. The Maya most typically applied cinnabar in great quantity to the dead bodies of royalty, where it may have had some role in preservation.[30]

In addition to materials extracted from the earth, the ancient Maya retrieved materials from seas and rivers. These often carried with them concepts of wetness and fertility embedded in their watery source, from manatee bones and stingray spines to shells and coral. The common offering of *Spondylus,* copious cinnabar, and a single jade bead or figurine found at Tonina, Copan, and elsewhere may unite notions of deep water, high mountain, and maize, with the jade replacing the pearl or creature that may have once resided within the shell (figure 8). Additionally, the material meaning of shell may have evoked long-distance trade and the privilege of access to luxuries from distant regions. The Maya kept some shells in their natural forms, using them as costume ornaments that evoked water

Figure 8. *Spondylus* shell containing cinnabar and a jade bead.

and distance and performed through their physicality, both in their beauty and in the noise they made with the human wearer's slightest movements. *Oliva* shells (the homes of predatory sea snails) "tinkled" when worn as costume edging; in contrast, jades rang out like bells. Tikal lords deposited conch shells by the basketful at the site[31]; the cut shell, rendered on Tikal bones in both section and elevation, symbolized the salty sea.

The Maya also transformed shells into other images and objects in which the watery nature of the shells became an essential part of their visual portrayal and symbolic and material meanings. For example, archaeologists at Topoxte found a small shell frog in an Early Postclassic burial (plate 17).[32] Made from a water creature, it depicts another animal in the water, the swimming frog flexing one leg and extending the other to propel himself. The shell's natural markings recall the bumpy patterns on a frog's back or the waves generated as the frog moves along.

The Maya also used the bones of both water and land mammals to make small sculptural forms and surfaces to be incised with miniscule designs. Because of their bones' compact nature, large manatee ribs lent themselves to the carving of three-dimensional objects such as human figurines (figure 2), musical instruments, and canoes.[33] A canoe formed from the water mammal's bone continued to evoke water in both its materiality and its representation. The bones of land mammals, such as humans and jaguars, were less suited to sculpture because of their marrow core, but the Maya finely incised their smooth surfaces with images and hieroglyphic texts. Long narrow bones used as elegant weaving picks often carry the names of their female owners. Other bones bear intricate designs of mythological and human actors. Burial 116 at Tikal, the tomb of Jasaw Chan K'awiil, who died in AD 734, held the single greatest cache of bones ever recovered.[34] Probably enclosed in a small cloth sack, they included jaguar, deer, and human tibiae; paired renderings suggest some bones formed tweezers. At tiny scale, the carvings reveal rain gods squabbling while fishing, and the paddler gods' delivery of the dead Tikal king — who appears as

8

the Maize God – via canoe into the Underworld, accompanied by a howling parrot, a monkey, and an iguana. In a stroke of artistic majesty, the delicate line runs right off the bone, the scene plunging into infinity. Stingray spines also are frequent offerings in tombs, often positioned over a male groin, a reference to the spine's principal use to draw sacrificial blood from the penis or the ear or tongue.

Conclusion The worlds the Maya constructed through myth, architecture, sculpture, and portable arts confirmed and reified their understandings of the natural order of earth, sky, and sea. Earth and sky were omnipresent for all Maya, but for those who lived far from the sea – and who might never hear the crash of ocean waves or collect a queen conch from the sand – the sea could still be present, invoked and created both through natural resources and the things humans made. Like the networked interface of scutes that form a turtle's carapace, pathways opened the surface of the earth to the surrounding bodies of water, and that image of the sea – with its manatees, crocodiles, and giant crayfish, or *pigua* – was channeled far from the coast. The menace of the distant sea, especially its dangerous sharks, eels, rays, and other sea creatures, loomed at the margins, and the Maya sought to control the uncontrollable by codifying and defining the threat, while simultaneously promulgating the sea's perils to those in distant forests or savannahs. The direct importation of shells from both the Atlantic and Pacific oceans to Tikal during the Early Classic period, like the later practice at the Aztec capital, Tenochtitlan, centered and recentered the city, both psychologically extending Tikal's boundaries and making the city a microcosm of the universe.[35] In this way, waters of the Maya world were pervasive, whether as a rich source of food, a means of approach or dispatch for friend and foe, or as the infinite surrounding frame that gave borders to and ultimately defined the Maya world.

1
Landa circa 1566/1937, p. 85.

2
Stephens 1984.

3
Franz Boas particularly deplored the museum object and encouraged his students to pursue life in the field. See Boas 1907, pp. 921–33. Ruth Bunzel would be the only one of his students to pursue study of the contemporary Maya. See Bunzel 1952. Robert Redfield would follow Frederick Starr (*Indians of South Mexico*, Chicago, 1899; *In Indian Mexico*, Chicago: Forbes, 1908) to Mexican villages. See Redfield 1941. Redfield would in turn inspire Alfonso Villa Rojas. Redfield and Villa Rojas 1934 became the model of a community study.

4
M. D. Coe 1992.

5
The Dumbarton Oaks conference of 1974 addressed practice but not belief. See Benson 1977.

6
Hansen 2001, pp. 50–65.

7
Webster 2002; Martin and Grube 2008.

8
Houston 1993.

9
Pérez de Lara 2005.

10
F. Columbus 1959/1992; T. Jones 1985.

11
M.E. Miller 2002, pp. 8–23.

12
Carrasco Vargas and Colón González 2005, pp. 40–47.

13
Stephen D. Houston, personal communication, 2009.

14
French 2007, pp. 123–34.

15
Ruppert and Denison 1943; Healy et al. 1995, pp. 337–48.

16
Woods and Titmus 1996, pp. 479–89.

17
Agurcia Fasquelle 2004, pp. 101–12.

18
Ringle et al. 2004, pp. 485–516; Vargas de la Peña and Castillo Borges 2006, pp. 56–63.

19
Cobean 2003.

20
Taube 2005A, pp. 25–50.

21
Pendergast 1969.

22
Taube, Hruby, and Romero 2005.

23
Rice 1984.

24
See also Taube, in Houston and Taube in press.

25
Taube 2004.

26
Cuevas García 2004, pp. 253–55; López Bravo 2004, pp. 256–58.

27
Piña Chán 1948; M. E. Miller 1975.

28
Rich 2008.

29
Magaloni Kerpel 2004, pp. 247–50.

30
Tiesler 2006, pp. 21–47.

31
Moholy-Nagy 1963, pp. 65–83.

32
Castillo 1999.

33
McKillop 1985, pp. 337–53.

34
Trik 1963, pp. 2–18.

35
Moholy-Nagy 1963, p. 81.

DROWNED LANDSCAPES

HEATHER MCKILLOP

Sea-level rise has inundated the coast of Belize and its ancient settlements, obscuring their visibility in the modern landscape.[1] The coral rock foundations of coastal buildings lie partially submerged at island communities in southern Belize.[2] Some island sites, such as Pelican Cay, are buried below mangroves and invisible from the ground. Still other sites, including more than one hundred salt works in Paynes Creek National Park, are under water. The inundation of Classic Maya communities on the coasts and offshore islands of Belize and the Yucatan peninsula of Mexico is a sobering reminder of the dangers currently threatening low-lying coastal areas worldwide.

For the ancient Maya, the sea was a resource for stingray spines and other ritual paraphernalia related to stories of creation and the Underworld. Some seafood was transported inland, but most important, the sea was the main source of salt for hundreds of thousands of inland Maya.[3] The waters provided a transportation corridor for trade goods from distant lands, such as obsidian, pottery, and chert stone tools. For the ancient Maya who lived on the coast and offshore islands around the Yucatan peninsula of Mexico and Belize, fish, turtles, and even manatees were the main source of sustenance. The sea also supplied coral rock for construction. The dangers of voyaging, underscored by stories of creation and the Underworld, were mediated by the knowledge and experience of travel in ocean-going canoes.[4] The

sea linked Maya communities with both nearby and distant lands accessible across waterways they controlled.

During the Classic period, coastal ports such as Wild Cane Cay and Moho Cay organized the inland trade of local marine resources and imported goods.[5] The island trading port on Moho Cay was well situated to participate in coastal-inland trade up the Belize River, sea trade along the coast, and the exploitation of estuarine resources in the coastal waters. Wild Cane Cay was first settled during the Early Classic period as a fishing community. In Late Classic times, it became a trading port, likely controlling the inland transportation of salt from the nearby Paynes Creek salt works (figure 1). Wild Cane Cay also funneled inland other maritime resources, such as stingray spines, conch shells, and seafood. The abundance of obsidian discovered at the island underscores the islanders' easy access to this imported material and its importance in long-distance sea trade during the Late Classic period.

During the height of Late Classic Maya civilization, a massive salt industry along the coast of Belize supplied inland cities where salt was scarce. The workshops are marked by "briquetage" – broken pots and vessel supports from boiling brine over fires to extract salt. The preservation of wooden build-ings, equipment, and a full-sized canoe paddle from the K'ak' Naab' salt work in a peat bog below the sea floor in Paynes Creek National Park underscores the industrial scale of production and distribution (figure 2).[6]

The K'ak' Naab' paddle resembles the paddles depicted in ancient Maya art, notably those incised on bones from Late Classic Burial 116 in Temple 1 at Tikal that show the deities Stingray Paddler and Jaguar Paddler operating a canoe (Finamore, figure 6).[7] Like the K'ak' Naab' paddle, the Tikal paddles have a straight handle without an expanded grip. The blades are straight along the upper side and rounded at the sides and tip. Classic-period Maya held paddles by the shaft, with one hand near the top and the other above the blade. Similar paddles are depicted in a scene on a painted Postclassic mural at Chichen Itza. Two-dimensional representations of boats resemble in shape canoe models carved from manatee rib bone from Altun Ha and Moho Cay, as well as clay examples from the Orlando's Jewfish and Stingray Lagoon near K'ak' Naab'.[8]

There was a strong demand for salt from the coast from the inhabitants of inland urban areas. Instead of sending overseers to control the salt works, or overpowering the coastal Maya of southern Belize and exacting salt as tribute, the inland dynastic Maya more likely created alliances with them. In this "alliance model," independent, local producers engaged in a negotiated trade relationship with the inland dynastic Maya.[9] Because of the distance and the special skills needed for salt production and canoe navigation, the inland Maya may have found it more cost-effective to negotiate trade and perhaps marriage alliances with the coastal producers than to manage the production and distribution of salt directly. Moreover, the Late Classic Maya polities of southern Belize, closest to the salt works, were

Opposite page. Aerial view of Wild Cane Cay, Belize.

Figure 1. Windward shore of Wild Cane Cay, Belize.

1

decentralized, putting the coastal Maya in an economically and politically advantageous position.

But why would the coastal elite have wanted to establish inland trade alliances? The main trading port of Wild Cane Cay was some three miles (seven kilometers) from the Paynes Creek salt works, at the mouth of the Deep River and the northern end of the relatively sheltered waters of Port Honduras. This location lay at the nexus of the riverine and coastal trading routes. In the "alliance model," as part of the political hierarchy of feasting, the coastal Maya, perhaps centered at the trading port of Wild Cane Cay, were incorporated into the ritual ideology and political structure of the dynasties that drove their understanding of the Maya world and the places held by the gods and the people. The coastal Maya received goods such as ocarinas (figurine whistles), serving vessels, and other trade pottery that were markers of status.

With the collapse by AD 900 of most Classic-period polities in the southern Maya lowlands, some coastal trading ports realigned their trading partners, focusing on emerging centers in the northern Yucatan, notably Chichen Itza, and later Tulum and Mayapan. In Belize, the Paynes Creek salt industry collapsed for lack of an inland market, but its port on Wild Cane Cay survived and played a major part in Postclassic sea trade and the Mesoamerican world.

Trade realignments continued. The mercantile Maya on Wild Cane Cay sought partnerships with more distant areas in Honduras, Guatemala, northern

Belize, the Yucatan, and central Mexico.[10] Trade with highland Guatemala yielded significant amounts of obsidian from that area, along with Tohil Plumbate pottery from the Pacific coast. Wild Cane Cay was linked to other coastal trading ports farther north, such as Marco Gonzalez and San Juan on Ambergris Cay in northern Belize, and Isla Cerritos, the coastal port for Chichen Itza (Cobos, pages 164–65). They included similar goods, notably Tohil Plumbate, green obsidian from central Mexico, and Tulum (or "Payil") red pottery. A Postclassic coral building foundation at Wild Cane Cay was dedicated with the sacrifice of a young woman accompanied by an imported Las Vegas polychrome pottery vessel from Honduras.[11] The painted feathered serpent on the vessel links the trading port to the wider Mesoamerican world of the Postclassic period.

1
McKillop 2002.

2
McKillop et al. 2004, pp. 347–58.

3
McKillop 2002.

4
McKillop 2007A, pp. 15–28.

5
McKillop 2005B; McKillop 2004, pp. 257–62.

6
McKillop 2005A, pp. 5630–34; McKillop 2005B; McKillop 2007A; see McKillop 2007B for the canoe paddle site; available online at http://www.famsi.org/reports/05032/index.html.

7
Trik 1963, pp. 2–18.

8
McKillop 2005B; McKillop 2007A.

9
Ibid.

10
McKillop 2005B.

11
McKillop and Joyce 2009.

Figure 2. Canoe paddle from the K'ak' Naab' salt works, Late Classic period, Wild Cane Cay, Belize.

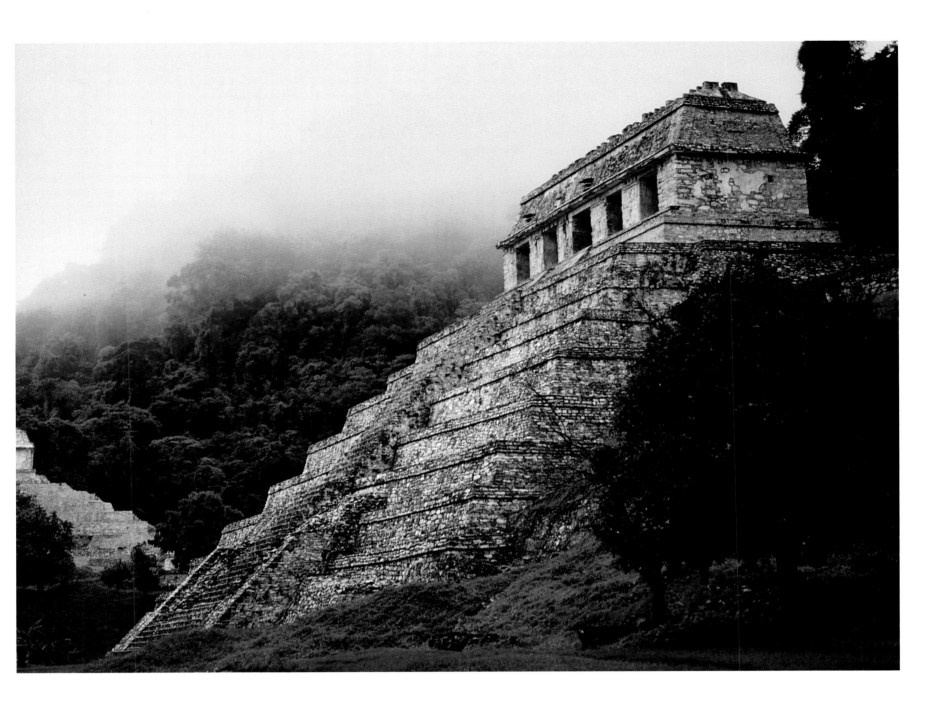

THE WIDE WATERS OF PALENQUE

DAVID STUART

The magnificent ruins of Palenque in Chiapas, Mexico, occupy a unique topographical setting in the Maya world. Built over several centuries along the face of a limestone ridge, its hundreds of buildings, courtyards, and plazas lie amidst numerous springs, cascading streams, and beautiful waterfalls (figures 1, 2). To the east and west along the same ridge, watercourses drop significantly in number, showing that the Palenque Maya had water very much in mind when they chose the location of their capital. Flowing water played a key role in Palenque's urban and ceremonial planning, often determining where and how elegant temples and residential areas were located.

Palenque was one of the great centers of elite Maya culture in the Classic period, when it reached its height as a political and ritual center. Among its numerous kings during that time, none was greater than K'inich Janab Pakal (603–682), who left an indelible mark on Palenque's history. Pakal (as most call him for short), his sons, and grandsons were responsible for most of the buildings still visible today; together, they created a remarkably cohesive vision of a ritual city, integrated into its landscape, and its equally important "waterscape."

Lakamha', or "Wide Waters," was Palenque's ancient name (figure 3). It may have referred to the entire site known today, or at least to the main portion

of the ancient ceremonial center where the largest buildings, including the Palace, are located. The name clearly refers to the broad pools of cascading water that form near the base of the hill at various points just below the city. The largest of these spectacular pools, situated next to several elite residential groups, collects water from the Otolum River – really a large stream – that courses above through the heart of Palenque's center before falling down the mountainside. The Otolum thus provided Palenque's true "Wide Waters," and lent its name to the larger community.

Above the pools and alongside the Otolum is the centerpiece of Palenque's ancient architecture, the Palace. This immense raised platform served as the locale for several of Pakal's ceremonial "houses," including his throne room and various reception halls. During Pakal's extensive modification to the Palace in the mid-seventh century, the Otolum stream was covered and channeled through a large and impressive aqueduct that ran under a paved surface for some ninety-eight-and-a-half feet (thirty meters) (figure 4). The aqueduct displays many of the same high design standards as buildings on the surface, including the use of a corbelled vault inside its main channel. The water emerges to the north, where a large sculpture of an alligator, nearly eleven-and-a-half feet (three-and-a-half meters) in length, is built into the wall. Its function remains

unknown, but it may well relate to important reptilian entities in Classic Maya cosmology, such as the cosmic-crocodiles in plates 71–74.

The heavy rains of late spring no doubt transformed the surrounding community of Palenque, as the Otolum and over fifty other nearby springs gushed immense amounts of water from the hillside. This presented significant problems and challenges for the built environment. Modern explorations in Palenque show ample evidence that its ancient inhabitants considered numerous ways to redirect and modify watercourses around their living and working spaces. Numerous artificial channels, small aqueducts, bridges, and drains can still be seen in the surrounding dense forest. One remarkable feature is known as the Piedras Bolas Aqueduct, located among ruined structures to the west of Palenque's center. Archaeologist Kirk French recently noted that this partially collapsed subsurface channel is unique in its design, showing a clear constriction along its passage that would have forced an impressive increase in water pressure as its stream passed through it. The designers evidently were intending to make the water spew out of its covered channel, a veritable water-work unlike any other known from the Maya region. Precious few of Palenque's outly-

Previous page. **Temple of the Inscriptions, AD 690, Palenque, Mexico.**

Figure 1. **Map of the rivers passing through the ruins of Palenque, Mexico. Based on a map by Ed Barnhart.**

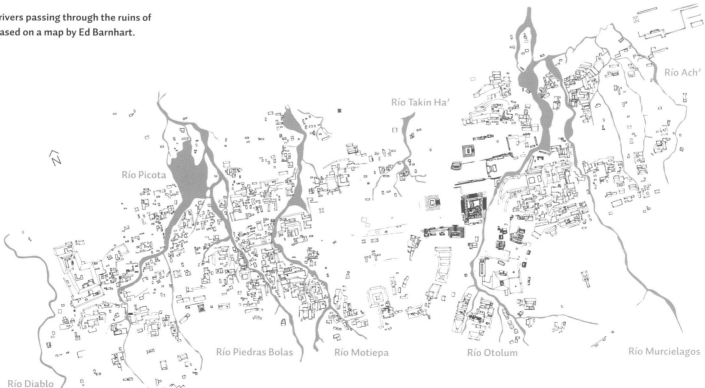

Río Ach'

Río Takin Ha'

Río Picota

Río Piedras Bolas

Río Motiepa

Río Otolum

Río Murcielagos

Río Diablo

ing groups have been excavated, but such surface remains provide very clear indication of an elaborately designed system for manipulating the flow of water throughout the city.

Palenque's rulers and nobles saw a great deal of importance in water's ritual and symbolic meaning as well. Above the Palace and its aqueduct, the Otolum emerges from a spring on the mountainside, just to the south of the ceremonial complex known as the Cross Group, with its three temples dedicated to the Palenque Triad, the patron deities of the local dynasty. Pakal's son K'inich Kan Bahlam built the three temples together, at the foot of a large hill overlooking the Otolum and the Palace. The principal building of the group, the Temple of the Cross, faces directly toward the Otolum to its south, and hieroglyphic inscriptions make clear that the larger complex was built "before the spring of Lakamha'." Evidently, the cosmological symbolism of the three temple-pyramids – each an artificial mountain – was designed to include this sacred spring, or *ch'e'n*, in its larger conception and design.

The complex mythology surrounding the Palenque Triad centered on a mystical locale called Matwiil, probably meaning "the Place of Cormorants," or, more generically, "Place of Water-birds." According to the written sources, Matwiil was the place where the three gods were born, or "touched the earth," at the moment of their creation. One image shows Matwiil as a freshwater snail shell, billowing out maize foliation (figure 5). It too was a watery realm, and held great symbolic importance for Palenque kings, who often assumed the title "Holy Lord of Matwiil." The honorific term suggests Palenque's rulers "held court" among the gods, and, like historical kings, oversaw ritual activities. In this way, Matwiil was something of a supernatural counterpart to Palenque's royal center, and to the visible watery word of Lakamha' and its ubiquitous "Wide Waters."

Figure 2. The waterfalls of the Río Otolum at Palenque, Mexico.

Figure 3. The hieroglyph for Palenque's ancient name, Lakamha', "Wide Waters." Drawing by David Stuart.

Figure 4. The interior of the Otolum aqueduct, circa AD 650, Palenque, Mexico.

Figure 5. Detail from the Tablet of the Foliated Cross, Late Classic period, Palenque, Mexico, showing the snail-shell emblematic reference to Matwiil. The feet are those of the ruler K'inich Kan Bahlam. Drawing by David Stuart.

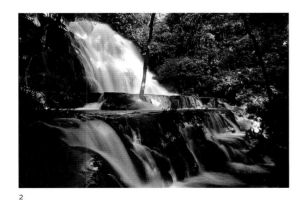

2

3

4

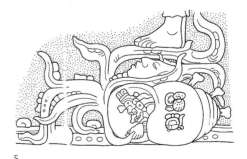

5

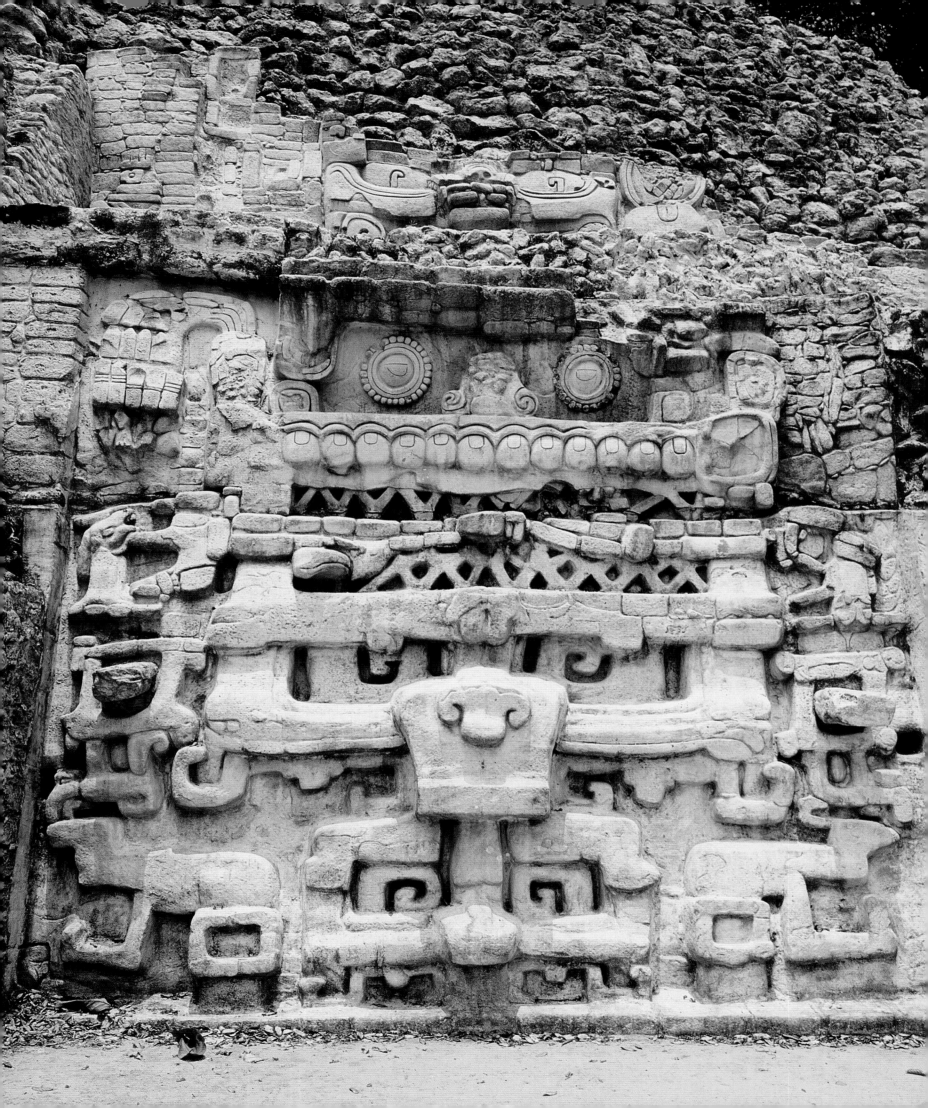

1

Cast of a temple façade with
the Water Lily Serpent
600–900
Caracol, Belize
Catalogue 6

Recent excavations at Caracol, Belize, uncovered massive façades flanking the stairway of Structure B5, a building that directly faces Caana, the largest structure at the site. This is a cast of the façade on the west side of the stairway. Both façades feature three identical superimposed masks formed by projecting masonry covered by stucco. The lowest supports the much larger mask above, and probably is a form of the zoomorphic head that appears below the chin of elaborate Classic-period headdresses. Although the central mask seems also to support the uppermost example, this is misleading, as it was fashioned later when the two lower masks were entirely buried. Rendered in a different style, it portrays Tlaloc, the central Mexican deity of rain and lightning. In this regard, it is noteworthy that the earlier principal mask below is also a god of water, although primarily of lakes, rivers, and the ocean rather than celestial rain.

The principal mask on the initial façade has a long, down-turned snout resembling a bird beak and a water-lily pad bound to its brow. On both sides of the head, the horizontal binding ends with flowers nibbled by fish. The zoomorphic ear spools are probably profile representations of the same deity, a being often referred to as the Water Lily Serpent, because of its serpentine body and lily-pad headdress. In Classic Maya texts, this being appears as the personification of the 360-day *Tun* position in the Long Count as well as a head variant for the number 13. In addition, it can also appear as the sign for water, or *ha'*, indicating that it is the moving embodiment of this element. In a number of Classic texts, it is referred to as the *Noh Chan* or Great Serpent. As David Stuart notes, the term *Noh Chan* is still used among the Ch'orti' of eastern Guatemala and neighboring Honduras to refer to the Chicchan serpents, the spirits of rain and water. Stuart also mentions that texts from Copan indicate that one term for this being was *witz'*, signifying splashing water as well as waterfalls in modern Mayan languages. Although in Classic texts the Water Lily Serpent is zoomorphic, it also appears in human form in mythic scenes. One of the most important examples is on a Late Classic codex-style vessel depicting the Maize God and Hero Twins taking a water gourd from this deity, who sits enthroned in his palace. Far earlier, the Late Preclassic murals of San Bartolo, Guatemala, portray him seated on a jaguar cushion in the cave

quatrefoil of the earth-turtle, along with Chahk and the Maize God (plate 83). In Late Classic Maya scenes, the human form of the Water Lily Serpent is of varying age, but often he appears as an old man, perhaps denoting him as a creator god of remote antiquity.

Located at the base of Structure B5 and in front of the stucco façades is Altar 13, which bears a version of the earlier cave quatrefoil at San Bartolo, in this case with stones and blossoms in its four inset corners. Located in the southern Pasión region of the Peten, Machaquila features a number of stelae portraying royal figures dressed as the Water Lily Serpent. They stand atop a quatrefoil containing the glyph for water, *ha'*. The monuments are in a plaza whose central feature is a sunken court in the form of the quatrefoil. Clearly, the Water Lily Serpent is closely identified with underworld, chthonic sources of water. – KAT

References: Beetz and Satterthwaite 1981, fig. 24; M. D. Coe 1978, vase no. 2; I. Graham 1967, figs. 42, 48–51, 57–61; Hellmuth 1987A, pp. 160–66; Houston and D. Stuart 1996; Ishihara, Taube, and Awe 2006; D. Stuart 2007B; D. Stuart and Houston 1994, pp. 33–36; Taube 1992, pp. 56–59.

2,3

2

Vase with a lord presented with
Spondylus [The Fenton Vase]
700–800
Nebaj, Guatemala
Catalogue 58

3

Vase with a tribute of *Spondylus*
600–800
Nebaj-Chajul Region, Guatemala
Catalogue 59

Spondylus or spiny oyster shells played a significant role in Maya culture: symbolically, as links to blood and embodiments of ancestors; and literally, as in the scenes painted on these two vases, prized objects of tribute given to rulers. On The Fenton Vase (plate 2), the seated lord, Aj Sihyaj, is noted in the glyphic text as a *bakab*, and a warrior in his own right (Aj Baak, "person of the captive"). He is being presented with several items, including a basket of tamales and cloth. However, the focal point of the scene is the valuable *Spondylus* shell proffered by a kneeling lord (K'inich?), who holds one arm across his body in a posture of deference. His importance is sufficient to merit the comment that the vase provides "his image," *u baah*. Further underscoring the shell's significance, the seated lord gestures toward it with a gracefully rendered extended hand. The vase from the Nebaj-Chajul region of Guatemala (plate 3), likewise depicts a seated lord looking over a basket of tribute, with blood-red *Spondylus* shells protruding prominently.

The Fenton Vase was excavated in 1904 from a tomb at Nebaj, a site in the highlands of Guatemala. It later came into the possession of Charles L. Fenton, a collector and British Consul to Guatemala. Plate 3 is associated stylistically with this same region. Other similar vessels, most lacking a provenance but taken from Guatemala in the 1960s and later, bear tribute or battle scenes, with some overlap of historical figures. Closely related pots are now in the Museum of Fine Arts, Boston; the Museum für Völkerkunde, Berlin; and the Virginia Museum of Fine Arts, Richmond.

Tribute scenes on Maya ceramics often take place before thrones or benches at the tops of stepped platforms. The transfer of tribute is usually from a subordinate, generally a captive or a person of inferior social rank, to one of higher rank. On The Fenton Vase, the overlord is not shown with the exalted "emblem" title used by rulers in the Maya lowlands to the north, which suggests a different pattern of titles or kingship. All individuals depicted on these two vessels, however, are of elite status, denoted by their dress and the glyphic captions. The painters of these and related pots worked relatively quickly and took pains to specify carefully the donors and recipients of tribute. Plate 3 stands out from the series in its use of illegible "pseudoglyphs." — GS

References: Grube and Gaida 2006, pp.167–72; M. E. Miller 1999, p. 213; M. E. Miller and Martin 2004, p. 35, pl. 6; Schele and M. E. Miller 1986, pp. 153–54, pl. 54; D. Stuart 1998, pp. 411–16.

Figure 1. Rollout photograph of plate 2.

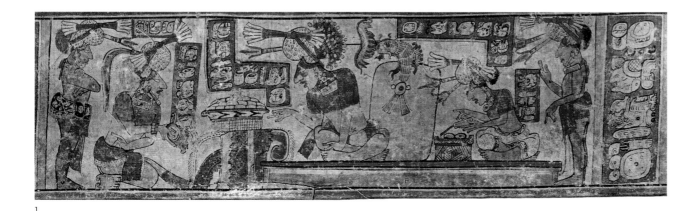

1

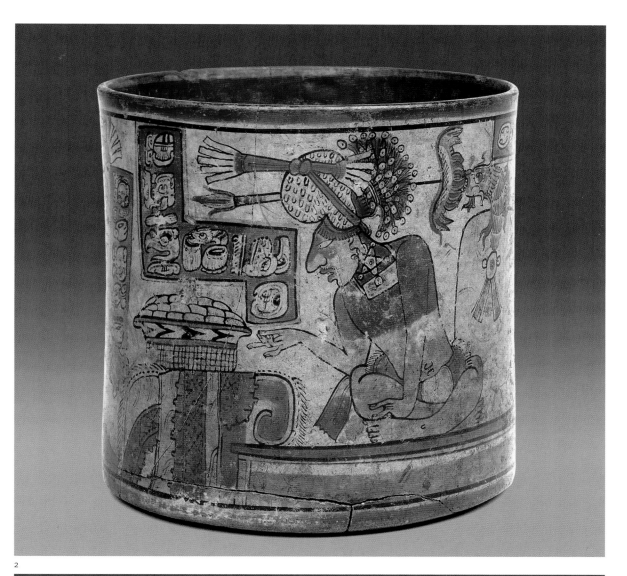

2

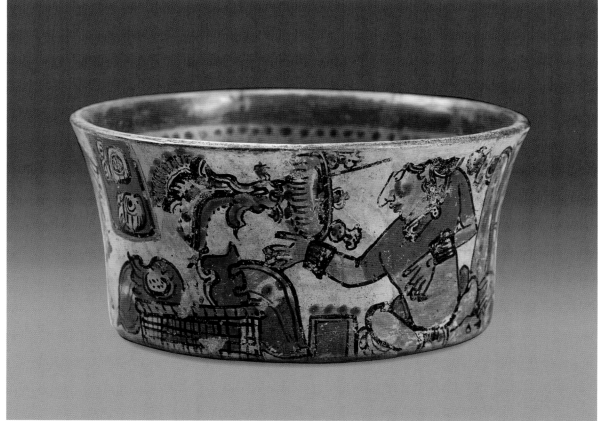

3

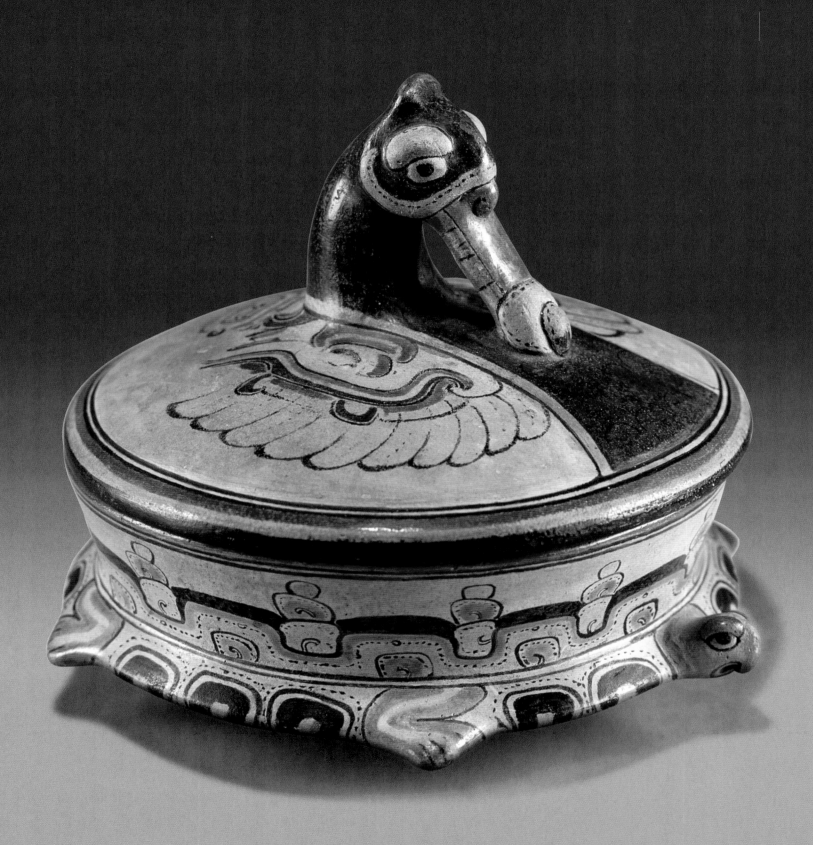

4

Lidded vessel of a world-turtle
300–400
Tikal, Guatemala
Catalogue 13

This lidded bowl serves as a microcosm of three vital areas: the sky indicat-
ed by a bird, the earth by a turtle, and the waters by a horizontal band with
shell-like volutes. The outstretched wings and beak ending in a rounded,
spiral element suggest that the bird is a limpkin (*Aramus guarauna*), which
abounds in the wetlands of the Maya lowlands and favors apple snails
(*Ampullariidae*). Its wings are shown, by common if poorly understood
convention, as open serpent jaws. Beneath the bird a submerged turtle,
whose body forms the curve of the bowl, likely alludes to the concept of
the world-turtle floating in water. Its limbs indicate a freshwater species
familiar to this potter working in northern, landlocked Guatemala. Delicate
volutes and dotted lines of orange and black evoke lapping waves.

 The bowl's restrained, earthen palette accords with an Early Classic
date. Smaller than most comparable ceramics, it probably held dainty por-
tions of food for individual consumption. The bowl comes from the burial
of a young woman, doubtless a royal, which was one of several in a long
platform just east of the main pyramid in the Mundo Perdido architectural
complex at Tikal, Guatemala. In the same burial were bowls depicting
other fauna, including monkeys, macaws, and reptiles. Avian themes ap-
pear on vessels in burials nearby, including a raptor, shore-birds, herons,
and turkeys. Together, the bowls illustrate the natural world of the Classic
Maya, and the shimmering lakes and reservoirs within their cities. – JD

References: Laporte and Fialko 1995.

5

Lidded bowl with a water-bird
300–400
Guatemala
Catalogue 28

This four-legged bowl features a water-bird painted in black, light orange, and red. The bird's arching neck and head compose a molded handle. For strength and aesthetic effect, the handle reconnects with the lid through a fish dangling from the bird's mouth; the fish tail is painted on the lid. The highly stylized feathers may indicate that the bird is in flight after catching its prey. The arched neck, crested head, and beak point to a heron, perhaps the yellow-crowned night heron (*Nyctanassa violacea*). Dots along the sides of its neck allude to water glistening off a diving bird.

The bird is perched on peccaries whose downward-turned snouts mimic the way a herd roots for food in the jungle. Rattles in the legs, barely visible through slits that double as peccary mouths, playfully refer to their noisy foraging. But the bowl could involve more than a witty reference to animal behavior. In some Mayan languages, words for "peccary" and "turtle" are nearly identical, and the allusion here may be to world-turtles or at least a terrestrial theme. The link between birds and peccaries may also refer to an unknown myth or story.

Square markings and diagonal motifs in black, green, and white over a red background around the body of the bowl constitute a geometric or batik design that corresponds to known depictions of fabric. Such textiles may have betokened great value – cloth was a key item of royal tribute – or even a domestic setting for the bowl. – JD

References: Fields and Reents-Budet 2005, p. 128, pl. 33; Looper 1991, pp. 1–5.

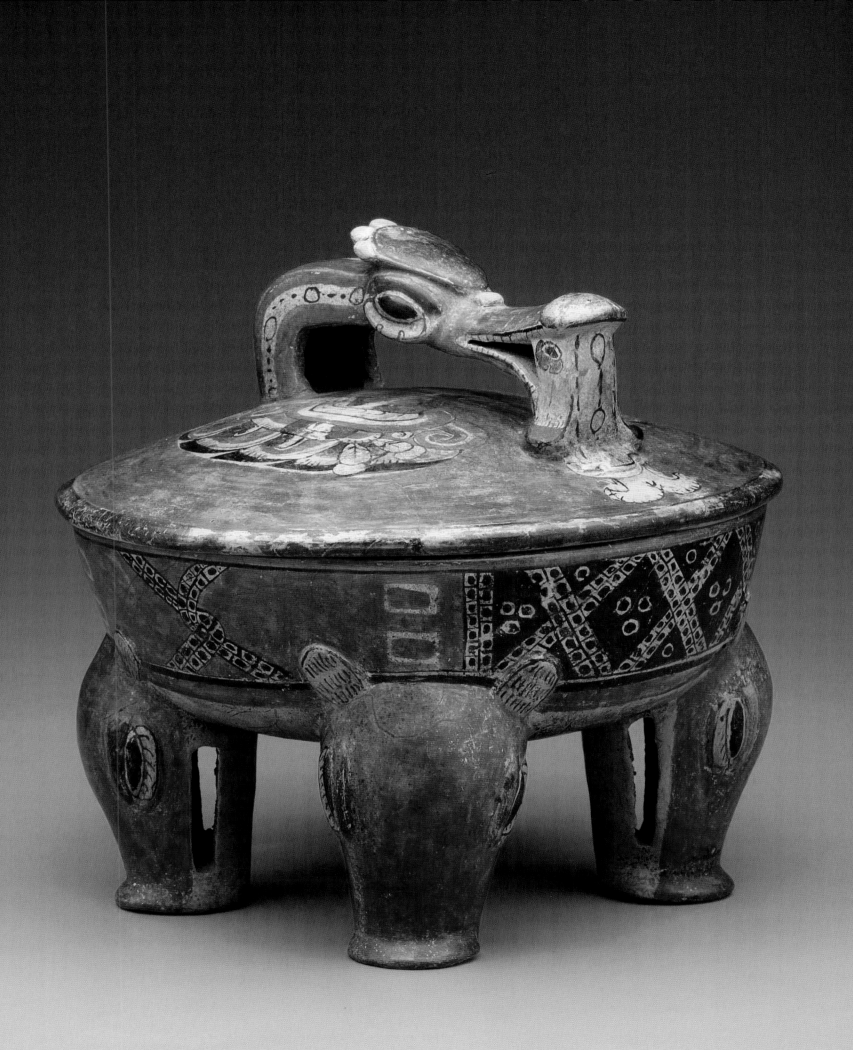

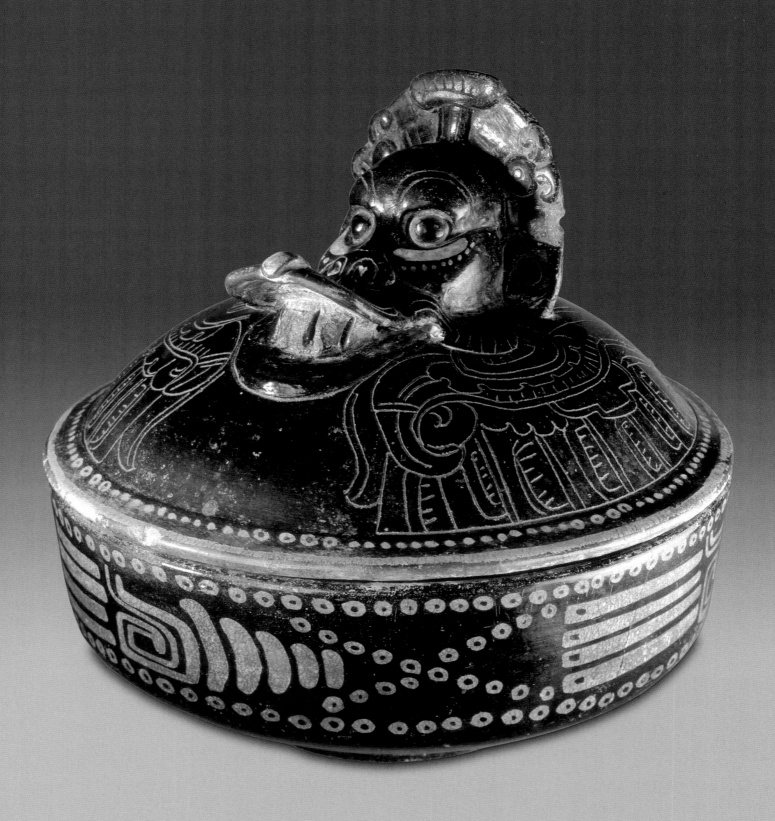

6

Vessel with a duck lid
circa AD 500
Becan, Mexico
Catalogue 29

Located in the center of the Yucatan peninsula, the Maya site of Becan lacks proximity to the sea and its creatures. Nevertheless, a rich funerary cache discovered at the summit of Temple IX contained a collection of ceramic bowls and lids whose iconography often references watery habitats, flora, and fauna. Included in the cache was this blackware vessel with an elaborately modeled, incised, and painted lid depicting the head of a duck. Incised details, such as the markings around the eyes, and the enlarged base of the slightly parted bill, suggest that the duck is a muscovy (*Cairina moschata*). Pervasive throughout Central America, the muscovy favors tropical lagoons, rivers, and *bajos* – all common in the Maya region – where it feeds on water-lily seeds, small fish, reptiles, and crustaceans. Bands of circles and dots around the rim of the lid and the outer body of the vessel represent the surface of still-water – a possible allusion to the swampy areas preferred by these ducks and their prey.

A stylized flower band, which in Maya art typically denotes pleasing fragrance, is perched upon the crest of the bird's head. Also on the lid are prominent incised "serpent-wings," a hybrid motif manifested throughout Mesoamerica. Although this particular zoological conflation conveyed complex and polyvalent meanings, plumed serpent imagery was closely and explicitly associated with the sea in both written myth and iconographic imagery. Emanating from the sides of the duck's bill are two finlike elements, which may depict fish barbels. Collectively, the iconography of this vessel, including the water beads and the specific amalgam of zoomorphic traits, relates to aquatic environs. The allusions underscore the symbolic importance of the sea and its mythic connotations to the Classic-period Maya, even those living in inland sites such as Becan. – CM

References: Campaña and Boucher 2002, p. 64; Houston and Taube in press; Johnsgard 1978, pp. 144–46, pl. 31; Parsons 1983, pp. 152–55; Webster 1976, pp. 11–15; Webster 1996, pp. 33, 35.

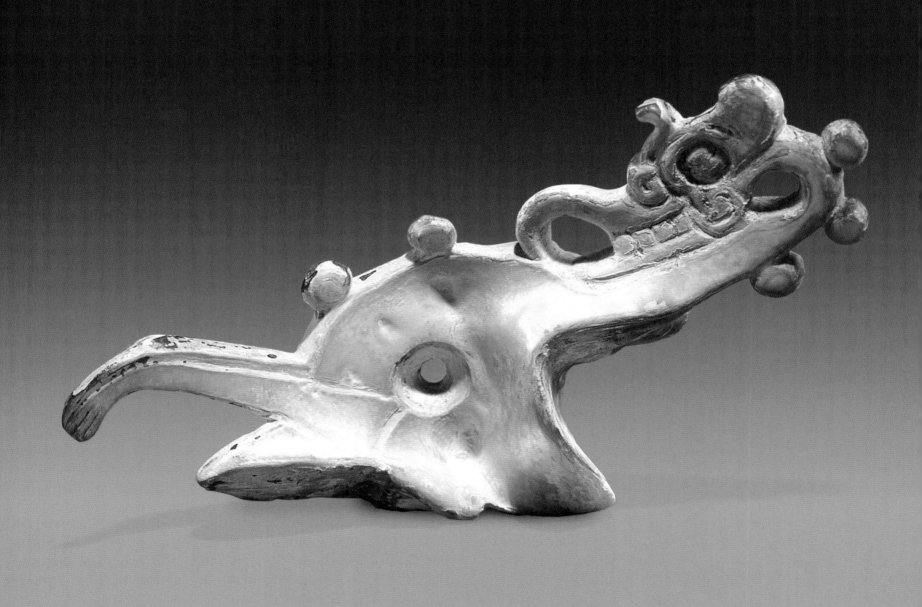

7

Pectoral in the shape of a water-bird
circa AD 500
Possibly Usumacinta region, Mexico
Catalogue 30

This pectoral appears to be carved from the interior portion of a shell and
bears traces of red pigment. It depicts the head of a long-necked water-bird,
with jewellike beads along its neck. Its round eye contains incised lines,
and two scrolling lines, one a nose, the other a tongue or watery emission,
emerge from the socket. An up-curving bill reveals a line of prominent
square teeth. Wave-shaped elements projecting from atop the bird's head
represent its plumage. Collectively, these attributes likely identify the bird
as a cormorant – a common subject in Maya art (plate 29). A large hole
created in the center of the pectoral may once have been inlaid with another
precious material, such as jade or obsidian. Four additional perforations
in the back portion of the pectoral may have been used for suspension or to
attach pendants or other decorative elements.

 Although shell is fragile and highly susceptible to degradation over
time, a variety of shell artifacts have been uncovered at Maya sites. Many
display intricate carvings and incisions that reveal the value attributed to
this material harvested from the sea. – CM

References: Schmidt, de la Garza, and Nalda 1999, p. 566, pl. 190.

8

Sculpture of a pelican
700–800
Comalcalco, Mexico
Catalogue 31

This stucco pelican – many times life-size – comes from the site of Comalcalco, a swampy city near the estuaries of the Gulf of Mexico. One of the very few depictions of a pelican from the Classic period, the naturalistic sculpture includes the rounded head, narrow bill, and featherless throat pouch of a brown pelican (*Pelecanus occidentalis*) or perhaps a migrating species such as the American white pelican (*Pelecanus erythrorhynchos*). Traces of brownish-red paint and delicate wavy incisions distinguish the feathered body from the bare, almost scaly pouch used in fishing.

The presence of sea birds signals proximity to the coastal marine environment. The ancient Maya would certainly have noticed the pelican, the largest and arguably strangest-looking bird residing near the sea. Marked by a distinctive long bill, expansive throat pouch, and large wingspan, the pelican feeds by diving into water at high speed, linking sky and water through its spectacular daily routine. This imposing pelican sculpture most likely came from the elevated palace at the site, the "Great Acropolis," forming part of a watery tableau that, to judge from the full modeling of the stucco, was partly free-standing.

Water-birds occur in stuccos at Comalcalco as well as on incised bricks, a hallmark of this settlement. The coastal orientation of Comalcalco is underscored by its urn burials, which contain large numbers of stingray spines. At least one Comalcalco brick shows a scene of sea travel or trade (plate 63). – JD

References: Álvarez Aguilar et al. 1990, pp. 36–43; Armijo Torres 2003, pp. 30–37.

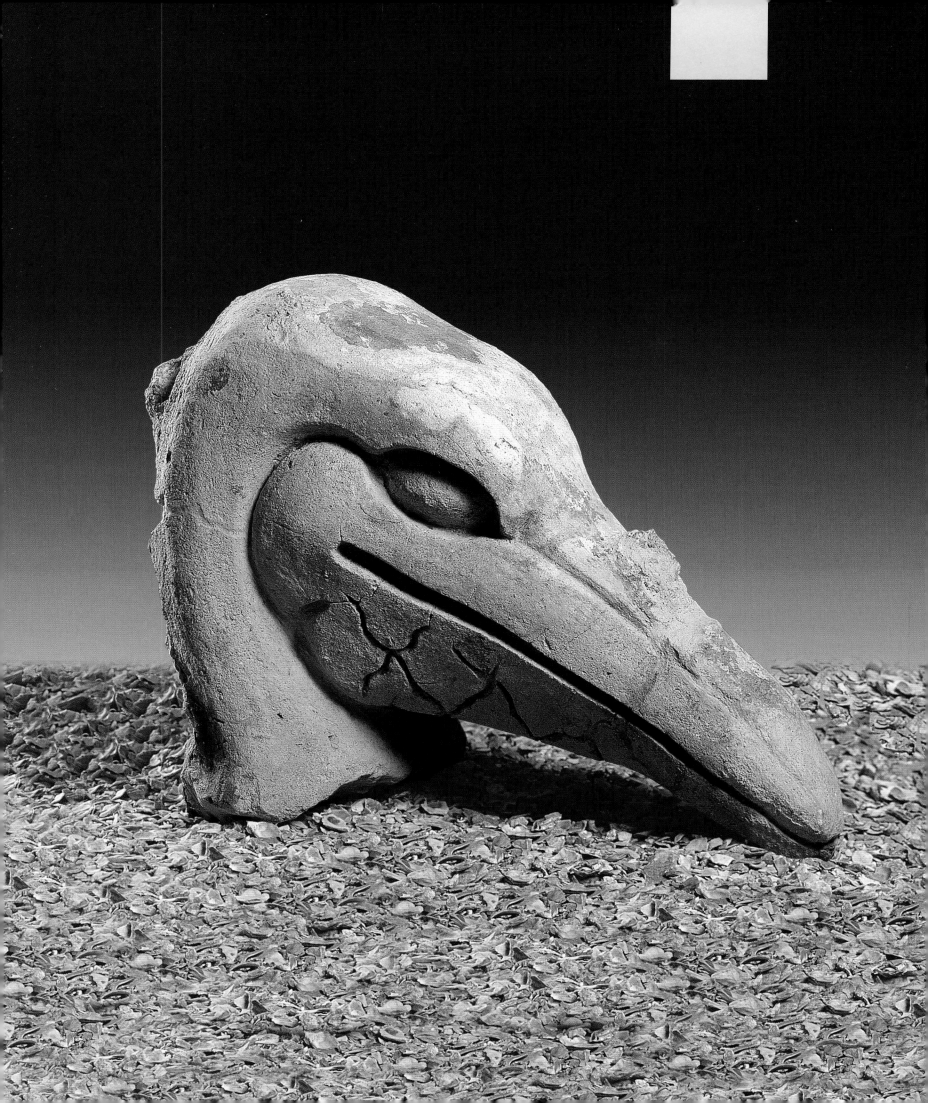

9
Figurine of a weaver
700–800
Jaina Island, Mexico
Catalogue 92

10
Figurine of an embracing
couple
700–800
Jaina Island, Mexico
Catalogue 93

11
Figurine of a female captive
700–800
Jaina Island, Mexico
Catalogue 94

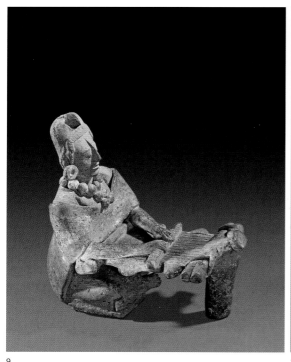

9

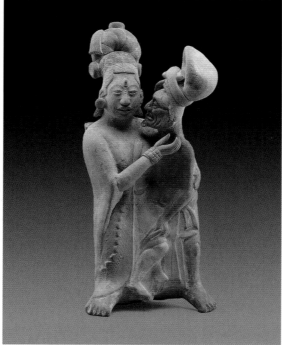

10

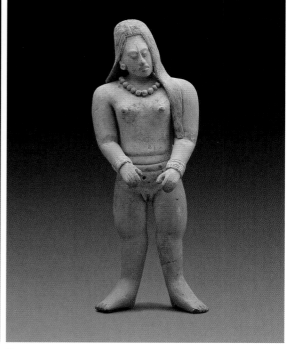

11

12
Figurine of a lord
700–800
Jaina Island, Mexico
Catalogue 95

13
Figurine of a warrior
700–800
Jaina Island, Mexico
Catalogue 96

14
Figurine of a dancer
700–800
Jaina Island, Mexico
Catalogue 97

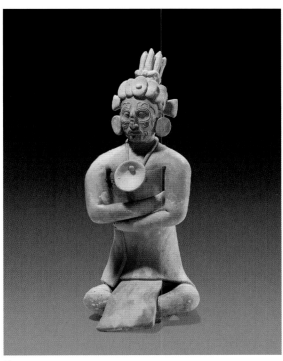 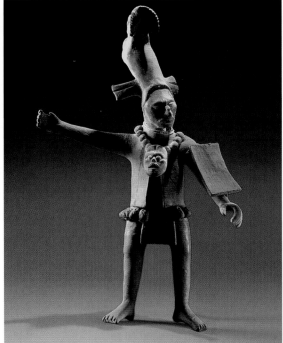 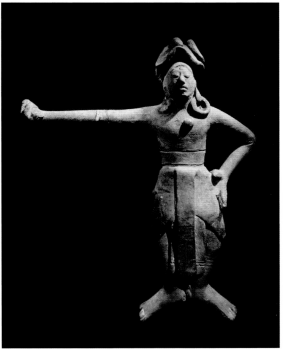

12

13

14

15
Figurine of an old drunkard
700–800
Jaina Island, Mexico
Catalogue 98

16
Figurine of the young Maize
God emerging from a corn stalk
700–800
Jaina Island, Mexico
Catalogue 99

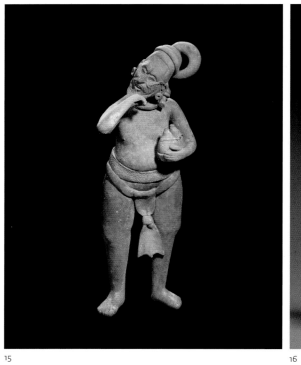

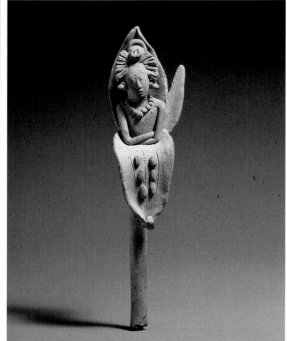

15

16

Located just off the western coast of Campeche, Mexico, the small island of Jaina was arguably a unique and important site to the Maya. Today, the nature of this Classic-period site remains debated, from those who believe that the island served exclusively as a ritual necropolis to those who argue for its position as a bustling, cosmopolitan Maya center. Less controversial is that Jaina served as the repository for hundreds of modeled, appliquéd, and painted figurines that vary in size and subject matter but share detailed and expertly rendered costumes, postures, and activities.

Statistically, women appear with greater frequency in Jaina statuary than in other forms of Maya art. Female weavers, for instance, are numerous. The example here portrays a seated young woman weaving on her backstrap loom (plate 9). She wears a large beaded necklace and prominent ear flares; a cavity near the crown of her head may have once held a feather panache.

Figurines also frequently depict young women in consort with elderly men. Plate 10 shows an old man with visibly wrinkled skin, pendulous jowls, and slumped posture gazing at the face of his female companion; he suggestively raises the hem of her long, flowing robe. The woman wears a mosaic bracelet, ear flares, and a twisted headdress; fine incisions demarcate an elaborate coiffure and facial scarification. She raises one hand to the man's face in a gentle gesture of acceptance. Contrary to these two examples of female Jaina figurines, plate 11 is a rare depiction of a woman as a captive and in nude form. Her hands are positioned in front of her to suggest that they may have once been bound with a perishable material.

Jaina statuettes depict numerous roles within Maya society. A figurine of a lord sits cross-legged, arms folded across his chest (plate 12). He wears a simple loincloth, rounded ear flares, a shell pectoral, knotted headdress, and vibrant red body paint. Of particular note are the prominent scarification patterns on his face: fish fins, scrolled volutes, and distinctively arched eyebrows link him to GI – a deity closely associated with sharks and the aquatic world. A warrior is captured in an active pose (plate 13). A rectangular shield rests on one arm, while the other is held out from his body. Partially open fists hint that he may have once held an object such as a spear, now deteriorated or lost. He wears a loincloth, a belt, and a jacket composed of shells that would have struck each other upon movement, perhaps conjuring sounds related to the sea (plate 28). Similarly lively poses characterize Jaina dancers, such as this example shown in classical Maya dance position with raised heels and bent knees (plate 14). One hand rests on his hip and he extends his other arm. He is dressed in a layered, gathered skirt, dangling earrings, and a folded hat.

The next figurine further exemplifies the dynamism of human movement (plate 15). This male wears a knotted belt, loincloth, looped headdress, and simple ear flares. He holds two gourds, held together with rope, in the crook of one arm while he touches his chin with the other and tilts his head to one side. His finely incised face reveals articulated teeth, a full beard, and scarification or tattooing patterns.

Although representations of deities are rare in the corpus of Jaina figurines, there are several examples of gods emerging from the center of flowers. The example here shows the stylized torso of the youthful Maize God emerging from a ripe ear of corn (plate 16). His arms are folded across his chest and he wears a beaded necklace, ear flares, and a fringed headdress. The figure bears traces of blue pigment.

The Jaina figurines are still a mystery. Were they portraits of historic individuals and everyday life or idealized exemplars of Maya society? Their identity and meaning will probably remain elusive until the island itself is better understood as a coastal center. – CM

References: M. E. Miller 2005, pp. 67–68; Schele and M. E. Miller 1986, pp. 153, 155, 227, pls. 51, 53, 58, 89; Simoni-Abbat 1974, pl. 90.

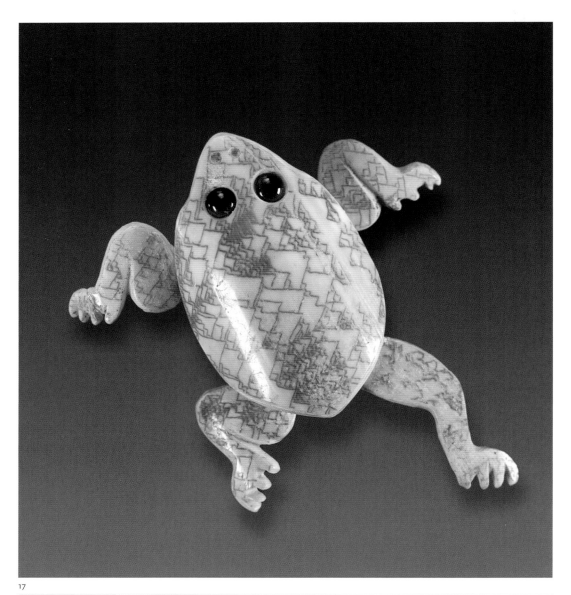

17

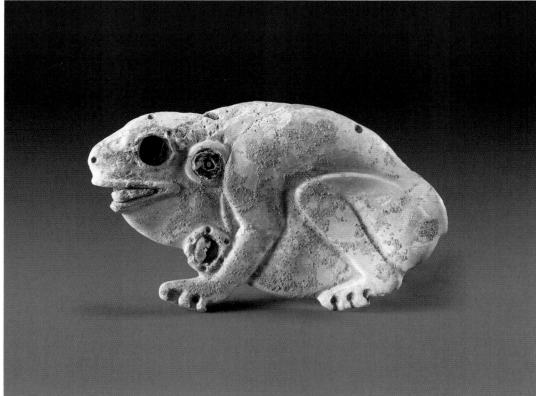

18

17, 18

17
Carving of a frog
700–800
Topoxte, Guatemala
Catalogue 33

18
Carving of a frog
750–850
Tayasal, Guatemala
Catalogue 34

Frogs and toads (order *Anura*) are inextricably related to water through their aquatic metamorphosis from egg to tadpole to adult. Originally part of a sumptuous burial offering from the island of Topoxte in Lake Yaxha, the first shell carving (plate 17) portrays a smooth and nimble swimming frog, limbs in motion, with pale eyes of inlaid stones. Its captivating color and delicate pattern come from the natural appearance of the *Oliva porphyria* shell, which is found in the Pacific Ocean in southern Central America. The second shell carving (plate 18) comes from a burial at the Maya island center of Tayasal, located near Lake Peten Itza, which was excavated by the University of Pennsylvania. It shows a fat, gaping frog or toad in profile, adorned with human jewelry. The eye is obsidian and inlaid jade beads form an ear flare and what might be a necklace or pectoral. The tongue, a wedge of shell, is highlighted by traces of red pigment, possibly cinnabar. Both frogs are composed mainly of shell, underscoring the relationship between frogs, water, and ultimately, the sea.

The Classic Maya consistently depicted frogs and toads as anthropomorphic beings and spirit co-essences, embodying rain and yearly renewal. The characters are vocal, active, and diverse in shape and color. Sometimes the artists indicated their green color or newness, marking them with the glyph *yax*, meaning "green, new, first," or they showed them as terrestrial with scaly, reptilian skin. Often they appear interacting with Chahk, the Rain God.

The Classic Maya held a special reverence for frogs and toads because they formed an integral part of the cycle beginning with water rising from the sea that eventually falls on land, causing the forest floor to come to life with a chorus of amphibian calls. Amphibians also connect several realms through their various habitats: living in trees, on land, and in water. Amphibians appear in the hieroglyphic inscriptions, as *ajmuuch* ("frog") and *amal* ("toad"), in royal names and the names of spirit companions. Key Maya glyphs, the syllables *mu* and *bu*, evolved from the word *muuch* for frog, as both signs include a small frog head. – JD

References: Castillo 1999; A. F. Chase 1983, p. 531, figs. 3–28; Schaafsma and Taube 2006, pp. 231–86.

19

Royal tomb offerings
circa AD 800
Ek Balam, Mexico
Catalogue 86

These elaborately carved shell ornaments were recovered from the royal
tomb of Ukit Kan Leek Took', the most important lord of Ek Balam. The
plentiful offerings include various carved animals, including a bird, deer,
and two shrimp, as well as a carved fish pectoral inscribed with glyphs
that name Ukit Kan Leek Took' as its owner. Five fine pendants in the form
of human skulls possess articulated lower jaws that would have clacked
and rattled as their wearer moved. Some additional pendants with geo-
metrical shapes and designs were finished with red paint; all are expert
and delicate works. An additional five thousand pieces of drilled *Oliva* shell
emphasize how exotic marine materials were valued as sacred offerings to
a revered holy lord.

Within the tomb itself, the king was laid out on a jaguar skin and
accompanied by a rich collection of funerary paraphernalia. In addition to
the carved shells were alabaster and ceramic vessels, heavy flint knives,
a frog made of gold, remains from human and animal sacrifices, and a
carved human femur that appears to be a relic of an ancestor of Ukit Kan
Leek Took'.

Located approximately seventy miles (one hundred and twelve
kilometers) from Chichen Itza in northeast Yucatan, the site of Ek Balam
("Starry Jaguar") can be characterized in part by extensive architectural,
epigraphic, and iconographic programs that peaked in the Late and
Terminal Classic periods. Throughout the texts found there, Ukit Kan
Leek Took' is portrayed as both a dynastic founder and as the instigator of
the site's florescence in the late eighth century AD. One of the structures
commissioned by this early lord, the Sak Xok Naah or "The White House of
Reading/Counting," eventually became the location of his interment. – CW

References: Grube, Lacadena, and Martin 2003; Vargas de la Peña and Castillo Borges
2001; Vargas de la Peña and Castillo Borges 2006.

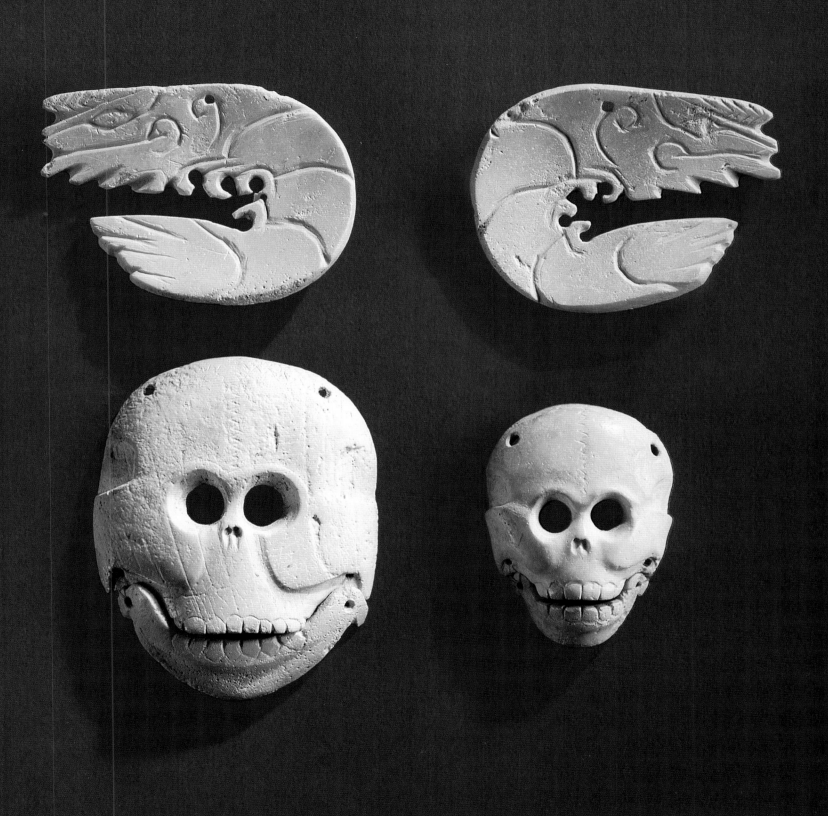

LIVING WATERS AND WON

STEPHEN D. HOUSTON

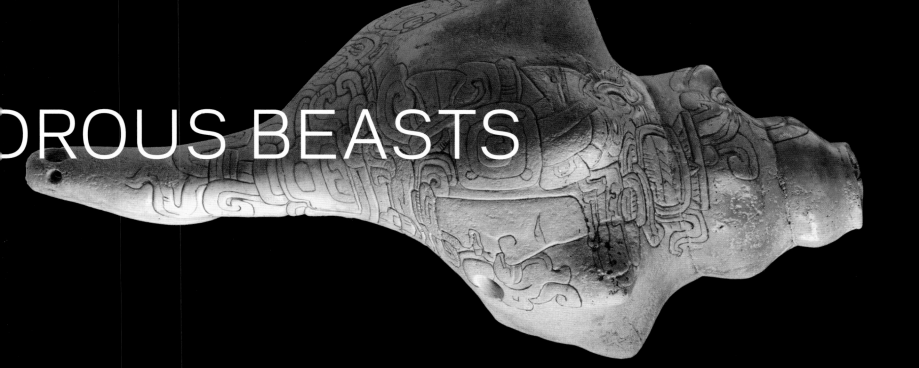

SONOROUS BEASTS

The Maya were not the only people in Mesoamerica for whom water played a fundamental role in the physical and spiritual world. Views of the sea and watery places appear throughout the region, and often in telling ways. One set of images identifies the sea as a point of origin for exotic shells and creatures, often linked, as among the Aztec of central Mexico, to the Rain God, Tlaloc.[2] A very late Aztec sculpture of Tlaloc presents him on his back, in a form linked to earlier Maya and Toltec peoples, cradling a bowl for sacrificial hearts. On the base of the sculpture, in imagery that would have been invisible after the carving was placed, courses a wavy, aquatic background with a conch shell, swirls of water, a bivalve, water serpent, even a puffer fish. In the middle is a splayed figure with the combined features of Tlaloc and the ravenous earth, which the Aztecs believed floated in a primordial sea (figure 1). The relation of the Rain God to the products of the sea finds even greater expression in the rich cached deposits of sand, small shells, conch, alligator, coral, and other items in the Great Temple (Templo Mayor) of the Aztecs, now in Mexico City.

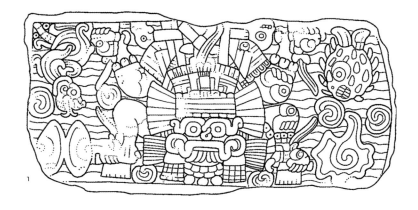

The image illustrates another important feature of such views: waters are unitary. Fluids gird the world, fall as rain, surge underground, and emerge as springs and rivers – all circulating in a system close to current understandings of hydrology. For the Aztecs, the sea or *huēiātl*, "large water," was a place where sky and water met – *ilhuica ātl*, "sky-water" – a logical response to a shimmering, far distant horizon on the ocean and an acknowledgment of connections between parts of the cosmos (Taube, pages 204–205). At the same time, Mesoamerican peoples sometimes depicted bodies of water, including the sea, as bounded regions. This stems partly from the representational convention that all elements that could be labeled with words were treated as discrete and definable. In Maya imagery of all periods, for example, the sky appears not as limitless but as a horizontal rectangular band embellished with celestial symbols, with distinct edges and ends. Likewise, the sea could be depicted with margins, as

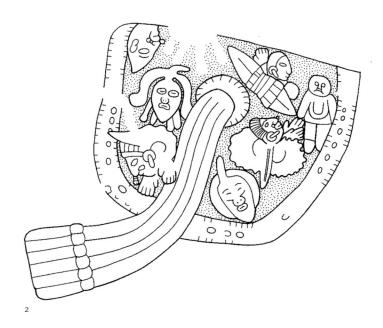

THEY SAY THE WORLD IS LIKE FOAM FLOATS ... WE RIPPLING ON THE WATER.

on Bilbao Monument 21, carved during the heyday of the Cotzumalhuapa civilization of southern coastal Guatemala during the middle of the second millennium AD. Although not certainly made by Mayan speakers, but not far from those who were, Monument 21 glories in sacrifice and rich harvest, with overtones of paradise and a jewel-bedecked landscape (figure 2). At the lower right, an encircled area is ringed by dots like the Maya convention for water and populated by shell creatures, a possible octopus and manta ray, and a shell being and composite *Spondylus*/stingray-spine figure close to Maya imagery.[3] Of great value in Mesoamerica, the quetzal feather panache may identify this section of Monument 21 as a precious sea filled with wondrous creatures.

Similar bounded seas appear in the Maya area itself. On Structure 16, from Tulum, Quintana Roo, Mexico, blue-hued murals from a century or so before the Spanish conquest have at their base a blue-and-white striated sea with fish and a possible manta ray; the dentition of a cosmic crocodile, a model of the earth, marks the sea's edge (figure 3; and Taube, pages 204–208). The same crocodile, with sea creatures darting underneath, marks roughly contemporary murals from Santa Rita Corozal, Belize.[4] In yet earlier Maya murals from the Temple of the Warriors at Chichen Itza, Yucatan, circa AD 1000, parallel scallop-edged striations indicate the sea, in a convention like the aquatic image under the Aztec carving of Tlaloc (plate 69). But here, the water is seemingly a lake enclosed by a rocky or sandy shore and containing creatures identical to those in other murals from the Temple of the Warriors, including rays, crabs, shells, and fish with long lines looping from their gills, perhaps a piscine version of the Maya breath and speech scrolls.[5] Many other Chichen Itza wall paintings from the Upper Temple of the Jaguars emphasize the omnipresence of waters through the insertion of underground streams or pools at their base. Water lilies, elderly gods, and the active spirit of water fill the blue depths. As with much of their iconography, the Maya employed a finite scene or image – a comprehensible, visible whole – to suggest a vast totality beyond

Previous spread. Cumulus clouds; and Conch trumpet with a floating ancestor (plate 42).

Figure 1. Base of Aztec *chacmool* (supine figure), circa AD 1500, at the Templo Mayor, Mexico City. Drawing by Stephen D. Houston.

Figure 2. Detail of Bilbao Monument 21, Late Classic period, Guatemala. Drawing by Stephen D. Houston after rendering by Oswaldo Chinchilla Mazariegos.

Figure 3. Detail of a mural in Structure 16, Late Postclassic period, Tulum, Mexico. Watercolor painting by Felipe Dávalos.

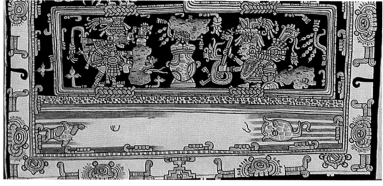

3

JUST FLOATING WITH US, ARE JUST FLOATING,

H'ORTI' MAYA ACCOUNT[1]

ready apprehension, much as the back of a crocodile or turtle can exemplify the terrestrial surface of the world (figure 4; and Taube, pages 204–12).

In a worldview that perceives waters with an overall pattern of circulation, salt and fresh bodies could share attributes. Water lilies (*Nymphaea apla*) do not flourish in even slightly saline conditions, yet they occur in several images of cosmic turtles with the Maize God emerging from their backs, a secure representation of a primordial sea.[6] Similarly, although Chahk was a celestial being associated with storms, clouds, and lightning, he could appear with caves and the underground waters that run through them or collect in their depths (plate 84). Two extraordinary finds illustrate that association. The first, a large stucco seated Chahk, lightning axe in one hand, from the cave of La Pailita, Peten, Guatemala, embodies the common Mesoamerican notion that clouds and rain emanated from the sea but also from caves and the waters therein (figure 5).[7] Indeed, in humid conditions, caves in the Maya region can often be detected by the mists that gather near their entrance. The La Pailita Chahk is now destroyed, unfortunately, as are many unprotected features in the Maya lowlands. The second example of close bonds between the waters of sky and earth comes from a stucco altar dating from 200 to 350, also destroyed, from Aguacatal, Campeche, Mexico, a site in an estuary near the Gulf Coast (figures 6, 7). Designed to allow the iconography to be seen while functioning as an altar, this four-lobed mass finished with stucco represents the entrance to a cave despite its elevation above ground. Undulating around the edges, a stucco band symbolizes water interspersed with shark heads and faces of Chahk, as though these ancient combatants were housed within subterranean waters. The altar was located in a plaza or open space,

which the Classic Maya at least understood to be like a watery cavity. This may have been because heavy rains could flood the plazas but it is more likely that, in symbolic terms, plazas served as points of access to waters underground (plate 20). The base of a Late Classic stela from Machaquila, Guatemala, emphasizes that link by situating the upward-facing head of Chahk within the sign for such a cave.

A visual vocabulary of water The Maya are much affected by seasonal rains that arise from a belt of low pressure known as the Intertropical Convergence Zone. Encircling the globe, the belt shifts northward or southward according to the sun's position at zenith.[8] Rains fall reliably over the summer months but also extend well into the fall and beyond. Thunderstorms of shocking size and energy carry moist air upward. Dominant wind patterns in the Maya region mean that the thunderheads generally travel from east to west. Rainfall varies greatly: in several areas, especially at the base of the Yucatan peninsula, precipitation occurs at any time of year; by contrast, seasonal dryness is most severe in the northwestern tip of the peninsula and in rain shadows – desertlike areas – near the Motagua River valley. From June to November, the clouds may also coalesce into hurricanes or less-organized systems that assault the coast and points inland. The devastation caused by storms like Hattie in 1961 or Mitch in 1998 gives some idea of the impact on earlier Maya. Their texts comment on such whirlwinds with clouds swirling with winds arriving from four directions, labeled in a glyphic text as an *ik' chan*, "windy sky" (figure 8). In human terms, rainfall is always more than a passing event. The Maya had to control, collect, and remove water, including the great flow from storms. Several scholars take this as reasonable evidence that water management was a central preoccupation of Maya builders and planners (Fash, pages 81–82).[9]

Not surprisingly, water symbolism abounds in Maya iconography.[10] The earliest, Late Preclassic, depictions highlight Chahk, the bringer of

Figure 4. Shell crocodile with holes for jade insets, Late Classic period. Peabody Museum of Archaeology and Ethnology, Harvard University, Cambridge, Massachusetts. Drawing by Stephen D. Houston.

Figure 5. Seated Chahk from the cave of La Pailita, Guatemala, Early Classic period.

4

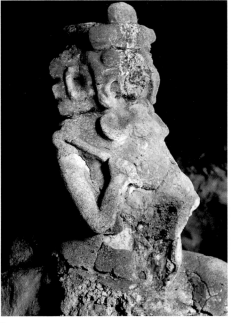

5

rains. On Izapa Stela 1, from the coastal area of Chiapas, Mexico, his feet are equipped with shark heads and fins (Taube, figure 11). Underfoot are waves defined on either end by two heads of Chahk. Water pours from the fishing creel on his back, much like in scenes incised on Late Classic bones from a royal burial at Tikal (Taube, figure 13). But, more often, Chahk appears in his celestial abode. Two Late Preclassic friezes, one from Calakmul, Mexico, another from El Mirador, Guatemala, show him looking downward from the sky. His body is in vigorous motion as though swimming through clouds, perhaps indicating that he is in the process of unleashing a storm. A related Early Classic image from a royal tomb at Copan, Honduras, takes the process further by having Chahk descend from the sky, lightning axe in hand. The storm no longer threatens – it has arrived in force.

The aquatic residue of Chahk takes several forms. The most common is a wavy or straight band with rhythmically repeated dots, several large ones followed by several small (plate 20). The dots may mimic the effect of aerated, bubbling water, a convention that extends from the San Bartolo murals of 100 BC (plate 83) to the Postclassic codices, which use wavy blue bands and dots to suggest a deluge. Volutes hint at waves. Another frequent form with three lobes remains less understood. Highly stylized shells probably indicate the rising steam, "conch-breath" as described by Karl A. Taube, by which Maya explained evaporation as the exhalation of watery creatures (plate 76).[11] In one curious conceit, also pointed out by Taube, a stucco frieze of entwined watery bands at Yaxchilan, Chiapas, intersperses such bubbles with the heads of frogs or toads, as though their breath were the source of the aeration. A related display of water includes

some of these elements but augments them with angled bands. Wavy in outline, these hint at the presence of flowing, agitated waters. Some appear behind dotted bands of water, others in front. Angular, geometrical conventions may introduce three dimensions to aquatic imagery or may suggest the interplay of currents. Very similar configurations occur in Late Preclassic depictions, but of the sky rather than the sea. The meaning is uncertain, but their shared features may emphasize the enormity of both such regions and their ultimate union on the ocean's horizon. The angled bands often nestle signs that resemble the *le* syllable in glyphic script. This sign also marks a glyph for another kind of vegetation, the "water lily," *nahb*.

In most aquatic scenes, the angled bands represent vibrant water, even among non-Maya. The Late Classic murals of Cacaxtla, Puebla, Mexico, hundreds of miles from the Maya region but made by painters closely versed in such imagery, show precisely these bands, probably as exemplifications of eastern seas dominated by Maya peoples. Traversed by canoes, these rich waters provided the exotic goods that eventually found their way to highland Mexico. At Cacaxtla, one painting near a stairway, itself a cue of human movement, highlights God L, the Maya God of Trade, whose jaguar attributes point to movement at night (Martin, figure 1). Nearby leans his bundle of trade objects, including feathers, possibly cacao beans, and perhaps a ball of wax, a known commodity from the Maya region. Below gushes an exuberant spill of shellfish, frogs, herons, and water lilies, all conforming to Maya conventions.

As Maya painters began to play with illusionistic effects in the Late Classic period, images of water departed from symbolic renderings and led to the experiments of codex-style pottery, so named because of its palette's resemblance to that of Postclassic codices. A brush loaded with diluted brown or black paint was swirled on a surface to suggest roiling fluid; dots sometimes picked out along broad lines smeared horizontally suggest opaque water. The lower halves of partly submerged bodies disappear within such masses of paint (figure 9). The concept is to indicate what

Figure 6. Detail of the Chahk altar at Aguacatal, Mexico, Early Classic period.

Figure 7. Detail of the shark altar at Aguacatal, Mexico, Early Classic period.

Figure 8. Detail of the hurricane or whirlwind icon, *ik' chan*, on a vessel circa AD 750. Museo Popol Vuh, Guatemala City.

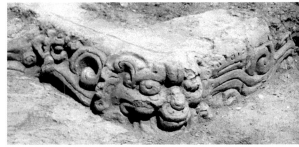

6

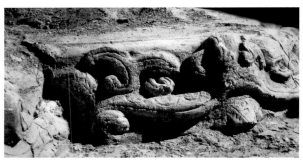

7

8

the eyes see, not what the mind knows to be there – a representational strategy that became increasingly common in the eighth century AD and that stresses the role and experience of the viewer more than the intrinsic content of the subject. Another naturalistic effect animates the clay supports of a large plate that commemorates Chahk rising from primordial waters (figure 10). Its sides adorned with water symbols, the plate rests on supports that represent pillars of rain, the sort that the Maya would have seen descending from isolated cloudbursts.[12] The plate embodies its own weather system, and the surface on which it rested would have doubled symbolically as the earth on which such rain falls.

As a disorderly mass, difficult to contain or control, water was likened by the Maya to other substances. Smoke billowing from a shark version of the Sun God contains the same dots as water; the swooping striations in the background may allude more directly to the watery setting of the god (plate 22). Blood, too, can overlap with water; the Maya may have likened blood's metallic tang to saltwater. A scene of a monstrous fish being speared by a deity takes place in red waters, identical to the effusions from the fish's wound (plate 80). More speculatively, the blood streaming from the creature may have formed the sea itself – a view supported by the reported decapitation of a mythic crocodile in 3301 BC connected at Palenque to the pooling of blood in large quantities (Taube, page 204).[13]

Waters in motion – surging, bubbling, ebbing and flowing – did not, in Maya minds, simply obey the physics of fluids. They took on the form of a living being, a serpent whose body consisted of beaded water and whose

headdress was a water-lily pad with a lashed flower; it bore a panache of quetzal feathers on its back. Accompanying fish nibbled at its tail or absorbed food, like aquatic hummingbirds, from the water-lily blossom (figure 11). Indeed, several hybrid forms are explicitly both fish and fowl. "Sentient" may be too strong a word to describe the water reptile, yet by its very existence and lashing movement the snake redefined the nature of water from physical substance to a creature with its own will and capacity for action: now a living being and no longer a thing. In glyphic texts, the serpent was probably read *witz'*, "waterfall" or other lively body of water.[14] In Yukatek, another Mayan language, *witz'* describes "spray" or "splashing."

Among the Ch'orti' Maya, a language group with close links to the Classic inscriptions, water snakes are thought to thrash in the sky or coil in lakes, where they influence the rain; their absence leads to drought. In one account, the great feathered snake *Noh Chih Chan* was said to be "the guardian of the water. It lives there and cannot leave … [and] is 'sleeping' or 'resting' during the summer season … [to be awakened, thus providing] the precious gifts of rain and food." The paradox of such serpents is that "[t]hey are both one and innumerable, being said to exist not only singly in certain localities [such as springs or lakes] but everywhere at once." In rare examples, the water serpent is used to record the glyph *ha'b*, "year," itself a word possibly derived from a term for the annual cycle of rains. When appearing in imagery, the serpent may signal the onset and duration of rains that will water the crops. Ethnography from the Ch'orti', who have a richly developed interest in supernatural serpents, reveals an understanding that the serpents mate during the rainy season, causing landslides and flooding. Farmers and archaeologists know that at the beginning of the rains, snakes also flush from their lairs, an event doubtless observed by ancient Maya. Rulers of the Classic period focused on such creatures and, in certain sites, such as those of the Pasión River drainage of Guatemala, sought to impersonate the serpent by wearing a costume and mask with

Figure 9. Plate with a mythic turtle and the emerging Maize God encouraged by the Hero Twins with a water lily and water below, 680–750, Guatemala. Museum of Fine Arts, Boston.

Figure 10. Cloudburst supports on a "cosmic pot," 700–800. Private collection.

Figure 11. Rollout photograph of a stucco vessel with a watery serpent, circa AD 600, Guatemala (detail). Museu Barbier-Mueller, Barcelona.

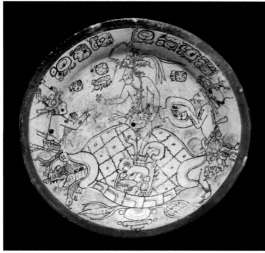

9

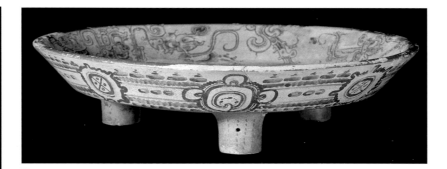

10

11

its features (figure 12). Important buildings at Classic-period sites like Caracol, Belize, and Dzibilchaltun, Yucatan, Mexico, were devoted to the water serpent, probably as a means of managing or propitiating a capricious force of nature. Related to this ritual practice was an awareness that, in mythic accounts, the water serpent provided water to the Maize God. In at least one scene from the Late Classic period, the deity is a supplicant to a lordly if anthropomorphic serpent, as though pleading for nourishing waters.[15]

For the Maya, "water" was *ha'*, a word going back to the beginnings of their language family, with close cognates in all descendant tongues. The most common glyph for it resembles the first day name in the Maya 260-day calendar, a precise parallel to the day "crocodile" in other calendars. Yet, it was also highlighted by crosshatching, an indication of darkness or color saturation. That *ha'* was crucial to largely agricultural peoples becomes clear by its prevalence in Maya place names, the oldest documented in the New World. Terms like *Yaxha'*, "Green/Blue Water," for a large city near a lake in northern Guatemala of that same name, goes back to the beginnings of the Early Classic period.[16] Other bodies of water, such as *lakamha'*, "broad/banner water" or "wide water," for Palenque, Chiapas, are known a few centuries later (Stuart, page 42).

To a striking extent, hieroglyphic texts seem not to specify whether a feature of the landscape was a lake, river, or spring, despite the existence of such terms, as in Ch'orti' Mayan *ut ha'*, "spring" or "eye [opening] of water." Even a large body of water like the Usumacinta River, running in part between what are now Guatemala and Mexico, presents no clear label for its entire length. A feeder river, now called the Río Pasión, might

have been *Chakha'*, "red/great water," and an area far downstream, in the plains of Tabasco, Mexico, went by *Pip(h)a'*, a watery designation of less secure meaning. With a word like *ha'*, the emphasis was less on the receptacle than the fluid it contained, a notion consistent with the pervasive concept of integrated waters.

Another term that describes both a body of water and its contents is *nahb*. Like *ha'*, the word is exceedingly ancient, from the first years of Mayan languages. The general meaning is a body of water, yet when augmented by the term for "fire," it becomes "sea" or "fiery pool," *k'ahk'nahb*, still found in several Mayan tongues (figure 13).[17] The term probably refers to the sun rising each morning as a fiery orb out of Caribbean seas and descending that same evening, often with spectacular effect, into the Gulf of Mexico. The very positioning of the sea to the east, north, and west of the Yucatan peninsula – the Pacific to the south completes a pattern of water in all cosmic directions – provides a logical tie between the sun and the sea (Taube, pages 215, 217–18). It is the place from which the sun rises and sinks before entering its episodic Underworld and underwater domain, only to emerge anew each morning.

The sun's movement may explain one of the most extraordinary Maya sites, the island of Jaina, "House in the Water," only a short distance off the western coast of Campeche, Mexico.[18] In the second half of the nineteenth century, when the island was heavily mined for materials to expand the city of Campeche, archaeological remains were discovered that in the first half of the twentieth century became a magnet for looting. Of special note was the discovery of hundreds of finely modeled figurines, most about five to ten inches (12.7 to 25 centimeters) in height, with crudely modeled feet but expressive faces and highly detailed clothing. The vast concentration of burials contributed to Jaina's reputation as a "necropolis island," a place for the dead in the direction of the setting sun. More recent excavations have downplayed that claim, with the counter-argument that Jaina enjoyed facilities of the sort common in dynastic centers, including

Figure 12. Detail of the water-serpent impersonation by ruler Sihyaj K'in Chahk on Machaquila Stela 3, AD 815, Guatemala.

Figure 13. Glyph for *ti' k'ahk'nahb* ("at the edge of the sea"), circa AD 700, on Tablet of Temple XIV, Palenque, Mexico. Drawing by Stephen D. Houston.

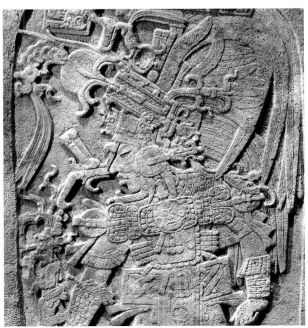

12

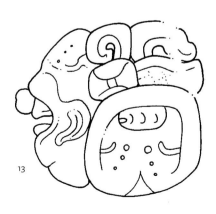

13

stelae of captives, ballcourts, plazas, and pyramids; numerous floors for residences; large-scale reworking of the island, composed of building fill brought from a few miles away (the shore near Jaina is swampy today); and docks for an active trading port. Furthermore, Jaina figurines were probably found over a much larger area and not made on the island itself. In sum, Jaina functioned as a robust trading center, perhaps endowed with its own dynasty during the Late Classic period, but not as an island of the dead where, to use a Classic idiom, *och-ha'*, the deceased "entered the water" (plate 97).

The difficulty with revised views of Jaina is that the island is only about 766 yards (700 meters) wide at its greatest extension, and much of that is given over to ceremonial architecture. Today at least, the terrain nearby is uninhabitable, although with shifts in water level, that might not always have been the case.[19] Yet, limited archaeological work reveals no fewer than a thousand burials, suggesting an immense number either looted or not yet uncovered. A small island is unlikely to have supported this quantity of people, and no Classic-period tanks for drinking water have been found. The few objects with texts thought to come from Jaina relate to dynasties dozens of miles inland, especially the city of Xcalumkin, Campeche, Mexico. Pending more information, the safest scholarly route lies between the two extremes, acknowledging Jaina as an active participant in coastal interaction yet with unusual features and a special mortuary role for the figurines of the zone.

The daily cycle of the sun explains some features of the Maya Sun God. Eagled-eyed, with the beaked nose of elderly deities, the god can also appear with fish barbels, rather like catfish or carp, watery designs on the sides of his face, a shark tooth, and the swirling eyes of fish (plate 25). In this guise, he may represent the deity emerging from or descending into

the sea. At Palenque, Chiapas, this version of the Sun God – regrettably, his name is still undeciphered – figures prominently in mythic accounts.[20] Known to scholars as "GI," he is one of three gods of central importance to Palenque; the third is another aspect of the Sun God and is often fused with the Rain God, Chahk. This fusion is especially evident in his shell ear ornaments, most likely of *Spondylus*, a prized product of the sea. The merging of Chahk with a fishy, watery variant of the Sun God is logical: barring unusual storms, the clouds in the Maya region move generally from east to west, along the same path as the sun. The ancient Maya might have attached the attributes of one god to the other to recognize their joint passage.

The usual shape of the glyph for "pool" or "sea" is revealing, as in part it represents a water-lily plant or *nahb* as spelled in glyphic texts. The origins of the words are not entirely clear, but it could be that "body of water" became linked to one of its principal denizens, an indicator of that water's clarity and potability. In full form, the *nahb* glyph shows both flower and floating leaf, sometimes nibbled by hungry fish, along with a human skull as its base (figure 14). Still a mystery for which no solid explanation exists, the presence of the skull may hint at the tenacious rooting of the water lily or, in bolder speculation, sea corals sprouting their own "plants" in the form of anemones or sea fans, some of which found their way into Maya architectural caches. The blurring of the water lilies and the bodies of water that hold the plants may explain why Maya painters placed cosmic turtles and the watery emergence of the Maize God (plate 88) atop water lilies and not above explicit markings of water: the plant served as shorthand for the pool or sea. Maya artists would also lash water lilies to the heads of underground figures. Many of these were subordinate lords, so identified by hieroglyphic captions, that adopted the role of Atlantean personages with their king often depicted above or, when part of thrones, supporting the flat surface for a living lord. Drawing on two metaphors, such images use water lilies to suggest the presence of subterranean

Figure 14. Carved sides of a water-drain, 700–800, El Paraiso, Honduras. Drawings by Stephen D. Houston after photographs from Marcello Canuto.

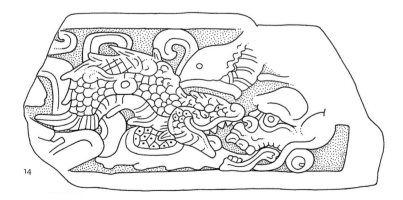

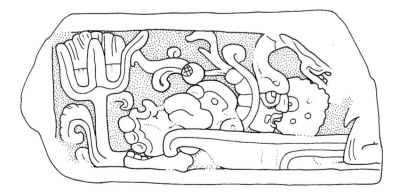

14

waters and to highlight the service of courtiers: tireless supporters of the royal throne and herculean supporters of the world itself (plate 26).[21] In several grim statements, Classic sculptors referred to *nahb*, but in relation to blood rather than water, principally the pooling of enemy blood followed by the heaping of their skulls.[22] A less horrific reference appears on a Late Classic watery band that runs across the base of a platform at Calakmul, Mexico. A blue oval cartouche links the *nahb* to *tok*, the word for "cloud," as part of a market facility recently uncovered at that site. Interpreted literally, the watery band could be seen as the means by which trade goods came from distant locations, perhaps in part by canoes on rivers and seas wreathed in mist or supplemented by rainfall from clouds.

Yet, the band at Calakmul is probably a more complex allusion: all such dotted depictions of water in the Classic period pertain to mythic seas and fluids. A scene in Temple XIV at Palenque, Mexico, was commissioned by the ruler Kan Bahlam to celebrate a rite in which an enigmatic person, Sak Baak Naah(?) Chapaht, "White Bone First Centipede," danced on a watery band marked as *ti' k'ahk' nahb*, "[at the] edge of the sea" (Zender, figure 1). Yet, the event supposedly took place many thousands of years in the past. For most Maya rulers, the sea was by all odds a distant, fabled home to supernatural personages and energies. When shown with the conventions described thus far – dots, angled bands, volutes – the waters might have been mythic, a deeper reality beyond humans' sight and experience. The images seldom describe an actual, specific observation of a particular body of water. Rather, mythic models or exemplars dominate the act of perception, molding any idiosyncrasy to a general expectation of what *should* be there, *is known* to be there. The evocations seem metaphoric, too. On a jade vase for chocolate drinks, excavated from a Late Classic tomb at Tikal, Guatemala, the drink is likened to a *k'an nahb*, "precious pool."

Figure 15. Tomb 1 with red water, AD 417, Río Azul, Guatemala.

Aside from *nahb*, there is another expression in Maya writing for "sea." This may be the very label for the surging, undulating flow of water in Maya iconography. One possible reading is *polaw* or *palaw*, "sea" or "ocean" in some Mayan languages of broad distribution.[23] The difficulty is that only the final consonant is confirmed in the reading. As an alternative, David Stuart proposes a reading of *tikaw*, a term for "warm" or "hot water" in the Ch'orti' Mayan language. This is consistent with the red coloration of the undulating water-band in the Early Classic Tomb 1, a looted royal sepulcher at Río Azul, Guatemala, as though boiling with heat, perhaps a feature of some primordial or mythic seas (figure 15). The body of the ruler would have been placed in such fluids in a figurative sense and, by magical means, literally so. At a site on the Usumacinta River, many miles to the west of Río Azul, the ruler of Chancala or Chinikiha, Chiapas, used the name "Fiery [hot water/ocean] Turtle." By linking the word for turtle to that for "fire," his name recalled the cosmic turtle floating on ancient warm and wavy seas.

A conjectural bestiary At least in imagery, Maya waters swarmed with a variety of creatures. Several tendencies underlie such images. The first is the improbable placement of freshwater organisms in saltwater settings. A cosmic turtle as a model of the earth (Taube, pages 210–13) floats of necessity in the girding salty sea, yet water lilies, which wither in saline conditions, appear beneath turtles. The blurring of salt- and freshwater creatures was thorough-going and reflected a second tendency: the mapping of features associated with freshwater turtles and fish on images depicting maritime settings. This might be described as the "principle of familiarity." Painters and sculptors showed what they knew: a pond turtle presented as though swimming in the sea, a fish, often shown rather generically, with the sharp tooth of a shark. Such teeth traveled inland as exotic trade items, but presumably the bodies of sharks did not. More common would have been the crocodiles, many with cosmic import

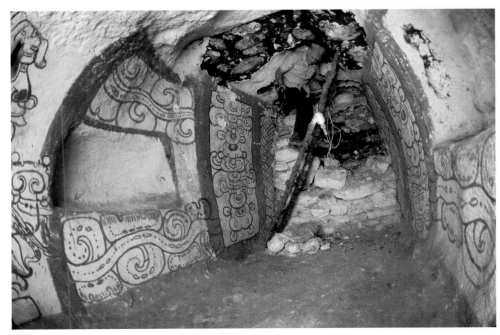

15

(Taube, pages 204–207). No ordinary creatures, these had multiple forms, some even celestial and linked to the beginnings of the current cycle of Maya time.

The closer the artist worked in proximity to the sea, the more likely it was that the turtle would resemble a sea turtle, with ovoid carapace and back-swept fins. An exquisite set of shell shrimp recovered from a royal tomb at Ek Balam, Yucatan, now in the Museo Palacio Cantón in Mérida, displays close awareness of the creature itself, but bent over, as though cooked and dried, an expected view for food that could be prepared and traded in this manner (plate 19). A Postclassic lobster effigy at Lamanai, Belize, shows greater blurring of features, as though the artist did not quite possess a model close at hand (plate 27). This is less true of the shark effigy of similar date from Lamanai, now in the National Museum of the American Indian, Smithsonian Institution, in Washington, DC, which emphasizes the upturned snout, dorsal fin, and open jaws – the last sight of a victim. These features suggest close familiarity with the fish, which might even have made an occasional appearance downstream from Lamanai, a city bordering a long lake connected to the sea. Crabs molded on bricks at Comalcalco, Tabasco (figure 16), or featured in various scenes at Chichen Itza, Yucatan, indicate that this creature, its hard carapace resistant to travel, could well have been seen by artists, who would have recognized its similarity to land crabs.[24] The lobsterlike dancers in the Bonampak murals were more likely monstrous versions of the river shrimp, the *pigua* (*Macrobrachium carcinus*), a crustacean captured at

Figure 16. Crab incised on ceramic brick, 700–800, Comalcalco. Museo Comalcalco, Mexico. Drawing by Stephen D. Houston.

Figure 17. Detail of a mural with human impersonators of watery creatures, including wind gods and a river shrimp, crocodile, water lily, and spirit of active water, circa AD 800, Room 1, Bonampak, Mexico. Painting by Heather Hurst with Leonard Ashby, courtesy of Mary E. Miller, Bonampak Murals Documentation Project, Yale University, New Haven, Connecticut.

night using cages, bait, and patience, to the delight of many a famished archaeologist (figure 17).

Birds, supremely mobile, would have been a common sight, and the Maya used them to suggest watery locales, in a pleasurable aesthetic of aquatic abundance (figure 18 and plate 28). Tropical peoples, the Maya favored moist, green places far more than the arid and lifeless, which figure little if at all in their imagery. In mythic scenes, the necks of birds were replaced by baubles or jewels, their own bodies understood as precious emblems. The Maya were consistently fascinated by creatures that bridged worlds, such as diving birds, crocodiles, the water-loving jaguar, even otters (Taube, pages 204–207), and with tokens of watery abundance in the form of ocean shells like *Oliva*, which, when suspended on a chain, created a percussive sound.[25]

The tension between creatures known or conjectured becomes particularly clear with fish. Most fish in Maya imagery are recognizable by their belly scales, fins, split tail, crosshatched body, and watery emblems on their back and as a point of articulation between tail fin and body (figure 19). Seemingly always hungry, fish nibble on water lilies or are plucked in turn from the water by herons and other water-birds like cormorants. By the end of the Classic period, at Chichen Itza, artists attached a looping curve to the gills of fish, probably to indicate that this was an organ of inhalation and exhalation, much like the speech scrolls connected to human mouths: the invisible given form and made visible. On the whole, fish were generic, lacking details that pertain to fish consumed by Maya, such as the *róbalo* (snook), *bagre* (catfish), or *mojarra* (perch). Rare exceptions replace the fish's head with that of another creature, pointing to a distinct nomenclature for certain species: one pot displays a fish with a jaguar head (plate 31), possibly reflecting the precise name of the fish.[26]

One of the earliest depictions, on a plate from the early centuries AD, displays a fish with jadelike emanations of breath and a single shark tooth – a Maya designation for a deadly creature. In a surprising etymology, the

16

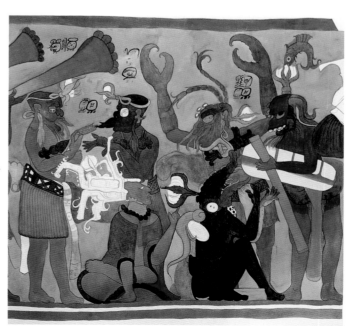

17

English word "shark" probably came from Maya *xook*, attested as a royal name in Classic times.[27] The bulging eye and single pupil of the humdrum fish are replaced by whirling eyes and one shark tooth – an item many Maya might have seen (plate 30). In some costuming, a shark image was worn at mid-section over the crotch, the shark mouth holding a *Spondylus* as an evocation of a receptacle for blood. If most fish presented a gentle demeanor, the shark was associated with blood, pain, and danger. Its upturned snout most resembles those of serpents, which humans dealt with at their peril. At Aguacatal, Campeche (figure 7), the companion and hunter of the shark in turbulent waters was Chahk – a hint that for most Maya, sharks were near-mythic beasts, to be considered and depicted but from a safe distance.

At a certain point, the imagination took over. Carvers and painters of inland cities created a conjectural bestiary. Creatures rumored to exist or thought to have a certain appearance acquired heads and bodies that departed considerably from the original.[28] Exotic beasts, often inferred from garbled accounts or partial physical remains, mark many traditions. In Europe, this gave rise to the "unicorn's horn," in fact, a narwhal tusk, or, as in the image from the early naturalist Ulisse Aldrovandi (1522–1605), an improbable reconstruction for a fossil from an ancient sea bed (figure 20). The Maya were little different, having eagerly received the products of the sea, including *Spondylus* shell, conch (*Strombus*), stingray spines (from the *Aetobatus*, *Dasyatis*, or *Rhinoptera*), fish, and a variety of corals.[29] The *Spondylus*, or spiny oyster, is an excellent example, linked to bloodletting in Maya thought and sometimes paired with stingray spines to convey the notion of *tz'ak*, two elements that complete a whole. When shown as

Figure 18. Rollout photograph of a stucco vessel depicting a water scene with birds, water lilies, and water elements, circa AD 600, Guatemala. Museum of Fine Arts, Houston.

Figure 19. Ceramic fish as snuff bottles, Early Classic period. The Jay I. Kislak Collection, Library of Congress, Washington, DC.

a living creature in Classic Maya depictions, it appears as a long snake, with the bivalve serving as a set of wings. The coveted *Spondylus* figured strongly in royal ritual as a tributary item par excellence. Bundles of cacao beans, feathers, cloth, and *Spondylus* were heaped before the king as tangible tokens of wealth and the ruler's ability to extract such treasure from underlings (plate 3).[30]

Karl A. Taube notes that, in a far cry from reality, single-shelled mollusks were imagined to be twin-armed, horned beasts or even more unusual creatures. A lightly incised piece of conch shell, now in the Cleveland Museum of Art, displays a conversation between a smoking youth and a conch, *huub*; the creature has an almost feathery mane and jagged teeth (Zender, pages 84–85). Its conversational abilities may not be surprising given that this was a musical instrument, for the Classic Maya in particular, an accompanying trumpet in some orchestral scenes on Maya pottery. A forceful blast confused prey, human and animal, and coordinated hunters and warriors. Yet more puzzling views of conch appear to derive from the influence of the Mexican city of Teotihuacan on the Maya. In these depictions, the conch is trimmed by feathers and the head of the conch beast is snakelike with a split tongue. The feathers may signal great value or some other, unknown, property.

At times, deities also occupy shells, like supernatural hermit crabs making use of discarded coverings. The old deity God N is the common example (plates 38, 39) but there are others, including a watery youth drawn out of his shell by a young woman (figure 21). The drilling by the other young attendant is a standard act of fire-making, but it may also refer to extracting mollusks from their shells by cutting key muscles through the shell itself, today a routine means of removing the sweet flesh of the conch. The Maya did, however, see shells in one singular way.[31] Precious arrivals from distant waters, evocative of worlds most Maya never visited, shells at times also contained another supernatural essence: the spirits of ancestors. In one of the more enduring features of Mesoamerican belief, sea

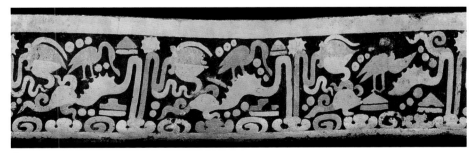

18

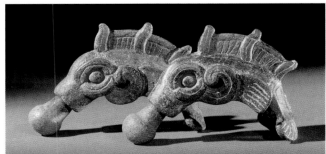

19

shells relate to the eastern winds, arriving in general from the direction of the Caribbean. Such a belief explains the evolution of the sign for "wind," *Ik'*, from deep roots in Olmec iconography of the early first millennium BC, on objects to be worn suspended as pectoral ornaments. Some early texts on them refer explicitly to "wind," confirming the link. Aside from the obvious proximity to the lungs and heart, the pectorals also show, especially in the Early Classic period, clear depictions of ancestors (plate 45). These typically lack limbs and exhibit mostly their head, name glyphs above, and perhaps an arm and wreathed smoke. Drill holes in the shells prove that the ancestral faces were always oriented face-down, much like depictions in Maya sculpture. The shells thus embodied ancestors as a concrete crystallization of wind or breath. It cannot be a coincidence that the shells themselves were always exotics from eastern seas, the origin point of most Maya winds. In such shells, the life-force of kings had come full circle: departed at some point from the royal courts they wandered in life, to be incorporated into wind-jewels from far waters, and to be worn, presumably, by descendants of the deceased. More than mere ornament, the shells brought the ancestors close to home, but in transformed guise. One carved conch gives voice to those ancestors as a trumpet (plate 42). When sounded, it was probably thought to boom with the deep voice of the ancestor whose head adorns its carving.

The Maya treatment of waters and beasts demonstrates the sense of wonder they experienced with natural phenomena that could be close at hand but were more often imagined and redirected to cosmic purpose. For the Maya, the particular tended to conform to the general. The idiosyncrasies of fish, shell, or bird species were folded into larger stories and

conforming models that sought, always, to communicate forcefully but by well-established convention. For those Maya who lived close to the sea, fished its depths, and braved its dangers, convention gave way to closer observation. But even in the more imaginative renderings, natural cycles were seen, accurately, as creators and drivers of conjoined waters, falling, evaporating, passing underground, conveyed by sun, storm, and wind. Whether saline or fresh, waters formed part of the same surging motion, invested with will and direction by the spirits that coursed within them.

Figure 20. Conjectural creature in a fossil snail. From Aldrovandi 1606.

Figure 21. Incised watery scene from an alabaster vessel, 600–750, Structure 10, Bonampak, Mexico. Drawing by Stephen D. Houston from Tovalín Ahumada, Velázquez de Leon Collins, and Ortíz Villareal 1999, fig. 2.

20

21

Author's note: This chapter and the exhibition itself build on collaborative work with Karl A. Taube and have been strengthened by his many useful suggestions.

1
Fought 1972, p. 375.

2
See Pasztory 1983, pp. 173–75, for thorough documentation of the so-called "Chac Mol"; fuller information on its find-spot appears in Solís Olguín and Velasco Alonso 2002, pp. 457–58. Morphological analysis of terms is in Karttunen 1992, pp. 85, 103. The caches of the Templo Mayor are detailed in López Luján 1994, pp. 192–206, 240–57.

3
Recent documentation of Cotzumalhuapa carving appears in Chinchilla Mazariegos 2003. An earlier, still useful report on Bilbao Monument 21 is Parsons 1969, pls. 30, 31.

4
The relevant Tulum murals may be found, partially documented, in A. G. Miller 1982, pls. 28, 37, 40, renderings by Felipe Dávalos. The sole source on the paintings at Santa Rita is Gann 1900, pp. 655–92, with an account of their destruction in Thompson 1975, pp. 741–43.

5
The murals may be found in E. Morris, Charlot, and A. A. Morris 1931. The renderings are now in the Peabody Museum of Archaeology and Ethnology, Harvard University. A necessary complement are Adela Breton's 1902 watercolors from the Upper Temple of the Jaguars, now in the City Museum and Art Gallery, Bristol, United Kingdom. See Coggins 1984A, pls. 201–208. Breton's work is described in McVicker 2005, esp. pp. 65–69.

6
Croat 1978, pp. 389–90.

7
Reported in I. Graham 1997, pp. 28–31. A definitive report on Chahk is García Barrios 2008. The Aguacatal altar appears in Houston et al. 2005, pp. 37–62. Discussion of the sign for plaza appears in D. Stuart and Houston 1994, p. 33. The entry for a panel from Cancuen (plate 20) reports on Stuart's reading for the sign as *panha'*, "cavity-of-water." The Machaquila monument, Stela 10, is in I. Graham 1967, figs. 61, 62; more than the drawing, the photograph reveals the shell ear ornament of Chahk with great clarity.

8
Shifts in climate and sea level, along with storms, are discussed in McCloskey and Keller 2009, pp. 1–2; and Beach et al. 2009, pp. 1–15, doi:10.1016/j.quascirev.2009.02.004. For hurricanes, see Dunning and Houston in press.

9
See Scarborough, 2007, pp. 163–74, with a more detailed treatment in Scarborough 1998, pp. 135–59; and a related perspective in Lucero 2006A, pp. 281–308.

10
Still the best study of water iconography is Hellmuth 1987A; for a report on Maya glyphs and concepts of the sea, there is Houston and Taube in press. Late Preclassic images of Chahk in celestial iconography appear in Carrasco Vargas 2005, figs. 3, 4; and Reuters 2009. For Izapa Stela 1, see Norman 1973, pls. 1, 2. At El Mirador, the excavator misidentifies the Chahk as another deity – although the scene may represent an impersonation of Chahk by a historical figure – and likely places the find a century or two prior to its actual date. The Copan scene appears on the west façade of the Margarita structure in Bell, Canuto, and Sharer 2004, pl. 2b.

11
Karl A. Taube, in Houston and Taube in press. For Cacaxtla, see Brittenham 2008. Kerr catalogue numbers for other such treatments of water include this sampling: 521, 1152, 1248, 1258, 1333, 1338, 1346, 1362, 1365, 1366, 1370, 1489, 1648, 1650, 1892, 2007, 2011, 2096. As of this writing, all are consultable at www.mayavase.com, with the caution that some ceramics have been repainted. The codex-style scribes also conveyed a sense of partial submersion by truncating figures with the base of a bowl, leaving the viewer to imagine the water underneath. The Yaxchilan stucco exists in a field drawing by Ian Graham at the Corpus of Maya Hieroglyphic Inscriptions Project, Peabody Museum of Archaeology and Ethnology, Harvard University.

12
The tripod plate appears in Schele and M. E. Miller 1986, pl. 122.

13
For the Palenque text and its implications, see Houston, D. Stuart, and Taube 2006, pp. 91–93; and D. Stuart 2005, pp. 68–77.

14
The reptile is described in Ishihara, Taube, and Awe 2006, pp. 213–23. The reading of *witz'* comes from Stuart 2007B. Ethnographic accounts of water serpents are in Girard 1995, pp. 115–17; and in the classic Wisdom 1940, pp. 392–97, esp. p. 393. See also Fought 1972, p. 376, for a report of serpent mating.

15
The vessel in question is K0512, published in M. D. Coe 1973, pl. 43. Karl A. Taube points out in a personal communication, 2007, that the image corresponds to an offering of the "first" (*yax*) water gourd featured in the Late Preclassic murals of San Bartolo, Guatemala. With the water serpent, the emphasis appears to be on surface or subterranean water. For impersonation, see Houston and D. Stuart 1996, pp. 289–312.

16
For place names, see D. Stuart and Houston 1994, pp. 19–42. A more recent study is Tokovinine 2008.

17
The glyphs appear in D. Stuart and Houston 1994, p. 69, fig. 81, with additional terms in Kaufman 2003, p. 429.

18
Still the best report on Jaina is Piña Chan 1968, esp. pp. 27–35, 77–80; along with M. E. Miller 1975; and M. E. Miller 2005, pp. 63–70; for reworked views, see Benavides 2002, pp. 88–101. Texts from Jaina include Spinden 1913/1975, fig. 196. For "death" as "water-entering," see D. Stuart 1998, pp. 373–425.

19
See Beach et al. 2009, pp. 1–11.

20
For an excellent discussion of GI, see D. Stuart 2005, pp. 161–74.

21
Examples of such Atlantean figures appear in Schele and Mathews 1979, pl. 140. Unpublished figures from Structure N5-21 at Dos Pilas, Guatemala, were excavated by Oswaldo Chinchilla Mazariegos in 1990 as part of the Vanderbilt Petexbatun Project; these fragments, from a bench destroyed in antiquity, are now in the Museo Nacional de Antropología e Etnología, Guatemala City. They display wind deities, common Atlantean figures in Mesoamerica, with water lilies tied to their foreheads (plate 26).

22
See D. Stuart 2005, p. 76, n. 24. The Calakmul water-band is presented in Martin 2006B. The Temple XIV panel is discussed in Schele 1988, fig.10.4. The jade vessel is described in D. Stuart 2006A, p. 200, fig. 9.16.

23
See Lopes 2004; also David Stuart, personal communication, 2007, for glyph reading; for the Río Azul tomb, see Hellmuth 1987A, pl. 594; recent discussion is in Fitzsimmons 2009, pp. 68–71.

24
Not well published or provenanced, aside from recent work by Dr. Ricardo Armijo Torres, the bricks at Comalcalco appear in part in Álvarez Aguilar et al. 1990, esp. fig. 82, with others on exhibit in the site museum of Comalcalco.

25
For birds known to the Maya, see the classic study L. I. Davis 1972; and with much of relevance, Janzen 1983, esp. pp. 502–618. A possible otter, swimming in a water milieu, was identified by Werner Nahm in K8948; see n. 26. A jeweled bird is published, with poor drawing, in Adams 1999, fig. 3–22c, with a label of uncertain meaning inscribed in Maya glyphs, *Ixk'ahk'is*.

26
Such anomalous fish appear in the Kerr database, K5460 (see plate 31) and K6626.

27
For etymology, consult T. Jones 1985, pp. 211–22.

28
See Pluskowski 2004, pp. 291–313. The figure comes from Aldrovandi 1606, p. 391.

29
A reliable if older survey is de Borhegyi 1961, pp. 273–96. Karl A. Taube reports on conjectural creatures and Teotihuacan-style conch in Houston and Taube in press. The Cleveland shell was first studied thoroughly in Schele and M. E. Miller 1986, p. 155, pl. 59. Feathered conches appear in the Kerr database, as in K2992, a vessel at the Indianapolis Museum of Art, published in Parsons, Carlson, and Joralemon 1988, pp. 106–107, pl. 71.

30
For tribute scenes, see D. Stuart 1998, pp. 409–17.

31
The discussion of ancestral spirits draws on Houston and Taube in press; see also Houston, D. Stuart, and Taube 2006, pp. 50–51, fig. 1.54.

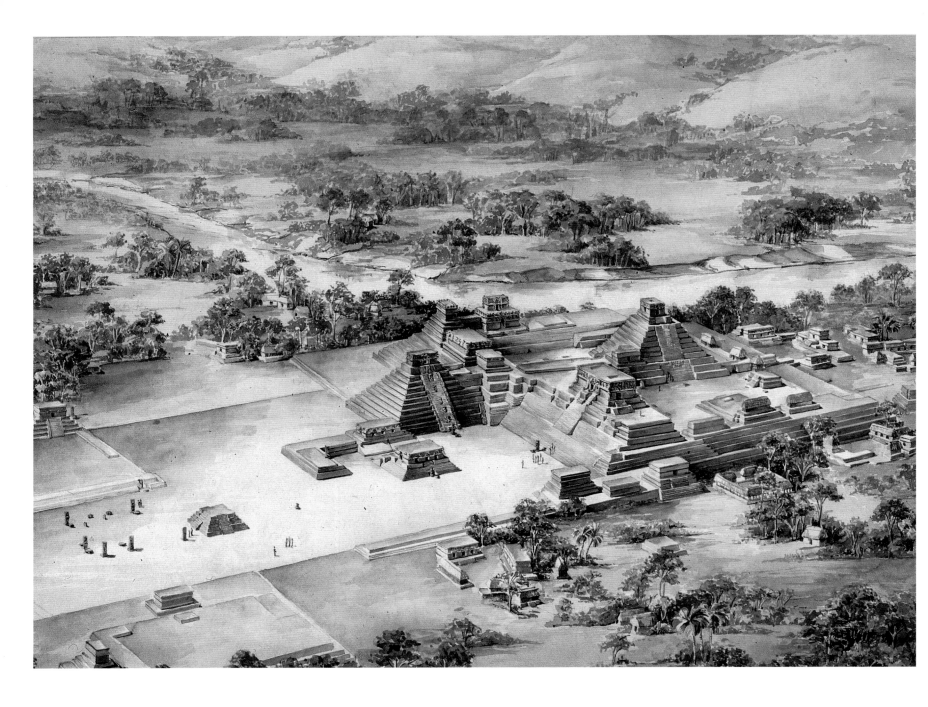

SYMBOLS OF WATER MANAGEMENT AT COPAN, HONDURAS

BARBARA W. FASH

Copan is located far from the sea in the water-rich highlands bordering the southern Maya area. Water symbolism on Copan's carved-stone buildings and monuments reflects the special significance it held not merely as a material necessity but also as a sacred resource. The set of symbols that developed in the Maya area appears to express the functional and cosmological importance water and its management played in the realms of subsistence, urban design, and political authority. Nowhere is this better exemplified than at Copan. There, watery environs were re-created in architectural structures and on façades, and surface water was managed for both ritual and functional purposes (figure 1). Rulers' tombs, for example, were rich with *Spondylus* shells, evoking the primordial sea upon death.[1] Rulers and deities were often positioned above or intertwined in wavy bands on carved monuments to signal they were in watery environs. Local aquatic animals – fish, crocodiles, cormorants, herons, turtles, snails – were food sources and water spirits symbolizing the fecundity and personification of Copan's still-water sources (figure 2).

Large-scale water-management projects in the highlands of Mexico and Guatemala, such as the impressive dam at Purron (circa 700 BC) and canals

Opposite page. The Principal Group and Acropolis at Copan, Honduras. Rendering by Tatiana Proskouriakoff. Peabody Museum of Archaeology and Ethnology, Harvard University, Cambridge, Massachusetts, 50–63–20/18487.

Figure 1. Eastern Courtyard basin at Copan, Honduras, which once captured water.

at Kaminaljuyu (600 BC), indicate that hydraulic engineering was already well advanced in Mesoamerica by the first millennium BC. Indeed, large urban nucleations at the early Maya centers of Nakbe (400 BC) and El Mirador (circa 150 BC) provide evidence of water sources being artificially modified by digging out the earth to construct pyramidal structures and large platforms, thereby forming reservoirs.[2] Similar technology was used at Copan to channel rainfall runoff from the surfaces of the built environment into reservoirs or catchment basins, thus ensuring a stable and clean water supply. Aquatic fauna and flora such as reeds were part of an integrated system that cleansed the water sources while nourishing the urban center. Engineering the drainage of potable water from temples and plazas into reservoirs took considerable expertise. Runoff from Copan's temples pooled in courtyards that once mimicked mountains and valleys, metaphorically reproducing sacred freshwater from mountain springs and caves. In one instance, a building façade (nicknamed "Indigo") formed a great earth monster whose mouth spewed water channeled from the rooftop.[3]

As water-management technology spread to many Maya centers, it increasingly required coordination and maintenance to function properly. Rulers and other political/religious specialists likely established calendrically timed rituals in an effort to attract and unite people in water maintenance. Fissures or caves in the mountains near lagoons and springs in the Copan valley became shrine areas where jade and other precious objects were deposited.[4] A scene on Structure 10L-18 showing a figure dancing above

a *nahb* sign may indicate a ritual in a watery courtyard. A water ritual continues today in the annual May 3 procession and ceremony on Cerro de las Mesas in Copan, and in many communities throughout Mesoamerica.[5] As the central figures in these activities, rulers and nobles became the chief water managers for their cities and states. Creative symbolism that enhanced the ruler's divine role reinforced a system that helped to ensure the availability of clean water, control pest infestation and disease, and promote fairness in water rights. Pageantry and ritual associated with these contexts can be identified on monuments showing heavily costumed lords sporting a complex of water symbols and frequently situated in an abstract landscape of watery places.

By the Late Classic period in Copan, water-management symbolism appears to have been a dominant component of many iconographic programs on building façades, monuments, murals, ceramics, and other forms of portable art. The water lily, tied into a knot with a fish nibbling the flower, came to symbolize sources where it grew, such as lagoons, reservoirs, and canals.[6] The quatrefoil, a symbol for a cave or entrance to the Underworld, can also represent a Maya temple courtyard (*nahb*) that may have retained shallow water reserves.[7] Rulers are often shown performing rituals above or framed within the half-quatrefoil stepped *nahb* sign, which may symbolize a toponym for a water source or feature. Such stepped niches with aquatic plants in their corners, usually depicted on a horizontal line, appear to be the visible half of full quatrefoil signs. The ancient Maya believed that celestial bodies entered caves on

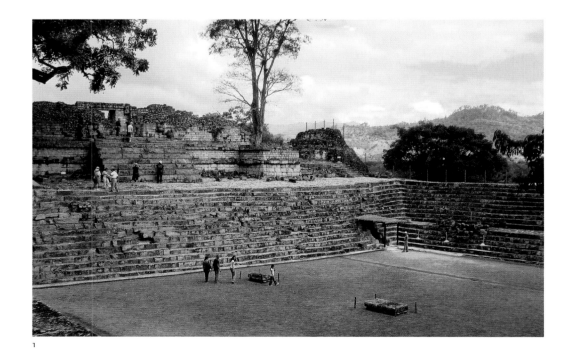

1

the horizon at sunset and began their Underworld journey, only to reemerge from another horizon cave portal at sunrise.[8] The stepped niche may symbolize a horizon cave and associated water features, such as springs or the primordial sea.

The water-lily headdress worn by many kings and nobles throughout the Maya region may be a sign of the water-management profession.[9] At Copan, the headdress became increasingly popular in Late Classic sculptural depictions. An eighth-century AD example on Structure 32 of Group 10L-2 shows six nobles in water-lily headdresses (figure 3). It dates from the reign of Yax Pasaj Chan Yopaat, the sixteenth ruler to live at this royal residence with a nearby reservoir, south of the main Acropolis. The fish, water-lily, and Chahk motifs prominent on buildings in this group may signify that the residents were strongly associated with Copan's water-management system, which was an important part of everyday and ritual life for the people living south of the Acropolis.[10]

Social organization in Maya centers seems to have centered around water sources in the landscape, which were associated with ancestors. Springs, caves with water, streams, rivers, lagoons, and reservoirs required maintenance and proper usage. Evidence from Copan implies that centers of all sizes and their internal subdivisions may have been organized first by water groups, then land-based groups, and finally along kinship lines.[11] Thus, water management became a cohesive yet fragile force.

The clusters of circular beads with wavy lines that form *tuun* signs appear to represent drip-water features in mountains and caves that produced virgin water often used for ritual purposes.[12] As part of a complex of symbols including the water lily and stepped niche, their appearance in architectural art may signal water-management roles for residential community leaders. It has been proposed that residential buildings at Copan with this iconography signify seats of water-management groups: non-kinship-based groups that shared and cared for the same water source. Agricultural groups, in contrast, based on kinship ties, might have been symbolized by maize iconography. Water-lily and maize imagery occurring together point to a fertility theme, and when coupled with the stepped niche, potentially labeled the residence as the head of a community water-source group. What one sees today in the architecture and landscape at Copan are the remains of a complex system in which these sustaining fundamentals of ancient Maya life took artistic form to celebrate water as a spiritual force and society's control of it.

1
W. L. Fash 2001, W. L. Fash et al. 2001.

2
Lucero and B. W. Fash 2006; Scarborough 1993; Scarborough 2003.

3
B. W. Fash 2005, p. 117.

4
Nuñez Chinchilla 1966.

5
B. W. Fash n.d.

6
B. W. Fash 2005; Puleston 1976.

7
Freidel, Schele, and Parker 1993.

8
Bassie-Sweet n.d.

9
B. W. Fash 2005, p. 123.

10
Ibid., pp. 123–30.

11
Ibid.; B. W. Fash and Davis-Salazar 2006.

12
B. W. Fash 1992; B. W. Fash 2005; Bassie-Sweet 1996.

Figure 2. Water-bird emerging from the head of a deity from the Hijole structure, 600–700, Copan, Honduras.

Figure 3. Figure with a water-lily headdress on Structure 32, Late Classic period, Copan, Honduras. Reconstruction and drawing by Barbara W. Fash.

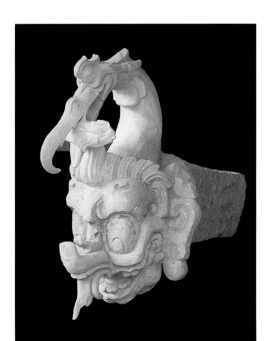

2

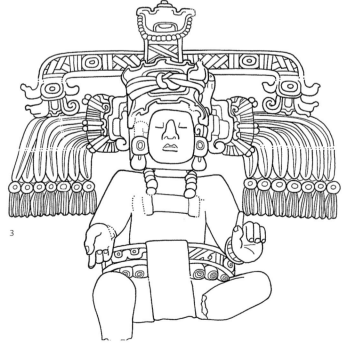

3

THE MUSIC OF SHELLS

MARC ZENDER

Anyone who has "listened" to a sea shell and wondered at the sound of distant waves will understand why the Maya associated shells with music. There are other connections, too, including the important role of the conch-shell trumpet in music, hunting, and warfare. Cut-shell ornamental pendants – such as the splendid inscribed examples excavated at Comalcalco, Tabasco, Mexico – would have chimed as their wearers moved or danced. But paramount was the association of shells with the sea. *Spondylus* and other marine shells often accompany stingray spines, corals, sponges, pearls, and other oceanic items in tombs and caches invoking the watery predawn otherworld.[1] In Classic iconography, shells serve as marine symbolism par excellence (figure 1), and *Spondylus* ear flares are a diagnostic attribute of the Maya Rain God, Chahk (Houston, page 74). Frequently labeled with the symbol for *Ik'* or "wind" (plates 40, 41), shell pendants and musical instruments partook of the mythology of the Maya Wind God, *Ik' K'uh*, himself linked to the east, the ocean, and the rain.[2] These ties suggest that in addition to serving as the birthplace of the sun and the origin of life-giving water in the form of rainclouds and precipitation, the eastern ocean may have been considered as the abode of music.

Music was at the center of Classic Maya ritual life, as evidenced by the many depictions of musical instru-

Previous page. Conch shell on a reef.

Figure 1. Tablet of Temple XIV depicting teenaged K'inich Kan Bahlam II of Palenque receiving a lightning effigy from his mother during a ceremony apparently in a cave, Late Classic period, Palenque, Mexico.

ments in scenes of ballplaying, dance, and other public performances. Actual instruments have also been discovered, occasionally with associated texts that name them and their owners or makers. Among the more common instruments in Maya ensembles were jade tinklers, cut-shell pendants, and snail-shell bells – all designed, like the much later copper bells, to make music in accompaniment to movement (plates 13, 84). Clay and wooden drums with animal-skin drum heads, bone and gourd rasps, rattles, clay flutes and whistles, and trumpets of shell, bone, and wood have also been found. The ancient names of a few are known: *lajab*, "clapping instrument," is known from a small ceramic hand drum excavated at Piedras Negras, Guatemala[3]; *chikab*, "rattle," appears on two small carved bone handles for rattles from the area of Naranjo, Guatemala[4]; *huub* seems to have been the term for marine-shell trumpets, yet the famous Chrysler Museum conch trumpet (plate 43) was identified in glyphs as a *uk'ees* – literally a "noisemaker" – aligning it with both jade tinklers and turtle-shell drums, two instruments that occasionally carried the same label.[5] In the Classic period, *uk'ees* may have served as a general term for "musical instrument." Shell instruments were certainly included in that category.

Unlike more conventional instruments such as the drum or rattle, marine-shell trumpets were considered to be a means of communication. For example, they played important roles in hunting, startling and disorienting prey, and coordinating activity with other hunters under the jungle canopy, where line-of-sight communication would have been difficult.

There are also signs that the trumpet was blown in proximity to settlements, perhaps to reassure inhabitants about the identity of visitors. Several Classic Maya vases depict successful hunters, game slung over their shoulders or suspended from poles, blowing conch-shell trumpets to announce their triumphal return. Indeed, one trumpet in a private collection boasts that its owner "speared (a) deer" (*u juluw chihj*) on a certain date,[6] suggesting that conch-shell trumpets may have been emblematic of hunting in general (figure 2). Perhaps this is why the Classic Maya God of the Hunt, Huk Siip, in his role of supernatural game warden, is so frequently depicted with a trumpet, calling deer from the forest (plate 36).[7]

Several intriguing Classic-period scenes highlight the role of shells not only as musical instruments and hunters' tools, but also as interlocutors, bringing timeless wisdom to the ears of fortunate humans. On one incised conch-shell fragment in the Cleveland Museum of Art, a priest named "Jewel Jaguar" sits cross-legged in apparent conversation with a large conch shell (plate 35).[8] The priest smokes a long thin cigar and wears the head of a deer as a headdress. He gestures in the direction of the conch, which emits a serpentine head representing either the denizen of the shell or, perhaps, the embodied voice and spirit of the conch itself.[9] The associated text reveals something of their conversation, though one sign resists decipherment:

CHAK-pa ta-na ?-bu-li ta-ha-ta ya-la-ji[ya] hu[bi] ti-chi-ji

chak patan (?) ta hat yaljiiy huub ti chihj

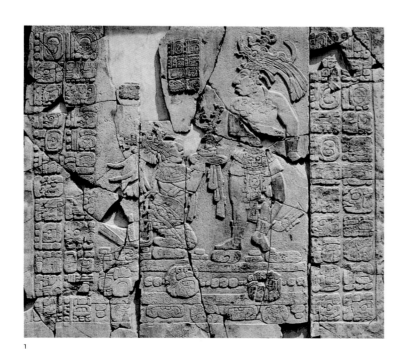

"Great tribute ... for you, said (the) conch shell to (the) deer"

As with many Maya texts, the exchange is in part self-referential. On the one hand, the conch shell plainly speaks to the priest, who is dressed as a deer. Presumably, the scene portrays the ritual reenactment of a myth wherein a conch shell informs a deer about a large amount of tribute.[10] Yet, it is the carved object – itself a conch shell – that recounts the narrative, casting viewers in the role of the deer, and thereby directly involving them in the narrative. In this instance at least, the music of shells moves far beyond the sound of waves and hunters' calls. Among the most versatile of Maya instruments, shells were evidently objects with many voices and meanings, pregnant with marine, musical, and even vocal associations.

Figure 2. Rollout photograph of a vessel with a hunting party, clad in the characteristic garb of travelers, blowing conch-shell trumpets to herald their successful return, 600–900, Guatemala. The Jay I. Kislak Collection, Library of Congress, Washington, DC.

1
Maxwell 2000.

2
Taube 2004, pp. 73–78.

3
Houston, D. Stuart, and Taube 2006, p. 261.

4
Grube and Gaida 2006, p. 214.

5
Zender 1999, p. 78, n.48.

6
Houston, D. Stuart, and Taube 2006, p. 264.

7
Taube 2003A, pp. 473–74; Zender 1999, pp. 77–81.

8
Schele and M. E. Miller 1986, p. 155.

9
Houston, D. Stuart, and Taube 2006, p. 264.

10
Zender 2004, p. 330.

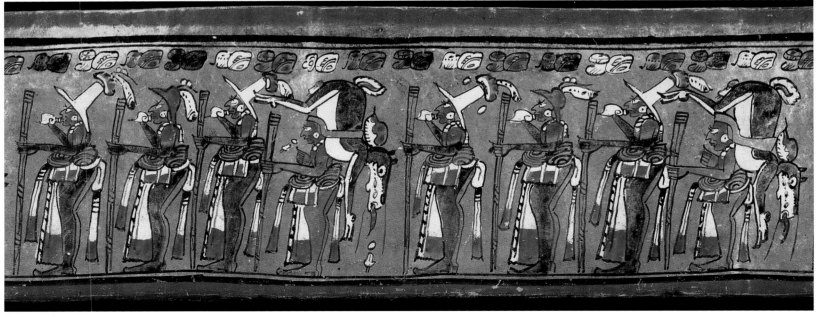

2

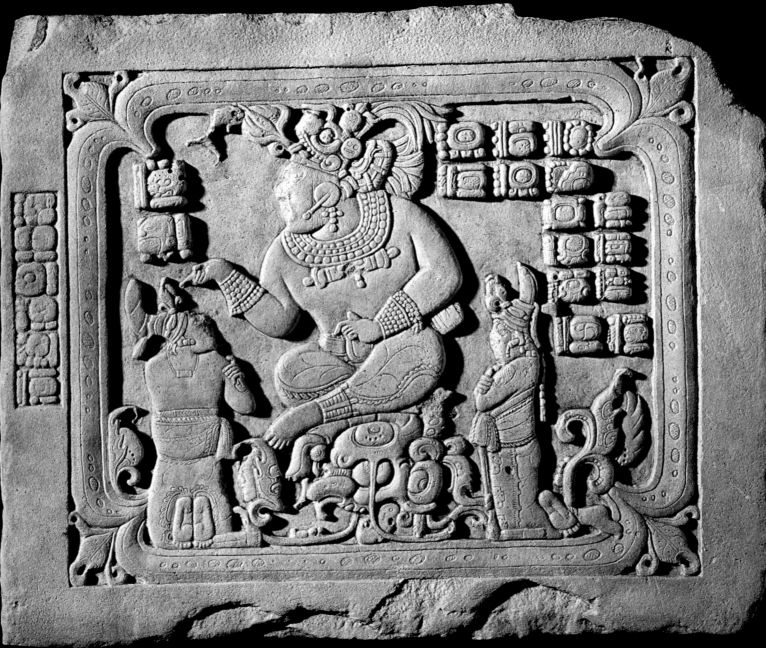

20

Panel with a seated ruler in a
watery cave [Cancuen Panel 3]
AD 795
Cancuen, Guatemala
Catalogue 4

Maya rulers and nobleman were believed to exist in two worlds at once: a royal court and, as on this panel, a cavity filled with water. Erected in AD 795, at the end of the Late Classic period and a few short years before the demise of the city Cancuen, Panel 3 highlights a ruler known as Tajchanahk, "Torch-Sky-Turtle." From a throne in the shape of a water lily, he presides over two lesser lords, identified by their courtly titles, simpler dress, and arm-gripping posture – a sign of subordination. The lord whose feet jut out toward the viewer is the chief focus of the king and likely a visitor. The other, known as *ajtz'akbu*, perhaps "he [who] orders," kneels patiently in the attitude of a local retainer. A vertical text to the left gives us the name of the sculptor, who was also responsible for the inscription in plate 70. A distinctive stylist, he favored rounded outlines and small glyphs. The text confirms his high status as the *baah-chehb*, "head-quill," of Tajchanahk.

The four-lobed shape with people within signals an underground hollow; hooked vegetation is at its corners. A bubbling, watery band encircles the scene. The lords have water lilies lashed to their foreheads; Tajchanahk's lily attracts a passing fish close to the name glyphs on his headdress. A small face replaces a water-lily flower near his foot. According to David Stuart's reading of the text, this hollow is a *pan-ha'*, "cavity-of-water." It is the abode or *otoot* of Tajchanahk, who glories in two exalted titles, including the claimed lordship of another regional power, Machaquila. Important dates on Panel 3, with endings of key periods for the Maya, chart the same theme found on sculptures from Caracol, Belize, in which similar cavities house symbols of completed time. In another fusion of history and mythic rite, the two lesser lords display markings of what may be "year-bearers," a role played at other Maya sites by subordinates with water-lily headdresses. As the sun sinks into water, time itself finds its passage underground, as embodied by courtly personages in this aquatic scene. Panel 3 assures the viewer that water lies underneath.

In AD 795, Tajchanahk was fifty-three. During his long reign, Cancuen came into its own as a regional power with the support of a yet more influential dynasty at Dos Pilas, some thirty-three miles (fifty-four kilometers) away. A great builder, Tajchanahk supervised the construction of the ball-court in which Panel 3 was found during recent excavations by Vanderbilt University and the Universidad del Valle de Guatemala. Perhaps originally inside Structure M7-1 on the western side of the ballcourt, the panel was dislodged and tossed face-down on a stairway outside. The faces of the figures display the mutilation common to most Maya sculptures, a disfigurement that probably took place at the end of the Classic period.
– NC, SDH

References: Barrientos 2008; Beetz and Satterthwaite 1981, figs. 20, 21, 24, 25; Didrichsen 2005, p. 74; Fahsen, Demarest, and Fernando Luin 2003.

21

**Frieze of a fish jumping
out of the water**
500–600
Altun Ha, Belize
Catalogue 1

This stucco architectural frieze, excavated from the site of Altun Ha, Belize,
is modeled exclusively with water-related iconography. At the center of
the scene, a fish nibbles the blossom of a water lily that undulates from an
anthropomorphic head carved on the left corner. The head's skeletal jaw,
characteristic ear flare, vegetal headdress, and association with these
aquatic flora and fauna identify it as a stylized water-lily plant, the *nahb*.
This plant and its singular features appear elsewhere in the canon of
Maya art, often with the same blossom and feeding fish. A horizontal band
containing raised circles – a common water motif thought to depict the
surface of water – bisects the scene. Abstract trilobal and swirling elements
emerge from the top and bottom of this band, representing the movement
of water as it rushes along its course. The "smoking *ajaw*," an element of
unknown meaning, pokes out from the watery band and is likely attached
to the tail of an aquatic creature whose body is now missing because of the
fragmented nature of the frieze.

Located approximately seven miles (twelve kilometers) inland from the
Caribbean Sea, the natural landscape of Altun Ha is dominated by water
in the form of creeks, lagoons, and swamps. The presence of this frieze
on one of its buildings suggests that the inhabitants of Altun Ha attempted
to transform their built landscape into a similarly aquatic world. The
frieze was discovered in the southwestern corner of Structure A-2. "Water
temples" with basal and upper zone friezes iconographically similar to this
one have been identified at other Maya sites in Mexico, such as Comalcalco
(Tabasco), Dzibilchaltun (Yucatan), and Palenque (Chiapas). Their symbolic
linkage with water, and by extension the Underworld, may hint at their an-
cient uses and meanings, providing us with a way to access Classic Maya
conceptions about the relationships among architecture, the natural envi-
ronment, and indigenous cosmology. – CM

References: G. F. Andrews 1989, fig. 20; Coggins 1983, figs. 8, 12, 36, 38–42; Coggins
1985, p. 173, pl. 120; Hellmuth 1987B, figs. 51b, 81a; Houston 1998, p. 520, n. 2;
Pendergast 1979, pp, 7, 96–99, pl. 17.

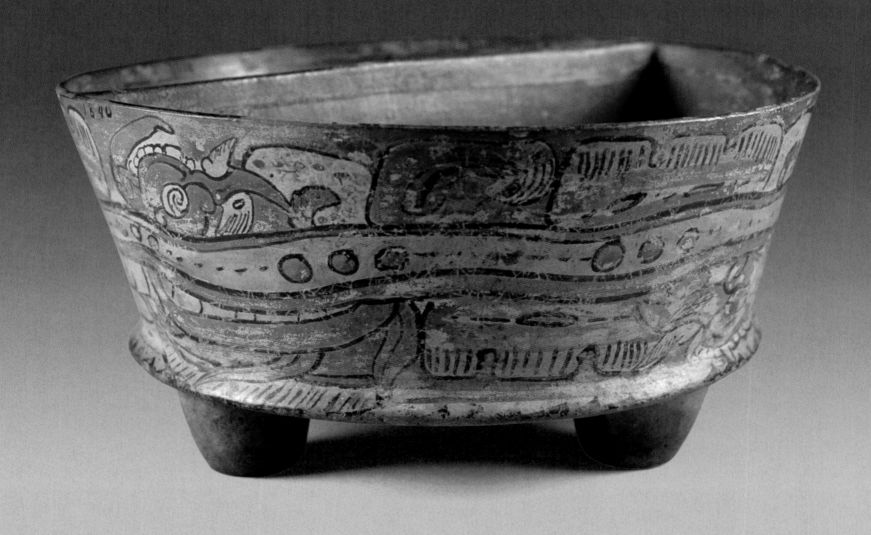

22

Tripod dish with a water-band
and aquatic creatures
400–500
Uaxactun, Guatemala
Catalogue 2

The exterior of this shallow tripod dish, excavated from a royal tomb,
Burial A20 at the site of Uaxactun, is decorated with the swirling water-
band motif Maya artists used to depict roiling waters. Jaws agape, a
fantastic aquatic serpent – the personification of rushing streams – seems
to dive down through the surface of the water; a shark and a writhing fish,
itself half serpent, complete the scene. The interior of the bowl is divided
into two uneven sections to accommodate two types of food, perhaps fish
or a hot stew, given the vessel's iconography. Baked clay pellets in its hol-
low feet would have rattled as the dish was moved, adding sound effects
to the visual aesthetic. – NC

References: Lopes 2004, pp. 1–9; R. E. Smith 1955, pp. 19–20, fig. 11.

Figure 1. Rollout photograph of plate 22.

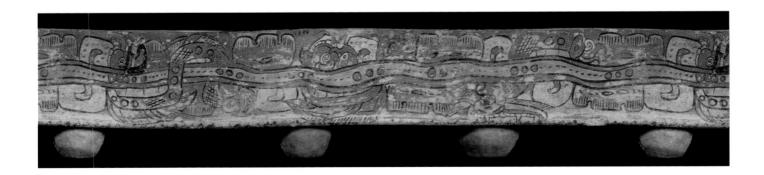

1

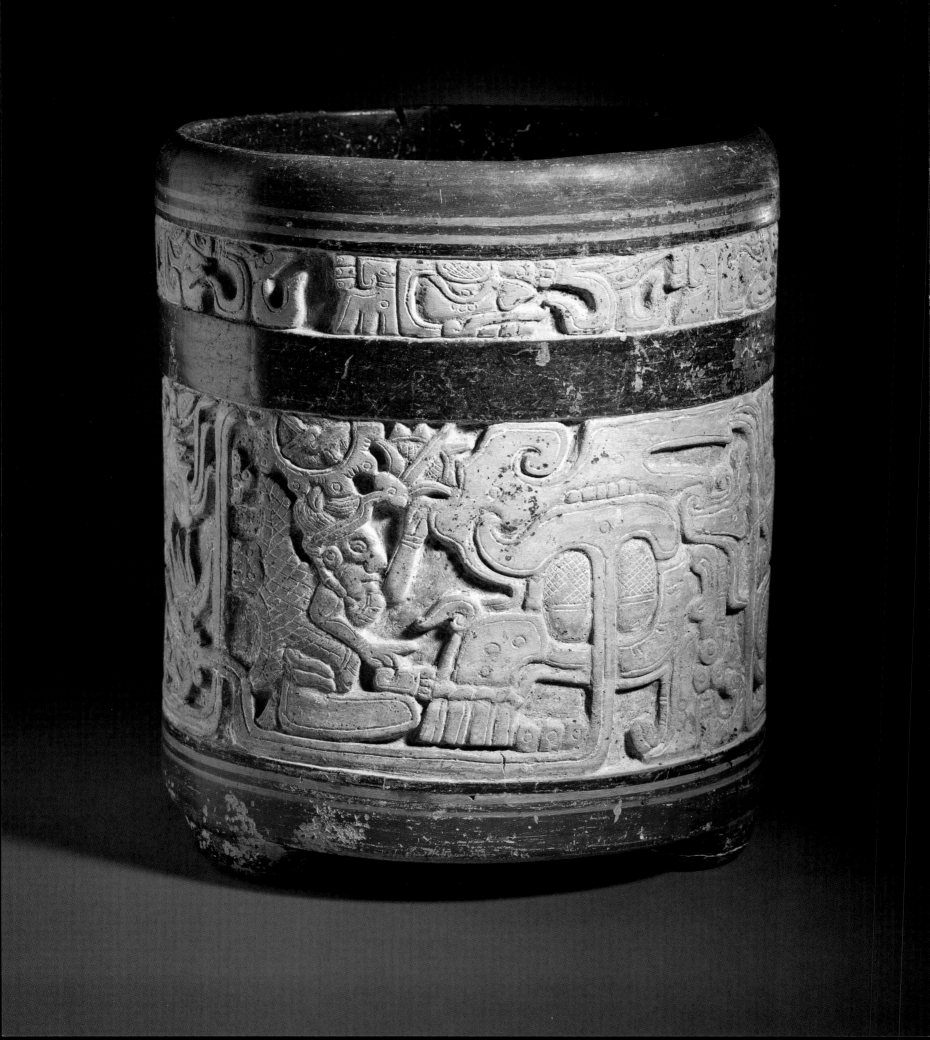

23

Vessel with a watery scene
600–900
Alta Verapaz region, Guatemala
Catalogue 3

The wraparound carving on this tall cylindrical vessel depicts a constellation of images associated with the aquatic sphere: a watery world of water lilies, conch shells, turtles, and fish (figure 1). In Late Classic ceramics, these elements together compose a distinct iconographic complex associated with water lilies and their environment. Commonly found in still-water, the water lily has flat green pads that float on the surface and produce flowers. The Maya word *nahb* refers to both the lilies and the pools in which they live. On this vessel, round objects with a scalloped frame and inscribed with a crosshatched design represent the lily pads. The flowers in cross-section can be identified by their long pointed petals and protuberant sepals.

The vessel features two carved panels: a band of deity heads that runs below the rim and a central panel that encircles the vessel body. The heads in the rim band face right rather than left, the traditional orientation of Maya images and texts. While their profiles bear a resemblance to known deities, they cannot be identified precisely. The water-lily vegetation sprouting from their foreheads matches that of the lower scene and stands as their most important attribute. Two seated deities in the central scene are each pictured in conjunction with a large skull in profile. The bigger individual wears a water-lily diadem and a turtle carapace on his back and sits cross-legged facing the skull, which he touches with his left hand. The second figure wears a conch shell around his middle and faces in the direction of the first figure; behind him is the second skull. The profile skulls

may be read as personified water lilies: the crosshatched eyes mimic the design of the lily pad and the cranial crests emit blossoming tendrils. Attendant aquatic fauna include a turtle atop a lily pad between the figures and two fish swimming within the vegetation. Fish often appear nibbling water-lily flowers, as in the Altun Ha frieze (plate 21), and such food may have been found here, too. A decapitated animal is attached to the vegetation behind the second skull. Markings on its belly and the body and serrated back suggest a reptile such as an iguana or crocodile. A severed zoomorphic head with a blunt nose floating above the turtle may have belonged to this creature. The vessel's high relief creates a play of light and shadow that in conjunction with the black, slip-painted bands above and below the central panel lends a certain darkness to this aquatic scene.

The turtle carapace and conch shell are frequent attributes of God N, a deity associated with the four cardinal directions and often represented in sets of four (plates 38, 39). Quadripartite renditions often depict him wearing different back ornaments: a turtle shell, conch shell, spider web, and insect wings. — VL

References: Bolles 1963; M. D. Coe 1978; Foster and Wren 1996; Hellmuth 1987A; Hellmuth 1987B; Ishihara, Taube, and Awe 2006; Thompson 1970B.

Figure 1. Rollout photograph of plate 23.

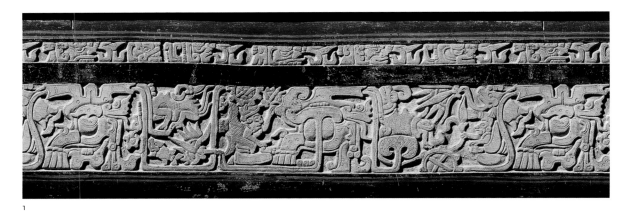

1

24

Panel with a seated lord
and a water serpent
700–800
Possibly Campeche, Mexico
Catalogue 5

This small limestone panel depicts a supernatural snake that personifies the power of a waterfall or surging water. A bearded lord seated in the center of the scene reaches out as if to placate the creature. Wearing little beyond a few jade ornaments and a water lily in his hair, he seems prepared to confront the water snake in its native element (figure 1). Used as a glyph, the water serpent's head may, in some texts, read *witz'*, "spray" or "waterfall." Similar serpents, called Chicchan, perhaps from "deer snake," a word today for boa constrictors, are believed by the contemporary Ch'orti' Maya to inhabit rivers and lakes and to be responsible for floods and landslides.

The accompanying text describes the dedication of "the dwelling-place of the *kamayi*," an enigmatic title that could refer to magical serpents or to the priests adept at controlling them. The panel itself was probably set into the wall of the building in question, a shrine used in the propitiation of supernatural powers governing water. Although it is not known where the panel was found, the style of the carving and the use of the term *kamayi* suggest an origin in southern Campeche, possibly around AD 750. The contrast between the finely worked head of the *witz'* serpent and its inexpertly carved body suggests that at least two artists, perhaps a master and an apprentice, collaborated on the sculpture. – NC

References: Fought 1972, pp. 75–124; D. Stuart 2007B; Wisdom 1940, pp. 390–97.

Figure 1. Drawing of plate 24 by Nick Carter.

1

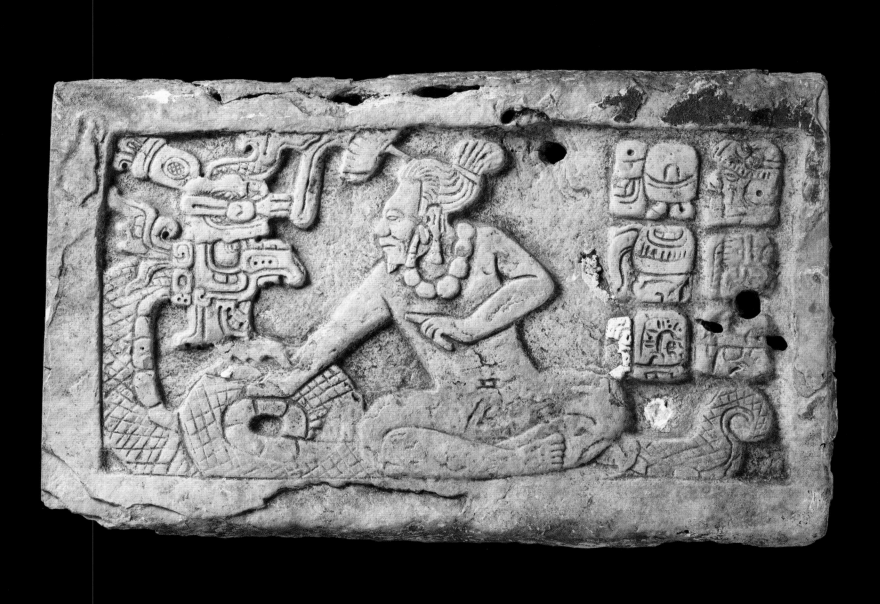

25

Incense burner with a deity
with aquatic elements
700–750
Palenque, Mexico
Catalogue 67

At Palenque, artisans devised elaborate cylindrical censer stands (*incensarios*). In this example, the face of a central deity is flanked by two lateral panels or flanges. As with most others, its brazier is now missing. The effigy features GI, a member of the Palenque Triad of deities, who plays a central role in Palenque's creation myth. A water curl marking his cheek shows his aquatic origins. He also carries the *Spondylus* shell ear ornaments linked to Chahk, the Rain God who rises like GI from the eastern sea. A shark serves as GI's headdress, and just above, in a flowery headband, protrudes the toothy head of a crocodile, as though the head of GI were rising from the depths to the surface of the water. A small Sun God and a royal diadem appear at yet higher levels of the headdress. Presumably, offerings burnt in the brazier functioned as sustenance for the figure celebrated on the stand. Depending on time of day or ritual cycle, Palenque would have been shrouded in smoke rising from this censer and its many companions in the central section of the city.

Nearly one hundred similar effigy censer stands have been recovered in excavations of the Cross Group (including the Temple of the Cross, Temple of the Foliated Cross, Temple of the Sun, Temple 14, and Temple 15) in the center of Palenque. The principal faces on the stands represent members of the Palenque Triad or venerated human ancestors, including, in smaller examples of stone, deceased local noblemen. On the flanges are stylized ear ornaments, knots, jewels, depictions of the sky, and, in this example, extrusions that may depict stylized cloth.

Though flanged and composite censers are found throughout the Maya lowlands, the craftsmanship demonstrated in this example is unique to the Palenque region during the eighth century AD. Technical studies of Palenque *incensarios* indicate that local potters made the stands from raw materials nearby, but the shape of their censers evolved from earlier censer and cache designs in Peten, Guatemala (plate 90). – CW

References: Cuevas García 2003, pp. 317–36; Cuevas García 2004, pp. 253–55; Goldstein 1977, p. 419; D. Stuart and G. Stuart 2008.

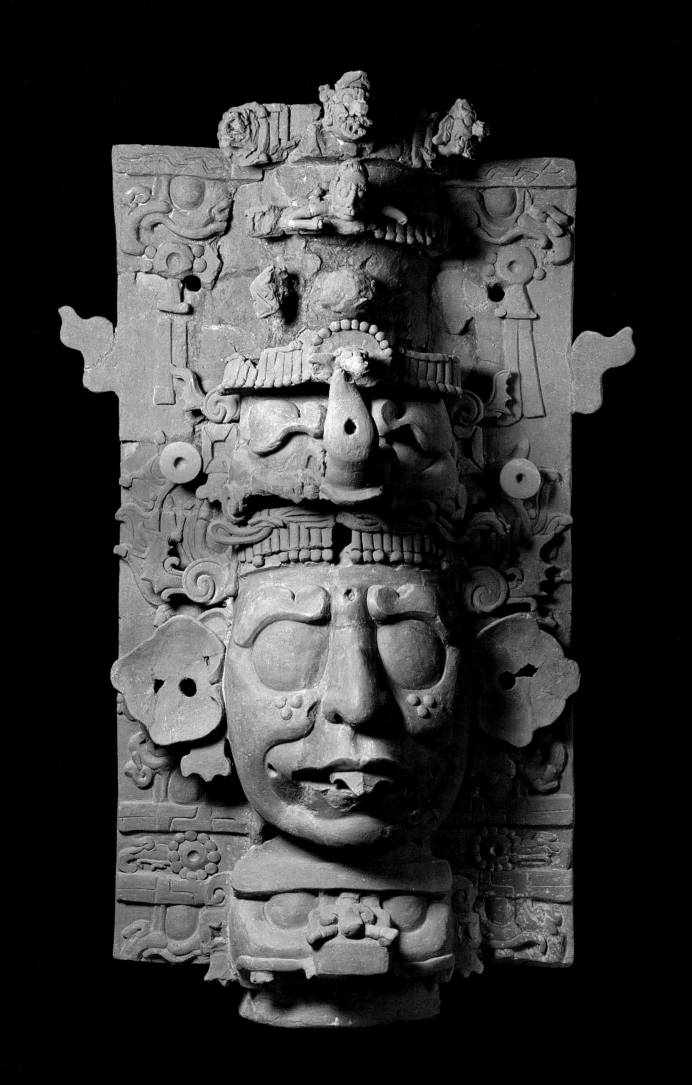

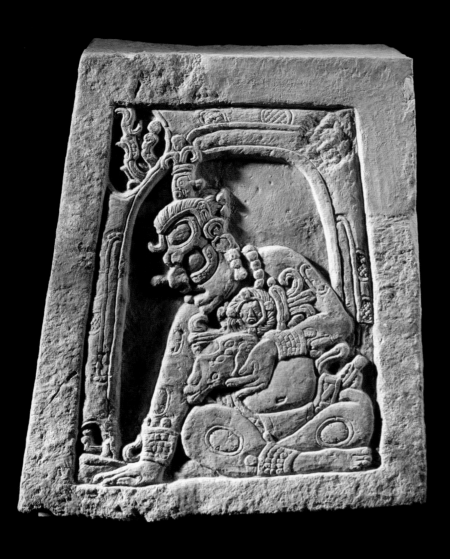

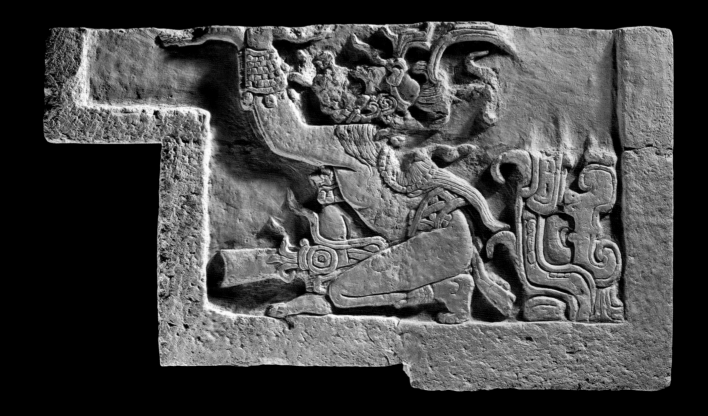

26

Throne blocks with Atlantean
figures and the Sun God
circa AD 750
Dos Pilas, Guatemala
Catalogue 16

The Maya believed that certain figures – much like the Greek Atlas – sustained the cosmos on their muscular backs. As the ultimate servants, subordinate to other, divine, wills, they could not drop their burden lest the world collapse on itself. These two sets of blocks from Dos Pilas, Guatemala, embody this selfless commitment to a ceaseless task: they portray two wind deities who support a microcosm of the world in the form of a throne.

Atlantean figures are common in Maya imagery. Most appear as aged but powerful deities known as the Itzam, often combined with attributes of stone and, along parts of the Usumacinta drainage between Guatemala and Mexico, merged with the identities of subordinate lords. Just as an Itzam sustains the earth – a head glyph of the deity conveys the notion of "ascending" or "rising up" – a noble figuratively supports the ruler who commands his obedience. A second set of Atlanteans holds up the sky. Without their service, earth, water, and heavens would implode calamitously. The exemplary beings for that duty include wind deities, whom the Maya thought rushed over the surface of the earth and oceans, sustaining and transporting celestial bodies such as the sun. The sky, too, figured as an eagle with a bold, intense gaze, was similarly held aloft by the work of the wind gods.

The Dos Pilas blocks embody cosmic and political themes. Two wind gods, contorted with exertion, support a throne that was destroyed in antiquity. The more complete deity, to the right, emerges from the open maw of a centipede. The Maya viewed the centipede as a ravenous scavenger and consumer of dead flesh; it symbolized a hole. The deities wear water lilies as tokens of their Atlantean or underwater status, but their essential attributes are duck-bills. Throughout Mesoamerica, ducks exemplify the wind, perhaps because they migrate along its blustery routes; wind gods from the earliest to the latest times wear stylized bills. The Dos Pilas blocks complete the cosmic tableau by including (in blocks not shown here) a radiant Sun God that functioned as an arm rest for the occupant of the throne. The sitter was positioned within a cosmic frame: wind gods below, radiant solar being to the side. The lower blocks themselves probably formed the sign for "wind," *Ik'*, a shape something like the letter "T."

Excavated in 1990 by Oswaldo Chinchilla Mazariegos as part of a project sponsored by Vanderbilt University, the Dos Pilas blocks formed part of an elaborate throne in Structure N5-21. No texts were found with the blocks, and the throne assemblage had been destroyed in ancient times: many blocks were missing, as well as what was presumably a stone bench. The front of the building, mapped by Stephen D. Houston in 1986, had stairway blocks with raised circular cartouches, perhaps to contain painted glyphs long since eroded away. For this reason, the date of the blocks is difficult to determine, but AD 750 remains a strong possibility, toward the end of the Dos Pilas dynasty, an early casualty of wars in the region. The puzzling feature of the throne and its mound group is that the imagery is clearly exalted and regal, yet the relatively small mound group, though of high-quality masonry, seems unsuitable for royal occupation. – SDH

References: Chinchilla Mazariegos 1990, pp. 120–45; Chinchilla Mazariegos 2006B; Houston 1993, p. 29, figs. 2–5; Martin 2008; O'Mack 1991; D. Stuart, personal communication, 1998; D. Stuart 2009.

Lobster effigy
circa AD 1550
Lamanai, Belize
Catalogue 26

This lobster cache vessel, one of the many effigy vessels found around the ruins of the Spanish colonial structures at Lamanai, demonstrates the Maya people's commitment to traditional iconography following Spanish contact and their longstanding association with the sea. Unlike the heavily stylized portrayals of animals in Maya art, this effigy evokes an actual Caribbean spiny lobster (*Panulirus argus*) and is the only known Maya representation of a lobster (figure 1). The skillful artist even alluded to the species' long antennae in a manner that would not readily break upon interment. Along with the effigy's physical appearance, a plugged concavity inside the body included a stingray spine, three shark teeth, and two chert bladelets, which refer to sacred water connections and the likely offering of human blood from auto-sacrifice. The presence of similar offerings in turtles (plate 85) suggests further cosmic associations, and the head emerging from the lobster's mouth may represent a late Maya deity.

One of the oldest sites in Belize, Lamanai was inhabited for over three thousand years, from 1500 BC to the Spanish missionary activities of the sixteenth and seventeenth centuries AD. The city is located in the New River Lagoon on an important river trading route approximately forty-nine miles (eighty kilometers) south of Chetumal Bay and the Caribbean as the river flows. The literal translation of its colonial name, Lamanai is a corruption of *Lama'an*, the Yukatek word for "submerged thing," but it has also been translated as "submerged crocodile" or "drowned bug." The ancient name for Lamanai, though different, still has references to water based on a *ha* or *'a* glyph carved on a stela found at the site.

When Spanish missionaries entered indigenous settlements, some Maya buildings were razed and European constructions built over them — a powerful act of religious and ideological conversion. The lobster effigy was discovered in 2007 just outside the north stair of the earliest Spanish church, constructed over a razed Precolumbian structure (similar to many temples at Tulum) between 1544 and 1550 by missionaries based in Mérida, Mexico. When Maya structures were constructed or enlarged, dedicatory offerings were placed within or near them as memorials to mark the end of certain religious events, periods, or ceremonies. The lobster cache, one of the last objects to be made in Precolumbian style, thus exemplifies Maya resistance to Catholicism. – GS

References: E. Graham 2008; E. Graham, Pendergast, and G. D. Jones 1989, pp. 1255–59; Pendergast 1998, pp. 55–63.

Figure 1. Profile and cross-section drawings of plate 27 by Louise Belanger, Lamanai Archaeological Project.

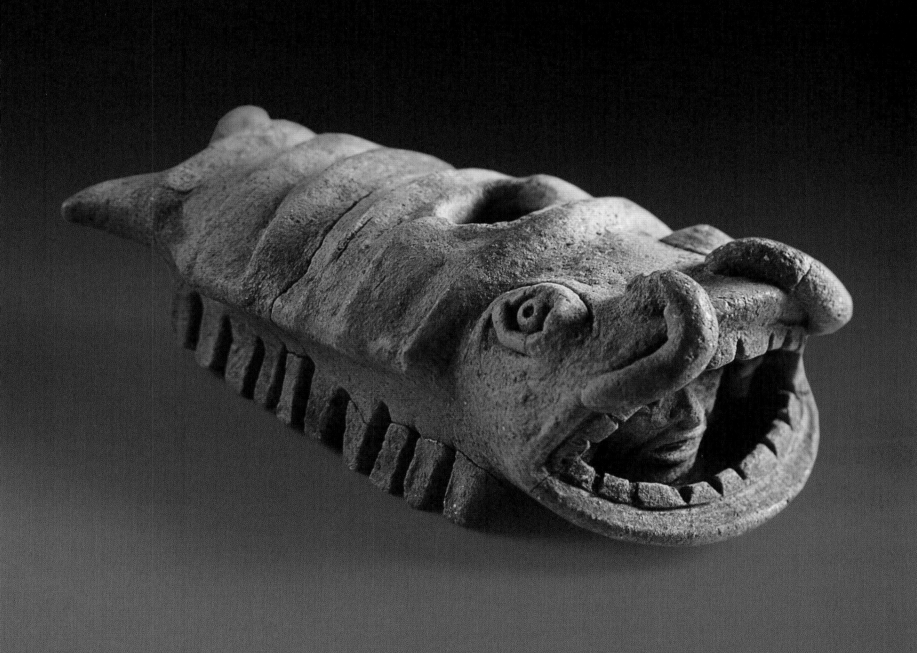

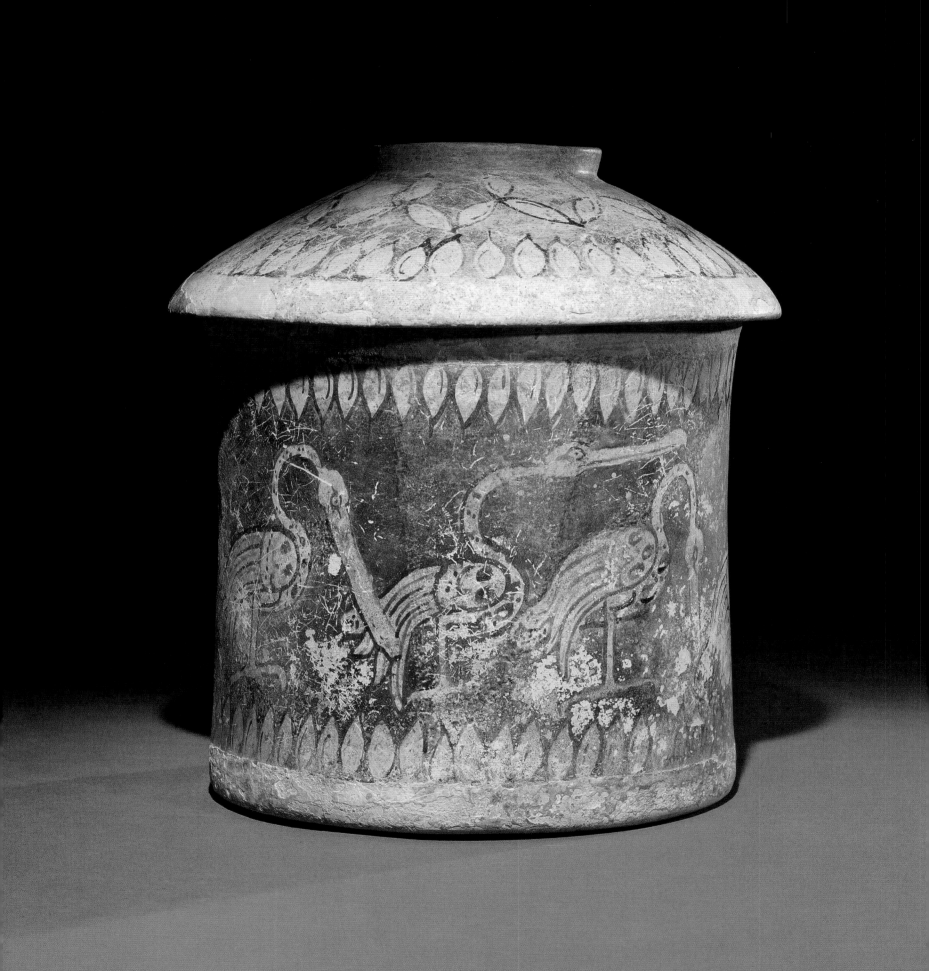

28

Lidded vessel with water-birds
and *Oliva* shell tinklers
600–700
Peten, Guatemala
Catalogue 32

This cylindrical vessel features a scene of graceful spotted water-birds
– possibly cormorants – fishing in dark waters indicated by the murky
background. *Oliva* or *Olivella* shells appear in rows above and below, as
well as in a triangular pattern around the top of the vessel's lid. Bands of
thin white stucco, colored blue and applied after firing the vessel, frame
the pot and line the rim of the lid. The lid itself might also have doubled as
a drinking cup. Water-birds in aquatic environments frequently appear
on painted vases, often with fish or shells of many varieties floating
nearby – an indication to the Maya that these birds can also inhabit under-
water realms.

The geometrical design on this pot likely reflects shells that were
sewn onto clothing rather than as found in nature. Marine shells of the
family *Olividae* were of great interest to the Classic Maya. They served as
emblems of the sea and on a costume added a percussive sound to a dance
performance also intended to evoke the sea. Multiple strands of shells,
along with slabs of jade, would likely have enhanced royal dance garb,
serving as noisemaking tinklers for what would have been extravagant
performances by Classic Maya rulers (as indicated by images from monu-
mental sculpture). By the Late Classic period, extensive trade networks
made these symbols of the sea more accessible, and they became common
adornments for rulers throughout the Maya region. – JD

References: E. W. Andrews 1969, pp. 17–19; Isaza Aizpurúa 2004, pp. 335–52; Isaza
Aizpurúa and McAnany 1999, pp. 117–27; Moholy-Nagy 1963, pp. 65–83.

29

Vase with a water-bird
circa AD 750
Northern or northeastern
Peten, Guatemala
Catalogue 27

Painted in vibrant hues of red, orange, and pink, this cylindrical vessel exhibits iconography evocative of a watery landscape and aquatic creatures. The vase is divided into three main registers. The uppermost portion contains "pseudoglyphs" – hieroglyphic signs that imitate legible writing but lack any linguistic meaning. The central register, which is divided into two nearly identical scenes by vertical bands of pseudoglyphs, contains the main content of the iconographic program. Both scenes depict a long-legged water-bird with the symbol for Venus, *ek'*, painted on its rosy plumage. From the rounded chest of each bird emerges the toothless, sagging face of an old man with a *k'an* ("yellow") sign over his ear. Although his identity remains uncertain, he may represent God N, an elderly deity of the earth. In both scenes, the wizened face appears in conversation with a small fish or tadpolelike creature with prominent rounded teeth and skeletal features. The bottom register contains a ring of large circles punctuated by smaller circles, a pattern reminiscent of water symbolism elsewhere in Maya art. Furthermore, the large circles closely resemble the glyph *pet*, or "island," reinforcing the connection to water and possibly providing a toponymic reference. A comparable motif appears around the edge of a lidded bowl depicting an evisceration (plate 82).

A number of strikingly similar vessels appear in the corpus of Maya polychrome ceramics. All display the same overall format, iconographic attributes, shape, and palette, suggesting a wide interest in this theme. The consistent treatment of the water-birds – the bulging bill, unique plumage patterns, and overall posture – allows their tentative identification as cormorants, a species commonly depicted by Maya artists on painted ceramics. – CM

References: Reents-Budet 1994, pp. 244–51; R. E. Smith 1955, fig. 38b.29.

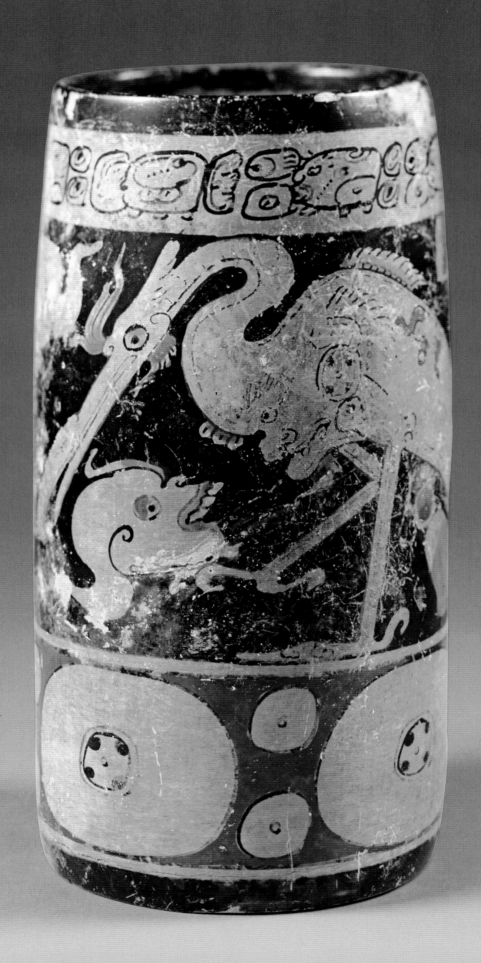

30, 31

30
Tetrapod plate with a fish
250–350
Peten, Guatemala
Catalogue 24

31
Tripod dish with a fantastic fish
circa AD 600
Peten, Guatemala
Catalogue 25

These two dishes show Classic Maya conceptions of fanciful fishlike beings. Part of the Maya "conjectural bestiary" (Houston, pages 75–78), these two aquatic denizens display traits of terrestrial animals, plants, and even jewels and polished stones. The first example (plate 30) contains the image of a large, snarling fish in one of the greatest paintings from the end of the Preclassic and beginning of the Early Classic periods (figure 1). Shell-like pendants hang above and below the creature, possibly a shark or carnivorous fish, as indicated by jagged dentition and a large front tooth. Jewellike elements and fins shown as hard, shiny objects exhibiting properties similar to polished celts mark this fish as precious. Delicate crosshatching, dark orange accents, and a flourishing brush stroke convey a mastery of paint at a time from which few such paintings are known. With a shallow rim and four feet that likely served as noise-making rattles, this dish would have been used as a serving plate, possibly for tamales. Vessels of this type are found at Peten sites, notably Holmul, from the Protoclassic period or very early years of the Early Classic period.

Executed in a style characteristic of the Uaxactun or El Zotz region, the second serving dish (plate 31), now with tripod supports, depicts a curling fantastic fish (figure 2). Though the creature has scales like those of a snake, its fins are rendered as tufts of quetzal feathers sprouting at intervals along its body; in place of tail fins, the artist has painted a personified seed with sprouting foliage, a characteristic of supernatural snakes in Maya art. The head combines catfish barbels with feline traits, including spots and, at its forehead, a water-lily leaf of the kind typical of Maya depictions of jaguars. These features may express a now lost Classic-period name of a particular kind of fish or a spirit being known as a *wahy*, a companion soul of a Classic Maya ruler. The text around the vessel's rim describes it as "his plate, his eating-instrument for white venison tamales," although the owner's name is not provided. The vessel underwent two structural modifications in antiquity. Perhaps to rebalance the plate after one of its legs was broken, the remaining legs were sawn off using a cord and abrasive sand. Later, a hole was drilled through the center of the dish to "kill" the object ritually prior to burial with its owner. – JD, NC

References: Boot 2003, pp. 1–4; Merwin and Vaillant 1932, pl. 20; D. Stuart 2008, p. 14; Zender, Armijo, and Gallegos 2001, pp. 1038–71.

Figure 1. Fish on plate 30. Drawing by James Doyle.

Figure 2. Feathered fish on plate 31. Drawing by Nick Carter.

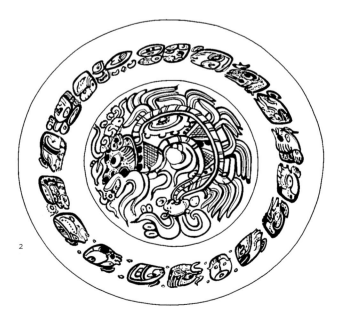

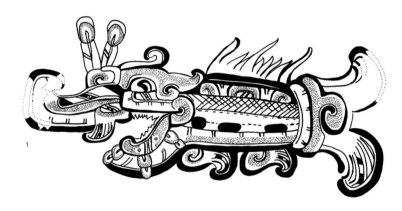

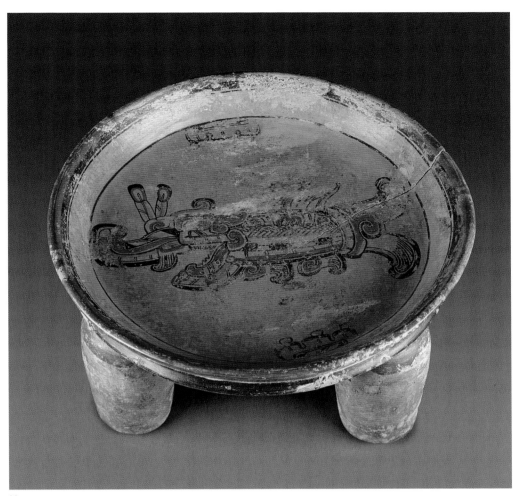

30

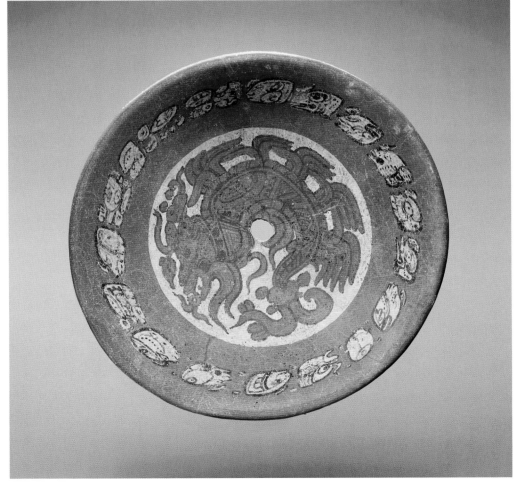

31

32

Plate with a sea creature
550–600
Uaxactun, Guatemala
Catalogue 55

This plate contains the image of a fantastic sea creature with feathery appendages, a large central stingray spine, and menacing jaws. It represents the Classic Maya conception of threatening watery fauna, as well as a series of visual puns. The two shells, doubling as eyes, evoke a bivalve, perhaps *Spondylus*. There is also a possible reference to male genitalia, the spine serving as both nose and phallus. Fangs protrude from the jaws as falling bloodlike droplets, suggesting that the creature feeds on blood. The blood elements, feathers, and rare frontal perspective relate to imagery from the great city of Teotihuacan, Mexico.

Decorated with red and black paint, the shallow tripod dish would have held food, perhaps tamales. Its three hollow feet contain ceramic pellets that rattle during movement. Although the initial glyph of the rim text is legible as the introductory sign of a formula known as the Primary Standard Sequence, the rest appear to be pseudoglyphs with the appearance rather than the reality of writing.

The dish comes from Burial A-23 at Uaxactun, Guatemala. The building that housed the vaulted tomb was perhaps a funerary structure added onto Group A, a large palatial residence, during the early Late Classic period. The burial contained three other polychrome vessels with images of ballcourts, shooting stars, and nighttime creatures. Jade, a stingray spine, and some charcoal also found in the tomb suggest that its occupant was of high status. A nearby stela, dating after AD 554, may have marked the dedication of this building and therefore the interment of the owner of this plate. – JD

References: I. Graham 1986, pp. 147–49; A. L. Smith 1950, table 7, figs. 69, 77, 123; R. E. Smith 1955, fig. 7.

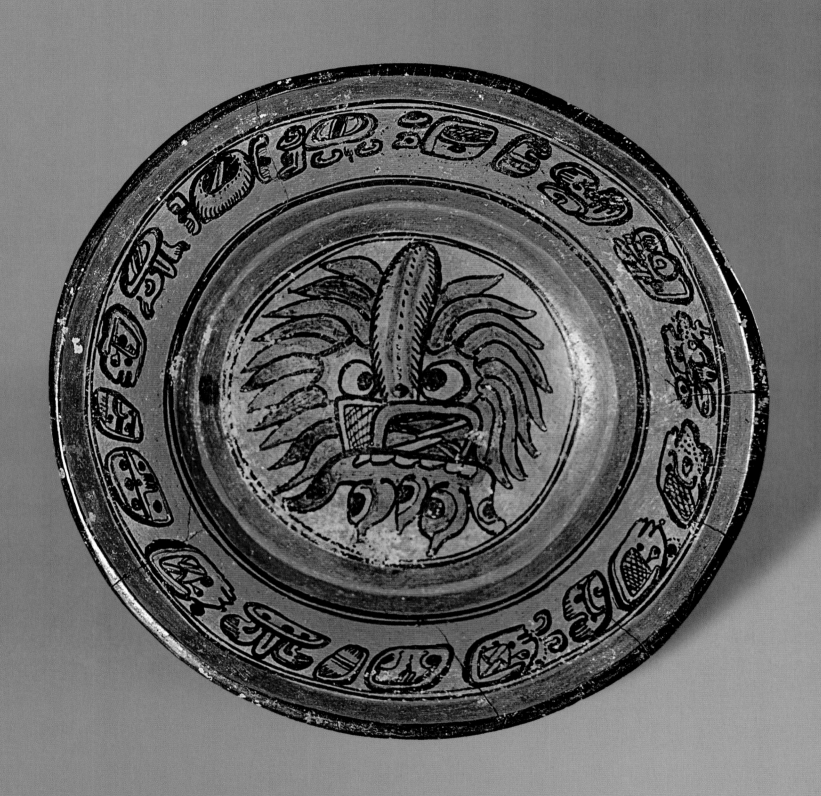

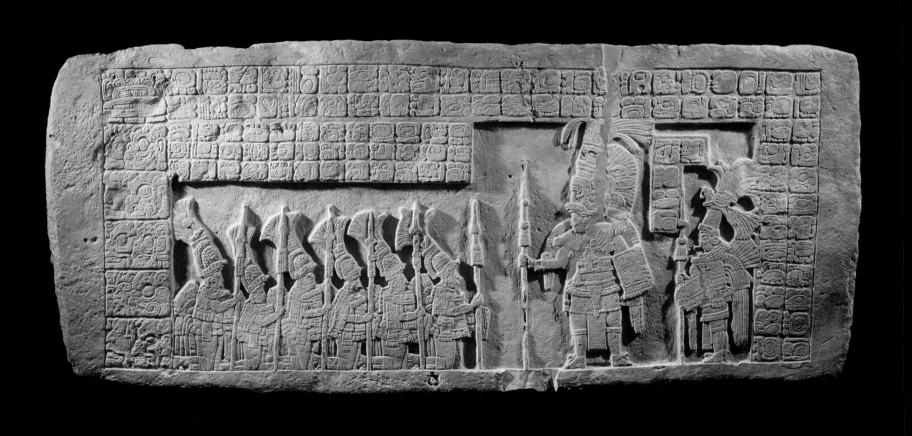

33

Panel with a king, prince, and
warriors [Piedras Negras Panel 2]
AD 667
Piedras Negras, Guatemala
Catalogue 38

This limestone panel was dedicated in AD 667 by the Piedras Negras king
Itzamk'anahk, also known to epigraphers as "Ruler 2." It shows a king
in full Teotihuacan warrior regalia, including shell goggles and a mosaic
headdress, probably also made of marine shell, depicting the so-called
War Serpent (figure 1). The precious *Spondylus* shells hanging from the
king's pectoral ornament were bright-red objects associated with blood
in Maya religion. In the context of the central Mexican costume worn
at Piedras Negras as a sign of authority and military might (figure 2),
Spondylus and other shells emphasized the War Serpent's maritime con-
nections and the hard, impervious quality of its body.

 The panel memorializes the king's predecessor, the late K'inich
Yo'nalahk, and commemorates Itzamk'anahk's taking of five mosaic war
helmets (*ko'haw*) in AD 658, but the major focus of the text is a similar
helmet-taking by another king more than 150 years earlier, in 510. This
earlier event was supervised by an individual named Tajoom U K'ab Tuun,
almost certainly the ruler of another site. Which site is uncertain, but
Tajoom U K'ab Tuun is described as an *ochk'in kaloomte'* – a quasi-imperial
title associated with the great central Mexican city of Teotihuacan. In
commissioning Piedras Negras Panel 2, Itzamk'anahk was asserting a
connection to his illustrious ancestor. However, the inscription notes
that Itzamk'anahk received his *ko'haw* not from a foreign overlord, but
"in the presence of his gods." It is unclear whether the scene portrays
Itzamk'anahk or the ancestral king, and the textual ambiguity must have
been a deliberate effort to conflate the two. – NC

References: Martin and Grube 2008, pp. 143–44; M. E. Miller and Martin 2004, p. 194;
Schele and M. E. Miller 1986, p. 84.

Figure 1. Detail showing the royal tunic made of *Spondylus* on plate 33. Drawing by
David Stuart.

Figure 2. Piedras Negras Stela 35 with ruler Itzamk' anahk, AD 662. Drawing by
Nick Carter.

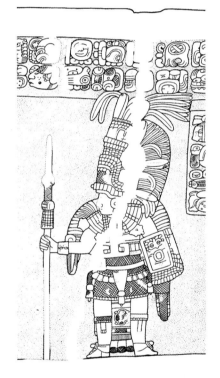

1

2

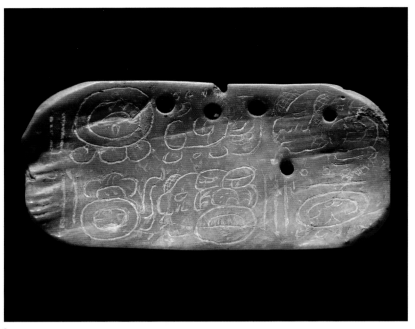

1

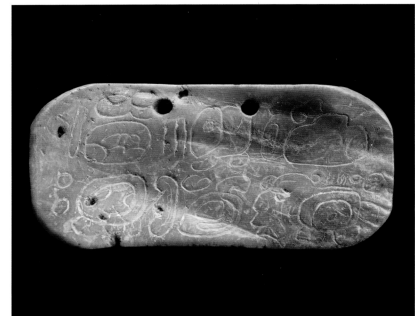

3

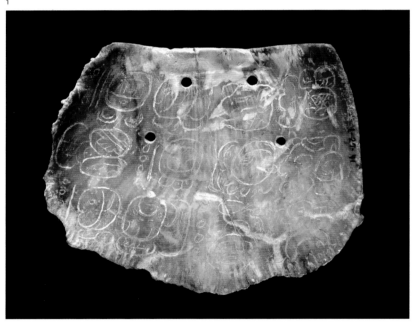

2

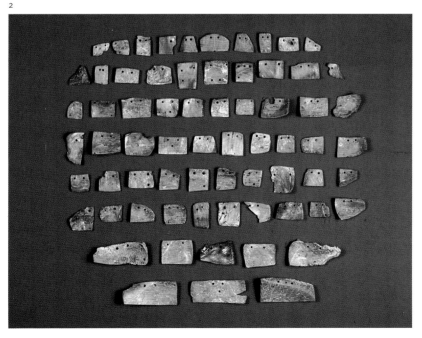

4

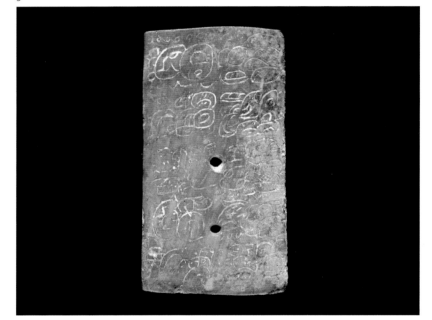

34

Plaques from a royal garment
AD 729
Piedras Negras, Guatemala
Catalogue 39

These plaques of cut, polished, and incised *Spondylus* shell recount a gripping story of generational transition. They are also the remains of a royal heirloom: sewn onto a now missing backing of textile or leather, the shells composed a battle garment worn by at least two Maya rulers. That garment is one of the few surviving objects that can be matched to its depiction in Classic Maya art (plate 40).

The plaques were discovered in a cluster within a large chamber under a platform in the Acropolis or royal palace of Piedras Negras. The contents of the collapsed tomb and texts on the plaques leave little doubt that this was the tomb of Yo'nalahk (644–729), a long-lived king of the city who acceded to the throne in 687. Yo'nalahk is known today for the series of stelae erected near the tomb of his father and for massive building projects around the city. He also commissioned, on four of the prized *Spondylus* shells, an account of life passages in the royal women of his life. Maya ladies are sometimes shown with *Spondylus*, and the gendered meaning of the shell may be applicable here.

The text, which runs continuously over the shells, begins with the birth of a foreign princess, "Lady K'atun Ajaw," probably from the site of La Florida to the northeast of Piedras Negras. At the tender age of twelve, perhaps her puberty, the princess was brought to Piedras Negras and "covered" (*mahkaj*) under the supervision of Itzamk'anahk, the father of Yo'nalahk, in preparation for his son's eventual marriage to the princess. Within days of the covering ceremony, the father was dead. The overriding impression is of an aged and dying king anxious to find a prestigious and suitable spouse for his twenty-two-year-old son. A court lady supervised some of the preliminaries for a marriage that eventually produced a local princess, Juuntahnahk ("Cherished Turtle"). This girl was lovingly de-picted on one of the king's stelae, cradled in her mother's lap. The text on the plaques concludes with events much like those at the beginning of Yo'nalahk's reign: a similar ceremony with a female, presided over by the queen – the dying ruler attending to the key passages in the lives of female kin.

The drilled holes and large number of plaques (more than two hun-dred) point to their use on what must have been a spectacular garment.

A panel from the reign of Yo'nalahk's father appears to show the garment in a scene in which war captives were brought to the ruler (figure 1). A treasure of the royal house, the very same costume probably found its way into the tomb of his son. A similar garment, also of *Spondylus*, was found in a cache within the so-called "Burnt Palace" at the distant Mexican ruins of Tula, associated with Toltec civilization of about 900 to 1000. It may have been modeled on a Maya original. – SDH

References: Cobean and Estrada Hernández 1994, p. 78; W. R. Coe 1959, figs. 53, 54, 64, 65; D. Stuart 1985, p. 182.

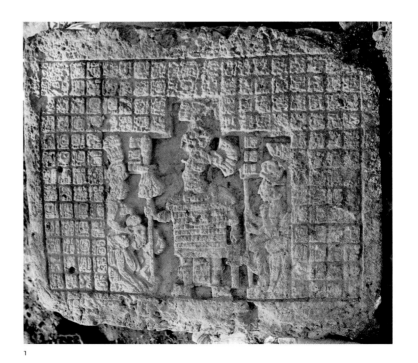

Figure 1. Piedras Negras Panel 15, AD 706, showing a royal garment of *Spondylus* shells.

1

35

Shell plaque with a lord smoking
700–800
Usumacinta region, Guatemala,
or Chiapas, Mexico
Catalogue 40

This shell fragment contains a scene of a lord interacting with a conch shell (Zender, pages 84–85). The delicate, calligraphic incising conveys the movement of the ruler, the shell creature, and even the wispy smoke emanating from the cigar in the lord's mouth. The ruler is a young male, adorned with jeweled earrings and a single beaded necklace. He wears an intricately woven loincloth that is fringed and contains a border with a step-fret design. On his bare torso, indicated by the visible navel, is either body paint or extensive tattooing in a crossed pattern that rings his chest. The deer headdress crowning the figure's sloping forehead possibly represents a brocket deer (*Mazama sp.*) with its small horns and large ears. The graceful depiction of the long-nailed curling fingers reaching toward the conch shell demonstrates the artist's skill.

A snarling serpent head emerges from the shell; its tongue almost reaches the toes of the central figure. This creature may represent the Classic Maya conception of the queen conch (*Strombus gigas*), whose feathery appendages resemble the volutes on the creature. The object itself is carved out of the lip of a queen conch, which was also used to fashion trumpets during the Classic period. Its easily portable size and the absence of drill holes for suspension suggest that it might have been a personal gift, not meant to be worn, or even a funerary offering.

The text provides information about the participants in this scene: the person addressing the shell is a courtly figure (*ajk'uhuun*) named "Jewel Jaguar" (Zender, page 84). A person with that name and carrying a priestly or subsidiary noble title participates in rituals commemorated on Pomona Stela 7, in conjunction with a king of Palenque, and on Jonuta Stela 1, both sites in Chiapas, Mexico. Another possible clue to the location of the original owner of this object comes from the lower text, mentioning a *ba witz ajaw* ("first hill lord") from a locale known as the *k'ina'* ("sun water") place. This location also appears in inscriptions from Palenque, Yaxchilan, and Piedras Negras. – JD

References: M. E. Miller and Martin 2004, p. 137, pl. 69; Schele and M. E. Miller 1986, p. 155, pl. 59a; Zender 2004, pp. 329–30, fig. 127.

Figure 1. Incised image on plate 35. Drawing by Marc Zender.

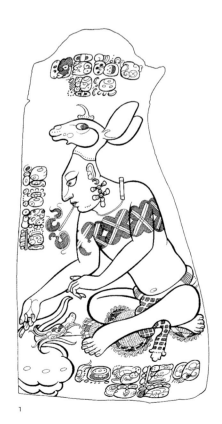

1

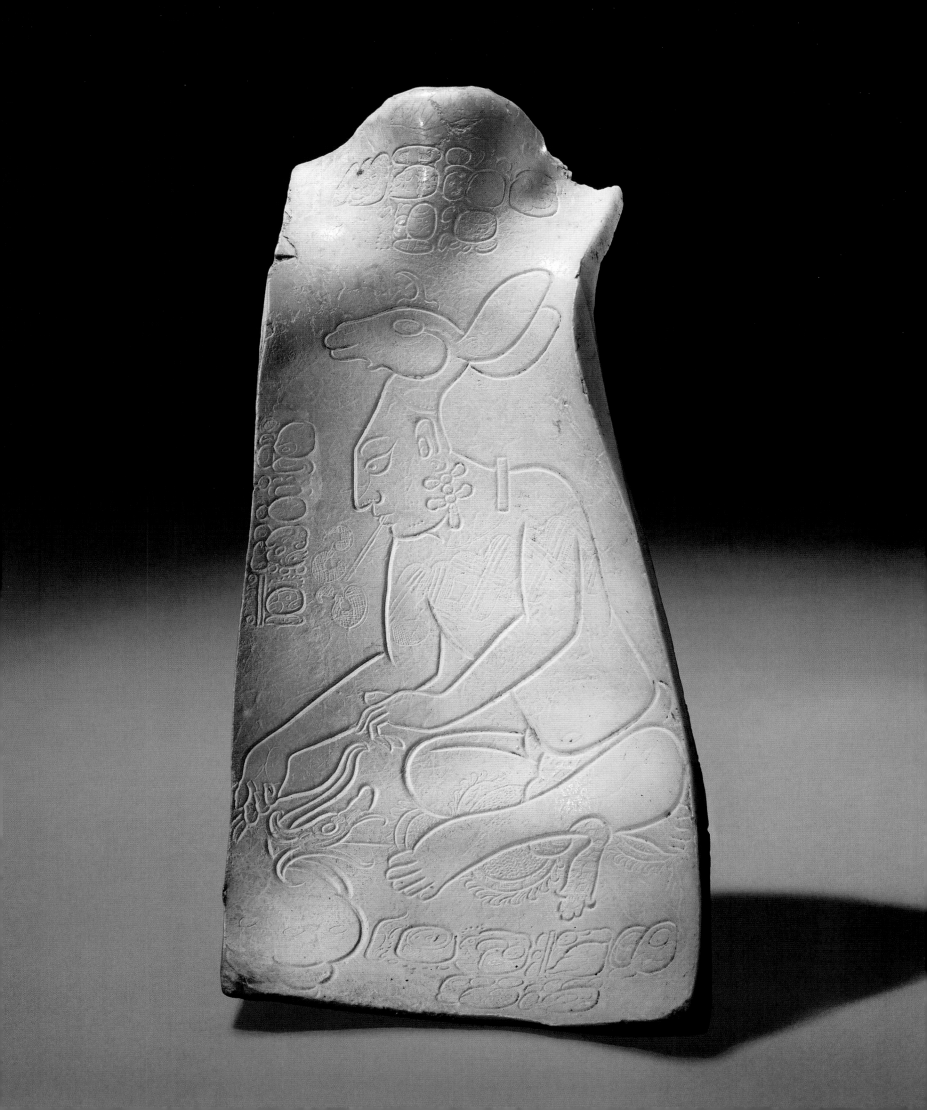

36

Vessel with the Hunter God
blowing a conch
700–800
Puuc region, Mexico
Catalogue 43

This v ... adition,
which ... r between
Yucata ... f the Maya
hunt. O ... th the
antlers ... enters
the dee ... htning.
The god ... his feet.
Conch-sh ... g at-
tributes. V ... attract
white-tail ... also
have been ... ould
have been a ... en
and the Hun ... s fig-
ure, leading ... nts,
protecting th ...
("wood") glyp ... s,
the spirits of t ...

The aftermath of the hunt may appear on the other side of the vessel. A human with vulture features looms over a dead deer whose severed leg dangles from his vulture beak. The deer's hoof raised to its forehead mimics a common Maya expression of woe. The glyphs on the vessel correspond roughly to a statement of ownership for this drinking vessel, but their extreme stylization places them on the edge of legibility. — NW

References: Brown 2005, p. 131; Brown and Emery 2008; M. D. Coe 1975, p. 15; Taube 1992, p. 61; Taube 1997, p. 39.

Figure 1. Rollout photograph of plate 36.

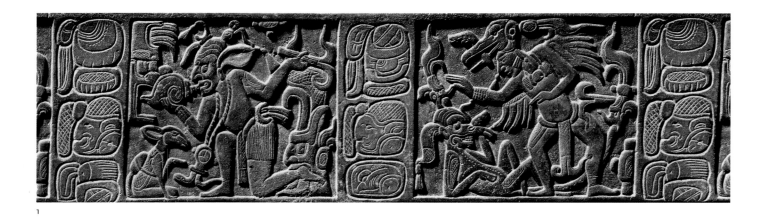

1

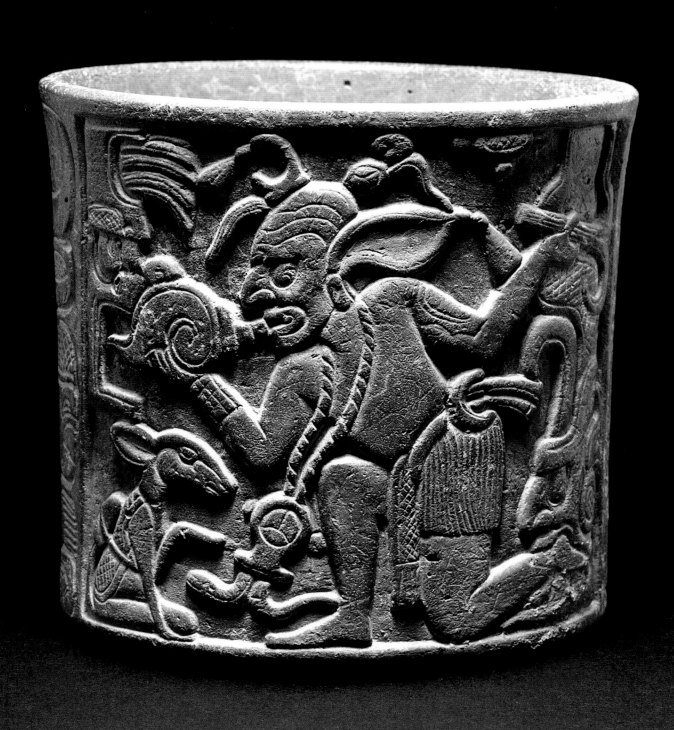

37

Plate with a feathery conch motif
AD 650
Northern or northeastern Peten,
Guatemala
Catalogue 41

This richly hued plate depicts a seated human figure wearing a headdress and body paint. He rests against a large, stylized conch shell, illustrated in cross-section. Descending from the lower end of the shell is a series of ovular and circular forms of progressively smaller size that terminates in a pair of outwardly curving volutes. This graphic convention appears frequently in the canon of Maya art, where it represents breath or wind.

The motif, and by extension the association between conch and wind, also finds expression in non-Maya regions of Mesoamerica. Though painted several hundred years apart, murals at the central Mexican sites of Teotihuacan and Cacaxtla similarly depict this "conch breath." Indeed, a Formative-period Olmec example shows a duck (an animal closely associated with wind and the Wind God) wearing a shell pectoral; and by Postclassic times, the Aztec Wind God, Ehecatl-Quetzalcoatl, was always portrayed with his "wind jewel" – a pendant made from a bisected conch shell, called the *ehecaila-cacozcatl* in Nahuatl.

The outer edge of the conch motif on this plate is flanked by colored feathers that radiate toward the rim. Like the visual link between conchs and wind/breath, the pairing of conch and feathers appears repeatedly in Mesoamerican iconography. The most notable examples are on architectural façades and murals at Teotihuacan, where the feathered serpent – a mythical creature with avian and snake characteristics – is a favorite subject. Closely associated with water and the sea, the feathered serpent often appears with marine creatures and shells. The placement of feathers directly next to the conch shell, as on this plate, almost acts as a visual synecdoche for such iconography.

Considered as a whole, the imagery on this plate may recount a Maya, possibly even a pan-Mesoamerican, belief of their origins in the eastern sea. Other iconographic evidence supports the association between wind and the sea as the givers and sustainers of life: the wind, which blows from the eastern seas of the Caribbean, brings the rains that support agriculture. Recorded origin myths from both Maya and Aztec sources further associate the plumed serpent, evoked here through the feathery conch motif, with the origins of the cosmos and the earthly world. – CM

References: Houston and Taube in press, figs. 6a, 8, 10; Kubler 1967, figs. 16, 17, 24, 25, 37, 46; A. G. Miller 1973, pp. 21–22, figs. 89–96; M. E. Miller and Taube 1993, pp. 84–85; O'Mack 1991, fig. 3.

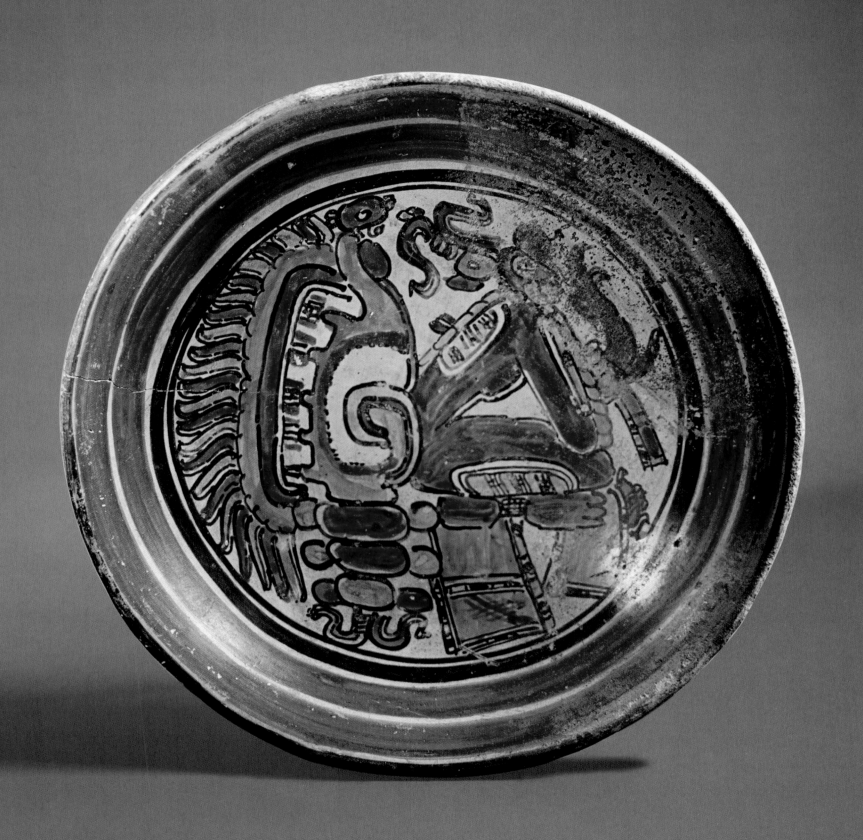

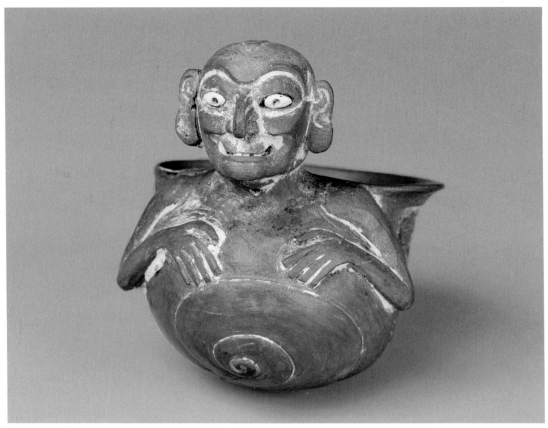

38

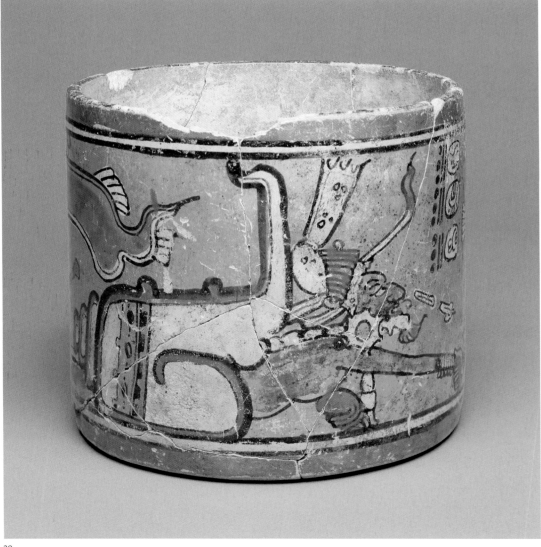

39

38, 39

38
Effigy vessel with God N
emerging from a snail shell
450–550
Possibly Uaymil, Mexico
Catalogue 10

39
Vessel with the Maize God
extracting God N from a snail shell
700–800
Alta Verapaz, Guatemala
Catalogue 11

In Classic Maya mythology, the deity known to scholars as God N is one of the wizened, gap-toothed "old gods" who embody knowledge and authority. He appears in a variety of depictions, most often emerging from a snail or turtle shell – a model of the earth floating on the sea – or from the mouth of a serpent. On the modeled ceramic cup (plate 38), God N peers out, perhaps apprehensively, from his carapace. A shell holds a tasty mollusk, and so, too, the cup served as a receptacle for a delectable food-beverage like chocolate. While drinking, the user would see a gouged and incised scene with three mythic beings from a lost narrative (figure 1). The beings include a nocturnal mammal, perhaps the kinkajou (*Potus flavus*), marked here with signs for "darkness," the high deity known as God D, and the Maize God, who strokes his hair or corn silk with one hand. The mammal offers a *Spondylus* shell with attached cloth, perhaps in tribute to the high god. On Stela 26 at Tikal, Guatemala, the deity is shown in glyphic form cradling just this mammal.

A polychrome vessel from Chama, Guatemala (plate 39), depicts a youthful deity holding a knife and wearing a headdress adorned with water lilies. He draws God N from a snail shell in order to sacrifice him. Pseudoglyphs to the right of the young god evoke the idea rather than the content of writing or speech, while the three calendrical glyphs between the two figures may refer to dates in the Maya almanac associated with this sacrifice, whose precise meaning has been lost.

As an Underworld deity connected to water and mountains, God N existed as a four-part being with one aspect for each of the cardinal directions. A similar god is the much later Pauahtun, from the Postclassic period, consisting of four aged deities believed to stand at the corners of the world and hold up the sky. – NC

References: M. D. Coe 1973, pl. 16; Foster and Wren 1996, pp. 261–65; B. Kerr and J. Kerr 2005, pp. 74–75; Spinden 1913/1975, pp. 83–84; D. Stuart 2007; von Winning 1963, pp. 60–61.

Figure 1. God N and a mythic being on the back of plate 38. Drawings by Nick Carter after von Winning 1963.

Figure 2. Rollout photograph of plate 39.

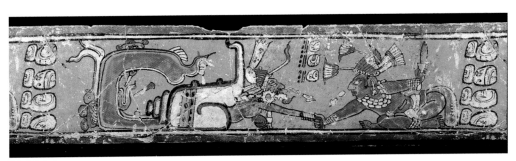

1

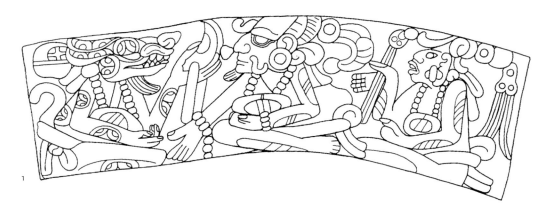

2

40, 41

40
Pectoral assemblage with an
engraved *Ik'* symbol
1300–1500 (?)
Chichen Itza, Mexico
Catalogue 84

41
Torso with an *Ik'* pectoral
600–800
Provenance unknown
Catalogue 85

The Cenote of Sacrifice, a large natural well at the Maya site of Chichen Itza, was once a place of ritual worship and became the repository for an extraordinary assemblage of artifacts deposited there as offerings. Explorations have allowed archaeologists to retrieve ceramics, metalwork, stone, shell, human and animal remains, textiles, and a host of jade beads, figurines, and carved plaques, such as plate 40. This jade plaque has a series of biconical holes along its edges to allow for suspension as a pectoral. Although it was not discovered with the jade beads and pendants shown here, this reconstruction aligns with portrayals of similar pectorals elsewhere in Mesoamerican art.

The plaque is perforated with a "T"-shaped, *Ik'* symbol for wind, a phenomenon often connected with jade in Mesoamerican thought. Jade, with its blue-green hue, was also related to water, a life-sustaining substance; it is likely no coincidence that wind brought rains to Mesoamerica. Additionally, Mesoamerican peoples link an individual's "life essence" with their breath – or wind. In fact, death was often conceptualized as the expiration of a person's breath, wind, and vital essence. This notion was likely expressed in the ancient and widespread practice of placing a jade bead in the mouth of decedents.

The incised cartouche that surrounds the *Ik'* sign furthers the polyvalent meanings encoded in this object. The cartouche's oblong form and trilobal elements at the top may be an attempt to represent the interior of a bivalve shell such as the *Spondylus*, which the Maya valued as a precious material. That such a meaningful object – associated with water and death – was thrown into a water-filled cenote related to ancestor veneration and rites to bring rain is not surprising.

However, such symbolism was manifested in other contexts throughout Mesoamerica. This diminutive fragmented bust formed from lime-based stucco depicts the upper torso of a human figure wearing a similar pectoral (plate 41). Like the jade example, it is suspended from a string of beads and features the same perforated *Ik'* symbol in its center. Dangling from the bottom of the pendant are oblong celtlike forms similar to the squared greenstone beads presented with the jade example; evidence suggests that a third bead was once present.

While the precise original location of this bust remains unknown, it may have been uncovered at the island site of El Bellote off the coast of Tabasco, Mexico, which is marked by towering mounds constructed from seashells. Given the importance of shell as a building material at El Bellote, it is probable that its inhabitants employed this readily available aquatic resource to produce significant amounts of stucco, a malleable material made from burning shells that the Maya frequently used to create architectural sculpture. – CM

References: Coggins 1992, pp. 12–26; Marcus 1999, figs. 4, 5; Proskouriakoff 1974, pp. 150–51, 159, pl. 65; Schmidt, de la Garza, and Nalda 1999, p. 555, pl. 145; Stirling 1957, p. 31; Taube 2005A, pp. 30–33, figs. 8, 9.

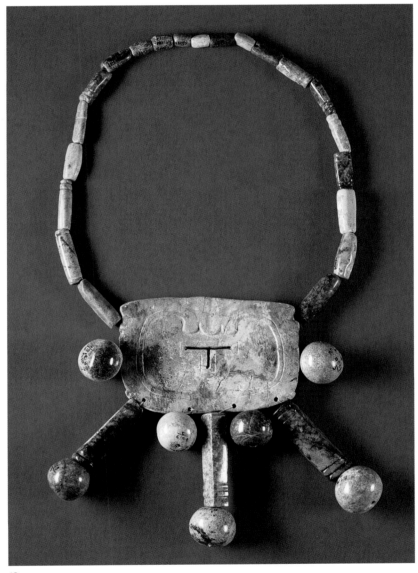

40

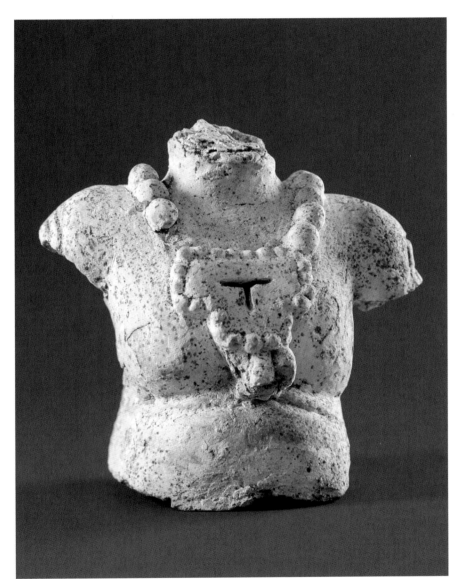

41

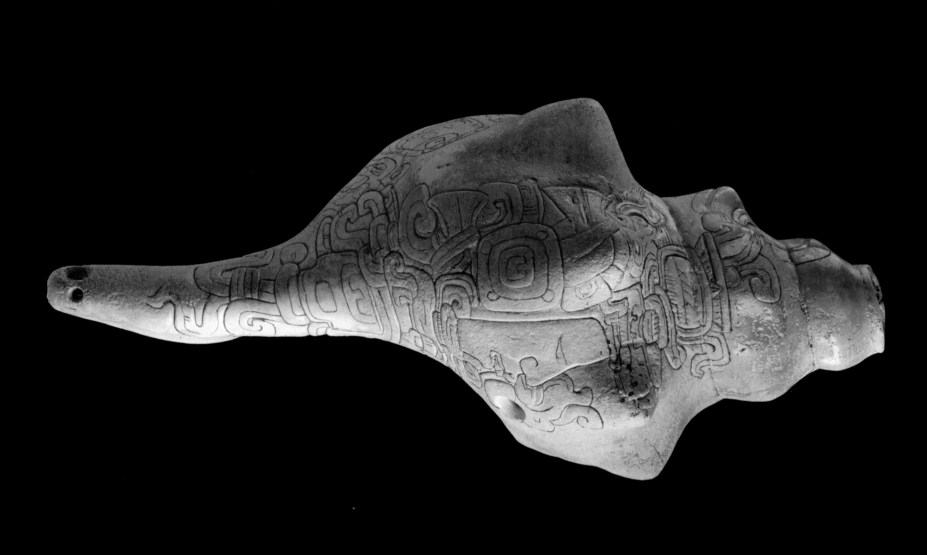

42

Conch trumpet with
a floating ancestor
300–500
Possibly northeastern
Peten, Guatemala
Catalogue 70

Among the Classic Maya and other peoples of ancient Mesoamerica, the conch served as a basic symbol of the sea. Not only are conch among the largest shells, but their spiral form evokes volutes of breath and wind, phenomena closely identified with the moist ocean breezes. Thus, a cross-sectioned conch served as the emblematic pectoral for the Aztec Wind God, Ehecatl-Quetzalcoatl. As wind instruments sounded by breath, conch trumpets clearly evoked the symbolism of breath and wind.

This conch trumpet features a floating ancestor, a motif often appearing in roughly contemporaneous Early Classic sculpture, including Stela 31 and other monuments at Tikal (figure 1). As in the case of many ancestor figures, only the head and elaborate headdress are shown. The headdress portrays the Rain God, Chahk, and it is likely that this is part of the individual's name, as Chahk also appears as a personal name in the accompanying glyphic text describing the owner of this trumpet. The cloud scrolls swirling below his chin convey the ethereal nature of the ancestor as the embodiment of rain. When the trumpet was held horizontally to be played, the ancestor would be oriented as if looking face down from the sky, the usual orientation of ancestor figures in Classic Maya monumental sculpture. The stylized serpent head before the face of the figure was a fairly common convention in Early Classic Maya art. Such serpent heads are more elaborate versions of the breath beads or flowers often found floating before Classic Maya faces. Much like the plumed serpent Quetzalcoatl of central Mexico, Maya serpents are also the embodiment of breath and wind. A hole drilled at the mouth of this serpent would have allowed breath and music to emanate, quite possibly with a distinct tone, when the conch was played. The aperture served not only as the breath of the serpent but also the breath and voice of the ancestor, the active "owner" of the trumpet.

In Early Classic Maya art, royal ancestors commonly appear on marine shells – bivalves as well as conch. Marine shell probably held important symbolic significance, as the eastern Caribbean Sea was the source of rain clouds as well as the dawning sun, phenomena closely related to royal ancestors in ancient Maya thought. Thus, ancestors often appear with clouds or within solar cartouches. In the case of Tikal Stela

31, the ruler Nun Yax Ayiin appears apotheosized as the Sun God in the uppermost portion of the monument. In the crook of his arm he grasps a serpent, his vehicle and road for traversing the sky. A more ancient version of this motif appears in the upper portion of the Late Preclassic Stela 2 of Takalik Abaj (figure 2). Here, too, a downward-facing Sun God grasps a serpent in his arm. However, in this case, swirling volutes surround the solar deity, constituting a conflation of the ancestral themes of the diurnal sun and rain-bearing clouds. – KAT

References: Schele and M. E. Miller 1986, pp. 83–84, pl. 27; Taube 2001; Taube 2003B; Taube 2004.

Figure 1. Glyphic text and ancestral image on plate 42. Drawing by Linda Schele, © David Schele, courtesy Foundation for the Advancement of Mesoamerican Studies, Inc., www.famsi.org.

Figure 2. Detail of the Maya Sun God with a serpent and cloud scrolls, Late Preclassic period, from the upper portion of Takalik Abaj Stela 2, Guatemala. Drawing by Karl A. Taube.

1

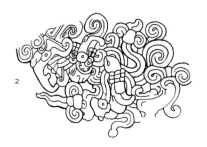

2

43

Conch trumpet with inscriptions
and ancestral figures
circa AD 500
Guatemala
Catalogue 71

The two incised figures on this conch-shell trumpet are those of the Moon
Goddess and a young male grasping a supernatural serpent (figure 1). The
goddess, in a netted skirt made of beads, sits on a stuffed cushion before a
crescent moon. The "mirror" markings on her arms, legs, and back denote
the shining, hard quality of her divine body. The ornament on the youth's
forehead and the crosshatched circles on his body identify him as Juun Ajaw,
one of the Classic Maya Hero Twins. The snake in the crook of his arm ap-
pears to emerge from the conch shell and is marked with watery motifs,
suggesting that it may represent the animal itself or its breathy emanation.
When the trumpet is oriented spire-downward, another anthropomorphic
face appears from its whorls: that of the trumpet itself as an animate being
with a voice. Its nose is defined by one of the knobs of the conch shell; a
finger hole forms one eye; crosshatched areas represent patches of face
paint; and four triangular elements complete the being's identifying
decorations. The inscriptions on the sides of the trumpet indicate that the
uk'ees or "noisemaker" (Zender, page 84) face forms part of the object's
proper name. The text goes on to name the trumpet's owner – a k'ayoom or
"singer" as well as a hunter – and perhaps his parents as well. – NC

References: M. E. Miller and Martin 2004, pp. 96–97; Schele and M. E. Miller 1986,
pp. 308–309; Karl A. Taube, personal communication, 2009.

Figure 1. A young male grasping a supernatural serpent, and the Moon Goddess, on
plate 43. Drawings by Linda Schele, © David Schele, courtesy Foundation for the
Advancement of Mesoamerican Studies, Inc., www.famsi.org.

Figure 2. Glyphic text on the sides of plate 43. Drawings by Linda Schele,
© David Schele, courtesy Foundation for the Advancement of Mesoamerican Studies,
Inc., www.famsi.org.

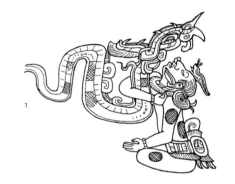
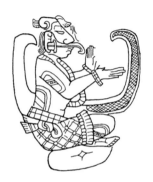

1

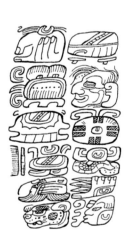

2

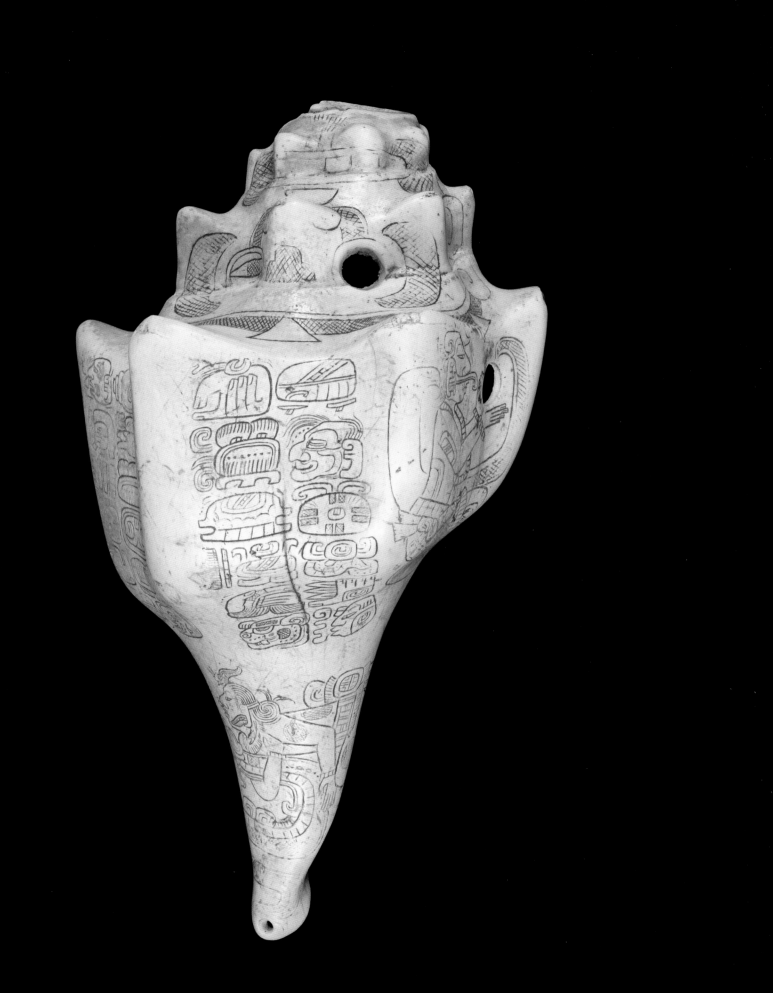

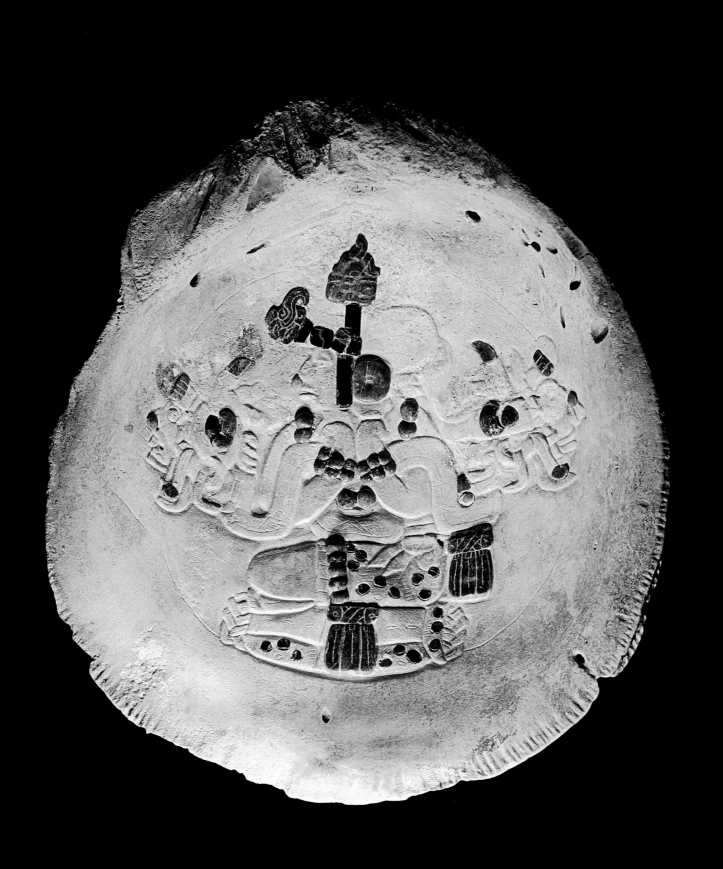

44

Pectoral with a lord seated
on a throne
450–550
Dzibanche, Mexico
Catalogue 67

This pectoral fashioned from *Spondylus* shell inlaid with jade and black coral is engraved with the image of a ruler wearing a trefoil headdress and black headband. A jade bead in front of his upper lip represents his breath or life essence. Jade jewelry adorns his ears, wrists, neck, and jaguar-pelt skirt. A belt encircling his waist contains three jade celts dangling off its back. The lord's cushioned throne mimics his costume: it too has dangling jade celts and is partly covered in jaguar pelts.

Across his chest, the ruler holds a bicephalic serpent bar; deities emerge from the mouths of this mythical animal. Such ritual objects appear frequently in Maya art and are generally associated with rites of ancestor and deity conjuring. The Sun God, K'inich Ajaw, is depicted at the left and an unidentified visage appears on the right. On the reverse side of the shell is a poorly preserved incised motif portraying an abstract terraced shape possibly flanked by human figures (figure 1).

During the Early Classic period, a pyramid now known as the Templo del Búho dominated the site of Dzibanche, Mexico. Excavations uncovered two burial chambers accessed via a narrow staircase that burrowed deep into the temple's base. One chamber contained only the remains of an elderly male, but the other revealed the richly appointed grave of a middle-aged man. In addition to this pectoral were alabaster and polychrome vessels, green obsidian blades, a necklace, a pyrite mirror, and a wooden tablet covered with stucco and codex-style drawings. The interred man's teeth were inlaid with jade, and a jade bead had been placed in his mouth. Jade ear flares and a shell and jade necklace rounded out the burial finery.

The absence of inscriptions on this pectoral makes identification of this individual impossible, but it may represent the buried ruler himself or one of his ancestors. Indeed, the trefoil element on his head and the black headband hint that he is none other than an early historical figure, with similar name elements, active at Copan, Honduras, and Pusilha, Belize, in AD 159, at the very beginnings of Classic civilization. The Dzibanche figure, from some centuries later, might represent this influential person. The presence of the jade bead near the central figure's mouth, his possession of an object linked with ancestral conjuring, the prevalence of objects associated with water and the sea, and the discovery of this object in a funerary context would support a connection among death, ancestors, and the rituals that bind them. – CM

References: Campaña Valenzuela 1995, pp. 30–31; Fields and Reents-Budet 2005, pl. 65, p. 168; D. Stuart 2004, pp. 134–37.

Figure 1. Incised abstract terraced shape, possibly flanked by human figures, on the back of plate 44.

1

45

Pectoral with an ancestor
400–500
Tikal, Guatemala
Catalogue 73

Recovered from Burial 162 in the residential group 6D-V at Tikal, this small shell pendant would have been worn on the chest. It features the head of an ancestor as a smoky, floating being (figure 1). The gaze of the ancestor faces downward, as though focusing on the body core of the descendant. During the Late Preclassic and Early Classic periods, floating ancestor heads were common on Maya monuments, ceramics, and other carved items. Although Burial 162 is Late Classic in date, this pectoral is Early Classic and was either handed down as an heirloom or exhumed from another location.

The artist incised the image into the inner surface of a marine limpet (*Patellogastropoda*), whose outer shell is striped and ridged. The ancestor has a youthful visage and, by convention, no body or an incomplete body. Above his large ear flare is a backward-facing shark's head. The headdress shows the head of the Principal Bird Deity, a god associated with origins, mythic conflict, and supernatural communication. A human head and a vulture crown the headdress. As in other ancestral depictions at Tikal, glyphs record the name of this particular ancestor, although no such king is known from surviving texts at Tikal. The smoke issuing from both ends of the image expresses the Maya notion that ancestral power could be found in mist; the shell itself embodies an ancestral presence rising from the eastern sea. – JD

References: Houston, D. Stuart, and Taube 2006, pp. 50–51; Iglesias Ponce de León 1987, pp. 162–64; Iglesias Ponce de León and Tomás Sanz 1998, pp. 157–67.

Figure 1. Image of an ancestor on plate 45. Drawing by James Doyle.

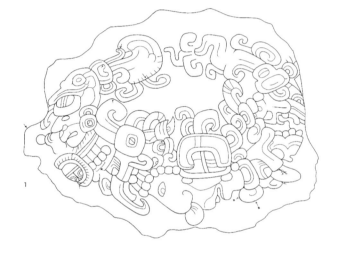

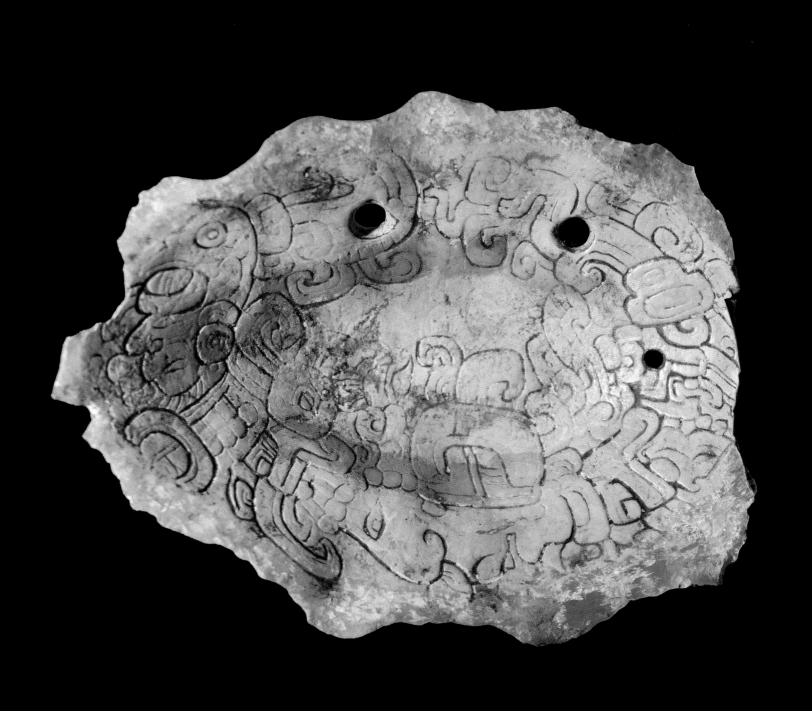

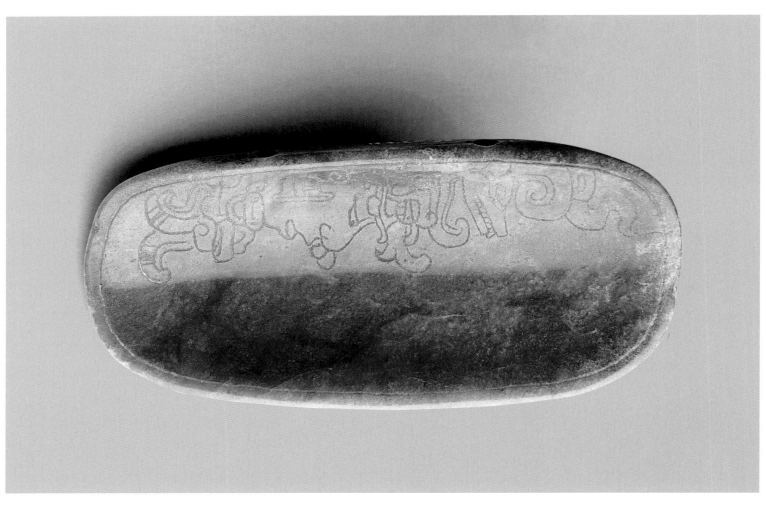

46

Pectoral ornament in the
form of a bivalve shell
200–400
Nakum, Guatemala
Catalogue 74

Discovered in 2006 in a royal tomb at the Classic Maya site of Nakum, in
Guatemala, this jade pectoral ornament in the shape of a bivalve shell is
incised with a short hieroglyphic text and the image of a royal ancestor
surrounded by clouds. The inscription attests to the object's original
owner, a king whose name may read Ixiim Chan. Glyphic elements in the
ancestor's headdress seem to cue a different name, however, strongly
suggesting another identity for this figure. By wearing this pectoral on
their chest, later rulers would have commingled their own breath-souls
with that of their honored forebear, whose own breath is indicated by a
pair of jewels at his nose. The swirling mists from which the ancestor looks
out and the form and material of the ornament all suggest a connection
between rain clouds and ancestral souls. The object may have been traded
or passed down as an heirloom over generations: while the tomb in which
it was found dates to around AD 700, the style of the carving is Early
Classic, several hundred years earlier. – NC

References: Taube 2005A, pp. 31–32, 38–39, 47; Zralka 2007, pp. 37–40.

Figure 1. Image of a royal ancestor surrounded by clouds on plate 46; short
hieroglyphic text on the reverse. Drawings by Simon Martin.

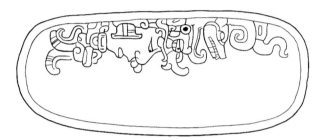

1

47

Lintel with a bloodletting rite
[Yaxchilan Lintel 25]
AD 723
Yaxchilan, Mexico
Catalogue 75

This lintel is one of three commissioned in 723 and 724 by Ix K'abal Xook, the chief wife of a king known as Itzamnaaj Bahlam of Yaxchilan. Set above the three doorways of Structure 23 at that site, the lintels depict Ix K'abal Xook and her husband in a variety of ritual acts. In this scene, dated in the text at the top to the day of the king's accession in 681, Ix K'abal Xook has pierced her own flesh with stingray spines and let blood onto strips of bark paper to be burned as an offering to the gods. Kneeling, she holds a bowl of bloody paper in her hand. From the smoke of the offering plate in front of her rises a manifestation of the local version of the Rain God, Chahk, dressed in the war costume of the distant Mexican city of Teotihucan and wearing the mask of the Mexican Rain God, known later as Tlaloc. The apparition seems to emerge from the maw of a giant, double-headed centipede. The main text connects the ritual to a war conducted by Itzamnaaj Bahlam, probably to legitimize his rule; two smaller captions name Ix K'abal Xook and describe her impersonation of an ancestral lady also tied to central Mexican notions of lineage and rule.

Laden with meaning, stingray spines were important components of elite Maya rituals. Initial perforations in capillary-rich parts of the body – the penis for males, the ears and tongue for females – may have been made with chert or obsidian implements like the one resting in the bowl before Ix K'abal Xook; the serrated spine was used to encourage the blood to flow. – NC

References: M. E. Miller and Martin 2004, pp. 106–107; Schele and M. E. Miller 1986, pp. 186–88.

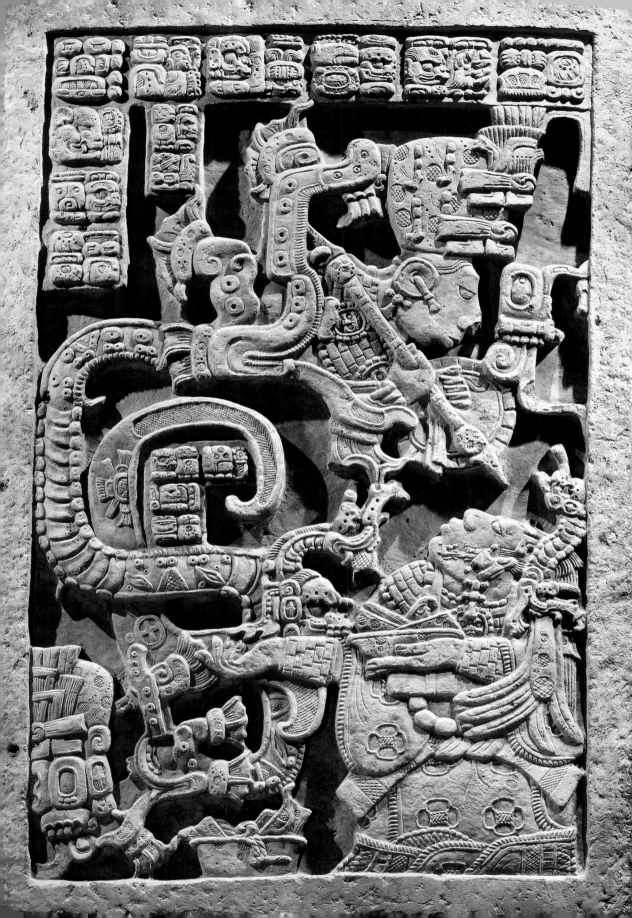

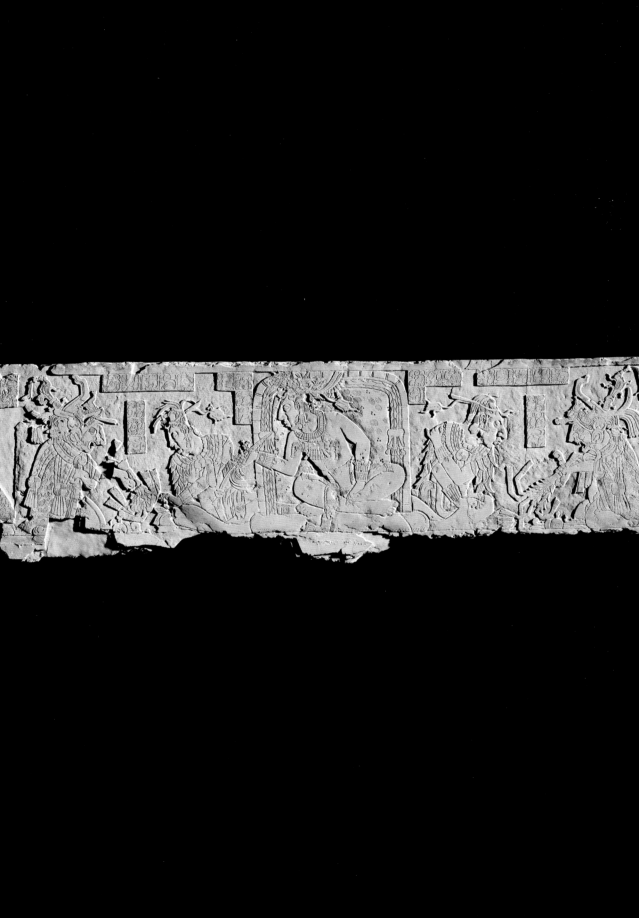

48

Carved platform panel with
a bloodletting ritual
AD 736
Palenque, Mexico
Catalogue 76

This incised low-relief panel shows the use of a stingray spine at a prominent royal court of the Late Classic period. The scene depicts K'inich Janahb Pakal – one of Palenque's most important rulers – flanked by his two grandsons, K'inich Ahkal Mo' Nahb and U Pakal K'inich Janahb Pakal. Each receives a benediction from an elaborately costumed priest. The ornate object that K'inich Janahb Pakal extends to K'inich Ahkal Mo' Nahb will be used by the youth in his first ritual bloodletting (figure 1). The rite dramatizes the reciprocal sacrifice between gods and humans and helps the younger lord, who commissioned the sculpture, to stake his claim to future rule. Made from the spines of the dangerous southern stingray, imported to the interior from distant coasts, these precious objects would have been kept in special wooden coffers. Elite males favored the penis as a site for ritual bloodletting, and the devices had strong connections with masculine potency. In a later text, K'inich Ahkal Mo' Nahb's own son is called "the stingray spine of" his father.

Both youths were probably the offspring of K'inich Janahb Pakal's youngest son, who died two years before his father; unlike his two older brothers, he never occupied the throne. Although they are shown here as young men, their grandfather died when K'inich Ahkal Mo' Nahb was five years old, so the princes must have been children when the ritual took place. The inscription reports that K'inich Janahb Pakal impersonated two much earlier kings. One, with an undeciphered name, is from the fifth century AD; the other is a quasi-mythical ruler, U Kokan (?) Chan, "The Bloodletter of the Serpent." He was supposedly born in 1012 BC, long before the foundation of the historical Palenque dynasty. Both royal names are incorporated into K'inich Janahb Pakal's headdress (figure 2), confirming their merged identity.

The panel was discovered in 2002 in the sanctuary of Palenque's Temple XXI, across the front of a throne or bench. The panel's long text records the dedication of the sanctuary in 736 by the Palenque ruler K'inich Ahkal Mo' Nahb, and looks back to a similar ritual by an ancestral king in 252 BC. According to the inscription, the name of Temple XXI was K'inich O' Naah, "The Resplendent Owl House," the shrine of a deity known to scholars as "GIII," one of Palenque's three tutelary gods. – NC

References: González Cruz and Bernal Romero 2004, pp. 264–67; D. Stuart and G. Stuart 2008, pp. 225–30.

Figure 1. Detail of K'inich Janahb Pakal on plate 48.

Figure 2. Detail of K'inich Janahb Pakal's headdress on plate 48. Drawing by Nick Carter.

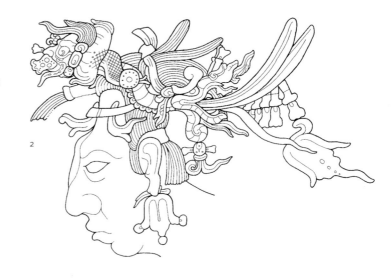

1

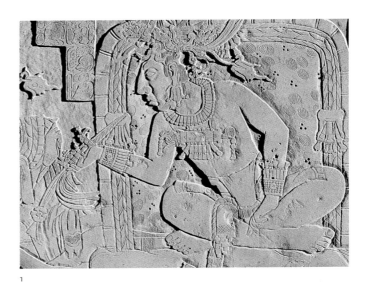

2

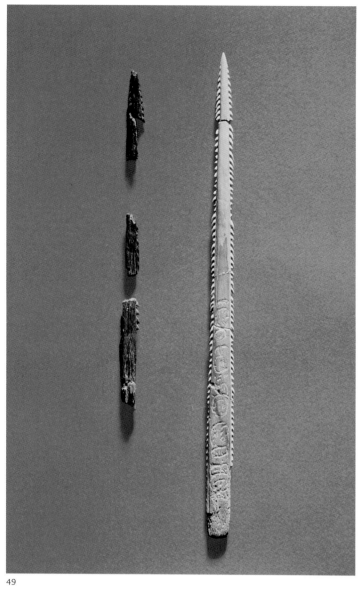

49

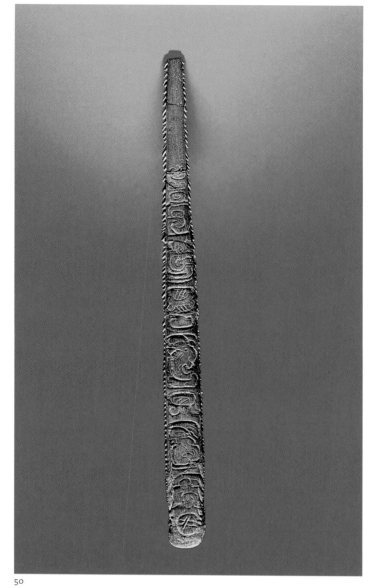

50

49

49

49, 50

49
Engraved stingray spines and
bone handles from royal burials
687–757
Piedras Negras, Guatemala
Catalogue 77

50
Engraved stingray spine
300–850
Xicalango, Mexico
Catalogue 78

Among the Classic Maya, a key role for any king was to let blood. Such sacrifice fulfilled covenants with gods and ancestors and released a spirit essence, *k'uh*, that coursed through regal veins. Bloodletting also served as part of the dynastic and priestly duties of other members of the royal family. Archaeological finds related to bloodletting are usually in the form of spines, such as the example from Xicalango, Campeche, Mexico (plate 50). Equipment for letting blood is seldom found in full, but these examples from Piedras Negras, Guatemala, include interchangeable instruments and handles for them in the shape of the Rain God, Chahk, and perhaps a supernatural bird (plate 49).

Many means were used to let blood. The Maya sliced skin, pierced tongues and other soft tissues of the mouth, and the men cut and peforated penises in what was presumably a play on seminal fluids. The resulting pain must have been part of the offering. Stingray spines were among the most common devices employed. Extracted from rays and then brought from the sea, spines were cleaned, polished, and, in rare cases, inscribed with the names of their owners. Relatively delicate, especially after vigorous use, they sometimes broke and needed replacement. The sets of spines and handles from Piedras Negras are extraordinary. They represent a complete assemblage of bloodletting equipment, including, in an example from Burial 13, the tomb of Itzamk'anahk or Ruler 4, alternates of jade; or, in the tomb of a prince, Burial 82, a blade of obsidian. This piece of sharp volcanic glass might have initiated cutting, to be extended by prodding and laceration with the spine. In tombs, the tight, parallel clustering of the implements suggests storage in now rotted wooden boxes. An exquisitely carved example from Tortuguero, Mexico, highlights the Kislak Collection at the Library of Congress in Washington, and a larger box, with text related to Piedras Negras, came from a cave just across the border, in Tabasco, Mexico. Insertion into the carved bones literally turned the spines into the "teeth" of the deity represented in the handle. Depictions of such assemblages at Yaxchilan, as on Lintel 14, show further embellishments of feathers and paper wrapped in knots around the handle. The blood-saturated paper could be unwrapped and thrown into sacred fires whose smoke would carry the acrid essence aloft for consumption by dei-

ties or ancestors. The presence of Chahk as the "piercer" points to service in rain-making as well as purely dynastic rites.

These spines and handles can be dated to just before the deaths of Ruler 4 (AD 757, Burial 13), and a prince, "Nighttime Turtle" (perhaps a few years earlier, Burial 82). The prince's spine is engraved with his name and a rare term for "spine," perhaps *kokan*, "fish spine." These were clearly treasured possessions of royalty, part of the equipment thought necessary for existence after death. – SDH

References: Anaya, Guenter, and Mathews 2002; W. R. Coe 1959, pp. 63–65; Daveletshin 2003; Escobedo 2004, p. 278; Fitzsimmons et al. 2003, figs. 10–12.

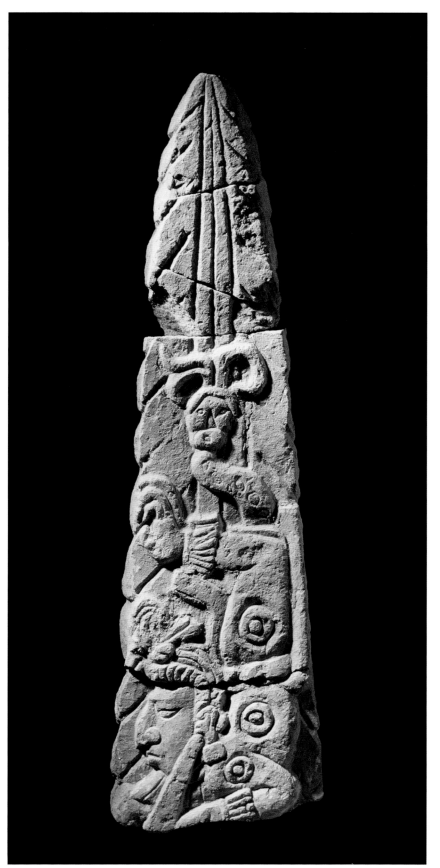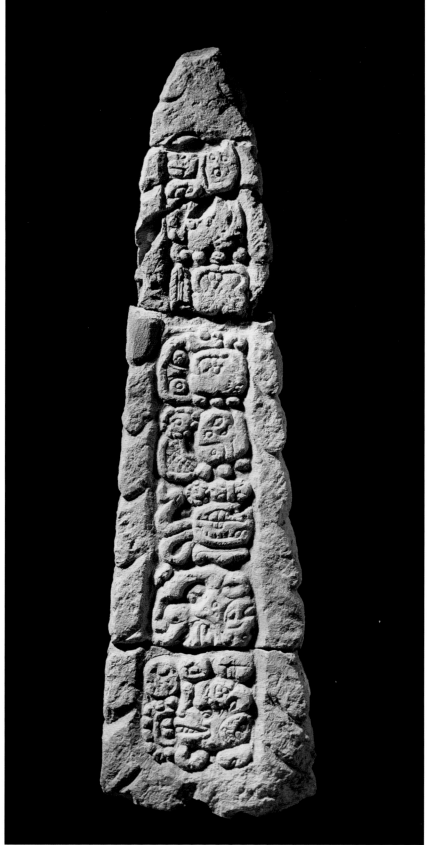

51

Stone stingray spine
763–810
Copan, Honduras
Catalogue 79

Monumental sculptures of stingray spines are rare, making this example, hewn from the soft volcanic tuff of Copan, an unusual find. It also represents part of a sacred mountain that belonged to a god of the final important king of the city. The stingray spine, an implement of sacred bloodletting, is also linked in this sculpture to the burning of incense.

The front of the spine displays an acrobatic god with feline features. His body is covered by emblems of jade and smoke issues from his tail. The hieroglyphic text on the reverse reveals that the spine is the "stingray hill" – an apt description of the sculpture – of a figure called *chajoom*, "person of incense" (figure 1). In an unusual turn, the owner of the spine, K'ahk' Patchan Bolaay (?), perhaps "Cat Who Shapes Fires in the Sky," is also said to be a holy lord of Copan, but of a special sort: he was a supernatural companion of the sixteenth ruler of the city, its final great builder and the patron of some of its most ambitious architectural projects. As David Stuart has shown, several other gods were enthroned on the same day as the king, hinting at the special meaning of these personal deities. Clearly, the acrobatic figure on the other side is a depiction of the god.

According to Barbara W. Fash, who helped assemble the fragments of the stone stingray spine, the sculpture almost certainly came from the lid of an incense burner. This is consistent with the title of the god. To judge from its style and location, the carving is late in Copan dynastic history, from the final half of the eighth century AD, when the last great king ruled the site. – SDH

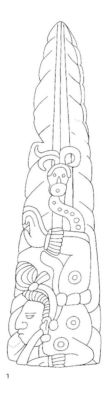 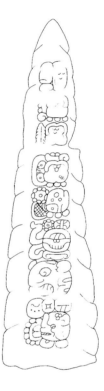

1

References: Barbara W. Fash, personal communication, 2009; David Stuart, personal communication, 1998; D. Stuart 1992, p. 178.

Figure 1. Acrobatic figure on the front and glyphic text on the reverse of plate 51. Drawings by Nick Carter.

52

Figures engaged in bloodletting
rituals on the backs of turtles
1300–1550
Santa Rita Corozal, Belize
Catalogue 80

These figurines represent an intensive Postclassic tradition of ritually significant modeled and painted figures at Santa Rita Corozal, a site in northern coastal Belize. The site has been of particular interest because of its sizable Postclassic- and Colonial-period occupations. Found in two structures, the two burial caches comprise several sets of figurines, including deer, dogs, monkeys, jaguars, crocodiles, sharks, coatimundi, unidentified animals, and human characters. They sometimes occur in groups of four, as well as one central, conch-blowing human. Four other human characters each stand on the back of a turtle (in an arrangement similar to plate 84) and practice penis perforation, a bloodletting ritual from the Preclassic period onward. The location of life-size and larger-than-life turtle sculptures in shrines at Postclassic sites such as Santa Rita Corozal and Mayapan suggest that turtle-shell sculptures – functioning metaphorically as the surface of the earth – were used as receptacles for blood from self-sacrifice. The penis-perforating cache figures are most likely supernatural characters – possibly *bakabs* or world-sustaining deities – engaged in an idealized portrayal of self-sacrifice in which deities themselves let blood onto the earth to maintain its fertility, all the while holding up the four corners of the sky. – CW

References: D. Z. Chase 1986; D. Z. Chase and A. F. Chase 1988; Taube 1988.

Figure 1. Dedicatory cache assemblage from Structure 213, Santa Rita Corozal, Belize.

Figure 2. Dedicatory cache assemblage from Structure 183, Santa Rita Corozal, Belize. Drawing from D. Z. Chase and A. F. Chase 1998, fig. 19, used with authors' permission.

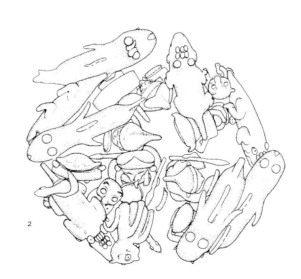

1

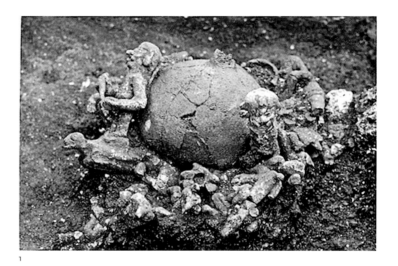

2

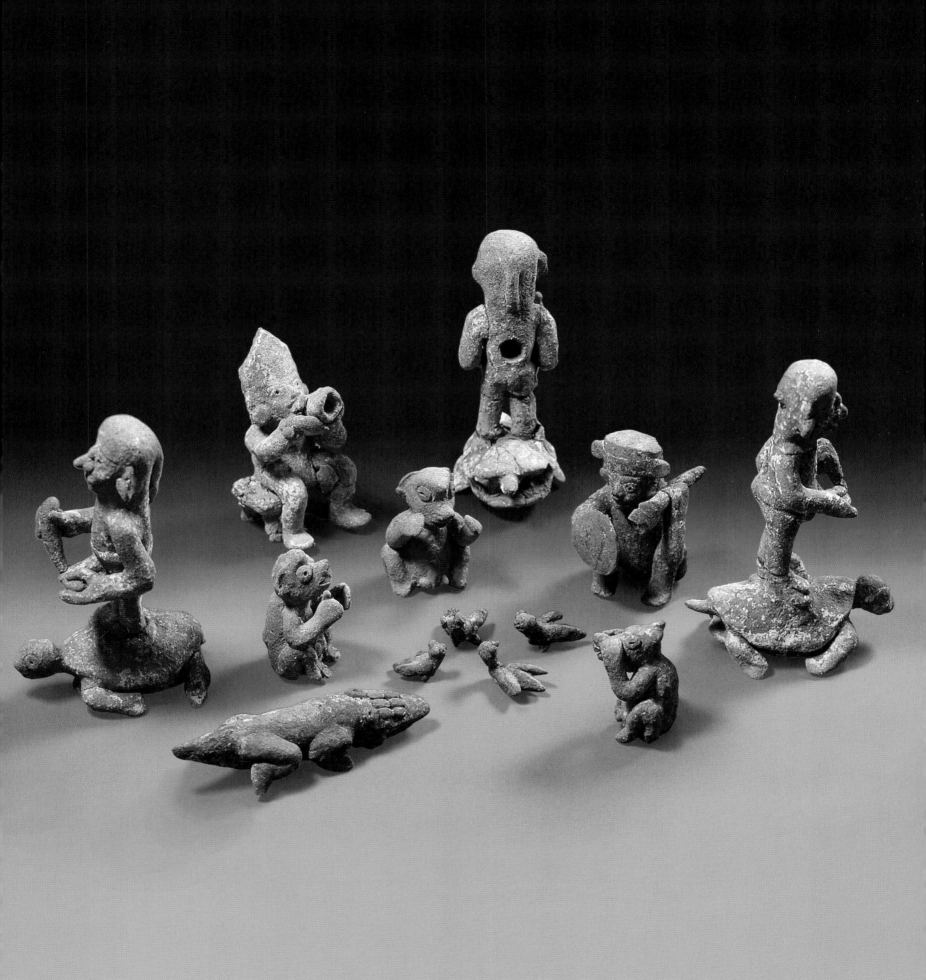

NAVIGATING THE MAYA WORLD

DANIEL FINAMORE

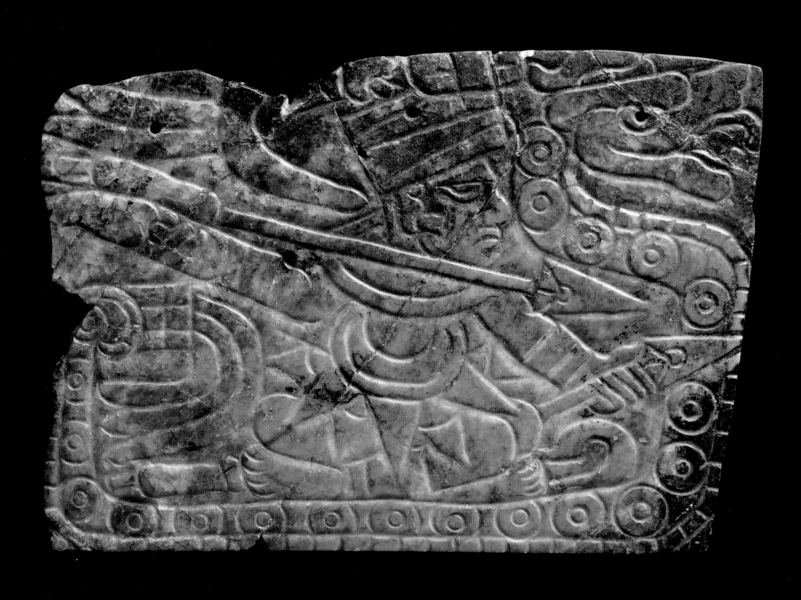

At the Late Preclassic site of Izapa, one of the earliest Maya cities with monumental art, a low stone stela bears a relief carving of a figure with arms held straight out in a gesture of triumph, his hands grasping scepters of authority (figure 1). He is shown from the waist up, his lower body obscured by a long low rectangle with overhanging flanges, a shape very similar to the canoes of later Maya art. Although its depiction is only schematic, the water on which the canoe floats is carefully defined. A top band with big fish flows rapidly while a lower band of large curling waves suggests darker turbulent depths. Whether the passenger is mortal or a deity is not clear, but his triumph is clearly linked to his voyage in the canoe. The stylized vessel offers a vision of Maya boats that remained consistent over several subsequent centuries and across hundreds of miles. The vision was codified into a specific set of characteristics that the Maya identified with their boats and related equipment – eliminating detail but maintaining what they believed were the fundamental points of interest.

The Maya paddled their boats through the cosmic world as well as along rivers and coasts and into open ocean. Maritime activity turned the sea into a source of luxury goods that the Maya perceived to be embodiments of its power. They harvested its natural resources, in particular shells of certain species, to serve as tribute to rulers. Works in coveted materials such as jade, gold, obsidian, and turquoise, as well as distinctive pottery from far-off workshops, were the direct product of canoe voyaging and reflected sacred power associated with the sea. These objects and images not only indicate how, where, and why the Maya traveled by water, but also allude to the function seafaring served in Maya culture that elevated the stature of the boat to one deserving of reverential artistic representation.

From the sea For Maya people living along the coasts, the sea was an abundant food source. Fish were netted from shore; manatee, turtles, and larger fish like sharks may have been hunted from boats with spears or

Previous spread. Agua Azul cascades, Chiapas, Mexico; and Plaque with the Warrior Sun God riding a plumed serpent (plate 65).

Figure 1. Izapa Stela 67, Late Preclassic period, Mexico. Drawing by Ayax Moreno, courtesy of the New World Archaeological Foundation.

THERE WAS NOT A SINGLE ROAD TO BE FOUND A

EVIDENCE TO SHOW THAT IT HAD BEEN TROD BY

ONLY BY CANOES ON ACCOUNT OF THOSE GREAT

IS COMPLETELY SURROUNDED BY LAGOONS AND

ALTHOUGH THE TRUTH OF IT IS NOT YET KNOWN

OTHER SEA, THUS MAKING THE LAND CALLED YU

harpoons. Though plentiful at coastal sites, marine species only occasionally appear any distance inland. Fish bones found at Tikal and Seibal, and a small number of fish and turtle bones from Mayapan, are more likely the result of an elite feast or a sacred ritual than a common meal.[2] Tikal especially has yielded a wide diversity of remains, including at least twenty-nine Atlantic and five Pacific saltwater species, mostly shellfish, that were transported from at least 160 miles (260 kilometers) away, along with freshwater species from nearby waterways and lakes.[3] Rather than garbage tossed out following a meal, these shells were sealed into tombs and cached offerings at the bases of stelae and building foundations. Most were unmodified, though some were ground, shaped, or pierced to be worn as body adornments.

From the Atlantic, the queen conch was carried far inland to be carved into trumpets, ink pots, and elaborate pendants with faces of ancestors peering downward from clouds onto the world of the living (plate 42). Lowland Maya artists also used Pacific Ocean species for ornately carved gorgets and pendants, which required transport over mountainous highlands. The *Spondylus* genus was accorded great significance, but other species were also utilized, including the Pacific pearl oyster (*Pinctada mazatlanica*).[4] Erosion, decay, and artistic modification prevent the identification of many of the shells used by the Maya. Several species of *Spondylus* are distinguished by long spines on the exterior surface that give the animal a distinctive appearance in life, but most shells from Maya sites have had these spines removed to expose rich interior colors that range from red to orange to yellow. These robust hues may have been the feature that for the Maya linked the shells to sacred creatures associated with origin myths, gods, and ancestors. The engraved shell in plate 99 is unusual because the interior is entirely orange although most *Spondylus calcifer* shells are white with an orange border; furthermore, shell color usually degrades with time, but this example remains vibrant to this day.

A large shell with engraving and inlay of jadeite and black coral on the interior (plate 44) is undoubtedly *Spondylus calcifer*.[5] This Pacific Ocean animal was the largest of the genus to be harvested and traded over the highlands for use as art objects. The species first came to the attention of Western science in the late 1820s when an English conchologist encountered residents of an island in the Bay of Panama diving for them to burn into lime.[6] Though well south and east of the Maya area, this activity could have represented a tradition dating back to Classic Maya times. Another large shell harvested from the Pacific was the limpet *Patella mexicana*, sometimes carved into "horse collars" such as the one found in the tomb of the dynastic founder of Classic-period Copan. At least one such shell was used in its entirety, engraved with an image of a Maya lord seated within a stylized cavity bordered by hieroglyphs (figure 2).[7]

The maritime trade in luxury goods that integrated distant regions of the Maya world also extended beyond its cultural and linguistic borders, probably by way of the canoes of both the Maya and their neighbors. An intriguing object discovered at Guácimo, on the slope of the Atlantic watershed of Costa Rica, illustrates this trade in two significant ways. A decorated slate disk that was intended for mounting against the back of a pyrite mirror bears an image presented in two registers with an empty central band between them (figure 3). The bilaterally symmetrical image permits the viewer to see one register in upright orientation at the bottom and a parallel register upside down on the top. The scene is the sea, with a band of water beneath which divers are swimming and reaching toward a multitude of *Spondylus* shells on the bottom.[8] The disk is either designed to be viewed from either orientation, or else it is a curiously sophisticated perspective of one looking downward through the surface of the water to swimmers and shells below. Discovered in a region far to the southeast of the Maya area, this mirror back shows artistic influence from the city of Teotihuacan. As such, it simultaneously offers a pictorial illustration showing the acquisition of valued objects for trade,

WHERE IN THE WHOLE COUNTRY NOR ANY [H]UMAN FEET, BECAUSE THE INDIANS TRAVEL [R]IVERS AND MARSHES.... THE PROVINCE [E]STUARIES ... AND IT HAS EVEN BEEN SAID, [T]HAT THEY PASS THROUGH THERE TO THE [YUCA]TÁN AN ISLAND. —HERNÁN CORTÉS[1]

in an artistic style that reflects the impact of the cross-cultural interaction that the trade fostered.

Trade from over the sea Ferdinand Columbus's narrative of the fourth voyage of his father, Christopher, in 1502, includes a detailed description of a large trading canoe at the island of Guanaja (off north Honduras) that "by good luck" arrived there during their visit. "As long as a galley and eight feet wide" and "all of one tree," the canoe was operated by twenty-five male paddlers, with additional women, children, and cargo housed under a shelter of palm leaves that the observers likened to the enclosed space of a Venetian gondola.[9] The canoe was carrying a striking cross-cultural mixture of luxury goods that were distinctive to Mesoamerican peoples across the length of the Maya realm and beyond in both directions. They included multicolored quilts and tunics embroidered with many designs (probably from Yucatan); long wooden swords with sharp flint or obsidian chips set into the edges as blades (central Mexico); copper axes and bells (Tabasco); as well as crucibles for smelting copper into other forms. They also carried cacao beans (likely from Honduras or Belize), which the Europeans noted were valued "at a great price, for … when any of these nuts fell, they all stooped to pick them up, as if an eye had fallen from their heads."[10] Whether the canoe and its passengers were Maya or from lands farther east, the contents of this single vessel illustrate the broad reach and integrated nature of maritime trade at a moment just prior to its obliteration with the arrival of Europeans.

It is striking that the canoe Columbus encountered was carrying none of the subsistence goods that undoubtedly formed the basis of

Figure 2. Incised limpet shell depicting a Maya lord, circa AD 700, on loan to the Houston Museum of Natural Science from Mr. John B. Taylor.

Figure 3. Incised slate disk depicting *Spondylus* divers, circa AD 500, Guacimo, Costa Rica. Adobe Illustrator rendering after Stone and Balser 1965, fig. 22.

the Late Postclassic–era Maya terrestrial economy. Salt, honey, maize, unworked cotton, other bulk products, and slaves may have been important economically, but the true foundation of maritime trade was largely in long-distance transport of raw materials and finished objects from regionally circumscribed sources.[11] High concentrations of imported goods found at the sites that ring the Yucatan peninsula – Jaina, Punta Canbalam, Isla Cerritos, Uaymil, Cozumel, Wild Cane Cay, and others – signal trade distribution nodes in the Maya coastal network.[12] These high-value objects were utilized for artistic display and ritual by a small elite stratum of Maya society. The social interaction fostered by their exchange led to an increasingly unified "Maya" identity and perspective on the world across large distances. In this way, art objects fashioned from materials obtained over and under the sea, sometimes from beyond the Maya sphere, became agents that helped define what was quintessentially Maya.

Objects that through their craftsmanship or inherent materials reveal a history of having traveled long distances also define the boundaries of Maya cultural identity. An elongated spoon found at Altun Ha is carved of manatee bone, a material utilized by residents of that city for other sculptural objects, but its form indicates it was not of Maya manufacture (plate 55). Identified by its excavator as a product of the Taino culture of the Greater Antilles, it reflects physical interaction between the mainland Maya area and a Caribbean island separated by a formidable stretch of sea. Caribbean people populated most of those islands via canoe, but avoided particularly treacherous passages with strong currents, such as the stretches that separate Jamaica from Cuba and Hispaniola.[13] Though the distance from Cancun to the western tip of Cuba is just over 130 miles (209 kilometers), this stretch of open water known as the Yucatan Channel is a pinch-point for Atlantic Ocean water flowing from the Caribbean Sea into the Gulf of Mexico. Its swift surface current flows consistently northward in all seasons. Wind is an equally influential factor in such a crossing.

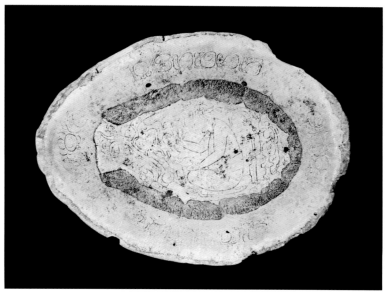

2

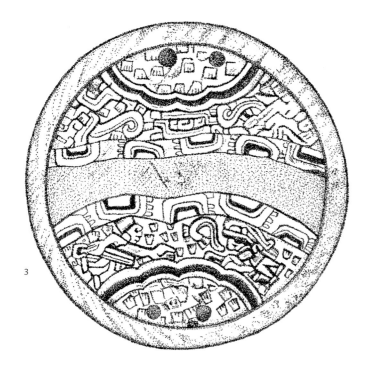

3

It would be far easier for a canoe to travel from Cuba to Yucatan than vice versa. The trade winds blow easterly in winter and somewhat southeasterly in summer, but rarely if ever from the west. Though lighter wind occurs in summer, it blows consistently with few calm days, suggesting that even if a Maya canoe could fight the current running north on its beam, the wind would blow it back onto shore.[14]

Conversely, Columbus's chronicles report Taino canoes that were larger than those of the Maya, propelled by seventy to eighty paddlers.[15] A canoe that, intentionally or not, caught the easterlies from Cuba may have marked a notable moment in Maya history that is recorded in the *Book of the Chilam Balam of Chumayel*, when unclothed strangers appeared on the Yucatan coast in 1359 "to eat men."[16] The Maya who placed the spoon in a grave at Altun Ha probably viewed it as a curiosity associated with dangerous anthropomorphic beings from the eastern sea who sporadically appeared on their shores.[17]

The canoe encountered by Columbus at Guanaja had made an ocean crossing of at least twenty miles (if island hopping), but even the eleven-and-a-half-mile passage from the mainland to Cozumel Island was considered a dangerous undertaking that had to be timed propitiously. When the conquistador Francisco de Montejo attempted to make the crossing with ten Spanish soldiers, he was warned that "they should not embark because the sea was angry." Nine soldiers drowned in the attempt; the tenth was killed shortly after his return, perhaps to accommodate the perceived wishes of the supernatural beings within the sea. Over one hundred years later, the Franciscan historian Lopez de Cogolludo reported that the Maya performed rituals before making this particular trip.[18] Such ocean passages may have been undertaken seasonally, with an attendant threat of retribution if one was mistimed. In 1566, Bishop Landa reported that "they held Cozumel and the well at Chichen Itza in the same venera-

tion as we have for pilgrimages to Jerusalem and Rome, and so they used to go to these places and offer presents."[19]

Conquistadors passing Cozumel Island in 1518 reported seeing shore-side bonfires atop shrines. Remnants of numerous such shrines have been found along the entire east coast of Yucatan at seemingly regularly spaced intervals. Many are in isolated coastal locations but may have been access points for direct veneration of the sea and its deities by fishermen or inland populations or, alternatively, landmarks to be viewed from offshore.[20]

The Maya made skillful observations of the natural world and their almanacs demonstrate that they were attuned to celestial patterns and events, but this expertise did not lead to developments in celestial navigation. Their extensive familiarity with the night sky no doubt informed the nocturnal mariner of cardinal directions, which may have been necessary for open-water crossings. It is tempting to envision the exploratory paddler driven to investigate unknown water courses by the desire for discovery of marvelous goods unavailable within the Maya region. But, most Maya voyages were in boats that hugged the coast. They had little reason to be far offshore at night, and traversed waters well known to their operators. Staying in sight of land obviated the need for sophisticated navigation techniques and created a subset of experienced mariners who specialized in certain stretches of water, in effect becoming regional pilots. Such a journey would conclude in a protected harbor that was either natural or enhanced by a man-made breakwater, such as at Isla Cerritos (Cobos, pages 164–65). Sites such as Cerros in the Late Preclassic period and Tulum in the Postclassic featured architecture designed to create either a commanding view of the sea or a view of the city from the water. Assuming the latter, since Tulum's towering El Castillo has no ocean-facing windows, researchers have found that light emitted from two upper air shafts could have directed paddlers through a break in the reef.[21] But, in any case, since canoes are designed to draw very little water, they would have coasted over most coral heads with ease.

Figure 4. San Jose Canyon on the Usumacinta River, Guatemala.

The coastal canoe network was matched inland by an equally important riverine one (figure 4). The letters of Hernán Cortés to Emperor Charles V, written between 1519 and 1526, are peppered with information about inland waterborne transportation. When trying to reconnoiter a passage across the Maya realm from Campeche to the Bay of Honduras, he was frustrated to find a lack of roads and paths because most Maya travel in that region took place in canoes.[22] Over centuries of riverine travel, certain stones along the shore of the Usumacinta River (figure 5), mostly clustered near major Maya centers, were repeatedly utilized for tying up boats; others were used for warping cargo-laden canoes upriver against the current, resulting in distinctive wear from ropes.[23] Coastal voyages and riverine travel were part of a single network. Boats carried obsidian, a volcanic glass, in huge quantities from southern Guatemala north along the Belize coast and entirely around the Yucatan peninsula, where it was brought to inland centers. Similarly, jade mined in the Motagua valley of eastern Guatemala was transported throughout the Maya world in such quantities that thousands of pieces were recovered from the cenote at Chichen Itza alone.[24]

The emerging prominence of northern cities during 950–1200 that followed the decline of the Classic centers of the southern lowlands was linked to an energizing of long-distance trade. Several varieties of ceramic produced in discrete regions became popular and widely dispersed items of trade through a network of sea, river, and land routes, but the most stylistically and technologically distinct was Tohil Plumbate (plate 57). Artists employed both special raw materials (a clay high in iron and alumina) and firing technology (a reducing atmosphere) to create lustrous gray surfaces that in some cases actually vitrified to form a true glaze — the only glazed ware ever made in Mesoamerica. These materials and techniques were combined with unusual incising and modeling to produce idiosyncratic vessels that were highly coveted and widely traded, but not copied by ceramicists in other areas.

Tohil Plumbate ceramics were produced only in a small region along the Pacific Coast near today's Mexico-Guatemala border, but they were disseminated widely through trade.[25] Examples have been found on many coastal and island sites, from Wild Cane Cay off southeastern Belize and farther east beyond the Maya regions into Central America, and west as far as Tula in Veracruz. Inland, significant quantities have been found at Chichen Itza, a city with direct links to coastal maritime trade via seaports, some linked by direct roadways (Cobos, page 164). The predominance of this ceramic at locales affiliated with maritime trade may be a result of more than mere transport. The lustrous Tohil Plumbate pottery may have been intended to emulate the attractive surfaces of copper and bronze trade items that became available to the Maya at almost the very same time.

The canoe trade that brought about a unified set of art styles and symbols across different regions within the Maya realm was also an agent for introducing and adopting cosmopolitan artistic trends from beyond. A pair of ear spools buried with a noble at Santa Rita Corozal, a waterside town that thrived up to European arrival, illustrates the breadth of the sea trade and its direct impact on Maya aesthetics (plate 58). Worked in gold from lower Central America, turquoise from the distant American Southwest, and obsidian from the southern highlands, they demonstrate how Maya artistic vision was empowered by this broad reach. The style of design also extends beyond borders, displaying attributes associated more with the Aztec than the Maya. But, rather than signifying invasion by new populations, this elegant regalia reflects the growth of a pan-Mesoamerican style and resulting changes in taste.[26]

On the sea: painted and incised canoes As the Maya viewed goods obtained from and over the sea as materializations of that sacred domain,

Figure 5. Stone bollard on the Usumacinta River, Guatemala.

5

so images of the boats in which they traveled were similarly imbued with overtones of the supernatural. Within the tomb of Jasaw Chan K'awiil I, who ruled Tikal from 682 to 734, archaeologists discovered fragments of approximately ninety narrow bones engraved with mythical scenes. Several of the minute but fluidly executed scenes present figures in canoes, illustrating the continuity of canoe imagery as central to Maya iconography of the spiritual world since the creation of the monument at Izapa.[27] Two scenes depict deities sitting in a boat or standing in the water nearby, catching fish with their bare hands. The significance of deities, including Chahk, employing boats to harvest resources from the sea, suggests that the Maya viewed not only the bounty of the sea but the very act of fishing as having a significant if metaphorical role in the interplay between the earthly and supernatural realms (Taube, pages 209–10).

Three other bones present a menagerie of animal deities riding along with the Maize God, who sits in the center of a boat (figure 6). In one scene, he holds the gunwale with one hand while the craft glides over an invisible sea. He is traveling through life, heading toward his moment of death. Two gods, sitting respectively atop the projecting bow and stern, paddle earnestly while the Maize God sits in the well of the boat wearing a woeful expression. The countenances of the other animal-god occupants at first look comedic, but closer examination reveals expressions of abject terror. On two other bones, the canoe plunges downward, breaking the unseen surface to continue its voyage in the watery Underworld. Viewed as a sequence, these images illustrate a journey that transitions from life to the afterlife. Since the central character is the Maize God, whose birth, death, and rebirth constitute the planting cycle that sustains humans, these bones may have comprised a priestly bundle of implements whose function included conjuring rain.

Figure 6. Carved bones from Burial 116, AD 734, Tikal, Guatemala. Drawings by Annemarie Seuffert.

The canoes conform somewhat to the shapes of the bones they are engraved upon. Wrapping to follow the curves, some sterns (along with the water signs beneath) turn steeply upward, but they also convey three-dimensional metaphorical hulls no doubt derived directly from the designs of actual Maya boats. The engravings also employ artistic conventions that distill the presentation of canoes into essentialized elements: the overhanging bow and stern, a double line connecting them to indicate the gunwale, and roughly vertically curved double lines that provide a sense of curvature to the hull and indicate that the boat is made of wood.

The canoe as a conveyance symbolizing passage along the life cycle is codified in a dramatic cylindrical vessel portraying the journey of the Maize God through the watery Underworld (plate 60). He sits atop a canoe, supported at the height of the gunwales as if the boat has no well at all, while the paddling gods at the bow and stern straddle the canoe as though it were a log. In addition to being narrow, the canoe appears to be of extremely shallow draft for these oversized deities. Nonetheless, the paddlers seemingly handle the slight craft easily, suggesting calm waters and their mastery of the passage. The boat also displays platform ends that curl downward at the edges to partially encircle water plants below. Unlike the Tikal canoes, the bottom of this boat is fully delineated with no indication of a water surface: vessel and passengers seem suspended within perpetual darkness, like a maize kernel germinating within a moist subterranean milieu. The white vessel imparts a mystical glow against the inky pre-dawn background.

Another vessel with a related scene twice presents a canoe at once more perfunctorily painted yet more symbolically potent (plate 61). Again, the Maize God stands erect in a canoe on his Underworld journey from death toward rebirth; he strikes the same pose on each side of the pot. In this Early Classic–period example (circa AD 600), as with the Izapa Stela 67 (figure 1), there is little concern for depicting a canoe accurately. The narrative emphasizes the god's transcendence, rather than the act of pas-

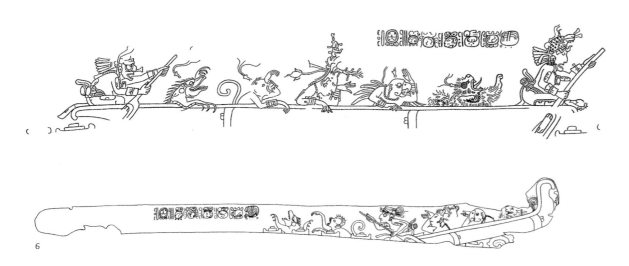

6

sage. His canoe glides along effortlessly with no means of propulsion. On one side, the vessel bears black spots reminiscent of the jaguar, whose pelt was a luxury item of Maya nobility. The pattern here may symbolize an appropriately regal conveyance for this powerful deity. It does not indicate the tradition of construction for the boat, such as in high latitudes where canoes have been created from animal skins stretched over wood or bone frameworks. Without a more detailed depiction of pelage, it may well be that the spots refer more literally to the wood from which the canoe was built.

The overhanging bow and stern are the singular reductive artistic elements that convey to the viewer that the Maize God stands in a canoe, and is thus engaged in a passage from one phase of life to another. In another vessel painted with a related scene of the Maize God's rebirth, a group of musicians is transported in similar short and deep canoes (figure 7).[28] Though greatly outsized for these short vessels, they appear at ease, some playing their music with one foot in the well and the other resting upon the gunwale. With their highly stylized down-flaring bow and stern projections, these canoes reflect little interest in realism, but serve as visual metaphors celebrating the cycles of life and the water that fosters new generations of growth.

Canoes bearing similar spots and one with wavy lines appear in the Dresden Codex, where the Rain God, Chahk, is portrayed several times, in most instances paddling alone (figure 8). This rare surviving painted book, largely an almanac for astronomical prediction, astrology, and divination, was most likely produced in northeastern Yucatan in the early 1200s, but it is undoubtedly a distillation of earlier Maya manuscripts. Though these lines could be interpreted to suggest elements of a bark canoe, it is possible that the patterns on the hulls became a form of visual shorthand developed over generations of copying, and refer to the material of the

boat, which was probably wood.[29] The spots could indicate hollowed-out areas inset with precious materials such as shell or jade.

There is a noticeable visual similarity between these more schematically presented canoes and the bowls that are frequently shown holding the blood-soaked paper that was burned to conjure the vision serpent following ritual bloodletting.[30] This similarity is the result at least in part of the broadside angle of view for both types of objects, obscuring the elongated aspect of the canoe and rendering it similar in profile to a radially symmetrical bowl (figure 9). Just as open bowls of spotted paper became a visual symbol of the rite of ancestor veneration through contact with Underworld spirits, so the same profile in a different context was viewed as a diagrammatic representation of a canoe journey through that Underworld. If these two contexts yielded a single shape that represented a vehicle for spiritual transcendence more generally, then its appearance in Izapa Stela 67 (figure 1) indicates that it became a tenet of Maya artistic expression of cosmology at a very early date. The direct relationship between canoes and bloodletting is further elucidated by a glyphic inscription on an enormous stingray spine from the site of Comalcalco near the Gulf coast, which refers to "the carving of his white canoe" (*u-sak jukuub*).[31]

In contrast to works produced by highly skilled artists, a piece of graffito inscribed on a brick from the same site offers insight into the role of boats in more private aspects of Maya beliefs. This major architectural complex was constructed of millions of thin fired clay bricks that were stacked, mortared, and sealed over with stucco. Although the individual bricks were not visible on the completed buildings, decorations modeled and incised into many of them record a broad spectrum of images. Some, such as a cosmic crocodile and mythic fish, relate to metaphysical themes that probably carried sacred relationships within the context of the construction and use of a building.

One of the more casually drawn images depicts a narrow canoe with sides that dip low to the waterline but a pronounced curvature that

Figure 7. Rollout photograph of a vase depicting the death and resurrection of the Maize God, 600–700, El Peten, Guatemala. Museum of Fine Arts, Boston.

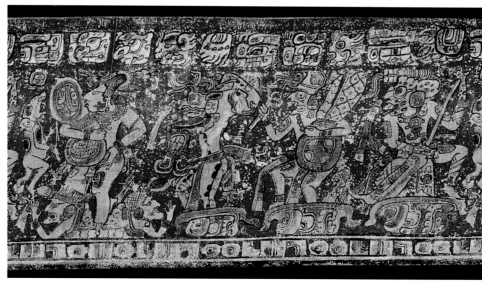

7

suggests the ability to enter the more rapidly moving waters of the main river channels in this vast low marshland (plate 63). A standing figure in the extreme bow holds a paddle, while a figure at the stern, perhaps also standing, has just completed a stroke. Instead of a central passenger, three protrusions formed from a single line suggest baskets of cargo. It is possible that like the painted pots, this scene illustrates a significant moment in a mythological story, but if so, the paddlers – not the passenger – are the central protagonists. It is also possible that the image simply addresses more local concerns of the brick-maker/artist. Whatever the subject, the brick lies at the opposite end of the artistic spectrum, but is no less effective than the sophisticated paintings created in artistic ateliers specializing in ceremonial ceramics.

Voyaging in miniature: model canoes Three-dimensional representations of canoes exist in a variety of media. A chipped flint sculpture, known as an eccentric, presents a silhouette of three figures seated in a hollow well of what may be a canoe (figure 10). Portrayed from the chest up, one is seated facing the other two and presumably opposite the direction of movement. Large deity heads or masks protrude above the bow and stern, creating the appearance of a double-ended boat with figureheads at each end, while a row of many small, centipedelike feet animates the bottom of the hull. Though chipped from stone, the scene is presented in outline with no attempt to portray a boat as a man-made means of transport, but rather to give attributes of a chimerical creature with animal characteristics on all sides except the top where the figures sit. Another flint eccentric, almost

Figure 8. Canoes and paddles from pages 29, 36, 40, 43, and 65 of the Dresden Codex, 1250–1350, Sächsische Landesbibliothek, Dresden, Germany. Drawings by Carlos A. Villacorta in C. Villacorta and J. Villacorta C. 1992.

Figure 9. Yaxchilan Lintel 15, AD 755, Mexico. Drawing by Ian Graham, reproduced courtesy of the Corpus of Maya Hieroglyphic Inscriptions, Peabody Museum of Archaeolorgy and Ethnology, © President and Fellows of Harvard College.

certainly knapped by the same artist, depicts similar seated figures but with one end of the boat replaced by the head of a crocodile that leads the party in an arcing dive reminiscent of the sinking canoe on the Tikal bone (figure 11).[32] Though carefully detailed in areas such as the faces and headdresses, these eccentrics display animal attributes sufficient to obliterate any features of nautical architecture that might identify them as canoes.

Numerous small rudimentary canoe models found at Altun Ha and nearby Moho Cay in Belize carved from what is thought to be manatee bone were recovered from trash middens.[33] One example from Altun Ha possesses attributes that suggest a direct connection to the mythological boats painted on ceramics. Two perforations through the sides near one end indicate that it was once worn as a pendant, perhaps by a priest, for whom a vertically oriented boat would indicate a plunge from the world of the living into that of the dead. Two similar boats carved from jade are associated with Olmec artists of the Middle Formative period (900–300 BC). One is inscribed with jaguar faces (figure 12) while the other is carved into the shape of a hand, indicating both the deep antiquity and complexity of Mesoamerican use of the canoe as metaphor for otherworldly passage.[34] Both boats are perforated for suspension with enough holes to allow a vertical or horizontal orientation.

A hand-molded clay canoe model reputedly excavated on the island of Jaina may have formed part of the grave goods deposited with a deceased person (plate 64). Of surprisingly deep draft, this canoe is the largest and most elaborate of several discovered. A second clay boat without any known provenance, now in the Belize national collection (figure 13), bears certain similarities but subtle differences in design as well. It is not clear whether these differences reflect varied purposes in the boats they are modeled after or as containers shaped as boats. Both examples possess more pronounced bow and stern platforms than any represented in paint or bone, perhaps a result of their function as vessel handles. The Jaina boat in particular displays extraordinarily straight and high sides

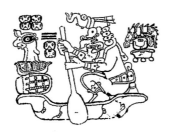

8

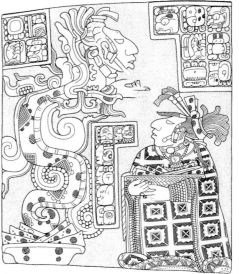

9

that connect to a flat bottom with a hard chine (a sharp corner where the side meets the boat bottom), quite unlike the rounded hulls of modern canoes and those illustrated on the Tikal bones. The nearly vertical bow, sizable width, and deep draft suggest not so much an attempt at extreme accuracy as an evocation of a metaphorical boat for passage into the next world; doubling as an open container, it may have held additional needs for that voyage. Hand-modeled appliqués affixed to each side beneath the gunwale are the strongest indication that Maya boats bore decoration. The orientation of the creature on the starboard side allows identification of the bow and stern. In contrast, the Belize clay boat has a slightly shallower draft, narrower beam, and softer chine between the straight sides and bottom. The result is a more realistic design, though it too may have been crafted as a boat-shaped container rather than strictly a nonfunctional sculptural representation of a boat. On the island of Roatan, two other clay vessels that may be rudimentary canoes were excavated from a cache, indicating a ceremonial aspect to their use.[35] Though separated by many years and miles, these canoe vessels are remarkably similar in form to "gravy boat" ceramics found at pre-Maya sites on both the Gulf of Mexico and Pacific coasts. These vessels and an oar-shaped spatula have been considered as possible equipment for frothing cacao, a beverage today frequently fermented in long narrow troughs and sometimes even in actual canoes.[36]

Making and using canoes In Yukatek Maya, the word for boat, *chem*, is related to the word for a trough used in preparing the dough masa, *chem*

che'. The colonial Tzotzil word *jom* was used for something hollowed out in form and probably conveys the same notion of "dugout." The word is etymologically linked to the calabash gourd, which is also hollow and buoyant.[37] Maya dugouts were among the simplest type of watercraft. Without frames or planks to join, skins or bark to sew, fabricating these canoes required only large trees, fire, and durable adzes for felling, hollowing, and shaping.[38] Unlike the raft that floats by buoyancy or the planked boat that stays afloat through water displacement and built-up sides, the canoes represented by Maya artists would fill and swamp easily in rough conditions. If one assumes that centuries of boat-building technology reflect appropriate adaptation to the needs of the makers, then the boats were built primarily for protected waters such as rivers, lakes, and lagoons, and in ocean conditions that offered protection, such as on coast-hugging passages, inside reefs, and along windward shores where waves would not wash over the low sides.

The most architecturally distinctive design features of Maya canoes are the overhanging square platforms at bow and stern. While these could be nonfunctional stylistic elements, the general lack of adornment suggests that they served some as yet unidentified purpose. Curiously, figures are never shown poling canoes while standing on the platforms, a technique for propelling pitpans employed historically by non-Maya people in nineteenth-century Belize (figure 14). Some images show figures sitting on them, perhaps to allow a less obscured representation of those on board who, in reality, would be seated within the well, lower to the waterline, for more secure balance of the craft. The projections are strongly reminiscent of the square bow and stern platforms on shallow-draft Thai market boats, employed in protected waters as floating stores with both the open interiors and platforms arrayed with goods for sale. In crowded markets with much competition for space, boats are arranged side by side with only one platform extending to land. Customers can see the contents but must request it from the merchant (figure 15).

Figure 10. Eccentric flint of three figures in a canoe, 550–800, Guatemala. Museum of Fine Arts, Houston, Museum purchase with funds provided by the Alice Pratt Brown Museum Fund.

Figure 11. Eccentric flint with figures seated in a canoe with one end in the form of a crocodile head, 600–900, Guatemala. Dallas Museum of Art.

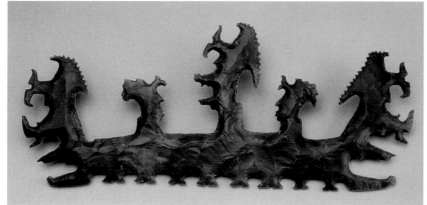

10

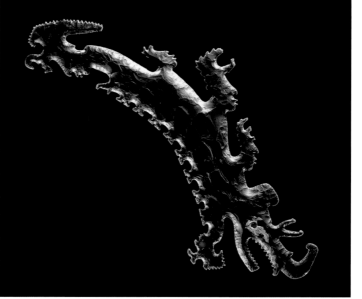

11

The first reliable historical account of a Maya boat propelled by wind power was reported off Cozumel in 1518. Gerónimo de Aguilar, a Spanish friar who had drifted to Yucatan following a shipwreck several years earlier, was among the passengers. It is quite likely that Aguilar, perhaps the first European to live among the Maya, introduced them to the concept of sail.[39] Even if pre-contact Maya canoes did occasionally hoist sail, no pictorial reference is known. Since most Maya imagery of boats depicts mythic voyages in mystical milieus, it is possible that setting a sail was simply unnecessary when the destination was the watery Underworld.

Paddles, on the other hand, appear to bear great visual significance as the primary means of conveyance. In several scenes, two paddlers propel the canoe from the same side, emphasizing for the viewer the act of paddling above any nautical realism (plate 60 and figure 6). Paddle shapes are more varied than hulls, ranging from symmetrical and elongated flat blades similar to modern manufactured canoe paddles (plate 60), to asymmetrical forms with a flat blade on only one side of the shaft, or loom (figure 6), to unusual round-bladed examples (plate 68). Long-loom narrow paddles are generally considered optimal for deep water, while the round-bladed variety, associated in modern times with Tarascan people from the region of Michoacán, are particularly well suited to shallow paddling and avoiding entanglements in weedy lakes. Maya artists may have intended specific designs to act as implicit cultural signifiers, or to reflect adaptations to regional environment conditions. But, since these examples alone span several hundred years and miles between them, some stylistic diversity is not surprising.[40] The medium in which they are presented may also affect their form. The Sun God in his little canoe atop an Early Classic

vessel (plate 66) propels himself with a relatively fat-loomed paddle that flares only modestly toward the blade end. If it was not for his posture, boat, and surrounding water imagery, the paddle could be misconstrued for a hafted stone adze, though this inelegant form in an otherwise gracefully sculpted figure is likely due to limitations of modeling and firing the clay.

Canoe paddles also appear divorced from surrounding maritime settings, referencing curious relationships with other environmental or supernatural settings. The Chochola-style vessel in plate 67 presents an unusually formal portrait of a deity in a jaguar headdress holding an asymmetrical paddle that sprouts from a mass of water-lily plants. These plants frame the scene in a tangled writhing mass that may include watery mist or even smoke. The deity emerges from this primordial morass brandishing his paddle as a highly significant gesture.

In Yukatek Maya, the word for paddle, *babche'*, is much the same as a term for a similarly shaped stick used in blending lime plaster and mortar, perhaps conflating all sticks with broad ends. Images of people holding tools strikingly similar to paddles appear in several Aztec codices, most of which date to just after the conquest.[41] These are employed primarily as digging sticks, though in the Vaticanus B Codex one is used to strike a subordinate on the head or push him into a hole, while in the Borgia Codex one stick cuts open a plant while another stick itself bursts open, releasing what may be seeds (figures 16, 17). The parallel between paddles for plowing the sea with sticks for plowing the earth is undoubtedly both functional and symbolic, with perhaps both images relating to reaping the bounty of the earth via attentiveness to seasonal cycles and their attendant gods, while alluding emblematically to passage through phases of a cycle.

Boats and the imagery of Maya history In 1974, a group of Maya stone objects including jade was discovered by skin divers in shallow water just off Cozumel Island, possibly the remains of a trade canoe cargo.[42] Surveys for submerged canoes have been undertaken in harbors, reef

Figure 12. Olmec jade pectoral in the shape of a canoe, Middle Formative period, Cerro de las Mesas, Veracruz. Museo Nacional de Antropologia, Mexico City. Drawing by Daniel Finamore after Benson and Fuente 1996, pl. 103.

Figure 13. Clay boat model, origin unknown. National Institute of Culture and History, Belize. Drawing by Daniel Finamore.

openings, and inland waterways, but beyond the discovery of a single paddle (McKillop, pages 39–40), artistic representations remain the primary preserved material legacy of this nautical tradition. Through their monumental carvings that combine images with text, the Maya recorded their history with reverence equal to that for their cosmology. But the symbolism of their watercraft was so strongly associated with their creation myth and views of the afterlife that, with few exceptions, maritime exploits took a back seat to mythic events.

Among the multitude of offerings cast into the cenote at Chichen Itza in veneration of Underworld deities is a gold disk with a repoussé depiction of a canoe bearing warriors in a battle at sea (plate 68).[43] Unlike the serene Underworld passage scenes, the naval action is frenetic, involving aggressors, defenders, and two vessel types, clearly presented to offer compositional depth perspective; the horizon line on the seas is a rarity in Maya art. A dragon deity flies fiercely across the sky, but in a subsidiary or supporting role to the human protagonists. The canoe displays the typical low freeboard and flat sheer, though the pictorial space suggests the setting is open sea. The defenders are either swimming or clinging to rafts; one who twists around to observe his attacker displays a gorget, perhaps a *Spondylus* shell, against his chest.

Figure 14. *Mode of Travelling of the Woodcutters in the British Settlement of Honduras.* Engraving showing the distinctive overhanging ends of a pitpan, from the *Honduras Almanack*, 1828 (detail). Attributed to William B. Annin and George G. Smith, Boston, after Andrew Bayntun, 1828.

Figure 15. View of Thailand market boats.

Figure 16. Use of a paddle-shaped digging stick to strike a subordinate figure on page 58 of the Codex Vaticanus B (3773), circa AD 1500, region of Cholula, Puebla, Mexico. Vatican Library, Vatican City.

Figure 17. The Aztec Rain Deity, Tlaloc, cultivating corn with a paddle-shaped digging stick on page 26 of the Borgia Codex, circa AD 1500, Puebla, Mexico. Vatican Library, Vatican City.

At the same site, the Temple of the Warriors was once decorated with a complex visual narrative of three now fragmentary murals. The final scene is of a coastal village with numerous canoes paralleling the shore. As in the gold disk, the view is near bird's-eye with the emphasis on the canoes and water in the foreground; the land action farther up the picture plane recedes in the distance. The canoes possess elevated bows and sterns and standing figures are pushing them along rather than paddling. The elevated elements suggest more sturdy, ocean-going vessels than the other images, with the possible exception of the Comalcalco brick (plate 63), but since the general shape is the same, it is possible that the upturned prows are an artistic flourish to add volume and visual emphasis to boats that would otherwise appear flat in the foreground amidst the spatial depth of the setting.

The gold disk and the mural are part of a small category of historical imagery in which the sea is the domain of living humans. The mural possesses no supernatural references beyond the carefully rendered sea creatures in the foreground water. Both on sea and land, light-skinned figures appear subservient to dark-skinned figures bearing arms. There are no clear indicators to location or even region within the set of murals, though the murals were likely commissioned by those affiliated with the dark-skinned figures.

The distinctive mural styles, building forms, sculptural images, and political and religious symbolism of Postclassic-period northern Yucatan are traditionally attributed to an era of military domination by Toltec-influenced Maya maritime traders-cum-conquerors from farther west.[44] But, alternative to a scenario involving two belligerent peoples, the adoption of the more Mexican-inspired arts and motifs likely reflects an expanding internationalization of Mesoamerican culture in the centuries leading up to European contact. Depending on the symbolic intent of their work, northern Yucatan artists consciously manipulated two iconographic systems simultaneously. To express a political rather than an ethnic affiliation, the Maya of Chichen Itza deliberately adopted the artistic motifs

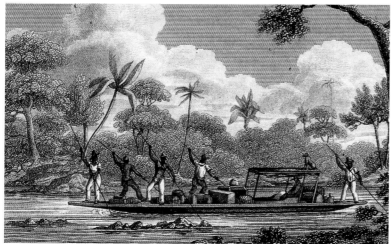

14

15

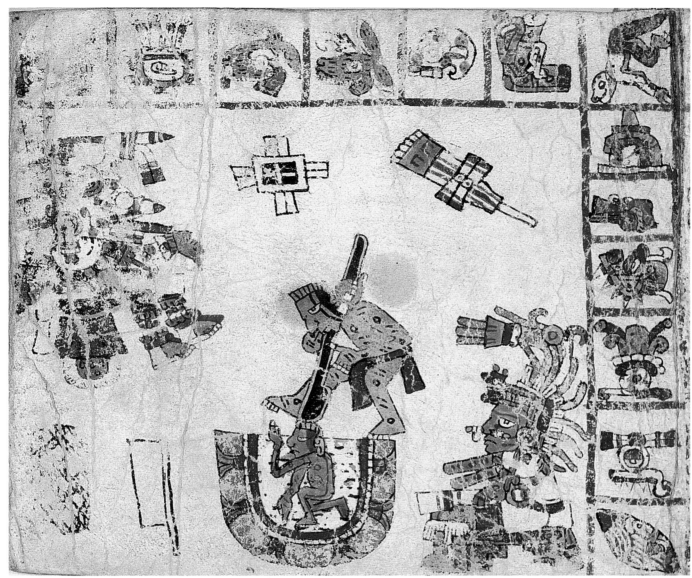

16

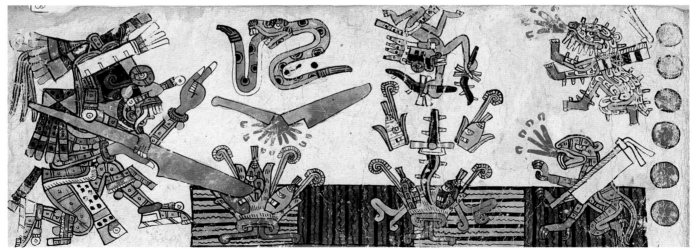

17

and style of a foreign state, which they perceived to be the iconography of power.[45]

The rafts depicted on the gold disk, supported by gourds or similar flotation elements, constitute the only known images of a Maya watercraft other than the canoe. They may have been common at the time the disk was produced, but without the capability of transporting trade cargo or deities through the Underworld, they did not inspire image-making. With no cosmological associations, it was only their role in a momentous historical event that inspired their representation. As the primary vehicle of seaborne trade, the canoe was imbued with the sacred aura of the desirable materials it carried from the sea and up the rivers. The power of its image was compounded through its additional associations with related waters: those that fell as seasonal rains to sustain the Maya.

1
Cortés 1971, pp. 346, 367.

2
At coastal Tulum, large shark and catfish bones were found associated with a burial. See Lothrop 1924, p. 97. Surprisingly, only modest amounts of turtle bones were found at coastal sites like Cerros, Cancun, Cozumel and Tancah-Tulum, despite what must have been ready availability. At the time of Spanish contact, tunny, saw-fish, skates, and smaller species were sun-dried and salted for transport to inland markets, but there is little evidence of extensive earlier trade. See Tozzer 1941, p. 190; and Pollock et al. 1962, pp. 378–79.

3
Moholy-Nagy 1963, pp. 65–83.

4
Fine Pre-Columbian Art Including a Collector's Vision, Christies Sale 1775 (November 21, 2006), lot 179.

5
Species identification of shell pendants was undertaken by Gary Rosenberg, PhD, Pilsbry Chair of Malacology, Academy of Natural Sciences, personal communication, February 25, 2009.

6
Carpenter 1857, p. 153.

7
Fields and Reents-Budet 2005, p. 246. Limpets of this species reach eight inches (twenty centimeters) in length.

8
Stone and Balser 1965, pp. 310–29; I am grateful to Karl A. Taube for identifying the images as shells.

9
Morison 1963, pp. 326–27.

10
Ibid., p. 327.

11
McAnany 1989, pp. 347–72.

12
Dahlin et al. 1998, pp. 1–15; A. P. Andrews 2008, pp. 15–40.

13
Roberts and Shackleton 1983, p. 17.

14
Gyory, Mariano, and Ryan 2002.

15
Off Jamaica on his second voyage, Columbus measured the largest dugout canoe he was to see in the Americas, at ninety-six feet long and eight feet wide. He compared it to a European barge of eighteen seats, narrower but faster.

16
Roys 1967, p. 95.

17
Recently, axes made of jadeite sourced to the Motagua valley of Guatemala have been found on the island of Antigua, but these, like the Mesoamerican ballcourts in Puerto Rico and the Dominican Republic, could reflect the gradual passage of objects and ideas along the north coast of South America and upward through the Windward Islands. See Petit 2006.

18
Relación de Valladolid, quoted in Tozzer 1941, p. 59.

19
Tozzer 1941, p. 109. Cozumel Island was the destination for pilgrimages to the shrine of Ix Chel, goddess of childbirth and associated with the moon.

20
A. Andrews 1990, pp. 162–63.

21
Creamer 1989, pp. 4–6.

22
Landa noted a waterway heading in from the coast that was so "full of little islands that the Indians place signs on the trees, in order to know which way to go, in coming and going by water from Tabasco to Yucatan." Tozzer 1941, p. 5.

23
Canter and Pentecost 2008, pp. 5–14.

24
Although it is possible that not all Mesoamerican jade came from the one known source, at least the bulk of it must have, fostering a massive export business both down the coast of Central America and into the Maya heartland. See Taube et al. 2004, pp. 203–20.

25
Neff 1989A, p. 175; Neff 2001.

26
Also found at the site was a spouted blackware vessel thought to be from Ecuador, but no doubt a product of a trade in many stages and not direct contact between the two areas. D. Z. Chase and A. F. Chase 1986B.

27
Coggins 1975, pp. 173–85; Hammond 1981, pp. 173–85; Schele and M. E. Miller 1986, p. 270, fig. VII.1.

28
Reents-Budet 1994, p. 208; Zender 2005, p. 8.

29
Thompson 1949, p. 70.

30
Shatto 1998, p. 217.

31
Comalcalco spine E11, Urn 26; Zender 2004, p. 256.

32
Berjonneau, Deletaille, and Sonnery 1985, pl. 384; Schele and M. E. Miller 1986, p. 114.

33
Pendergast 1979, p. 140; McKillop 1985, p. 343.

34
Benson and de la Fuente 1996, pp. 257–58.

35
Strong 1935, pl. 8.2e.

36
Powis 2007. The volume editors observed the use of a canoe for this purpose on a *finca* outside of Comalcalco, Tabasco, in 2007.

37
A European boat was a *kastelan chem*. Laughlin 1988, p. 213; Kaufman 2003, p. 992.

38
In Honduras, Squier noted that the best canoes were hollowed from trunks of cedar, which is relatively light and resistant to insects. Ceiba was employed for the most enormous canoes: "I have seen boats, hollowed from a single trunk, which would measure seven feet 'in the clear' between the sides." Squier 1855, p. 182.

39
Tozzer 1941, p. 234; Thompson 1949, p. 71; Edwards 1965, pp. 351–58; Epstein 1990, pp. 187–92.

40
Thompson 1949, p. 71; Romero R. 1998, pp. 6–15.

41
Including the Borgia, Osuna, Florentine, and Vatican codices.

42
Farris and A. G. Miller 1977, pp. 141–51, n. 7.

43
Lothrop 1952, pp. 50–52.

44
Thompson 1970A.

45
Kristan-Graham and Kowalski 2007, pp. 13–84; Taube 1994, pp. 212–46.

THE DARK LORD OF MAYA TRADE

SIMON MARTIN

Elemental tales of mythology are invariably equipped with both heroes and villains – most often exemplars of purity and goodness on the one hand and corruption and immorality on the other. In their conflict lies not only much of the dynamism of supernatural narratives but much of their purpose and meaning. For the ancient Maya, beneficence was encapsulated in the youthful Maize God. Representing the bounty of the fecund earth and its resulting harvest, his story is an elaborate metaphor of the agricultural cycle. A pivotal episode concerns his descent into the Underworld: a death and burial that correspond to the planting of the corn kernel in the soil. The Maize God faces many dangers before germination and sprouting mark his resurrection.

The most powerful of the Maize God's adversaries is the paramount lord of the Underworld. "God L" – his original name remains undeciphered – is an old man fused with feline features: jaguar ears and sometimes claws as well. His skin is either black or marked with the glyphic sign for "darkness." He wears a broad feather-trimmed hat with the head or whole body of an owl in its center, together with a cape of fancy woven textile or jaguar skin. He is often depicted smoking a cigar and carrying a walking staff, sometimes with a merchant's bundle on his back. In one mural image at Cacaxtla in central Mexico, his goods – including exotic feathers and a turtle shell – are strapped to a large backpack (figure 1). In the

Maya area, his portrait appears painted in books and on cylindrical vessels or carved into panels and columns. The densest concentration of such sculptures is in the northern lowlands of Campeche and Yucatan – the areas most closely associated with maritime trade.

This dark lord is particularly linked to cacao, the quintessential item of wealth for the Maya.[1] Many scenes of tribute payment include sacks of cacao beans, and in later times the beans were used as a rudimentary currency. Ground-up and mixed with water, corn, and spices, cacao formed the basis of the stimulant-rich chocolate beverage that played a key role in elite life. Thousands of finely painted cylinder vessels produced to hold this drink constitute an extraordinary artistic legacy and attest to the powerful cultural role chocolate played in noble identity and community. On one example, God L is shown in his palace attended by beautiful young women who mix and pour chocolate to produce the frothy head favored by the Maya (figure 2).

No source fully explains the origin of God L's connection to cacao, but fragments of his great myth cycle offer important leads to the seasonal story. While "dead" in the Underworld, the Maize God takes the form of a cacao tree – shown with the distinctive pods growing from his body or else with his head in the tree like a fruit.[2] God L is shown together with this magical arbor and, fulfilling the idiom "money grows on trees," this could well be the source both of his wealth and mercantile proclivities. But God L's ascendency ends with the arrival of the summer rains, as the dormant seed returns to life. Restored

to anthropomorphic form, the Maize God takes his revenge on God L, stripping him of his clothes and emblems of authority and delivering a healthy kick into the bargain.

Ancient sources recount further defeats and humiliations for this now hapless figure. In an episode with comedic overtones, God L has become a subject of the Sun God. Evidently on his way to pay tribute at the solar deity's mountaintop home, he is robbed by the trickster rabbit, the companion or child of the Moon Goddess, and left with nothing but rueful complaints. A more cataclysmic fate still awaited him. In the three ancient Maya books now in Europe – the Dresden, Madrid, and Paris codices – God L appears as the victim of a world-destroying flood: eclipses spew rain and storm gods empty water-jars to strike him down from the sky. One scene shows the rain deity Chahk in a canoe having retrieved the dark lord's hat and merchant pack from the deluge (figure 3).

In highland Guatemala (and formerly in Yucatan as well), there is a character who so closely resembles God L that he must be taken as a rare survivor of the ancient Maya pantheon. Known as the Mam "Ancestor/Grandfather," he too wears a broad hat and fancy clothes and smokes cigars. A patron of merchants, he must be placated with gifts of money and fruit, including cacao. In Easter celebrations in the traditional town of Santiago Atitlan, the Mam's image is set up to rule in place of Christ, symbolically dead in his tomb. For five days, the Mam holds the rank of town mayor and is feted with gifts and prayers. Then, in a grand public ceremony, he battles and is defeated by the reborn Christ.[3] In earlier

Opposite page. Storm clouds over the Gulf of Mexico.

Figure 1. Mural painting showing God L resting his merchant pack on a prop and facing a cacao tree, circa 700–800, Cacaxtla, Mexico.

1

times, his image was stripped and beaten in a power-ful echo of God L's fate.

These fragmentary tales show something of the ambivalence the Maya felt toward trade and trad-ers. Merchants were rich and useful, but they were also potentially dangerous and corrupt outsiders who needed to be kept in their place. Symbolically opposed to the purity of subsistence farming, they were unfavorably contrasted to the humble peas-ants whose labors constituted the foundations of Maya civilization. Maya kings enjoyed the riches and comforts brought from afar, but their ideologi-cal positioning as procreators and nurturers clearly aligned them to the wealth of agriculture rather than that of commerce.

Figure 2. Rollout photograph of a vase with God L enthroned in his Underworld palace attended by a group of young women, 600–800. Princeton University Art Museum, Princeton, New Jersey. At the right, one pours a chocolate drink from one vessel into another, the traditional way of producing a frothy head.

Figure 3. The Rain God, Chahk, retrieving God L's hat and merchant pack from the flood, from page 43 of the Dresden Codex, 1250–1350. Sächsische Landesbibliothek, Dresden, Germany. Drawing by Simon Martin.

1
M. E. Miller and Martin 2004, pp. 51–65.

2
Martin 2006A.

3
Christenson 2001.

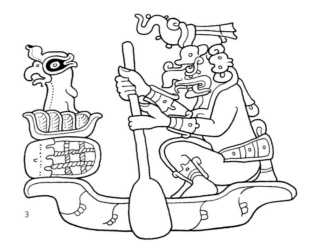

3

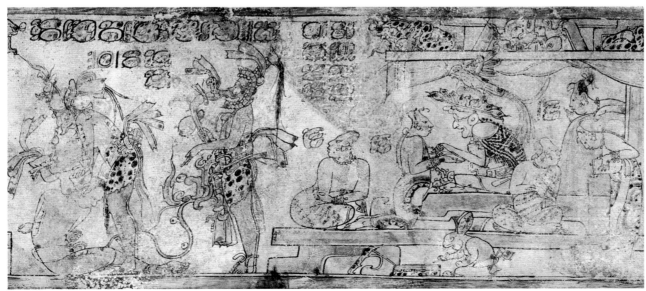

2

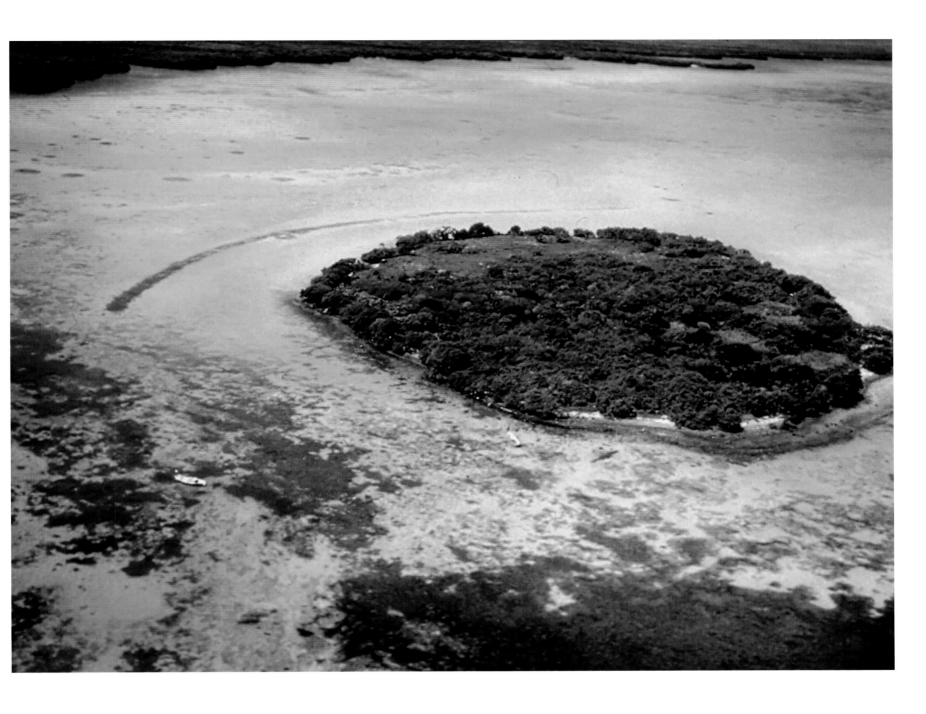

THE MAYA PORTS ISLA CERRITOS AND UAYMIL

RAFAEL COBOS

From the beginning of the tenth century AD, Isla Cerritos and Uaymil, located respectively on the north and west coasts of Yucatan, functioned as maritime ports for Chichen Itza. They were established on the coast of the Gulf of Mexico to fulfill a specific function: to facilitate the traffic of goods and precious objects whose final destination was Chichen Itza. Uaymil served as a way station, while Isla Cerritos operated as the entry point for all kinds of products transported by canoe along the marine littoral. Newly arrived goods were then transported by porters over the fifty-six-mile (ninety-kilometer) terrestrial corridor that linked Chichen Itza to its principal port on the northern coast of Yucatan.

Uaymil is an island approximately 330 yards (300 meters) in diameter and likely the port that provided a resting place for maritime caravans made up of merchants and rowers. Among their valuable cargo were obsidian from distant sources such as Ucareo (Michoacán), Pachuca, Paredón (Hidalgo), Pico de Orizaba (Veracruz), Tohil Plumbate ceramic vessels from western Guatemala, and turquoise from sources in the American Southwest. The physical layout of Uaymil includes various buildings and a central plaza on the east side of the island that contains two temples, an altar, and a C-shaped structure with columns. The temples are located on the east and south sides of the plaza; the altar is in the center; and the distinctive C-shaped building is on the north

Opposite page. Aerial view of Isla Cerritos, Mexico.

Figure 1. Looking out from Isla Cerritos, Mexico.

Figure 2. Excavations at Islas Cerritos, Mexico.

side, oriented on an east-west axis and facing south. Its walls are positioned on the west, north, and east sides and a bench runs all the way along them. Almost fourteen inches (thirty-five centimeters) in front of the bench, a row of ten columns runs parallel to the bench and the north wall. Each column once supported a large capital, or capstone, on which sat a flat roof made of perishable materials. There is evidence that only the capstones of two columns in the center of the structure had hieroglyphic inscriptions carved in them; while the other capstones were smooth, texts could have been painted on their stucco surfaces.

Enclosing the principal plaza of Uaymil on its west side are two colonnaded edifices designated Structures 5 and 6. Structure 5 bears strong similarities to the colonnaded structures documented at Chichen Itza. The various columns discovered in Structure 5 suggest that two rows with a total of ten columns formed the interior of the building. The flat roof was made of perishable materials. These unusual colonnaded buildings of open arrangement are likely to have been especially designed for ceremonial or commercial activities that took place at the island. The west side of Uaymil is characterized by a large open space without masonry structures, somewhat similar to the pattern observed at Isla Cerritos.

Located approximately mid-way between the east and west coasts of Yucatan, Isla Cerritos was the receiving point on the coast for precious objects and goods from different parts of the Maya region and other areas of Mesoamerica (figure 1). Obsidian

from Veracruz and central and western Mexico, Tohil Plumbate ceramic vessels, and turquoise arrived at Isla Cerritos from the west side of the Yucatan peninsula, while obsidian from Ixtepeque and jade ornaments from the Motagua valley, both in Guatemala, and gold and tumbaga (an alloy of gold and copper) from Costa Rica and Panama, arrived via the Caribbean Sea and a small area on the northeast coast of Yucatan. Once the goods landed on the island, porters were charged with transporting them overland to Chichen Itza.

The spatial organization of Isla Cerritos can be divided into three areas. The first sector, the center of the settlement, includes the largest structures and principal plaza. This area occupies the northwest portion of the island. The buildings around the central plaza replicate on a smaller scale the constructions in the center of Chichen Itza. At Isla Cerritos, the buildings include a temple (Structure 1), an altar (Structure 7), a ballcourt structure (Structure 3), and a colonnaded structure with pillars (Structure 5). The temples and altars had religious/ceremonial functions, the ballcourts were ritual in purpose, and pillared/colonnaded rooms appear to have had a semipublic ceremonial function (figure 2).

A second area of importance on Isla Cerritos is the plain constructed at the beginning of the tenth century AD on the south side of the island. This low, flat place with calm water conditions would have provided easy landing for watercraft. At present, however, little archaeological evidence remains to elucidate the activities that took place in this part of Isla Cerritos. Nearby, in the third and final

1

sector, stone piers jut outward from land, and a sea wall unconnected to the island runs parallel to the southern shore. It is over 350 feet (107 meters) long, with periodic breaks as well as platforms at each end that appear to have been the bases for large wooden structures. It is notable that the sea wall runs along the landward side of the island. Rather than protecting Cerritos from the sea, it may have been constructed to control access to the island or even protect it from mainland people.

2

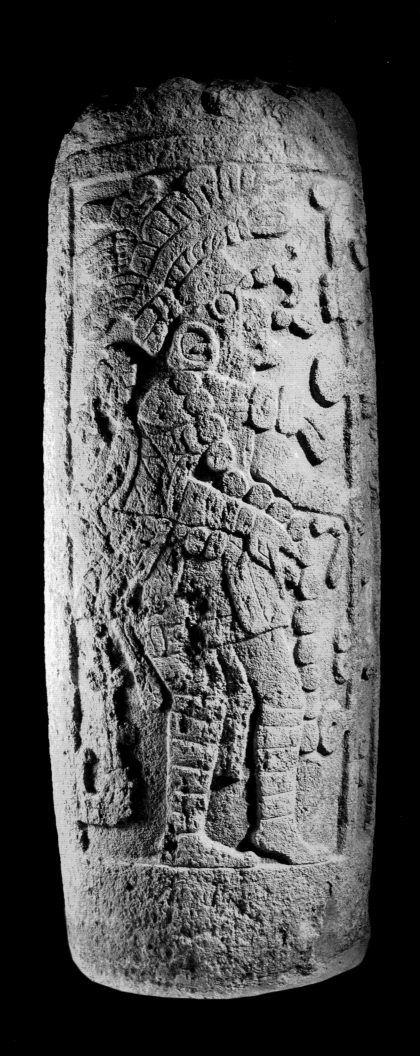

53

Column with God L
circa AD 800
Bakna, Mexico
Catalogue 44

This column bears an image of the deity known to scholars as "God L" (his ancient name is not yet understood). In keeping with his role as the deity of trade, he has the trappings of a wandering merchant. His walking stick is adorned with noisy rattles, perhaps to signal his arrival. His wide-brimmed hat sports the head and feathers of the moan owl; this night raptor is a recurring symbol of God L, a being with sinister, nocturnal qualities (Martin, pages 161–62). The home of the deity is usually depicted as cavelike and watery or as a house embellished with carnivorous jaguars or sharks. Here, God L carries the god K'awiil in his backpack – a deity linked to lightning and, in this part of the Maya region, to crops.

Many buildings in and around the Puuc region of Yucatan and Campeche featured a primary entrance framed by a pair of columns, occasionally sculpted in relief. The mate to this example is now in the Museo Nacional de Antropología in Mexico City. Both columns feature nearly identical mirror images of God L, and were most likely turned inward toward one another. Their profiles framed the doorway of what was probably a temple erected in honor of God L and associated with this deity linked to the accumulation of treasure brought by land and sea. – NW

References: Gillespie and Joyce 1998, p. 292; Pollock 1980, p. 535; Sabloff 1977, p. 76; Schmidt, de la Garza, and Nalda 1999, p. 527; Taube 1992, p. 81.

54

Vessel with God L
circa AD 800
Tabasco, Mexico
Catalogue 45

The god known today only as "God L" was a complex deity, appearing in many different mythical settings in the Maya codices, in sculpted architectural forms, and painted and incised on ceramics. This vessel was shaped from coiled clay, then molded, gouged, and incised to create its design. It shows God L gesturing within a frame. On his wizened head rests his trademark wide-brimmed hat for protection from the elements while traveling the long trade routes of the ancient Maya. Other attributes are his textured cape and the head and plumage of a moan owl on top of his hat. This representation places the deity under the eaves and matlike markings indicating a building. The Maya often playfully compared houses to pottery – a convention that became more frequent toward the end of the Classic period. The Bakna column (plate 53) came from a building dedicated to this god, and the vessel may allude to such an edifice.

Depicted as an old man with a hooked nose and lips sunken into a toothless mouth, God L is both a deity of the Underworld and the god of commerce and wealth (Martin, pages 161–62). His prosperity and personality lead him into excesses and debauchery. On the "Princeton Vase," a masterwork of the Late Classic period, he revels in his palace accompanied by a harem of beautiful maidens, one of whom pours chocolate (Martin, figure 2). This vessel with his image, a trade ware with ties to pottery from Yucatan, probably held such a beverage. – NW

References: M. E. Miller and Martin 2004, p. 76, pl. 32; Taube 1992, p. 81.

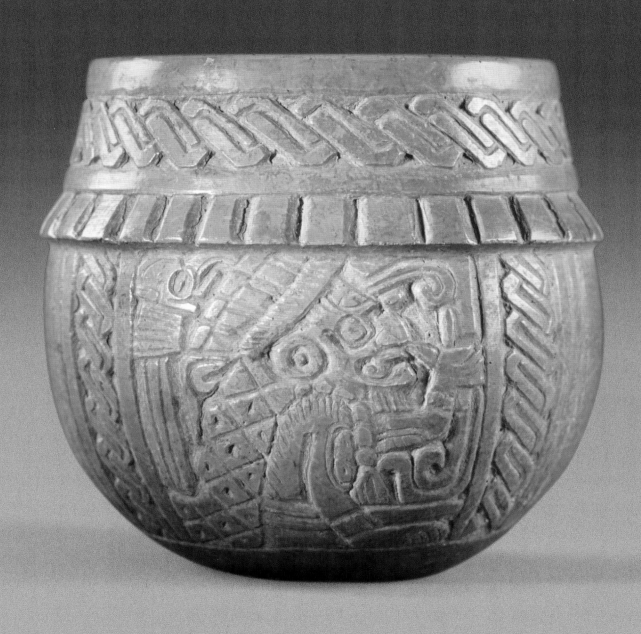

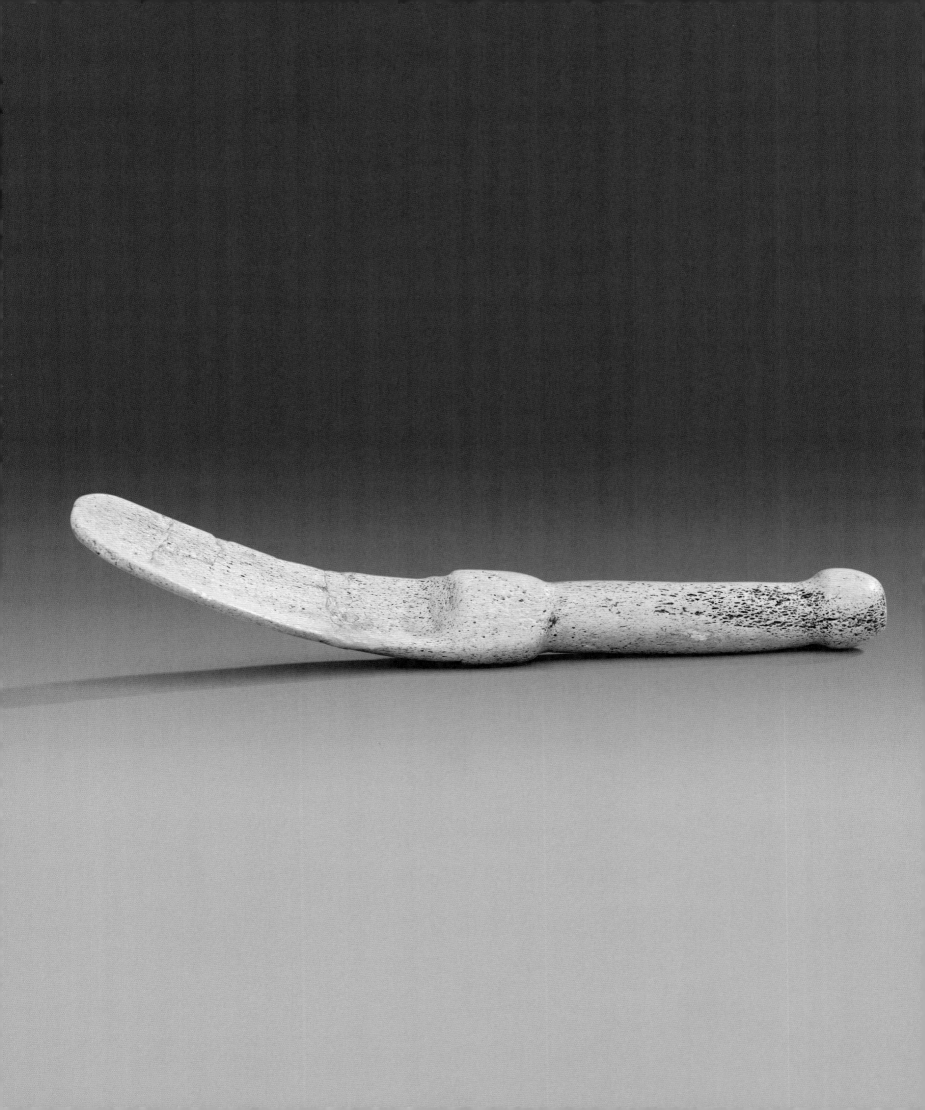

55

Taino vomit spoon
circa AD 750
Altun Ha, Belize
Catalogue 56

This unadorned elongated spoon was discovered in a burial at the Maya site of Altun Ha in northeastern Belize. Its smooth handle terminates in rounded knobs at both ends, while the gently curved spatulate end is concave. The pronounced surface pitting is characteristic of bones from the manatee, a sea creature formerly heavily hunted along the Caribbean coast and throughout the Gulf of Mexico. Also in the grave were skeletal remains of an adult male and a young child, bone tools, a jade bead, a pendant fashioned from a human incisor, and a cut *Strombus* shell.

According to documents from the fifteenth and sixteenth centuries, spoons such as this example were used in purification rites by the Taino of Cuba. Best known as the first New World people encountered by Christopher Columbus, the Taino used these spoons to induce vomiting during curing rituals and in worshiping *zemis*, or supernatural beings. The spoons recovered in Taino contexts were frequently carved from the bones of deceased ancestors; other materials believed to be imbued with supernatural powers, including manatee bone and wood, were also used.

The presence of a probable Taino artifact at a Maya site hints at contact between the Maya and Caribbean cultures. Growing awareness of ancient Maya navigation systems, watercraft, and cross-cultural contact via waterways suggests that the Caribbean region must be considered within the broader spectrum of Mesoamerican culture. – CM

References: Arrom 1989, pls. 61, 71; Canter 2006, pp. 1–2; Dacal Moure and Rivero de la Calle 1996, p. 44, color pl. 10, black-and-white pls. 53–60; Pendergast 1982, pp. 226–36, fig. 113b; Rouse 1992, pp. 13–15, 119–21, fig. 30b; Wilson 2007, pp. 3–4; Wilson, Iceland, and Hester 1998, pp. 348–51.

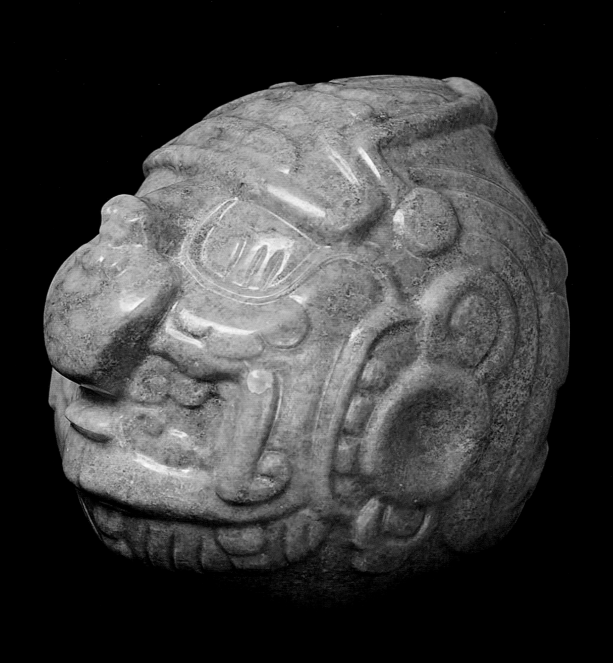

56

Sculpture of the Jester God
550–650
Altun Ha, Belize
Catalogue 54

Weighing nearly ten pounds and carved from a single cobble of jadeite, this head is one of the most exquisite works of art discovered in the Maya world. A complex representation, it depicts the Jester God, indicated by the world-tree on its forehead, but the eyes are characteristic of the Sun God. The head is partially wrapped by the Principal Bird Deity (plate 45), whose wings drape around its ears. The Jester God, a symbol of power in Classic-period Maya art, was so named by scholars for its resemblance to the hat worn by medieval court jesters. Maya rulers wore jewelry with the likeness of the Jester God on their head to symbolize their centrality to the world center (*axis mundi*). It may be that this object also refers to a figure in remote Maya history, who appears in inscriptions at Pusilha, Belize, and Copan, Honduras (plate 44).

This sculpture was discovered in 1968 at the site of Altun Ha, Belize, in the burial of an elderly male within a large tomb in the temple. Found resting on top of the right wrist of the skeleton, it had likely been cradled in his arm. It is possible that the deceased commissioned the object. Remains of cloth around the head suggest it was wrapped, as sacred objects often were in burials.

Altun Ha, located about seven miles (ten kilometers) west of the Caribbean Sea, was likely a center for long-distance coastal trade. This head is made from stone quarried in the Motagua River valley in Guatemala and was probably transported north via canoe. Many other objects found at the site from other regions of the Maya world – Teotihuacan, Costa Rica, and the Greater Antilles (plate 55) – testify to Altun Ha's important position at the confluence of several trading networks. It has been suggested that given its location on the eastern edge of the Maya world, the site might have had a connection with the rising sun and the renewal of the daily cycle of life. The polished green surface of this sculpture reflects the blue-green waters of the Caribbean and supports that connection. – GS

References: Awe n.d.; Fields 1991, p. 1; Fields and Reents-Budet 2005, pl. 152; Taube 1998, pp. 454–60.

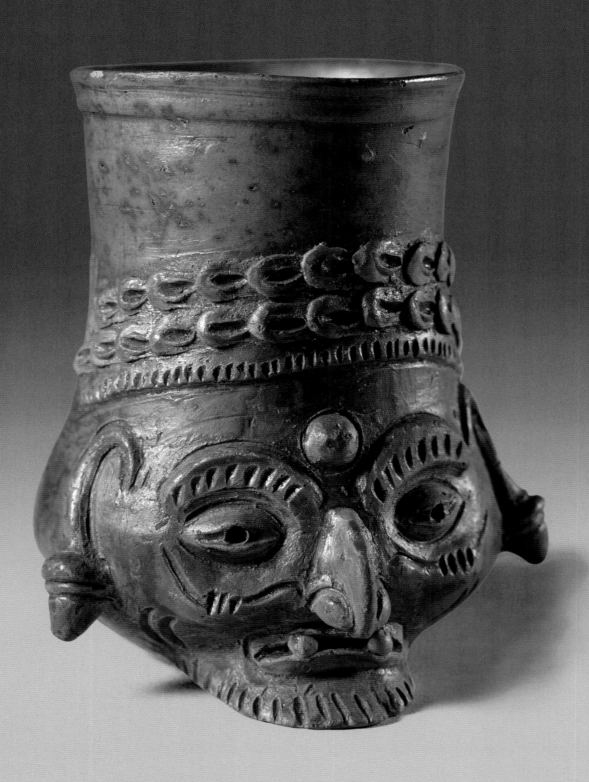

57

Vessel with the face of an old man
900–1250
Jutiapa region, Guatemala
Catalogue 55

Effigy jars embody the complex movement of prestige goods in
Mesoamerica. This lustrous vessel is a fine example of "Plumbate" ware,
so named because of its resemblance to European lead glazes (Latin:
plumbum). Plumbate arose from technological innovations and traditions
of local pottery at the end of the Classic and beginning of the Postclassic
periods. The ware occurs from western Mexico to Panama, but it origi-
nated in the Soconusco region of coastal Pacific Guatemala and southern
Chiapas, Mexico. Although initial dispersal was limited, increased demand
for its metallic sheen reflects a shifting aesthetic, as metals became more
common in Mesoamerica.

 Effigies from the later Tohil phase of Plumbate production (900–1250)
feature animals such as jaguars, toads, armadillos, and birds; also com-
mon are head, bust, or full-figure human and supernatural beings. The
inclusion of central Mexican and Yucatec motifs, such as the Rain God
Tlaloc, on Tohil vessels may speak to their producers' intended markets
within trade networks.

 This effigy from the Jutiapa region of Guatemala depicts a common
form: the face of a gap-toothed old man with a prominent bearded chin,
parted mouth, "pellet" teeth, deep-set eyes, and pronounced brows and
cheekbones. Earlier sculptures at Bilbao, Guatemala, show the same
figure, down to an identical band around the forehead. Often wearing
decorative ear plugs and headdresses, the figure may represent a super-
natural being of wisdom and power. – CW

References: Stephen D. Houston, personal communication, 2009; Neff 1989B; Neff
and Bishop 1988; Parsons 1969, pl. 65e; Shepard 1948.

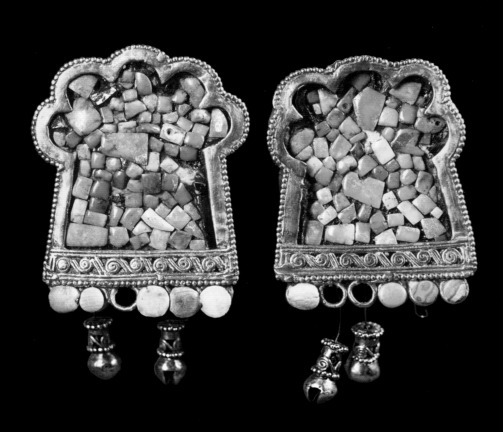

58

Ear spools
1300–1550
Santa Rita Corozal, Belize
Catalogue 57

These ear spools formed part of a burial that also contained the remains of two adult males, stingray spines, and jade and *Spondylus*-shell jewelry. The ornaments feature an inlaid turquoise mosaic surrounded by a filigreed band of gold or tumbaga, a copper and gold alloy commonly used by Mexican goldsmiths. Small pendant bells were suspended to the bottom scalloped edge, although some are now lost. The unique form of these ear spools renders their interpretation difficult, but they may represent a shield panache or towering thunderheads.

The site of Santa Rita Corozal, as well as the modern town of the same name that now lies atop it, was a fully maritime Maya settlement. Situated between the New and Hondo rivers on the Bay of Chetumal, Santa Rita has produced a material record that demonstrates its inhabitants maintained a pragmatic and symbolic appreciation for the sea, particularly during the Postclassic period when it prospered.

Given that the Maya lacked metallurgy as well as native sources of turquoise, the presence of these ear spools at Santa Rita attests to long-distance maritime trade with central Mexico. Technologically, the ear spools share much with Aztec and Mixtec traditions, including lost wax casting, filigree, and mosaic work. Trade in prestige goods among Aztec, Mixtec, and Maya peoples is amply attested in the Postclassic archaeological and historical records. Furthermore, the materials used in the original manufacture of the earrings were likely imported to central Mexico from other areas of Mesoamerica, including the American Southwest, Costa Rica, and Panama. The Santa Rita ear spools are evidence of a vast and complicated network of communication, contact, and trade – a network facilitated by and reliant upon the sea. – CM

References: Bray 1977, pp. 394–96; D. Z. Chase and A. F. Chase 1985, pp. 14, 17; D. Z. Chase and A. F. Chase 1988, pp. 55–56, fig. 30; M. E. Miller 2001, pp. 220–21, pl. 184; M. E. Smith 2001, pp. 92–100, pl. 184.

59

Chocolate frothing pot
in the shape of a shell
400–500
Tabasco, Mexico
Catalogue 37

In the Early Classic period, Maya artisans linked sea shells to chocolate drinks. Found on an island in an estuary of coastal Tabasco, this shell-shaped pot held just such a beverage. Resting solidly on nubbin feet, it is quite stable, unlikely to upset. Like bright shell, its exterior was slipped white, its interior the vivid red of certain mollusks. Drinkers blew into the short spout to aerate the beverage and then consumed the prized froth. A design gouged and incised on the side of the effigy shell is difficult to identify, but it may represent the snout and head of the snakelike creature thought to live within. An actual shell in The Jay I. Kislak Collection at the Library of Congress labels itself as a holder of chocolate drink; and several effigy pots, all probably used for chocolate drinks, combine the head and body of an elderly deity associated with shells (plate 38). At Santa Rita Corozal, Belize, another Early Classic bowl, also labeled a vessel for choco-late, appears with the elderly God N on either side. Precious containers were clearly thought appropriate for holding precious drinks. – SDH

References: D. Z. Chase and A. F. Chase 1985, p. 15; Powis et al. 2002, p. 94; Marc Zender, personal communication, 2009; http://www.loc.gov/exhibits/earlyamericas/online/precontact/precontact3.html#object28.

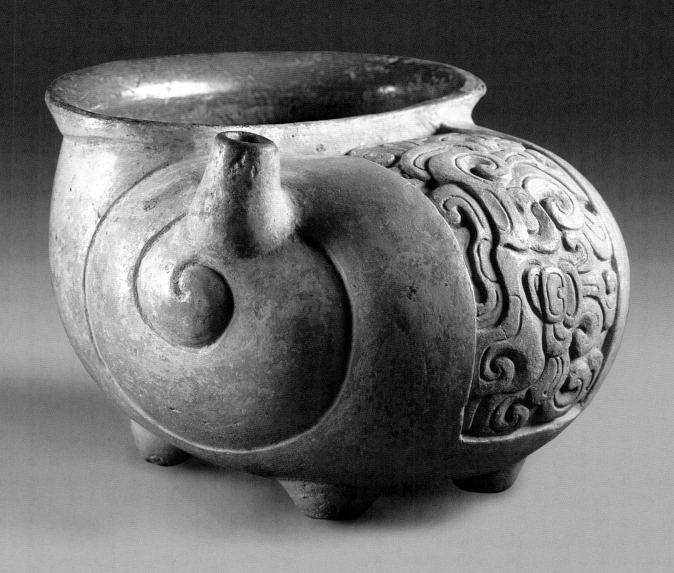

60

Drinking vessel with the death and
rebirth of the Maize God
700–800
Holmul region, Guatemala
Catalogue 91

In the Maya world, the cyclical harvesting of maize and the cycle of life from birth to rebirth were embodied in the form of the Maize God and integrally tied to water. His watery passage and reemergence were agricultural tropes of maize entering water (death) and the watering of seed corn (emergence). This vessel depicts the watery voyage of the Maize God, rendered on a black background to mimic the murk of primordial time. In one part of the image, the Maize God is being transported by a canoe guided by the so-called Paddler Gods, elderly deities who perform this task in many other scenes from the Classic period. They propel the watercraft in asynchronous fashion: the bow paddle enters the water just as the stern paddle is about to be drawn up. Though this arrangement adds compositional balance, the process is nautically discordant. The Maize God, seated in the center of the canoe, carries a sack of grain on his shoulder as though literally carrying seed corn into the water. Beneath the canoe is another version of Maize God, about to be consumed by a watery serpent. He is also being nibbled on by a fish – perhaps a witty allusion to the Maya using corn dough as bait. The final, almost erotic, image shows the Maize God

being dressed by two naked women, possibly corn maidens preparing him for emergence in dance.

This vessel is similar in style to other black-background pots, including one at the Museum of Fine Arts, Boston. The Primary Standard Sequence (PSS) of the glyphs around the rim suggests the vessel was used for drinking chocolate. Repair holes to bolster a cracked rim indicate long service prior to deposition in a tomb. Most of the vertical text on the vessel is too eroded for interpretation, but the final glyph appears to be a variant of the Tikal emblem glyph, a dynastic title of that city. This suggests a connection between the vessel and the Tikal ruling lineage, though the vase's chemical profile matches potsherds excavated at Holmul in the northeastern Peten region of Guatemala. – GS

References: Fitzsimmons 2009, pp. 35–39, 69–72; Reents-Budet 1994, pp. 273–75, 350, pl. 82; Taube 1985, p.177; Taube 1992, pp. 41–50.

Figure 1. Rollout photograph of plate 60.

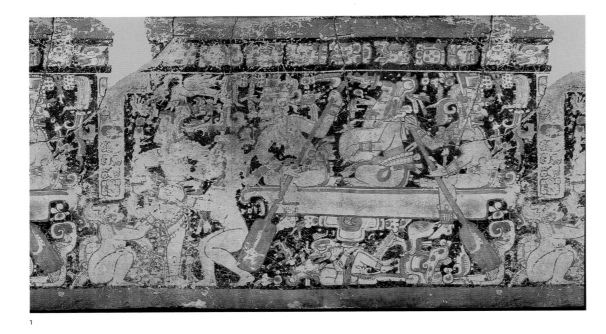

1

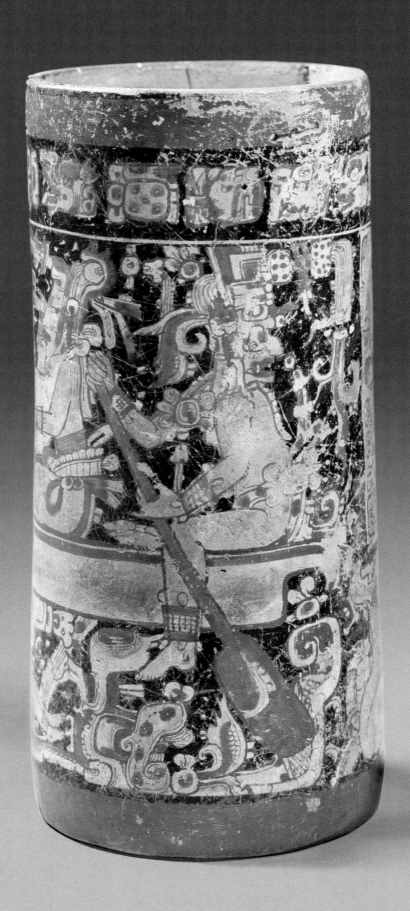

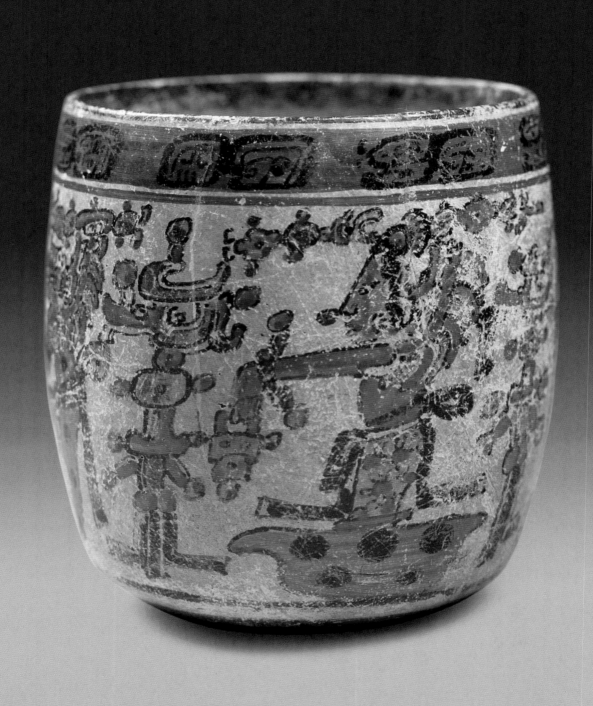

61

Vase with the Maize God riding
in a canoe
circa AD 600
Northern Peten, Guatemala
Catalogue 47

This vase chronicles the Maize God's watery journey from death toward rebirth as a paradisiacal one, with the deity poised as if prepared to dance. He appears twice on this pot: richly bedecked and surrounded by jewels, and standing erect in a canoe. On one side of the vessel, his canoe bears black spots, possibly alluding to a jaguar pelt, which was a luxury item of Maya nobility. Here, it may symbolize an appropriately regal conveyance for this powerful deity. The god is flanked by the Hero Twins of Maya origin mythology, who stand without sources of buoyancy in front of and behind the canoe. They hold extremely long paddles with asymmetrically shaped blades, similar to those on bones from Tikal; mirrorlike markings show them to be adamantine or at least highly polished, like an adze. Painted nearly a thousand years before the oral stories of the *Popol Vuh* were transcribed in the mid-sixteenth century, the scene portrays known characters but does not relate directly to any recorded tale.

Much like a Late Classic-period canoe scene (plate 60), this vase contains many agricultural allusions to the Maize God's journey. The Hero Twins' paddles can be interpreted as digging sticks (Finamore, pages 155, 157), and therefore they literally "cultivate" the Maize Gods they surround. The Maize Gods have fragrant flowers coming from their foreheads, and one holds an incense bag, both synaesthetic motifs. Finally, attached to the foreheads of the Hero Twins are large *yax* signs ("first, new, green"), an allusion to their own cycles of destruction and rebirth, or simply denoting that they are the first in a particular series.

This vase exhibits physical, artistic, and thematic characteristics similar to two examples in the Nasher Museum of Art, Duke University. All are Tepeu 1 style of the northern Peten: vessels with rounded sides and dark red and orange slip on a cream background and a thick red band beneath the rim with simple black pseudoglyphs painted on top and a thin red line below. The Nasher vases, as in the example here, deal with the Underworld voyage of the Maize God and what Dorie Reents-Budet labels as the "dance of apotheosis." The similarity in the way figures are rendered on all three vases points to their being produced by the same hand or workshop. — GS

References: Oswaldo Chinchilla Mazariegos, personal communication, 2009; Stephen D. Houston, personal communication, 2009; Reents-Budet 1994, pp. 203–205.

Figure 1. Rollout photograph of plate 61.

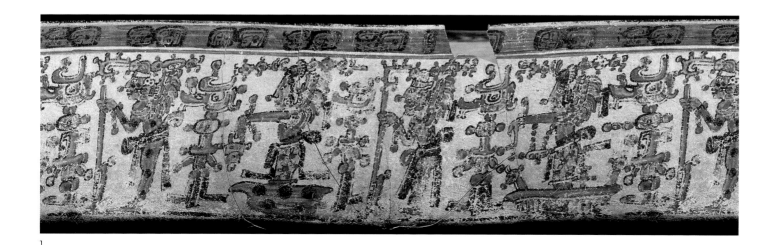

1

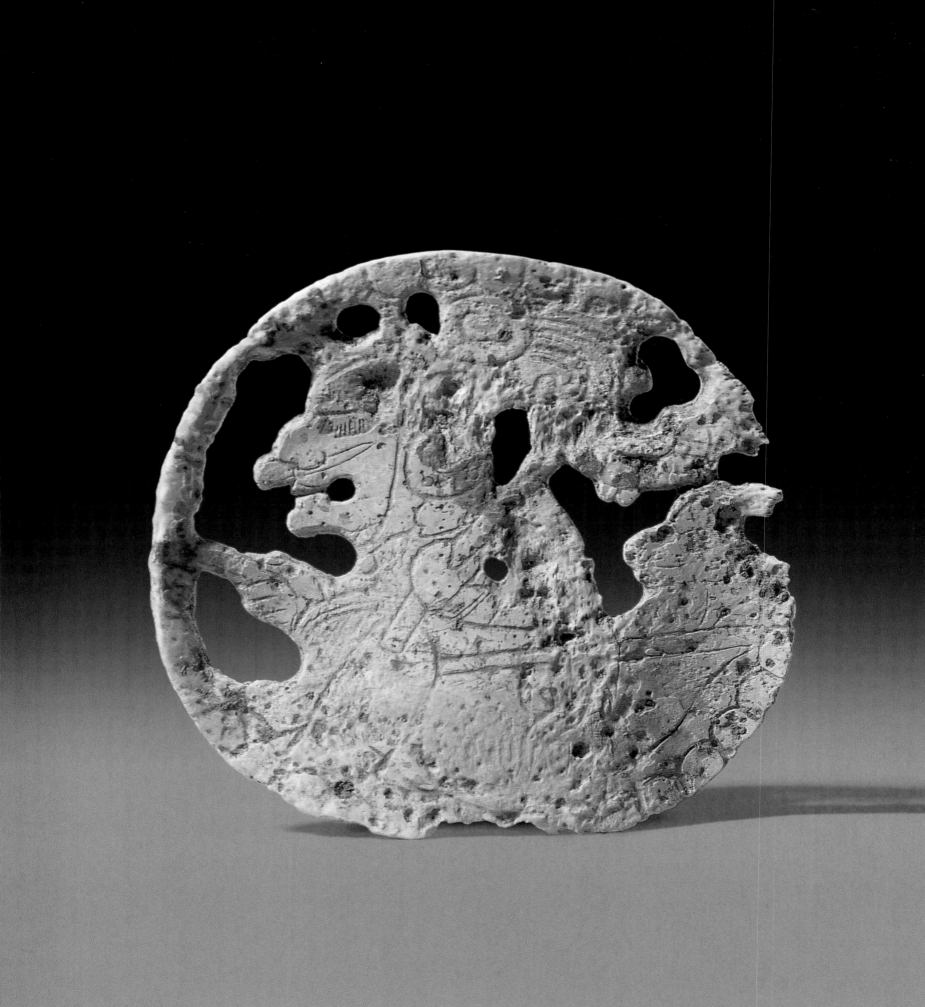

62

Ear flare with the Stingray Paddler
in a canoe
500–600
Stann Creek District, Belize
Catalogue 48

This carved and perforated shell ear flare, lined with small circles probably denoting beads of water, is incised with an image of the Stingray Paddler in a canoe. Behind him sits either a small rabbit – a Maya symbol of the moon – or a dog. This boat shares many similarities with Classic Maya canoes (Finamore, pages 151–55). It most closely resembles those depicted on the bones from Burial 116 at Tikal, with a clearly delineated gunwale and a platform end, at least at the stern (Finamore, figure 6; and Taube, figure 14). Erosion has made it difficult to determine whether the Stingray Paddler sits within a small canoe shown in its entirety or near the stern of a larger craft as in one of the Tikal bones. If the latter, then this image is unique in showing only a segment of a canoe rather than the complete but foreshortened one commonly rendered in the Dresden Codex (Finamore, figure 8). The Stingray Paddler on this ear flare holds a paddle with his left hand only; in his right hand is another object, perhaps a rope, fishing pole, or second paddle. If it is a paddle, his pose relates to that of the far-left figure on Disk G from Chichen Itza (plate 68), who holds paddles of two different types.

The Stingray Paddler is named for the stingray spine that frequently pierces his nasal septum. A glyph on Quirigua Stela C clearly shows the deity's pierced nose. This same glyph is inscribed on a stingray-spine fragment from a burial at Holmul, Guatemala, that directly relates the stingray spine of an interred lord to that of the Stingray Paddler. This deity, along with the Jaguar Paddler deity, transported the Maize God on his watery journey from death to resurrection. Integrally tied to water, this important agricultural myth was the central metaphor of Maya life.

This ear flare was part of a set attached to ear spools; its mate likely depicted the Jaguar Paddler. Similar shell ear flares from Holmul, as well as a pair in the collection of the Denver Art Museum, show possible breath or speech scrolls emanating from the mouths of the figures. The round circle under the nose of the Stingray Paddler is likely such a scroll. All these examples would have been worn with the figures oriented inward as if they were speaking directly to the wearer, thus making the Stingray Paddler cover part of the left ear spool. – GS

References: Schele and M. E. Miller 1986, pl. 113; Stephen D. Houston, personal communication, 2009; Shatto 1998, pp. 201–202; D. Stuart et al. 1999, p. 157.

63

Brick with an incised canoe
600–800
Comalcalco, Mexico
Catalogue 46

Bricks from Comalcalco typically contain some form of adornment, which varies in content and skill of execution. This example features a crudely incised canoe. A long-handled oar or paddle projects from the stern of the vessel, possibly held by a human figure and operated as a rudder. The elongated prow, if not a second paddler, suggests that this portion of the canoe may have been embellished with a zoomorphic motif. Three amorphous shapes – possibly cargo or even passengers – project from the hull.

Located on the western outskirts of the Maya region in present-day Tabasco (Mexico), Comalcalco is an exceptional site: unlike the ubiquitous masonry at other Maya centers, its buildings were constructed from un-fired mud bricks. This aberrant technological choice likely stemmed from the lack of building stone in the low-lying, water-logged Tabasco plain (plate 73). The bricks also raise the issue of gender, in that most Maya pot-tery was probably created by women. Thus, at Comalcalco, females may have been involved to a unique extent in supplying materials for monu-mental construction. The presence of legible texts on certain bricks further complicates our understanding. Elsewhere in the Maya region, literacy was usually an accomplishment of men, suggesting that at Comalcalco, gender roles or the objects linked to them may have varied from other sites.

Although little iconographic information can be extracted from this rudimentary incision, the brick does provide a rare glimpse of "low-end" or unskilled artistic production among the Maya. Most of the artifacts stud-ied by Mesoamerican archaeologists, epigraphers, and art historians come from elite contexts and thus were produced by skilled scribes and artists. However, not all artistic ventures were carried out by such exceptional members of a highly stratified and specialized society. Although its precise iconography remains elusive, this brick allows a fuller view of the spec-trum of artistic skill, knowledge, and production in Classic Maya culture. Indeed, it may even have come from the hands of a child. – CM

References: Álvarez Aguilar et al. 1990, p. 220; Blom and La Farge 1926, p. 113; M. E. Miller and Martin 2004, p. 155; Navarrete 1992, pp. 219–20.

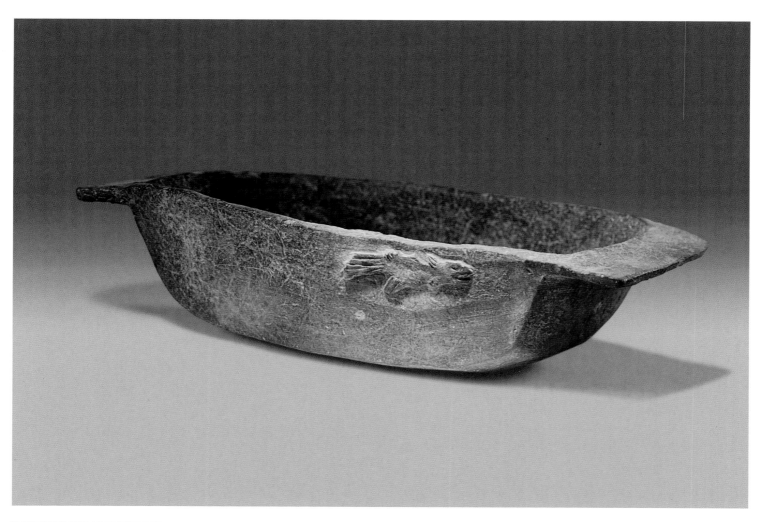

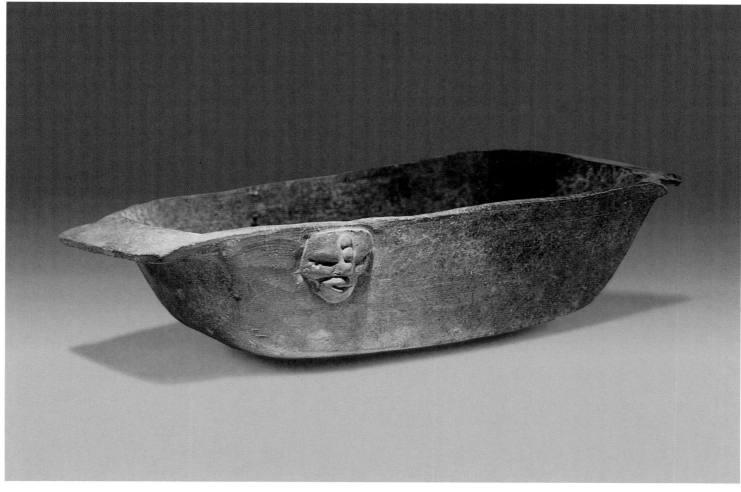

64

Model of a canoe
700–800
Jaina Island, Mexico
Catalogue 50

Because of the vagaries of preservation, little material evidence survives
for ancient Maya watercraft. This exception, recovered from the island of
Jaina, Mexico, constitutes one of the few archaeological artifacts directly
attesting to Maya boats. In this ceramic model, a rapidly swimming fish
with pronounced fins and tail has been carved in relief on the starboard
side of the hull; its features are possibly conflated with the plumage of
a bird in flight (figure 1). The port side bears a face of unknown identity
or significance, with forehead scars or cicatrices similar to decorative
scarification on other figurines, in particular those from Jaina. These might
have named the vessel, as on present-day craft whose names indicate the
owners or invoke protective forces. The hull consists of straight sides and
a flat bottom. The bow and stern terminate with broad, flat projections
that may have served as platforms for paddlers. Here, one platform bears a
small hole in the center, perhaps a means of mooring the craft.

The Jaina canoe appears consistent with other representations of
Maya watercraft (Finamore, pages 151–55). Although some models are
made from manatee bone rather than clay, all possess flat-bottomed,
straight-sided hulls with squared platforms at the bow and stern. The
apparent uniformity in canoe form exists throughout the Maya lowlands.
This diminutive model might have been a child's toy, but it more likely
served as a ritual vessel associated with the watery movements of the
dead. The deeply hollowed interior may have doubled as a container for
food and drink. – CM

References: Gann 1918, pp. 25–26; Hammond 1981; Lothrop 1929; McKillop 1984, p. 30,
fig. 4; McKillop 1985, pp. 343–44, figs. 3–5; Pendergast 1979, pp. 100–102, 127, 138,
fig. 46b; Shatto 1998, pp. 195–241; Thompson 1949; Tozzer 1907, pp. 54–55 , fig. 2.

Figure 1. Carvings on opposite sides of plate 64. Drawings by Stephen D. Houston.

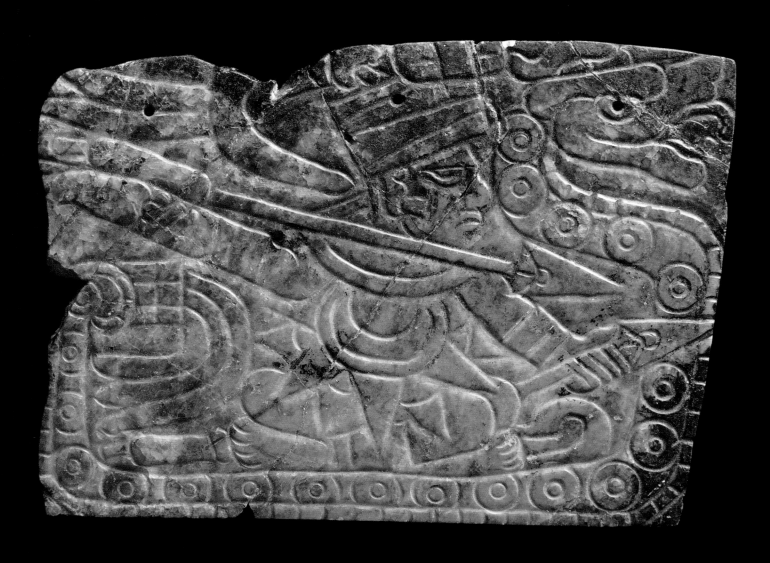

65

Plaque with the Warrior Sun God
riding a plumed serpent
800–900
Chichen Itza, Mexico
Catalogue 51

Carved into this jadeite plaque is a portrayal of a plumed serpent as a supernatural vehicle, almost like a canoe. Its head and tail mimic the flared ends of Classic Maya canoes (Finamore, pages 151–55), and its shape resembles the canoes depicted on page eighty in the Mixtec Codex Nuttall. Numerous perforated disks (*chalchihuitls*) indicate the preciousness of the feather-tailed serpent. Sitting in the center of this serpent-boat is a figure. His outstretched right arm marks his readiness to launch the atlatl dart he holds over his shoulder; another dart is in his left hand. His Mexican-style dress and rendering denote a pan-Mesoamerican artistic influence – originating in the highlands of Mexico – at Chichen Itza during this period. Although previous interpretations identified this armed figure as the Morning Star, the rayed solar disk he wears on his chest marks him as the warrior Sun God riding on a plumed serpent. The triangular solar rays appear on two levels with the outer second level behind the circular rim – a convention also found in depictions of large solar disks surrounding the Sun God at Chichen Itza (figure 1). To the ancient Maya, supernatural serpents served as transport for the rain and sun gods (Taube, page 215). Similar depictions of warriors riding serpents can be seen in the murals of the Upper Temple of the Warriors.

Rather than the Classic Maya Sun God, who displays large eyes and a "Roman nose," this figure is probably an early version of Tonatiuh, the Late Postclassic Sun God of highland Mexico, who commonly wields an atlatl. In fact, some of the earliest known examples occur at Chichen Itza, where he commonly sits on a jaguar throne in a large solar disk (figure 1). In this example and other scenes, he appears before a feather-rimmed bowl containing human hearts, an antecedent form of the Aztec *cuauhxicalli* offering bowls used to feed hearts to the sun. Aside from Chichen Itza, a roughly contemporary solar figure appears on the Terminal Classic Cotzumalhuapa-style El Castillo Monument 1, where a rayed solar element surrounds a celestial figure who grasps a serpent element as his probable road or vehicle.

One of the many objects dredged from the Cenote of Sacrifice by Edward H. Thompson between 1904 and 1907, this very thin plaque with numerous bored holes on the backside perhaps was once adhered to a backing. The black coating that covered the plaque when it was brought up was most likely soot from the ritual burning of copal. – GS, KAT

References: Coggins 1984B, pl. 28; Proskouriakoff 1974, p. 192; Taube 1992, pp. 140–42.

Figure 1. Detail of a wooden lintel depicting the Sun God seated on a jaguar throne and surrounded by a large solar disk, Early Postclassic period, Upper Temple of the Jaguars, Chichen Itza, Mexico. Drawing by Karl A. Taube.

1

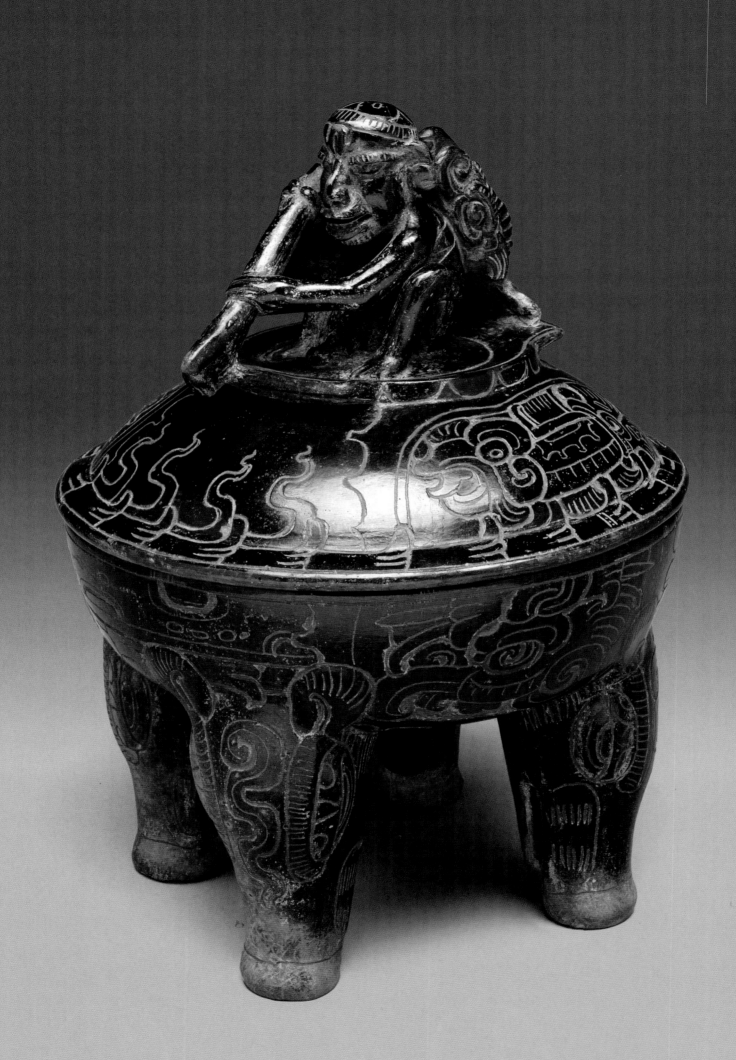

66

Lidded vessel with the Sun
God paddling across the aquatic
floral road
200–450
Mexico or Guatemala
Catalogue 53

This elaborately carved and highly burnished Early Classic vessel graphically portrays on the lid a figure paddling a canoe across a body of water. Fish in oval cartouches on both sides underscore the aquatic theme. In addition, the bowl below portrays the Water Lily Serpent of terrestrial water, along with undulating beaded water-bands. The bowl's four peccary-head supports have a large Kaban Curl on their brows, a Maya sign denoting the earth. Linda Schele suggested that here the sign relates to a word-play between Mayan terms for peccary, *ak*, and turtle, *ahk*, as the turtle was a widespread ancient Maya symbol of the earth. One Late Classic shell carving portrays a scribal figure, possibly the Maize God, emerging from a split peccary, much like the many scenes of the deity rising out of the cleft earth-turtle.

Bearded and crowned by a prominent solar *K'in* sign, the paddler is clearly the Sun God. Horizontal "daisy chains" of blossoms encircling both the lid and bowl denote the floral path of the sun. In contemporary Tzotzil Maya thought, the dawning sun rises to noon zenith on a celestial path lined with blossoms. The basal register of Tikal Stela 1 portrays a solar disk along with a band of water atop a horizontal chain of blossoms, and it is likely that this scene also denotes the flower road (figure 1). Similar floral chains appear in Early Classic Teotihuacan vessel scenes before winged figures, much as if the figures were ascending a celestial road of flowers (Taube, figure 32).

A series of sinuous forms rise from the floral band on the carved vessel lid. Although these elements may refer to the moist, breathlike aroma of the flowers, they probably concern a related natural phenomenon: evaporating mist rising out of bodies of water. In contemporary Maya thought, clouds derive from moisture rising from bodies of water, as can be seen in this account by Rafael Girard for the Ch'orti Maya of eastern highland Guatemala: "the native concept of the origin of rain is the same as that of modern science: by the evaporation of ground sources, condensation, and precipitation." Clearly, the sun plays an active and powerful role in this process. In Tzotzil belief, the daily path of the sun evaporates the eastern sea at dawn and the western sea at dusk (Taube, page 217). An Early Classic stucco-painted vessel from Tikal portrays the Sun God

waist-deep in water raising into the sky a symbolic rain cloud in the form of a serpent with the *Ak'bal* sign for darkness (figure 2). The horizontal elements hovering above the water also denote evaporation; they appear as well on the Liverpool vessel (plate 92). In the case of the canoeing Sun God, it is important to note that he is fishing as well as paddling; his catch hangs from his back. In Izapa Stela 1 and scenes in Classic Maya art, the Sun God conjures rain clouds through the act of fishing, an activity he also performs in his daily journey through the watery Underworld and up into the heavens. – KAT

References: Freidel, Schele, and Parker 1993, pp. 82–84, fig. 2: 19a; Girard 1995, p. 41; Gossen 2002, pp. 27–29, 1028, n. 3; Holland 1961, p. 168; Taube 2004.

Figure 1. Basal register of Tikal Stela 1 depicting a solar disk with an undulating water-band atop the flower road, Early Classic period, Guatemala. Drawing by Karl A. Taube.

Figure 2. Detail of a stucco-painted wooden bowl with the Sun God raising from the water a serpent with an *ak'bal* ("darkness") sign, Early Classic period, Tikal, Guatemala. Note the probable floating evaporation motifs in the background. Drawing by Karl A. Taube.

1

2

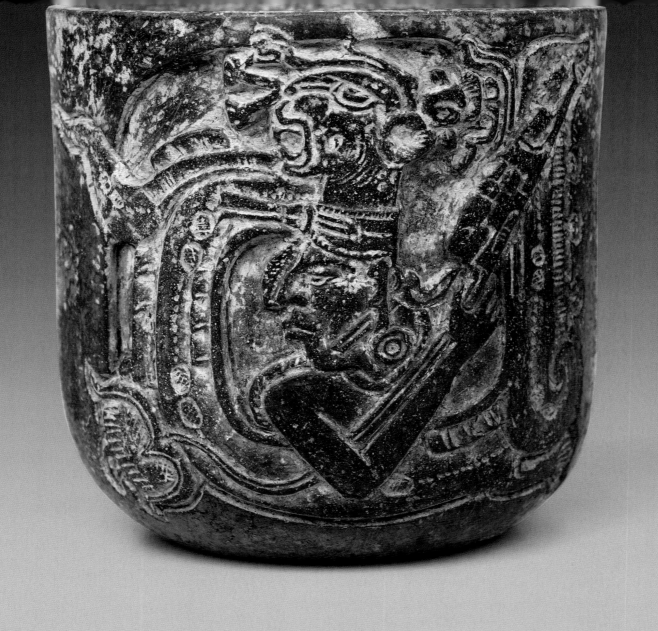

67

Drinking vessel with a figure
holding a paddle
700–800
Calcehtok region, Yucatan
Catalogue 49

This carved drinking vessel depicts a youth looking out from a cartouche
formed by the flower and foliage of a water lily. His nose piece and jadeite
ear ornaments mark him as a Maya lord, but his jaguar headdress and
long, stylized paddle coming out of a water lily identify him as the Jaguar
Paddler, one of a pair of gods who ferry the Maize God through the waters
of the Underworld in their canoe. The text on the back of the cup identifies
its owner as a *kaloomte'*, a high title of unknown meaning, under whose
patronage the so-called Chochola-style of high-relief carved ceramics
flourished, most likely in the area of the dynastic capital of Oxkintok,
Yucatan. Near identical versions of this scene occur on a variety of pots,
suggesting an active workshop behind their production and a master who
crafted numerous such ceramics.

The vessel owes a formal and technical debt to relief carving in
stone or wood. Its style is close to the Chochola-Maxcanu ceramics of
the Yucatan peninsula in the Late and Terminal Classic periods. Themes
common to such pottery include an emphasis on ownership by young men
of *sajal* or noble rank. The vessel is one of the earliest known in a private
collection, having been once in the possession of Don Enrique Camara of
Mérida, Yucatan, by the early 1900s. – NC

1

References: Ardren 1996, pp. 1–9; Boot 2006, pp. 1–15; M. D. Coe 1973, cat. 59; García
Campillo 1992, pp. 186–89; Spinden 1913/1975, fig. 186; Tate 1985, pp. 123–33.

Figure 1. Glyphic text on the reverse of plate 67. Drawing by Cassandra Mesick.

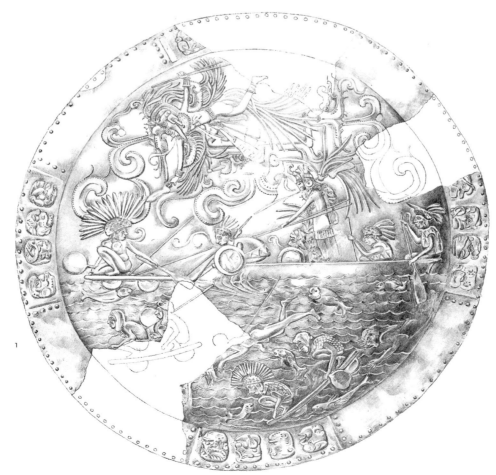

1

68

Disk with a great naval battle
800–900
Chichen Itza, Mexico
Catalogue 60

The city of Chichen Itza is renowned for its watery sinkhole, the so-called "Cenote of Sacrifice." A natural feature over 120 feet (40 meters) deep, the cenote served as a place of ritual sacrifice centuries before the Spanish conquest and missionaries' accounts of humans and treasure tossed into its depths. Attracted by these reports, in 1904, with support from Harvard University, the explorer Edward H. Thompson began to dredge the cenote. This gold disk (Disk G) was one of the many objects pulled from the black depths. Based on its composition, the gold probably came from southern Veraguas or Costa Rica, where similar but undecorated gold disks were reported by Columbus on his fourth voyage. The disk had once been attached to a backing but was torn away, crumpled, and cast into the cenote, evidently to destroy not only the object but the power of the people and deity portrayed. A solar emblem, the disk likely served as the face of a small shield. A meticulous drawing by Tatiana Proskouriakoff (figure 1) shows it to contain one of the few known depictions of a Maya naval engagement.

In the scene, a victorious group in a dugout canoe attack other less fortunate warriors on three small rafts. The attackers have both Toltec and Maya features and are difficult to identify. Two men in the back of the canoe are paddling; a speech scroll, a visible cry, extends from the mouth of the figure at the end. Two shield-bearing warriors sit in the front of the canoe. The foremost, also with a speech scroll, attempts to use his wooden oar to overturn the enemy craft. A lord with a skull on his back stands in the center of the canoe. He has thrown two spears and is preparing to launch a third. From the sky, a fierce winged deity descends on the battle, clearly on the side of the triumphant attackers. A double-headed serpent looming in the background exudes smoke or fire. The losing side of this confrontation escapes on small rafts, probably made of planks supported by buoyant, air-filled gourds. One of the defeated oarsmen has been pierced by a spear; two other figures swim for their lives. One, also hit by a spear, may already be dead: a fish is ready to nibble his limp fingers.

Surrounding the disk is a decorative frame with four hieroglyphic passages. These employ head signs, none clearly legible. Strangely, the glyphs face backward. When pressing the gold sheet onto a template, the metalworker may have failed to anticipate the reversed text. Another possibility is that this and at least some other disks have been presented backward and the goldwork is actually chased (molded from the front) rather than repoussé (molded from the back). – NW

References: Coggins 1992, p. 4; Lothrop 1952, p. 51, n. 35; Thompson 1949, p. 73.

Figure 1. Graphite drawing of plate 68 by Tatiana Proskouriakoff from Lothrop 1952. © 1952 by the President and Fellows of Harvard College.

69

Mural from the Temple
of the Warriors
900–1100
Chichen Itza, Mexico
Watercolor on vellum by
Ann Axtell Morris
Catalogue 61

When a Carnegie Institution team of archaeologists excavated Chichen Itza's Temple of the Warriors in the 1920s, they made a remarkable discovery: when the structure collapsed, large murals had been encased and preserved for a thousand years. Ann Axtell Morris performed the task of reassembling the shattered images piece by piece. Then, knowing that their restoration could make them vulnerable to the elements, she painstakingly reproduced them in watercolor. Sadly, her fears proved correct: the original murals are now almost entirely eroded. This modern re-creation is an invaluable record of Terminal Classic Maya mural painting in the Yucatan. The historical data it contains are unique if enigmatic.

The original mural was part of a cycle that seems to depict a conquest. At least two distinct peoples were embroiled in this epic, the Maya, native to Chichen Itza, and the Toltecs, from Tula in the Mexican highlands northwest of the Yucatan. In the Terminal Classic period, these two peoples formed a large and complex political system, perhaps after the Maya were in some capacity subdued by the Toltecs. The murals may tell the story of political life in the Yucatan before and after what was likely broad-ranging contact with the Toltecs. They show many scenes of conflict and destruction, including sieges, prisoner-taking, and human sacrifice. Dark-skinned warriors, who appear to be Toltec, are repeatedly led to victory by a divine plumed serpent. Less fortunate people, rendered in a lighter hue, may be Maya.

This particular painting records a moment of apparent peace. A bustling Maya coastal village goes about its business while armed warriors slip past in canoes. The scene shows common, white-plastered wooden houses with thatched roofs. Inside, a pot is set upon the central fire, and floating scrolls suggest the ambient chatter and singing of a busy community. The villagers are light-colored Maya, as are the paddlers manning canoes. But the warriors are Toltec; interestingly, so are the figures of spiritual authority in the rustic village temple, who watch as the plumed serpent deity rises from its sacred precincts.

The clear, pale blue ocean is rich in detail. Waves undulate across the surface, while the depths teem with life: fish, crabs, stingrays, oysters, and a shoreline-hugging turtle are joined by a fantastic conch-shell creature. The canoes, with their tall bows and sterns, appear well adapted to choppy seas; tall paddles double as poles in shallow waters. An egret swoops in the air and stylized trees, perhaps inspired by plumeria or canistels, dot the coast. The earthy-red land is evocative of clay or terra cotta. Throughout the village are catches of fish, and a lone villager pounds a washboard in the lapping waves. Two strange structures next to the water – possibly symbolic banners or "stelae" made of perishable materials such as paper or feathers – greet the water-borne traffic. – NW

References: Kristan-Graham and Kowalski, 2007, p. 21; A. A. Morris 1931, p. 317, n. 318; Wray 1945, p. 26; Wren and Schmidt 1990, p. 224.

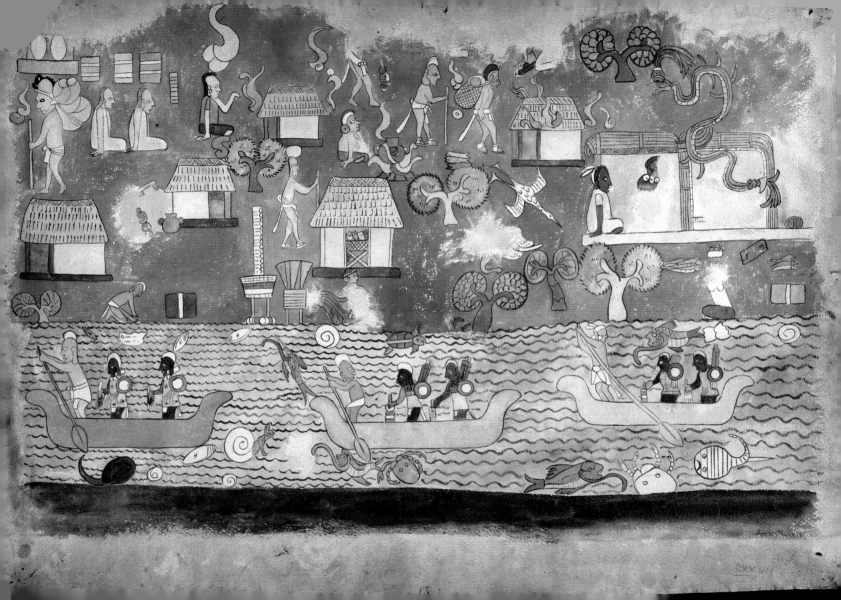

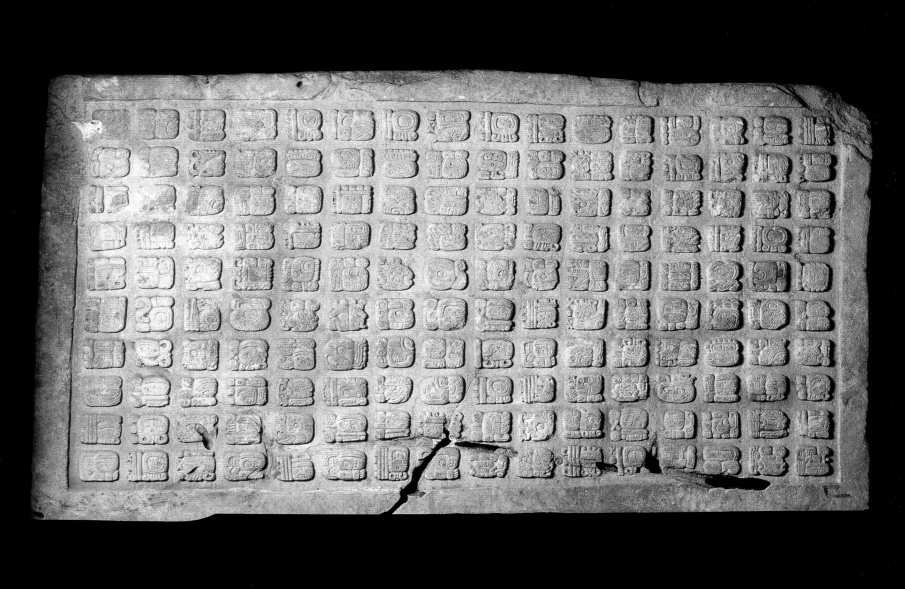

70

Panel describing a king's
pilgrimage to the sea
circa AD 799
Cancuen region, Guatemala
Catalogue 62

1

Most inland Maya never saw the Caribbean or the Gulf of Mexico. Yet, this limestone wall panel, of unknown provenance but certain to have come from the area of Cancuen, Guatemala, suggests that kings could and did. Carved by the same sculptor responsible for Cancuen Panel 3 (plate 20), the inscription recounts a dynastic tale that spans the years 652–799. A missing panel – most likely still at the unknown site from which this sculpture came – began the story. The end of the text, composed of 160 glyph blocks in an exceptional state of preservation, situates Cancuen within a larger geopolitical setting, referring to an overlord named Yuknoom Ch'e'n from the great city of Calakmul, Mexico. Born in 600, acceding to power in 636, this king operated as a strongly intrusive force in most of the Maya region during his fifty-year reign. The panel records that he presided over an unknown event in 652, and the area of Calakmul itself was invoked in the following passage, in connection with the death of a ruler, perhaps from Cancuen. On December 9, 656, Yuknoom Ch'e'n then supervised the accession of a Cancuen ruler. A variety of patron gods, including the "5 Stingray God" and a version of the Rain God, Yaxha' ("New Rain") Chahk, also "witnessed" this ritual. That the lord came to the throne on the day sign "lord," *ajaw*, suggests special emphasis, as though the king represented a new dynasty or royal line.

The pacing of the story then slows. On March 21, 657, the Cancuen ruler arrived at a hilly or mountainous location, *Makan Witz*, where he is said to be a "giver" (*ak'noom*). Another person accompanied (*ani*) the king on this ceremonial route. By August 25, 657, in a crucial passage, the ruler arrived (*huli*) at a place characterized in couplet form by four expressions that, by Maya poetical convention, describe something in complementary ways. The first is a location linked to foliage. The second is unclear, but the third and fourth are highly revealing: *? nahb 3 ahk peten ? yohl ahk*, "within/inside the pool, the 3 turtle island, within/inside the heart of the turtle."

The passage may describe a metaphoric journey, or one to local shrines. However, the cosmic expressions, all connected to the primordial sea, along with references to turtle islands and a pool, raise the possibility that the new ruler, perhaps seeking further legitimization, made a pilgrimage to the sea following his enthronement. The time from his accession in December to his arrival in August could reflect the actual duration of walking through foreign kingdoms from Cancuen to the hilly massif in Belize known as the Maya Mountains, and finally on to the Caribbean. The king might also have traveled from Cancuen to the Sierra Lacandon, another area of broken hills and valleys, to the Tabasco plains and the Gulf of Mexico. The Maya had no beasts of burden. Other than walking, a sedan chair carried slowly on human shoulders would have been the only conveyance available.

This panel thus provides tantalizing clues that Maya kings visited the sea and that such pilgrimages strengthened what might have been weak or questionable claims to royal thrones. The final passages on the panel record another accession at Cancuen under the patronage of Yuknoom Ch'e'n and culminate in the commissioning of the panel itself, in 799, to mark the tomb of the second lord to accede at Cancuen under this influential lord of Calakmul. The Cancuen ruler who ordered up this mortuary panel was Tajchanahk, "Torch-Sky-Turtle," the same ruler featured on Panel 3. – SDH

References: Fahsen and Jackson 2003, pp. 899–900; Guenter 2002, pp. 8–9; Martin and Grube 2008, pp. 110–11.

Figure 1. Glyphic text describing the Cancuen ruler's pilgrimage to the sea on plate 70. Drawing by Nick Carter.

WHERE EARTH AND SKY M
THE SEA IN ANCIENT AND
MAYA COSMOLOGY

KARL A. TAUBE

EET:

CONTEMPORARY

All encompassing, the sea surrounds and defines the Maya world. Not only do its waters extend beyond all horizons, but they also underlie and sustain the earth. The shifting of this floating world is the cause of earthquakes, landslides, and cataclysmic floods. As water underlying the earth, the sea relates to the Underworld, with cenotes, lakes, and streams being portals to this dark and fertile region. In Maya thought, the Underworld and the forest wilds are interconnected concepts: both distant and dangerous realms inhabited by spooks and demons. At the perimeters of the world, the sea also is a realm of awe-inspiring and threatening supernatural powers, including tree-ripping hurricanes and gigantic serpents of the final deluge. Although a place of danger, the sea is also a source of precious goods and forces of life and fertility. The eastern Caribbean is of special importance, as it is not only the daily birthplace of the sun, but also the creator of clouds and wind that bring the spring and summer rains. Important vehicles for the Sun God, rain, and ancestral beings are supernatural sea serpents that carry such forces and elements into the sky.

The Maya concept of the eastern sea as the source of light, abundance, and riches extended to their contemporaries in central Mexico, including the great ancient metropolis of Teotihuacan (circa 250–600). In fact, it is likely that from the perspective of central Mexico, the Maya were the people of this magical eastern realm of supernatural power, beauty, and wealth. By no means a lost ancient tradition, native conceptions of the sea continue to this day among Maya and other peoples of Mesoamerica. In addition, recent and present Maya traditions concerning the sea also exist among distant cultures such as that of the ancient Aztec, and contemporary cultures of western Mexico and the American Southwest, indicating that these shared concepts existed long before the Spanish arrived on the eastern shores of Veracruz in 1519.

The four-sided world and the earth-crocodile Among both the ancient and contemporary Maya, there is more than one conceptual model of the earth and its relation to the sea, but in all cases the sea surrounds terra firma. A widespread fundamental belief is that the world is four-sided, a concept that relates directly to human habitation. The intercardinal points of this cosmic square commonly allude to the four corners of a house and the maize field, or *milpa*. Directional trees are an important part of this model, but although ancient Maya texts describe them in the cardinal points, actual structures and fields are never oriented in this fashion. Rather, the sides denote the world directions, as is graphically portrayed in the Early Classic Tomb 12 from Río Azul, Guatemala, which on its four walls displays the glyphs of the directions in their correct orientation.[2] The colonial Yukatec *Ritual of the Bacabs* refers to four shores as well as lagoons, each with its own directional color. Similarly, in modern Yukatek belief, the sea surrounds the world on four sides: "each 'edge of the earth' has a form of a beach."[3] The contemporary Ch'orti and Tzotzil Maya also conceive of the world as square with the sea at its four sides.[4]

The four-cornered world has its zoomorphic corollary: a crocodile of cosmic proportions with its four limbs extended to the intercardinal points. In Late Postclassic central Mexico, this being was known as Cipactli, or "spiny one," referring to its rough back and tail, which resemble mountain chains extending over the earth. In Aztec mythology, this animal was slain by the gods Quetzalcoatl and Tezcatlipoca to create the world, with one portion of its body forming the earth and the other the heavens. The sixteenth-century *Popol Vuh* of the K'iche' Maya mentions a version of this myth, here concerning a monstrous being known as Sipak, a name clearly derived from the Aztec Cipactli. Capable of creating mountain chains overnight, Sipak was eventually bested by the Hero Twins, who buried him under a great mountain. In addition, early colonial Yukatek Maya accounts describe the mythic crocodile Itzam Kab Ayin, sacrificed to create the world after the flood.[5] A recently excavated mural from Mayapan graphically portrays this episode, with a bound and speared crocodile floating

THE WATERS OF THE CENO CONNECTED TO THE WATE AND FROM THESE WATERS EVIL AND GOOD. CHAN K' OM MAYA

in water with other sea creatures (figure 1). An inscribed platform from Temple XIX at Palenque indicates the presence of this myth still earlier among the Late Classic Maya. David Stuart notes that the text describes the decapitation of a creature, which he names the Starry Deer Crocodile. In Classic Maya iconography, the Starry Deer Crocodile commonly appears in sky-bands, indicating its celestial as well as terrestrial significance. A large Early Classic jade ear spool portrays this creature swimming in a rain of precious elements (figure 2). For the Palenque text, the protagonist who slays the Starry Deer Crocodile appears to be GI of the Palenque Triad, a poorly understood deity who probably denotes an aquatic aspect of the Sun God, perhaps the dawning sun rising from the eastern sea.[6]

Dating to shortly before the Spanish conquest, the Dresden Codex features on page 74 a reptilian sky-band with a deer forelimb, probably a Late Postclassic version of the Starry Deer Crocodile (figure 3). As in the case of the Classic-period creature, gouts of water stream from its mouth and body. Below, the old goddess Chak Chel pours water from a jar and a black god with an owl headdress – probably God L – brandishes weapons. The accompanying text mentions a black sky and a black earth, and it is generally believed that this scene concerns the cosmic flood myth. A roughly contemporaneous mural from Tulum features a downward-facing crocodile with streams of water falling from its body, clearly a portrayal of the deluge (figure 4). Dresden page 74 introduces the new year pages, which in part refer to the erection of four directional world-trees, each with its own specific color, offerings, and gods. The introductory flood

1

2

Previous spread. Aerial view of cenotes in Mexico; and Brick with a crocodile (plate 73).

Figure 1. Detail of a mural portraying a bound and speared crocodile and other creatures in the sea, Late Postclassic period, Mayapan, Mexico. Drawing by Karl A. Taube.

Figure 2. Incised jade ear spool with the Starry Deer Crocodile swimming in a rain of precious elements, 400–500. Drawing by Karl A. Taube.

TE ARE MYSTERIOUSLY

RS OF THE SEA,

ARISE THE WINDS,

CCOUNT[1]

scene and new year pages concern the aforementioned creation myth of the world crocodile, Itzam Kab Ayin. Accounts in the colonial Chilam Balam books of Chumayel, Mani, and Tizimin of the Itzam Kab Ayin myth describe the setting up of the four directional world-trees – and thus the four-sided world – following the flood.[7]

In the Dresden Codex, the celestial flood crocodile appears in relation to the four directions pertaining to the 365-day calendar of the vague solar year. Among the Classic Maya, a very similar crocodile appears in relation to a still grander calendrical event, the beginning of the present Long Count cycle in 3114 BC or 13.0.0.0.0 4 Ajaw 8 Kumk'u. The Late Classic Vase of the Seven Gods illustrates this episode in the context of the Calendar Round date 4 Ajaw 8 Kumk'u, corresponding to the beginning of the current Long Count cycle. The vase portrays the smoking merchant deity, God L, seated in a structure facing six other gods (Martin, pages 161–62). The roof of this building is in the form of a crocodile atop an explicit water-band (figure 5). At its rear is another water element, the *Imix* sign, one version of which serves as the glyph for water. The creature wears a "death collar" ruff and faces a curtain of eyeballs and crossed bones – all elements denoting death and the world deluge. The composition of a watery crocodilian "roof" atop God L is notably similar to the aforementioned Dresden Codex flood page. In Classic Maya texts, the principal theme of the 4 Ajaw 8 Kumk'u episode is the three-stone hearth-place, the pivotal center of the four-sided cosmic house. A vase with a remarkably similar portrayal of the same mythic episode shows a four-sided hearth, clearly alluding to the house model for the world (figure 6). One side of the vase features God L, and as with the Vase of the Seven Gods, he smokes a cigar

while seated within a structure. The roof of this building again displays the crocodile with the water sign at its loins. Moreover, like in the Vase of the Seven Gods, the creature is furry and has a deer ear; it is likely that both are versions of the Starry Deer Crocodile.

One of the rare references to the 4 Ajaw 8 Kumk'u event in Late Classic Maya inscriptions appears in the Tablet of the Temple of the Cross at Palenque, which features GI as the principal protagonist. David Stuart notes that the interior shrine and possibly the entire temple were in part termed "6 Sky house," with one portion of the name remaining undeciphered. He further mentions that a mythic version also appears in the temple text in relation to the 4 Ajaw 8 Kumk'u event: "the same '6 ? Sky' house is an important location in the mythical narrative, naming a certain temple that was established in the north soon after the era creation day on 13.0.0.0.0 4 Ajaw 8 Kumk'u. The Temple of the Cross and its shrine are a conscious reproduction of that ancient celestial locale.[8] The Tablet of the Cross text mentions the three-hearthstone place roughly a year and a half after 4 Ajaw 8 Kumk'u, along with the celestial descent of GI and the creation of the 6 ? Sky house, which is also named "the Eight GIs House." Stuart suggests that the four exterior cornices of the Temple of the Cross may have portrayed eight GI figures brandishing arms. For the relatively intact north and west façades, they are atop massive, cosmic crocodiles (figure 7). Although not the Starry Deer Crocodile, the creatures are clearly aquatic and have fish nibbling at the sides of their heads. In addition to the water crocodiles on top of the roof and the 4 Ajaw 8 Kumk'u reference, the

Figure 5. Detail of a crocodile with death elements atop a water-band from the Vase of the Seven Gods, Late Classic period, Naranjo region, Guatemala. On loan to The Art Institute of Chicago.

Figure 6. Crocodile with a "death collar," from the Vase of the Eleven Gods, Naranjo region, Late Classic period, Guatemala. Private collection.

Figure 7. The west and north roof façades of the Temple of the Cross, Late Classic period, Palenque, Mexico. Drawing by Karl A. Taube.

Figure 3. Detail of the saurian sky-band with a deer leg from page 74 of the Dresden Codex, 1250–1350. Sächsische Landesbibliothek, Dresden, Germany. Drawing by Karl A. Taube.

Figure 4. Detail of the saurian creature with rain from a mural at Tulum, 1000–1100, Quintana Roo, Mexico. Drawing by Karl A. Taube.

3

4

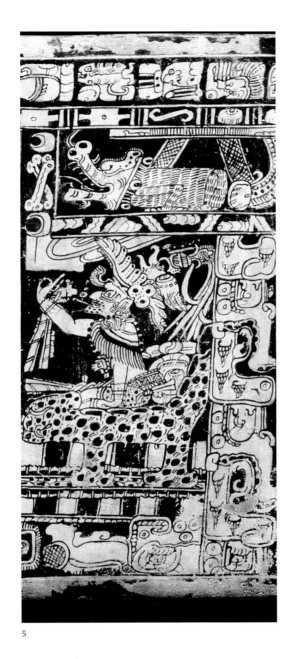

5

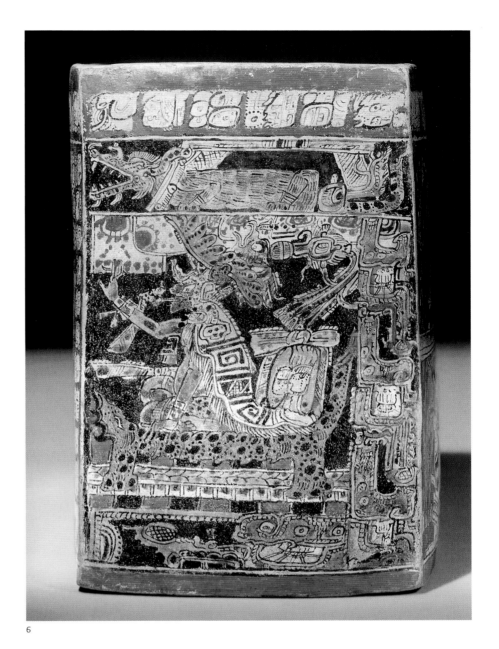

6

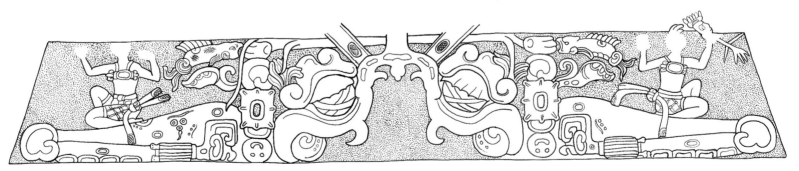

7

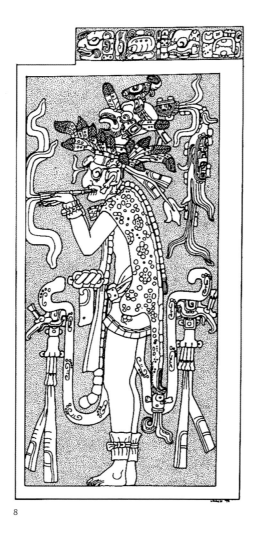

8

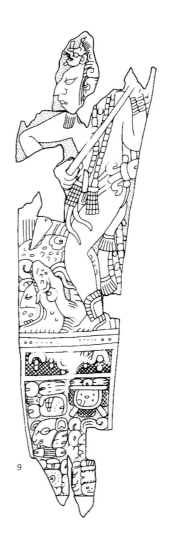

9

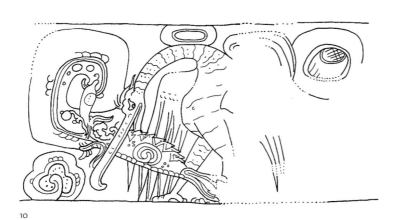

10

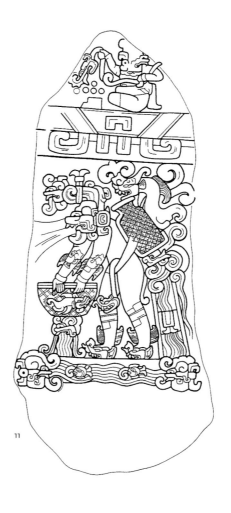

11

Temple of the Cross shares yet another striking trait with the Vase of the Seven Gods and Vase of the Eleven Gods: the smoking God L prominently portrayed on the right side of the interior (figure 8).

The supernatural act of fishing Along with the slaying of the cosmic crocodile, Classic Maya scenes also portray gods spearing a large fish frequently displaying serpent attributes (figure 9).[9] Although crocodiles can appear with piscine features, including fish tails, in Classic Maya art, the spearing scenes are probably not versions of the Itzam Kab Ayin myth but rather illustrate supernatural acts of rain-making. A Late Classic incised vessel from Tikal portrays a heron biting a serpent-headed fish spewing a volute of water from its mouth, with floating *Imix* water signs hovering in the background (figure 10). A number of fish-spearing scenes feature the Rain God, Chahk, as a main protagonist. Dating to roughly the first century BC, Izapa Stela 1 portrays an especially early scene of Chahk fishing, in this case lifting a fish in a net from the sea; another fish resides atop a large creel on his back (figure 11). Streams of water descending from Chahk heads on both fish indicate that fishing symbolically constitutes a rain-making act. In fact, the Classic Maya glyph for conjuring, or *tzak*, is a hand grasping a fish. In colonial Yukatek, *tzak* specifically means to conjure clouds or rain. A carved vase portrays an Early Classic version of the Chahk fishing episode in which fish hover or fly around the god, who grasps a long pole attached to a circular net (figures 12, 13). This vessel constitutes an important link between the Izapa stela and the Late Classic scenes of fishing Chahks on the incised bones from Tikal (figure 14).

These distinct mythic episodes, the slaying of the world-crocodile and the spearing of the supernatural fish, both denote the sea as a realm of bloody and violent conflict. Indeed, the sea's very taste evokes the saline flavor of blood. For one Late Classic scene, blood from the speared serpent fish falls into a pool of red water, as though it were a sea of blood (plate 80). A similar concept is documented for the contemporary Ch'orti: "And they say that there was one sea that was pure blood, perfectly red."[10] In addition, according to a modern Yukatek Maya curer from Tepich, Yucatan, water constitutes the cosmic blood of the earth:

The water in the earth is like the blood in your veins. Your soul is your wind…. It is said that water is the blood of the earth. When you want to make a well, you must dig a well to reach the water inside the earth. Thus you reach the veins of the earth. It is like our body: the earth has a lot of veins where there is water, the blood of the earth.[11]

In native Maya thought, such underground bodies of water are inextricably linked to the sea.

As suggested by the Cipactli myth, the Aztec also related the sea to bloody cosmic battles. During the slaying of the earth-monster, Cipactli devoured the foot of Tezcatlipoca, as illustrated in the Borgia Codex (page 51) and the Vaticanus B Codex (page 26). Whereas the Borgia mon-

Figure 8. Panel depicting God L smoking, from the Temple of the Cross, Late Classic period, Palenque, Mexico. Drawing by Linda Schele, © David Schele, courtesy the Foundation for the Advancement of Mesoamerican Studies, Inc., www.famsi.org.

Figure 9. Carved bone depicting a human figure dressed as Chahk spearing a supernatural fish, Late Classic period, Aguateca, Guatemala. Drawing by Stephen D. Houston.

Figure 10. Detail of an incised vase depicting a heron with floating water signs catching a serpent fish, Late Classic period, Tikal, Guatemala. Drawing by Karl A. Taube.

Figure 11. Izapa Stela 1 depicting Chahk fishing atop a probable sea as an act of rain-making, Late Preclassic period, Mexico. Drawing by Ayax Moreno, courtesy of the New World Archaeological Foundation.

Figure 12. Carved vase depicting Chahk with a net and pole surrounded by fish, Early Classic period.

Figure 13. Detail of figure 12. Drawing by Karl A. Taube after a photograph by Justin Kerr, K7443.

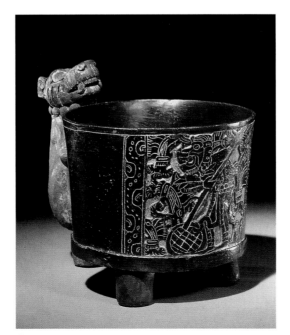

12

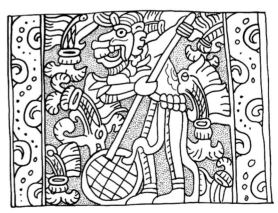

13

ster is clearly a crocodile, the Vaticanus B creature is a shark (figures 15, 16). One Aztec monument portrays Itzpapolotl, a fearsome goddess of warfare and discord, along with a sacrificed warrior and bleeding severed heads, limbs, hearts, and other viscera, all floating against a background of un-dulating bands of water, much as if the sea were the field of battle (figure 17). The format of the floating figures and body parts is notably similar to the Mayapan mural portraying a speared shark, a probable plumed ser-pent, and the bound earth-crocodile in the undulating sea (figure 1). Aside from illustrating the slaying of Itzam Kab Ayin, this mural may depict the mythic domination of creator gods over fierce, primordial creatures of the sea.

In the aforementioned Yukatek account, two human life essences are compared to greater cosmic principles, with blood linked to terrestrial water and breath to celestial wind. In both Mesoamerican and American Southwest belief, rain is ultimately terrestrial in origin, with water carried

Figure 14. Detail of a carved bone depicting Chahks engaged in fishing, Late Classic period, Burial 116, Tikal, Guatemala. Drawing by Annemarie Seuffert.

Figure 15. Detail of a crocodile biting off the foot of Tlahuizalpantecuhtli, the God of the Morning Star, from page 51 of the Borgia Codex, circa AD 1500, Puebla, Mexico. Vatican Library, Vatican City.

Figure 16. Detail of a shark consuming the foot of Piltzintecuhtli, from page 26 of the Vaticanus B (3773) Codex, circa AD 1500, Choluli region, Puebla, Mexico. Vatican Library, Vatican City.

Figure 17. Detail of a flower and dismembered human body parts atop an undulating sea from the Altar of Itzpapolotl (the Obsidian Butterfly), circa AD 1500. Museo Nacional de Antropología, Mexico City. Drawing by Karl A. Taube.

Figure 18. Zoomorph P with the earth-crocodile exhaling a pair of Chahks with outpouring jars from the corners of its mouth, Late Classic period, Quirigua, Guatemala.

Figure 19. Detail of figure 18. Note the spoked conch form of Chahk and the breath volute detail. Drawing by Karl A. Taube.

upward in jars by rain gods or exhaled as cloud-bearing winds from the earth.[12] For ancient Mesoamerica, the earth-crocodile exhaled rain-bringing wind and clouds into the sky. Quirigua Zoomorph P portrays the cosmic crocodile exhaling a pair of volutes containing Chahk figures embracing outpouring vessels, a graphic portrayal of the earth exhaling wind and rain into the sky (figure 18). For Zoomorph P, the volutes at the corners of the crocodilian mouth are knobbed, denoting them as cross-sectioned conch, a widespread symbol of breath in ancient Mesoamerica.[13] In ancient Maya art, the earth-crocodile commonly displays a conch in profile on its snout, a convention denoting both wind and its origin from the sea, the unequivocal source of these great shells. Although the earliest known example of the crocodilian conch snout appears on Stela 25 from Late Preclassic Izapa, the cross-sectioned conch as a breath element is known far earlier in the Maya region. Dating to the fifth century BC, Kaminaljuyu Stela 9 portrays a hu-man figure exhaling an explicit conch breath element while standing upon the earth-crocodile (plate 75). Only slightly earlier, Olmec-style petroglyphs from Chalcatzingo, Morelos, depict similar crocodiles with sharply up-turned heads exhaling pairs of breath volutes and rain clouds into the sky.

The earth-turtle and the round world On top of the primordial sea with its four limbs extending to the intercardinal points, the earth-crocodile relates closely to the concept of the cosmos as a four-sided house. Possibly for this reason, it suffers the act of cosmic dismemberment, much as raw materials such as wood, thatch, and stone are cut and fashioned to create a structure. However, both the ancient and contemporary Maya have a notably different model of the world, this being a disk or rounded mound surrounded by the sea.[14] In terms of the sea or the flat plain of Yucatan, this view corresponds closely to the perspective of the individual, who rather than seeing corners at the far distance, views in turning only an encircling edge bounded by the sky. In Yukatek, *pet* signifies a circular or round form, and in early colonial dictionaries *peten u pepetacil cah* is

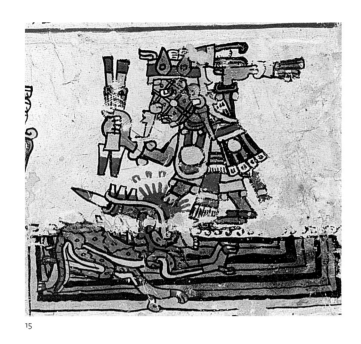

15

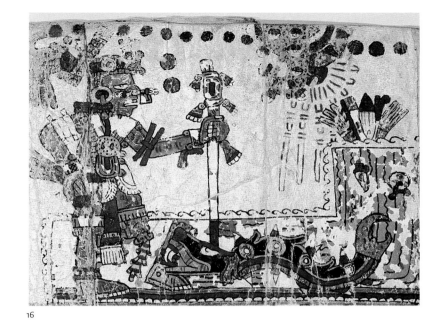

16

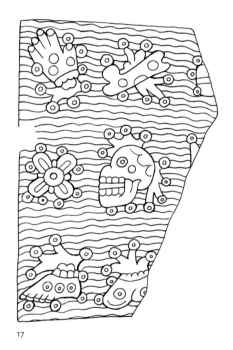

17

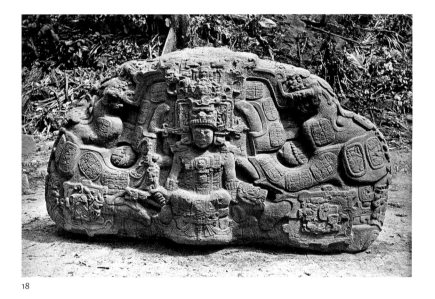

18

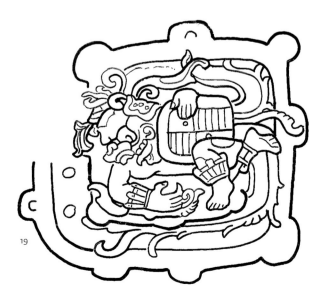

19

glossed as "roundness of the world." Clearly enough, the term *peten* for the central Maya lowlands derives from this concept of a round world surrounded by the sea. Among the modern Lacandon inhabitants of this region, the earth is conceived metaphorically as a round tamale or inverted gourd bowl. Virginia D. Davis describes the Lacandon world similarly: "The circular plane of earth is surrounded by ocean (*k'ak'nah*)."[15]

Among the ancient Maya, a sea turtle surrounded by ocean embodied the concept of the circular or semispherical earth.[16] Stephen D. Houston has indicated that a Late Classic text attributed to Cancuen refers to this turtle in relation to the glyph for *pet*, depicted as a disk with a central hole (figure 20). The text also mentions the phrase within *yohl ahk* meaning "heart of the turtle." The reference to the turtle as *pet*, or round, recalls the colonial and contemporary allusions to the earth as a great disk. In contrast to the threatening crocodile slain to create the ordered world, the circular turtle seems to have suffered no such dismemberment in ancient Maya myth, with only the carapace pierced to allow for passage between the watery Underworld, earth, and sky. In Classic Maya scenes, the figure that emerges out of the central fissure of this earth-turtle is the Maize God. Surrounded by the sustaining waters of the sea, the Maize God appears as the pivotal *axis mundi* linking the three levels of the cosmos through the center of the earth.

Like the cosmic crocodile, the earth-turtle also relates closely to calendrical cycles. A stone turtle from Mayapan features thirteen twenty-year *k'atuns* around its carapace, referring to the roughly 256-year *k'atun* cycle. A number of Classic Maya monuments portray turtles with large *k'atuns* and other period ending dates on their shell. A Late Classic altar from El Peru features a ruler seated in a bicephalic turtle (figure 21). As in the San Bartolo mural, the carapace is in the form of a quartrefoil, indicating the lord is within its cavelike interior. In fact, the accompanying text states that he is in the heart or center of the turtle, *yohl ahk*. The text begins with the Calendar Round date of 2 Imix 4 Pop, Imix being the first day name of the 260-day cycle, and Pop the first month of the 365-day year. The text then mentions that the ruler in the turtle finishes his completion of fifty-two years, that is, a complete Calendar Round cycle. In this remarkable text, the turtle is discussed not in relation to the completion of *k'atuns* in the Long Count calendar but in terms of the completion of the fifty-two-year Calendar Round cycle.[17]

In both the four-sided and circular worlds, the four directions are a dominant presence in Maya thought. A round map, or *upepet tz'ibil*, in the *Book of the Chilam Balam of Chumayel*, portrays Yucatan as a disk sectioned into four quarters by a cross oriented to the four directions (figure 22). The pre-Hispanic Maya earth-turtle can also appear with a cross atop its carapace, thereby dividing the world into four quarters (figures 23, 24). Whether in circular or square models of the world, directional colors as well as surrounding seas are of critical importance. Among the modern Ch'orti, there are bodies of water at the four directions, each inhabited by powerful horned and feathered serpents known as the Chicchans: "The four sky Chicchans live in lakes, each inhabiting one in his own direction."[18] John Fought notes that according to his Ch'orti source Isidro González, there are four oceans with their own directional colors: "These colored seas are obviously a vestige of the ancient Maya color-directional symbolism … there are said to be four seas: milk white, blood red, blue-green and pitch black."[19] Similarly, the colonial Yukatek *Ritual of the Bacabs* specifically refers to four seas of world directions and colors, these being red to the east, white to the north, black to the west, and yellow to the south. In

Figure 20. Detail of a stone panel (plate 70) with a phrase referring to the Three Turtle *pet*, meaning "disk" or "island" as the heart or center of the turtle (*yohl ahk*). Drawing by Karl A. Taube.

Figure 21. El Peru altar portraying a ruler within a quatrefoil turtle, Late Classic period, Guatemala. The accompanying text refers to his completion of fifty-two years in relation to the Calendar Round date 2 Imix 4 Pop at the "heart of the turtle" (*tuyohl ak*). Drawing by David Stuart.

20

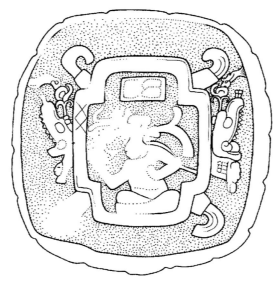

21

another passage, four shores with the same color directional orientation are mentioned in relation to ocean estuaries, *uk'umil*.[20]

The meeting of earth and sky Rather than an ethereal element gently allowing the flow of celestial elements through the air, the sky in native Maya thought is a giant solid bowl atop the earth at the edge of the sea. Thus, in contemporary Yukatek belief, the rain-bringing Chahks first emerge through a small hole in the wall of the eastern sky.[21] In a contemporary Achi Maya version of the Sipak myth, Sipak escapes certain death by escaping through the horizon "crack" between earth and sky.[22] Formed of a bowl with another inverted on top, ancient Maya "lip to lip" cache vessels are graphic models of the sky bowl on top of the circular earth. Such caches frequently contain jade and shells oriented to the cardinal or intercardinal points. For one Early Classic cylindrical cache vessel from Copan, a jade image of the Maize God sits as the central *axis mundi* in the middle of a complex directional composition formed of jades and *Spondylus* shells (plate 89). This concept of the sky as a bowl on top of the earth is very much present among contemporary highland Guatemala Maya, who view the cosmos as an inverted celestial bowl above the earth floating on the sustaining sea.[23] A Ch'orti Maya account recorded by John Fought vividly describes the joining of the sky and sea at the edge of the world:

where the edge of the world remains, which we live on, and at the edge, they say, there is just water – which is called – the sea of tar. Because

they say that it is the sea of tar because they say that There – there they join, the edge of the world and sky. They say that The – sea of tar which we know where the sky is put together with the world, they say it glistens beautifully.[24]

According to one Yukatek religious practitioner from Yalkoba, virtually in the center of the Yucatan peninsula, we are "tied or locked" rather than "glued" to the edges of the world:

the *hmeen* believes that way *k'ala'ano'on*, "we are bounded here," and that in any of the four directions that we might travel, we will eventually reach *playah* or *k'amnab*, "the beach." This boundary between the land of the earth and the *saantoh ha'* or "sacred water" that he believes to surround it on its four sides, which is described as a[s] *ch'o'och'*, or "salty," is also made equivalent then to the boundary between the earth and the sky.[25]

Existing far before the sixteenth-century contact with the Western world, the concept of the earth seas bounded by an inverted celestial bowl is very much present among contemporary Maya peoples. The cosmic model of the circular earth floating on the sea with a solid celestial bowl above is wholly Mesoamerican, with no ready comparisons with Spanish thought. That this same world model is documented for the contemporary Zuni of New Mexico suggests that this is a supremely basic and ancient cosmogram for this region of the world. To the Zuni, the sky lies atop the earth as a stone bowl with exit holes in the east and west for the sun's "houses."[26] Furthermore, the underlying sea supporting the round earth and celestial realm is also fully present:

The earth is circular in shape and is surrounded on all sides by ocean. Under the earth is a system of covered waterways all connecting ultimately with the surrounding oceans. Springs and lakes, which are always regarded as sacred, are the openings to this system. On the shores of the encircling earth live the Uwanami, or rain makers. They have villages

Figure 22. Round map depicting Yucatan as a quartered disk, from page 79 of the *Book of the Chilam Balam of Chumayel*. Drawing by Karl A. Taube.

Figure 23. Stone turtle with a cross on its back, Late Postclassic period, Mayapan, Mexico. Drawing by Karl A. Taube.

Figure 24. Detail of a vessel with a turtle carapace sectioned into quarters, Early Classic period, Kaminaljuyu, Guatemala. Drawing by Karl A. Taube.

22

23

24

in the four world quarters. The underground waters are the home of Kolowisi, the horned serpent.[27]

The Uwanami rain spirits at the world directions have their clear corollaries in terms of Mesoamerican rain gods of the four directions, including the directional Chahks present among the contemporary Yukatek Maya. In addition, there are the Zuni directional plumed serpents of four colors in the surrounding seas: "In the oceans live the yellow, blue, red, and white *kolo'wisi*, four giant plumed serpents who are capable of causing a flood."[28] These beings clearly relate to the four directional Ch'orti Chicchan serpents, which are commonly plumed and horned. Indeed, plumed and horned serpents are among the most prevalent supernatural beings of the seas in native Mesoamerican belief.

In Maya belief, terrestrial and ocean waters are a single, dynamically connected entity. In part, this clearly relates to the presence of similar creatures in both realms, including fish, crustaceans, and mollusks. In addition, particularly large and fearsome beings inhabit both waters, including sharks that can extend well into the interior of great rivers and crocodiles that readily inhabit both marine and inland waters. Writing some sixty years ago, Alfonso Villa Rojas noted that among Kruzo'ob Maya of Tusik' there was great concern that if waters of the local lake of Chichank'anab', or "little sea," would reach the ocean, there would be a world-ending deluge.[29] As with the sea pilgrimages of the contemporary Huichol of western Mexico, the ceremonial linking of terrestrial and ocean water was probably a major focus of pilgrimage and rain-making ritual among the ancient Maya.

Modern Yukatek Maya meteorological thought is profoundly interested in the *sayab'*, a mysterious current of underground water that

Figure 25. Detail of a pair of intertwined serpents with floral bodies carrying gods out of the sea from a mural in Structure 16, Late Postclassic period, Tulum, Mexico. Watercolor painting by Felipe Dávalos.

extends like a pulsing artery of the earth westward from the eastern Caribbean Sea. The Yukatek term for the life-sustaining *bejuco de agua* or "water vine" for thirsty travelers is *sayab' ak'*, or "*sayab'* vine," alluding to the coursing flow of this body of water. According to accounts from Yukatek informants from Yalkoba, "the source of all water is the underground *sayab'* current." Robert Redfield and Alfonso Villa Rojas noted that according to Maya of Chan K'om, the *sayab'*, and by extension the clouds and wind, derive from the sea: "[t]he waters of the cenote are mysteriously connected to the waters of the sea, and from these waters arise the winds, evil and good."[30] From his research at Yalkoba, Sosa notes that "everything in the sky, including the sun, moon, stars and clouds, and the *sayab'*, or underground water current, all move in a *lak'in* [east] to *chik'in* [west] direction."[31] In addition, the rain gods travel from the east to the west carrying water from the *sayab'*. Writing about the western portion of the Yucatan peninsula, William Hanks also notes the relation of the *sayab'* to the sea:

Below the earth, westward, is a huge body of water which supports the ground and courses through it in the great underground rivers called *saáyab'ó'ob'*. Driven by earthly winds, these feed the wells and cenotes, providing the water that is ultimately sucked up into the sky in a vortex of celestial winds, to then be cast down to earth as rain by the *chaák* rain spirits and their helpers.[32]

The mention of the *sayab'* source to the west contradicts Yukatek accounts from central Yucatan and more eastern Quintana Roo, and this may well relate to the Maya informant's broader description of the east as celestial and the west subterranean, that is, the Underworld realm of the sea.

Just as the underground *sayab'* passes from east to west under the Yucatan peninsula, so too do the rain gods as clouds congregate on the eastern shore to begin the rainy season.[33] Far from being a folk rationalization of rain patterns, this is indeed the case in Mesoamerica. For both the

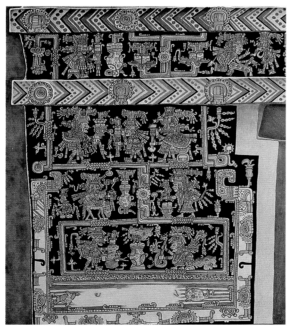

25

Maya region and central Mexico, the rain-bringing winds of the spring and summer derive squarely from the east. In addition, east is also the place of the dawning sun. It is thus not surprising that this direction is widely considered a positive and beneficial realm. According to the Ch'orti: "The east is said to be a good direction and there is some belief that it is the source of all life and good in the world."[34] Among the contemporary Huastec Maya of San Luis Potosí, the eastern sea is identified with the dawning sun, paradise, and the source of beneficial rain.[35] A similar merger of the eastern sea with the dawning sun and paradise is present among the modern Sierra Nahuat of nearby Puebla:

In the east is the place known as *apan*, "the waters," and it is from there that the sun leaves the underworld to begin its daytime journey over the surface of the earth bringing mankind its holy light. *Apan* is a great lake or sea in the underworld that is united in its depths with all the waters of the surface of the world.[36]

For both the Huastec and Sierra Nahuat, this eastern sea is a realm of fertility and abundance where the souls of the dead dwell happily with no want of food, and it is likely that this concept of paradise relates to the Aztec Tlalocan, the watery afterlife realm presided by the Rain God, Tlaloc.

In ancient Maya thought, supernatural serpents were dynamic conduits linking the watery Underworld, earth, and sky, serving as vehicles or roads for the rain and sun gods as well as other deities to rise from the eastern sea into the sky. In many cases, these serpents display quetzal crests on their heads, denoting them as Maya forms of the plumed serpent. The Early Classic Hauberg Stela depicts three deities with the visage of the Sun God as well as an axe-wielding Chahk grasping a serpent rising

into the sky.[37] Late Postclassic scenes in the Madrid Codex and at Tulum portray the rain gods atop feathered serpents, much as in Maya thought today Chahks ride celestial horses. One of the most elaborate scenes pertaining to sea serpents appears in a mural from Structure 16 at Tulum, located only some 328 feet (100 meters) from the eastern Caribbean shore (figure 25). A pair of intertwined serpents ornamented with flowers carry a series of gods on their backs as they rise out of a sea flanked by a pair of zoomorphic mountains. The composition of this scene is much like Takalik Abaj Stela 4, carved some 1,500 years earlier, in which an undulating serpent with the solar *k'in* sign in its coils rises from a pool of water flanked by mountains with wide-open maws (figure 26). This early Maya monument portrays the dawning sun rising with the serpent out of the eastern sea. The flanking mountains with blossoms on their brows likely portray Flower Mountain, an eastern paradise related to rebirth and the sun.[38]

An Early Classic vase from Kaminaljuyu depicts a zoomorphic Flower Mountain exhaling a serpent with the seated Sun God in its maw—another portrayal of the sun emerging out of Flower Mountain (figure 27). Similarly, a finely incised Late Classic vase at the American Museum of Natural History, bears an elaborate scene of a feathered serpent carrying a solar disk in its mouth and the Moon Goddess on its back.[39] The serpent is exhaled out of the earth-crocodile placed within a T-shaped form marked with eyeballs denoting darkness (figure 28). The two skeletal heads at both sides of this dark opening have plumelike crests, identifying them as the sea creature Nicholas Hellmuth termed the Tubular Headdress Monster.[40] These heads denote the T-shaped element as the eastern sea from which the serpent emerges.

Among the contemporary Tzotzil Maya of San Andrés Larrainzar, the dawning sun follows the Morning Star, a great feathered serpent, as it rises into the sky. Juan de León described a similar concept for the K'iche' Maya, for whom a plumed serpent carries the sun into the sky in its open maw.[41] An Early Classic stucco-painted vessel portrays a notably

Figure 26. Detail of a serpent carrying a four-petaled solar *K'in* sign out of a pool of water flanked by mountains with flowers on their brows from Takalik Abaj Stela 4, Late Preclassic period, Guatemala. Drawing by Karl A. Taube.

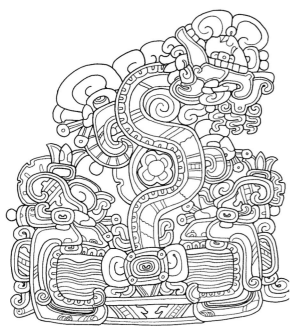

26

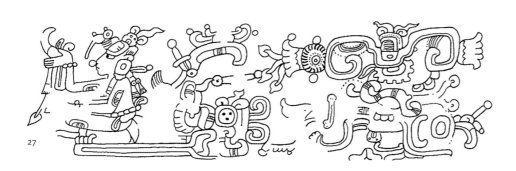

27

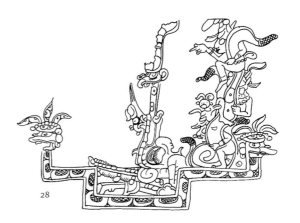

28

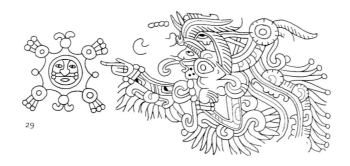

29

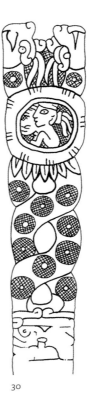

30

similar theme. Although its style is essentially pure Maya, this vessel was probably painted at distant Teotihuacan, which frequently emulated the traditions of the Maya to the east.[42] Both sides of this remarkable vase portray an avian Maya Sun God in the mouth of a rising plumed serpent marked with flowers on its body and a large earlike extension behind its head (figure 29). The sun deity is accompanied by his name glyph, a human face surrounded by four jade elements, a common convention for portraying the sun in Late Postclassic Mesoamerica. In highland Mexico, depictions of plumed serpents carrying the sun continued into the Late Postclassic period. A carved bone from Tomb 7 at Monte Alban portrays a pair of horned and feather-crested serpents carrying the sun on their backs (figure 30). According to Alfonso Caso, the serpents are carrying the sun skyward out of the earth-monster, which appears as the eroded element at the base of the scene.[43] This earth motif is a stylized maw, again the eastern opening from which the dawning sun emerges.

For both the Maya and Teotihuacan, plumed serpents often appear with flowers, emerging from them or with them as a backdrop or atop their bodies or on their tails. This theme clearly relates to the "flower road" motif described by Jane Hill for Uto-Aztecan – speaking peoples of central Mexico and the greater Southwest, including the Aztec, Huichol, and Hopi. Hill notes that the flower road represents the celestial road of the sun, a concept very much present among the contemporary Tzotzil Maya of San Andrés Larráinzar, who believe that the sun travels on a path covered by blossoms.[44] Among the ancient Maya, the floral road also related to the watery Underworld, but again with clear solar significance. The basal register of the Early Classic Stela 1 of Tikal features a solar disk with the floral road below an undulating band of water probably denoting the sea. The bowl and lid of the Liverpool Vessel also display this chain of flowers below the sea (plate 92). The lid of an Early Classic bowl portrays the Sun God paddling a canoe above the same border of flowers, which in this case emanate undulating and rising scrolls denoting mist and evaporation. The fish on the god's back establishes him as a fisherman, again denoting *tzak*, the act of conjuring clouds and rain (plate 66). The daily dawn event of mist rising out of lakes and rivers vividly illustrates the power of the sun in pulling clouds and moisture into the sky. For the Tzotzil Maya, the heat of the rising sun entirely evaporates the eastern sea, with the same occurring when it sets in the west. At the first dawning and setting of the sun, the flood waters covering the earth disappeared, and because the two seas are emptied every day, the world is never flooded by rivers pouring from the mountains.[45] Clearly, along with the rain deity and feathered sea serpents, the Maya Sun God is also closely linked to the creation and generation of rain out of the sea.

Figure 27. Detail of a vase with the Sun God in the maw of a serpent emerging out of a zoomorphic Flower Mountain, Early Classic period, Kaminaljuyu, Guatemala. Drawing by Karl A. Taube.

Figure 28. Detail of a finely incised vase with a world-crocodile and three climbing sun gods within a T-shaped water sign, Late Classic period. American Museum of Natural History, New York. Drawing by Karl A. Taube.

Figure 29. Detail of a Maya-style vase with a Maya avian Sun God and a plumed serpent marked with blossoms, Early Classic period, Teotihuacan, Mexico. Museum of Anthropology, University of Arizona, Tucson. Drawing by Karl A. Taube.

Figure 30. Carved bone with a pair of plumed serpents rising out of the maw of the earth-monster with a solar disk on their back from Tomb 7 at Monte Alban, Mexico, Late Postclassic period. Drawing by Karl A. Taube.

Figure 31. Plumed serpents emerging out of a flower from the west façade of the Temple of Quetzalcoatl, AD 200, Teotihuacan, Mexico. The marine shells denote the sea.

Figure 32. Detail of a bowl with a winged figure wearing a flower necklace and rain drops facing a floral crossroads, Early Classic period. Los Angeles County Museum of Art. Drawing by Karl A. Taube.

Figure 33. Mural fragment depicting the body of a plumed serpent with a flowering plant and flanked by rows of flowers, 600–750, Techinantitla, Teotihuacan, Mexico. Note the band of water-lily flowers at the upper edge. Drawing by Karl A. Taube.

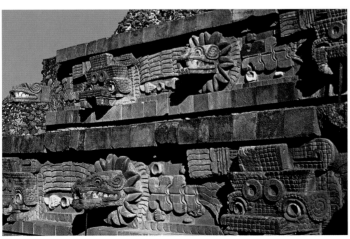

31

32

33

Early Classic Teotihuacan art exhibits a clear interest in both the Maya and the sea. By far the most ambitious Teotihuacan portrayal of the sea appears on the great Temple of Quetzalcoatl, located on the east side of the central Street of the Dead. The richly sculpted tiers on all sides of the pyramid originally featured rising serpents emerging through massive flowers out of a sea laden with marine shells (figure 31). The serpents are covered with plumes of the quetzal, a bird squarely from the Maya region, and this pyramid likely portrays Flower Mountain from where the dawning sun emerges.[46] As with the Classic Maya, flower road was very much present at Teotihuacan, and a number of stucco-painted vases portray this element before a figure scattering drops of rain, the probable Teotihuacan Sun God ascending a celestial flower road (figure 32).[47] At Teotihuacan, plumed serpents also appear with flowers atop or flanking their bodies, probably denoting them as zoomorphic embodiments of the celestial flower road (figure 33).

From Teotihuacan times to the Aztec, butterflies symbolized the souls of warriors who reside in the eastern paradise of the sun. Teotihuacan vessel scenes portray human figures before Flower Mountain with an underlying register of water, a probable reference to the sea (figure 34). Rendered in strong Teotihuacan style, ceramic censers from the Escuintla region of the southern coastal piedmont of Guatemala depict similar figures rising out of water basins while backed by Flower Mountain (figure 35). As in the case of the water-bands at Teotihuacan, these basins may represent the eastern sea portal from which the sun rises. Although the Escuintla region may have symbolized the eastern paradise in Teotihuacan thought, the Caribbean may have been held in similar regard. Located adjacent to the Caribbean shore, a mural from Xelha, Quintana Roo, portrays a Teotihuacan-style warrior wearing a butterfly headdress and wielding a shield and spear thrower (figure 36). Clearly, the concept of the eastern sea has been of great interest to not only the Maya but to more distant regions of Mesoamerica as well.

Figure 34. Detail of a vessel depicting a warrior and a shield with Flower Mountain atop a water-band, Early Classic period, Teotihuacan, Mexico. Yale University Art Gallery, New Haven, Connecticut. Drawing by Karl A. Taube.

Figure 35. Two views of an Escuintla-style censer with a winged figure emerging out of a water basin before Flower Mountain, Early Classic period, Guatemala. Drawing by Karl A. Taube.

Figure 36. Detail of a mural depicting a Teotihuacan warrior with butterfly attributes wielding a spear-thrower and shield, Early Classic period, Xelha, Quintana Roo, Mexico. Drawing by Karl A. Taube.

34

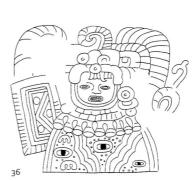

36

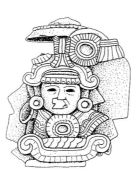

35

1
Redfield and Villa Rojas 1934, p. 116.

2
Freidel, Schele, and Parker 1993, p. 72.

3
Roys 1965, pp. 23, 26–27. For contemporary Yukatek, see Sosa 1985, p. 319.

4
Fought 1972, p. 354. For Tzotzil, see Gossen 2002, p. 1029, n. 5; and Guiteras-Holmes 1961, p. 152.

5
Taube 1993, pp. 69–70.

6
For discussion of the Starry Deer Crocodile and GI, see D. Stuart 2005, pp. 68–75, 161–70.

7
Taube 1993, pp. 72–73.

8
D. Stuart 2006B, p. 111.

9
For other examples of the serpent-fish spearing, see Quenon and Le Fort 1997, figs. 8–11.

10
Fought 1972, p. 354.

11
Jong 1999, p. 306.

12
Schaafsma and Taube 2006, pp. 231–85.

13
Taube 2001, pp. 102–23.

14
Taube 1988, pp. 183–203.

15
For Lacandon conceptions of the world, see Cline 1947, pp. 108–10; and V. D. Davis 1978, p. 19.

16
Taube 1988.

17
Houston, D. Stuart, and Taube 2006, p. 186.

18
Wisdom 1940, p. 425.

19
Fought 1972, p. 433.

20
Roys 1965, pp. 23, 26–27, 64.

21
Redfield and Villa Rojas 1934, p. 116.

22
Shaw 1972, p. 57.

23
Ibid., p. 36.

24
Fought 1972, p. 373.

25
Sosa 1985, p. 23.

26
Tedlock 1979, p. 499.

27
Bunzel 1932, p. 487.

28
Tedlock 1979, p. 499.

29
Villa Rojas 1945, p. 156.

30
Redfield and Villa Rojas 1934, p. 205.

31
Sosa 1985, p. 307.

32
Hanks 1990, pp. 305–306.

33
Villa Rojas 1945, p. 144; Sosa 1985, p. 378.

34
Wisdom 1940, p. 427.

35
Alcorn 1984, p. 85.

36
Knab 2004, pp. 110–11.

37
Schele and M. E. Miller 1986, pl. 66b.

38
Taube 2004, pp. 69–98.

39
Schele and M. E. Miller 1986, pl. 120a.

40
Hellmuth 1987A, pp. 193–98.

41
See Holland 1964, p. 14; and León 1945, p. 45.

42
Taube 2003C, pp. 273–314.

43
Caso and Rubín de la Borbolla 1969, pp. 198–99.

44
Hill 1992, p. 125; for the Tzotzil account of the solar floral road, see Holland 1961, p. 168.

45
Gossen 2002, pp. 27–29, 1028, n. 3; for a similar account for the Tzotzil of San Pedro Chenalho, see Guiteras-Holmes 1961, p. 152.

46
Taube 2004, pp. 88, 90.

47
Taube 2005B, pp. 33–34; and Taube 2006, pp. 153–70.

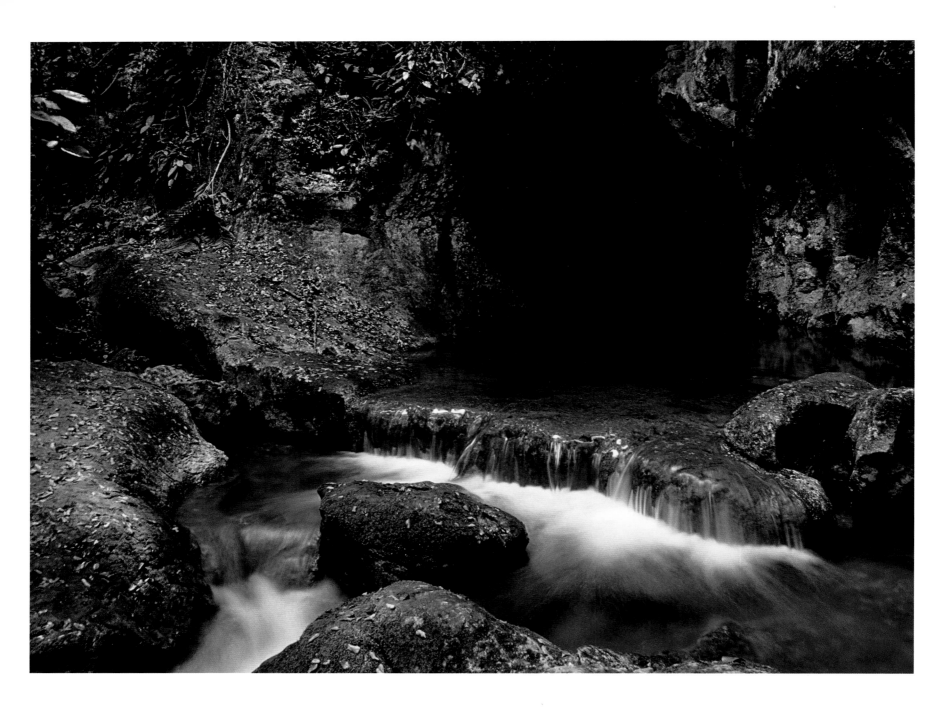

OFFERINGS TO THE RAIN GODS: THE ARCHAEOLOGY OF MAYA CAVES

JAMES E. BRADY

Caves are closely associated with water in the Maya area. Cave passages are formed by water that dissolves the bedrock as it moves to the water table, with the passages serving as conduits for the movement of water and often providing humans access to the water table. The contemporary Maya believe that rain is created by the earth, a sacred and animate entity. The gods form lightning, clouds, and rain within caves, then release them into the sky to provide life-giving moisture.[1] Across the Maya area, traditionalists still conduct ceremonies and leave offerings in caves for rain and a good harvest on May 3, the Day of the Cross (figure 1). Undoubtedly pre-Christian in origin, these rituals are celebrated on this Catholic holy day because of its proximity to the onset of the rainy season. Because of their close association with both rain and the fertility of the earth, caves are generally the most revered features in the Maya landscape.

A fundamental difference between ourselves and the Maya was their use of caves as we would use churches. For the Maya, elements in the natural landscape were of primary importance and human construction was simply a copy of nature. In ancient inscriptions, for instance, the term for human architecture is often a metaphor for hill,[2] and the

Opposite page. Water flowing from the mouth of Actun Tunichil Muknal cave, Belize.

Figure 1. A modern Maya ceremony associated with rain and harvest in Naj Tunich cave, southern Peten, Guatemala.

Figure 2. Cached pots from the Cueva de Sangre (Cave of Blood), Dos Pilas, Guatemala.

sixteenth-century Yukatek Maya used *aktun* ("cave") to refer to both caves and stone buildings. A Q'eqchi' Maya shaman summed up the indigenous view: "For us, this cave is sacred and although other people say that church is a sacred place I know that this cave is important because this is the first temple of the world (*el primer templo del mundo*)."[3] In many Mayan languages, the word for cave translates as "stone house," reflecting the fact that the Maya see caves as the dwelling places of their most important deities. Caves are far more awesome and frightening than churches, however, because they are living, breathing, feeling, and thinking entities.

While these points hint at the central role caves have played in Maya religion, archaeology has been slow to recognize this fact. Systematic investigations of caves have been carried out only during the last two decades. These studies have revealed huge deposits of artifacts. As with excavations in the abandoned urban centers, no artifacts are more common than ceramics (figure 2). What makes cave archaeology exciting is that it is one of the few contexts (tombs are another) in which vessels may be found intact where they were left more than a millennium earlier.

The real story, however, is told in the recovery and analysis of tens of thousands of broken sherds. These attest to the intensive and sustained use of caves over centuries. Many of these sherds are from the most ordinary types of Maya household vessels, but they are distinctive in that their interior surface bears evidence that incense was burned in the vessels. Such burning accompanied virtually all Maya rituals,

but was particularly important in petitions for rain. Because petitions for rain are one of the primary focuses of cave ritual, it is not surprising that activities have tended to be concentrated in wet areas, often around dripping cave formations. These places were frequently too wet to permit incense to be burned except in protective containers. The burning incense gives off huge quantities of thick black smoke, which the Maya often compared to the black clouds that bring the rain.

Items of personal adornment make up a large category of artifacts recovered from caves. These are often what would be considered luxury items made of imported materials such as jade, pyrite, and marine shells. The largest collection of jade ever recovered in the Maya area came from the Cenote of Sacrifice, a cave feature, at Chichen Itza. A related artifact may be the *hacha*, or axe head made of blackish jade. Although the *hacha* is supposedly a utilitarian implement, at Dos Pilas, a Maya site in western Guatemala where buildings were constructed atop a complex warren of caves and were aligned to reflect these subterranean chambers, eighty-eight percent of the *hachas* by weight came from caves and showed little evidence of use. It is interesting that contemporary Maya believe that *hachas* are found where lightning has struck because they are the heart of the Rain God's bolt. This idea is widely distributed and thus may be quite old and possibly indicate that *hachas* are artifacts related to rain ceremonies.

Nowhere has the systematic investigation of caves changed our thinking more than in relation to the

1

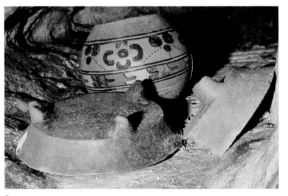

2

frequent discovery of human skeletal material (figure 3).[4] Close attention to archaeological context often suggests that these individuals were victims of human sacrifice. Bodies are regularly found in places with standing or dripping water. At Midnight Terror Cave in Belize, the remains of dozens of individuals were recovered from a seasonally active pool. The large number of children in many cases also strongly indicates that the ritual may have been rain-related because children were the preferred offering to rain deities.

The discovery of such large concentrations of artifacts and remains offers dramatic documentation that caves were the focus of an enormous amount of ritual activity. The sheer quantity of material found has led to the suggestion that such rituals were economically important.[5] Maya folk beliefs offer a curious type of corroboration. The Earth Owner, the most important indigenous deity in the Maya highlands, who dwells in the cave, is viewed as possessing great wealth, which is sometimes bestowed on a worthy individual. Perhaps the basis of the Earth Owner's wealth is the ancient knowledge of the massive tribute he has received. For the archaeologist, that tribute underscores just how important water was to the ancient Maya.

Figure 3. Calcified skull found in Actun Tunichil Muknal cave, Cayo District, Belize.

1
Brady and Prufer 2005B.

2
D. Stuart and Houston 1994.

3
Brady 2005A, p. f–9.

4
Scott and Brady 2005.

5
Brady 2005B.

3

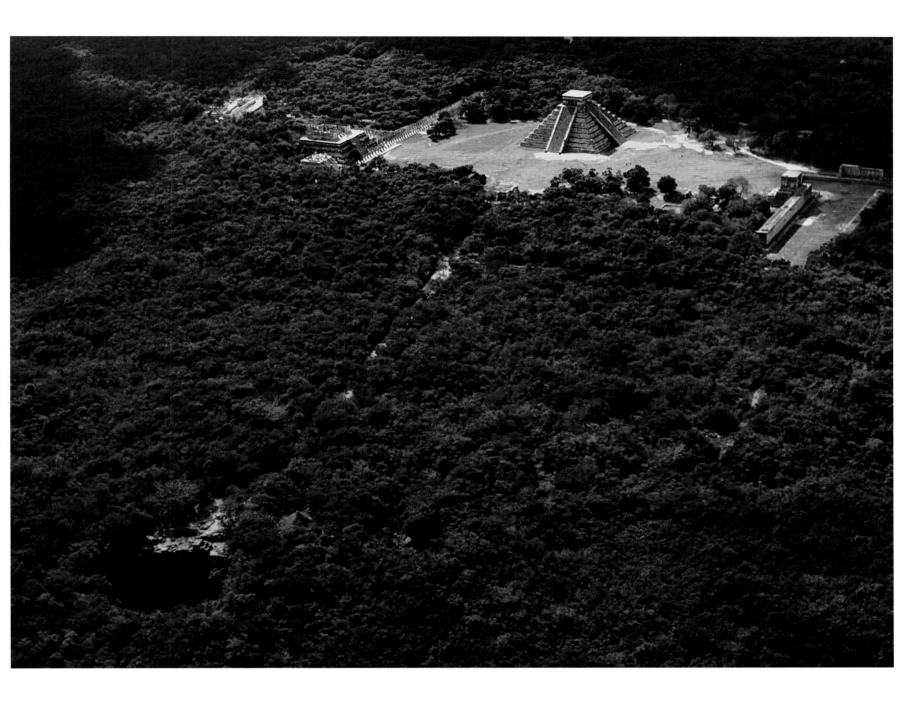

OBJECTS CAST INTO CENOTES

LUIS ALBERTO MARTOS LÓPEZ

In geological terms, the Yucatan peninsula is an enormous slab of highly permeable limestone that was formed over centuries through continuous dissolution by water. As a consequence of this geomorphological process, the Yucatan lacks any significant surface water, although underground springs and aquifers abound in the subsoil. It is these subterranean water sources that instigate dissolution of the limestone, often causing the bedrock to collapse and form openings in the terrain. The resultant natural wells or *cenotes* expose and permit access to many of the underground water sources.

In addition to their importance as life-sustaining sources of water, cenotes were sacred places for the Maya of the Yucatan: sites for rituals and ceremonies related to cycles of rain and fertility, as well as life, death, and rebirth. They also functioned as portals that allowed mortals to communicate with the supernatural world, while the dark, damp environment inside these caverns simultaneously symbolized the primordial waters of creation.

The first written document to mention the presence of cultural materials at the bottom of cenotes dates to the sixteenth century and was composed by Bishop Diego de Landa. While discussing the ruins of Chichen Itza, Landa described the performance of ceremonies celebrating the sacred cenote:

Previous page. Aerial view of El Castillo Pyramid and the Cenote of Sacrifice, Chichen Itza, Mexico.

Figure 1. The Cenote of Sacrifice, Chichen Itza, Mexico.

This well, which is seven *stadia* deep down to the water, and more than a hundred feet wide, and of round shape, and of sheer rock, down to the water, which is a wonder, appears to have very green water, and I think that the grooves with which it is surrounded cause this, and it is very deep. Near the top close to the edge is a small building in which I found idols made in honor of all the principal buildings of the country, almost like the Pantheon at Rome. I do not know whether this was an ancient idea or one of the people of the present time, so as to find their idols, when they went with offerings to that well. I found there lions sculptured in the round, vases, and other objects....[1]

The allusions to the rich offerings deposited at the bottom of the cenote, and the myth of sacrificial virgins flung into its dark waters, excited the imagination of later explorers who attempted unsuccessfully to extract the secrets of the sacred cenote and recover its precious contents. Only in the early twentieth century, when Edward H. Thompson systematically dredged the Cenote of Sacrifice at Chichen Itza (1904–1907), did archaeologists recover many of the objects cast into it by the ancient Maya.

Today, Thompson's finds still constitute the richest array of artifacts recovered from a cenote. The collection includes objects fashioned from a wide variety of materials. There are monochrome, polychrome, and painted stucco ceramics in diverse forms, such as vases, jars, pots, plates, bowls, and incense burners. Needles, ear spools, pendants, rings, necklaces, and pectorals crafted from finely carved bone and shell were uncovered, as were jade plaques engraved with images of serpents and deities (plate 65). Thompson also retrieved gold, copper, and tumbaga objects, such as ear spools, rings, pendants, bells, hatchets, and round disks depicting battle scenes (plate 68). There are points and knives knapped from flint and obsidian, and a host of more perishable artifacts, including wooden idols, vessels, clubs, scepters (plate 95), and spear-throwers; textiles; rubber and copal; and human skeletal remains.[2]

After Thompson, recovery efforts ceased until Roman Piña Chan resumed exploration of the well between 1968 and 1969. Assisted by a team of divers from the Club de Exploraciones y Deportes Acuáticos de México (CEDAM), Piña Chan recovered artifacts similar to those Thompson had found a half-century earlier. In recent years, more sophisticated diving equipment and new recording techniques have permitted archaeologists to systematically explore numerous other cenotes in the Maya region. Such undertakings have yielded important paleontological, Precolumbian, colonial, and even more recent objects.

Pleistocene materials have been discovered in many of these cenotes as a result of natural, rather than cultural, processes. Remains of camels, horses, tapirs, mammoths, giant sloths, and the glyptodont (an extinct mammal closely related to the armadillo), were found in various cenotes of Yucatan and Quintana Roo. However, the most important discovery came from the cenote of Naharón, where the skeletal fragments of a woman were discovered. Carbon dating indicates that these bones were deposited there approximately $11,670 \pm 60$ years ago.[3]

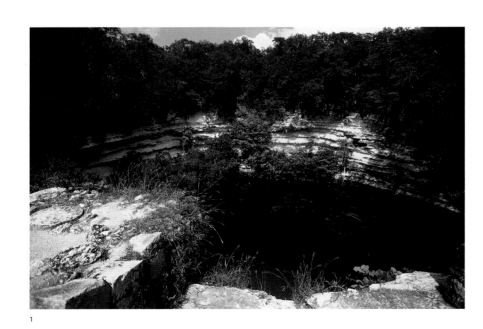

1

In contrast to Chichen Itza, the majority of cenotes in the Yucatan peninsula contain only human and animal bones and simple ceramic vessels such as large jars, pots, vases, plates, and incense burners. However, a special type of vessel known as the "chocolate pot" has been discovered in many cenote offerings. Similar in form to kettles, with a rounded handle and spout, they were supposedly used to prepare frothed cacao – an important beverage for the ancient Maya.

Although cenotes may assume numerous forms, human remains were cast only into "bottleneck" cenotes that terminated in a water-filled cavern. This choice may reflect a ritualized desire to return the remains of the ancestors to the waters of creation and guarantee their rebirth. The presence of complete skeletons could also signify human sacrifice. Cenotes with such remains include those at Chichen Itza, Mayapan, San Antonio, and Calaveras – the last with approximately 118 human skeletons deposited at the bottom.

Pots, porcelain vases, and other artifacts dating to the colonial era indicate that Maya communities were still making offerings at cenotes in the sixteenth century. However, many of the colonial-period items – like *tinaja* earthenware jars, Majolica ceramics, broken porcelain, and wooden buckets – could have fallen into the cenotes accidentally. The remains of wheels and pulleys from waterwheels, glass fragments, and bones from cows, horses, pigs, and crocodiles have also been found. The cenote at

Ziiz Ha, located below the convent of San Bernadino de Siena in Valladolid, one of the most important colonial sites, has yielded at least 153 English rifles from the eighteenth and nineteenth centuries, as well as a cannon thrown in during the Yucatan Caste Wars, when the Maya came close to ejecting the Spanish-speaking residents of Yucatan.

With many levels of significance for the ancient Maya, cenotes served simultaneously as sources of water, sacred and symbolic spaces, magical portals to mythic realms, and centers of religious and ancestral veneration. Offerings deposited in them, together with their accompanying rituals, were believed to facilitate communication between the everyday and sacred worlds, thereby guaranteeing the preservation of the natural cycles of life, death, and rebirth.

1
Tozzer 1941, pp. 182–84.

2
Coggins and Shane, 1984.

3
González and Rojas 2006.

Figure 2. Ceramic vessels from Cenote Canun, Mexico.

2

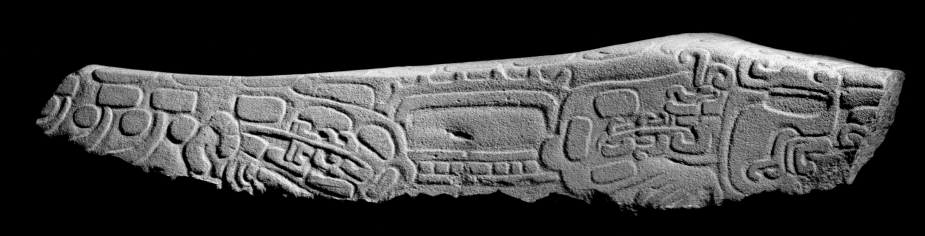

71

Sculpture of a world-crocodile
[Kaminaljuyu Monument 2]
300 BC–AD 100
Kaminaljuyu, Guatemala
Catalogue 17

Carved in low relief on a naturally formed column of volcanic basalt, this early Maya sculpture represents a fearsome crocodile at home in water and on land. As a creature linked to primordial seas and able to bridge different worlds, it served as a compelling model of the earth.

Crocodiles are found throughout the lowlands of Central America and Mexico, from coastal mangrove swamps to lakes, rivers and streams, ponds, and artificial reservoirs. The most common species, *Crocodylus moreleti*, grows more than twelve feet (four meters) long – large enough to kill humans and jaguars. Crocodiles strike quickly and use their powerful jaws to drown their prey. Hunting crocodiles glide beneath the surface, leaving only eyes and nostrils exposed; most of the time, they drift along with their body partly visible. For the Maya and other Mesoamerican peoples, the floating crocodile recalled the corrugated surface of the world. Some scholars even suggest a resemblance to agricultural plots in drained or raised fields. In beliefs that go back to the Olmec in the early second and first millennia BC, crocodiles breathed out clouds, wind, and rain (plate 76).

When excavated in 1926, this basalt crocodile lay in the center of the basinlike "Palangana" of Kaminaljuyu. Seasonal rains and poor drainage in this plaza may have created the effect of a floating beast. Sometime in antiquity, the head and tail of the crocodile were broken off. Like many sculptures at Kaminaljuyu, the monument was probably reset from another location. Recent excavations show the Palangana to be mostly Early Classic in date, some centuries later than the carving. Plain columnar sculptures are known from an earlier site to the north of Kaminaljuyu, and the crocodile may once have been such a column, fashioned later into this life-sized effigy. – NW

References: Cheek 1977, p. 12; Parsons 1986, pl. 52; Puleston 1976, p. 9; Schlesinger 2001, p. 234; Taube 1996B.

Figure 1. High-definition three-dimensional laser scan of plate 71. Courtesy of Travis Doering and Lori Collins, University of South Florida, Alliance for Integrated Spatial Technologies.

72

Crocodile effigy
700–800
Jaina Island, Mexico
Catalogue 18

The island of Jaina, Mexico, is thought to contain thousands of graves, many with small, exquisitely formed earthenware figurines. Some of these objects are mold-made, but most are unique and anthropomorphic, suggesting their function as idealized effigies of the deceased. Effigies such as this crocodile are rare. After being formed out of clay, it was scored to evoke scaly skin, then fired and painted in the indigo- and clay-based pigment known as Maya blue. Like many Jaina figurines, the crocodile operated as a whistle and a rattle, with small clay pellets inside.

Crocodiles as Maya symbols of the floating world often have scaly extrusions resembling cacao beans, as on this effigy. These evoke the terrestrial surface cultivated by the ancient Maya. The tail, too, has sacred meaning: its notched edges occur in Preclassic depictions of cosmic crocodiles from Kaminaljuyu Stela 9 (plate 75) to Late Classic figurines (plate 96). In later Aztec imagery, a similar notched tail, now on a fiery serpent, functioned as a cosmic weapon capable of dismembering deities. For crocodiles, the tail was also a powerful instrument for stunning fish and warning potential assailants. – NW

References: Sahagún 1978, p. 4; Schmidt, de la Garza, and Nalda 1999, pl. 12.

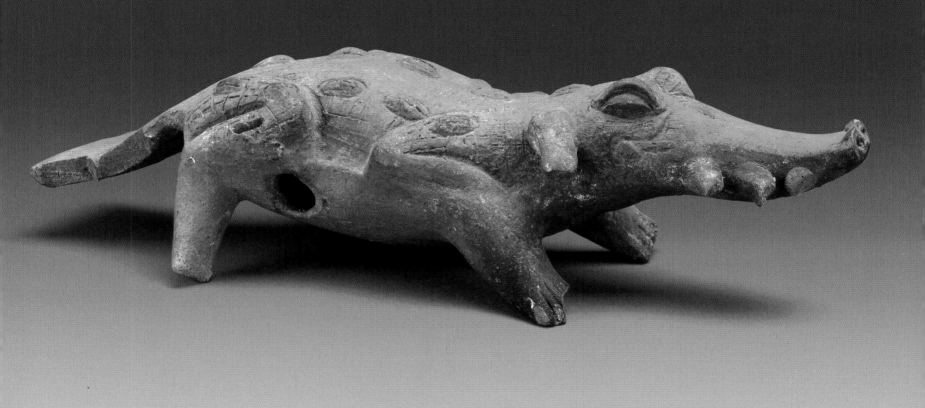

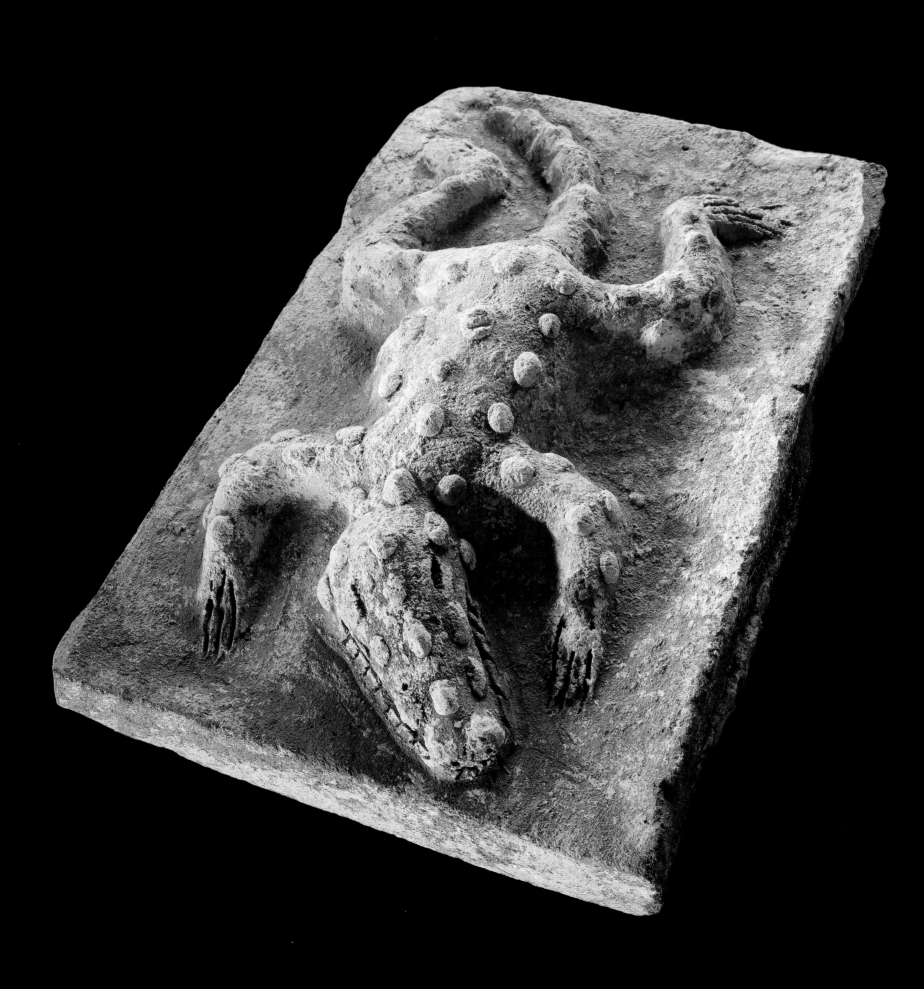

73

Brick with a crocodile
700–800
Comalcalco, Mexico
Catalogue 19

The vast majority of Classic Maya monuments are made of stone. Stone is unavailable, however, in the swampy Tabasco floodplain that is home to Comalcalco, the westernmost of all large Classic Maya settlements. As a consequence, its temples, plazas, and palaces are made exclusively of baked brick and mortar.

Mud brick from other Maya settlements is rarely fired. The Maya of Comalcalco and other sites nearby derived their innovation from the ancient Mesoamerican practice of firing pottery – indeed, the name "Comalcalco" comes from the Nahuatl term for "Place of the House of the Flat Plate." The Classic-era word for the bricks was *lak*, a play on a term for wide dishes or other objects of fired clay. The thousands of flat, platelike bricks that make up the city come in countless shapes and sizes, suggesting that they were cut individually from large sheets of leather-hard mud rather than mold-made.

Many Comalcalco bricks were embellished, usually by inscribing with a stylus (plate 63) but also occasionally through painting and, as here, sculptural relief. Portraits, architecture, animals, supernaturals, hieroglyphs, and geometric designs can all be found.

Crocodiles are a fixture of Maya iconography. Their bumpy hides compare to an arrangement of cacao beans, a similarity stressed at other sites, such as Copan. The creature also represents a world-tree or serves as a symbol for the ridge-covered world, floating as a liminal and at times threatening beast in a primordial sea. – NW

References: Álvarez Aguilar et al. 1990, p. 220; Álvarez Asomoza et al. 1992, pp. 242, 247; Blom and La Farge 1926, p. 113.

74

Crocodile effigy
1500–1540
Santa Rita Corozal, Belize
Catalogue 20

Cosmic crocodiles remained important symbols in Maya art up to the time
of the Spanish conquest. In this Postclassic effigy, well-modeled claws and
sharp teeth highlight the ferocity of the creature. As in other Postclassic
examples, an aged deity peers from the mouth, a sure indication that this
is not an ordinary reptile. Blue paint on the forehead and cheeks is another
sign of its sacred nature and a reference to precious jade or turquoise; two
polished and drilled jade beads were found inside the effigy. This example
resembles Classic Maya depictions of crocodiles as models of the world
(plates 72, 73). The scaly back evokes a set of cacao pods, although less
pronounced than in other examples. Santa Rita Corozal, where the work
was found, was rich in cacao at the time the crocodile was made.

 Dr. Thomas Gann, a medical officer stationed in Belize (then British
Honduras), carried out the first excavations of major sites in Belize. In
1900, he discovered this effigy in a mound that also contained a conch
trumpet and a sea turtle carved from limestone – all references to sacred
water connections. Santa Rita Corozal, on Chetumal Bay between the New
River and the Río Hondo, was a crucial site for long-distance trade beyond
the Maya region; it has yielded important Postclassic finds. Like Lamanai,
Santa Rita Corozal was continuously occupied from the Preclassic period
to the time of European contact. Its population was greatest during the
Late Postclassic period, when it served as the capital of the Maya province
of Chetumal. – GS

References: A. F. Chase and D. Z. Chase 1986, pp. 20–27; A. F. Chase and D. Z. Chase
1989, pp. 25–29; D. Z. Chase 1985, p. 230; D. Z. Chase, 1988, pp 89–92; D. Z. Chase and
A. F. Chase 1986B; Gann 1918, pp. 63–65.

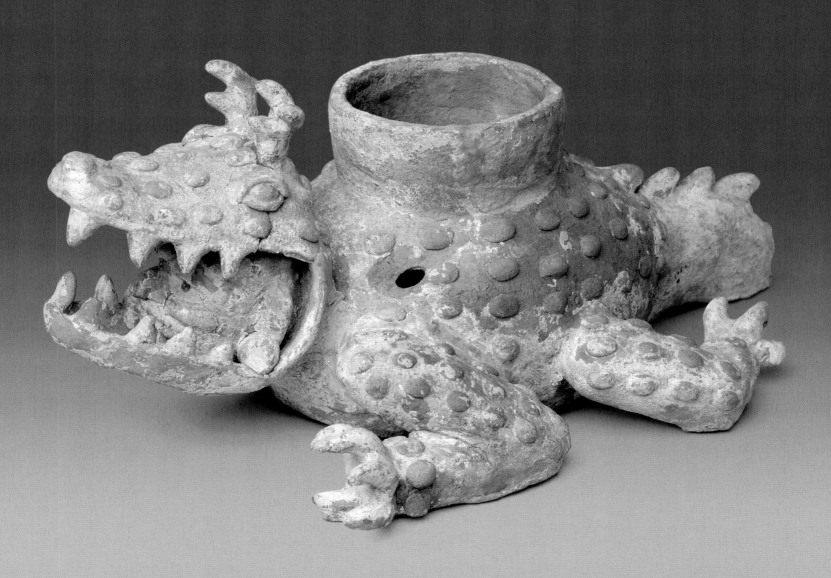

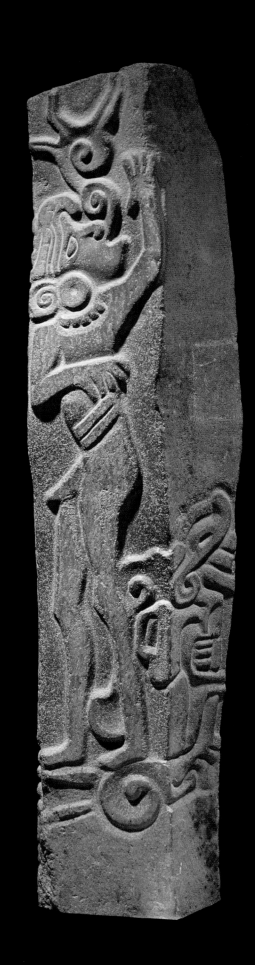

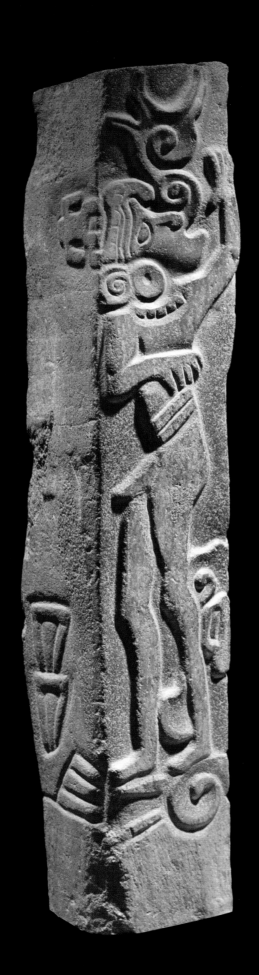

75

Stela with a male figure emitting
breath or wind in the form of conchs
[Kaminaljuyu Stela 9]
700–500 BC
Kaminaljuyu, Guatemala
Catalogue 68

Carved from a natural five-sided column of prismatic basalt, Kaminaljuyu Stela 9 is among the earliest monumental stone sculptures known for the ancient Maya. When this monument was created and where it was originally placed remain unknown. In antiquity, it was buried along with a rich array of other material atop a massive stone slab in a pit dug into an early mound dating to roughly 700 BC. Although the associated ceramics in this later intrusive pit date to the fourth century BC, according to Lee Parsons, this stela could have been carved as early as 700 BC, making it roughly contemporaneous with Middle Formative sculpture from the Olmec site of La Venta, Tabasco. In addition, the offering deposit contained many fine jades, including hollowed, spoon-shaped pendants consistent with late Olmec-style jade carving. However, although probably contemporaneous with the Middle Formative Olmec, Stela 9 is by no means in Olmec style, in contrast to monuments known for such sites as Ojo de Agua, Pijijiapan, Xoc in Chiapas, Takalik Abaj in Guatemala, and Chalchuapa, El Salvador. Rather than being a copy of Olmec art or created by the Olmec themselves, Kaminaljuyu Stela 9 represents still poorly known local sculptural traditions of highland Guatemala.

Three sides of the basalt column portray an attenuated male in a dynamic pose, his left arm upraised and the head turned backward 180 degrees from the lower portion of his body (figure 1). His avian headdress with a capping trefoil element possibly portraying maize recalls later examples of the Late Preclassic and Early Classic Principal Bird Deity, which often bears growing maize on its head and tail. The figure may well be both singing and dancing, as his upturned face emits two breath or song volutes into the sky. The spines emanating from the uppermost spiral indicate that it is a conch. According to Tatiana Proskouriakoff, the figure is engaged in shouting or sounding a conch trumpet, both acts that require powerful exertions of breath. This spiral element is the earliest explicit example in ancient Mesoamerica of a cross-sectioned conch as breath or wind, a motif that continued for some two thousand years until the Spanish conquest of the Aztec in the sixteenth century. However, this remarkable monument has another "first": the complex basal form on which the human stands is the sustaining earth-crocodile, its upturned tail on one side of the male

figure and the head and torso on the other. Formed of joined trapezoidal forms, the crocodile's tail has highly developed angular flanges on its dorsal edge. The sharply upturned head of the creature echoes the exhaling human standing above. This is surely no coincidence, as from Late Preclassic to Late Postclassic times, Maya crocodiles were portrayed with conch on their snouts, denoting this shell as the breath of the earth (plates 72, 76, 96). The Late Classic Zoomorph P from Quirigua portrays the earth-crocodile exhaling cross-sectioned conch and rain gods from the corners of its mouth (Taube, figures 18, 19).

The Kaminaljuyu Stela 9 crocodile recalls roughly contemporaneous petroglyphs from Chalcatzingo, Morelos, portraying crocodilians with sharply upturned snouts exhaling rain clouds into the sky. They are adjacent to the major seasonal stream falling from the face of Cerro Chalcatzingo as well as to Monument 1, the famed scene of an earth maw exhaling elaborate breath swirls amidst falling rain. However, an Olmec-style petroglyph from Ticumán in central Morelos depicts a crocodile with the same segmented tail found on the Kaminaljuyu Stela 9 and, in addition, a trefoil ear of maize growing from its tail (figure 2). As in the case of the Chalcatzingo petroglyphs, the Ticumán crocodile was carved near natural sources of water, in this case a series of seasonal and perennial springs. The material emerging from the mouth surely relates to the breath and clouds exhaled by the Chalcatzingo crocodiles. It is noteworthy that although the concept of crocodiles exhaling wind and rain is well documented for both the Middle Formative Olmec and Classic Maya, the Stela 9 human figure emits the breath scrolls. It could well be that this monument depicts the ritual role of humans in the creation of agricultural fertility, that is, through prayer, song, and dance, people also can cause rain and the growth of maize. In contrast to the many scenes of crocodilian world-trees in Mesoamerican art, on this columnar monument it is the human figure that links heaven and earth. – KAT

References: Angulo Villaseñor 1987, figs. 10.1–10.4; Córdoba Tello 2008, p. 54; Houston and Taube 2000, p. 265; Parsons 1986, p. 16; Proskouriakoff 1968, p. 123; Shook 1951; Taube 2001.

Figure 1. Rollout view of the human figure and crocodile carved on three sides of plate 75. Drawing by Karl A. Taube.

Figure 2. Olmec-style petroglyph of a crocodile from Ticumán, Mexico. Drawing by Karl A. Taube.

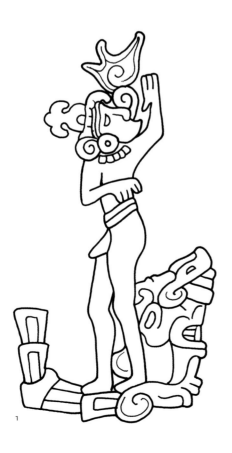

76

Frieze with a crocodile
breathing clouds
750–800
Possibly Copan region, Honduras,
or Guatemala
Catalogue 69

In Maya iconography, the crocodile served as a model of the world and a generator of clouds. In this block, carved in high relief, the nostrils of the crocodile emit rainy mist, shown as a cross-section of a conch shell. In front of its clenched mouth is a head, of uncertain meaning, perhaps emerging from the crocodile's snout.

Classic-period carvings have resisted erosion in the general region of Copan, Honduras, and in areas just across the border in Guatemala. Yet, over the centuries, many complex façades have fallen apart from the action of tree roots, earthquakes, failed mortar, even human destruction. This block came from a façade composition erected in the time of Yax Pahsaj Chan Yopaat, the sixteenth ruler of Copan, or in the few decades before his reign. Its size, flat upper surface, and framing borders suggest that it may have been part of a sculpted stairway, with the crocodile's body stretching lengthwise across a riser. It came, perhaps, from a bench or cornice of one of the noble houses that proliferated in the area of Copan, including adjacent areas of Guatemala, during the eighth century AD.

Yax Pahsaj acceded to the throne in 763. A great builder, he commissioned projects around the city that featured mosaics of the local volcanic tuff. Quarried from nearby cliffs, this stone was easy to cut and durable – an ideal combination for large-scale construction. Local stoneworkers took advantage of its properties by creating stelae and altars, along with building façades of carefully fitted blocks of tuff. – NW

References: W. L. Fash 2001, pp. 36, 113–16; W. L. Fash 2002; W. L. Fash 2005; Webster, Freter, and Gonlin 2000, p. 6.

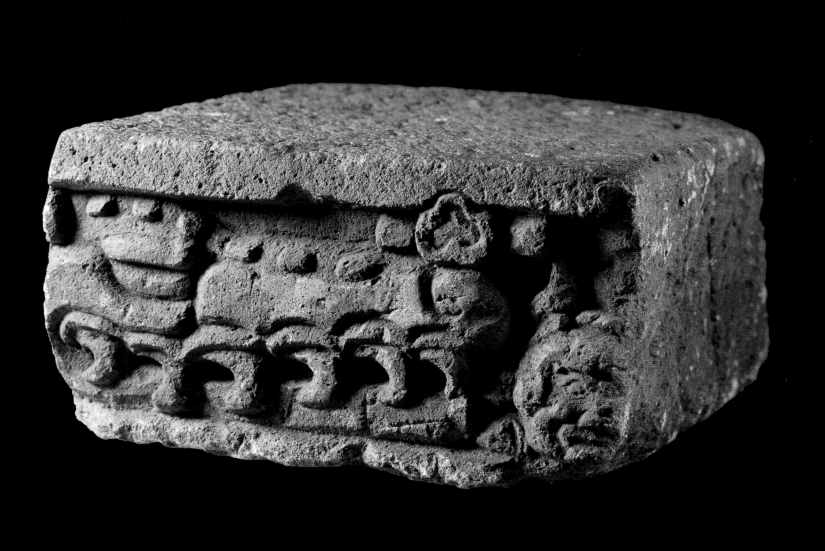

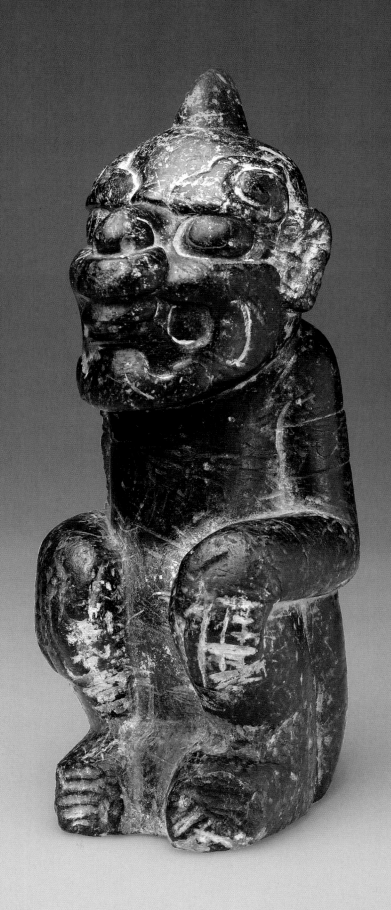

77

Statuette of Chahk
300–100 BC
Provenance unknown
Catalogue 7

This small but potent Late Preclassic effigy of Chahk provides an impor-
tant link between later Maya versions of this being and the earlier Olmec
rain god. This Maya example displays a number of early Chahk traits,
including whirls in the brows, the broad beard element often marked with
drops, the open mouth, and a hornlike form on the head – a curious but
common trait of Late Preclassic Chahks. The "horn" is more likely a fish
fin, as Chahk displays clear piscine attributes in both Late Preclassic and
Classic Maya art. A water-band marks the lone preserved upper arm of the
figure. Like this Chahk, diminutive effigies of similar date often sit on their
haunches. One slightly later statuette appears to represent a dwarf, in
ethnographic sources a being associated with bringing rain and lightning
(figure 1). Other Classic Chahks show the god wielding an axe or a stone
ball or bludgeon. Royalty sometimes wore these small effigies on their
belts, but this statuette lacks holes for suspension and more likely was a
cult item, and perhaps part of a sacred bundle.

 This figure bears one of the oldest known examples of Maya writing
(figure 2), although the text may not have been carved at the same time as
the effigy. Its opening glyphic formula is present in other Late Preclassic
texts, but the meaning is unclear and cannot be linked to Chahk himself;
perhaps it refers to the owner of the object. The glyphs have little affix-
ation, a pattern common to the earliest Maya texts. – SDH, KAT

References: Bacon 2007, pp. 369, 373; M. D. Coe 1973, p. 25; Houston 2004B, p. 306;
Mora-Marín 2001, pp. 212–15; Taube 2009.

Figure 1. Stone statuette of kneeling Chahk, circa AD 250. Drawing by Karl A. Taube.

Figure 2. Glyphic text on the back of the statuette in plate 77. Drawing by Stephen D.
Houston.

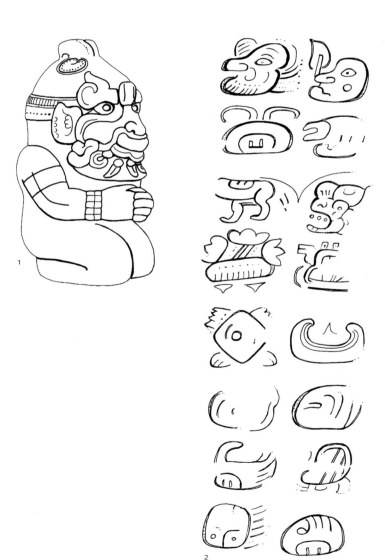

78

Stela fragment with Chahk
[Oxkintok Stela 12]
800–850
Oxkintok, Mexico
Catalogue 8

This fragment from Stela 12 from the site of Oxkintok depicts the Rain
God, Chahk, the embodiment of seasonal rains coming from the eastern
Caribbean Sea or violent storms from the north. Floating in the topmost
register, Chahk brandishes a shield and an axe with a writhing serpent
handle. The handle and its snake tongue represent lightning; these at-
tributes, along with lank hair, appear in most depictions of the god in the
northern Maya lowlands. Chahk's broad headdress, crowned with vertical
feathers, also occurs at places near Oxkintok, such as Itzimte and Uxmal.
On Stela 12, his eyes peer out from a circular ring or "goggle" worn by
the central Mexican Storm God, Tlaloc. The use of central Mexican style
characterizes much imagery in Yucatan at this time and later. At Oxkintok
and other sites in the Puuc hills, rulers incorporated Chahk into their royal
names as a reflection of kingly power in this water-scarce region. In this
representation, the warlike garb and posture emphasize the dominant role
of rain and water.

Originally over six feet (two meters) high, Stela 12 contained four
registers, including the warrior partially visible below, who wears a jaguar
headdress and feathered cape and grips a square shield and a spear. His
costume is common for depictions of warriors in the northern Yucatan
during the Terminal Classic period. Below the jaguar warrior was a figure
burning incense to a winged individual; underneath that scene were seated
lords engaged in conversation. The text on the monument is illegible.

The registers displaying different scenes are similar to the layout of a
codex. The iconographic program contrasts sharply with the use of regis-
ters in the southern Maya lowlands, where one scene is shown in multiple
realms. The style of this stela with its many registers and crude hiero-
glyphs suggests a date in the first half of the ninth century AD. The rough,
low-relief style of others found in the Court of the Portal Vault supports a
time near 849, the final date recorded at Oxkintok. – JD

References: García Barrios 2008, pp. 68–101; Pollock 1980, fig. 545f.

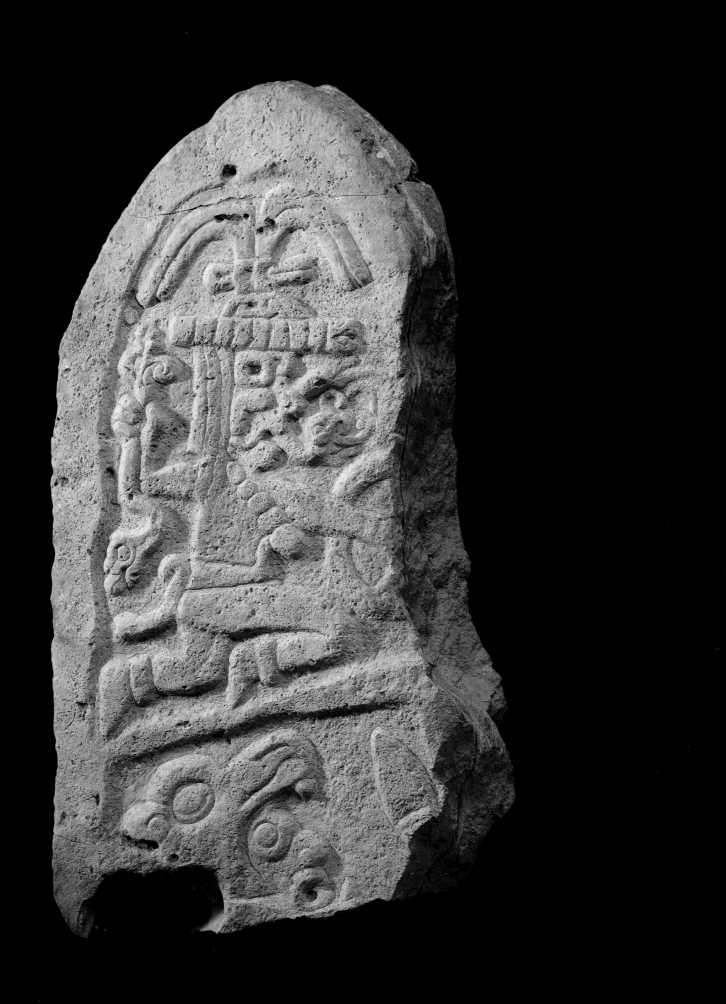

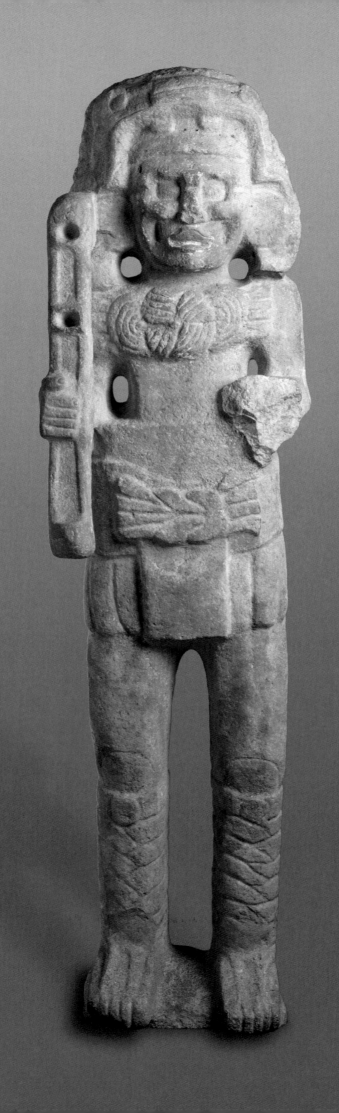

79

Sculpture of Chahk
800–900
Campeche or Yucatan, Mexico
Catalogue 9

This grand sculpture portrays the deity Chahk as an axe-wielding per-
sonification of rain, storms, and lightning. Clutching the handle of a large
axe – symbolic of lightning – Chahk is shown as the Storm God with an
open mouth and pronounced cheeks as if shouting or threatening. The
two holes in the axe would have been filled with blades of stone, per-
haps greenstone or obsidian. Scenes from a bench at the Temple of the
Chacmool at Chichen Itza and a doorjamb at Kabah confirm that multiple
axe blades were common in the northern Maya lowlands. Although the left
hand of this sculpture is missing, it would have likely held a battle shield,
as in many depictions of the warrior Chahk. Further adding to his menac-
ing appearance, Chahk's headdress seems to be the head of an animal,
perhaps a feline or serpent, with its two blunt teeth protruding above his
eyes. This Chahk also wears a large belt and loincloth assemblage, similar
to the padded waistbelts of ballplayers, and displays a pectoral decora-
tion, indicated by finely chiseled knots. The knotted rope and large ear
flares are typical of Chahk's attire throughout the Classic period.

Carved from a solid piece of limestone, the statue is one of many
representations of the warlike Chahk in the lowlands during the Late and
Terminal Classic periods. Its scale and stiff stature are consistent with
architectural façade sculpture. Elements of this statue's style, such as
the sandals with lashings, also occur in architectural sculpture at Kabah,
indicating this Chahk was originally from the Puuc hills of Yucatan and
Campeche (such as Sayil). It likely formed part of a royal court building,
fixing its imposing gaze on all who entered. – JD

References: García Barrios 2008, pp. 476–95; Pollock 1980, pp. 333–34, fig. 190.

80

Drinking vessel with deities
spearing a shark
700–800
Northern Peten, Guatemala, or
southern Campeche, Mexico
Catalogue 21

This polychromed vessel shows a primordial sea marked as such by water lilies and a swirling water-band design. Two deities, the so-called Jaguar God of the Underworld – the nocturnal version of the sun as it travels beneath the earth at night – and a poorly understood deity with feline characteristics, attack a monstrous fish-reptile. The Jaguar God of the Underworld, wearing a broad-brimmed hat with paper used in sacrifice, has driven his spear through the creature's side, releasing a torrent of blood that seems to compose the very sea in which the two gods stand half-submerged. *K'in* or "sun" motifs frame the action, and repeating pseudoglyphs mimic a hieroglyphic text.

This vase may record a local variation of a myth known from texts at the Classic site of Palenque, in which a god associated with the rising sun decapitates a cosmic alligator whose blood forms three seas. Here, as in that myth, a solar deity defeats an aquatic monster, bringing order to the world through bloodletting and sacrifice. – NC

References: M. D. Coe 1975, pp. 21–22; D. Stuart 2005, pp. 66–77, 176–80.

Figure 1. Rollout photograph of plate 80.

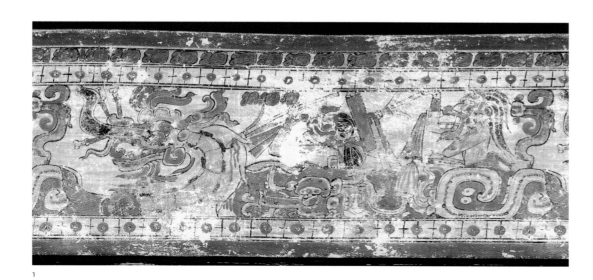

1

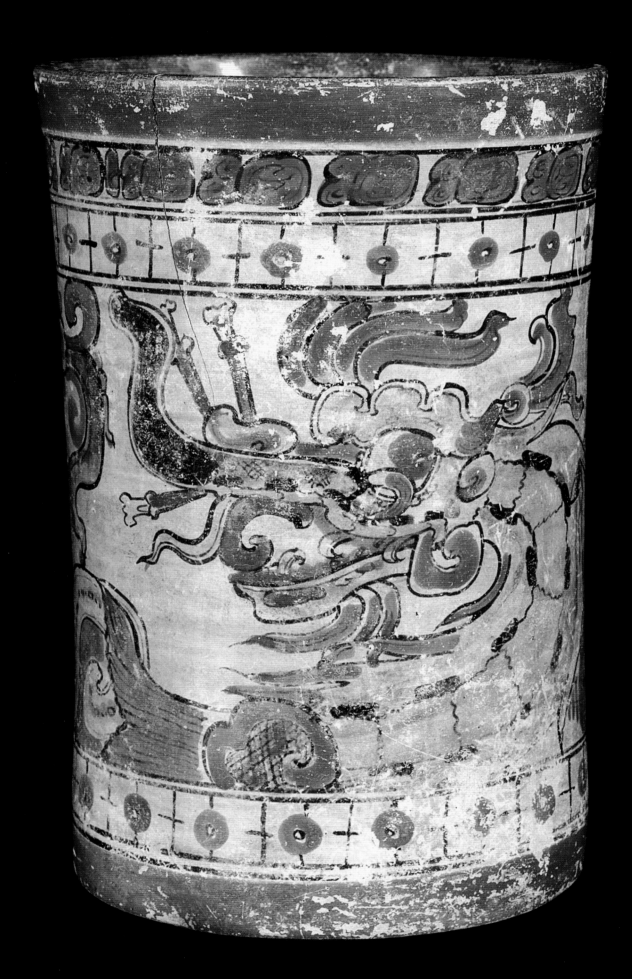

81

Vessel with an aquatic creature
and a deity head
700–800
Probably Yucatan, Mexico
Catalogue 22

Part of a group of about one hundred known examples of carved brown or
slateware vessels known from the region of Chochola-Maxcanu, this ovoid
vessel features two scenes showing mythological creatures from a still
dimly understood narrative of the late Classic period. The undulating body
of a water serpent, its body pierced with a spear, seems to writhe against
the confines of the rectangular frame on one side. On the other side is a
disembodied head, the spirit of active water or *witz'*, looking upward. From
its mouth hangs a bearded crossed-bands motif; its forehead has a tied
bundle with a fish nibbling at a water-lily blossom. The segmented body of
a crustacean, its legs just visible at the edge of the frame, completes
the headdress.

The image may relate to the narrative of spearing by two deities on
plate 80, as well as on objects now in the Museum of Fine Arts, Boston,
the Michael C. Carlos Museum of Emory University, Atlanta, and a private
collection. The head of the water-spirit most closely resembles the prow of
the canoe on a bone from Tikal Burial 116 and, perhaps, an eccentric flint in
the collection of the Dallas Museum of Art (Finamore, figure 11). Combined,
the two scenes reference a sequence of aquatic conflict and bloodletting,
taking place or resulting in turbulent waters. Since the vessel shows the
monsters but not the other actors, it may have materially defined its pos-
sessor as the protagonist of this myth. – MR

References: Ardren 1996; Freidel, Schele, and Parker 1993, p. 91; Parsons 1980, p. 203;
D. Stuart 2005, pp. 66–77, 176–80; Tate 1985, fig. 2.

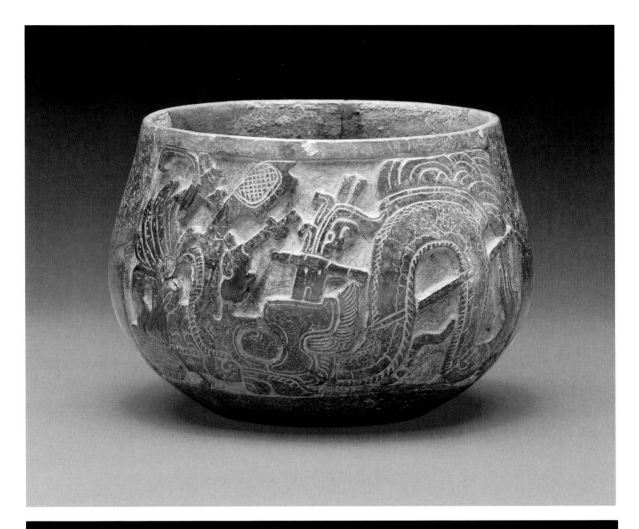

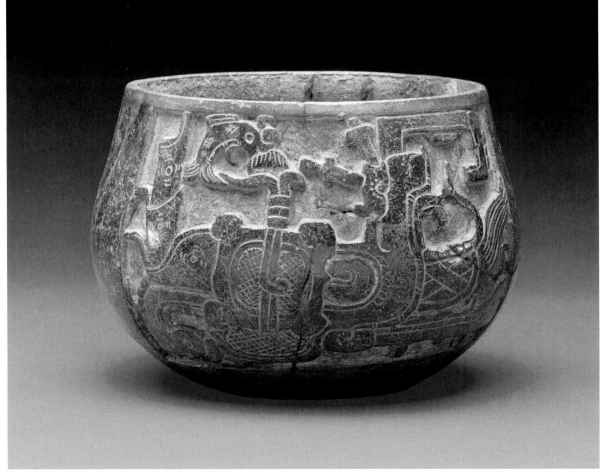

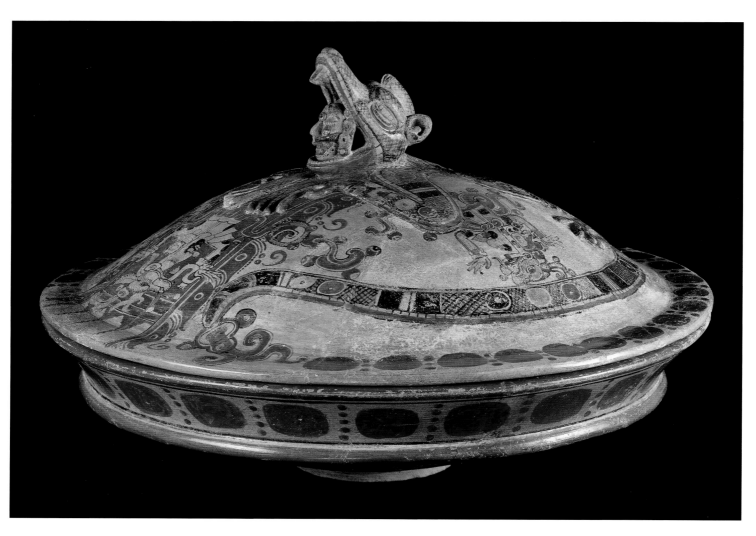

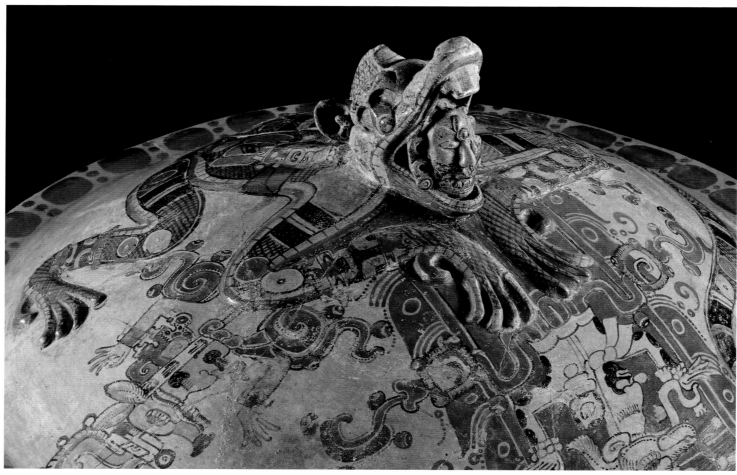

82

Lidded bowl with the Iguana-
Jaguar eviscerating humans
circa AD 500
Becan, Mexico
Catalogue 23

One of the finest Early Classic Maya ceramics known, this lidded vessel, found in Structure IX at Becan, Mexico, is almost monumental in scale. Its grandeur results in part from the cosmic theme depicted on the lid: a mythic combat between three humans, all with name glyphs in their headdresses, and a great saurian creature splayed across much of the lid's surface. The scene may well relate to the Itzam Kab Ayin myth of Yucatan concerning the deluge and the slaying of a cosmic crocodile (Taube, page 204). However, in this case, the creature is the victor and the three human figures its prey. All three have been chewed in half, a grisly but real outcome when great crocodiles come into contact with hapless humans (figure 1). Judging from its size, the Becan creature would be easily capable of biting humans in half, yet it is no ordinary reptile. The hybrid beast displays mammalian traits as well as saurian scutes on the sides of its body and fine scales denoted by crosshatching: its ears are those of a spotted jaguar. Oswaldo Chinchilla Mazariegos has compared this creature to Cotzumalhuapa "iguana jaguar" sculptures from the Pacific piedmont of Guatemala, some of which portray iguanas with explicit jaguar heads. With its prominent crest, banded tail, and elongated digits, the Becan beast is probably based on the spiny tailed iguana (*Ctenosaur similis*), the most prevalent iguana of Central America and a creature capable of reaching five feet in length. One colonial Yucatec term for iguana is *itzam*, linked to the primordial crocodilian known as Itzam Kab Ayin, or "Iguana Earth Crocodile." An Early Classic ceramic lid excavated at Holmul, Guatemala, portrays a creature in the same flexed and splayed position. It, too, has a crested head and zones of incised crosshatching to denote scales, and may be a less elaborate example of the Becan iguana monster.

As in the case of Itzam Kab Ayin and Cipactli, the Becan creature is probably in water (Taube, pages 204–205). The same flexed-limb position appears on a Late Classic codex-style scene of a swimming jaguar in a water cartouche (figure 2). Far from random, the jaguar spots in the center of its back exhibit the basic Maya cosmogram of the four corner points and the three hearthstones. Similarly, the great iguana wears in the center of its back a jade belt assemblage of the Maize God, both maize and jade being closely identified with the world center in ancient Maya thought (plate 89).

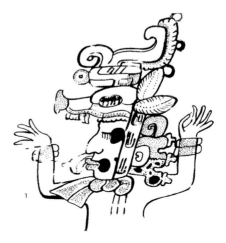

1

The central Mexican Codex Laud depicts a crocodile with a jade sign in the center of its back swimming in the sea with other marine creatures. An Early Classic vessel lid depicts another jaguar in the same splayed position as the Becan creature, along with the same column of blood pouring down from the face (figure 3). In this case, three streams of beaded water-bands fall from the head and back, indicating that the jaguar is also swimming in water. Jaguars in this position recall the jaguar component of the Becan creature. Although generally terrestrial animals, both iguanas and jaguars are excellent swimmers and well adapted to water.

A dark beast of death, the iguana creature has bracelets and anklets marked with *Ak'bal* signs denoting darkness, along with "death collar" fringes of hair and eyeballs. The viscera of the central slain figure end with two shieldlike forms also rimmed with the death collar motif; the central spiral eye also denotes darkness. The left eye of the creature hangs grotesquely from its socket, perhaps a wound from battle with the three slain figures. The human head in the creature's open maw bears a similarly damaged right eye along with a ruff of hair with three red eyeballs and a fleshless lower jaw. Rather than a body devoured by the giant iguana, the head probably represents a death deity emerging from the mouth, a common motif in Classic Maya art.

Perhaps because of the primordial, mythic theme, the Becan vessel displays a number of archaic traits evocative of Late Preclassic Maya art. These include the elaborate band of blood falling before the creature, recalling the delicate portrayals of blood and breath in the recently discovered murals at San Bartolo, Guatemala (plate 83). Although rare in Classic art, the inverted, halved human bodies occur in Late Preclassic art, including on a round altar from the vicinity of Tikal. Dating to approximately AD 350, an early version of the main stairway of the North Acropolis at Tikal featured massive stucco sculptures of similar inverted features, possibly labeling the stairway as a place of human sacrifice, as is well documented for the period of contact with the Aztec. Although carved during the Early Classic, the Hauberg Stela, now in the Princeton University Art Museum, portrays three severed figures falling headlong down a curious crenel-

lated form issuing from the mouth of the sharklike solar deity GI (plate 25 and figure 4). On close inspection, this band displays the same horizontally oriented V-shaped blood elements appearing in the Becan stream. The accompanying text mentions the first blood sacrifice or "penance," *yax ch'ahb*, with the *yax* sign displaying the same crenellation lining the stream of blood. Clearly, the three dismembered figures in the falling gout of blood represent the same first sacrifice. — KAT, SDH

References: Campaña and Boucher 2002, p. 65; Chinchilla Mazariegos 2006A, pp. 82–85; W. R. Coe 1990, fig. 316; Houston, D. Stuart, and Taube 2006, pp. 89–97, figs. 2.39, 2.40; Merwin and Vaillant 1932, pl. 20; Schele and M. E. Miller 1986, pl. 66.

Figure 1. Details of dismembered figures with name glyphs in their headdresses on plate 82. Drawing by Stephen D. Houston.

Figure 2. Swimming jaguar in a water cartouche from a codex-style vessel, Late Classic period. Museum of Fine Arts, Boston. Drawing by Karl A. Taube.

Figure 3. Detail of the lid of a vessel with a jaguar with a column of blood pouring down from its face, Early Classic period. Private collection. Drawing by Karl A. Taube after photograph K6001 by Justin Kerr.

Figure 4. Hauberg Stela, date uncertain. Princeton University Art Museum, Princeton, New Jersey. Drawing by Linda Schele, © David Schele, courtesy Foundation for the Advancement of Mesoamerican Studies, Inc., www.famsi.org.

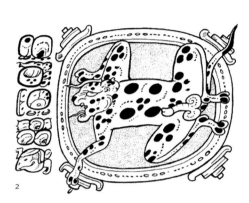

2

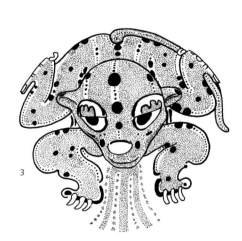

3

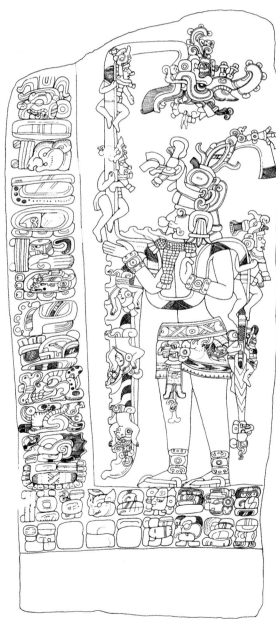

4

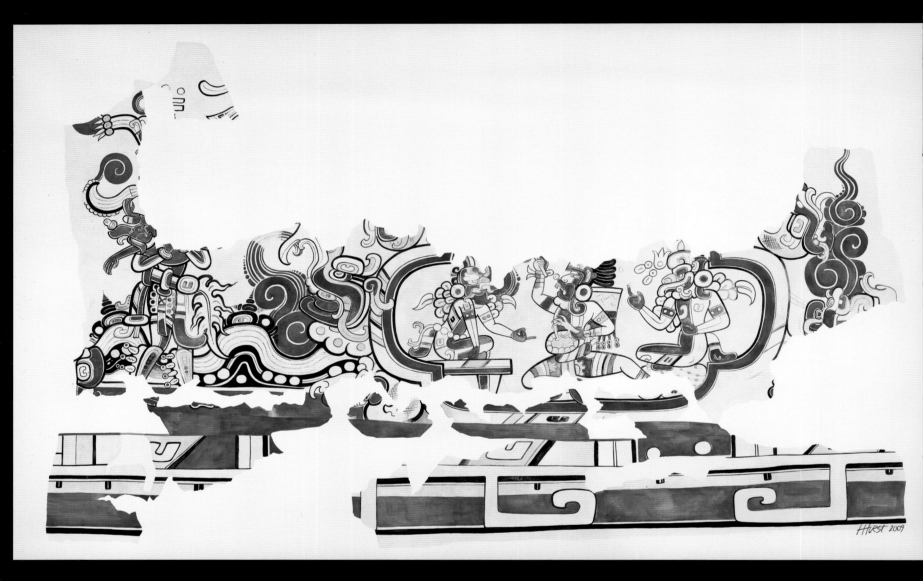

83

Mural with a world-turtle
circa 100 BC
San Bartolo, Guatemala
Watercolor on paper by
Heather Hurst
Catalogue 12

The first-century BC murals of San Bartolo, Guatemala, provide a re-markably detailed view of Maya creation mythology. Because the mural chamber, Pinturas Sub-1A, was buried deep under later construction, the paintings are well preserved. Although the east and south walls were dis-mantled when the chamber was filled with loose stone and soil to create a larger pyramid roughly two thousand years ago, the west and north wall murals remain largely intact. This painting by Heather Hurst, staff artist for the San Bartolo Project, illustrates a detail from the west wall mural portraying the earliest explicit Maya depiction of the Maize God within the earth-turtle – a theme well known in later Classic art where the god emerges through a central fissure of the carapace. Versions of this myth still exist among contemporary peoples of Veracruz, including the Tepehua and Totonac. Even earlier than the San Bartolo example, an Olmec plaque from Tabasco portrays the head of the infant Maize God atop the under-side of a turtle carapace, making this theme possibly the longest living myth in ancient Mesoamerica.

In this scene, the cosmic turtle appears with a prominent beak and limbs partly transforming into zoomorphic heads – a convention also used in the great crocodile monument from Kaminaljuyu (plate 71). The quatre-foil form of the carapace constitutes a common Mesoamerican cave sign known from Olmec times to sixteenth-century colonial Aztec documents. Within the cave quatrefoil, the Maize God dances enthusiastically before enthroned water gods: the Rain God, Chahk, to the viewer's left, and the God of Terrestrial Waters on the opposite side; both gods were necessary for the germination and growth of maize. From the turtle head, a band of black-and-white water ends with the remnants of a deity head, probably that of Chahk, given the red *Spondylus* earpiece and curving, cloudlike brow. The composition of the Rain God head with water is very similar to the basal band of Izapa Stela 1 (Taube, figure 11), which features Chahk heads at both ends of an undulating band of water (not shown here). Both bands probably refer to the rolling waves of the ocean. The San Bartolo water-band has especially sharp waves with bubbles of spume on their up-per crests. Below the face of the earth-turtle, crashing waves raise volutes of red mist, denoting breath or wind. In a concept similar to the exhaling earth-crocodiles and the fishing Chahk on Izapa Stela 1, this elaborate scene may depict another conceptual origin of wind and clouds in the pow-erful waves cast against the shore of the earth-turtle. A similar exegesis exists among the contemporary Huichol of western Mexico, in which the Mother of the Sea, Tatéi Haramara, smashed her head as a cresting wave into a rock to be carried in a breeze as precious dew: "Our Mother Dew Soul ... is the reincarnation of Haramara's soul ... and in that guise, the Daughter of the Sea. Dew Soul lives on the foam of the exploding wave." The San Bartolo mural is the only known representation of volutes of wind emerging before the earth-turtle, but many scenes of the turtle in water denote the earth floating on the sea. – KAT

References: Braakhuis 1990; Negrín 1975, p. 105; Saturno 2006; Saturno, Taube, and G. Stuart 2005; Taube 1985; Taube 1996A, fig. 22c; Taube and Saturno 2008.

84

Incense burner with a deity
on a world-turtle
770–850
Chiapas, Mexico
Catalogue 14

This censer stand in the form of a male deity speaks to the ancient Maya conception of the earth as a turtle's rounded carapace. In this scene, a supernatural being with solar features and attributes of the Jaguar God of the Underworld is cosmically situated on the surface of the earth, bridging the space between the earth and the heavens in his daily transit. He wears a bivalve pendant, perhaps of *Spondylus*, and an *Oliva* shell belt often worn by human dancers (Zender, pages 84–85). Looping under his eyes is the "cruller" attribute of the Jaguar God of the Underworld, an aspect of the sun as it passes underground. The figure also wears a headdress with a double-headed reptile and is armed with either a shield or spear. The deity stands firmly on the back of a turtle that here appears quite naturalistic, although it sometimes takes on a more human or supernatural visage. Modeled in relief upon the vessel's lateral flanges and flanking the central character are two stylized figures of the Rain God, Chahk, with spears. Truculent, their mouths open as though bellowing, with stylized clouds close by, they show the passage of the Jaguar God to be a stormy one.

Few incense burners of this sort survive, yet many have similar components. Probably from the same workshop near Palenque, an example at The Metropolitan Museum of Art closely resembles the one pictured here. Effigy censers might have been used for rituals in caves – closed spaces intense with incense smoke and fragrance – to invoke rain and to harness Underworld powers (Brady, page 221). Cave incrustations from dissolved limestone cover much of the surface of the example pictured here, especially the back.

Censer stands in the shape of standing figures emerged as part of the Palenque flanged-*incensario* tradition during the final years of the Classic period. These composite censers, which included cone-shaped brazier bowls, were used for the ritual burning of incense. Though technically similar to the tiered-effigy flanged censers found in late seventh- and early eighth-century contexts in Palenque's Cross group (plate 25), the standing figure motif of the late eighth and early ninth centuries is rarely found within the polity's site center. Rather, these shapes appear most frequently in peripheral areas of the Palenque zone, notably within the caves at Xupa, some nine miles (fifteen kilometers) southeast of the capital. – CW

References: Rands, Bishop, and Harbottle 1978; Rice 1999; Taube 1988.

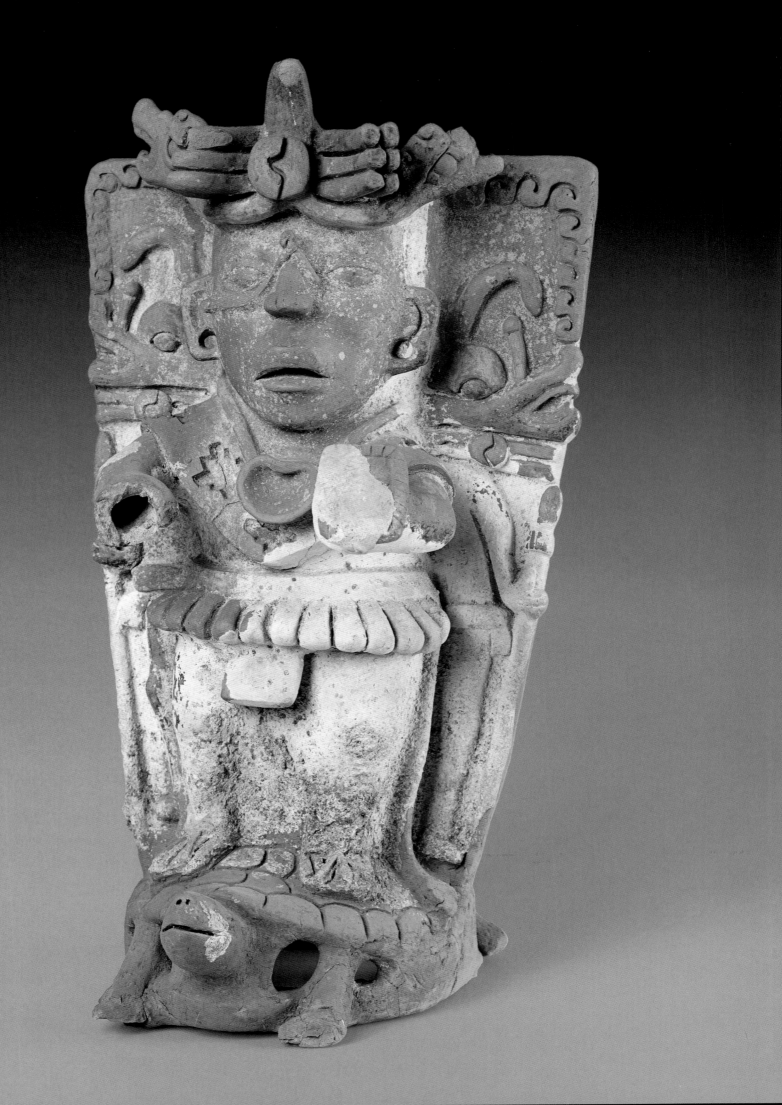

85

Sculpture of a world-turtle
1250–1500
Topoxte, Guatemala
Catalogue 15

Although similar limestone turtles are known from other contemporaneous Late Postclassic sites such as Mayapan, Santa Rita Corozal, and Caye Coco, this sculpture from the Tayasal region of the northern Peten is noteworthy for its size and the considerable amount of blue and black paint still adhering to its surface. The head of an old man with sunken features emerges from the turtle's open beak. This being is clearly God N, an aged deity identified with the earth and the cosmological world directions who often appears in a turtle carapace in ancient Maya art.

These Late Postclassic stone sculptures denote the earth-turtle from which the Maize God is born. This example's painted limbs have an undulating net pattern with dots, a convention first appearing in Classic Maya portrayals of turtles and round water-lily pads, another symbol of the circular, floating earth. However, Classic and Postclassic Maya placed this motif on turtle carapaces rather than on the skin, which instead is typically rendered with small, irregular scales. In this regard, the Tayasal turtle relates more to Late Postclassic art of highland Mexico, where this netted motif was commonly used to indicate the skin of the cosmic crocodile as well as on hills to portray the rough, corrugated surface of the earth.

One prominent feature of the Late Postclassic stone turtles is the deep hole in the center of the carapace. This feature clearly relates to Classic Maya portrayals of the carapace as the quatrefoil cave motif, a convention that can be traced back to Late Preclassic Izapa, Takalik Abaj, and the murals of San Bartolo (plate 83). The elaborate quatrefoil scene on the recently excavated altar from Cancuen probably refers to this same place, here as a watery region with the head of the Maize God emerging through tendrils of growth at the base of the scene.

Although the symbolism of the central hole in the Tayasal turtle is clear, the function of such sculptures is less so. The Late Postclassic Madrid Codex and a roughly contemporaneous cache from Santa Rita Corozal portray males letting blood through their phalli atop these objects (plate 52). A Mayapan stone turtle provides direct evidence for such rites, as the capped central orifice contained stingray spines and obsidian lancets for letting blood. At Caye Coco, Belize, a turtle sculpture contained in a similar hole a blade of obsidian and another of chert, along with a celt

and a potsherd. Some stone turtles from Mayapan bear dates pertaining to the roughly 256-year *k'atun* cycle, often referred to as the "Short Count." One example even has the thirteen *ajaw* signs of the Short Count surrounding the carapace, a clear antecedent to the colonial *k'atun* wheel diagrams denoting the thirteen divisions of this calendar. The central pit of this and other Late Postclassic turtle sculptures probably relates to bloodletting for the rejuvenation of the world at the end of calendric cycles. Yet, it has a still more basic meaning in Mesoamerican concepts of sacrifice: by feeding the earth with our "food," the earth feeds us. One of the most widespread rituals in Mesoamerica concerns offerings to the four corners and center of the maize field. Frequently, blood from a sacrificed fowl is placed in a hole in the middle of the field as an offering to the center of the earth from which maize will rise as the most pivotal and essential form of the tree of life. – KAT

References: Barrett 2000, p. 33, fig. 4.5; D. Z. Chase and A. F. Chase 1988, fig. 9; Taube 1988.

86

Drinking vessel with the Maize
God born from the waters of the
Underworld
650–750
Calakmul, Mexico
Catalogue 63

This drinking vessel – identified in the rim text as intended "for fruity choc-olate" – was discovered in Tomb 1 of Structure XV in the Maya metropolis of Calakmul. It depicts the birth of the infant Maize God from a cleft skull bursting with foliage. Flowing waters abounding with aquatic emblems and fishlike tadpoles appear below, alluding to the necessity of watering maize so that it germinates. The skull motif may represent an animate seed, but its use as a basal register on a Late Classic stela of unknown provenance suggests a possible role as a mythological place-name. The scene on the Calakmul vessel originally included three versions or aspects of the newborn Maize God, each with his own nominal caption. Only one has survived the erosion of the cup's surface.

The vessel is painted in the so-called codex style, which flourished at Calakmul and neighboring sites in the late seventh and early eighth centuries. Its graceful lines and calligraphy executed in a spare palette on a creamy background allude to a now lost Classic tradition of illuminated manuscripts. Although the original owner's name has been destroyed, the painter can be identified by his distinctive hand as the same artist who produced several other codex-style vessels under the patronage of a local lord named Yopaat Bahlam. – NC

References: Burnard 1998, pl. 215; Freidel, Schele, and Parker 1993, pp. 92, 283–84; Lucero 2006B, p. 126; Scarborough 1998, pp. 149–53; Schele and M. E. Miller 1986, p. 42; Thompson 1970A, pp. 183–84.

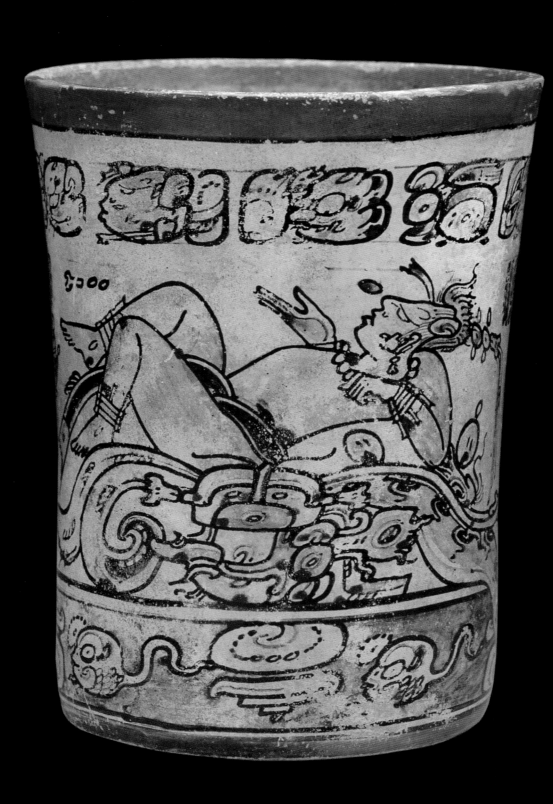

87

Plaque with the Maize God
emerging from a shark
750–800
Campeche, Mexico
Catalogue 64

Although exquisitely carved from the lip of a Caribbean conch (*Strombus gigas*), this plaque still retains on its back much of the deeply furrowed, natural exterior of the shell. The piece portrays the handsome Maize God emerging from a supernatural fish. The deity displays a curling ear of corn, or *nal*, atop his head; below, a horizontal portion of the brow originally held an inlay – probably jade or *Spondylus* – to denote hair. Although this coiffure is commonly found with the Classic Maya Tonsured Maize God, he rarely appears with the ear of maize on his head as well. The god's ear spool and necklace also had inlays, in this case almost surely small pieces of brightly colored jadeite. This carving recalls the common Classic Maya practice of drilling and inlaying incisors with bits of polished jade or iron ore. In fact, it is likely that such "dentists" were the very artisans who worked shell, a material similar in hardness to teeth and requiring the same tools and techniques. A biconically drilled hole pierces the back and side of the Maize God's left elbow to accommodate a cord for suspension, which on the opposite side was probably tied where his shoulder touches the snout of the fish. If strung in such a fashion, this object was likely worn as a pectoral.

The whiskerlike barbels on the snout and the triangular teeth identify the supernatural fish as a shark or Mayan *xook*, and is commonly referred to as the Xook Monster. Shark heads appear often above a *Spondylus* shell on Late Classic belt assemblages worn by the Maize God and his human impersonators. As great fish of almost crocodilian proportions, sharks held a prominent position in ancient Mesoamerican thought; they appear in Olmec art as early as the first millennium BC (figure 1). As a shark, the creature here with the Maize God probably relates to the mythic slaying of a primordial sea monster to create the world. In both sixteenth-century Aztec and Yucatek Maya sources, the earth-monster is described as a piscine as well as crocodilian being. In pre-Hispanic central Mexican portrayals of this mythic creation battle, the shark and crocodile can substitute for one another (Taube, figures 15, 16). In addition, a related mural from Mayapan shows the spearing of both creatures (Taube, figure 1). In the case of the Mayapan mural, a dart penetrates the mouth of the fish; similarly, the curious element emerging out of the mouth of

the Classic Maya shark may be the butt of a penetrating weapon. The mythic battle with a primordial shark-monster may be of great antiquity in Mesoamerica, perhaps present even in Olmec times. Philip Arnold suggests that La Venta Monument 63, a tall stela depicting a human struggling with a great supernatural shark, may be an early version of the Cipactli myth. If this indeed is the case, this would be one of the longest-lived creation myths known for ancient Mesoamerica.

On this plaque, the Maize God rises out of a crossed circle in the center of the shark's back. The crossed bands refer to the Mayan locative *tan*, meaning "within," and perhaps by extension, in the center. It is conceivable that the shell portrays the Maize God emerging out of the primordial earth, much as he rises out of center of the cosmic turtle in Classic Maya vessel scenes. However, it is noteworthy that the god looks intently forward in the same direction as the shark. His pose is notably similar to that of the Maize God in a canoe in a Late Classic incised vessel fishing scene. Just as the large figurine of the Jaguar God of the Underworld atop the crocodile portrays this creature as his mount (plate 96), the shark shown here is probably intended as the vehicle of the Maize God. – KAT

References: Arnold 2005; T. Jones 1985; Kerr 1989, p. 79 (K1391).

Figure 1. The Olmec shark on Monument 58, circa 1000 BC, San Lorenzo, Veracruz. Drawing by Karl A. Taube.

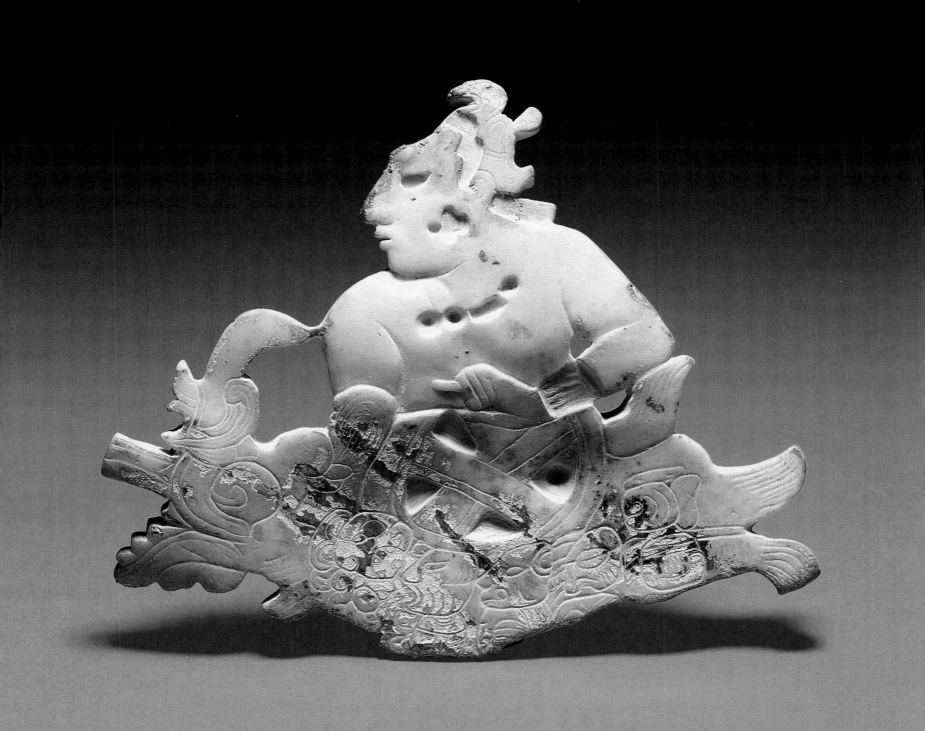

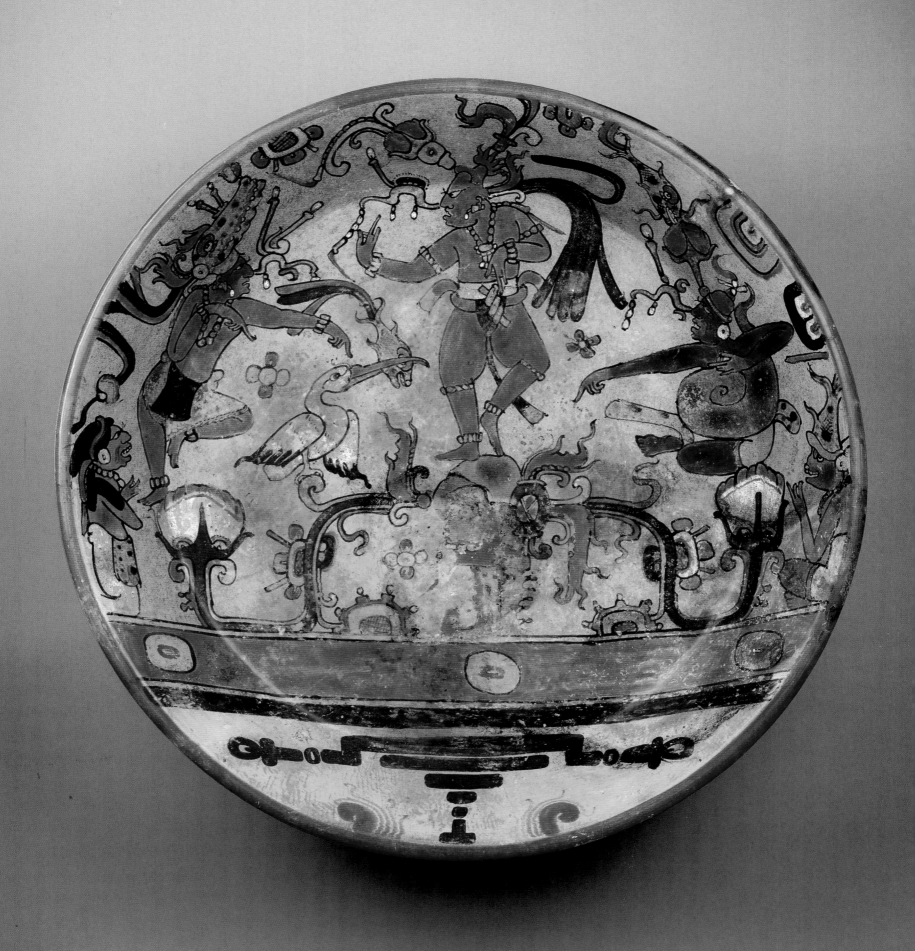

88

Plate with the Maize God
dancing above water
700–800
Possibly Peten region, Guatemala
Catalogue 65

On this large plate, its sides wrapped with a depiction of jaguar pelt, a shapely Maize God dances under the gaze of several aquatic characters. The dance takes place above water, as indicated by the abstract horizontal lines decorated with jewels and a wide band with circles toward the bottom of the scene. Celebratory flowers float in the air.

Under the god's feet is a skull with red fluid, perhaps blood, gushing from its maxilla. On one of two large water lilies sprouting from the skull rests a heron with a fish in its bill. The water-lily creature is found on many Classic Maya vessels, often in association with fishing birds and their prey. It personifies the hieroglyph for *nahb*, meaning "pool" or "water lily."

The Maize God, with an elongated, sloping head that resembles a corn cob, wears a woven loincloth and jewelry. He raises his heel in the characteristic pose of Classic Maya dance and gestures to the dancer on the left of the scene. His headdress contains aquatic flowers and splayed quetzal feathers. He is intended here to represent the maize plant nurtured by summer rains. Jeweled, almost reptilian snouts issue from the noses of the god and his attendants.

Pointing downward with delicate fingers, the other dancing figure balances on a water-lily blossom. He wears a crocodile headdress and a loincloth. An aged god with a shell for his body – known to scholars as "God N" – sits on the opposing water lily and gestures toward the feet of the Maize God. A kneeling female figure on the far left and a seated anthropomorphic fish in the far right also attend the god, as though fulfilling the role of progenitors. The focus of the secondary characters on the dance of the Maize God denotes that they are facilitating his emergence. This scene contrasts with those in which the deity emerges from the back of a cosmic turtle: this representation emphasizes the role of water, the other the earth.

The artist accentuated the liveliness and action in the scene by using a bright palette to distinguish subtle details in the costumes of the figures. The ceramic painting technique is characterized by "reverse chiaroscuro," a darkening of areas closest to the viewer's eye and a lightening near figural outlines. It is especially noticeable on the limbs of the conch-shelled individual.

To judge from its large size, the plate once held tamales, important products of maize, and for a repast of some scale. Although the provenance is not known, it is likely that the plate originated in the Peten of Guatemala, possibly in the area west of Lake Peten Itza. The god's somewhat plump physique is a type common for rulers pictured in Late Classic centers such as Motul de San José. – JD

References: M. D. Coe 2005, pp. 53–55; Taube 1985, pp. 171–73.

89

Cache vessel with
directional shells and jades
500–600
Copan, Honduras
Catalogue 52

Excavations in Group 10J-45, to the west of the Copan Acropolis, uncovered this lidded limestone vessel containing an elaborate Early Classic cache offering coated in cinnabar. At the center is a jadeite image of the Maize God wearing a headdress capped by an ear of corn flanked by downturned leaves. The statuette is set within a large *Spondylus* shell with four smaller ones containing small jade beads placed at the cardinal points. In addition, four carved jades are situated between the shells. The entire composition clearly denotes directional symbolism. The cache is a cosmic diagram portraying the Maize God as the pivotal *axis mundi* in the center of the cardinal and intercardinal points. In addition, the stone lid probably symbolized the overarching sky, a widespread concept in Mesoamerica as well as in the American Southwest (Taube, page 213). Stephen D. Houston notes that an Early Classic cache vessel from Caracol, Belize, features a supernatural bird on the interior of the lid, suggesting that it also symbolized the heavens.

The occurrence of jade with *Spondylus* is common at Copan and elsewhere in ancient Mesoamerica, including a nearby offering from Group 10J-45 that also features a central jade Maize God surrounded by directional *Spondylus* and jade. A cache from the Copan Acropolis contained a jade statuette of the Maize God within a *Spondylus* shell, with a nearby offering of twenty-three *Spondylus* shells and roughly thirty carved jades. In addition, jade beads within *Spondylus* are also known for Tonina and other Maya sites. A Late Preclassic cache from Caracol, Belize, included a stone box containing a jade mask and two beads, one jade and one of shell, within a large *Spondylus* shell. Another Caracol cache featured a central jade ear spool surrounded by four marine bivalves, recalling the caches from Copan. The tradition of placing jade in *Spondylus* shells continued into the Late Postclassic period, with one of the caches from the Aztec Templo Mayor featuring greenstone beads within a *Spondylus* shell.

For the Classic Maya, the two materials are related closely to the Maize God, who commonly wears jade ornaments and a *Spondylus* shell belt piece. The earlier Olmec also appear to have connected *Spondylus* to maize. In the elaborately incised Olmec serpentine statuette often referred to as "The Young Lord," the left thigh is ornamented with a

crocodile and the right leg with a fish. The crocodile has an ear of corn growing from its abdomen and the fish has a *Spondylus* shell in the same region, much as if it were the "maize of the sea." Both this *Spondylus* and another in the mouth of the fish are supplied with probable maize silk, again suggesting this shell's connection to corn. Recent excavations at the site of Chiapa de Corzo, Chiapas, have uncovered a Middle Formative, Olmec-style offering of greenstone celts and a polished jade cobble in a probable *Spondylus* shell. The practice of placing jade in *Spondylus* can be traced even earlier in Ecuador, one of the major sources of *Spondylus* for the ancient Andes. Karen Stothert describes a cache excavated in southern Ecuador as "a votive offering consisting of a whole spondylus shell containing two jadeite artifacts dated between 1000 and 1300 b.c." – KAT

References: Bachand, Gallaga Murrieta, and Lowe 2008, p. 192, figs. 70, 120a; Stephen D. Houston in D. Z. Chase and A. F. Chase 1998, pp. 315–18; Fields and Reents-Budet 2005, pp. 114, 116–17; Guthrie 1995, no. 193; Matos Moctezuma 1988, fig. 104; M. E. Miller and Martin 2004, pl. 62; Nakamura 2003, p. 98, figs. 2–17, 2–18; pp. 130–31; Sharer, J. C. Miller, and Traxler 1992, p. 154, fig. 10; Stothert 2003, p. 359, n. 7.

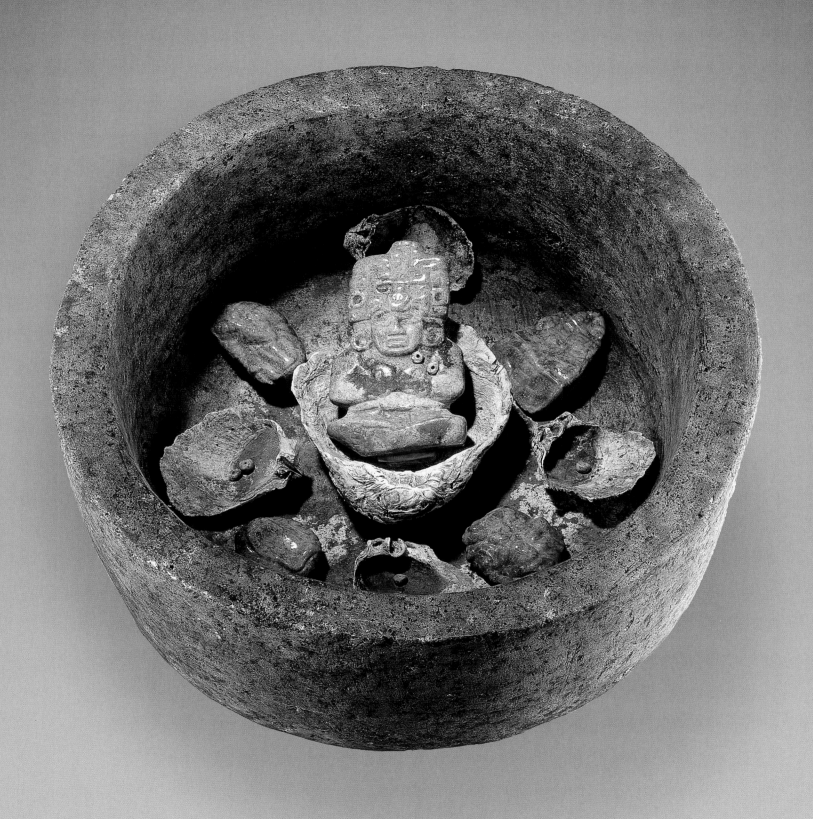

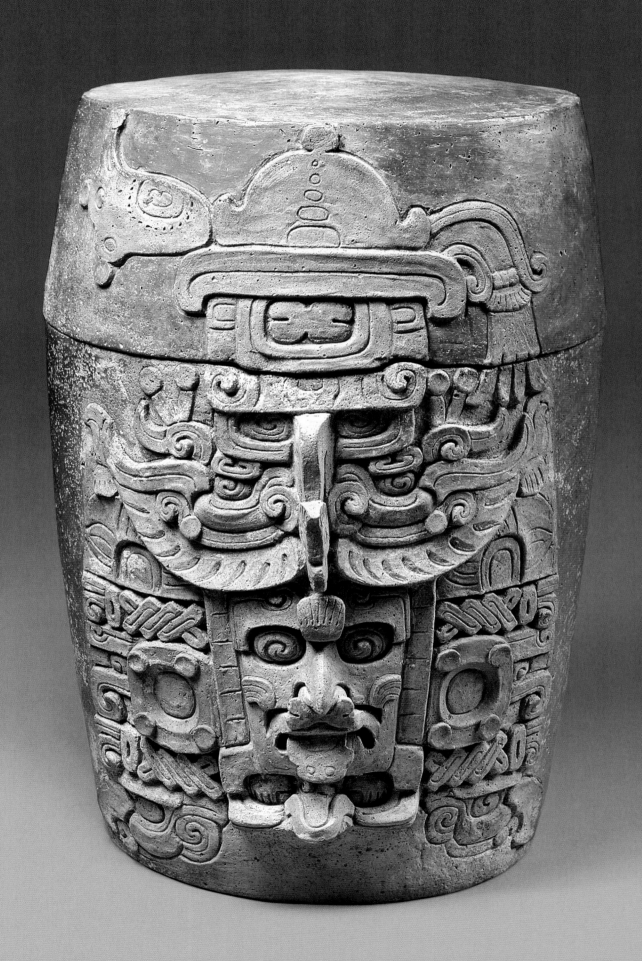

90

Cache vessel with the birth of the
Sun God in the form of a shark
350–550
Guatemala
Catalogue 66

The central character on this lidded vessel is a composite god with both aquatic and solar associations. Found in imagery throughout the Early and Late Classic periods, he exhibits a shark's tooth, swirling fishy eyes, and fish barbels or fins protruding from his cheeks. At Palenque, where scholars label him "GI" – the first in a local triad of deities – he may also have features of the Rain God, Chahk, but he is principally an aspect of the sun rising from eastern waters (plate 25). Hieroglyphic texts within the Cross Group at Palenque richly describe GI's birth and rebirth and his connection to primordial seas to the east, along with the storms, winds, and ritual items that come from that zone. In a few depictions, there is also a bird resting above his head. In turn, the head supports the so-called "quadripartite badge," a bowl, possibly a stylized incense burner, emblazoned with a solar disk and elements of a Maya day-sign. On top of these features are marine motifs such as stingray spines and shells, both linked to bloodletting, along with sacrificial cloth.

The frame of plaited mat symbols and other iconography around GI's head recall architectural elements flanking stairways in Late Preclassic and Early Classic structures. This style of head was adapted to smaller, portable objects from a tradition of building grand and elaborate god masks on ceremonial buildings. Perhaps the architectural motifs speak to the role of this vessel as a cache object inserted into the ground when the Maya dedicated buildings. It is likely the vessel once held ritually charged objects, much like those in the solar bowl above the head of the god. – CW

References: Bassie 2002; Fields and Reents-Budet 2005, p. 132; D. Stuart 2005, pp. 162–78.

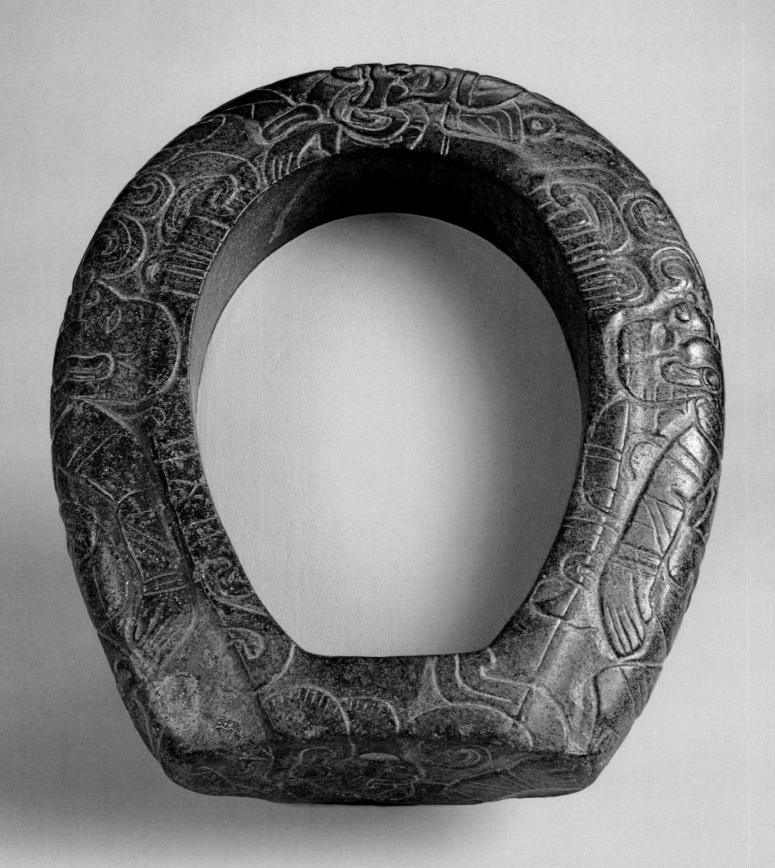

91

Stone ballgame belt with the
Maize God and swimmers in the
aquatic Underworld
circa AD 100
Veracruz, Mexico
Catalogue 89

Fashioned of hard greenstone, this stone belt is a tour de force of ancient Mesoamerican sculpture. It also constitutes a rare example of the Late Preclassic Isthmian iconography of southern Veracruz and neighboring Chiapas. The sculpture is an early form of the well-known Classic Veracruz *yugo* or "yoke" sculptures, which mimic the thick, protective belts worn in their ballgames. The entire surface of this stone belt is covered with figures enclosed by gently curving elements denoting water (figure 1). These water scrolls are very similar to forms on Tres Zapotes Monument C, a stone basin that portrays mythic figures battling in undulating waves with U-shaped tabs on their edges – a convention also found in the stone *yugo*. Stylistically, the carving is notably similar to an early Veracruz *yugo* portraying an apparently dead human figure with eyes closed and prominent lips wrapped around the exterior of the sculpture. With the projecting upper lip, his snarling mouth recalls earlier Olmec conventions; the motif appears in the four figures on this yoke as well. More specifically, the figure appearing in the central, rounded surface of the present yoke is the same Isthmian Maize God who shares traits with both the Olmec and Late Preclassic corn deities. In the Isthmian area, the Maize God also appears as a head jewel on La Mojarra Stela 1 and on the carved bones from Tomb 1 at Chiapa de Corzo. As in the case of the *yugo* published by Covarrubias, the god's eye is plainly shut, as if he were dead. His presence in water recalls Classic Maya scenes of his death and aquatic Underworld journey of resurrection, a motif that can be traced back to the Late Preclassic murals of San Bartolo (plate 83). In addition, contemporary myths of Veracruz describe the death and rebirth of the infant Maize God, who is thrown lifeless into water and then revived.

The Maize God is the central figure on the yoke. He wears a complex knotted headdress that wraps under his chin and across his brow. During the Late Preclassic period, this headdress seems to have denoted royal authority; it is also found on the early carved slabs from Mound J at Monte Alban as well as the recently excavated murals at San Bartolo, Guatemala. The west wall mural at San Bartolo features four youths – probable forms of the spotted Hero Twin Hun Ajaw – wearing this headdress while performing self-sacrifice before directional world-trees. Although it would be tempting to identify the two swimming figures flanking the Maize God as the Hero Twins, this is probably not the case, as a third, similar figure is also carved on the flat surface of the yoke opposite the Maize God. The elaborate volutes probably indicate that the figures are swimming, a convention also found in the bones from Chiapa de Corzo. A fragmentary, Early Classic *yugo* carved in Teotihuacan style depicts a swimming figure with shells in undulating waves, recalling mural scenes from the apartment compound of Tetitla, Teotihuacan (figure 2). In terms of symbolism, the depiction of swimmers on ballgame belts is appropriate. In ancient Mesoamerica, ballcourts were widely considered as fertile entrances to the watery Underworld, which probably explains why they are frequently sunken, much as if they were cavelike fissures, pools, or cisterns. As in the ballgame itself, this early yoke bears aquatic symbolism of fertility and rebirth as well as death. – KAT

References: Agrinier 1960; Braakhuis 1990; Covarrubias 1957, fig. 73; A. G. Miller 1973, figs. 274–77; Saturno 2006; Schele and Freidel 1991, p. 309; Stirling 1943, pls. 5, 6, 17, 18; Taube 1996, pp. 57, 59, figs. 18, 19; Winfield Capitaine 1988.

Figure 1. Rollout view of four figures on plate 91. Drawing by Karl A. Taube based on original drawing by John T. Hales.

Figure 2. Fragmentary stone yoke portraying a figure swimming in waves with shells, Early Classic period. Museo Nacional de Antropología, Mexico City. Drawing by Karl A. Taube.

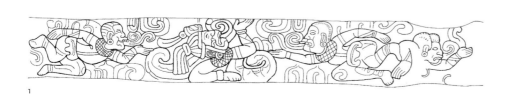

1

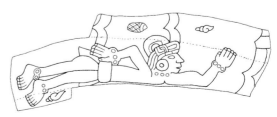

2

92

Lidded bowl with the Maize God
in the aquatic Underworld
450–500
Río Hondo region, Mexico
Catalogue 90

During the Early Classic period, finely produced ceramics with elaborate scenes began to be fashioned from molds in many regions of ancient Mesoamerica. In addition to the Maya lowlands, such bowls were also produced in the Escuintla region of south coastal Guatemala, the Río Blanco area of southern Veracruz, and at the metropolis of Teotihuacan. The technique allowed the production of many intricately ornamented vessels from a single series of molds. Discovered by Thomas Gann in an ancient structure in the Río Hondo region of southern Quintana Roo, this vessel bears scenes on both its bowl and lid. Gann also discovered in the same mound an essentially identical lid but without the supporting bowl.

The vessel portrays detailed scenes of the watery Underworld (figure 1). The primary image is a skeletal zoomorphic head with flanking fish nibbling floral elements emerging from its brow. Although Nicolas Hellmuth identified this being as a sea anemone, Stephen D. Houston suggests that it portrays coral, an organism with hard, bonelike protrusions. Behind the heads and encircling the lid and bowl are horizontal water-bands marked with circular elements denoting bubbles or drops of water. These bands are occupied by a variety of beings, including *Spondylus* shells with emerging bifurcated breath elements and human figures in conch. Whereas *Spondylus princeps* derives from the Pacific, the preeminent conch, *Strombus gigas*, comes from the Atlantic, suggesting that the vessel portrays both sides and therefore the totality of the encompassing ocean. The aquatic Underworld connects both seas and seems to be the central theme.

Of chief importance in the vessel scenes is the recumbent figure languidly embracing a water-band. His long, back-curved cranium identifies him as the Maize God, a deity who both appears in and travels through water in Classic Maya scenes. Here, however, the figure appears limp and lifeless; according to Linda Schele and Mary E. Miller, it is a "dead soul in the watery Underworld." A similar Late Classic scene on a vessel in the Museo Popol Vuh in Guatemala City depicts the dressing of the Maize God in preparation for his canoe journey of death and resurrection. In one portion of the scene, he floats on his back with his eyes shut; a fish nibbles his face, as if he were a corpse (plate 60).

It is likely that this Early Classic lidded vessel concerns the resurrection as well as death of the Maize God. Thus, his head also appears in the maws of the aquatic plumed serpents swimming in the same central water-band – beings that also serve as vehicles for the sun in its daily dawn emergence out of the eastern sea (Taube, page 215). In addition, the lower edge of both the lid and bowl is rimmed with a line of blossoms denoting the floral road of the sun (Taube, pages 217–18; and plate 66). Atop the opposing upper edge are elements that diminish in size as they rise out of the water. Similar forms are found in scenes of the Sun God in water, and they may well concern evaporation: water rising from the sea into the sky.
– KAT

References: Gann 1918, pp. 105–107, pls.17, 18b; Hellmuth 1987A, pp. 181–91; Schele and M. E. Miller 1986, p. 280, pl. 106; Quenon and Le Fort 1997, pp. 885–86.

Figure 1. Detail of the lid in plate 92. Drawing by Linda Schele, © David Schele, courtesy Foundation for the Advancement of Mesoamerican Studies, Inc., www.famsi.org.

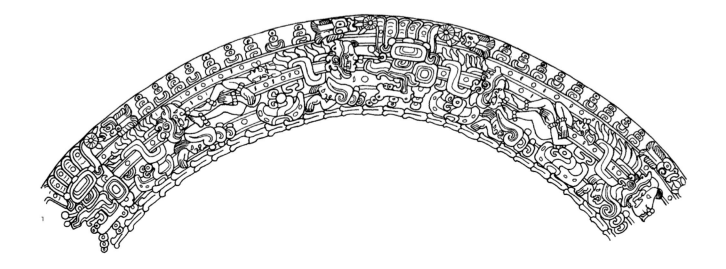

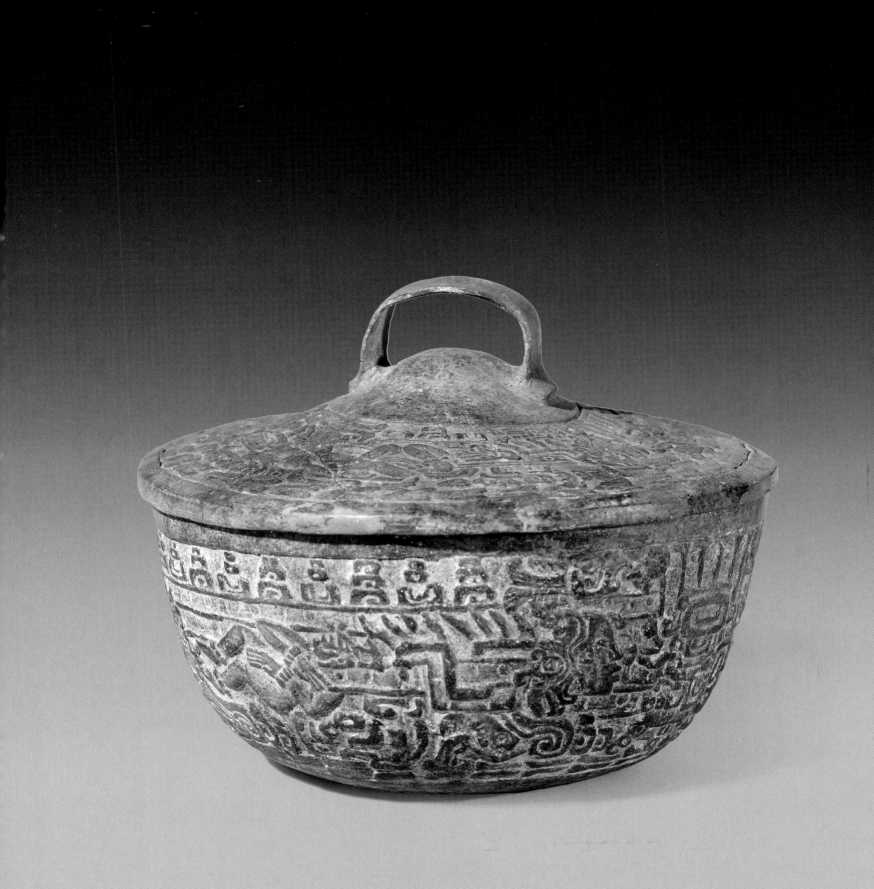

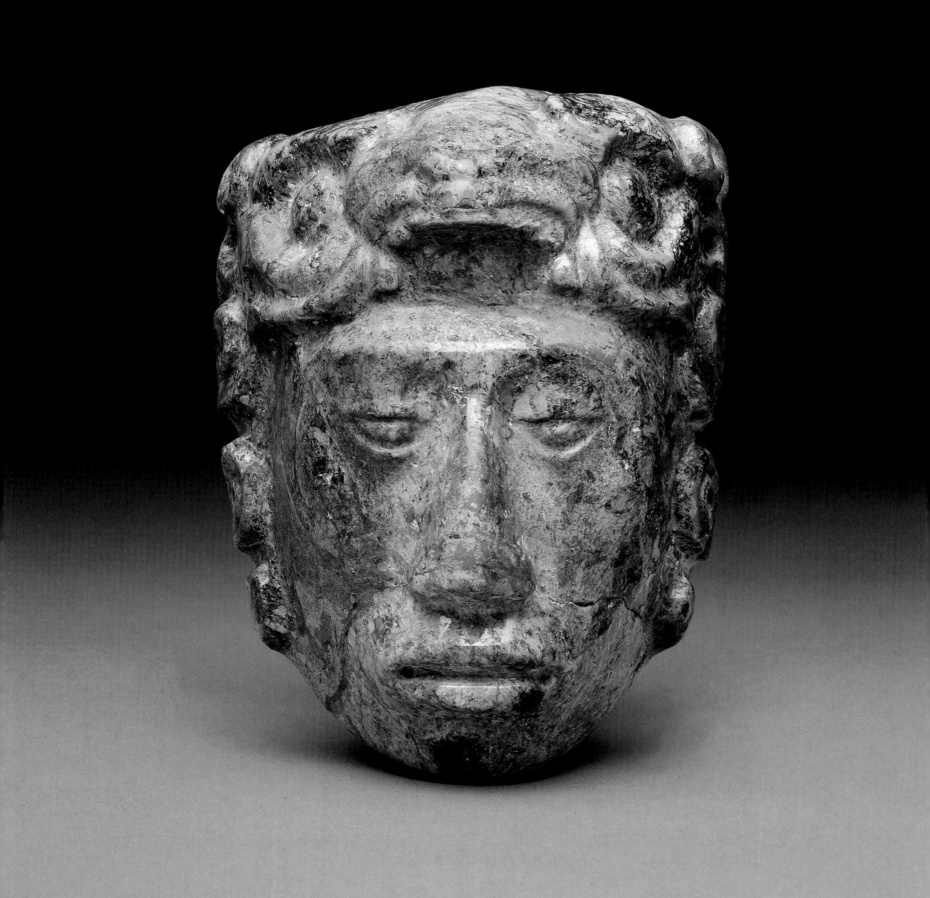

93

Belt ornament with the head
of an ancestor
AD 699
Chichen Itza, Mexico
Catalogue 81

At the beginning of the twentieth century, dredging in the water-filled sinkhole Cenote of Sacrifice of Chichen Itza, Yucatan, retrieved a vast amount of gold, wood, bone, stone, basketry, ceramics, chipped stone, textiles, incense, and jade from near and far. The precise intention behind such deposits or how they came to Chichen Itza is unknown. Their differing dates and places of origin suggest varying intentions and complex stories. Yet, by tossing the objects into the cenote, the Maya seemingly invoked relations to underground water and emphasized the permanent, ostentatious disposal of precious things.

This jade belt ornament displaying a youthful, male head and feline headdress was among the objects recovered. It offers a more traceable history than most treasure from the cenote. The jade records three glyphic dates, one highlighting the thirteenth year (ha'b) since a royal ascension at Piedras Negras, Guatemala (figure 1). Among the more important settlements of Classic civilization, this city lies some 311 miles (500 kilometers) in direct air flight from Chichen Itza – farther still by the indirect routes of foot or canoe. Enthroned in 687, the ruler in question was known as Ch'ooj K'inich Yo'nalahk; his forty-two-year reign was matched by only a few other kings. The ornament also recounts a momentous anniversary to come, in 706, when the king hoped to celebrate twenty years on the throne. The use of a future construction implies that the thirteenth anniversary is the real date of the jade. A small vertical text bears the probable name of the scribe, one of the few known signatures on a small lapidary object.

When used as an item of dress, especially during a royal dance, the head would have suspended three polished adzes underneath, tied in place by string passing through holes drilled in the bottom of the jade. Common in Classic and even Preclassic scenes of kings, sets of two or three such ensembles were often worn around the belt; the striking of the adzes during movement would have added a musical element. In the Early Classic period (250–550), such ensembles represented the heads of ancestors but could also be roped to the back of captives, in all cases as name glyphs. This Late Classic belt ornament, along with other examples at Piedras Negras and sites nearby, recalls that early use. The personal

name of Ch'ooj, or "Puma," is shown as a feline chewing on a human face, a glyph explained by the widespread belief, found among Maya today, that pumas attack humans. The portrait of the lord, unfazed by the assault, may thus double as the puma's meal. A literal heirloom, both depicting and embodying an ancestor, the jade remains puzzling because dates from a living ruler are unexpected in an heirloom. Its journey to Chichen is equally murky. Enemies may have looted the jade in the early ninth century AD when, as glyphs tell us, Piedras Negras was sacked. Or perhaps the city rulers extracted the jade when opening ancestral tombs, a form of veneration attested at Piedras Negras.

Elsewhere at this time, and in contrast to Piedras Negras, belt heads depict generic, comely youths, partly covered by bound cloth. Belt ensembles ceased to be made when courtly society collapsed at the end of the Classic period. – SDH

References: Escobedo 2004, pp. 278–79; Houston 2004A, p. 276; Martin and Grube 2008, p. 145; Proskouriakoff 1974, p. 205, pl. 60.

Figure 1. Glyphic text on the reverse of plate 93.

1

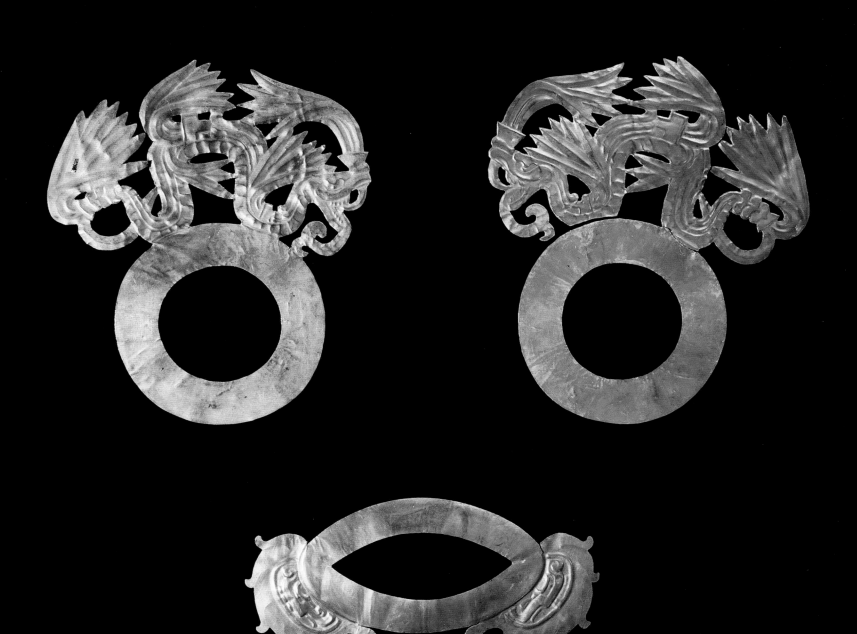

94

Three face ornaments of
Quetzalcoatl
800–900
Chichen Itza, Mexico
Catalogue 82

Objects crafted from gold were recovered in great numbers from the Cenote of Sacrifice at Chichen Itza. Some of the finest repoussé metal objects found in the Americas, these ornaments were cut from sheets and embossed by gentle hammering. Originally, these three items probably outlined the eye and mouth openings of a wooden mask now long lost. Above the two eyepieces, or goggles, are "animate eyebrows" in the form of feathered rattlesnakes, their fangs and tongues extended as if about to strike. Their style, similar to that of other gold disks from the cenote, reflects the artistic influence of highland Mexico to the west. Quetzal feathers emanate from the serpents' snout, body, and tail; their backs display pairs of ear spools with projecting quetzal plumes – both widespread Classic Maya symbols of breath and wind. In fact, the ear spools' profile closely resembles the ancient Maya "T"-shaped *Ik'* or "wind" sign. Two cartouches flanking the mouthpiece resemble the Classic serpent-wing motif – a jawless profile serpent head atop a bird's wing. Two embossed gold disks from the Cenote of Sacrifice, Disk G (plate 68) and Disk P, depict avian figures with these supernatural wings.

A dark resinous material on the backs of the overlays suggests that they were adhered to a surface and worn as a mask of Quetzalcoatl, the feathered-serpent god of wind. At Chichen Itza, portrayals of this deity in both his human and feathered-serpent form are numerous; in the latter guise, he is viewed as the bringer of rain and agricultural fertility. Murals in the Lower and Upper Temple of the Jaguars include figures wearing similar masks with plumed serpents on the goggles and accompanied by a feathered serpent. Feathered serpents also appear frequently in the upper sanctuary and upper chamber of the Temple of the Warriors. They also often serve as balustrades at Chichen Itza, probably denoting certain stairways as symbolic roads of the plumed serpent.

From the time of Early Classic Teotihuacan until the contact period Aztec, the preeminent figure with goggle eyes was Tlaloc, the central Mexican God of Rain and Lightning. In murals at Teotihuacan, Tlaloc appears in the mouth or on the back of the plumed serpent, likely portraying it as a rain bringer. In view of the relation of Quetzalcoatl to rain, it is conceivable that the gold goggle eyes allude to Tlaloc. However,

human figures at Chichen Itza wearing this mask are accompanied by great plumed serpents with no Tlaloc attributes, indicating their primary identity as Quetzalcoatl. In addition, during the Classic period, central Mexican warriors commonly wear shell goggles over their eyes or on their brow. Similar Early Classic examples have been discovered at Teotihuacan, Kaminaljuyu, and Copan. At Chichen Itza, the most elaborate and best-preserved masked Quetzalcoatl figure appears in a bas-relief on the western wall in the Lower Temple of the Jaguars. Backed by a great plumed serpent, he holds in his upraised left arm what appears to be a circular shield. Given the mask of gold, it is possible that the shield framed a version of the disks recovered from the cenote. Perhaps this figure represents the very individual who wore this gold mask, and its eventual deposition into the cenote reflects veneration or disfavor for Quetzalcoatl at a particular moment. – GS, KAT

References: Coggins 1984C, pl. 32; Freidel, Schele, and Parker 1993, p. 158; Taube 2005, p. 43, fig. 19; Lothrop 1952, pp. 67–72, figs. 35, 44; Taube 1992, pp. 136–37; Taube 1994, p. 221; Taube 2002; Taube 2005A.

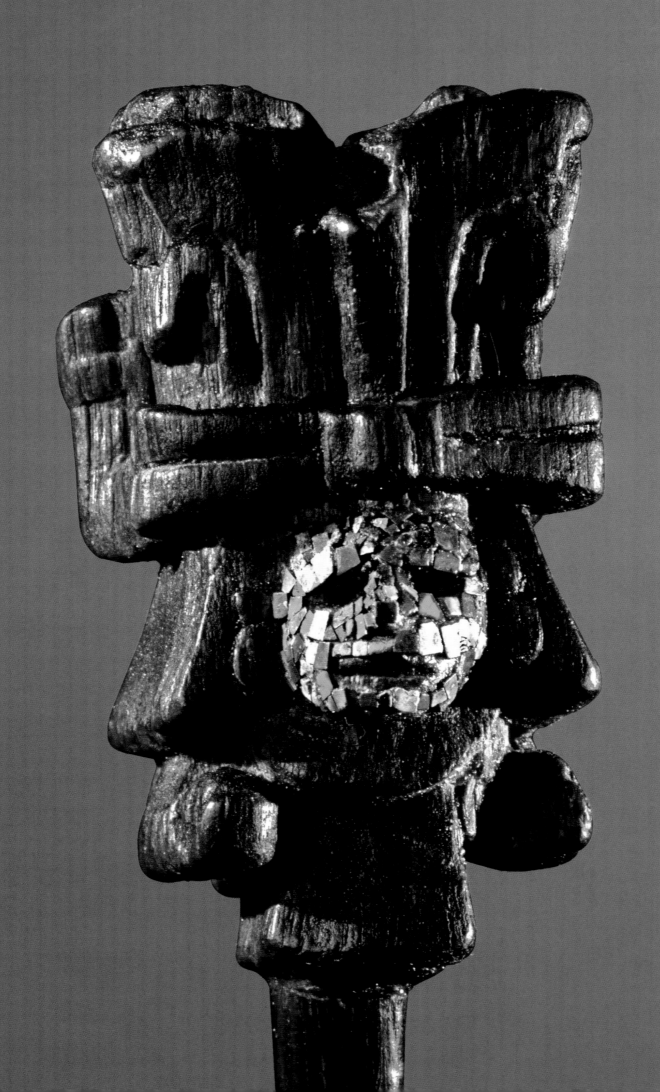

95

Scepter with a diving figure
1300–1450
Chichen Itza, Mexico
Catalogue 83

This wooden scepter, one of three found in Chichen Itza's Cenote of Sacrifice, portrays a diving figure. He wears a mask made up of more than a hundred jade and turquoise tesserae, an overt reference to trade. At the top is a charred, perforated chamber with small holes at the rim that may have held a lid to direct smoke from burning copal out through the slots behind the headdress and the lattice panel between the figure's upturned legs (figure 1). The ball the figure holds in his right hand is most likely a maize tamale or copal, the symbolic food of the gods. Late Postclassic diving figures such as this one have been interpreted as relating to Venus, the cult of the Morning Star, as a scene in the Dresden Codex portrays a diving figure with a prominent star on its rear. Other Late Postclassic diving figures have been attributed as bee gods, due to the presence of diving bees in passages of the Madrid Codex. However, the foliated headdress of this and other diving figures is a clear indication that they are representations of the Maize God.

The figure on the scepter relates to two examples on the central column in Structure 16 at Tulum. A large stucco diving Maize God is displayed in a niche above the painted mural and on a painted column directly below is another one encircled by a snake as he dives into water. A Late Preclassic Maize God wrapped in a coral snake and diving into water exists on the west wall mural at San Bartolo. It is paired with a scene of the infant Maize God in the earth-turtle (plate 83), and therefore suggests that diving refers to the Classic Maya term for death, *och ha'* (Houston, page 74).

Scepters being held by dynastic kings are featured in Classic-period monuments. This scepter may have been used as an aspergillum for rainmaking – not surprising, given its agricultural symbolism and the diving Maize God's association with life and fertility. On La Mar Stela 2, five individuals, one of whom is dancing, are depicted impersonating the Water Lily Serpent and carrying aspergillums. In addition, the Yukatek Maya make mention of native priests consecrating areas using serpent-tailed aspergillums to scatter water collected from dew on leaves and from caves and cenotes. In Postclassic Yucatan, however, the diving Maize God was often affiliated with death, so its deposition into the cenote was appropriate. – GS, KAT

References: Coggins 1984D, pl. 125; Coggins 1992, p. 280; Ishihara, Taube, and Awe 2006, p. 215; M. E. Miller and Taube 1993, p. 18; Taube 1992, p. 41.

Figure 1. Three views of plate 95. Drawing by Symme Burstein in Coggins 1992. © 1992 by the President and Fellows of Harvard College.

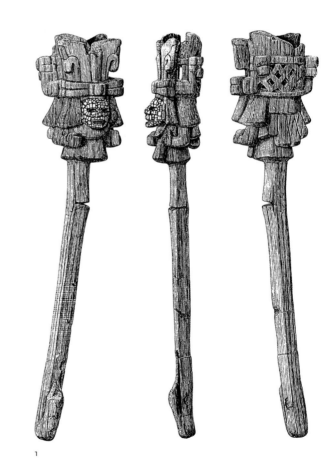

1

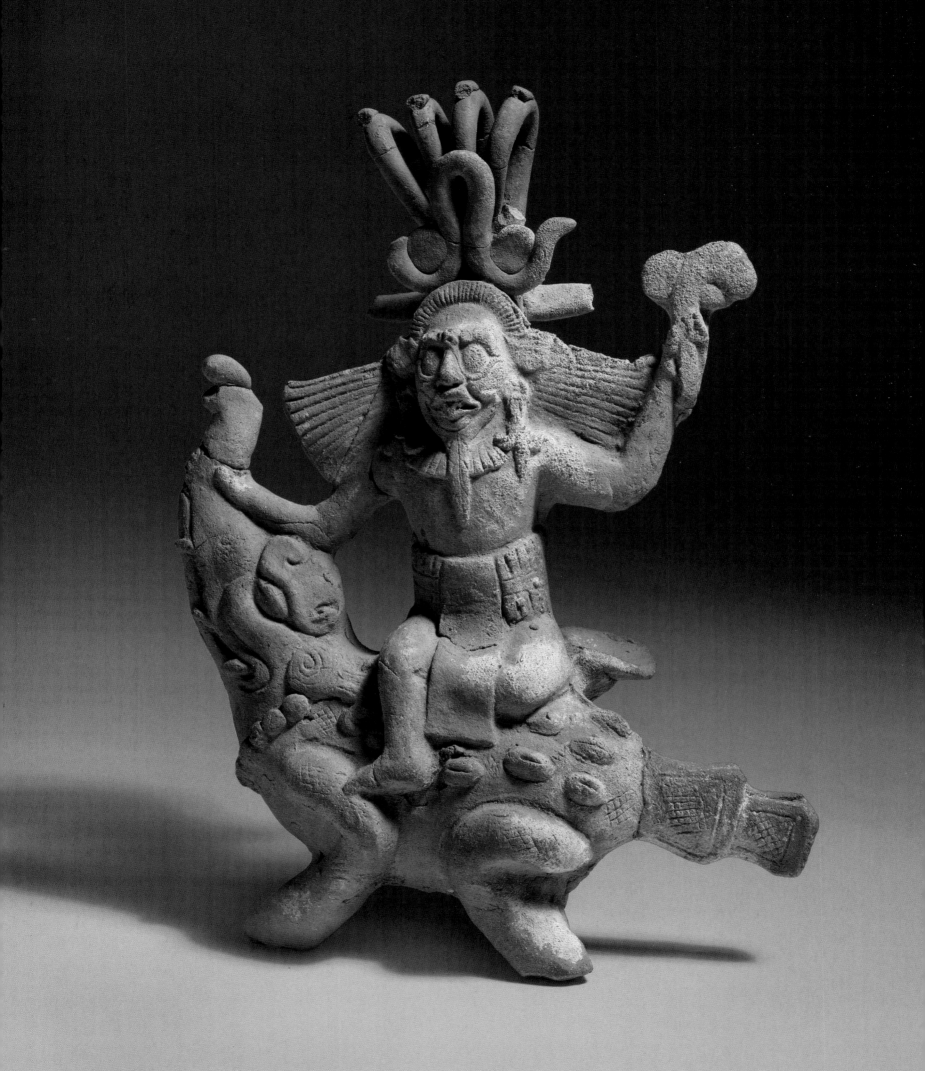

96

Figurine of the Jaguar God of the
Underworld riding a crocodile
700–800
Jaina Island, Mexico
Catalogue 87

Fashioned from a mold with appliqué details, this figurine is remarkable both for its elaborate composition and impressive size. Reportedly from Jaina, it portrays a deity seated on the back of a crocodile and brandishing an axe. This is clearly the Jaguar God of the Underworld, who displays the visage of the Sun God but also a diagnostic facial band that frames the lower portion of the eyes and twists cruller-fashion sharply above the nose. Other, secondary attributes of this god include the jaguar ears and long beard. In addition, the pendant, trefoil ear elements are often worn by gods of death and darkness, including the Jaguar God of the Underworld.

Appearing in Maya writing as the personification of the numeral seven, the day name Kib, and the supernatural patron of the month of Uo, the Jaguar God of the Underworld is a nocturnal aspect of the Sun God relating closely to darkness and the Underworld. According to David Stuart, he may also be the ancient Maya God of Fire, which would explain why he commonly appears on Classic-period ceramic incense burners. In fact, David Joralemon noted that a protruding shallow dish on the back of this crocodile was probably for burning incense, making the object an elaborate effigy censer. In terms of Maya mythology, this is of great importance. According to the *Relación de Mérida*, fire was burned on the back of a crocodilian effigy to commemorate the original flood. In addition, the eighth-century AD text from Temple XIX at Palenque mentions a fire burning atop the back of the Starry Deer Crocodile as the final act of its immolation. In many Late Classic scenes, this being appears as a sky-band with a censer in its loins as the probable birth conduit of the sun. Quite possibly, the Starry Deer Crocodile embodies the primordial night before the birth of the dawning sun.

The Jaguar God of the Underworld wears an undulating headdress element containing two disks. This prominent element is the ancient Maya star sign, which appears with other Classic Maya portrayals of the Jaguar God of the Underworld. For example, the upper portion of Stela 4 at Yaxchilan displays a sky-band with two profile heads of this being emerging from star signs. In addition, the central portion of the Jaguar Stairway on the west side of the East Court at Copan features a massive head of the deity flanked by star signs. Rather than alluding to a particular constellation or planet, such as Venus, the stars denote darkness and the Underworld; for the Yaxchilan and Copan sculptures, they also relate to concepts of the night sky and the western realm of the setting sun.

The rotund crocodile displays a short, segmented tail formed of two trapezoidal elements, in profile resembling conjoined triangles. This striking motif was extremely widespread in ancient Mesoamerica, and in addition to Classic Maya portrayals of crocodiles is found in roughly contemporaneous examples from Guerrero as well as Middle Formative sculptures from Kaminaljuyu, Guatemala, and an Olmec-style sculpture from Ticumán, Morelos (plate 75).

Here, the Jaguar God of the Underworld grasps the crocodile by the snout, much as victors seize the hair of their captives in Classic Maya scenes of combat. The upraised axe suggests imminent decapitation, probably relating the scene to the slaying of the cosmic crocodile in Mesoamerican creation mythology. However, rather than a violent sacrifice, the scene primarily suggests the dominance of the night sun over the earth-crocodile. In contrast to most Maya portrayals of captives, this reptile wears an opulent necklace and affects a relaxed, docile pose with its head inclined toward the deity. On its back, the Jaguar God of the Underworld sits with his left leg under his right. Anne-Louise Schaffer noted that his pose, or "posture of royal ease," is that of a ruler on his throne. Late Classic Maya scenes portray the day sun in the same pose atop sky-band thrones terminating in eagle heads, probably the celestial vehicle of the day sun. In a similar sense, this ceramic figurine portrays the crocodilian Earth as the seat and transport of the night sun. A stairway relief at Yaxchilan depicts the Sun God inside the earth-crocodile with a censer at its loins, much as if the sun were traveling through the "bowels of the earth" to the fiery eastern place of dawn. – KAT

References: Joralemon 1975, p. 64; Schaffer 1986, pp. 212–13; D. Stuart 2005, p. 76.

97

Celt with a ruler
circa AD 455
Guatemala
Catalogue 88

This celt or axe was originally one of a set of three suspended from the belt of a dancer. The carving on one side of the plaque portrays a young Maya ruler in full costume, wearing the three-lobed crown of kingship and holding a ceremonial "serpent bar" from which emerge the heads of two gods or ancestors. Another ancestral head – probably an actual portrait – hangs from the front of the king's belt, with three jade celts suspended below it. Still another portrait mask hangs behind his legs: known to Mayanists as "GI," this shark-toothed deity personifies the morning sun emerging out of the eastern ocean. The king is shown here with *ak'ab*, "darkness," signs at his wrists and ankles and in the band at his feet. Another such plaque, probably from the same assemblage, depicts the same individual with solar rather than nighttime imagery.

The inscription on the back begins with the celt's presentation in 451 to a lord whose name may read Machaye Chan Yopaat. References in the text to that ruler's death nine days later and a *k'atun* ending in 455 strongly suggest that the glyphs, if not the portrait, were added much later, perhaps to identify the celt as a royal heirloom. Machaye Chan Yopaat's death is described with the metaphorical phrase *och-ha'aj*, "he enters the water" (figure 1), an allusion to the Maya concept of the Underworld as a subterranean aquatic realm. The king's entry into that world was like the sun's nightly descent into the western sea or the Maize God's immersion in water. Like the sun, his soul was expected to rise again; like the Maize God, he would grow anew from watered seed. – NC

References: Fitzsimmons 2009, pp. 34–39, 68–72; Schele and M. E. Miller 1986, pp. 121–22; D. Stuart 2005, pp. 178–84; D. Stuart and G. Stuart 2008, pp. 188–89, 196; Taube 2005A, p. 32.

Figure 1. Glyphic phrase on the reverse of plate 97: *och-ha'aj*, "he enters the water." Drawing by Nick Carter.

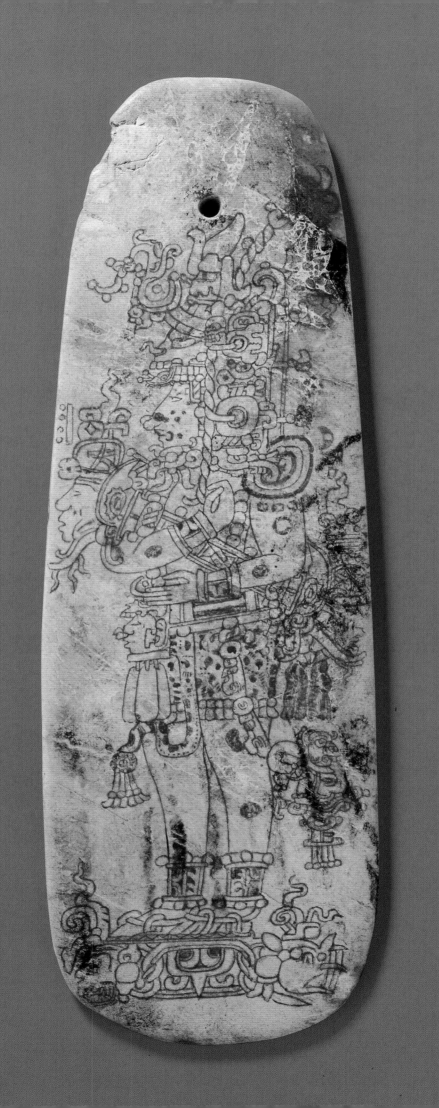

Assemblage of figurines from the
tomb of an unknown ruler
550–650
El Peru-Waka', Guatemala
Catalogue 42

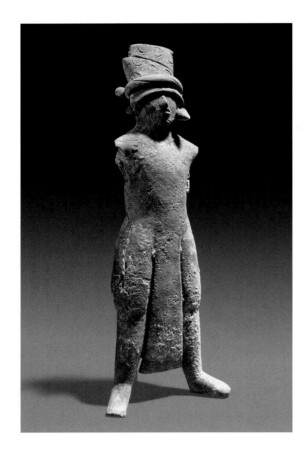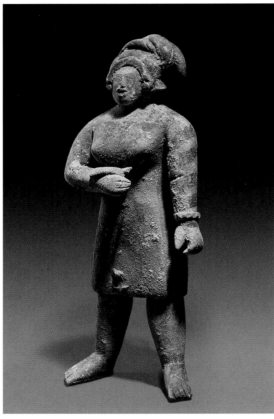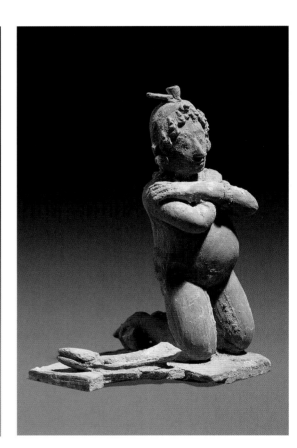

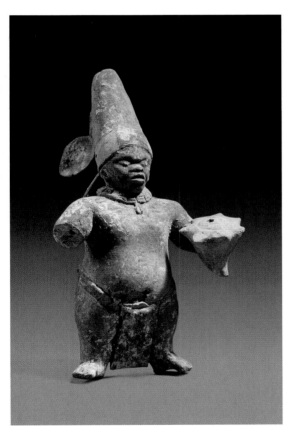

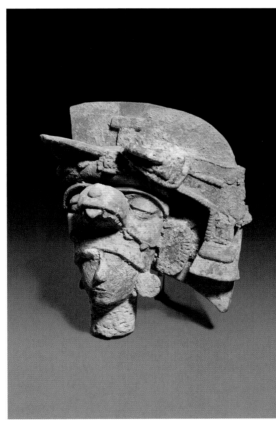

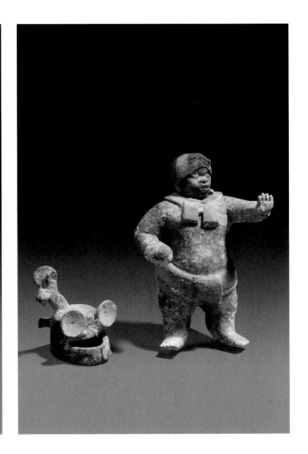

A vaulted masonry tomb chamber containing the remains of an unknown Classic-era ruler was discovered in April 2006 in the Mirador Group, a temple acropolis located at the ancient Maya city of El Perú-Waka'. Many of the tomb's elaborate contents allude to water and the sea. For example, jewelry made of shell was associated with skeletal remains of the deceased ruler, including a pendant crafted from an Atlantic deer cowrie and hundreds of small beads fashioned from pink, pock-marked *Spondylus*. Stingray spines, implements used in blood-letting rituals, were recovered on the ruler's torso, beneath a polychrome plate depicting Maya God GI. This water deity wears shell ear flares and has fish barbels at the corners of his mouth, from which a prominent shark tooth protrudes. GI's identity is conflated with Chahk, the god of rain and lightning.

An exquisite assemblage of one-of-a-kind figurines also accompanied the ruler into the afterlife. Both mold-made and modeled, many of the twenty-three figurines display unerring attention to detail in their composition and the scene they portray. Purposefully arrayed on the chamber's stone bench, this ritual tableau depicts the transformation by supernatural characters of a dead Maya king into a healed and reborn spirit. Members of the royal court, arranged in a circle surrounding the performance, witness the event (figure 1).

A portly male, arms crossed in the distinctive supplicant pose, represents the deceased king preparing for resurrection. An anthropomorphic deer leans over him with "arms" outstretched and mouth open in chant or prayer, behaving as a shaman curer. The deer may be the "way creature" – a supernatural co-essence or spirit companion – of the shaman seated in the center of the ring. The shaman's contorted face and open mouth also allude to the chanting or singing associated with conjuring the miracle of rebirth.

A frog, a hunchback scribe, and four dwarves hold court with the shaman at the center of the tableau. For ancient Mesoamericans, dwarves and frogs were among the creatures inhabiting the kingdom between the real and supernatural worlds. One dwarf mimics the scribal hunchback, while two others represent ballplayers or wrestlers. The final dwarf is one of the most potent references to the ocean within the tomb chamber: outfitted in an elegant deer headdress, he has tucked his fist inside a tiny ceramic conch-shell trumpet. The conch, distributed across Mesoamerica through either trade or tribute, is an enduring example of how symbols of the ocean became cosmologically charged in their own right. Conch trumpets were used to create serpent conduits to convey gods and ancestral souls from this world to the Otherworld. Along with the shaman, one possible interpretation for the conch-blowing dwarf is that he is opening a portal to allow the soul of the dead king to pass through the watery path of the night sun to resurrection. – MR, DAF

References: Grube and Nahm 1994; Houston and D. Stuart 1989; Prager 2001, p. 279; Rich 2008; Rich, Matute, and Piehl 2007; Schele and M. E. Miller 1986.

Figure 1. Assemblage of figurines in Burial 39, El Peru-Waka'.

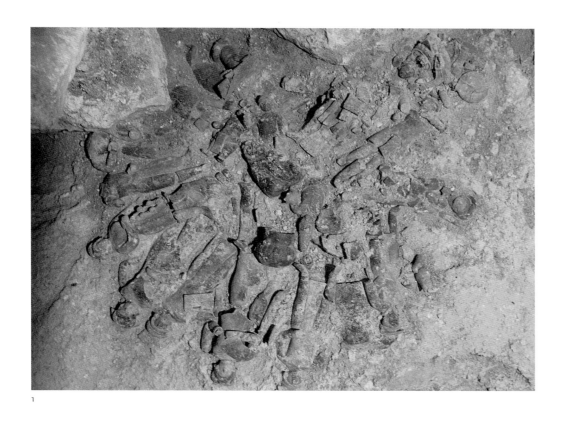

1

99

Pectoral with a watery being
circa AD 200
Peten region, Guatemala
Catalogue 36

Shaped of *Spondylus* shell, this pectoral represents one of the earliest examples of a widespread theme in ancient Mesoamerica: the *tuerto*, a grotesquely distorted face with one eye missing and a loosely lolling, asymmetrical tongue. For the ancient Maya, the motif was aquatic, including beaded streams of water that descend down the face. On this example, water also flows from the left eye as a large teardrop. Under the right eye socket is a conch, shown with an emerging serpent breathing bifurcated breath scrolls. The forehead of the *tuerto* displays a spiral, possibly denoting a cowlick. For the Aztec, children with pairs of cowlicks were thought to be suitable sacrifices to their Rain God, Tlaloc. The extruded, twisting tongue, beard, and stylized water of the Maya shell denote a watery spirit embodied in a paralytic face. On the back is an early Maya text that may refer to the lord of Tikal, Guatemala, suggesting the provenance of the shell. A glyph with an *Ik'* or "wind" sign accords with the function of the pectoral as a "wind" jewel of a lord in the early years of the Classic period (figure 1). A peccary head and skull mark two emblems, along with other stylized but enigmatic symbols. Also carved of *Spondylus*, a Late Classic Maya example in the Museo Palacio Canton, Mérida, Yucatan, captures many of the same elements as this shell, with dripping water and twisted face (figure 2); another example is in the Barbier-Mueller Museum in Barcelona (figure 3).

The first *tuertos* appeared in Mesoamerica with the Early Formative Olmec, and include figurine examples from San Lorenzo, Veracruz, and Canton Corralito, Chiapas. During the Classic period, *tuerto* carvings were present at Teotihuacan in central Mexico as well as the Atlantic coast and among the Late Postclassic Aztec, but not yet in two-dimensional painting for all of Mesoamerica. A Veracruz stone *hacha* at Dumbarton Oaks, Washington, DC, portrays a *tuerto* with a fish as well as a conch, again denoting the aquatic nature of the being. One of the more significant examples of the *tuerto* motif was for the Aztec, in this case the earliest sculpture from the great Templo Mayor in Mexico City. Found in the lowest excavated level of the northern, Tlaloc, side of the temple, it again appears with water. According to the excavator, Eduardo Matos Moctezuma, the twisted face may relate to a well-known paralysis caused by exposure to

extreme cold. Such an ailment would be entirely appropriate for Tlaloc, who resided atop mountains buffeted by harsh winds and snow. Clearly, the *tuerto* motif was widely identified with rain and water in ancient Mesoamerica. – KAT, SDH

References: Benson and Coe 1963, no. 93; Matos Moctezuma 1991, p. 4; M. E. Miller and Taube 1993, p. 174; Sahagún 1980, p. 42.

Figure 1. Glyphic text on the back of plate 99. Drawing by Stephen D. Houston.

Figure 2. *Tuerto*, Late Classic period. Museo Regional de Yucatán "Palacio Canton," Mérida, Mexico. Drawing by Karl A. Taube.

Figure 3. *Tuerto*, Late Classic period. Museu Barbier-Mueller, Barcelona. Drawing by Karl A. Taube.

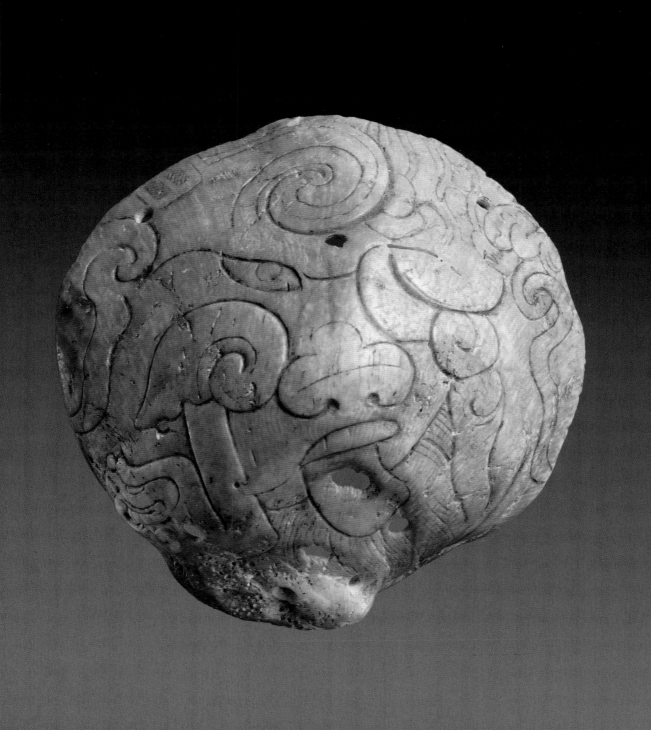

CODA: THE SEA AND ART

DANIEL FINAMORE

We do not associate the idea of antiquity with the ocean, nor wonder how it looked a thousand years ago, as we do of the land, for it was equally wild and unfathomable always.... The ocean is a wilderness reaching round the globe, wilder than a Bengal jungle, and fuller of monsters.

– Henry David Thoreau[1]

The sea as muse The dominant vision that equates maritime art with European painting is not entirely accurate. In that sense, the West came late to an art of the sea. At the end of the sixteenth century, when Flemish artists began painting undulating waters and distant horizons, sometimes with rolling ships or a spouting whale, and thereby established the European tradition of seascape painting that continues to this day, Maya artists had been creating their own vision of the sea for many centuries. In fact, oceans have figured prominently in human thought and artistic expression from the earliest surviving articulations of cultural creativity. It is no surprise that people living at the water's edge, from the Nile and Euphrates to tiny islands scattered across the Pacific Ocean, scratched images of their boats into stone, painted them onto pots, and crafted models of them from ceramic, wood, and even gold. Yet, even in the Tassili n'Ajjer mountains of southern Algeria, a group of rock paintings, some dating back more than five thousand years, includes at least one boat amidst a sea of painted ungulates, hippopotomi, and hunting men – an image of water transport in the middle of what is today the greatest desert in the world. Beyond actual depictions of waterborne activity, artistic representations of shellfish on Peruvian ceramics and Marshall Islands tattoos that emulate the striped patterning of reef fish also embrace symbolic and

Opposite page. Sea turtle swimming in Caribbean waters.

Figure 1. Conch shell cup fragments engraved with four men in two canoes, 800–1600, Spiro, Oklahoma. Drawing from Phillips and Brown 1979. © 1979 by the President and Fellows of Harvard College.

literal qualities of the sea and its denizens as forces central to daily life. These examples are all facets of a thematic body of art that explores and expresses the dimensions of human cognition of the sea.

Osmosis or independent wellsprings? Cross-cultural comparisons of artistic motifs and styles or common patterns in the use of objects frequently leave archaeologists and art historians with feelings of discomfort. There is a danger of oversimplifying critical issues of communication and the transmission of ideas among disparate populations or, conversely, common cognitive responses to phenomena based on hard-wiring of the human brain. This essay does not assume that imagery or concepts of the sea were invented in a single locale and diffused around the world (though commonalities in iconography in some cases do suggest cross-cultural communications by land or sea). Nor is it an argument in support of large-scale historical patterns that have created a common human experience across divergent places and times. It does not assume the existence of a pervasive psychic unity for artistic responses to natural phenomena, even one so awe-inspiring as the sea. Rather, by reflecting upon examples of commonalities and unique aspects of the conceptualization of water and its denizens that have emerged in different places and times, this discussion seeks to situate Maya art within a broader interpretive context. Irrespective of their unique social complexity and writing, the Maya expressed their vision of the centrality of the sea in their lives explicitly through their art, and the motivating factors shaping their vision, if not its specifics, were similar to those of people in many other parts of the world. At the most basic level, overarching commonalities derive from common experiences: people travel on the sea, they obtain food from it and, despite the resultant limited familiarity, they are afraid of it. The most apparent dissimilarities are the product of idiosyncratic cultural and artistic responses to these unpredictable experiences of both opportunity and danger.

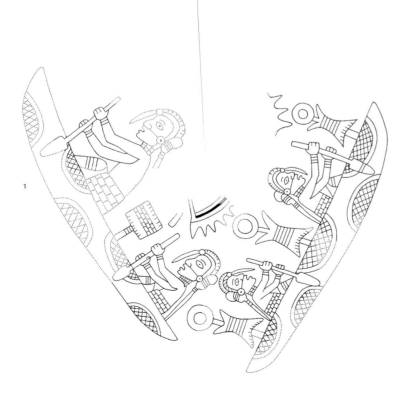

American neighbors It is hard to ignore common artistic elements that seem to point to the migration of populations or ideas at a discreet moment in the distant past, especially when they imply direct seaborne contact. Due north of the Yucatan peninsula, across the Gulf of Mexico and far inland but near major rivers, a Mississippian-period (800–1600) earthen mound in Spiro, Oklahoma, yielded hundreds of fragments of conch shells that had been fashioned into cups and gorgets and engraved with complicated abstract patterns, serpents, and human figures.[2] Discovered alongside necklaces made from pearl and *Olivella* shell beads, these engravings appear eerily similar to those of the Classic-period Maya. Much of the mysterious iconography is thought to relate to events in a watery Underworld, and four fragments even portray figures paddling canoes (figure 1). Others may even be linked to travel across the celestial realm.[3] But, overt similarities in materials, artistic techniques, and environmental associations may in this case be archaeological red herrings. Both peoples viewed these shells in relation to their watery Underworld origin, but only for the Maya did they physically or even metaphorically embody ancestors who traveled across the sky to influence daily events.

On the other hand, iconography on vessels painted by the Moche people of Pacific South America between 100 and 700 illustrates elements of a narrative with strong similarities to the Maya mythological stories recorded in the *Popol Vuh*.[4] In the most general description, two supernatural figures bring a period of chaos upon earth, demanding blood sacrifice and passing through the Underworld in their reed boats until they are defeated by the sun, who thereafter must be honored instead.

Figure 2. Nasca bowl with depictions of lobsters, 100–400, Peru. Peabody Essex Museum, Gift of Joan Eliachar, 1991, E77336.

Figure 3. Nasca double-spout-and-bridge vessel with fish or killer whales, 100–400, Peru. Peabody Essex Museum, Gift of Charles G. Weld, 1910, E13325.

The iconographical similarities between the Moche and other New World mythological narratives may derive from an ancient common origin, but those archetypes gave birth to diverse interpretations and artistic evocations of environmental phenomena that bore relevancy to a multitude of people at the local level in different places and times. Painted and molded pottery of other South American groups, including the Nasca (figures 2, 3), offer tantalizing but still undeciphered allusions to narratives possibly linked to those of the Moche but which, like the African water-spirit Mami Wata who was revisualized in a multitude of manifestations through the worldwide diaspora of her worshippers, reflect the idiosyncratic interpretations of different cultural groups.[5]

Painted themes and narratives from farther afield Images of boats appear in art around the world. Although the European and American tradition of commemorating specific trade voyages and sea battles has influenced our perceptions, it is likely that most art depicting boats over the last three millennia employed generic ships as symbols of ideas or identity rather than as historical records. Some of the earliest known images of vessels, from the Early Bronze Age in the Cyclades Islands (2800–2000 BC), are of longboats with many oars incised on flat clay objects of unknown function, called "frying pans." The boats are sometimes shown with large fish projecting from the bow and surrounded by dense spirals signifying waves, currents, or winds (figure 4). These rudimentary but potent images date from a time of increasing inter-island travel, but are far more likely to represent the trials and vicissitudes of life than a specific ship or voyage. Less needs to be inferred about the ceremonial banners, or *Palepai Maju*, of south coastal Sumatra. Created well into the twentieth century, they depict highly stylized ships and were made for display during important rites of passages such as baby namings, circumcisions, and marriages. The ships are multivalent design elements symbolizing a range of momentous transitions in life.[6]

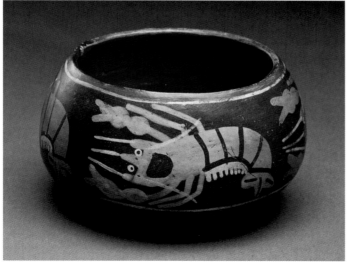

2

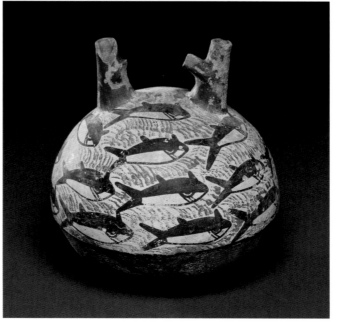

3

As in other traditions, Maya artists repeatedly explored facets of a small range of themes they held in particular regard. The boat appeared as a visual trope in an oft-related story of symbolic passage, carrying the Maize God as an ungerminated seed through the watery Underworld on his way to becoming a plant that fed the Maya people. As such, the boat was part of a complex package of visual symbols in a story of importance to Maya viewers; its very telling may even have been so powerful as to play a role in conjuring the rains.

Similarly, in European medieval and Renaissance art, Jonah being tossed from a ship into the gaping maw of a great fish was a common subject. The story was so visually familiar that even in paintings with tacitly unrelated subject matter, the appearance of a sea monster or even a spout of water within undulating surf brought themes of piety, forgiveness, and redemption into the narrative. Other visual references to the moods and mythologies of the sea would be far less obvious to a viewer unfamiliar with European cultural traditions of the time. Images of St. Nicholas, the patron saint of sailors, for example, allude to divine protection on the seas, yet frequently the sea is referenced only as water dripping from his clothes and beard. Neptune and Poseidon grace grand civic fountains and the bows of ships as muscular gods holding three-pronged spears, sometimes atop aquatic horses or shell chariots. Though more recognizable in modern culture than St. Nicholas, their exact relationship to the sea by those unfamiliar with Classical mythology must be inferred. Even today, many people would recognize images from the story of Odysseus and his twenty-year voyage home from war that graced a multitude of ancient Greek pottery, murals, and mosaics. But, it would be virtually impossible to re-create

narrative or significance armed only with individual scenes, such as a burly man clinging to the underside of a ram while a blind giant reaches out (Odysseus escapes from the Cyclops), or the same man strapped to the mast of a ship while huge birds with women's heads fly about him menacingly (Odysseus hears the call of the Sirens) (figure 5).

Since the Renaissance, European painters of the sea have largely perceived their challenge as creating a convincing representation of the surface of a body of water, defining it primarily by the air above and the light reflecting off it. The nexus of these elements within the two-dimensional plane of the canvas or panel is the horizon, whose presence is an essential compositional component within the standardized Western framework of linear perspective. Curiously, this approach was not entirely unknown to the Maya, but neither was it fully embraced: it has been found in surviving ancient Maya art only once. The picture plane of the gold disk from the Cenote of Sacrifice at Chichen Itza (plate 68) is evenly divided by the juncture of water and air, and the various swimmers, canoes, rafts, and flying creatures are placed to lend a sense of depth to the scene, with those at the bottom being the closest and receding with elevation.

Painters of the Northern European Baroque, German Romantic, and American Hudson River School traditions all embraced the seascape in which light filters through clouds and water-laden atmosphere to integrate these three elements. This unification actually became the primary subject of the works, elevated above geography or narrative. In essence, the real theme of such paintings is the pervasiveness of water. Dense atmosphere hovering above the sea, pierced by shafts of light or connected by rainbows, evoked the vulnerability of humans amidst nature and the ubiquitous presence and power of God. Though vastly different in all measurable artistic elements such as technique, style, and pictorial content, the underlying theme and resulting expression are remarkably similar to Maya representations of their sea.

Figure 4. "Frying pan" with an engraved image of a ship, 2500–2200 BC, from a tomb at Chalandriani, Syros Island, Greece. National Archaeological Museum, Athens, inv. No 6184.

Figure 5. Red-figured storage jar (*stamnos*) representing Odysseus and the Sirens, 480–470 BC, painted by the Siren Painter, Athens. The British Museum, London.

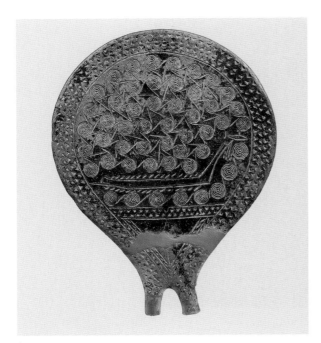

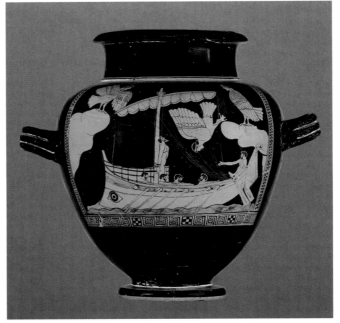

4

5

Boat models Ship models have been created for a multitude of reasons. Beyond conveying technical information in relatively compact fashion, some models were intended simply to entertain children while others were built to be hung from the rafters of Christian churches to convey to heaven seamen's prayers for protection. Models have been celebratory symbols of honor, such as the silver nefs ornamented with cresting waves and mythical sea creatures that were placed before the most important guests in the French court. Others crafted of rock crystal, gold, and gems served as table-top saltcellars that literally brought the sea to the dining table (figure 6).[7]

Much of the portable art that has come down from antiquity, including models of boats, has survived because it sat in tombs undisturbed for centuries. This fact has skewed perception of many of these works as mortuary art, created explicitly to be buried alongside the dead. Much painted Maya pottery recovered from tombs displays evidence of prior use and even repair by the living; interment was only one phase in their lives. Kayak models placed with mummified bodies in Aleutian Island burial caves and large, elaborate wood and ceramic boat models in Han-period tombs in China – complete with deckhouses and figures operating the vessels – have each been interpreted within their context of discovery as a tool necessary for the soul of the deceased to travel to the next life. This perspective has perhaps been overzealously adapted to finds around the world based on what is known about ancient Egypt, where models and images of boats were frequent grave goods. The most important individuals in Egypt were buried with full-sized boats, along with an array of other objects thought to be useful in the afterlife. A boat was not necessarily sacred in and of

itself, but was thought to be a practical addition to the burial assemblage as a facilitator of the initial stage of the passage of the deceased across the Nile. Such a view of Egyptian grave goods as wholly utilitarian may be a simplification of religious belief, but the frequency with which boat models were placed in tombs is testament to the perspective of them as crucial to, or at least representative of, a portion of the passage undertaken by the deceased. This interpretation cannot comfortably be universally adapted to Maya canoe models. Of the few surviving examples, those in bone and stone appear to have been designed as pendants, while only the clay models may have been interred in burials or caches and these may have been important primarily as containers for precious liquid or objects and secondarily as symbols for metaphorical passage.

Actual boats At what point did the boat cease to be a tool of everyday life and become an object of ritual? Aztec canoes were decorated when used in ceremonies devoted to the Rain God, Tlaloc, but there is no direct indication that the Maya animated their boats with oculi or figureheads at their bows to evoke creatures that might make them more buoyant at sea, stronger in battle, or successful at fishing. In the Orinoco delta and some Caribbean islands, builders of dugout canoes perceived the process as akin to bringing life to an animate being or of transferring the spirit of the living tree into the finished canoe.[8] The process required a series of prescribed rituals from selection of the tree through decoration of the hull to initial launching. The soul boats of the Asmat people of New Guinea are elaborately carved canoes of nearly working scale (though without bottoms, since spirits do not need them to stay afloat) that are created exclusively for a ceremony that simultaneously sends off the spirits of the recently departed and initiates adolescent boys into manhood.[9] For the Asmat, the obvious symbolism of the voyage of life is related to more than just death: in a single ceremony, the boat carries the soul of the deceased out of the community while transporting a new generation in. Supernatural canoes

Figure 6. Gold saltcellar with rock crystal, emeralds, pearls, and spinel or balas rubies, mid-thirteenth century, Paris. The Metropolitan Museum of Art, The Cloisters Collection, 1983 (1983.434).

Figure 7. Henri Julien (French-Canadian, 1852–1908), *La Chasse-galerie*, 1906, oil on canvas. Musée national des beaux-arts du Québec, Museum purchase, 1925, 34.352.

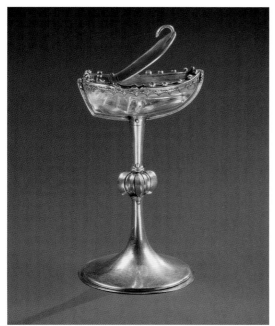

6

7

with special powers appear in the folklore of many cultures – even in a French-Canadian tale of lumberjacks who asked the devil for a flying canoe to carry them over the forest (figure 7). Whether inherently benevolent or evil, all of the spirits associated with boats have the power to protect or destroy the occupants. Did the Maya think of their boats as mere tools in the struggle to survive on the sea, or might their now eroded clay and bone models have once been decorated in a manner that transgressed the boundary between boats as tools and their images as symbols? On one of the Tikal bones, a canoe that morphs at the bow into a serpent head offers only the merest glimpse into a possible Maya vision of a spirit within.

The Maya employed images of canoe paddles, some of which appear to bear decoration, to convey specific ideas. The symbolic significance of the canoe paddle beyond a means of propulsion has been embraced well beyond the Maya area, across the expanse of the Pacific Ocean. The paddles' two broad, flat surfaces have been decorated to express various ideas. Some recognize supernatural entities who could influence a boating venture; others proclaim social distinction and group affiliation, prominently visible in a rapidly approaching trade or war canoe. Many highly adorned paddles were primarily ceremonial, never used, and displayed only periodically on important occasions. In the northern Solomon Islands, paddles ornamented with spirit figures may have guided headhunting raids.[10] In New Zealand, Maori war canoes were central forms for expressing tribal unity and strength, and paddles were decorated with nonrepresentational designs named after plants or animals that announced inherited tribal authority or genealogical mana (figure 8).[11] Adorned with fugitive pigments, such paddles were likely exhibited primarily on land,

Figure 8. Maori canoe paddle, wood with painted blade, before 1811. Peabody Essex Museum, Gift of Captain William P. Richardson, 1812, E5492. The design name, *puhoro*, refers to bad weather.

Figure 9. Mosaic portraying creatures of the sea, circa 100 BC, Rome. Museo Archeologico Nazionale, Naples.

much as many a boathouse along the Thames and Charles rivers features oars similarly adorned with college and rowing club insignia.

Sea creatures Maya artists painted, incised, or sculpted representations of realistic and fanciful sea creatures, both as free-floating entities (plate 27) and set within their natural milieus (plate 69). These works were unlikely ever to have been mere flights of artistic fancy, but were based in mutually understood notions of these animals as embodiments of a pantheon of supernatural entities. In some cases, their appearance had direct impact on human life, such as the images on the Tikal bones of Chahk fishing (Taube, figure 13; Finamore, figure 6), which suggests that these bones may have been part of a priest's tools for rain-making (Taube, page 209).

In Christian-era Roman culture, fish and seawater itself each carried fairly straightforward symbolic associations. In elaborate mosaics, fish were interpreted to represent Christian souls. A fishermen who collects these souls, therefore, symbolized Christ or an apostle. The view of water, on the other hand, was more complex: it may be a nurturing environment symbolizing God as the source of life, or conversely, a polluting place of sin from which fish must be caught to be saved.[12] Mosaics presenting a wide array of aquatic species living in harmony, often depicted with near-scientific accuracy, call to mind the wonders of Creation or Paradise (figure 9). Mosaics of sea life were also created during pre-Christian times, and though they are usually (and possibly inaccurately) interpreted as mere decorative vignettes or illustrations of myths such as the triumph of Neptune and Amphitrite, their symbolic dimensions were undoubtedly entirely different.

As a varied metaphor for different states of being, the significance of water and its attendant creatures was contextually based. The visual potency of the natural phenomenon of the sea was adapted to symbolize different elements as the belief systems of the ancient Romans evolved. This seems to be truly analogous to Maya imagery over the course of

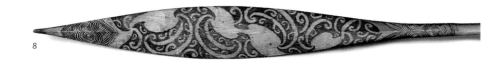

8

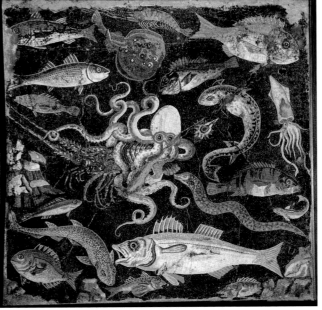

9

centuries and perhaps regions, since there are clear variations in the presentations of the central visual stories of the birth of the Maize God, and some elements that were apparently lost or significantly changed between the time a Classic-period pot was painted and the *Popol Vuh* was first written down centuries later.

Shells Much as the medium of the whale's tooth infuses the art of scrimshaw with its mystical milieu of origin, carved shell, mother-of-pearl, and coral inlay are material evocations of the inaccessible but imagined maritime worlds that surrounded the Maya on all sides. Brittle, but soft enough to incise and to shape by grinding, colorful and variegated, the seashell has been commonly employed as ornamentation since antiquity. Adornment of the body with jewelry made of shells has been interpreted as some of the oldest evidence of distinctly human behavior.[13] Seashells have been employed as a decorative medium the world over, yet the Maya and some other peoples also found their origins in the sea significant for symbolic associations with spiritual transcendence. The recently discovered Lupercale Grotto, revered by ancient Romans as the site where the city's mythic founder Romulus and his twin brother Remus were suckled, is encrusted with shells between stone mosaics.

Regardless of why the Spanish conquerors chose St. James as the patron saint of their new capital city of Santiago de Guatemala (Antigua), Maya people in colonial times found that his image bore potency well beyond established Christian references. In art, St. James (Santiago) is integrally associated with the scallop and is often portrayed wearing a single shell on his breast or hat brim or even surrounded and covered by them

(figure 10). The pilgrimage to his reputed grave at Santiago de Compostela in Spain is symbolized by a single shell, both for the wayfarer along the route and as an emblem of having accomplished it. Within this context of Christian imagery, the scallop shell references death and resurrection from the sea – a concept no doubt easily grasped by a Maya person who readily recognized the sea as the locus of both death and rebirth. No longer *Spondylus* and conch, the scallop was a new shell for a new religion.

The liminal sea According to art historian Esther Pasztory, the Maya were "thinking with things" when they developed a visual vocabulary to cognitively frame their ideas about the place of the sea in their world.[14] As such, many of their works represent how they worked out concepts that were of central concern to them, whether they are best classified as a set of beliefs, folklore, or worldview. The complexity of discussions of the Maya cognitive landscape, or more accurately, seascape, risk relegating the sea to an abstract metaphor. For the Maya, however, the sea was a very real location, where proximity and interaction with its edges and surface fostered familiarity that rendered it part of their sphere of daily social life. But beyond, the penumbral depths sheltered intangible and elemental forces of nature at the center of their cosmos that occasionally traveled to the Maya in the form of sea creatures or jade and gold from distant regions. This duality is conveyed through the varied approach to artistic expression that embraces both extremely naturalistic and conceptual approaches, and the development of intensely localized styles to express regional and even individual identity. Much of the symbolism conveys attitudes and ideas that made the Maya distinct from all other cultures. But, thinking about them within the broader context of how people around the world have perceived and incorporated the sea into their corpus of artistic expression highlights convergences that integrate Maya artistic forms and the social contexts of their creation into the larger realm of human experience (figure 11).

Figure 10. Sculpture of St. James wearing pilgrim's clothing and a hat with symbolic seashells (detail), eighteenth century. Santiago de Compostela, Spain.

Figure 11. Grave marker of Samuel Comfort with crossed oars as bones, slate, 1704. Charter Street Cemetery, Salem, Massachusetts.

10

11

1
Thoreau 1865/2004, p. 133.

2
Phillips and Brown 1978.

3
Reilly 2007, pp. 39–55.

4
Quilter 1990, pp. 42–65; Quilter 1997, pp. 113–33.

5
Drewal 2008, p. 25.

6
Gittinger 1976, pp. 207–27.

7
"Saltcellar [French] (1983.434)." In *Heilbrunn Timeline of Art History*. New York: The Metropolitan Museum of Art, 2000–. http://www.metmuseum.org/toah/hd/loui/ho_1983.434.htm (October 2006).

8
Wilbert 1977.

9
Schneebaum 1990.

10
"Paddle (Hose) [Buka or northern Bougainville Island, northern Solomon Islands] (1978.412.1491)." In *Heilbrunn Timeline of Art History*. New York: The Metropolitan Museum of Art, 2000–. http://www.metmuseum.org/toah/hd/solo/ho_1978.412.1491.htm (April 2008).

11
Hamilton 1896.

12
Drewer 1981, pp. 533–47.

13
Bouzouggar et al. 2007, pp. 9964–69.

14
Pasztory 2005.

Note to the reader: Although the preceding plates and entries are organized to reflect ideas as they are introduced in the essays, the exhibition's thematic structure is reflected in the organization of the following catalogue. Throughout the volume, all dates not otherwise noted are AD. Measurements are given in standard format: height precedes width precedes depth. Since the application of paint, slip, or pigmentation occurred prior to firing the majority of ceramics herein, the notation of color has been omitted from the entries. Although a few works in the catalogue are reproductions or renderings of ancient works, they appear here because of the importance of the subjects they represent.

Section 1
Water and cosmos

Catalogue 1
Frieze of a fish jumping out of the water
500–600
Altun Ha, Belize
Stucco
10 1/2 x 40 1/2 x 1 1/4 inches (26 x 103 x 3 cm)
Royal Ontario Museum, Canada, 967.71.151. Photograph with permission of the Royal Ontario Museum © ROM, 2009.
Plate 21

Catalogue 2
Tripod dish with a water-band and aquatic creatures
400–500
Uaxactun, Guatemala
Ceramic
5 x 9 7/8 x 9 7/8 inches (12.7 x 25 x 25 cm)
Museo Nacional de Arqueología y Etnología, Guatemala City. Courtesy Peabody Essex Museum, photograph © 2009 Jorge Pérez de Lara. Rollout photograph K2705 © Justin Kerr.
Plate 22

Catalogue 3
Vessel with a watery scene
600–900
Alta Verapaz region, Guatemala
Ceramic
9 3/4 x 7 1/2 x 7 1/2 inches (25 x 19 x 19 cm)
Los Angeles County Museum of Art, Gift of Camilla Chandler Frost, M.2009.93. Digital image © 2009 Museum Associates/LACMA/Art Resource, NY.
Plate 23

Catalogue 4
Panel with a seated ruler in a watery cave
[Cancuen Panel 3]
AD 795
Cancuen, Guatemala
Limestone
22 5/8 x 26 1/4 x 3 inches (57.5 x 66.5 x 7.6 cm)
Museo Nacional de Arqueología y Etnología, Guatemala City. Courtesy Peabody Essex Museum, photograph © 2009 Jorge Pérez de Lara.
Plate 20

Catalogue 5
Panel with a seated lord and a water serpent
700–800
Possibly Campeche, Mexico
Limestone
13 3/8 x 21 3/4 x 2 inches (34 x 55 x 5 cm)
Department of Art and Art History, University of Texas at Austin. Photograph © 2009 Peabody Essex Museum/ Eric Beggs.
Plate 24

Catalogue 6
Cast of a temple façade with the Water Lily Serpent
600–900
Caracol, Belize
Fiberglass
12 3/4 x 16 x 1 1/2 feet (3.9 x 4.9 x .5 meters)
National Institute of Culture and History, Belize. Courtesy Peabody Essex Museum, photograph © 2009 Jorge Pérez de Lara.
Plate 1

Catalogue 7
Statuette of Chahk
300–100 BC
Provenance unknown
Steatite
6 3/4 x 2 5/8 x 3 inches (17.2 x 6.5 x 7.6 cm)
Peabody Museum of Natural History, Yale University, YPM 236866. Photograph © Peabody Museum of Natural History, Yale University, New Haven, Connecticut, William Sacco.
Plate 77

Catalogue 8
Stela fragment with Chahk [Oxkintok Stela 12]
800–850
Oxkintok, Mexico
Limestone
28 x 14 x 7 1/2 inches (71.2 x 35.6 x 19.1 cm)
Denver Art Museum, Gift of Mr. and Mrs. Cedric Marks,
1971.389. Photograph © Denver Art Museum.
Plate 78

Catalogue 9
Sculpture of Chahk
800–900
Campeche or Yucatan, Mexico
Limestone
84 1/2 x 24 1/2 x 20 inches (214.2 x 62.2 x 50.8 cm)
The Metropolitan Museum of Art, New York, Harris
Brisbane Dick Fund, 66.181. Photograph ©
The Metropolitan Museum of Art.
Peabody Essex Museum only.
Plate 79

Catalogue 10
Effigy vessel with God N emerging from a snail shell
450–550
Possibly Uaymil, Mexico
Ceramic
5 1/2 x 3 1/4 x 3 1/4 inches (14 x 8.5 x 8.5 cm)
American Museum of Natural History, New York, Ernest
Erickson Foundation, Inc., 30.3/ 2485. Photograph
courtesy Division of Anthropology, American Museum
of Natural History.
Plate 38

Catalogue 11
Vase with the Maize God extracting God N from
a snail shell
700–800
Alta Verapaz, Guatemala
Ceramic
6 1/4 x 7 x 7 inches (15.9 x 17.9 x 17.9 cm)
Princeton University Art Museum, Gift of Gillett G.
Griffin, 2008-350. Photograph by Bruce M. White.
Plate 39

Catalogue 12
Mural with a world-turtle
circa 100 BC
San Bartolo, Guatemala
Watercolor on paper by Heather Hurst
45 x 77 inches (114.3 x 195.6 cm)
Photograph by Walter Silver, courtesy
Peabody Essex Museum.
Plate 83

Catalogue 13
Lidded vessel of a world-turtle
300–400
Tikal, Guatemala
Ceramic
7 1/8 x 6 1/2 x 6 1/2 inches (18 x 16.5 x 16.5 cm)
Museo Nacional de Arqueología y Etnología, Guatemala
City, MNAE 11416a, b. Courtesy Peabody Essex Museum,
photograph © 2009 Jorge Pérez de Lara.
Plate 4

Catalogue 14
Incense burner with a deity on a world-turtle
770–850
Chiapas, Mexico
Ceramic
22 3/4 x 14 x 12 1/4 inches (58 x 35.5 x 31 cm)
American Museum of Natural History, New York, Ernest
Erickson Foundation, Inc., 30.3/2502. Photograph
courtesy Division of Anthropology, American Museum
of Natural History.
Plate 84

Catalogue 15
Sculpture of a world-turtle
900–1200
Topoxte, Guatemala
Limestone
6 3/4 x 19 3/4 x 12 5/8 inches (17 x 50 x 32 cm)
Museo Nacional de Arqueología y Etnología, Guatemala
City, 17.7.21.214
Courtesy Peabody Essex Museum, © 2009 photograph
by Jorge Pérez de Lara.
Plate 85

Catalogue 16
Throne blocks with Atlantean figures and the Sun God
circa AD 750
Dos Pilas, Guatemala
Limestone
Sun God block: 24 1/4 x 20 1/2 x 15 1/2 inches
(61.8 x 52 x 39.4 cm)
Support blocks: 20 1/2 x 33 3/8 x 11 5/8 inches
(52 x 84.5 x 29.5 cm); 12 1/8 x 12 1/4 x 8 3/4 inches
(30.8 x 31 x 22 cm)
Museo Nacional de Arqueología y Etnología, Guatemala
City. Courtesy Peabody Essex Museum, photograph
© 2009 Jorge Pérez de Lara.
Plate 26

Catalogue 17
Sculpture of a world-crocodile
[Kaminaljuyu Monument 2]
300 BC–AD 100
Kaminaljuyu, Guatemala
Basalt
17 3/4 x 103 7/8 x 37 3/4 inches x (45 x 264 x 96 cm)
Museo Nacional de Arqueología y Etnología, Guatemala
City, MNAE 2042. Courtesy Peabody Essex Museum,
photograph © 2009 Jorge Pérez de Lara.
Plate 71

Catalogue 18
Crocodile effigy
700–800
Jaina Island, Mexico
Ceramic
2 x 3 3/8 x 7 3/8 inches (5.1 x 8.5 x 18.7 cm)
The Metropolitan Museum of Art, New York, The
Michael C. Rockefeller Memorial Collection, Bequest of
Nelson A. Rockefeller, 1979, 1979.206.1143. Photograph
© The Metropolitan Museum of Art.
Plate 72

Catalogue 19
Brick with a crocodile
700–800
Comalcalco, Mexico
Ceramic
11 1/8 x 7 5/8 x 2 1/2 inches (28.1 x 19.3 x 6.4 cm)
Consejo Nacional para la Cultura y las Artes – Instituto
Nacional de Antropología e Historia, Museo de Sitio
de la Zona Arqueológica de Comalcalco, Tabasco,
Mexico, 10-575756. Courtesy Peabody Essex Museum,
photograph © 2009 Jorge Pérez de Lara.
Plate 73

Catalogue 20
Crocodile effigy
1500–1540
Santa Rita Corozal, Belize
Ceramic
8 1/4 x 14 1/2 x 6 7/8 inches (21 x 37 x 17.5 cm)
World Museum, Liverpool, Gift of Thomas Gann,
20.11.13.45. Photograph © National Museums Liverpool.
Plate 74

Catalogue 21
Drinking vessel with deities spearing a shark
700–800
Northern Peten, Guatemala, or southern
Campeche, Mexico
Ceramic
8 7/16 x 5 1/2 x 5 1/2 inches (21.4 x 13.9 x 13.9 cm)
Dumbarton Oaks, Pre-Columbian Collection,
Washington, DC, PC.B.584. Photograph © Dumbarton
Oaks, Pre-Columbian Collection, Washington, DC.
Plate 80

Catalogue 22
Vessel with an aquatic creature and a deity head
700–800
Probably Campeche, Mexico
Ceramic
4 3/4 x 6 x 6 inches (11.9 x 15.1 x 15.1 cm)
Saint Louis Art Museum, Gift of Morton D. May, 341:1978.
Plate 81

Catalogue 23
Lidded bowl with the Iguana-Jaguar eviscerating
humans
circa AD 500
Becan, Mexico
Ceramic
13 3/8 x 19 3/8 x 19 3/8 inches (34 x 49.3 x 49.3 cm)
Consejo Nacional para la Cultura y las Artes – Instituto
Nacional de Antropología e Historia, Museo Fuerte
de San Miguel, Campeche, Mexico, 10-568677 0/2.
Courtesy Peabody Essex Museum, photograph © 2009
Jorge Pérez de Lara.
Peabody Essex Museum only.
Plate 82

Section 2
Creatures of the Fiery Pool

Catalogue 24
Tetrapod plate with a fish
250–350
Peten, Guatemala
Ceramic
7 x 14 x 14 inches (17.8 x 35.6 x 35.6 cm)
Museo Príncipe Maya, Coban, Guatemala, 16.2.5.264.
Courtesy Peabody Essex Museum, photograph © 2009
Jorge Pérez de Lara.
Plate 30

Catalogue 25
Tripod dish with a fantastic fish,
circa AD 600
Possibly Peten, Guatemala
Ceramic
2 3/4 x 12 1/2 x 12 1/2 inches (7 x 31.7 x 31.7 cm)
Nasher Museum of Art at Duke University, Durham,
North Carolina, no.1978.40. Photograph by Walter
Silver, courtesy Peabody Essex Museum.
Plate 31

Catalogue 26
Lobster effigy
circa AD 1550
Lamanai, Belize
Clay and paint
2 3/4 x 8 1/4 x 3 in (7 x 21 x 8 cm)
National Institute of Culture and History, Belize.
Courtesy Peabody Essex Museum, photograph © 2009
Jorge Pérez de Lara.
Plate 27

Catalogue 27
Vase with a water-bird
circa AD 750
Northern or northeastern Peten, Guatemala
Ceramic
9 5/8 x 4 1/4 x 4 1/4 inches (24.5 x 11 x 11 cm)
Museo Vigua de Arte Precolombino y Vidrio Moderno,
Antigua, Guatemala. Courtesy Peabody Essex Museum,
photograph © 2009 Jorge Pérez de Lara.
Plate 29

Catalogue 28
Lidded vessel with a water-bird
300–400
Guatemala
Ceramic
10 3/4 x 10 3/4 x 10 3/4 inches (27.3 x 27.3 x 27.3 cm)
Yale University Art Gallery, New Haven, Connecticut,
Gift of Peggy and Richard M. Danziger, LLB 1963,
2001.82.1a-b.
Plate 5

Catalogue 29
Vessel with a duck lid
circa AD 500
Becan, Mexico
Ceramic
8 3/4 x 9 1/4 x 9 1/4 inches (22 x 23 x 23 cm)
Consejo Nacional para la Cultura y las Artes – Instituto
Nacional de Antropología e Historia, Museo Fuerte
de San Miguel, Campeche, Mexico, 10-568668 0/2.
Courtesy Peabody Essex Museum, photograph © 2009
Jorge Pérez de Lara.
Plate 6

Catalogue 30
Pectoral in the shape of a water-bird
circa AD 500
Possibly Usumacinta region, Mexico
Shell
2 x 4 x 1 inches (5 x 10 x 2.5 cm)
Gobierno del Estado de Tabasco, Instituto Estatal
de Cultura, Museo Regional de Antropología "Carlos
Pellicer Cámara," Villahermosa, Mexico, A-0633
Courtesy Peabody Essex Museum, photograph © 2009
Jorge Pérez de Lara.
Plate 7

Catalogue 31
Sculpture of a pelican
650–850
Comalcalco, Mexico
Stucco
19 3/4 x 27 5/8 x 13 3/8 inches (50 x 70 x 34 cm)
Consejo Nacional para la Cultura y las Artes – Instituto
Nacional de Antropología e Historia, Museo de Sitio
de la Zona Arqueológia de Comalcalco, Tabasco,
Mexico, 10-508110. Courtesy Peabody Essex Museum,
photograph © 2009 Jorge Pérez de Lara.
Plate 8

Catalogue 32
Lidded vessel with water-birds and *Oliva* shell tinklers
600–700
Peten, Guatemala
Ceramic
9 x 7 1/8 x 7 1/8 inches (23 x 18 x 18 cm)
The Jay I. Kislak Collection at the Library of Congress,
Rare Book and Special Collections Division, Washington,
DC, Kislak PC 0037. Photograph K6218 © Justin Kerr.
Plate 28

Catalogue 33
Carving of a frog
700–800
Topoxte, Guatemala
Shell and quartz
2 1/8 x 2 3/4 x 1/4 inches (6.7 x 7 x 0.4 cm)
Museo Nacional de Arqueología y Etnología, Guatemala
City, Guatemala.Courtesy Peabody Essex Museum,
photograph © 2009 Jorge Pérez de Lara.
Plate 17

Catalogue 34
Carving of a frog
750–850
Tayasal, Guatemala
Shell, jadeite, obsidian, and cinnabar
2 3/4 x 4 1/8 x 3/8 inches (6.9 x 10.4 x 0.8 cm)
Museo Nacional de Arqueología y Etnología, Guatemala
City, 1.1.1.535. Courtesy Peabody Essex Museum,
photograph © 2009 Jorge Pérez de Lara.
Plate 18

Catalogue 35
Plate with a sea creature
550–600
Uaxactun, Guatemala
Ceramic
3 1/4 x 9 7/8 x 9 7/8 inches (8.2 x 25.1 x 25.1 cm)
Museo Nacional de Arqueología y Etnología, Guatemala
City, MNAE 3122. Courtesy Peabody Essex Museum,
photograph © 2009 Jorge Pérez de Lara.
Plate 32

Catalogue 36
Pectoral with a watery being
circa AD 200
Peten region, Guatemala
Shell and cinnabar
4 15/16 x 4 1/4 x 1 7/8 inches (11 x 10.8 x 4.8 cm)
Princeton University Art Museum, Museum purchase
with funds given by Carl D. Reimers, y1985-48.
Photograph by Bruce M. White.
Plate 99

Catalogue 37
Chocolate frothing pot in the shape of a shell
400–500
Tabasco, Mexico
Ceramic
5 3/4 x 9 1/8 x 7 1/4 inches (14.5 x 23 x 18.5 cm)
Gobierno del Estado de Tabasco, Instituto Estatal
de Cultura, Museo Regional de Antropología "Carlos
Pellicer Cámara," Villahermosa, Mexico, A-0072.
Courtesy Peabody Essex Museum, photograph © 2009
Jorge Pérez de Lara.
Plate 59

Catalogue 38
Panel with a king, prince, and warriors
[Piedras Negras Panel 2]
AD 667
Piedras Negras, Guatemala
Limestone
25 3/4 x 53 1/2 x 7 1/8 inches (65.5 x 136 x 18 cm)
Peabody Museum of Archaeology and Ethnology,
Harvard University, Cambridge, Massachusetts,
00-36-20/C2740. Photograph © President and Fellows
of Harvard College.
Plate 33

Catalogue 39
Plaques from a royal garment
AD 729
Piedras Negras, Guatemala
Shell
Plaque 1: 1 3/8 x 2 7/8 inches (3.5 x 7.5 cm); Plaque 2: 2 1/2
x 3 1/4 inches (6.6 x 8.5 cm); Plaque 3: 1 3/8 x 2 7/8 inches
(3.5 x 7.5 cm); Plaque 4: 2 7/8 x 1 3/4 inches (7.3 x 4.2 cm)
Plaques 1, 3, Museo Nacional de Arqueología y
Etnología, Guatemala City. Courtesy Peabody Essex
Museum, photograph © 2009 Jorge Pérez de Lara.
Plaques 2, 4, on loan to the University of Pennsylvania
Museum of Archaeology and Anthropology, L-27-41,
L-27-42, L-27-44, photograph numbers 152949, 182619.
Plate 34

Catalogue 40
Shell plaque with a lord smoking
700–800
Usumacinta region, Guatemala, or Chiapas, Mexico
Conch shell
6 1/2 x 3 1/8 x 1 3/8 inches (16.5 x 7.9 x 3.5 cm)
Cleveland Museum of Art, The Norweb Collection,
1965.550. Photograph K2880 © Justin Kerr.
Plate 35

Catalogue 41
Plate with a feathery conch motif
AD 650
Northern or northeastern Peten, Guatemala
Ceramic
2 1/2 x 11 5/8 x 11 5/8 inches (6.3 x 29.5 x 29.5 cm)
Museo Vigua de Arte Precolombino y Vidrio Moderno,
Antigua, Guatemala. Courtesy Peabody Essex Museum,
photograph © 2009 Jorge ge Pérez de Lara.
Plate 37

Catalogue 42
Assemblage of figurines from the tomb
of an unknown ruler
550–650
El Peru-Waka', Guatemala
Ceramic
Various sizes
Instituto de Antropología e Historia (IDAEH) and the
El Peru-Waka' Archaeological Project, Guatemala City.
Courtesy Peabody Essex Museum, photograph © 2009
Jorge Pérez de Lara.
Plate 98

Catalogue 43
Vessel with the Hunter God blowing a conch
700–800
Puuc region, Mexico
Ceramic
5 3/4 x 6 x 6 inches (14.6 x 15.2 x 15.2 cm)
Dumbarton Oaks, Pre-Columbian Collection,
Washington, DC, PC.B.582. Photograph © Dumbarton
Oaks, Pre-Columbian Collection, Washington, DC.
Plate 36

Section 3
Navigating the cosmos

Catalogue 44
Column with God L
circa AD 800
Bakna, Mexico
Limestone
67 1/4 x 25 5/8 x 25 5/8 (171 x 65 x 65 cm)
Consejo Nacional para la Cultura y las Artes – Instituto
Nacional de Antropología e Historia, Museo Baluarte
de la Soledad, Campeche, Mexico, 10-342791. Courtesy
Peabody Essex Museum, photograph © 2009 Jorge
Pérez de Lara.
Plate 53

Catalogue 45
Vessel with God L
circa AD 800
Tabasco, Mexico
Ceramic
4 7/8 x 5 1/8 x 5 1/8 inches (12.5 x 13 x 13 cm)
Gobierno del Estado de Tabasco, Instituto Estatal
de Cultura, Museo Regional de Antropología "Carlos
Pellicer Cámara," Villahermosa, Mexico, A-0608.
Courtesy Peabody Essex Museum, photograph © 2009
Jorge Pérez de Lara.
Plate 54

Catalogue 46
Brick with an incised canoe
600–800
Comalcalco, Mexico
Ceramic
5 7/8 x 6 3/4 x 1 1/4 inches (15 x 17 x 3 cm)
Consejo Nacional para la Cultura y las Artes – Instituto
Nacional de Antropología e Historia, Museo de Sitio
de la Zona Arqueológia de Comalcalco, Tabasco,
Mexico, 10-577117. Courtesy Peabody Essex Museum,
photograph © 2009 Jorge Pérez de Lara.
Plate 63

Catalogue 47
Vase with the Maize God riding in a canoe
circa AD 600
Northern Peten, Guatemala
Ceramic
7 x 5 1/2 x 5 1/2 inches (17.4 x 14 x 14 cm)
Museo Popol Vuh, Universidad Francisco Marroquín,
Guatemala City. Courtesy Peabody Essex Museum,
photograph © 2009 Jorge Pérez de Lara.
Plate 61

Catalogue 48
Ear flare with the Stingray Paddler in a canoe
500–600
Stann Creek District, Belize
Shell
2 1/2 x 2 1/2 inches (6.4 x 6.4 cm)
National Museum of the American Indian, Smithsonian
Institution, Washington, DC, 23/4107. Photograph
K2837a © Justin Kerr.
Peabody Essex Museum only.
Plate 62

Catalogue 49
Drinking vessel with a figure holding a paddle
700–800
Calcehtok region, Mexico
Ceramic
5 1/8 x 4 7/8 x 4 7/8 inches (13 x 12.5 x 12.5 cm)
American Museum of Natural History, New York, Ernest
Erickson Foundation, Inc., 30.3/ 2474. Photograph
courtesy Division of Anthropology, American Museum
of Natural History.
Plate 67

Catalogue 50
Model of a canoe
700–800
Jaina Island, Mexico
Ceramic
2 3/8 x 10 3/8 x 3 3/4 inches (9.3 x 26.3 x 6 cm)
Consejo Nacional para la Cultura y las Artes – Instituto
Nacional de Antropología e Historia, Museo Fuerte de
San Miguel, Campeche, Mexico, 10-342638. Courtesy
Peabody Essex Museum, photograph © 2009 Jorge
Pérez de Lara.
Plate 64

Catalogue 51
Plaque with the Warrior Sun God riding
a plumed serpent
800–900
Chichen Itza, Mexico
Jadeite
3 3/4 x 5 x 1/4 inches (9.3 x 12.8 x .5 cm)
Peabody Museum of Archaeology and Ethnology,
Harvard University, Cambridge, Massachusetts,
10-71-20/C6666. Photograph © President and Fellows
of Harvard College.
Plate 65

Catalogue 52
Cache vessel with directional shells and jades
500–600
Copan, Honduras
Ceramic, jade, and shell
8 x 14 x 14 inches (20.3 x 35.6 x 35.6 cm); central figure
5 inches (12.7 cm) high
Instituto Hondureño de Antropología e Historia
(IHAH), Museo Copan Ruinas, Honduras, CPN-P-11717,
CPN-J-2688. Courtesy Peabody Essex Museum,
photograph © 2009 Jorge Pérez de Lara.
Plate 89

Catalogue 53
Lidded vessel with the Sun God paddling across the
aquatic floral road
200–450
Mexico or Guatemala
Ceramic and cinnabar
12 x 9 1/4 x 9 1/4 inches (30.48 x 23.5 x 23.5 cm)
Dallas Museum of Fine Arts, 1988.82.A-B.
Plate 66

Catalogue 54
Sculpture of the Jester God
550–650
Altun Ha, Belize
Jadeite
5 7/8 x 4 3/8 x 5 3/4 inches (14.9 x 11.2 x 14.8 cm)
National Institute of Culture and History, Belize.
Photograph courtesy National Institute of Culture and
History, Belize.
Plate 56

Catalogue 55
Vessel with the face of an old man
900–1250
Jutiapa region, Guatemala
Tohil Plumbate ceramic
5 3/4 x 4 3/4 x 4 7/8 inches (14.8 x 12 x 12.5 cm)
Museo Nacional de Arqueología y Etnología, Guatemala
City, MNAE 3491. Courtesy Peabody Essex Museum,
photograph © 2009 Jorge Pérez de Lara.
Plate 57

Catalogue 56
Taino vomit spoon,
circa AD 750
Altun Ha, Belize
Manatee bone
1 1/2 x 8 x 1 inches (4 x 20 x 2.5 cm)
Royal Ontario Museum, Canada, Property of the
Government of Belize, L972.30.383. Photograph with
permission of the Royal Ontario Museum © ROM, 2009.
Plate 55

Catalogue 57
Ear spools
1300–1550
Santa Rita Corozal, Belize
Turquoise, gold, and obsidian
2 1/2 x 1 1/2 x 1 5/8 inches (6.4 x 3.9 x 4.1 cm)
National Institute of Culture and History, Belize.
Courtesy Peabody Essex Museum, photograph © 2009
Jorge Pérez de Lara.
Plate 58

Catalogue 58
Vase with a lord presented with Spondylus
[The Fenton Vase]
700–800
Nebaj, Guatemala
Ceramic
7 1/2 x 6 3/4 x 6 3/4 inches (19 x 17.2 x 17.2 cm)
The British Museum, London, AOA 1930-1. Photograph
© The Trustees of the British Museum.
Plate 2

Catalogue 59
Vase with a tribute of Spondylus
600–800
Nebaj-Chajul region, Guatemala
Ceramic
4 1/8 x 9 1/2 x 9 1/2 inches (10.5 x 24 x 24 cm)
Museo Popol Vuh, Universidad Francisco Marroquín,
Guatemala City. Courtesy Peabody Essex Museum,
photograph © 2009 Jorge Pérez de Lara.
Plate 3

Catalogue 60
Disk with a great naval battle
800–900
Chichen Itza, Mexico
Gold
9 1/16 x 7 7/8 x 1/8 inches (24 x 20 x .1 cm)
Peabody Museum of Archaeology and Ethnology,
Harvard University, Cambridge, Massachusetts,
10-71-20/C10067. Photograph © President and Fellows
of Harvard College.
Plate 68

Catalogue 61

Mural from the Temple of the Warriors
900–1100
Chichen Itza, Mexico
Watercolor on vellum by Ann Axtell Morris
22 x 30 1/4 inches (56 x 77 cm); original mural
9 x 12 1/2 feet (3 x 4.2 m)
Peabody Museum of Archaeology and Ethnology,
Harvard University, Cambridge, Massachusetts,
46-34-20/26287. Photograph © President and Fellows
of Harvard College.
Peabody Essex Museum only.
Plate 69

Catalogue 62

Panel describing a king's pilgrimage to the sea
circa AD 799
Cancuen region, Guatemala
Limestone
38 1/4 x 51 1/4 x 3 7/8 inches (97 x 130 x 10 cm)
Museo Príncipe Maya, Coban, Guatemala, 16.2.5.264
Courtesy Peabody Essex Museum, photograph © 2009
Jorge Pérez de Lara.
Plate 70

Section 4
Birth to rebirth

Catalogue 63

Drinking vessel with the Maize God born from the
waters of the Underworld
650–750
Calakmul, Mexico
Ceramic
6 1/8 x 4 3/8 x 4 3/8 inches (15.5 x 11.2 x 11.2 cm)
Consejo Nacional para la Cultura y las Artes – Instituto
Nacional de Antropología e Historia, Museo Nacional
de Antropología, Mexico City, 10-566398. Courtesy
Peabody Essex Museum, photograph © 2009 Jorge
Pérez de Lara.
Plate 86

Catalogue 64

Plaque with the Maize God emerging from a shark
750–800
Campeche, Mexico
Shell
3 1/8 x 3 3/4 x 1/4 inches (7.9 x 9.5 x .6 cm)
Dumbarton Oaks, Pre-Columbian Collection,
Washington, DC, PC.B.543. Photograph © Dumbarton
Oaks, Pre-Columbian Collection, Washington, DC.
Plate 87

Catalogue 65

Plate with the Maize God dancing above water
700–800
Peten region, Guatemala
Ceramic
14 3/4 x 14 3/4 x 4 1/2 inches (37.5 x 37.5 x 11.4 cm)
Princeton University Art Museum, Museum purchase,
Fowler McCormick, Class of 1921 Fund, 1997-465.
Photograph by Bruce M. White.
Plate 88

Catalogue 66

Cache vessel with the birth of the Sun God in the form
of a shark
350–550
Guatemala
Ceramic
18 7/8 x 14 5/8 x 14 5/8 inches (48 x 37 x 37 cm)
Fundación Televisa A.C., Mexico City, R21 P.J. 181.
Courtesy Peabody Essex Museum, photograph © 2009
Jorge Pérez de Lara.
Plate 90

Catalogue 67

Incense burner with a deity with aquatic elements
700–750
Palenque, Mexico
Ceramic
46 3/4 x 22 1/4 x 7 7/8 inches (118.5 x 56.5 x 20 cm)
Consejo Nacional para la Cultura y las Artes – Instituto
Nacional de Antropología e Historia, Museo de Sitio de
la Zona Arqueológia de Palenque, Chiapas, Mexico,
10-604759. Courtesy Peabody Essex Museum,
photograph © 2009 Jorge Pérez de Lara.
Plate 25

Catalogue 68

Stela with a male figure emitting breath or wind in the
form of conchs
[Kaminaljuyu Stela 9]
700–500 BC
Kaminaljuyu, Guatemala
Columnar basalt
51 1/8 x 8 7/8 x 10 inches (129.7 x 22.5 x 25.5 cm)
Museo Nacional de Arqueología y Etnología, Guatemala
City, MNAE 2359. Courtesy Peabody Essex Museum,
photograph © 2009 Jorge Pérez de Lara.
Plate 75

Catalogue 69

Frieze with a crocodile breathing clouds, 750–800
Possibly Copan region, Honduras, or Guatemala
Volcanic tuff
9 x 18 1/2 x 15 inches (22 x 47 x 38 cm)
Museo Popol Vuh, Universidad Francisco Marroquín,
Guatemala City, MPV0426. Courtesy Peabody Essex
Museum, photograph © 2009 Jorge Pérez de Lara.
Plate 76

Catalogue 70

Conch trumpet with a floating ancestor
300–500
Possibly northeastern Peten, Guatemala
Shell and cinnabar
5 1/4 x 11 9/16 x 4 1/2 inches (13.4 x 29.3 x 11.4 cm)
Kimbell Art Museum, Fort Worth, Texas, AP 1984.11.
Photograph © Kimbell Art Museum 2001 by Michael
Bodycomb.
Plate 42

Catalogue 71

Conch trumpet with inscriptions and ancestral figures
circa AD 500
Guatemala
Shell and hematite
9 x 4 3/4 x 3 inches (22.9 x 12.1 x 7.6 cm)
Chrysler Museum of Art, Norfolk, Virginia, Gift of Edwin
Pearlman and Museum purchase, 86.457. Photograph by
Ed Pollard.
Plate 43

Catalogue 72

Pectoral with a seated lord on a throne
450–550
Dzibanche, Mexico
Spondylus shell, jade, and black coral
6 1/4 x 6 1/4 x 2 1/4 inches (15.9 x 16 x 5.5 cm)
Consejo Nacional para la Cultura y las Artes – Instituto
Nacional de Antropología e Historia, Museo Nacional de
Antropología, Mexico City, 10-571167. Courtesy Peabody
Essex Museum, photograph © 2009 Jorge Pérez de Lara.
Plate 44

Catalogue 73

Pectoral with an ancestor
400–500
Tikal, Guatemala
Shell and cinnabar
2 1/4 x 2 3/4 x 1/8 inches (5.5 x 6.8 x 0.2 cm)
Museo Nacional de Arqueología y Etnología, Guatemala
City. Courtesy Peabody Essex Museum, photograph
© 2009 Jorge Pérez de Lara.
Plate 45

Catalogue 74

Pectoral ornament in the form of a bivalve shell
200–400
Nakum, Guatemala
Jade
2 x 4 1/4 x 1/4 inches (4.9 x 10.6 x .75 cm)
Instituto de Antropología e Historia (IDAEH),
Guatemala City. Courtesy Peabody Essex Museum,
photograph © 2009 Jorge Pérez de Lara.
Plate 46

Catalogue 75
Lintel with a bloodletting rite
[Yaxchilan Lintel 25]
AD 723
Yaxchilan, Mexico
Limestone
49 3/4 x 33 3/4 x 5 1/4 inches (126.5 x 85.5 x 13.5 cm)
The British Museum, London, AOA 1886-316.
Photograph K2888 © Justin Kerr.
Plate 47

Catalogue 76
Carved platform panel with a bloodletting ritual
AD 736
Palenque, Mexico
Limestone
23 5/8 x 89 1/4 inches (60 x 228 cm)
Consejo Nacional para la Cultura y las Artes – Instituto
Nacional de Antropología e Historia, Museo de Sitio de
la Zona Arqueológia de Palenque, Chiapas, Mexico,
10-629761. Courtesy Peabody Essex Museum,
photograph © 2009 Jorge Pérez de Lara.
Not in exhibition.
Plate 48

Catalogue 77
Engraved stingray spines and bone handles from
royal burials
687–757
Piedras Negras, Guatemala
Stingray spines and jaguar ulnae
Spines: 2 3/4 x 1/4 x 1/8 inches (6.9 x 0.5 x 0.3 cm);
4 3/4 x 1/4 x 1/8 inches (12.1 x 0.6 x 0.3 cm)
Handles: 2 3/8 x 1 1/4 x 3/4 inches (6 x 3.3 x 2.1 cm);
2 5/8 x 1 x 1 inches (6.5 x 2.5 x 2.5 cm)
Museo Nacional de Arqueología y Etnología, Guatemala
City. Courtesy Peabody Essex Museum, photograph
© 2009 Jorge Pérez de Lara.
Plate 49

Catalogue 78
Engraved stingray spine
300–850
Xicalango, Mexico
Stingray spine
8 x 5/8 inches (20.2 x 1.6 cm)
Consejo Nacional para la Cultura y las Artes – Instituto
Nacional de Antropología e Historia, Centro INAH
Campeche, Mexico, 10-170208. Courtesy Peabody Essex
Museum, photograph © 2009 Jorge Pérez de Lara.
Plate 50

Catalogue 79
Stone stingray spine, 763–810
Copan, Honduras
Volcanic tuff
40 1/2 x 11 1/4 x 3 1/2 inches (103 x 29 x 9 cm)
Instituto Hondureño de Antropología e Historia (IHAH),
Sculpture Bodega, Copan Ruinas, Honduras, CPN 28097.
Courtesy Peabody Essex Museum, photograph © 2009
Jorge Pérez de Lara.
Plate 51

Catalogue 80
Figurines engaged in bloodletting rituals on
the backs of turtles
1300–1550
Santa Rita Corozal, Belize
Ceramic
Various sizes
National Institute of Culture and History, Belize.
Courtesy Peabody Essex Museum, photograph
© 2009 Jorge Pérez de Lara.
Plate 52

Catalogue 81
Belt ornament with the head of an ancestor
AD 699
Made in Piedras Negras, Guatemala; found in Chichen
Itza, Mexico
Jade
3 1/8 x 2 1/4 x 2 inches (8 x 5.8 x 5.2 cm)
Peabody Museum of Archaeology and Ethnology,
Harvard University, Cambridge, Massachusetts,
10-70-20/C6100. Photograph © President and Fellows
of Harvard College.
Plate 93

Catalogue 82
Three face ornaments of Quetzalcoatl
800–900
Chichen Itza, Mexico
Gold
Right eye overlay: 6 1/4 x 5 1/4 inches (15.9 x 13.5 cm)
Left eye overlay: 6 1/4 x 5 3/8 inches (16.1 x 13.6 cm)
Mouth overlay: 3 x 5 3/4 inches (7.4 x 14.8 cm)
Peabody Museum of Archaeology and Ethnology,
Harvard University, Cambridge, Massachusetts,
10-71-20/C7678-C7679. Photograph © President and
Fellows of Harvard College.
Plate 94

Catalogue 83
Scepter with a diving figure
1300–1450
Chichen Itza, Mexico
Wood, jade, and turquoise
16 x 3 x 2 3/8 inches (41 x 7.4 x 6 cm)
Peabody Museum of Archaeology and Ethnology,
Harvard University, Cambridge, Massachusetts,
10-71-20/C6753. Photograph © President and Fellows
of Harvard College.
Plate 95

Catalogue 84
Pectoral assemblage with an engraved *Ik'* symbol
1300–1500
Chichen Itza, Mexico
Jade
Pectoral: 4 x 3 inches (10.5 x 7.3 cm)
Consejo Nacional para la Cultura y las Artes – Instituto
Nacional de Antropología e Historia, Museo Regional
de Antropología "Palacio Cantón," Mérida, Mexico,
10-425694. Courtesy Peabody Essex Museum,
photograph © 2009 Jorge Pérez de Lara.
Plate 40

Catalogue 85
Torso with an *Ik'* pectoral
600–800
Provenance unknown
Stucco
5 1/2 x 5 1/2 x 3 1/2 inches (14 x 14 x 9 cm)
Gobierno del Estado de Tabasco, Instituto Estatal de
Cultura, Museo Regional de Antropología "Carlos
Pellicer Cámara," Villahermosa, Mexico, A-0633.
Courtesy Peabody Essex Museum, photograph © 2009
Jorge Pérez de Lara.
Plate 41

Catalogue 86
Royal tomb offerings
circa AD 800
Ek Balam, Mexico
Shell
Shrimp: 1 7/8 x 1 3/8 x 1/8 inches (4.8 x 3.5 x 0.3 cm)
Skulls: 2 1/8 x 1 3/4 x 1/4 inches (5.4 x 4.3 x 0.5 cm);
1 1/2 x 1 1/8 x 1/8 inches (3.7 x 2.8 x 0.3 cm)
Consejo Nacional para la Cultura y las Artes – Instituto
Nacional de Antropología e Historia, Museo Regional
de Antropología "Palacio Cantón," Mérida, Mexico,
10-626524, 10-626525, 10-626532, 10-626533. Courtesy
Peabody Essex Museum, photograph © 2009 Jorge
Pérez de Lara.
Plate 19

Catalogue 87
Figurine of the Jaguar God of the Underworld
riding a crocodile
700–800
Jaina Island, Mexico
Ceramic
9 3/4 x 7 1/2 x 7 1/4 inches (24.9 x 19.1 x 8.4 cm)
National Gallery of Australia, Canberra, 1977.135.
Plate 96

Catalogue 88
Celt with a ruler
circa AD 455
Guatemala
Jade
9 1/16 x 3 1/16 x 1/4 inches (23 x 7.8 x .6 cm)
Kimbell Art Museum, Fort Worth, Texas, AP 2004.05.
Photograph © Kimbell Art Museum.
Plate 97

Catalogue 89
Stone ballgame belt with the Maize God and
swimmers in the aquatic underworld
circa AD 100
Veracruz, Mexico
Greenstone
4 1/8 x 20 x 15 3/4 inches (10.5 x 50.8 x 40 cm)
Fine Arts Museums of San Francisco, Gift of
Lewis K. and Elizabeth M. Land, 2009.1.95.
Plate 91

Catalogue 90
Lidded bowl with the Maize God in the aquatic
Underworld
450–500
Río Hondo region, Mexico
Ceramic
4 1/8 x 8 1/4 x 8 1/4 inches (10.3 x 21.4 x 21.4 cm)
World Museum, Liverpool, Gift of Thomas Gann,
20.11.13.113-4. Photograph © National Museums
Liverpool.
Plate 92

Catalogue 91
Drinking vessel with the death and resurrection
of the Maize God
672–830
Homul region, Guatemala
Ceramic
9 x 4 1/8 x 4 1/8 inches (22.7 x 10.3 x 10.3 cm)
Museo Popol Vuh, Universidad Francisco Marroquín,
Guatemala City, MPV0368. Courtesy Peabody Essex
Museum, photograph © 2009 Jorge Pérez de Lara.
Peabody Essex Museum only.
Plate 60

Catalogue 92
Figurine of a weaver
700–800
Jaina Island, Mexico
Ceramic
6 x 6 1/4 x 3 5/8 inches (15 x 15.9 x 9.2 cm)
National Museum of the American Indian, Smithsonian
Institution, Washington, DC, 23/2865. Photograph
K2833 © Justin Kerr.
Plate 9

Catalogue 93
Figurine of an embracing couple
700–800
Jaina Island, Mexico
Ceramic
9 7/8 x 4 1/4 x 3 3/4 inches (25.3 x 10.8 x 9.5 cm)
The Detroit Institute of Arts, Founders Society
Purchase, Katherine Margaret Kay Bequest/Fund and
New Endowment Fund, 77.49. Photograph courtesy
The Bridgeman Art Library.
Peabody Essex Museum only.
Plate 10

Catalogue 94
Figurine of a female captive
700–800
Jaina Island, Mexico
Ceramic
9 x 3 1/4 x 2 13/16 inches (22.8 x 8.3 x 7.1 cm)
Yale University Art Gallery, New Haven, Connecticut,
Gift of the Olsen Foundation, 1958.15.9.
Plate 11

Catalogue 95
Figurine of a lord
700–800
Jaina Island, Mexico
Ceramic
7 3/4 x 3 1/2 x 2 7/8 inches (21.8 x 9 x 7.4 cm)
National Museum of the American Indian, Smithsonian
Institution, Washington, DC, 23/8368. Photograph
K2834 © Justin Kerr.
Plate 12

Catalogue 96
Figurine of a warrior
700–800
Jaina Island, Mexico
Ceramic
12 3/8 x 7 1/8 inches (31.5 x 18 cm)
Consejo Nacional para la Cultura y las Artes – Instituto
Nacional de Antropología e Historia, Museo Regional
de Antropología "Palacio Cantón," Mérida, Mexico,
10-631611. Courtesy Peabody Essex Museum, photograph
© 2009 Jorge Pérez de Lara.
Plate 13

Catalogue 97
Figurine of a dancer
700–800
Jaina Island, Mexico
Ceramic
7 3/8 x 5 7/8 inches (18.9 x 15 cm)
Consejo Nacional para la Cultura y las Artes – Instituto
Nacional de Antropología e Historia, Museo Nacional de
Antropología, Mexico City, 10-78168. Courtesy Peabody
Essex Museum, photograph © 2009 Jorge Pérez de Lara.
Plate 14

Catalogue 98
Figurine of an old drunkard
700–800
Jaina Island, Mexico
Ceramic
14 1/4 x 5 1/4 x 4 1/4 inches (35.9 x 13.4 x 10.9 cm)
National Museum of the American Indian, Smithsonian
Institution, Washington, DC, 23/2573. Photograph
K2837b © Justin Kerr.
Plate 15

Catalogue 99
Figurine of the young Maize God emerging from
a corn stalk
700–800
Jaina Island, Mexico
Ceramic
8 1/8 x 2 x 1 1/2 inches (20.7 x 5.1 x 3.8 cm)
The Metropolitan Museum of Art, New York, The
Michael C. Rockefeller Memorial Collection, Bequest of
Nelson A. Rockefeller, 1979, 1979.206.728. Photograph
© The Metropolitan Museum of Art.
Plate 16

BIBLIOGRAPHY

The following reference list includes short titles for all works cited in this book.

Adams 1999
Adams, Richard E. W. *Río Azul: An Ancient Maya City.* Norman: University of Oklahoma Press, 1999.

Agrinier 1960
Agrinier, Pierre. *The Carved Human Femurs from Tomb 1, Chiapa de Corzo, Chiapas, Mexico.* Orinda, California: Papers of the New World Archaeological Foundation, no. 6 (1960).

Agurcia Fasquelle 2004
Agurcia Fasquelle, Ricardo. "Rosalila, Temple of the Sun-King." In *Understanding Early Classic Copan.* Eds. Ellen E. Bell, Marcello A. Canuto, and Robert J. Sharer. Philadelphia: University of Pennsylvania Museum of Archaeology and Anthropology, 2004, pp. 101–12.

Alcorn 1984
Alcorn, Janis B. *Huastec Maya Ethnobotany.* Austin: University of Texas Press, 1984.

Aldrovandi 1606
Aldrovandi, Ulisse. *De reliquis animalibus exanguibus libri quatuor, post mortem eius editi nempe de mollibus, crustaceis, testaceis, et zoophytis.* Bologna: Baptiste Bellagamba,1606. http://amshistorica.cib.unibo.it/diglib.php?inv=18.

Álvarez Aguilar et al. 1988
Álvarez Aguilar, Luis Fernando, María Guadalupe Landa Landa, and José Luis Romero Rivera. "Los ladrillos decorados de Comalcalco, Tabasco." *Antropológicas* 2 (1988), pp. 5–12.

Álvarez Aguilar et al. 1990
Álvarez Aguilar, Luis Fernando, María Guadalupe Landa Landa, and José Luis Romero Rivera. *Los ladrillos de Comalcalco.* Villahermosa: Gobierno del Estado de Tabasco, 1990.

Álvarez Asomoza et al. 1992
Álvarez Asomoza, Carlos et al. "Los ladrillos decorados de Comalcalco, Tabasco." In *Comalcalco.* Ed. Elizabeth Mejia Perez Campos. Mexico City: Instituto Nacional de Antropología e Historia, 1992, pp. 239–51.

Anaya, Guenter, and Mathews 2002
Anaya, Armando, Stanley Guenter, and Peter Mathews. "An Inscribed Wooden Box from Tabasco, Mexico." *Mesoweb*: http://www.mesoweb.com/reports/box/index.html, 2002.

A. P. Andrews 1990
Andrews, Anthony P. "The Role of Trading Ports in Maya Civilization." In *Vision and Revision in Maya Studies.* Eds. F. S. Clancy and Peter D. Harrison. Albuquerque: University of New Mexico Press, 1990, pp. 159–67.

A. P. Andrews 2006
Andrews, Anthony P. "Facilidades Portuarias Mayas." *El Territorio Maya: Memoria de la Quinta Mesa Redonda de Palenque.* Mexico City: Instituto Nacional de Antropología e Historia, 2008, pp. 15–40.

E. W. Andrews 1969
Andrews, E. Wyllys IV. *The Archaeological Use and Distribution of Mollusca in the Maya Lowlands.* New Orleans: Middle American Research Institute, Tulane University, 1969.

G. F. Andrews 1989
Andrews, George F. *Comalcalco, Tabasco, Mexico: Maya Art and Architecture.* 2nd ed. Culver City, California: Labyrinthos, 1989.

Angulo Villaseñor 1987
Angulo Villaseñor, Jorge. "The Chalcatzingo Reliefs: An Iconographic Analysis." In *Ancient Chalcatzingo.* Ed. David C. Grove. Austin: University of Texas Press, 1987, pp. 132–58.

Antochin 1999
Antochin, Michel. "Yucatán, Cenotes y Grutas." In *Cenotes y Grutas de Yucatán. Mérida: Editorial CEPSA-Secretaría de Ecología del Gobierno de Yucatán,* 1999, pp. 11–47.

Ardren 1996
Ardren, Traci. "The Chocholá Ceramic Style of Northern Yucatan: an Iconographic and Archaeological Study." In *Eighth Palenque Round Table, 1993.* Eds. Martha J. Macri and Jan McHargue. San Francisco: Pre-Columbian Art Research Institute, 1996, pp. 237–45.

Armijo Torres 2003
Armijo Torres, Ricardo. "Comalcalco: la antigua ciudad maya de ladrillos." *Arqueología Mexicana* 11, 61 (2003), pp. 30–37.

Armijo, Zender, and Gallegos 2000
Armijo, Ricardo, Marc Zender, and Miriam Judith Gallegos. "La Urna Funeraria de Aj Pakal Tahn, un sacerdote del siglo VIII en Comalcalco, Tabasco, México." *Temas Antropológicos* 22 (2000), pp. 242–54.

Arnold 2005
Arnold, Philip J. III. "The Shark-Monster in Olmec Iconography." *Mesoamerican Voices* 2 (2005), pp. 5–36.

Arrom 1989
Arrom, José Juan. *Mitología y artes prehispánicas de las antillas.* 2nd ed. Mexico: Siglo Veintiuno Editores, 1989.

Awe n.d.
Awe, Jaime J. "Crown Jewel of Belize: The Altun Ha Jade Head." http://www.belize.com/articles/archaeology/belize-maya-jade-head.html.

Bacon 2007
Bacon, Wendy J. "The Dwarf Motif in Classic Maya Monumental Iconography: A Spatial Analysis." PhD dissertation. University of Pennsylvania, 2007.

Bahand, Gallaga Murrieta, and Lowe 2008
Bachand, Bruce R., Emiliano Gallaga Murrieta, and Lynneth S. Lowe. *The Chiapa de Corzo Archaeological Project Report of the 2008 Field Season*. Provo, Utah: New World Archaeological Foundation, Brigham Young University, 2008.

Barrett 2000
Barrett, Jason W. "Excavations at Structure 5: Postclassic Elite Architecture at Caye Coco." In *Belize Postclassic Project 1999: Continued Investigations at Progresso Lagoon and Laguna Seca*. Eds. Robert M. Rosenwig and Marilyn A. Masson. Albany: Institute of Mesoamerican Studies, State University of New York, Albany, 2000, pp. 31–58.

Barrientos 2008
Barrientos, Tomás. "Hydraulic Systems in Central Cancuén: Ritual, Reservoir, and/or Drainage?" Report submitted to the Foundation for the Advancement of Mesoamerican Studies, Inc., 2008. http://www.famsi.org/reports/05082/05082Barrientos_full.pdf, 2008.

Bassie 2002
Bassie, Karen. "Maya Creator Gods." *Mesoweb*, 2002. http://www.mesoweb.com/features/bassie/CreatorGods/CreatorGods.pdf, 2002.

Bassie-Sweet 1996
Bassie-Sweet, Karen. *At the Edge of the World: Caves and Late Classic Maya World View*. Norman: University of Oklahoma Press, 1996.

Bassie-Sweet n.d
Bassie-Sweet, Karen. "Maya Gods of Renewal." Unpublished manuscript.

Beach et al. 2009
Beach, Tim et al. "A Review of Human and Natural Changes in Maya Lowlands Wetlands over the Holocene." *Quaternary Science Reviews* 28 (2009), pp. 1–15, doi:10.1016/j.quascirev.2009.02.004.

Beetz and Satterthwaite 1981
Beetz, Carl P. and Linton Satterthwaite. *The Monuments and Inscriptions of Caracol, Belize*. Philadelphia: University of Pennsylvania, University Museum Monograph 45, 1981.

Bell, Canuto, and Sharer 2004
Bell, Ellen E., Marcello A. Canuto, and Robert J. Sharer, eds. *Understanding Early Classic Copan*. Philadelphia: University of Pennsylvania Museum of Archaeology and Anthropology, 2004.

Benavides 2002
Benavides, Antonio. "Principales hallazgos de la temporada 2000 en Jaina." In *Los investigadores de la cultura maya 10, tomo 1*. Campeche: Universidad Autónoma de Campeche, 2002, pp. 88–101.

Benson 1977
Benson, Elizabeth P., ed. "The Sea in the Pre-Columbian World: A Conference at Dumbarton Oaks, October 26th and 27th, 1974." Washington, DC: Dumbarton Oaks Research Library and Collection, 1977.

Benson and Coe 1963
Benson, Elizabeth P. and Michael D. Coe. *Handbook of the Robert Woods Bliss Collection of Pre-Columbian Art, Dumbarton Oaks, Washington*. Washington, DC: Dumbarton Oaks, 1963.

Benson and de la Fuente 1996
Benson, Elizabeth P. and Beatriz de la Fuente, eds. *Olmec Art of Ancient Mexico*. Washington, DC: National Gallery of Art, 1996.

Berjonneau, Deletaille, and Sonnery 1985
Berjonneau, Gerald, Emile Deletaille, and Jean-Luis Sonnery, eds. *Rediscovered Masterpieces of Mesoamerica: Mexico-Guatemala-Honduras*. Boulogne: Editions Arts, 1985.

Blom and La Farge 1926
Blom, Frans and Oliver La Farge. *Tribes and Temples*. New Orleans: The Tulane University of Louisiana, 1926.

Boas 1907
Boas, Franz. "Some Principles of Museum Administration." *Science* 25, 650 (1907), pp. 921–33.

Bolles 1963
Bolles, John S. *La Iglesia: Chichen Itza, Yucatan*. San Francisco: John S. Bolles, 1963.

Bonor Villarejo 1989
Bonor Villarejo, Juan Luis. *Las Cuevas Mayas: Simbolismo y Ritual*. Madrid: Universidad Complutense de Madrid, 1989.

Boot 2003
Boot, Erik. "A New Classic Maya Vessel Type Collocation on a Uaxactun-style Plate." Mayavase.com, 2003. http://www.mayavase.com/bootplate.pdf.

Boot 2006
Boot, Erik. "A Chocholá-Maxcanu Ceramic Vessel in a 1930's Collection in Mérida, Yucatan, Mexico: History and Analysis of Image and Text." *Wayeb Notes* 24 (2006).

Borhegyi 1961
Borhegyi, Stephan F. de. "Shark Teeth, Stingray Spines, and Shark Fishing in Ancient Mexico and Central America." *Southwestern Journal of Anthropology* 17, 3 (1961), pp. 273–96.

Bouzouggar et al. 2007
Bouzouggar, Abdeljalil et al. "82,000-Year-Old Shell Beads from North Africa and Implications for the Origins of Modern Human Behavior." *Proceedings of the National Academy of Sciences* 104, 24 (June 12, 2007), pp. 9964–69.

Brady 2002
Brady, James E. "The Significance of the Study of Caves and Cenotes for our Understanding of Maya Cosmovision." Paper presented at the *Primer Congreso de Arqueología Subacuática y Espeleología*. Akumal, Quintana Roo, 2002.

Brady 2005A
Brady, James E. Foreword. In Henry C. Mercer. *The Hill-Caves of Yucatan*. Austin, Texas: Association for Mexican Cave Studies, 2005.

Brady 2005B
Brady, James E. "The Impact of Ritual on Ancient Maya Economy." In Keith M. Prufer and James E. Brady, eds. *Stone Houses and Earth Lords: Maya Religion in the Cave Context*. Boulder: University Press of Colorado, 2005, pp. 115–34.

Brady and Prufer 2005A
Brady, James E. and Keith M. Prufer. *In the Maw of the Earth Monster: Mesoamerican Ritual Cave Use*. Austin: University of Texas Press, 2005.

Brady and Prufer 2005B
Brady, James E. and Keith M. Prufer. "Maya Cave Archaeology: A New Look at Religion and Cosmology." In Keith M. Prufer and James E. Brady, eds. *Stone Houses and Earth Lords: Maya Religion in the Cave Context*. Boulder: University Press of Colorado, 2005, pp. 365–79.

Braakhuis 1990
Braakhuis, H. E. M. "The Bitter Flour: Birth Scenes of the Tonsured Maize God." In *Mesoamerican Dualism / Dualismo Mesoamericano*. Eds. Rudolf van Zantiwijk, Rob de Ridder, and Edwin Braakhuis. Utrecht: ISOR, 1990, pp. 125–47.

Bray 1977
Bray, Warwick. "Maya Metalwork and Its External Connections." In *Social Processes in Maya Prehistory*. Ed. Norman Hammond. New York: Academic Press, 1977, pp. 365–403.

Brittenham 2008
Brittenham, Claudia L. "The Cacaxtla Painting Tradition: Art and Identity in Epiclassic Mexico." PhD dissertation. Yale University, 2008.

Brown 2005
Brown, Linda. "Planting the Bones: Hunting Ceremonialism at Contemporary and Nineteenth-Century Shrines in the Guatemalan Highlands." *Latin American Antiquity* 16, 2 (2005), pp. 131–46.

Brown and Emery 2008
Brown, Linda and Kitty F. Emery. "Negotiations with the Animate Forest: Hunting Shrines in the Guatemalan Highlands." *Journal of Archaeological Method and Theory* 15 (2008), pp. 300–37.

Bunzel 1932
Bunzel, Ruth. "Introduction to Zuñi Ceremonialism." In *47th Annual Report of the Bureau of American Ethnology for the Years 1929–1930*. Washington, DC: Smithsonian Institution, 1932.

Bunzel 1952
Bunzel, Ruth. *Chichicastenango*. Seattle: University of Washington, 1952.

Burnard 1998
Burnard, Gaston. *Mexique, Terre des Dieux, Trésors de l'Art Précolumbien*. Geneva: Musée Rath, 1998.

Campaña and Bouher 2002
Campaña, Luz Evelia and Sylviane Boucher. "Nuevas imágenes de Becán, Campeche." *Arqueología Mexicana* 56 (2002), pp. 64–69.

Campaña Valenzuela 1995
Campaña Valenzuela, Luz Evelia. "Una tumba en el Templo del Búho Dzibanché." *Arqueología Mexicana* 3, 14 (1995), pp. 28–31.

Canter 2006
Canter, Ronald L. "Yucatan Channel and Trade." FAMSI *Journal of the Ancient Americas*. http://research.famsi.org/aztlan/papers_index.php, November 2006.

Canter and Pentecost 2008
Canter, Ronald L. and David Pentecost. "Rocks, Ropes, and Maya Boats; Stone Bollards at Ancient Waterfronts along the Rio Usumacinta: Yaxchilan, Mexico to El Porvenir, Guatemala." *The PARI Journal* 8, 3 (2008), pp. 5–14.

Carpenter 1857
Carpenter, Philip P. *Catalogue of the Collection of Mazatlan Shells in the British Museum*. London: Printed by order of the Trustees [by P. P. Carpenter], 1857.

Carrasco Vargas 2005
Carrasco Vargas, Ramón. "The Sacred Mountain: Preclassic Architecture in Calakmul." In Virginia M. Fields and Dorie Reents-Budet, eds. *Lords of Creation: The Origins of Sacred Maya Kingship*. Los Angeles: Los Angeles County Museum of Art, 2005, pp. 62–66.

Carrasco Vargas and Colón González 2005
Carrasco Vargas, Ramón and Marinés Colón González. "El reino de Kaan y la Antigua ciudad Maya de Calakmul." *Arqueología Mexicana* 13, 75 (2005), pp. 40–47.

Caso and Rubín de la Borbolla 1969
Caso, Alfonso and Daniel Fernando Rubín de la Borbolla. *El Tesoro de Monte Albán*. Mexico City: Instituto Nacional de Antropología e Historia, 1969.

Castillo 1999
Castillo, Thelma, ed. *Yaxhá: Laguna encantada: naturaleza, arqueología y conservación*. Guatemala: Fundación G y T, 1999.

A. F. Chase 1983
Chase, Arlen F. "A Contextual Consideration of the Tayasal-Paxcaman Zote, El Peten, Guatemala." PhD dissertation. University of Pennsylvania, 1983.

A. F. Chase and D. Z. Chase 1986
Chase, Arlen F. and Diane Z. Chase. "Archaeological Insights on the Contact Period Lowland Maya." In *Los Mayas de Tiempos Tardios*. Eds. M. Rivera and A. Ciudad. Madrid: Sociedad Espanola de Estudios Mayas y Instituto de Cooperacion Iberoamericana, 1986, pp. 13–30.

A. F. Chase and D. Z. Chase 1989
Chase, Arlen F. and Diane Z. Chase. "Routes of Trade and Communication and the Integration of Maya Society: The Vista from Santa Rita Corozal." In *Coastal Maya Trade and Exchange*. Eds. Heather McKillop and Paul F. Healy. Toronto: Trent University, Occasional Papers in Anthropology 8 (1989), pp. 19–32.

D. Z. Chase 1985
Chase, Diane Z. "Between Earth and Sky: Idols, Images, and Postclassic Cosmology." In *Fifth Palenque Roundtable, 1983*. Eds. Merle Green Robertson and Virginia M. Fields. San Francisco: Pre-Columbian Art Research Institute, 1985, vol. 7, pp. 223–33.

D. Z. Chase 1986
Chase, Diane Z. "Lifeline to the Gods: Ritual Bloodletting at Santa Rita Corozal." In *Sixth Palenque Round Table, 1983*. Eds. Merle Green Robertson and Virginia M. Fields. Norman: University of Oklahoma Press, 1986, pp. 89–96.

D. Z. Chase 1988
Chase, Diane Z. "Caches and Censerwares: Meaning from Maya Pottery." In *A Pot for All Reasons: Ceramic Ecology Revisited.* Eds. Charles C. Kolb, Louana M. Lackey, and Muriel Kirkpatrick. Philadelphia: Temple University, Laboratory of Anthropology, 1988, pp. 81–104.

D. Z. Chase and A. F. Chase 1985
Chase, Diane Z. and Arlen F. Chase. "Refining Maya Prehistory: Archaeology at Santa Rita Corozal." *The New Belize,* November/December 1985, pp. 14–17.

D. Z. Chase and A. F. Chase 1986
Chase, Diane Z. and Arlen F. Chase. *Offerings to the Gods: Maya Archaeology at Santa Rita Corozal.* Orlando: University of Central Florida, 1986.

D. Z. Chase and A. F. Chase 1988
Chase, Diane Z. and Arlen F. Chase. *A Postclassic Perspective: Excavations at the Maya Site of Santa Rita Corozal, Belize.* San Francisco: Pre-Columbian Art Research Institute, 1988.

D. Z. Chase and A. F. Chase 1998
Chase, Diane Z. and Arlen F. Chase. "The Architectural Context of Caches, Burials, and Other Ritual Activities for the Classic Period Maya (as Reflected at Caracol, Belize)." In Stephen D. Houston, ed. *Function and Meaning in Classic Maya Architecture.* Washington, DC: Dumbarton Oaks Research Library and Collection, 1998, pp. 299–332.

Cheek 1977
Cheek, Charles D. "Excavations at the Palangana and the Acropolis, Kaminaljuyu." In *Teotihuacan and Kaminaljuyu.* Eds. Joseph W. Michels and William T. Sanders. University Park: Pennsylvania State University Press, 1977, pp. 1–204.

Chinchilla Mazariegos 1990
Chinchilla Mazariegos, Oswaldo. "Operación DP14: Investigaciones en el Grupo N5-6." In *Proyecto Arqueológico Regional Petexbatun, informe preliminar no. 2, segunda temporada, 1990.* Eds. Arthur A. Demarest and Stephen D. Houston. Nashville: Department of Anthropology, Vanderbilt University, 1990.

Chinchilla Mazariegos 2003
Chinchilla Mazariegos, Oswaldo. "A Corpus of Cotzumalhuapa-Style Sculpture, Guatemala." http://www.famsi.org/reports/96008/index.html, 2003.

Chinchilla Mazariegos 2006A
Chinchilla Mazariegos, Oswaldo. "El jaguar iguana." *Arqueología Mexicana* 16, 81 (2006), pp. 82–85.

Chinchilla Mazariegos 2006B
Chinchilla Mazariegos, Oswaldo. "The Stars of the Palenque Sarcophagus." *Res: Anthropology and Aesthetics* 49/50 (2006), pp. 40–58.

Christenson 2001
Christenson, Allen J. *Art and Society in a Highland Maya Community: The Altarpiece of Santiago Atitlán.* Austin: University of Texas Press, 2001.

Cline 1947
Cline, Howard. "Lore and Deities of the Lacandon Indians, Chiapas, Mexico." *Journal of American Folklore* 57 (1947), pp. 108–10.

Cobean 2003
Cobean, Robert H. *Un mundo de obsidiana: mineria y comercio de un vidrio volcanico en el Mexico antiguo; A World of Obsidian: The Mining and Trade of a Volcanic Glass in Ancient Mexico.* Mexico: Instituto Nacional de Antropología e Historia; and Pittsburgh: University of Pittsburgh, 2003.

Cobean and Estrada Hernández 1994
Cobean, Robert H. and Elba Estrada Hernández. "Ofrendas toltecas en el Palacio Quemado de Tula." *Arqueología mexicana* 1, 6 (1994), pp. 77–78.

M. D. Coe 1973
Coe, Michael D. *The Maya Scribe and His World.* New York: The Grolier Club, 1973.

M. D. Coe 1975
Coe, Michael D. *Classic Maya Pottery at Dumbarton Oaks.* Washington, DC: Dumbarton Oaks, 1975.

M. D. Coe 1978
Coe, Michael D. *Lords of the Underworld: Masterpieces of Classic Maya Ceramics.* Princeton, New Jersey: Princeton University Press, 1978.

M. D. Coe 1992
Coe, Michael D. *Breaking the Maya Code: The Last Great Decipherment of an Ancient Script.* London and New York: Thames and Hudson, 1992.

M. D. Coe 2005
Coe, Michael D. "Art and Illusion among the Classic Maya." *Princeton University Art Museum Record* 64 (2005), pp. 53–62.

W. R. Coe 1959
Coe, William R. *Piedras Negras Archaeology: Artifacts, Caches, and Burials.* Philadelphia: The University Museum, University of Pennsylvania, 1959.

W. R. Coe 1990
Coe, William R. *Excavations in the Great Plaza, North Terrace and North Acropolis of Tikal.* Philadelphia: The University Museum, University of Pennsylvania, Tikal Report No. 14, 1990.

Coggins 1975
Coggins, Clemency C. "Painting and Drawing Styles at Tikal: An Historical and Iconographic Reconstruction." PhD dissertation. Harvard University, 1975.

Coggins 1983
Coggins, Clemency C. *The Stucco Decoration and Architectural Assemblage of Structure 1-Sub, Dzibilchaltun, Yucatan, Mexico.* New Orleans: National Geographic Society – Tulane University Program of Research on the Yucatan Peninsula, Middle American Research Institute, Publication No. 49, 1983.

Coggins 1984A
Coggins, Clemency C. "Murals in the Upper Temple of the Jaguars, Chichén Itzá." In Clemency C. Coggins and Orrin C. Shane III, eds. *Cenote of Sacrifice: Maya Treasures from the Sacred Well at Chichén Itzá.* Austin: University of Texas Press, 1984.

Coggins 1984B
Coggins, Clemency C. "Plate 28 – Picture plaque." In Clemency C. Coggins. and Orrin C. Shane III, eds. *Cenote of Sacrifice: Maya Treasures from the Sacred Well at Chichén Itzá.* Austin: University of Texas Press, 1984.

Coggins 1984C
Coggins, Clemency C. "Plate 32 – Three face ornaments." In Clemency C. Coggins. and Orrin C. Shane III, eds. *Cenote of Sacrifice: Maya Treasures from the Sacred Well at Chichén Itzá.* Austin: University of Texas Press, 1984.

Coggins 1984D
Coggins, Clemency C. "Plate 125 – Diving figure scepter." In Clemency C. Coggins and Orrin C. Shane III, eds. *Cenote of Sacrifice: Maya Treasures from the Sacred Well at Chichén Itzá.* Austin: University of Texas Press, 1984.

Coggins 1985
Coggins, Clemency C. "Plate 120 – Architectural Frieze." In *Maya: Treasures of an Ancient Civilization.* Eds. Charles Gallenkamp and Regina Elise Johnson. New York: Harry N. Abrams, in association with The Albuquerque Museum, 1985, p. 173.

Coggins 1992
Coggins, Clemency C. *Artifacts from the Cenote of Sacrifice, Chichén Itzá, Yucatan.* Cambridge, Massachusetts: Memoirs of the Peabody Museum of Archaeology and Ethnology, Harvard University 10, 3 (1992).

Coggins and Shane 1984
Coggins, Clemency C. and Orrin C. Shane III, eds. *Cenote of Sacrifice: Maya Treasures from the Sacred Well at Chichén Itzá.* Austin: University of Texas Press, 1984.

F. Columbus 1959/1992
Columbus, Ferdinand. *The Life of the Admiral Christopher Columbus.* Trans. Benjamin Keen. New Brunswick, New Jersey: Rutgers University Press, 1992. Originally pub. 1959.

Córdova Tello 2008
Córdova Tello, Mario. "Elementos olmecas en Morelos." In *Olmeca: Balance y perspectivas*. Eds. María Teresa Uriarte and Rebecca B. González Lauck. Mexico City: Universidad Nacional Autónoma de México, 2008, pp. 287–318.

Cortés 1971
Hernán Cortés. *Letters from Mexico*. Trans. Anthony Pagden. New York: Grossman Publishers, 1971.

Covarrubias 1957
Covarrubias, Miguel. *Indian Art of Mexico and Central America*. New York: Alfred A. Knopf, 1957.

Creamer 1989
Creamer, Michael. "Maritime Secrets of the Maya." *Institute of Nautical Archaeology Newsletter* 13, 2 (1989), pp. 4–6.

Croat 1978
Croat, Thomas B. *Flora of Barro Colorado Island*. Stanford, California: Stanford University Press, 1978.

Cuevas García 2003
Cuevas García, Marta. "Ritos Funerarios de los Dioses-Incensarios de Palenque." In *Antropología de la Eternidad: La Muerte en la Cultura Maya*. Eds. Andrés Ciudad Ruiz, Mario Humberto Ruz Sosa, and Josefa Iglesias Ponce de León. Madrid: Sociedad Española de Estudios Mayas, 2003, pp. 317–36.

Cuevas García 2004
Cuevas García, Marta. "The Cult of Patron and Ancestor Gods in Censers at Palenque." In Mary E. Miller and Simon Martin, eds. *Courtly Art of the Ancient Maya*. London and New York: Thames and Hudson, 2004, pp. 253–55.

Dacal Moure and Rivero de la Calle 1996
Dacal Moure, Ramón and Manuel Rivero de la Calle. *Art and Archaeology of Pre-Columbian Cuba*. Trans. Daniel H. Sandweiss. Pittsburgh: University of Pittsburgh Press, 1996.

Dahlin et al. 1998
Dahlin, Bruce H. et al. "Punta Canbalam in Context." *Ancient Mesoamerica* 9, 1 (1998), pp. 1–15.

Daveletshin 2003
Daveletshin, Albert. "Glyph for Stingray Spine." *Mesoweb*: www.mesoweb.com/features/davletshin/Spine.pdf, 2003.

L. I. Davis 1972
Davis, L. Irby. *A Field Guide to the Birds of Mexico and Central America*. Austin: University of Texas Press, 1972.

V. D. Davis 1978
Davis, Virginia D. "Ritual of the Northern Lacandon Maya." PhD dissertation. Tulane University, 1978.

Didrichsen 2005
Didrichsen, Maria. "Rescuing a Lost Kingdom." In Maria Didrechsen, ed. *Maya II: The Mystery of the Lost City/ El misterio de la cuidad perdida*. Helsinki: Didrechsen Museum of Art and Culture, 2005, pp. 58–113.

Drewal 2008
Drewal, John Henry. *Mami Wata: Arts for Water Spirits in Africa and Its Diasporas*. Los Angeles: Fowler Museum, 2008.

Drewer 1981
Drewer, Lois. "Fisherman and Fish Pond: From the Sea of Sin to the Living Waters." *The Art Bulletin* 63, 4 (1981), pp. 533–47.

Dunning and Houston in press
Dunning, Nicholas and Stephen D. Houston. "'Chan Ik': Hurricanes as a Destabilizing Force in the Prehispanic Maya Lowlands." In *Ecology, Power, and Religion in Maya Landscapes: Proceedings of the 11th European Maya Conference*. Eds. Christian Isendahl and Bodil Liljefors Persson. Markt Schwaben: Verlag Anton Saurwein, in press.

Edwards 1965
Edwards, Clinton R. "Aboriginal Sail in the New World." *Southwestern Journal of Anthropology* 21, 4 (1965), pp. 351–58.

Epstein 1990
Epstein, Jeremiah F. "Sails in Aboriginal Mesoamerica: Reevaluating Thompson's Argument." *American Anthropologist*, New Series 92, 1 (1990), pp. 187–92.

Escobedo 2004
Escobedo, Héctor L. "Tales from the Crypt: The Burial Place of Ruler 4, Piedras Negras." In Mary E. Miller and Simon Martin, eds. *Courtly Art of the Ancient Maya*. London and New York: Thames and Hudson, 2004, pp. 277–79.

Estrada Monroy 1979
Estrada Monroy, Agustín. *El mundo K'ekchi' de la Vera-Paz*. Guatemala: Editorial del Ejercito, 1979.

Exploring the Early Americas: The Jay I. Kislak Collection-Online Exhibition. http://www.loc.gov/exhibits/earlyamericas/online/precontact/precontact3.html#object28 .

Fahsen, Demarest, and Fernando Luin 2003
Fahsen, Federico, Arthur A. Demarest, and Luis Fernando Luin. "Sesenta años en la escalinata jeroglífica de Cancuen." *In XVI Simposio de investigaciones arqueológicas en Guatemala, 2002*. Eds. Juan Pedro Laporte, Barbara Arroyo, Héctor L. Escobedo, and Héctor Mejía. Guatemala City: Museo Nacional de Arqueología y Etnología, 2003, pp. 703–13.

Fahsen and Jackon 2003
Fahsen, Federico and Sarah Jackson. "Nuevos datos e interpretaciones sobre la dinastía de Cancuen en el periodo clásico." In *XV Simposio de investigactiones arqueologicas en Guatemala, 2000*. Eds. Juan Pedro Laporte, Héctor L. Escobedo, and Barbara Arroyo. Guatemala City: Museo Nacional de Arqueología y Etnología, Ministerio de Cultura y Deportes, 2003, pp. 899–908.

Farris and A. G. Miller 1977
Farris, Nancy and Arthur G. Miller. "Maritime Culture Contact of the Maya: Underwater Surveys and Test Excavations in Quintana Roo, Mexico." *International Journal of Nautical Archaeology* 6, 2 (1977), pp. 141–51.

B. W. Fash 1992
Fash, Barbara W. "Copan Mosaic Sculpture; Puzzles within Puzzles." Paper presented at the Tenth Annual Maya Weekend, Copan: Multiple Approaches to Discovery and Understanding, University of Pennsylvania, April 4, 1992.

B. W. Fash 2005
Fash, Barbara W. "Iconographic Evidence for Water Management at Copán, Honduras." In E. Wyllys Andrews and William L. Fash, eds. *Copán: History of an Ancient Maya Kingdom*. Santa Fe: School of American Research Press, 2005, pp. 103–38.

B. W. Fash n.d.
Fash, Barbara W. "Watery Places and Urban Foundations Depicted in Maya Art and Architecture." In *The Art of Urbanism: How Mesoamerican Cities Represented Themselves in Architecture and Imagery*. Washington, DC: Dumbarton Oaks Research Library and Collection, unpublished ms.

B. W. Fash and Davis-Salazar 2006
Fash, Barbara W. and Karla L. Davis-Salazar. "Copan Water Ritual and Management: Imagery and Sacred Place." In *Precolumbian Water Management: Ideology, Ritual, and Power*. Eds. Lisa J. Lucero and Barbara W. Fash. Tucson: University of Arizona Press, 2006, pp. 129–43.

W. L. Fash 2001
Fash, William L. *Scribes, Warriors, and Kings: The City of Copán and the Ancient Maya*. London and New York: Thames and Hudson, 2001.

W. L. Fash 2002
Fash, William L. "Religion and Human Agency in Ancient Maya History: Tales from the Hieroglyphic Stairway." *Cambridge Archaeological Journal* 12, 1 (2002), pp. 5–19.

W. L. Fash 2005
Fash, William L. "Towards a Social History of the Copán Valley." In E. Wyllys Andrews and William L. Fash, eds. *Copán: The History of an Ancient Maya Kingdom*. Santa Fe: School of American Research Press, 2005, pp. 73–102.

W. L. Fash et al. 2001
Fash, William L., Harriet. F. Beaubien, Catherine Magee, Barbara W. Fash, and Richard Williamson. "Trappings of Kingship among the Classic Maya: Ritual and Identity in a Royal Tomb from Copan." *In Fleeting Identities: Perishable Material Culture in Archaeological Research*. Ed. Penelope Drucker. Carbondale: Center for Archaeological Investigations, Southern Illinois University, 2001.

Fields 1991
Fields, Virginia M. "The Iconographic Heritage of the Maya Jester God." In *Sixth Palenque Round Table*, 1986. Eds. Merle Greene Robertson and Virginia M. Fields. Online version. Norman: University of Oklahoma Press, 1991.

Fields and Reents-Budet 2005
Fields, Virginia M. and Dorie Reents-Budet, eds. *Lords of Creation: The Origins of Sacred Maya Kingship*. London: Los Angeles County Museum of Art in conjunction with Scala Publishers, 2005.

Fine Pre-Columbian Art Including a Collector's Vision, Christies Sale 1775 (November 21, 2006), lot 179.

Fitzsimmons 2009
Fitzsimmons, James L. *Death and the Classic Maya Kings*. Austin: University of Texas Press, 2009.

Fitzsimmons et al. 2003
Fitzsimmons, James, Andrew Scherer, Stephen D. Houston, and Héctor L. Escobedo. "Guardian of the Acropolis: The Sacred Space of a Royal Burial at Piedras Negras, Guatemala." *Latin American Antiquity* 14, 4 (2003), pp. 449–68.

Foster and Wren 1996
Foster, Lynn and Linnea Wren. "World Creator and World Sustainer: God N at Chichén Itzá." In *Eighth Palenque Round Table*, 1993. Eds. Martha J. Macri and Jan McHargue. San Francisco: Pre-Columbian Art Research Institute, 1996, pp. 259–69.

Fought 1972
Fought, John G. *Chorti (Mayan) Texts (1)*. Ed. Sarah S. Fought. Philadelphia: University of Pennsylvania Press, 1972.

French 2007
French, Kirk D. "Creating Space through Water Management at the Classic Maya Site of Palenque, Chiapas." In *Palenque: Recent Investigations at the Classic Maya Center*. Ed. Damien R. Marken. Lanham, Maryland: Altamira Press, 2007, pp. 123–34.

Freidel, Schele, and Parker 1993
Freidel, David, Linda Schele, and Joy Parker. *Maya Cosmos: Three Thousand Years on the Shaman's Path*. New York: William Morrow & Co., 1993.

Gann 1900
Gann, Thomas. *Mounds in Northern Honduras*. Washington, DC: Smithsonian Institution, Bureau of American Ethnology, Annual Report 19 (1900), pp. 655-692.

Gann 1918
Gann, Thomas. *The Maya Indians of Southern Yucatan and Northern British Honduras*. Washington, DC: Smithsonian Institution, Bureau of American Ethnology Bulletin 64, 1918.

García Barrios 2008
García Barrios, Ana. "Chaahk, El Dios De La Lluvia, En El Periodo Clásico Maya: Aspectos Religiosos y Políticos." PhD dissertation. Universidad Complutense de Madrid, 2008.

García Campillo 1992
García Campillo, José Miguel. "Informe epigráfico sobre Oxkintok y la cerámica Chocholá." In *Misión Arqueológica de España en México*. Ed. Miguel Rivera Dorado. Madrid: Ministerio de Cultura, 1992, pp. 185–200.

Gates 1932
Gates, William E. *The Dresden Codex: Reproduced from Tracings of the Original, Colorings Finished by Hand*. Baltimore: The Maya Society, 1932.

Gillespie and Joyce 1998
Gillespie, Susan D. and Rosemary A. Joyce. "Deity Relationships in Mesoamerican Cosmologies: The case of God L. *Ancient Mesoamerica* 9 (1998), pp. 279–96.

Girard 1995
Girard, Rafael. *People of the Chan*. Chino Valley, California: Continuum Foundation, 1995.

Gittinger 1976
Gittinger, Mattiebelle. "The Ship Textiles of South Sumatra: Functions and Design System." *Bijdragen tot de Taal-, Land- en Volkenkunde* 132, 2/3 (1976), pp. 207–27.

Goldstein 1977
Goldstein, Marilyn. "The Ceremonial Role of the Maya Flanged Censer." *Man* 12, 3 (1977), pp. 405–20.

González and Rojas 2006
González, Arturo and Carmen Rojas. *Informe Técnico Atlas Arqueológico Subacuático para el registro, estudio y protección en los cenotes de la península de Yucatán*. Mexico: Archivo Técnico de la Coordinación Nacional de Arqueología, INAH, 2006.

González Cruz and Bernal Romero 2004
González Cruz, Arnoldo and Guillermo Bernal Romero. "The Throne Panel of Temple 21 at Palenque." In Mary E. Miller and Simon Martin, eds. *Courtly Art of the Ancient Maya*. London and New York: Thames and Hudson, 2004, pp. 264–67.

Gossen 2002
Gossen, Gary H. *Four Creations: An Epic Story of the Chiapas Mayas*. Norman: University of Oklahoma Press, 2002.

E. Graham 2008
Graham, Elizabeth with contributions by Claude Belanger. *Lamanai Historic Monuments Conservation Project: Recording and Consolidation of New Church Architectural Features at Lamanai, Belize*. Report submitted to the Foundation for the Advancement of Mesoamerican Studies, Inc., 2008. http://www.famsi.org/reports/06110C/06110CGraham01.pdf.

E. Graham, Pendergast, and G. D. Jones 1989
Graham, Elizabeth, David M. Pendergast, and Grant D. Jones. "On the Fringes of Conquest: Maya-Spanish Contact in Colonial Belize." *Science*, New Series 246, 4935 (1989), pp. 1254–59.

I. Graham 1967
Graham, Ian. *Archaeological Explorations in El Peten, Guatemala*. New Orleans: Tulane University, Middle American Research Institute, Publication 33, 1967.

I. Graham 1977
Graham, Ian. *Corpus of Maya Hieroglyphic Incriptions*. Vol. 3, Pt. 1. Cambridge, Massachusetts: Harvard University Press, 1977.

I. Graham 1986
Graham, Ian. *Corpus of Maya Hieroglyphic Incriptions*. Vol. 5, Pt. 3. Cambridge, Massachusetts: Harvard University Press, 1986.

I. Graham 1997
Graham, Ian. "Discovery of a Maya Ritual Cave in the Peten, Guatemala." *Symbols*, Spring 1997, pp. 28–31.

Grube and Gaida 2006
Grube, Nikolai and Maria Gaida. *Die Maya: Shrift und Kunst*. Berlin: SMB Dumont, 2006.

Grube, Lacadena, and Martin 2003
Grube, Nikolai, Alfonso Lacadena, and Simon Martin. "Chichen Itzá and Ek' Balam: Terminal Classic Inscriptions from Yucatan." In *Notebook for the XXVIIth Maya Heiroglyphic Forum at Texas, Part II*. Austin: The University of Texas at Austin, 2003, pp. 1–84.

Grube and Nahm 1994
Grube, Nikolai and Werner Nahm. "A Census of Xibalba: A Complete Inventory of Way Characters on Maya Ceramics." In *The Maya Vase Book*. Vol. 4. Ed. Justin Kerr. New York: Kerr Associates, 1994, pp. 686–715.

Guenter 2002
Guenter, Stanley. "A Reading of the Cancuén Looted Panel." *Mesoweb*: www.mesoweb.com/features/cancuen/Panel.pdf, 2002.

Guiteras-Holmes 1961
Guiteras-Holmes, Calixta. *Perils of the Soul*. New York: Free Press of Glencoe, 1961.

Guthrie 1995
Guthrie, Jill, ed. *The Olmec World: Ritual and Rulership*. Princeton, New Jersey: The Art Museum, Princeton University, 1995.

Gyory, Mariano, and Ryan 2002
Gyory, Joanna, Arthur J. Mariano, and Edward H. Ryan. "The Yucatan Current." Ocean Surface Currents. http://oceancurrents.rsmas.miami.edu/caribbean/yucatan.html. *Atlas of Pilot Charts North Atlantic Ocean*, *NVPUB106*. Washington, DC: National Imagery and Mapping Agency Secretary of Defense, 2002.

Hamilton 1896
Hamilton, Augustus. *Maori Art*. Dunedin, New Zealand: Fergusson and Mitchell, 1896.

Hammond 1981
Hammond, Norman. "Classic Maya Canoes." *The International Journal of Nautical Archaeology and Underwater Exploration* 10, 3 (1981), pp. 173–85.

Hanks 1990
Hanks, William F. *Referential Practice: Language and Lived Space among the Maya*. Chicago: University of Chicago Press, 1990.

Hansen 2001
Hansen, Richard D. "First Cities, the Beginnings of Urbanization and State Formation in the Maya Lowlands." In *Maya: Divine Kings of the Rainforest*. Ed. Nikolai Grube. Cologne: Könemann Verlagsgesellschaft, 2001, pp. 50–65.

Healy et al. 1995
Healy, Paul F. et al. "Pacbitun (Belize) and Ancient Maya Use of Slate." *Antiquity* 69, 263 (1995), pp. 337–48.

Hellmuth 1987A
Hellmuth, Nicholas M. *Monster und Menschen in der Maya-Kunst: Eine Ikonographie der alten Religionen Mexikos und Guatemalas*. Graz: Akademische Druck- und Verlagsanstalt, 1987.

Hellmuth 1987B
Hellmuth, Nicholas M. *The Surface of the Underwaterworld: Iconography of the Gods of Early Classic Maya Art in Peten, Guatemala*. Culver City, California: Foundation for Latin American Anthropological Research, 1987.

Hill 1992
Hill, Jane H. "The Flower World in Old Uto-Aztecan." *Journal of Anthropological Research* 48 (1992), pp. 117–44.

Holland 1961
Holland, William R. "El tonalismo y el nagualismo entre los Tzotiles." *Estudios de Cultura Maya* 1 (1961), pp. 167–81.

Holland 1964
Holland, William R. "Conceptos cosmológicos Tzotziles como un base para interpretar la civilización Maya prehispánica." *América Indígena* 24 (1964), pp. 11–28.

Houston 1993
Houston, Stephen D. *Hieroglyphs and History at Dos Pilas: Dynastic Politics of the Classic Maya*. Austin: University of Texas Press, 1993.

Houston 1998
Houston, Stephen D. "Finding Function and Meaning in Classic Maya Architecture." In Stephen D. Houston, ed. *Function and Meaning in Classic Maya Architecture*. Washington, DC: Dumbarton Oaks Research Library and Collection, 1998, pp. 519–31.

Houston 2004A
Houston, Stephen D. "The Acropolis of Piedras Negras: Portrait of a Court System." In Mary E. Miller and Simon Martin, eds. *Courtly Art of the Ancient Maya*. London and New York: Thames and Hudson, 2004, pp. 271–76.

Houston 2004B
Houston, Stephen D. "Writing in Early Mesoamerica." In Stephen D. Houston, ed. *The First Writing: Script Invention as History and Process*. Cambridge: Cambridge University Press, 2004, pp. 274–309.

Houston et al. 2005
Houston, Stephen D. et al. "The Pool of the Rain God: An Early Stuccoed Altar at Aguacatal, Campeche, Mexico." *Mesoamerican Voices* 2 (2005), pp. 37–62.

Houston and D. Stuart 1989
Houston, Stephen D. and David Stuart. "The Way Glyph: Evidence for 'Co-essences' among the Classic Maya." *Research Reports on Ancient Maya Writing* 30. Washington, DC: Center for Maya Research, 1989.

Houston and D. Stuart 1996
Houston, Stephen D. and David Stuart. "Of Gods, Glyphs, and Kings: Divinity and Rulership among the Classic Maya." *Antiquity* 70 (1996), pp. 289–312.

Houston, D. Stuart, and Taube 2006
Houston, Stephen D., David Stuart, and Karl A. Taube. *The Memory of Bones: Body, Being and Experience among the Classic Maya*. Austin: University of Texas Press, 2006.

Houston and Taube 2000
Houston, Stephen D. and Karl A. Taube. "An Archaeology of the Senses: Perception and Cultural Expression in Ancient Mesoamerica." *Cambridge Archaeological Journal* 10, 2 (2000), pp. 261–94.

Houston and Taube in press
Houston, Stephen D. and Karl A. Taube. "The Fiery Pool: Water and Sea among the Classic Maya." In *Ecology, Power, and Religion in Maya Landscapes: Proceedings of the 11th European Maya Conference*, in press.

Iglesias Ponce de León 1987
Iglesias Ponce de León, María Josefa. "Excavaciones en el grupo habitacional 6D-V, Tikal, Guatemala." PhD dissertation. Universidad Complutense de Madrid, 1987.

Iglesias Ponce de León and Tomás Sanz 1998
Iglesias Ponce de León, María Josefa and Luis Tomás Sanz. "Patrones de replicación iconográfica en materiales del Clásico Temprano de Tikal." In *XII Simposio de Investigaciones Arqueológicas en Guatemala, 1998*. Eds. Juan P. Laporte and Hectór L. Escobedo. Guatemala City: Museo Nacional de Arqueología y Etnología, 1998, pp. 157–73.

Isaza Aizpurúa 2004
Isaza Aizpurúa, Ilean Isel. "The Art of Shell Working and the Social Uses of Shell Ornaments." In Patricia A. McAnany, ed. *K'axob: Ritual, Work, and Family in an Ancient Maya Village*. Los Angeles: Cotsen Institute of Archaeology, University of California, 2004, pp. 335–52.

Isaza Aizpurúa and McAnany 1999
Isaza Aizpurúa, Ilean Isel and Patricia A. McAnany. "Adornment and Identity: Shell Ornaments from Formative K'axob." *Ancient Mesoamerica* 10 (1999), pp. 117–27.

Ishihara, Taube, and Awe 2006
Ishihara, Reiko, Karl A. Taube, and Jaime J. Awe. "The Water Lily Serpent Stucco Masks at Caracol, Belize." In *Research Reports in Belizean Archaeology, Volume 3*. Eds. John Morris, Sherilyne Jones, Jaime J. Awe, and Christophe Helmke. Belmopan: Institute of Archaeology, 2006, pp. 213–23.

Janzen 1983
Janzen, Daniel H., ed. *Costa Rican Natural History*. Chicago: University of Chicago Press, 1983.

Johnsgard 1978
Johnsgard, Paul A. *Ducks, Geese, and Swans of the World*. Lincoln and London: University of Nebraska Press, 1978.

L. Jones 1993
Jones, Lindsay. "The Hermeneutics of Sacred Architecture: A Reassessment of the Similitude between Tula, Hildalgo and Chichen Itza, Yucatan, Part I." *History of Religions* 32, 3 (1993), pp. 207–32.

T. Jones 1985
Jones, Tom. "Xoc, the Sharke, and the Sea Dogs: An Historical Encounter." In *Fifth Palenque Round Table*, 1983. Ed. Virginia M. Fields. San Francisco: Pre-Columbian Art Research Institute, 1985, pp. 211–22.

Jong 1999
Jong, Harriet J. de. "The Land of Corn and Honey: The Keeping of Stingless Bees (Meliponiculture) in the Ethno-ecological Environment of Yucatan (Mexico) and El Salvador." PhD dissertation. University of Utrecht, 1999.

Joralemon 1975
Joralemon, David. "Appendix II, The Night Sun and the Earth Dragon: Some Thoughts on the Jaguar God of the Underworld." In Mary E. Miller, ed. *Jaina Figures: A Study of Maya Iconography*. Princeton, New Jersey: The Art Museum, Princeton University, 1975, pp. 63–68.

Juan Arrom 1989
Juan Arrom, José. *Mitología y artes prehispánicas de las antillas*. 2nd ed. Mexico: Siglo Veintiuno Editores, 1989.

Karttunen 1992
Karttunen, Frances. *An Analytical Dictionary of Nahuatl*. Norman: University of Oklahoma Press, 1992.

Kaufman 2003
Kaufman, Terrence. *A Preliminary Mayan Etymological Dictionary*. http://www.famsi.org/reports/01050/ index. html, 2003.

B. Kerr and J. Kerr 2005
Kerr, Barbara and Justin Kerr. "The Way of God L: The Princeton Vase Revisited." *The Record of the Princeton Art Museum* 64 (2005), pp. 71–79.

J. Kerr 1989
Kerr, Justin. *The Maya Vase Book*. Vol. 1. New York: Kerr Associates, 1989.

Knab 2004
Knab, Timothy J. *The Dialogue of Earth and Sky: Dreams, Souls, Curing, and the Modern Aztec Underworld*. Tucson: University of Arizona Press, 2004.

Kristan-Graham and Kowalski 2007
Kristan-Graham, Cynthia and Jeff K. Kowalski. "Chichén Itzá, Tula, and Tollan: Changing Perspectives on a Recurring Problem in Mesoamerican Archaeology and Art History." In Jeff K. Kowalski and Cynthia Kristan-Graham, eds. *Twin Tollans: Chichén Itzá, Tula, and the Epiclassic to Early Postclassic Mesoamerican World*. Washington, DC: Dumbarton Oaks, 2007, pp. 13–84.

Kubler 1967
Kubler, George. *The Iconography of the Art of Teotihuacán*. Washington, DC: Dumbarton Oaks Research Library and Collection, Studies in Pre-Columbian Art and Archaeology No. 4, 1967.

Landa circa 1566/1937
Landa, Diego de. *Yucatán before and after the Conquest*. Trans. with notes, William E. Gates. Baltimore: The Maya Society, 1937.

Lange 1971
Lange, Frederick W. "Marine Resources: A Viable Subsistence Alternative for the Prehistoric Lowland Maya." *American Anthropologist*, New Series 73, 3 (1971), pp. 619–39.

Laporte and Fialko 1995
Laporte, Juan Pedro and Vilma Fialko. "Un Reencuentro con Mundo Perdido, Tikal, Guatemala." *Ancient Mesoamerica* 6 (1995), pp. 41–94.

Laughlin 1988
Laughlin, Robert M. *The Great Tzotzil Dictionary of Santo Domingo Zinacantán*. Vol. 1 [Tzotzil-English]. Smithsonian Contributions to Anthropology 31. Washington, DC: Smithsonian Institution Press, 1988.

León 1945
León, Juan de. *Mundo Quiché: Miscelánea*. Guatemala City: Tall. Tipográficos "San Antonio,"1945.

Lombardo de Ruíz 1998
Lombardo de Ruíz, Sonia. "La navegación en la iconografía maya." *Arqueología Mexicana* 6, 33 (1998), pp. 40–47.

Looper 1991
Looper, Matthew G. "The Peccaries above and below Us." *Texas Notes on Precolumbian Art, Writing, and Culture* 10 (1991), pp. 1–5.

Lopes 2004
Lopes, Luís. "The Water-Band Glyph." *Mesoweb*. http://www.mesoweb.com/lopes/Waterband.pdf., 2004.

López Bravo 2004
López Bravo, Roberto. "State and Domestic Cult in Palenque Censer Stands." In Mary E. Miller and Simon Martin, eds. *Courtly Art of the Ancient Maya*. London and New York: Thames and Hudson, 2004, pp. 256–58.

López Luján 1994
López Luján, Leonardo. *The Offerings of the Templo Mayor of Tenochtitlan*. Boulder: University Press of Colorado, 1994.

Lothrop 1924
Lothrop, Samuel Kirkland. *Tulum, an Archaeological Study of the East Coast of Yucatan*. Washington, DC: Carnegie Institution, Publication 335, 1924.

Lothrop 1929
Lothrop, Samuel Kirkland. "Canoes of Lake Atitlan." *Indian Notes* 6 (1929), pp. 216–21.

Lothrop 1952
Lothrop, Samuel Kirkland, ed. *Metals from the Cenote of Sacrifice: Chichén Itzá, Yucatan*. Cambridge, Massachusetts: Memoirs of the Peabody Museum of Archaeology and Ethnology, Harvard University, Vol. 10, No. 2, 1952.

Lucero 2006A
Lucero, Lisa J. "Agricultural Intensification, Water, and Political Power in the Southern Maya Lowlands." In *Agricultural Strategies*. Eds. Joyce Marcus and Charles Stanish. Los Angeles: Cotsen Institute of Archaeology, University of California, Los Angeles, 2006, pp. 281–308.

Lucero 2006B
Lucero, Lisa J. "The Political and Sacred Power of Water in Maya Society." In Lisa J. Lucero and Barbara W. Fash, eds. *Precolumbian Water Management: Ideology, Ritual, and Power*. Tucson: University of Arizona Press, 2006, pp. 116–28.

Lucero 2006C
Lucero, Lisa J. *Water and Ritual: The Rise and Fall of Classic Maya Rulers*. Austin: University of Texas Press, 2006.

Lucero and B. W. Fash 2006
Lucero, Lisa J. and Barbara W. Fash, eds. *Precolumbian Water Management: Ideology, Ritual, and Power*. Tucson: University of Arizona Press, 2006.

McAnany 1989
McAnany, Patricia A. "Economic Foundations of Prehistoric Maya Society: Paradigms and Concepts." In Patricia A. McAnany and Barry L. Isaac, eds. *Prehistoric Maya Economies of Belize*. Greenwich, Connecticut: JAI Press, Research in Economic Anthropology, Supplement 4, 1989, pp. 347–72.

McCloskey and Keller 2009
McCloskey, Terrence A. and Gerta Keller. "5000 Year Sedimentary Record of Hurricane Strikes on the Central Coast of Belize." *Quaternary International* 195 (2009).

McKillop 1984
McKillop, Heather. "Maya Reliance on Marine Resources: Analysis of a Midden from Moho Cay, Belize." *Journal of Field Archaeology* 11, 1 (1984), pp. 25–35.

McKillop 1985
McKillop, Heather. "Prehistoric Exploitation of the Manatee in the Maya and Circum-Caribbean Areas." *World Archaeology* 16, 3 (1985), pp. 337–53.

McKillop 2002
McKillop, Heather. *Salt: White Gold of the Ancient Maya*. Gainesville: University Press of Florida, 2002.

McKillop 2004
McKillop, Heather. "The Classic Maya Trading Port of Moho Cay." In *The Ancient Maya of the Belize Valley*. Ed. James F. Garber. Gainesville: University Press of Florida, 2004, pp. 257–62.

McKillop 2005A
McKillop, Heather. "Finds in Belize Document Late Classic Maya Salt Making and Canoe Transport." *Proceedings of the National Academy of Sciences* 102 (2005), pp. 5630–34.

McKillop 2005B
McKillop, Heather. *In Search of Maya Sea Traders*. College Station: Texas A & M University Press, 2005.

McKillop 2007A
McKillop, Heather. "Ancient Mariners on the Belize Coast: Salt, Stingrays, and Seafood." *Belizean Studies* 29, 2 (2007), pp. 15–28.

McKillop 2007B
McKillop, Heather. "GIS of the Maya Canoe Paddle Site, K'ak' Naab.'" http://www.famsi.org/reports/05032/index.html, 2007.

McKillop et al. 2004
McKillop, Heather et al. "The Coral Foundations of Coastal Maya Architecture." *Research Reports in Belizean Archaeology* 1 (2004), pp. 347–58.

McKillop and Joyce 2009
McKillop, Heather and Rosemary A. Joyce. "Maritime Trade in the Postclassic between the Maya and Intermediate Areas." Unpublished ms, 2009.

McVicker 2005
McVicker, Mary F. *Adela Breton: A Victorian Artist Amid Mexico's Ruins*. Albuquerque: University of New Mexico Press, 2005.

Magaloni Kerpel 2004
Magaloni Kerpel, Diana. "The Techniques, Color, and Art at Bonampak." In Mary E. Miller and Simon Martin, eds. *Courtly Art of the Ancient Maya*. London and New York: Thames and Hudson, 2004, pp. 247–50.

Marcus 1999
Marcus, Joyce. "Men's and Women's Ritual in Formative Oaxaca." In *Social Patterns in Pre-Classic Mesoamerica*. Eds. David C. Grove and Rosemary A. Joyce. Washington, DC: Dumbarton Oaks, 1999, pp. 67–96.

Martin 2006A
Martin, Simon. "Cacao in Ancient Maya Religion: First Fruit from the Maize Tree and Other Tales from the Underworld." In *Chocolate in Mesoamerica: A Cultural History of Cacao*. Ed. Cameron L. McNeil. Gainsville: University Press of Florida, 2006, pp. 154–83.

Martin 2006B
Martin, Simon. "Recently Uncovered Murals and Façades at Calakmul." Paper presented at the conference "Mysteries of the Ancient Maya Murals," Beckman Center of the National Academies of Sciences and Engineering, Irvine, California, October 21, 2006.

Martin 2008
Martin, Simon. "Gods within Gods: Theosynthesis and the Making of Divine Identity among the Ancient Maya." Unpublished paper, 2008.

Martin and Grube 2008
Martin, Simon and Nikolai Grube. *Chronicle of the Maya Kings and Queens: Deciphering the Dynasties of the Ancient Maya*. 2nd ed. London and New York: Thames and Hudson, 2008.

Martos López 2008
Martos López, Luis Alberto. "Underwater Archaeological Exploration of the Mayan Cenotes." *Museum International* 240 (2008), pp. 100–10.

Matos Moctezuma 1988
Matos Moctezuma, Eduardo. *The Great Temple of the Aztecs: Treasures of Tenochtitlan*. London and New York: Thames and Hudson, 1988.

Matos Moctezuma 1991
Matos Moctezuma, Eduardo. "Notes on the Oldest Sculpture of El Templo Mayor of Tenochtitlan." In *To Change Place: Aztec Ceremonial Landscapes*. Ed. Davíd Carrasco. Niwot, Colorado: University Press of Colorado, 1991, pp. 3–8.

Matthes 1999
Matthes, Andreas W. "Una pequeña guía de los cenotes de Yucatán." In *Cenotes y Grutas de Yucatán*. Mérida: Editorial CEPSA-Secretaría de Ecología del Gobierno de Yucatán, 1999, pp. 62–74.

Maxwell 2000
Maxwell, David. "Beyond Maritime Symbolism: Toxic Marine Objects from Ritual Contexts at Tikal." *Ancient Mesoamerica* 11 (2000), pp. 91–98.

Merwin and Vaillant 1932
Merwin, Raymond E. and George C. Vaillant. *The Ruins of Holmul, Guatemala*. Cambridge, Massachusetts: Memoirs of the Peabody Museum of American Archaeology and Ethnology, Harvard University, Vol. 3, No. 2, 1932.

A. G. Miller 1973
Miller, Arthur G. *The Mural Painting of Teotihuacán*. Washington, DC: Dumbarton Oaks Research Library and Collection, 1973.

A. G. Miller 1982
Miller, Arthur G. *On the Edge of the Sea: Mural Painting at Tancah-Tulum, Quintana Roo, Mexico*. Washington, DC: Dumbarton Oaks, 1982.

M. E. Miller 1975
Miller, Mary E. *Jaina Figurines: A Study of Maya Iconography*. Princeton, New Jersey: Princeton University Art Museum, 1975.

M. E. Miller 1999
Miller, Mary E. *Maya Art and Architecture*. London and New York: Thames and Hudson, 1999.

M. E. Miller 2001
Miller, Mary E. *The Art of Mesoamerica: From Olmec to Aztec*. 3rd ed. London and New York: Thames and Hudson, 2001.

M. E. Miller 2002
Miller, Mary E. "Willfulness of Art: the Case of Bonampak." *Res* 42 (2002), pp. 8–23.

M. E. Miller 2005
Miller, Mary E. "Rethinking Jaina: Goddesses, Skirts, and the Jolly Roger." *Record of the Art Museum, Princeton University* 64 (2005), pp. 63–70.

M. E. Miller and Martin 2004
Miller, Mary E. and Simon Martin, eds. *Courtly Art of the Ancient Maya*. London and New York: Thames and Hudson, 2004.

M. E. Miller and Taube 1993
Miller, Mary E. and Karl A. Taube. *The Gods and Symbols of Ancient Mexico and the Maya: An Illustrated Dictionary of Mesoamerican Religion*. London and New York: Thames and Hudson, 1993.

Moholy-Nagy 1963
Moholy-Nagy, Háttula. "Shells and Other Marine Material from Tikal, Guatemala." *Estudios de Cultura Maya* 3 (1963), pp. 65–83.

Mora-Marín 2001
Mora-Marín, David F. "The Grammar, Orthography, Content, and Social Context of Late Preclassic Mayan Portable Texts." PhD dissertation. State University of New York, Albany, 2001.

Morales 1999
Morales, Juan José. "Humedales y Cenotes en Yucatán." In *Cenotes y Grutas de Yucatán*. Mérida: Editorial CEPSA-Secretaría de Ecología del Gobierno de Yucatán. 1999, pp. 76–86.

Morison 1963
Samuel Eliot Morison, ed. and trans. *Journals and Other Documents of the Life and Voyages of Christopher Columbus*. New York: The Heritage Press, 1963.

A. A. Morris 1931
Morris, Ann A. "Temple of the Warriors Murals." *Art and Archaeology* 31 (1931), pp. 316–22.

E. Morris, Charlot, and A. A. Morris 1931
Morris, Earl, Jean Charlot, and Ann A. Morris. *The Temple of the Warriors at Chichen Itza, Yucatan*. 2 Vols. Washington, DC: Carnegie Institution of Washington, Publication 406, 1931.

Nakamura 2003
Nakamura, Seiichi. "The Rise and Fall of the Copan Dynasty." In *Shipono ocho maya bunmeiten (Dynasties of Mystery: Maya Exhibit Catalog)*. Eds. Masahira Ono and Hisao Baba. Tokyo: TBS, 2003, pp. 89–104.

Navarrete 1992
Navarrete, Carlos. "Los ladrillos grabados de Comalcalco, Tabasco." In *Comalcalco*. Ed. Elizabeth Mejia Perez Campos. Mexico City: Instituto Nacional de Antropología e Historia, 1992, pp. 219–36.

Neff 1989A
Neff, Hector. "Origins of Plumbate Pottery Production." In *Trade and Tribute: Economics of the Soconusco Region of Mesoamerica*. Ed. Barbara Voorhies. Salt Lake City: University of Utah Press, 1989, pp. 175–93.

Neff 1989B
Neff, Hector. "The Effect of Interregional Distribution on Plumbate Pottery Production." In *Economies of the Soconusco Region of Mesoamerica*. Ed. Barbara Voorhies. Salt Lake City: University of Utah Press, 1989, pp. 249–67.

Neff 2001
Neff, Hector. "Production and Distribution of Plumbate Pottery: Evidence from a Provenance Study of the Paste and Slip Clay Used in a Famous Mesoamerican Tradeware." http://www.famsi.org/reports/98061/section02.htm, 2001.

Neff and Bishop 1988
Neff, Hector and Ronald L. Bishop. "Plumbate Origins and Development." *American Antiquity* 53, 3 (1988), pp. 505–22.

Negrín 1975
Negrín, Juan. *The Huichol Creation of the World*. Sacramento, California: E.B. Crocker Art Gallery, 1975.

Norman 1973
Norman, V. Garth. *Izapa Sculpture, Part 1: Album*. Papers of the New World Archaeological Foundation 30. Provo, Utah: Brigham Young University, 1973.

Nuñez Chinchilla 1966
Nuñez Chinchilla, Jesús. "Una cueva vitiva en la zona arqueológico de las ruinas de Copán." *Revista de la Sociedad de Geografía e Historia de Honduras* 18 (1966), pp. 43–48.

O'Mack 1991
O'Mack, Scott. "Yacateuctli and Ehecatl-Quetzalcoatl: Earth-Divers in Aztec Central Mexico." *Ethnohistory* 38, 1 (1991), pp. 1–33.

Parsons 1969
Parsons, Lee A. *Bilbao, Guatemala: An Archaeological Study of the Pacific Coast, Cotzumalhuapa Region*. Vol. 2. Milwaukee, Wisconsin: Milwaukee Public Museum, 1969.

Parsons 1980
Parsons, Lee A. *Pre-Columbian Art: The Morton D. May and the Saint Louis Art Museum Collections*. New York: Harper and Row, 1980.

Parsons 1983
Parsons, Lee A. "Altars 9 and 10, Kaminaljuyu, and the Evolution of the Serpent-Winged Deity." In *Civilization in the Ancient Americas: Essays in Honor of Gordon R. Willey*. Eds. Richard M. Leventhal and Alan L. Kolata. Albuquerque: University of New Mexico Press; and Cambridge, Massachusetts: Peabody Museum of Archaeology and Ethnology, Harvard University, 1983, pp. 145–56.

Parsons 1986
Parsons, Lee A. *The Origins of Maya Art: Monumental Stone Sculpture of Kaminaljuyu, Guatemala, and the Southern Pacific Coast*. Washington, DC: Dumbarton Oaks Research Library and Collection, Studies in Precolumbian Art and Archaeology 28, 1986.

Parsons, Carlson, and Joralemon 1988
Parsons, Lee A., John B. Carlson, and David P. Joralemon. *The Face of Ancient America: The Wally and Brenda Zollman Collection of Precolumbian Art*. Indianapolis: Indianapolis Museum of Art, 1988.

Pasztory 1983
Pasztory, Esther. *Aztec Art*. New York: Harry N. Abrams, 1983.

Pasztory 2005
Pasztory, Esther. *Thinking with Things: Toward a New Vision of Art*. Austin: University of Texas Press, 2005.

Pendergast 1969
Pendergast, David M. *Altun Ha, British Honduras (Belize): The Sun God's Tomb*. Toronto: Royal Ontario Museum, Division of Art and Archaeology, Occasional Papers 19, 1969.

Pendergast 1979
Pendergast, David M. *Excavations at Altun Ha, Belize, 1964–1970, Volume 1*. Toronto: Royal Ontario Museum, 1979.

Pendergast 1982
Pendergast, David M. *Excavations at Altun Ha, Belize, 1964–1970, Volume 2*. Toronto: Royal Ontario Museum, 1982.

Pendergast 1998
Pendergast, David M. "Intercessions with the Gods: Caches and Their Significance at Altun Ha and Lamanai, Belize." In *The Sowing and the Dawning: Termination, Dedication, and Transformation in the Archaeological and Ethnographic*. Ed. S.B. Mock. Albuquerque: University of New Mexico Press, 1998, pp. 55–63.

Pérez de Lara 2005
Pérez de Lara, Jorge. "A Glimpse into the Watery Underworld." *The PARI Journal* 5, 4 (2005), pp. 1–5. www.mesoweb.com/pari/publications/journal/0504/Cenote.pdf.

Petit 2006
Petit, Charles. "Jade Axes Proof of Vast Ancient Caribbean Network, Experts Say." *National Geographic News*, June 12, 2006. http://news.nationalgeographic.com/news/2006/06/060612-caribbean.html.

Phillips and Brown 1978
Phillips, Philip and James A. Brown with Eliza McFadden, Barbara C. Page, and Jeffrey P. Brain. *Pre-Columbian Shell Engravings from the Craig Mound at Spiro, Oklahoma*. 2 Vols. Cambridge, Massachusetts: Peabody Museum Press, 1978.

Phillips and Brown 1979
Phillips, Philip and James A. Brown with Eliza McFadden, Barbara C. Page, and Jeffrey P. Brain. *Pre-Columbian Shell Engravings from the Craig Mound at Spiro, Oklahoma*. Vol. 4. Cambridge, Massachusetts: Peabody Museum Press, 1979.

Piña Chan 1948
Piña Chan, Roman. *Breve estudio sobre la funeraria de Jaina*. Campeche: Museo Arqueológico, Etnográfico e Histórico del Estado, 1948.

Piña Chan 1968
Piña Chan, Roman. *Jaina, la casa en el agua*. Mexico City: Instituto Nacional de Antropología e Historia, 1968.

Pluskowski 2004
Pluskowski, Aleksander. "Narwhals or Unicorns? Exotic Animals as Material Culture in Medieval Europe." *European Journal of Archaeology* 7, 3 (2004), pp. 291–313.

Pollock 1980
Pollock, H. E. D. *The Puuc: An Architectural Survey of the Hill Country of Yucatan and Northern Campeche, Mexico*. Cambridge, Massachusetts: Memoirs of the Peabody Museum of Archaeology and Ethnology 19, Harvard University, 1980.

Pollock et al. 1962
Pollock, H. E. D. et al. *Mayapan, Yucatan, Mexico*. Washington, DC: Carnegie Institution of Washington, Publication 619, 1962.

Powis 2007
Powis, Terry G. "An Archaeological Investigation of the Origins of Cacao Drinking: The Ceramic Evidence from the Gulf Coast and Pacific Coast of Mexico." Foundation for the Advancement of Mesoamerican Studies, Inc., 2007. http://www.famsi.org/reports/06047/06047Powis01.pdf.

Powis et al. 2002
Powis, Terry G., Fred Valdez, Jr., Thomas R. Hester, W. Jeffrey Hurst, and Stanley M. Tarka, Jr. "Spouted Vessels and Cacao Use among the Preclassic Maya." Latin American Antiquity 13 (2002), pp. 85–116.

Prager 2001
Prager, Christian. "Court Dwarves – The Companions of Rulers and Envoys of the Underworld." In Maya: Divine Kings of the Rain Forest. Ed. Nikolai Grube. Cologne: Könemann Verlagsgesellschaft mbH, 2001, pp. 278–79.

Proskouriakoff 1968
Proskouriakoff, Tatiana. "Olmec and Maya Art: Problems of Their Stylistic Interpretation." In Dumbarton Oaks Conference on the Olmec. Ed. Elizabeth P. Benson. Washington, DC: Dumbarton Oaks Research Library and Collection, 1968, pp. 119–34.

Proskouriakoff 1974
Proskouriakoff, Tatiana. Jades from the Cenote of Sacrifice, Chichen Itza, Yucatan. Cambridge, Massachusetts: Memoirs of the Peabody Museum of Archaeology and Ethnology 10, 1, Harvard University, 1974.

Pughe 2001
D.L. Pughe. "The Lost Notebook of Aqueous Perspective." In David Rothenberg and Marta Ulvaeus, eds. Writing on Water. Cambridge, Massachusetts, and London: MIT Press for Terra Nova Books, 2001, p. 230.

Puleston 1976
Puleston, Dennis E. "The People of the Cayman/Crocodile: Riparian Agriculture and the Origins of Aquatic Motifs in Ancient Maya Iconography." In Aspects of Ancient Maya Civilization. Ed. François-Auguste de Montêquin. St. Paul, Minnesota: Hamline University, 1976, pp. 1–25.

Puleston 1977
Puleston, Dennis E. "Art and Archaeology of Hydraulic Agriculture in the Maya Lowlands." In Social Process in Maya Prehistory: Studies in the Memory of Sir Eric Thompson. Ed. Norman Hammond. London: Academic Press, London, pp. 449–67.

Quenon and Le Fort 1997
Quenon, Michel and Genevieve Le Fort. "Rebirth and Resurrection in Maize God Iconography." In The Maya Vase Book. Vol. 5. Ed. Justin Kerr. New York: Kerr Associates, 1997, pp. 884–902.

Quilter 1990
Quilter, Jeffrey. "The Moche Revolt of Objects." Latin American Antiquity 1, 1 (1990), pp. 42–65.

Quilter 1997
Quilter, Jeffrey. "The Narrative Approach to Moche Iconography." Latin American Antiquity 8, 2 (1997), pp. 113–33.

Rands, Bishop, and Harbottle 1978
Rands, Robert L., Ronald L. Bishop, and Garman Harbottle. "Thematic and Compositional Variation in Palenque Region Incensarios." In Tercera Mesa Redonda de Palenque. Eds. Merle Greene Robertson and Donnan C. Jeffers. Monterrey, California: Pre-Columbian Research Center, 1978, pp. 19–30.

Redfield 1941
Redfield, Robert. Folk Culture of Yucatan. Chicago: University of Chicago Press, 1941.

Redfield and Villa Rojas 1934
Redfield, Robert and Alfonso Villa Rojas. Chan K'om: A Maya Village. Washington, DC: Carnegie Institution of Washington, 1934.

Reents-Budet 1994
Reents-Budet, Dorie. Painting the Maya Universe: Royal Ceramics of the Classic Period. Durham, North Carolina: Duke University Press, 1994.

Reilly 2007
Reilly, F. Kent. "The Petaloid Motif: A Celestial Symbolic Locative in the Shell Art of Spiro." In F. Kent Reilly and James F. Garber, eds. Ancient Objects and Sacred Realms: Interpretations of Mississippian Iconography. Austin: University of Texas Press, 2007, pp. 39–55.

Reuters 2009
Reuters. "Archeologists Find Rare Maya Panels in Guatemala," March 11, 2009. http://uk.reuters.com/article/lifestyleMolt/idUKTRE52A7FP20090311?sp=true.

Rice 1984
Rice, Prudence M., ed. Pots and Potters: Current Approaches in Ceramic Archaeology. Los Angeles: Institute of Archaeology, University of California, Los Angeles, 1984.

Rice 1999
Rice, Prudence M. "Rethinking Classic Lowland Maya Pottery Censers." Ancient Mesoamerica 10 (1999), pp. 25–50.

Rich 2008
Rich, Michelle E. "Analysis of Samples and Artifacts from the Mirador Group, El Peru-Waka'." http://www.famsi.org/reports/07087/index.html, 2008.

Rich, Matute, and Piehl 2007
Rich, Michelle E., Varinia Matute, and Jennifer Piehl. "WK-11: Further Excavation at Structure O14-04." In Proyecto Arqueológico El Perú-Waka': Informe No. 4, Temporada 2006. Eds. Héctor L. Escobedo and David Freidel. Report submitted to the Institute of Anthropology and History, Guatemala, 2007.

Ringle et al. 2004
Ringle, William M. et al. "The Decline of the East: the Classic to Postclassic Transition at Ek Balam, Yucatan." In The Terminal Classic in the Maya Lowlands: Collapse, Transition, and Transformation. Eds. Arthur A. Demarest, Prudence M. Rice, and Don S. Rice. Boulder: University Press of Colorado, 2004, pp. 485–516.

Río and Cabrera 1822
Río, Antonio del and Paul Felix Cabrera. Description of the Ruins of an Ancient City, Discovered near Palenque, in the Kingdom of Guatemala. London: H. Berthoud, and Suttaby, Evance and Fox, 1822.

Roberts and Shackleton 1983
Roberts, Kenneth G. and Phillip Shackleton. The Canoe: A History of the Craft from Panama to the Arctic. Camden, Maine: International Marine Publishing, 1983.

Robicsek and Hales 1981
Robicsek, Francis and Donald M. Hales. The Maya Book of the Dead: The Ceramic Codex. Charlottesville: University of Virginia Art Museum, 1981.

Romero R. 1998
Romero R., María Eugenia. "La Navegación Maya." Arqueología Mexicana 6, 33 (1998), pp. 6–15.

Rouse 1992
Rouse, Irving. The Tainos: Rise and Decline of the People Who Greeted Columbus. New Haven and London: Yale University Press, 1992.

Roys 1965
Roys, Ralph L. Ritual of the Bacabs. Norman: University of Oklahoma Press, 1965.

Roys 1967
Roys, Ralph L., trans. Book of Chilam Balam of Chumayel. Norman: University of Oklahoma Press, 1967.

Ruppert and Denison 1943
Ruppert, Karl and John H. Denison, Jr. Archaeological Reconnaissance in Campeche, Quintana Roo, and Petén. Washington, DC: Carnegie Institution of Washington, Publication 543, 1943.

Sabloff 1977
Sabloff, Jeremy. "Old Myths, New Myths: The Role of Sea Traders in the Development of Ancient Maya Civilization." In The Sea in the Pre-Columbian World. Ed. Elizabeth P. Benson. Washington, DC: Dumbarton Oaks, 1977, pp. 67–95.

Sahagún 1978
Sahagún, Bernadino de. *Florentine Codex: General History of the Things of New Spain, Book 3: The Origin of the Gods.* Trans. Arthur J. O. Anderson and Charles Dibble. Salt Lake City: University of Utah Press, 1978.

Sahagún 1980
Sahagún, Bernadino de. *Florentine Codex: General History of the Things of New Spain, Book 2: The Ceremonies.* Trans. Arthur J. O. Anderson and Charles Dibble. Salt Lake City: University of Utah Press, 1980.

Saturno 2006
Saturno, William. "The Dawn of Maya Gods and Kings." *National Geographic* 209, 1 (2006), pp. 68–77.

Saturno, Taube, and G. Stuart 2005
Saturno, William, Karl A. Taube, and George Stuart. *The Murals of San Bartolo, El Petén, Guatemala; Part 1: The North Wall.* Barnardsville, North Carolina: Center for Ancient American Studies, Ancient America 7, 2005.

Scarborough 1993
Scarborough, Vernon L. "Water Management in the Southern Maya Lowlands: An Accretive Model for the Engineered Landscape." In Vernon L. Scarborough and Barry L. Isaac, eds. *Economic Aspects of Water Management in the Prehispanic New World.* Greenwich, Connecticut: Jai Press Inc., Research in Economic Anthropology, Supplement 7, 1993, pp. 17–69.

Scarborough 1998
Scarborough, Vernon L. "Ecology and Ritual: Water Management and the Maya." *Latin American Antiquity* 9, 2 (1998), pp. 135–59.

Scarborough 2003
Scarborough, Vernon L. *The Flow of Power: Ancient Water Systems and Landscapes.* Santa Fe: School of American Research Press, 2003.

Scarborough 2007
Scarborough, Vernon L. "Colonizing a Landscape: Water and Wetlands in Ancient Mesoamerica." In Vernon L. Scarborough and John E. Clark, eds. *The Political Economy of Ancient Mesoamerica: Transformations during the Formative and Classic Periods.* Albuquerque: University of New Mexico Press, 2007, pp. 163–74.

Schaafsma and Taube 2006
Schaafsma, Polly and Karl A. Taube. "Bringing the Rain: An Ideology of Rain Making in the Pueblo Southwest and Mesoamerica." In Jeffrey Quilter and Mary E. Miller, eds. *A Pre-Columbian World.* Washington, DC: Dumbarton Oaks Research Library and Collection, 2006.

Schaffer 1986
Schaeffer, Anne Louise. "The Maya: Posture of Royal Ease." In *6th Mesa Redonda de Palenque.* Vol. 8. Ed. Merle Greene Robertson. Norman: University of Oklahoma Press, 1986, pp. 203–16.

Schele 1988
Schele, Linda. "Xibalba Shuffle: A Dance after Death." In *Maya Iconography.* Eds. Elizabeth P. Benson and Gillett G. Griffin. Princeton, New Jersey: Princeton University Press, 1988.

Schele and Freidel 1991
Schele, Linda and David Freidel. "The Courts of Creation: Ballcourts, Ballgames, and Portals to the Maya Underworld." In *The Mesoamerican Ballgame.* Eds. Vernon L. Scarborough and David R. Wilcox. Tucson: The University of Arizona Press, 1991, pp. 289–315.

Schele and Mathews 1979
Schele, Linda and Peter Mathews. *The Bodega of Palenque, Chiapas, Mexico.* Washington, DC: Dumbarton Oaks, 1979.

Schele and M. E. Miller 1986
Schele, Linda and Mary E. Miller. *The Blood of Kings: Dynasty and Ritual in Maya Art.* New York: George Braziller, in association with the Kimbell Art Museum, Fort Worth, 1986.

Schlesinger 2001
Schlesinger, Victoria. *Animals and Plants of the Ancient Maya: A Guide.* Austin: University of Texas Press, 2001.

Schmidt, de la Garza, and Nalda 1999
Schmidt, Peter, Mercedes de la Garza, and Enrique Nalda. *Maya.* Milan: Conalculta, Instituto Nacional de Antropología e Historia, 1999.

Schneebaum 1990
Schneebaum, Tobias. *Embodied Spirits: Ritual Carvings of the Asmat.* Salem, Massachusetts: Peabody Museum of Salem, 1990.

Scott and Brady 2005
Scott, Ann M. and James E. Brady. "Human Remains in Lowland Maya Caves: Problems of Interpretation." In Keith M. Prufer and James E. Brady, eds. *Stone Houses and Earth Lords: Maya Religion in the Cave Context.* Boulder: University Press of Colorado, 2005, pp. 263–84.

Sharer, J. C. Miller, and Traxler 1992
Sharer, Robert J., Julia C. Miller, and Loa P. Traxler. "Evolution of Classic Period Architecture in the Eastern Acropolis, Copan." *Ancient Mesoamerica* 3 (1992), pp. 145–59.

Shatto 1998
Shatto, Rahilla Corinne Abbas. "Maritime Trade and Seafaring of the Precolumbian Maya." MA thesis. Texas A & M University, 1998.

Shaw 1972
Shaw, Mary. *Según nuestros antepasados…: Textos folklóricos de Guatemala y Honduras.* Guatemala City: Instituto Lingüístico de Verano en Centro America, 1972.

Shepard 1948
Shepard, Anna. *Plumbate: A Mesoamerican Trade Ware.* Washington, DC: Carnegie Institution of Washington, 1948.

Shook 1951
Shook, Edwin M. "Guatemala." In *Carnegie Institution of Washington, Yearbook* 50 (1951), pp. 240–44.

Simoni-Abbat 1974
Simoni-Abbat, Mireille. *Art Maya du Mexique.* Paris: Musée National d'histoire naturelle, 1974.

A. L. Smith 1950
Smith, Augustus Ledyard. *Uaxactun, Guatemala; Excavations of 1931–1937.* Washington, DC: Carnegie Institution of Washington, 1950.

M. E. Smith 2001
Smith, Michael E. *The Aztecs.* 2nd ed. Malden, Massachusetts, and Oxford: Blackwell Publishers, 2001.

R. E. Smith 1955
Smith, Robert Eliot. *Ceramic Sequence at Uaxactun, Guatemala.* Vol. 2. New Orleans: Middle American Research Institute, Tulane University, 1955.

Solís Olguin and Velasco Alonso 2002
Solís Olguin, Felipe and Roberto Velasco Alonso. "#232, Chacmool." In Eduardo Matos Moctezuma and Felipe Solís Olguin, eds. *Aztecs.* London: Royal Academy of Arts, 2002.

Sosa 1985
Sosa, John. "The Maya Sky, the Maya World: A Symbolic Analysis of Yucatec Maya Cosmology." PhD dissertation. University of New York, Albany, 1985.

Soustelle 1937
Soustelle, Jacques. "La culture matérielle des Indiens Lacandons." *Journal de la société des américanistes* 29, 1 (1937), pp. 1–96.

Spinden 1913/1975
Spinden, Herbert J. *A Study of Maya Art, Its Subject Matter and Historical Development.* New York: Dover Publications, 1975. Originally pub. Cambridge, Massachusetts: Peabody Museum of American Archaeology and Ethnology, Harvard University, 1913.

Squier 1855
Squier, Ephraim George. *Notes on Central America.* New York: Harper and Brothers, 1855.

Starr 1908
Starr, Frederick. *Indian Mexico.* Chicago: Forbes, 1908.

Stephens 1841/1984
Stephens, John Lloyd. *Incidents of Travel in Central America, Chiapas, and Yucatan.* 2 Vols. New York: Harpers, 1984. Originally pub. 1841.

Stirling 1943
Stirling, Matthew W. *Stone Monuments of Southern Mexico*. Bureau of American Ethnology, Bulletin 138. Washington, DC: Smithsonian Institution, 1943.

Stirling 1957
Stirling, Matthew W. "An Archaeological Reconnaissance of Southern Mexico." *Smithsonian Institution Bureau of American Ethnology: Anthropological Papers* 164, 53 (1957), pp. 213–40.

Stone and Balser 1965
Stone, Doris and Carlos Balser. "Incised Slate Disks from the Atlantic Watershed of Costa Rica." *American Antiquity* 30, 3 (1965), pp. 310–29.

Stothert 2003
Stothert, Karen E. "Expression of Ideology in the Formative Period of Ecuador." In *Archaeology of Formative Ecuador*. Ed. Jeffrey Quilter. Washington, DC: Dumbarton Oaks Research Library and Collection, 2003, pp. 337–421.

Strong 1935
Strong, William D. *Archaeological Investigations in the Bay Islands, Spanish Honduras*. Washington, DC: Smithsonian Institution, Smithsonian Miscellaneous Collection 92(14), 1935.

D. Stuart 1985
Stuart, David. "Inscription on Four Shell Plaques from Piedras Negras, Guatemala." In *Fourth Palenque Round Table, 1980*. Ed. Elizabeth P. Benson. San Francisco: Pre-Columbian Art Research Institute, 1985, pp. 175–83.

D. Stuart 1989
Stuart, David. "An Early Maya Shell at Princeton." *Record of The Art Museum Princeton University* 48, 12 (1989), pp. 37–38.

D. Stuart 1992
Stuart, David. "Hieroglyphs and archaeology at Copan." *Ancient Mesoamerica* 3 (1992), pp. 169–84.

D. Stuart 1998
Stuart, David. "'The Fire Enters His House': Architecture and Ritual in Classic Maya Texts." In Stephen D. Houston, ed. *Function and Meaning in Classic Maya Architecture*. Washington, DC: Dumbarton Oaks Research Library and Collection, 1998, pp. 373–425.

D. Stuart 2004
Stuart, David. "La concha decorada de la tumba del Templo del Buho, Dzibanche." In *Los Cautivos de Dzibanché*. Ed. Enrique Nalda. Mexico: Instituto Nacional de Antropología e Historia, 2004, pp. 133–40.

D. Stuart 2005
Stuart, David. *The Inscriptions from Temple XIX at Palenque: A Commentary*. San Francisco: Pre-Columbian Art Research Institute, 2005.

D. Stuart 2006A
Stuart, David. "The Language of Chocolate: References to Cacao on Classic Maya Drinking Vessels." In *Chocolate in Mesoamerica: A Cultural History of Cacao*. Ed. Cameron L. McNeil. Gainesville: University Press of Florida, 2006, pp. 184–201.

D. Stuart 2006B
Stuart, David. "The Palenque Mythology: Inscriptions and Interpretations of the Cross Group." In David Stuart, ed. *Sourcebook for the 30th Maya Meetings*. Austin: The Mesoamerican Center, Department of Art and Art History, University of Texas at Austin, 2006, pp. 85–194.

D. Stuart 2007A
Stuart, David. "Old Notes on the Possible ITZAM Sign." *Maya Decipherment: A Weblog on the Ancient Maya Script*, September 29, 2007. http://decipherment.wordpress.com.

D. Stuart 2007B
Stuart, David. "Reading the Water Serpent as Witz." *Maya Decipherment*, 2007. http://decipherment.wordpress.com/2007/04/13/reading-the-water-serpent/.

D. Stuart 2008
Stuart, David. "Shining Stones: Observations on the Ritual Meaning of Early Maya Stelae." Paper presented at the 2007 Dumbarton Oaks Pre-Columbian Symposium, Antigua, Guatemala, 2008.

D. Stuart 2009
Stuart, David. "A Sun God Image from Dos Pilas, Guatemala." *Maya Decipherment*. http://decipherment.wordpress.com/2009/04/10/a-sun-god-image-from-dos-pilas-guatemala/.

D. Stuart and G. Stuart 2008
Stuart, David and George Stuart. *Palenque: Eternal City of the Maya*. London and New York: Thames and Hudson, 2008.

D. Stuart and Houston 1994
Stuart, David and Stephen D. Houston. *Classic Maya Place Names*. Washington, DC: Dumbarton Oaks Research Library and Collection, Studies in Pre-Columbian Art and Archaeology 33, 1994.

Tate 1985
Tate, Carolyn. "The Carved Ceramics Called Chocholá." In *Fifth Palenque Round Table, 1983*. Eds. Merle Green Robertson and Virginia M. Fields. San Francisco: The Pre-Columbian Art Research Institute, 1985, pp. 123–33.

Taube 1985
Taube, Karl A. "The Classic Maya Maize God: A Reappraisal." In *Fifth Palenque Round Table, 1983*. Eds. Merle Green Robertson and Virginia M. Fields. San Francisco: The Pre-Columbian Art Research Institute, 1985, pp. 171–81.

Taube 1988
Taube, Karl A. "A Prehispanic Maya Katun Wheel." *Journal of Anthropological Research* 44, 2 (1988), pp. 183–203.

Taube 1992
Taube, Karl A. *The Major Gods of Ancient Yucatan*. Washington, DC: Studies in Pre-Columbian Art and Archaeology 32, Dumbarton Oaks Research Library and Collection, 1992.

Taube 1993
Taube, Karl A. *Aztec and Maya Myths*. London: The British Museum Press, 1993.

Taube 1994
Taube, Karl A. "Iconography of Toltec Period Chichén Itzá." In *Hidden among the Hills: Maya Archaeology of the Northwest Yucatan Peninsula*. Ed. Hanns J. Prem. Möckühl: Verlad Von Flemming, 1994, pp. 212–46.

Taube 1996A
Taube, Karl A. "The Olmec Maize God: The Face of Corn in Formative Mesoamerica." *Res: Anthropology and Aesthetics* 29/30 (1996), pp. 39–81.

Taube 1996B
Taube, Karl A. "The Rainmakers: The Olmec and Their Contribution to Mesoamerican Belief and Ritual." In *The Olmec World: Ritual and Rulership*. Princeton, New Jersey: The Art Museum, Princeton University, in association with Harry N. Abrams, 1996, pp. 82–103.

Taube 1997
Taube, Karl A. "A God Named Zip." *Archaeology* 50 (1997), p. 39.

Taube 1998
Taube, Karl A. "The Jade Hearth: Centrality, Rulership, and the Classic Maya Temple." In Stephen D. Houston, ed. *Function and Meaning in Classic Maya Architecture*. Washington, DC: Dumbarton Oaks Research Library and Collection, 1998, pp. 454–60.

Taube 2001
Taube, Karl A. "The Breath of Life: The Symbolism of Wind in Mesoamerica and the American Southwest." In Virginia M. Fields and Victor Zamudio-Taylor, eds. *The Road to Aztlan: Art from a Mythic Homeland*. Los Angeles: Los Angeles County Museum of Art, 2001, pp. 102–23.

Taube 2002
Taube, Karl A. "La serpiente emplumada de Teotihuacan." *Arqueología Mexicana* 53 (2002), pp. 36–41.

Taube 2003A
Taube, Karl A. "Ancient and Contemporary Maya Conceptions About Field and Forest." In *The Lowland Maya Area: Three Millennia at the Human-Wildland Interface*. Eds. A. Gómez-Pompa et al. New York: Food Products Press, 2003.

Taube 2003 B
Taube, Karl A. "Maws of Heaven and Hell: The Symbolism of the Centipede and Serpent in Classic Maya Religion." In *Antropología de la eternidad: La muerte en la cultura Maya*. Eds. Andrés Ciudad Ruiz, Mario Humberto Ruz Sosa, and María Josefa Iglesias Ponce de León. Madrid and Mexico City: Sociedad Española de Estudios Mayas and El Centro de la Cultura Maya, Madrid and Mexico City, 2003, pp. 405–42.

Taube 2003C
Taube, Karl A. "Tetitla and the Maya Presence at Teotihuacan." In *Teotihuacan and the Maya: Reinterpreting Early Classic Maya Interaction*. Ed. Geoffrey Braswell. Austin: University of Texas Press, 2003, pp. 273–314.

Taube 2004
Taube, Karl A. "Flower Mountain: Concepts of Life, Beauty and Paradise among the Classic Maya." *Res: Anthropology and Aesthetics* 45 (2004), pp. 69–98.

Taube 2005A
Taube, Karl A. "The Symbolism of Jade in Classic Maya Religion." *Ancient Mesoamerica* 16 (2005), pp. 23–50.

Taube 2005B
Taube, Karl A. "Representaciones del Paraíso en el Arte Cerámico del Clásico Temprano de Escuintla, Guatemala." In *Iconografía y Escritura Teotihuacana en la Costa Sur de Guatemala y Chiapas*." Ed. Oswaldo Chinchilla Mazariegos and Barbara Arroyo. Utz'ib, Serie Reportes 1, 5 (2005), pp. 33–54.

Taube 2006
Taube, Karl A. "Climbing Flower Mountain: Concepts of Resurrection and the Afterlife in Ancient Teotihuacan." In *Arqueología e historia del Centro de México: Homenaje a Eduardo Matos Moctezuma*. Eds. Leonardo López Luján, Davíd Carrasco, and Lordes Cué. Mexico City: Instituto Nacional de Antropología e Historia, 2006, pp. 153–70.

Taube 2009
Taube, Karl A. "El dios de la lluvia Olmeca." *Arqueología Mexicana* 16, 96 (2009), pp. 26–29.

Taube et al. 2004
Taube, Karl A., Virginia B. Sisson, Russell Seitz, and George E. Harlow. "The Sourcing of Mesoamerican Jade: Expanded Geological Reconnaissance in the Motagua Region, Guatemala." In Karl A. Taube, ed. *Olmec Art at Dumbarton Oaks*. Washington, DC: Dumbarton Oaks Research Library and Collection, 2004, pp. 203–20.

Taube, Hruby, and Romero 2005
Taube, Karl A., Zachary Hruby, and Luis Romero. "Jadeite Sources and Ancient Workshops: Archaeological Reconnaissance in the Upper Río El Tambor, Guatemala." http://www.famsi.org/reports/03023/index.html, 2005.

Taube and Saturno 2008
Taube, Karl A. and William Saturno. "Los murales de San Bartolo: Desarrollo temprano del simbolismo y del mito del maíz en la antigua Mesoamérica." In *Olmeca: Balance y perspectivas*. Eds. María Teresa Uriarte and Rebecca B. González Lauck. Mexico City: Universidad Nacional Autónoma de México, 2008, pp. 287–318.

Tedlock 1979
Tedlock, Dennis. "Zuni Religion and World View." In *Handbook of North American Indians*. Vol. 9. Ed. Alfonso Ortíz. Washington, DC: Smithsonian Institution, 1979.

Thompson 1949
Thompson, John Eric Sidney. "Canoes and Navigation of the Maya and Their Neighbors." *The Journal of the Royal Anthropological Institute of Great Britain and Ireland* 79, 1/2 (1949), pp. 69–78.

Thompson 1970A
Thompson, John Eric Sidney. *Maya History and Religion*. Norman: University of Oklahoma Press, 1970.

Thompson 1970B
Thompson, John Eric Sidney. "The Bacabs: Their Portraits and Their Glyphs." In *Papers of the Peabody Museum of Archaeology and Ethnology, Harvard University, Volume 61*. Ed. W. R. J. Bullard. Cambridge, Massachusetts: Peabody Museum of Archaeology and Ethnology, 1970.

Thompson 1975
Thompson, John Eric Sidney. "Thomas Gann in the Maya Ruins." *British Medical Journal* 2 (1975).

Thoreau 1865/2004
Thoreau, Henry David. *Cape Cod*. Mineola, New York: Dover Publications, 2004. Originally published 1865.

Tiesler 2006
Tiesler, Vera. "Life and Death of the Ruler: Recent Bioarchaeological Findings." In Vera Tiesler and Andrea Cucina, eds. *Janaab' Pakal of Palenque: Reconstructing the Life and Death of a Maya Ruler*. Tucson: University of Arizona Press, 2006, pp. 21–47.

Tokovinine 2008
Tokovinine, Alexandre. "Power of Place: Landscape and Identity in Classic Maya Inscriptions, Imagery, and Architecture." PhD dissertation. Harvard University, 2008.

Torres Talamontes 2006
Torres Talamontes, Olmo. "Descripción Limnológica de un Cenote Meromíetico: Nohoch Hol, Quintana Roo, México." Thesis for Bachelor's Degree in Biology. UNAM, México, 2006.

Tovalín Ahumada, Velázquez de Leon Collins, and Ortíz Villareal 1999
Tovalín Ahumada, Alejandro, J. Adolfo Velázquez de Leon Collins, and Victor M. Ortíz Villareal. "Cuenco de alabastro con decoración incisa procedente de Bonampak." *Mexicon* 21, 4 (1999), pp. 75–80.

Tozzer 1907
Tozzer, Alfred M. *A Comparative Study of the Mayas and Lacandones*. New York: AMS Press, 1907.

Tozzer 1941
Tozzer, Alfred M., ed. and trans. *Landa's relación de las cosas de Yucatán*. Cambridge, Massachusetts: Papers of the Peabody Museum of American Archaeology and Ethnology, Harvard University, 1941.

Tozzer 1957
Tozzer, Alred M. *Chichén Itzá and Its Cenote of Sacrifice; A Comparative Study of Contemporaneous Maya and Toltec*. Cambridge, Massachusetts: Memoirs of the Peabody Museum of American Archaeology and Ethnology, Harvard University, 11 (1957).

Trik 1963
Trik, Aubrey S. "Splendid Tomb of Temple 1 at Tikal, Guatemala." *Expedition* 6, 1 (1963), pp. 2–18.

Vargas de la Peña and Castillo Borges 2001
Vargas de la Peña, Leticia and Victor Castillo Borges. "El Mausoleo de Ukit Kan Le'k Tok'." *Los Investigadores de La Cultura Maya* 9, 1 (2001), pp. 144–50.

Vargas de la Peña and Castillo Borges 2006
Vargas de la Peña, Leticia and Victor Castillo Borges. "Hallazgos Recientes en Ek' Balam." *Arqueologia Mexicana* 8, 76 (2006), pp. 56–69.

Villa Rojas 1945
Villa Rojas, Alfonso. *The Maya of East Central Quintana Roo*. Washington, DC: Carnegie Institution of Washington, 1945.

C. A. Villacorta and J. A. Villacorta C. 1930/1992
Villacorta, Carlos A. and J. Antonio Villacorta C. *The Dresden Codex : Drawings of the Pages and Commentary in Spanish*. Laguna Hills, California: Aegean Park Press, 1992. Originally pub. Guatemala, 1930.

Webster 1976
Webster, David. *Defensive Earthworks at Becan, Campeche, Mexico: Implications for Maya Warfare*. New Orleans: Middle American Research Institute, Tulane University, 1976.

Webster 1996
Webster, David. "Una ciudad maya fortificada: Becán, Campeche." *Arqueología Mexicana* 3, 18 (1996), pp. 32–35.

Webster 2002
Webster, David. *The Fall of the Ancient Maya*. London and New York: Thames and Hudson, 2002.

Webster, Freter, and Gonlin 2000
Webster, David, Anncorinne Freter, and Nancy Gonlin. *Copán: The Rise and Fall of an Ancient Maya Kingdom*. Orlando, Florida: Harcourt College Publishers, 2000.

Wilbert 1977
Wilbert, James. "Navigators of the Winter Sun." In *The Sea in the Pre-Columbian World*. Ed. Elizabeth P. Benson. Washington, DC: Dumbarton Oaks Research Library and Collection, 1977, pp. 17–46.

Wilson 2007
Wilson, Samuel M. *The Archaeology of the Caribbean*. Cambridge: Cambridge University Press, 2007.

Wilson, Iceland, and Hester 1998
Wilson, Samuel M., Harry B. Iceland, and Thomas R. Hester. "Preceramic Connections between Yucatan and the Caribbean." *Latin American Antiquity* 9, 4 (1998), pp. 342–52.

Winfield Capitaine 1988
Winfield Capitaine, Fernando. "La Estela 1 de la Mojarra, Veracruz, México." *Research Reports on Ancient Maya Writing* 16 (1988).

Wisdom 1940
Wisdom, Charles. *The Chorti Indians of Guatemala*. Chicago: University of Chicago Press, 1940.

Woods and Titmus 1996
Woods, James C. and Gene L. Titmus. "Stone on Stone: Perspectives of Maya Civilization from Lithic Studies." In *Eighth Palenque Round Table, 1993*. Eds. Merle Green Robertson, Martha J. Macri, and Jan McHargue. San Francisco: Pre-Columbian Art Research Institute, 1996, pp. 479–89.

Wray 1945
Wray, Donald E. "The Historical Significance of the Murals in the Temple of the Warriors, Chichen Itza." *American Antiquity* 11, 1 (1945), pp. 25–27.

Wren and Schmidt 1990
Wren, Linnéa and Peter Schmidt. "Elite Interaction during the Terminal Classic Period: New Evidence from Chichen Itza." In *Classic Maya Political History: Hieroglyphic and Archaeological Evidence*. Ed. T. Patrick Culbert. Cambridge and New York: Cambridge University Press, 1990, pp. 199–225.

Zender 1999
Zender, Marc Uwe. "Diacritical Marks and Underspelling in the Classic Maya Script: Implications for Decipherment." MA thesis. University of Calgary, 1999.

Zender 2001
Zender, Marc Uwe. "A Study of Two Uaxactun-style Tamale Serving Vessels." In *The Maya Vase Book*. Vol. 6. Ed. Justin Kerr. New York: Kerr Associates, 2001, pp. 1038–71.

Zender 2004
Zender, Marc Uwe. "A Study of Classic Maya Priesthood." PhD dissertation. University of Calgary, 2004.

Zender 2005
Zender, Marc. "Teasing the Turtle from Its Shell: AHK and MAHK in Maya Writing." PARI On-line Publications, 2005, pp. 1–14. http://www.mesoweb.com/pari/publications/journal/603/Turtle_e.pdf.

Zender, Armijo, and Gallegos 2001
Zender, Marc Uwe, Ricardo Armijo, and Miriam Judith Gallegos. "Vida y Obra de Aj Pakal Tahn, un sacerdote del siglo VIII en Comalcalco, Tabasco, México." In *Los Investigadores de la Cultura Maya 9, Tomo II*. Ed. Ricardo Encalada. Campeche, Mexico: Universidad Autonoma de Campeche, 2001, pp. 387–98.

Zralka 2007
Zralka, Jaroslaw. *The Nakum Archaeological Project: Investigations on the Banks of the Holmul River, Guatemala*. Foundation for the Advancement of Mesoamerican Studies, Inc., 2007. www.famsi.org/reports/06022/06022Zralka01.pdf.

INDEX

Page numbers in italics refer to illustrations.

IMAGE CREDITS

Figures

Frontispiece. © Edwin Beckenbach/Photographer's Choice/Getty Images. Introduction. © Jeff Rotman/Photonica/Getty Images.

Chapter 1

Miller/O'Neil
Page 24. © Michael S. Lewis/National Geographic Stock. Figure 1. © Sandra Critelli. Figure 2. K1925 © Justin Kerr. Figure 3. © President and Fellows of Harvard College. Figure 4. © Jorge Pérez de Lara. Figure 6. © Kimbell Art Museum, 1998 by Michael Bodycomb. Figure 7. © Jorge Pérez de Lara. Figure 8. K8019 © Justin Kerr.

McKillop
Page 38. Photograph by Heather McKillop. Figure 1. Photograph by Heather McKillop. Figure 2. Photograph by Heather McKillop.

Stuart
Page 41. © Kenneth Garrett/National Geographic Stock. Figure 2. Photograph by Kenneth Garrett. Figure 4. Photograph by Kirk French.

Plates
Plates 2, 3, figure 1. © The Trustees of the British Museum.

Chapter 2

Houston
Page 66. © Medioimages/Photodisc/Getty Images. Figure 3. © Dumbarton Oaks, Pre-Columbian Collection, Washington, DC. Figure 5. Photograph by Ian Graham, reproduced courtesy of the Corpus of Maya Hieroglyphic Inscriptions, Peabody Museum of Archaeology and Ethnology, Harvard University, Cambridge, Massachusetts. © President and Fellows of Harvard College. Figure 6. Courtesy of Ray Matheny. Figure 7. Courtesy of Ray Matheny. Figure 8. Photograph by Stephen D. Houston. Figure 9. K1892 © Justin Kerr. Figure 10. K1609 © Justin Kerr. Figure 11. K1162 © Justin

Kerr. Figure 12. Photograph by Ian Graham, reproduced courtesy of the Corpus of Maya Hieroglyphic Inscriptions, Peabody Museum of Archaeology and Ethnology, Harvard University, Cambridge, Massachusetts. © President and Fellows of Harvard College. Figure 15. Photograph by George Mobley, courtesy of George Stuart, Center for Maya Research. Figure 18. K4576 © Justin Kerr. Figure 19. K6225 © Justin Kerr.

Fash
Page 80. © President and Fellows of Harvard College. Figure 1. Photograph by Barbara W. Fash. Figure 2. K4400J © Justin Kerr.

Zender
Page 83. Photograph by Greg Grimes. Figure 1. Photograph by Merle Greene Robertson. Figure 2. K808 © Justin Kerr.

Plates
Plate 22, figure 1. K2705 © Justin Kerr. Plate 23, figure 1. K4705 © Justin Kerr. Plate 34, figure 1. Photograph by Stephen D. Houston. Plate 36, figure 1. K4336 © Justin Kerr. Plates 38, 39, figure 2. K2847 © Justin Kerr. Plate 44, figure 1. © Jorge Pérez de Lara. Plate 52, figure 1. Photograph from A. F. and D. Z. Chase 1986, used with authors' permission.

Chapter 3

Finamore
Page 144. © Jorge Pérez de Lara. Figure 2. Photograph by Carolyn Schroer, courtesy Houston Museum of Natural Science. Figure 4. Photograph by David Pentecost. Figure 5. Photograph by David Pentecost. Figure 6. University of Pennsylvania Museum of Archaeology and Anthropology, Philadelphia, negatives 63-5-96, 63-5-99. Figure 7. K731 © Justin Kerr. Figure 10. © Museum of Fine Arts, Houston. Figure 11. © Dallas Museum of Art. Figure 15. © Paul Chesley/National Geographic Image Collection. Figure 16. © Akademische Druck-u.

Verlagsanstalt – Graz. Figure 17. © Akademische Druck-u. Verlagsanstalt – Graz.

Martin
Page 160. © Tony Arruza/CORBIS. Figure 1. © Enrico Ferorelli. Figure 2. K511 © Justin Kerr.

Cobos
Page 163. Photograph by Anthony P. Andrews. Figure 1. Photograph courtesy of Rafael Cobos. Figure 2. Photograph courtesy of Rafael Cobos.

Plates
Plate 60, figure 1. K3033 © Justin Kerr. Plate 61, figure 1. K5608 © Justin Kerr.

Chapter 4

Taube
Page 202. © Patricio Robles Gil/Minden Pictures/National Geographic Image Collection. Figure 5. K2796 © Justin Kerr. Figure 6. K7750 © Justin Kerr. Figure 12. K7443 © Justin Kerr. Figure 14. University of Pennsylvania Museum of Archaeology and Anthropology, Philadelphia, negative 63-5-87. Figure 15. © Akademische Druck-u. Verlagsanstalt – Graz. Figure 16. © Akademische Druck-u. Verlagsanstalt – Graz. Figure 18. Photograph by Alfred P. Maudslay, Brooklyn Museum Library, Special Collections. Figure 25. © Dumbarton Oaks, Pre-Columbian Collection, Washington, DC. Figure 29. Photograph by Karl A. Taube.

Brady
Page 220. © Stephen Alvarez/National Geographic Stock. Figure 1. Photograph by James E. Brady. Figure 2. Photograph by Allan Cobbs. Figure 3. © Stephen Alvarez/National Geographic Stock.

Martos López

Page 223. © 2009 Robert Frerck/Odyssey Productions/ Chicago. Figure 1. © DEA/C.SAPPA/De Agostini Picture Library/Getty Images. Figure 2. Courtesy of Louis Alberto Martos López.

Plates

Plate 80, figure 1. K9152 © Justin Kerr and Dumbarton Oaks, Pre-Columbian Collection, Washington, DC. Plate 93, figure 1. © President and Fellows of Harvard College. Plate 98, figure 1. Photograph by Varinia Matute, courtesy El Peru-Waka' Archaeological Project.

Coda

Page 290. © Michael S. Lewis/National Geographic Image Collection. Figure 2. Courtesy Peabody Essex Museum, photograph by Walter Silver. Figure 3. Courtesy Peabody Essex Museum, photograph by Walter Silver. Figure 4. © Hellenic Ministry of Culture/ Archaeological Receipts Fund. Figure 5. © The Trustees of the British Museum. Figure 6. © The Metropolitan Museum of Art. Figure 7. Photograph of Henri Julien painting, 21 1/8 x 26 ¼ inches (53.5 x 66.5 cm), by Jean-Guy Kérouac. Figure 8. Courtesy Peabody Essex Museum, photograph by Walter Silver. Figure 9. © Mimmo Jodice/CORBIS. Figure 10. © Martin Gray/ National Geographic Stock. Figure 11. Courtesy Peabody Essex Museum, photograph by Walter Silver.

Visual glossary: water and creatures

Water

Preclassic, drawing by Ayax Moreno, courtesy of the New World Archaeological Foundation. Early Classic, drawing by Stephen D. Houston after Hellmuth 1987A, pl. 179. Late Classic, drawing by Stephen D. Houston after Hellmuth 1987A, pl. 162. Postclassic, drawing by Karl A. Taube.

Water lily

Preclassic, drawing by Karl A. Taube. Early Classic, drawing by Stephen D. Houston after Hellmuth 1987A, pl. 385. Late Classic, drawing by Simon Martin, courtesy Arq. Ramon Carrasco and the Proyecto Arqueológico de Calakmul. Postclassic, drawing by Karl A. Taube.

Conch

Preclassic, drawing by Karl A. Taube. Early Classic, drawing by Karl A. Taube. Late Classic, drawing by Karl A. Taube. Postclassic, drawing by George Schwartz after Gates 1932, p. 37.

Spondylus

Preclassic, drawing by Karl A. Taube. Early Classic, drawing by Linda Schele, © David Schele, courtesy Foundation for the Advancement of Mesoamerican Studies, Inc., www.famsi.org. Late Classic, drawing by Karl A. Taube. Postclassic, drawing by Karl A. Taube.

Fish

Preclassic, drawing by Ayax Moreno, courtesy of the New World Archaeological Foundation. Early Classic, drawing by James Doyle. Late Classic, drawing by Nick Carter. Postclassic, drawing by Karl A. Taube.

Crocodile

Preclassic, drawing by Karl A. Taube. Early Classic, drawing by Karl A. Taube after Lynn Crocker. Late Classic, drawing by Karl A. Taube. Postclassic, drawing by Karl A. Taube.

Turtle

Preclassic, painting by Heather Hurst. Early Classic, drawing by Ian Graham, courtesy of the Corpus of Maya Hieroglyphic Inscriptions, Peabody Museum, Harvard University, Cambridge, Massachusetts, © President and Fellows of Harvard College. Late Classic, drawing by Stephen D. Houston. Postclassic, drawing by Karl A. Taube.

Shark

Preclassic, drawing by Karl A. Taube. Early Classic, drawing by Karl A. Taube. Late Classic, drawing by Karl A. Taube. Postclassic, drawing by Karl A. Taube.

Water Lily serpent

Preclassic, drawing by Karl A. Taube. Early Classic, drawing by Karl A. Taube. Late Classic, drawing by Karl A. Taube after Parsons 1980, no. 314. Postclassic, drawing by Karl A. Taube.

Plumed serpent

Preclassic, drawing by Karl A. Taube. Early Classic, drawing by Karl A. Taube. Late Classic, drawing by Karl A. Taube. Postclassic, drawing by Karl A. Taube.

Visual glossary: deities

Chahk
Preclassic, drawing by Ayax Moreno, courtesy of the New World Archaeological Foundation. Early Classic, drawing by Karl A. Taube after Coe 1982, p. 71. Late Classic, drawing by Karl A. Taube. Postclassic, drawing by Simon Martin.

Shark Sun God
Early Classic, drawing by Karl A. Taube after Berjonneau, Deletaille, and Sonnery 1985, pl. 326. Late Classic, drawing by Linda Schele, © David Schele, courtesy Foundation for the Advancement of Mesoamerican Studies, Inc., www.famsi.org.

Jaguar God of the Underworld
Early Classic, drawing by Linda Schele, © David Schele, courtesy Foundation for the Advancement of Mesoamerican Studies, Inc., www.famsi.org. Late Classic, drawing by Karl A. Taube.

Sun God (solar deity)
Preclassic, drawing by Karl A. Taube after James Porter. Early Classic, drawing by Karl A. Taube. Late Classic, drawing by Karl A. Taube. Postclassic, drawing by Karl A. Taube.

Maize God
Preclassic, drawing by Karl A. Taube. Early Classic, drawing by Karl A. Taube. Late Classic, drawing by Karl A. Taube after Robicsek and Hales 1981, fig. 59. Postclassic, drawing by Karl A. Taube after A. G. Miller 1982, pl. 6.

God L
Early Classic, drawing by Karl A. Taube after photograph K3801 by Justin Kerr. Late Classic, drawing by Karl A. Taube after M. D. Coe 1973, p. 109. Postclassic, drawing by Karl A. Taube.

God N
Early Classic, drawing from D. Z. Chase and A. F. Chase 1986, used with authors' permission. Late Classic, drawing by Linda Schele, © David Schele, courtesy Foundation for the Advancement of Mesoamerican Studies, Inc., www.famsi.org. Postclassic, drawing by Karl A. Taube.